PORTABLE EDITION | BOOK 2 | FOURTH EDITION

ART HISTORY

Medieval Art

MARILYN STOKSTAD

Judith Harris Murphy Distinguished Professor of Art History Emerita
The University of Kansas

MICHAEL W. COTHREN

Scheuer Family Professor of Humanities
Department of Art, Swarthmore College

CONTRIBUTOR

D. Fairchild Ruggles

Prentice Hall

Boston Columbus Indianapolis New York San Francisco Upper Saddle River
Amsterdam Cape Town Dubai London Madrid Milan Munich Paris Montréal Toronto
Delhi Mexico City São Paulo Sydney Hong Kong Seoul Singapore Taipei Tokyo

Editorial Director: Craig Campanella
Editor-in-Chief: Sarah Touborg
Senior Sponsoring Editor: Helen Ronan
Editorial Project Manager: David Nitti
Editorial Assistant: Carla Worner
Editor-in-Chief, Development: Rochelle Diogenes
Development Editors: Margaret Manos and Cynthia Ward
Media Director: Brian Hyland
Media Editor: Dave Alick
Media Project Manager: Rich Barnes
Director of Marketing: Brandy Dawson
Senior Marketing Manager: Kate Mitchell
Marketing Assistant: Craig Deming
Senior Managing Editor: Ann Marie McCarthy
Assistant Managing Editor: Melissa Feimer
Production Project Managers: Barbara Cappuccio and Marlene Gassler
Senior Operations and Manufacturing Manager: Nick Sklitsis
Senior Operations Specialist: Brian Mackey
Manager of Design Development: John Christiana
Art Director and Interior Design: Kathy Mrozek
Cover Design: Kathy Mrozek
Site Supervisor, Pearson Imaging Center: Joe Conti
Pearson Imaging Center: Corin Skidds, Robert Uibelhoer, and Ron Walko
Cover Printer: Lehigh-Phoenix Color
Printer/Binder: Courier/Kendallville

This book was designed by
Laurence King Publishing Ltd, London
www.laurenceking.com

Commissioning Editor: Kara Hattersley-Smith
Senior Editors: Melissa Danny/Sophie Page
Production Manager: Simon Walsh
Production File Preparation: Jo Fernandes
Page Design: Nick Newton/Randell Harris
Photo Researcher: Emma Brown
Copy Editors: Tessa Clark/Jenny Knight/Robert Shore/Johanna Stephenson
Proofreader: Jennifer Speake
Indexer: Sue Farr

Cover photo: *Queen Blanche of Castile and King Louis IX*. From a Moralized Bible made in Paris. 1226–1234. Ink, tempera, and gold leaf on vellum, 15 × 10½″ (38 × 26.6 cm). The Pierpont Morgan Library, New York. MS. M. 240, fol. 8r. The Pierpoint Morgan Library, New York/Art Resource, NY.

Credits and acknowledgments borrowed from other sources and reproduced, with permission, in this textbook appear on the appropriate page within text or on the credit pages in the back of this book.

Library of Congress Cataloging-in-Publication Data
Stokstad, Marilyn
 Art History / Marilyn Stokstad, Michael W. Cothren; contributors,
Frederick M. Asher … [eg al.]. —4th ed.
 p. cm.
 Includes bibliographical references and index.
 ISBN-13: 978-0-205-74422-0 (hardcover : alk. paper)
 ISBN-10: 0205-74422-2 (hardcover : alk. paper)
 1. Art—History. I. Cothren, Michael Watt. II. Asher, Frederick M. III
Title.
N5300.S923 2011
709—dc22
 2010001489

10 9 8 7 6 5 4 3 2

Prentice Hall
is an imprint of

PEARSON
www.pearsonhighered.com

ISBN 10: 0-205-79092-5
ISBN 13: 978-0-205-79092-0

CONTENTS

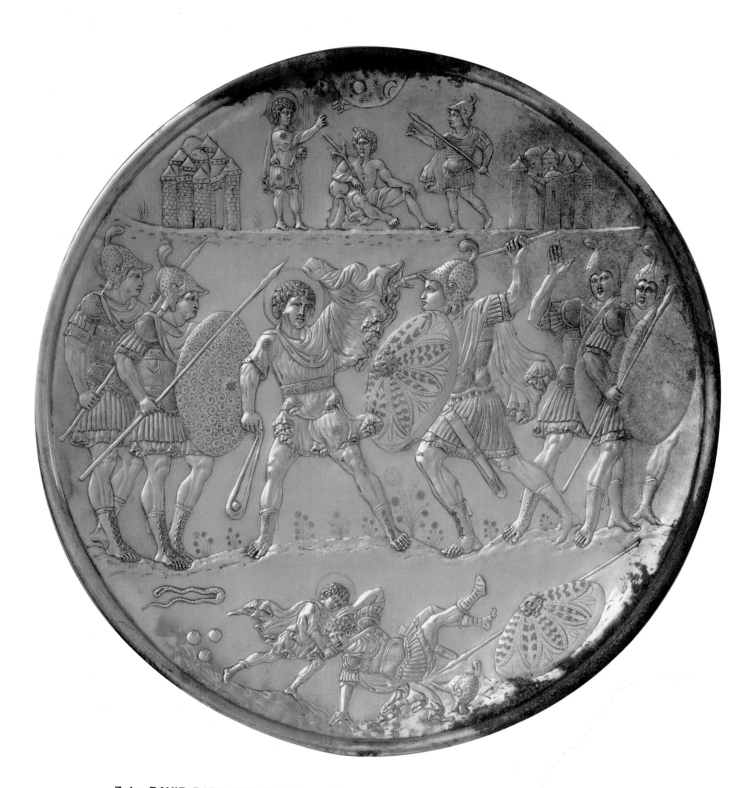

7-1 • DAVID BATTLING GOLIATH One of the "David Plates," made in Constantinople. 629–630 CE. Silver, diameter 19⅞" (49.4 cm). Metropolitan Museum of Art, New York.

JEWISH, EARLY CHRISTIAN, AND BYZANTINE ART

The robust figures on this huge silver plate (FIG. 7–1) enact three signature episodes in the youthful hero David's combat with the Philistine giant Goliath (I Samuel 17:41–51). In the upper register, David—easily identified not only by his youth but also by the prominent halo as the "good guy" in all three scenes—and Goliath challenge each other on either side of a seated Classical personification of the stream that will be the source of the stones David will use in the ensuing battle. The confrontation itself appears in the middle, in a broad figural frieze whose size signals its primary importance. Goliath is most notable here for his superior armaments—helmet, spear, sword, and an enormous protective shield. At the bottom, David, stones and slingshot flung behind him, consummates his victory by severing the head of his defeated foe, whose imposing weapons and armor are scattered uselessly behind him.

It may be surprising to see a Judeo–Christian subject portrayed in a style that was developed for the exploits of Classical heroes, but this mixture of traditions is typical of the eclecticism characterizing the visual arts as the Christianized Roman world became the Byzantine Empire. Patrons saw no conflict between the artistic principles of the pagan past and the Christian teaching undergirding their imperial present. To them, this Jewish subject, created for a Christian patron in a pagan style, would have attracted notice only because of its sumptuousness and its artistic virtuosity.

This was one of nine "David Plates" unearthed in Cyprus in 1902. Control stamps—guaranteeing the purity of the material, much like the stamps of "sterling" that appear on silver today—date them to the reign of the Byzantine emperor Heraclius (r. 613–641 CE). Displayed in the home of their owners, they were visual proclamations of wealth, but also of education and refined taste, just like collections of art and antiques in our own day. A constellation of iconographic and historical factors allows us to uncover a subtler message, however. For the original owners, the single combat of David and Goliath might have recalled a situation involving their own emperor and enemies.

The reign of Heraclius was marked by war with the Sassanian Persians. A decisive moment in the final campaign of 628–629 CE occurred when Heraclius himself stepped forward for single combat with the Persian general Razatis, and the emperor prevailed, presaging Byzantine victory. Some contemporaries referred to Heraclius as a new David. Is it possible that the set of David Plates was produced for the emperor to offer as a diplomatic gift to one of his aristocratic allies, who subsequently took them to Cyprus? Perhaps the owners later buried them for safekeeping—like the early silver platter from Mildenhall (SEE FIG. 6–67)—where they awaited discovery at the beginning of the twentieth century.

LEARN ABOUT IT

7.1 Investigate how aspects of Jewish and Early Christian art developed from the artistic traditions of the Roman world.

7.2 Interpret how Early Christian and Byzantine artists used narrative and iconic imagery to convey the foundations of the Christian faith for those already initiated into the life of the Church.

7.3 Analyze the connection between form and function in buildings created for worship.

7.4 Assess the central role of images in the devotional practices of the Byzantine world and explore the reasons for and impact of the brief interlude of iconoclasm.

7.5 Trace the growing Byzantine interest in conveying human emotions and representing human situations when visualizing sacred stories.

HEAR MORE: Listen to an audio file of your chapter **www.myartslab.com**

JEWS, CHRISTIANS, AND MUSLIMS

Three religions that arose in the Near East dominate the spiritual life of the Western world today: Judaism, Christianity, and Islam. All three are monotheistic—believing that the same God of Abraham created and rules the universe, and hears the prayers of the faithful. Jews believe that God made a covenant, or pact, with their ancestors, the Hebrews, and that they are God's chosen people. They await the coming of a savior, the Messiah, "the anointed one." Christians believe that Jesus of Nazareth was that Messiah (the name Christ is derived from the Greek term meaning "Messiah"). They believe that, in Jesus, God took human form, preached among men and women, suffered execution, then rose from the dead and ascended to heaven after establishing the Christian Church under the leadership of the apostles (his closest disciples). Muslims, while accepting the Hebrew prophets and Jesus as divinely inspired, believe Muhammad to be the last and greatest prophet of God (Allah), the Messenger of God through whom Islam was revealed some six centuries after Jesus' lifetime.

All three are "religions of the book," that is, they have written records of God's will and words: the Hebrew Bible; the Christian Bible, which includes the Hebrew Bible as its Old Testament as well as the Christian New Testament; and the Muslim Qur'an, believed to be the Word of God as revealed in Arabic directly to Muhammad through the archangel Gabriel.

Both Judaism and Christianity existed within the Roman Empire, along with various other religions devoted to the worship of many gods. The variety of religious buildings excavated in present-day Syria at the abandoned Roman outpost of Dura-Europos (see "Dura-Europos," page 223) represents the cosmopolitan religious character of Roman society in the second and third centuries. The settlement—destroyed in 256 CE— included a Jewish house-synagogue, a Christian house-church, shrines to the Persian cults of Mithras and Zoroaster, and temples to Greek and Roman gods, including Zeus and Artemis.

EARLY JEWISH ART

The Jewish people trace their origin to a Semitic people called the Hebrews, who lived in the land of Canaan. Canaan, known from the second century CE by the Roman name Palestine, was located along the eastern edge of the Mediterranean Sea (MAP 7–1). According to the Torah, the first five books of the Hebrew Bible, God promised the patriarch Abraham that Canaan would be a homeland for the Jewish people (Genesis 17:8), a belief that remains important for some Jews to this day.

Jewish settlement of Canaan probably began sometime in the second millennium BCE. According to Exodus, the second book of the Torah, the prophet Moses led the Hebrews out of slavery in Egypt to the promised land of Canaan. At one crucial point during the journey, Moses climbed alone to the top of Mount Sinai, where God gave him the Ten Commandments, the cornerstone of Jewish law. The commandments, inscribed on tablets, were kept in a gold-covered wooden box, the Ark of the Covenant.

Jewish law forbade the worship of idols, a prohibition that often made the representational arts—especially sculpture in the round—suspect. Nevertheless, artists working for Jewish patrons depicted both symbolic and narrative Jewish subjects, and they looked to both Near Eastern and Classical Greek and Roman art for inspiration.

THE FIRST TEMPLE IN JERUSALEM. In the tenth century BCE, the Jewish king Solomon built a temple in Jerusalem to house the Ark of the Covenant. According to the Hebrew Bible (2 Chronicles 2–7),

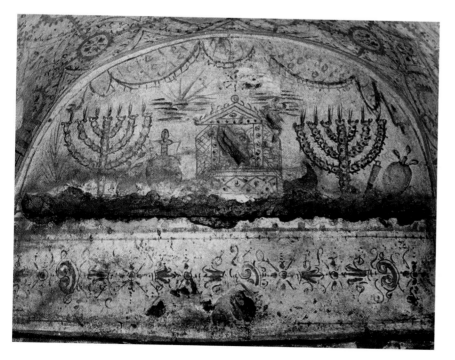

7-2 • MENORAHS AND ARK OF THE COVENANT
Wall painting in a Jewish catacomb, Villa Torlonia, Rome. 3rd century. 3'11" × 5'9" (1.19 × 1.8 m).

The menorah form probably derives from the ancient Near Eastern Tree of Life, symbolizing for the Jewish people both the end of exile and the paradise to come.

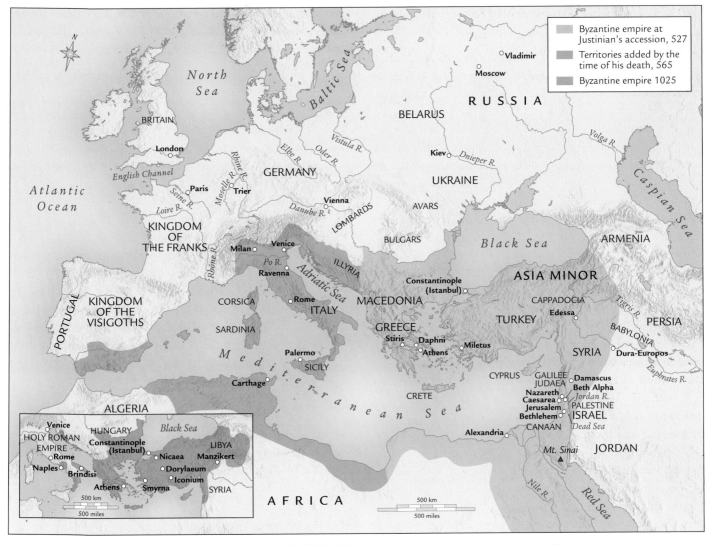

MAP 7-1 • THE LATE ROMAN AND BYZANTINE WORLD

The eastern shores of the Mediterranean, birthplace of Judaism and Christianity, were the focal point of the Byzantine Empire. It expanded further west under the Emperor Justinian, though by 1025 CE it had contracted again to the east.

he sent to nearby Phoenicia for cedar, cypress, and sandalwood, and for a superb construction supervisor. Later known as the First Temple, it was the spiritual center of Jewish life. Biblical texts describe courtyards, two bronze **pillars** (large, free-standing architectural forms), an entrance hall, a main hall, and the Holy of Holies, the innermost chamber that housed the Ark and its guardian cherubim, or attendant angels.

In 586 BCE, the Babylonians, under King Nebuchadnezzar II, conquered Jerusalem. They destroyed the Temple, exiled the Jews, and carried off the Ark of the Covenant. When Cyrus the Great of Persia conquered Babylonia in 539 BCE, he permitted the Jews to return to their homeland (Ezra 1:1–4) and rebuild the Temple, which became known as the Second Temple. When Canaan became part of the Roman Empire, Herod the Great (king of Judaea, 37–34 BCE) restored the Second Temple. In 70 CE, Roman forces led by the general and future emperor Titus

destroyed and looted the Second Temple and all of Jerusalem, a campaign the Romans commemorated on the Arch of Titus (SEE FIG. 6–33). The site of the Second Temple, the Temple Mount, is also an Islamic holy site, the Haram al-Sharif, and is now occupied by the shrine called the Dome of the Rock (SEE FIGS. 8–3, 8–4, 8–5).

JEWISH CATACOMB ART IN ROME. Most of the earliest surviving examples of Jewish art date from the Hellenistic and Roman periods. Six Jewish **catacombs** (underground cemeteries), discovered on the outskirts of Rome and in use from the first to fourth centuries CE, display wall paintings with Jewish themes. In one example, from the third century CE, two **menorahs** (seven-branched lamps), flank the long-lost **ARK OF THE COVENANT (FIG. 7–2)**. The continuing representation of the menorah, one of the precious objects looted from the Second Temple, kept the memory of the lost Jewish treasures alive.

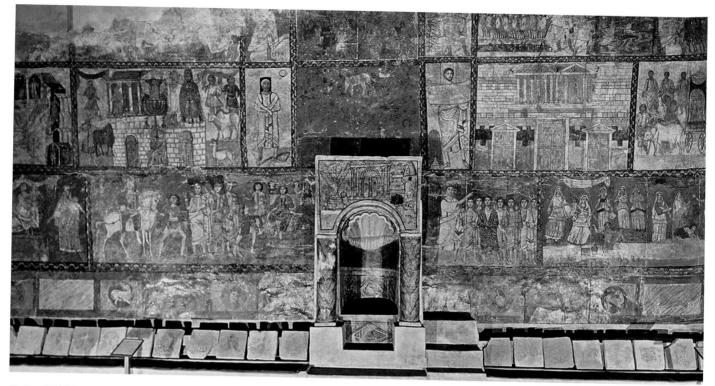

7-3 • WALL WITH TORAH NICHE
From a house-synagogue, Dura-Europos, Syria. 244–245 CE. Tempera on plaster, section approx.
40′ (12.19 m) long. Reconstructed in the National Museum, Damascus, Syria.

SYNAGOGUES. Judaism has long emphasized religious learning. Jews gather in synagogues for study of the Torah—considered a form of worship. A synagogue can be any large room where the Torah scrolls are kept and read; it was also the site of communal social gatherings. Some synagogues were located in private homes or in buildings originally constructed like homes. The first Dura-Europos synagogue consisted of an assembly hall, a separate alcove for women, and a courtyard. After a remodeling of the building, completed in 244–245 CE, men and women shared the hall,

and residential rooms were added. Two architectural features distinguished the assembly hall: a bench along its walls and a niche for the Torah scrolls **(FIG. 7–3)**.

Scenes from Jewish history and the story of Moses, as recorded in Exodus, unfold in a continuous visual narrative around the room, employing the Roman tradition of epic historical presentation (SEE FIG. 6–44). In the scene of **THE CROSSING OF THE RED SEA (FIG. 7–4)**, Moses appears twice to signal sequential moments in the dramatic narrative. To the left he leans toward the army of Pharaoh

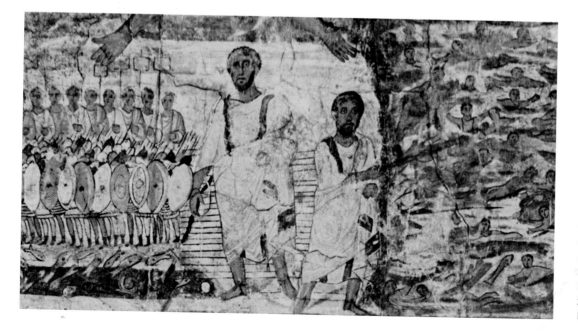

7-4 • THE CROSSING OF THE RED SEA
Detail of a wall painting from a house-synagogue, Dura-Europos, Syria. 244–245 CE. National Museum, Damascus.

The Mosaic Floor of the Beth Alpha Synagogue

by Marianos and Hanina. Ritual Objects, Celestial Diagram, and Sacrifice of Isaac. Galilee, Israel. 6th century CE.

The shrine that holds the Torah is flanked by menorahs and growling lions, perhaps there as a security system to protect such sacred objects.

The figures in the four corners are winged personifications of the seasons; this figure holding a shepherd's crook and accompanied by a bird is Spring.

At the center of the zodiac wheel is a representation of the sun in a chariot set against a night sky studded with stars and a crescent moon.

The 12 signs of the zodiac appear in chronological order following a clockwise arrangement around the wheel of a year, implying perpetual continuity since the series has no set beginning and no end. This is Scorpio.

The peaceful coexistence of the lion and the ox (predator and prey) may represent a golden age or peaceable kingdom (Isaiah 11:6–9; 65:25).

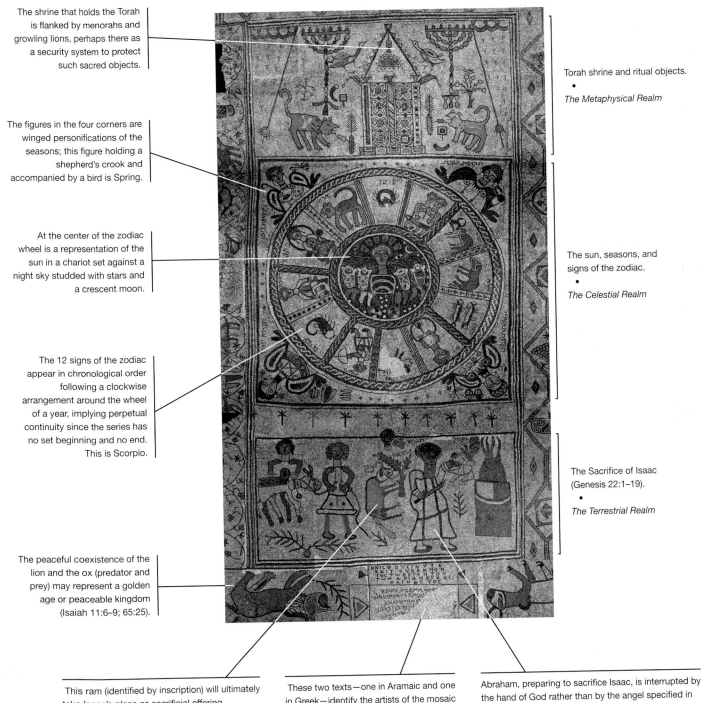

Torah shrine and ritual objects.

• *The Metaphysical Realm*

The sun, seasons, and signs of the zodiac.

• *The Celestial Realm*

The Sacrifice of Isaac (Genesis 22:1–19).

• *The Terrestrial Realm*

This ram (identified by inscription) will ultimately take Isaac's place as sacrificial offering. Throughout the mosaic, animals are shown consistently in profile, human beings frontally.

These two texts—one in Aramaic and one in Greek—identify the artists of the mosaic as Marianos and his son Hanina, and date their work to the reign of Emperor Justin I or II (518–578).

Abraham, preparing to sacrifice Isaac, is interrupted by the hand of God rather than by the angel specified in the Bible. Both Abraham and Isaac are identified by inscription, but Abraham's advanced age is signaled pictorially by the streaks of gray in his beard.

SEE MORE: View the Closer Look feature for the Mosaic Floor of the Beth Alpha Synagogue www.myartslab.com

marching along the path that had been created for the Hebrews by God's miraculous parting of the waters, but at the right, wielding his authoritative staff, he returns the waters over the Egyptian soldiers to prevent them from pursuing his followers. Over both scenes hovers a large hand, representing God's presence in both miracles—the parting and the unparting—using a symbol that will also be frequent in Christian art. Hieratic scale makes it clear who is the hero in this two-part narrative, but the clue to his identity is provided only by the context of the story, which observers would have already known.

In addition to house-synagogues, Jews built meeting places designed on the model of the ancient Roman basilica. A typical basilica synagogue had a central nave; an aisle on both sides, separated from the nave by a line of columns; a semicircular apse with Torah shrine in the wall facing Jerusalem; and perhaps an atrium and porch, or **narthex** (vestibule). The small, fifth-century CE synagogue at Beth Alpha—discovered between the Gilboa mountains and the River Jordan by farmers in 1928—fits well into this pattern, with a three-nave interior, vestibule, and courtyard. Like some other very grand synagogues, it also has a mosaic floor, in this case a later addition from the sixth century. Most of the floor decoration is geometric in design, but in the central nave there are three complex panels full of figural compositions and symbols (see "A Closer Look," page 221) created using 21 separate colors of stone and glass tesserae. The images of ritual objects, a celestial diagram of the zodiac, and a scene of Abraham's near-sacrifice of Isaac, bordered by strips of foliate and geometric ornament, draw on both Classical and Near Eastern pictorial traditions.

EARLY CHRISTIAN ART

Christians believe in one God manifest in three persons—the Trinity of Creator-Father (God), Son (Jesus Christ), and Holy Spirit—and that Jesus was the Son of God by a human mother, the Virgin Mary. At the age of 30, Jesus gathered a group of followers, male and female; he performed miracles of healing and preached love of God and neighbor, the sanctity of social justice, the forgiveness of sins, and the promise of life after death. Christian belief holds that, after his ministry on Earth, Jesus was executed by crucifixion, and after three days rose from the dead.

THE CHRISTIAN BIBLE. The Christian Bible is divided into two parts: the Old Testament (the Hebrew Bible) and the New Testament. The life and teachings of Jesus of Nazareth were recorded between about 70 and 100 CE in New Testament Gospels attributed to the four evangelists (from the Greek *evangelion*, meaning "good news"): Matthew, Mark, Luke, and John. The order was set by St. Jerome, an early Church Father who made a translation of the books from Greek into Latin.

In addition to the four Gospels, the New Testament includes the Acts of the Apostles and the Epistles, 21 letters of advice and encouragement written to Christian communities in Greece, Asia Minor, and other parts of the Roman Empire. The final book is Revelation (Apocalypse), a series of enigmatic visions and prophecies concerning the eventual triumph of God at the end of the world, written about 95 CE.

THE EARLY CHURCH. Jesus limited his ministry primarily to Jews; it was his apostles, as well as later followers such as Paul, who took his teachings to gentiles (non-Jews). Despite sporadic persecutions, Christianity persisted and spread throughout the Roman Empire. The government formally recognized the religion in 313, and Christianity grew rapidly during the fourth century. As well-educated, upper-class Romans joined the Christian Church, they established an increasingly elaborate organizational structure along with ever-more complicated rituals and doctrine.

Christian communities became organized by geographic units, called dioceses, along the lines of Roman provincial governments. Senior church officials called bishops served as governors of dioceses made up of smaller units, parishes, headed by priests. A bishop's church is a **cathedral**, a word derived from the Latin *cathedra*, which means "chair" but took on the meaning of "bishop's throne."

Communal Christian worship focused on the central "mystery," or miracle, of the Incarnation of God in Jesus Christ and the promise of salvation. At its core was the ritual consumption of bread and wine, identified as the Body and Blood of Christ, which Jesus had inaugurated at the Last Supper, a Passover seder meal with his disciples just before his crucifixion. Around these acts developed an elaborate religious ceremony, or liturgy, called the **Eucharist** (also known as Holy Communion or the Mass).

The earliest Christians gathered to worship in private apartments or houses, or in buildings constructed after domestic models such as the third-century church-house excavated at Dura-Europos (see "Dura-Europos," opposite). As their rites became more ritualized and complicated, however, Christians developed special buildings—churches and baptisteries—as well as specialized ritual equipment. They also began to use art to visualize their most important stories and ideas (see "Narrative and Iconic," page 224). The earliest surviving Christian art dates to the early third century and derives its styles and its imagery from Jewish and Roman visual traditions. In this process, known as **syncretism**, artists assimilate images from other traditions and give them new meanings. The borrowings can be unconscious or quite deliberate. For example, **orant** figures—worshipers with arms outstretched in prayer—can be pagan, Jewish, or Christian, depending on the context in which they occur. Perhaps the best-known syncretic image is the Good Shepherd. In pagan art, he was Apollo, or Hermes the shepherd, or Orpheus among the animals, or a personification of philanthropy. For Early Christians, he became the Good Shepherd of the Psalms (Psalm 23) and the Gospels (Matthew 18:12–14, John 10:11–16). Such images, therefore, do not have a stable meaning, but are associated with the meaning(s) that a particular viewer brings to them. They remind rather than instruct.

Our understanding of buildings used for worship by third-century Jews and Christians was greatly enhanced—even revolutionized—by the spectacular discoveries made in the 1930s while excavating the Roman military garrison and border town of Dura-Europos (in modern Syria). In 256, threatened by the Parthians attacking from the east, residents of Dura built a huge earthwork mound around their town in an attempt to protect themselves from the invading armies. In the process—since they were located on the city's margins right against its defensive stone wall—the houses used by Jews and Christians as places of worship were buried under the earthwork perimeter. In spite of this enhanced fortification, the Parthians conquered Dura-Europos. But since the victors never unearthed the submerged margins of the city, an intact Jewish house-synagogue and Christian house-church remained underground awaiting the explorations of modern archaeologists.

We have already seen the extensive strip narratives flanking the Torah shrine in the house-synagogue (SEE FIG. 7–3). The discovery of this expansive pictorial decoration contradicted a long-held scholarly belief that Jews of this period avoided figural decoration of any sort, in conformity to Mosaic law (Exodus 20:4). And a few blocks down the street that ran along the city wall, a typical Roman house built around a central courtyard held another surprise. Only a discreet red cross above the door distinguished it from the other houses on its block, but the arrangement of the interior clearly documents its use as a Christian place of worship. A large assembly hall that could seat 60–70 people sits on one side of the courtyard, and across from it is a smaller but extensively decorated room with a water tank set aside for baptism, the central rite of Christian initiation (FIG. A). Along the walls were scenes from Christ's miracles and a monumental portrayal of women visiting his tomb about to discover his resurrection (below). Above the baptismal basin is a **lunette** (semicircular wall section) featuring the Good Shepherd with his flock, but also including at lower left diminutive figures of Adam and Eve covering themselves in shame after their sinful disobedience (FIG. B). Even this early in Christian art, sacred spaces were decorated with pictures proclaiming the theological meaning of the rituals they housed. In this painting, Adam and Eve's fall from grace is juxtaposed with a larger image of the Good Shepherd (representing Jesus) who came to Earth to care for and guide his sheep (Christian believers) toward redemption and eternal life—a message that was especially appropriate juxtaposed with the rite of Christian baptism, which signaled the converts' passage from sin to salvation.

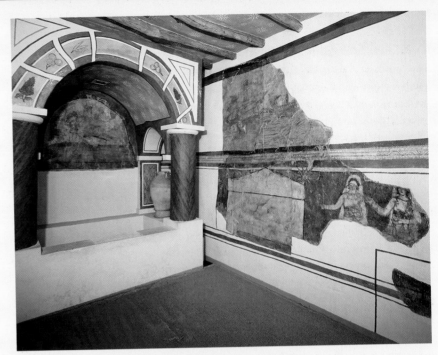

A. MODEL OF WALLS AND BAPTISMAL FONT
Baptistery of a Christian house-church, Dura-Europos, Syria. Before 256. Fresco. Yale University Art Gallery, New Haven, Connecticut.

B. THE GOOD SHEPHERD WITH ADAM AND EVE AFTER THE FALL
Detail of lunette painting above.

Narrative and Iconic

In this Roman catacomb painting (scene at left), Peter, like Moses before him, strikes a rock and water flows from it. Imprisoned in Rome after the arrest of Jesus, Peter converted his fellow prisoners and jailers to Christianity, but he needed water with which to baptize them. Miraculously a spring gushed forth at the touch of his staff.

In the star-studded heavens painted on the vault of this chamber floats the face of Christ, flanked by the first and last letters of the Greek alphabet, alpha and omega. Here Christ takes on the guise not of the youthful teacher or miracle-worker seen so often in Early Christian art, but of a Greek philosopher, with long beard and hair. The halo of light around his head indicates his importance and his divinity, a symbol appropriated from the conventions of Roman imperial art, where haloes often appear around the heads of emperors.

These two catacomb paintings represent two major directions of Christian art—the narrative and the iconic. The **narrative image**

recounts an event drawn from St. Peter's life—striking the rock for water—which in turn evokes the establishment of the Church as well as the essential Christian rite of baptism. The **iconic image**—Christ's face flanked by alpha and omega—offers a tangible expression of an intangible concept. The letters signify the beginning and end of time, and, combined with the image of Christ, symbolically represent not a story, but an idea—the everlasting dominion of the heavenly Christ.

Throughout the history of Christian art these two tendencies will be apparent—the narrative urge to tell a good story, whose moral or theological implications often have instructional or theological value, and the desire to create iconic images that symbolize the core concepts and values of the developing religious tradition. In both cases, the works of art take on meaning only in relation to viewers' stored knowledge of Christian stories and beliefs.

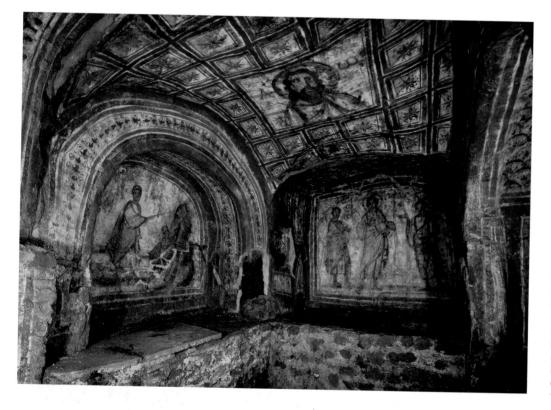

CUBICULUM OF LEONIS, CATACOMB OF COMMODILLA
Near Rome. Late 4th century.

In the niche seen on the right, two early Roman Christian martyrs, Felix (d. 274) and Adauctus (d. 303) flank a youthful, beardless Jesus, who holds a book emphasizing his role as teacher. By including Peter and Roman martyrs in the chamber's decoration, the early Christians, who dug this catacomb as a place to bury their dead, emphasized the importance of their city in Christian history.

CATACOMB PAINTINGS. Christians, like Jews, used catacombs for burials and funeral ceremonies, not as places of worship. In the Christian Catacomb of Commodilla, dating from the fourth century, long rectangular niches in the walls, called *loculi*, each held two or three bodies. Affluent families created small rooms, or **cubicula** (singular, *cubiculum*), off the main passages to house sarcophagi (see "Narrative and Iconic," above). The *cubicula* were

hewn out of tufa, soft volcanic rock, then plastered and painted with imagery related to their owners' religious beliefs. The finest Early Christian catacomb paintings resemble murals in houses such as those preserved at Rome and Pompeii.

One fourth-century Roman catacomb contained remains, or relics, of SS. Peter and Marcellinus, two third-century Christians martyred for their faith. Here, the ceiling of a *cubiculum* is

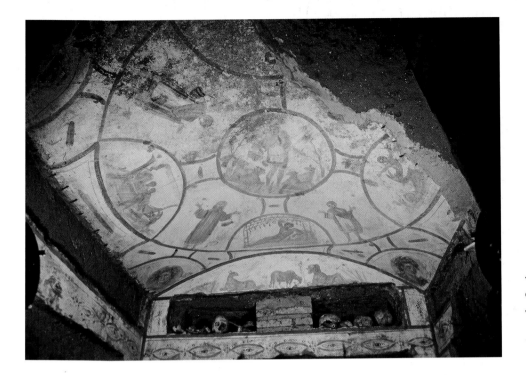

7-5 • THE GOOD SHEPHERD, ORANTS, AND THE STORY OF JONAH
Painted ceiling of the Catacomb of SS. Peter and Marcellinus, Rome. Late 3rd–early 4th century.

partitioned by a central **medallion**, or round compartment, and four **lunettes**, semicircular framed by arches (**FIG. 7–5**). At the center is a Good Shepherd, whose pose has roots in Classical sculpture. In its new context, the image was a reminder of Jesus' promise "I am the good shepherd. A good shepherd lays down his life for the sheep" (John 10:11).

The semicircular compartments surrounding the Good Shepherd tell the story of Jonah and the sea monster from the Hebrew Bible (Jonah 1–2), in which God caused Jonah to be thrown overboard, swallowed by the monster, and released, repentant and unscathed, three days later. Christians reinterpreted this story as a parable of Christ's death and resurrection—and hence of the everlasting life awaiting true believers—and it was a popular subject in Christian catacombs. On the left, Jonah is thrown from the boat; on the right, the monster spits him up; and at the center, Jonah reclines in the shade of a vine, a symbol of paradise. Orant figures stand between the lunettes, presumably images of the faithful Christians who were buried here.

SCULPTURE. Early Christian sculpture before the fourth century is even rarer than painting. What survives is mainly sarcophagi and small statues and reliefs. A remarkable set of small marble figures, discovered in the 1960s and probably made in third-century Asia Minor, features a gracious **GOOD SHEPHERD** (**FIG. 7–6**). Because it was found with sculptures depicting Jonah—as we have already seen, a popular Early Christian theme—it is probably from a Christian home.

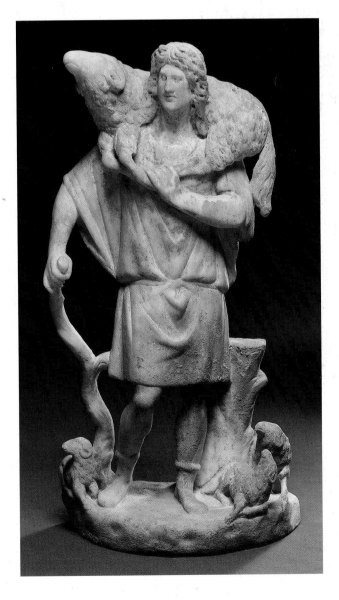

7-6 • THE GOOD SHEPHERD
Eastern Mediterranean, probably Anatolia (Turkey). Second half of the 3rd century. Marble, height 19¾″ (50.2 cm), width 16″ (15.9 cm). Cleveland Museum of Art. John L. Severance Fund, 1965.241

IMPERIAL CHRISTIAN ARCHITECTURE AND ART

When Constantine issued the Edict of Milan in 313, granting all people in the Roman Empire freedom to worship whatever god they wished, Christianity and Christian art and architecture entered a new phase. Sophisticated philosophical and ethical systems developed, incorporating many ideas from Greek and Roman pagan thought. Church scholars edited and commented on the Bible, and the papal secretary who would become St. Jerome (c. 347–420) undertook a new translation from Hebrew and Greek versions into Latin, the language of the Western Church. The so-called Vulgate (from the same root as the word "vulgar," the Latin *vulgaris*, meaning "common" or "popular") became the official version of the Bible.

ARCHITECTURE

The developing Christian community had special architectural needs. Greek temples had served as the house and treasury of the gods, forming a backdrop for ceremonies that took place at altars in the open air. In Christianity, an entire community gathered inside a building to worship. Christians also needed places or buildings for activities such as the initiation of new members, private prayer, and burials. From the age of Constantine, pagan basilicas provided the model for congregational churches, and tombs provided a model for baptisteries and martyrs' shrines (see "Longitudinal-Plan and Central-Plan Churches," page 228).

OLD ST. PETER'S CHURCH. Constantine also ordered the construction of a large new basilica to mark the place where Christians believed St. Peter was buried (see "Longitudinal-Plan and Central-Plan Churches," page 228, FIG. A). Our knowledge of what is now called Old St. Peter's (it was destroyed and replaced

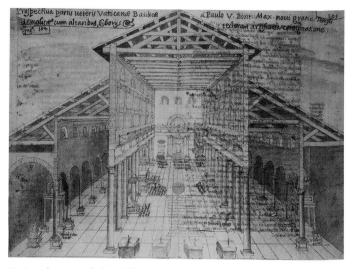

7-7 • Jacopo Grimaldi INTERIOR OF OLD ST. PETER'S
1619 copy of an earlier drawing. Vatican Library, Rome. MS Barberini Lat. 2733, fols. 104v–105r

EXPLORE MORE: Gain insight from a primary source related to Old St. Peter's **www.myartslab.com**

by a new building in the sixteenth century) is based on written descriptions, drawings made before and while it was being dismantled (**FIG. 7–7**), the study of other churches inspired by it, and modern archaeological excavations at the site.

Old St. Peter's included architectural elements in an arrangement that has characterized Christian basilica churches ever since. A narthex across the width of the building provided a place for people who had not yet been baptized. Five doorways—a large, central portal into the nave and two portals on each side—gave access to the church. Columns supporting an entablature lined the nave, forming what is called a nave colonnade. Running parallel to the nave colonnade on each side was another row of columns that

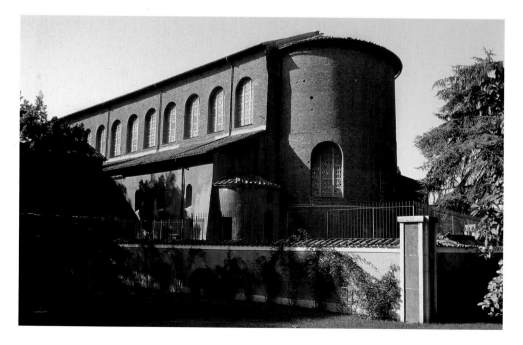

7-8 • CHURCH OF SANTA SABINA
Rome. Exterior view from the southeast. c. 422–432.

SEE MORE: Click the Google Earth link for Santa Sabina **www.myartslab.com**

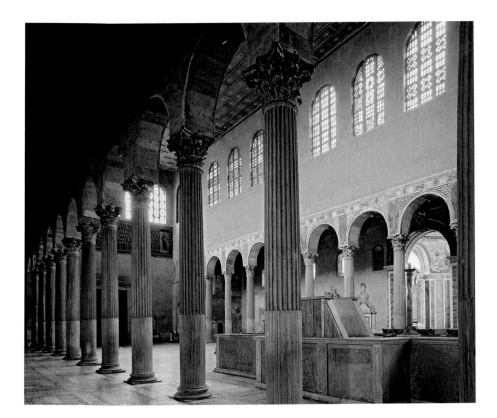

7-9 • INTERIOR, CHURCH OF SANTA SABINA
Rome. View from the south aisle near the sanctuary toward the entrance. c. 422–432.

created double side aisles; these columns supported round arches rather than an entablature. The roofs of both nave and aisles were supported by wooden rafters. Sarcophagi and tombs lined the side aisles. At the apse end of the nave, Constantine's architects added an innovative transept—a perpendicular hall crossing in front of the apse. This area provided additional space for the large number of clergy serving the church, and it also accommodated pilgrims visiting the tomb of St. Peter. Old St. Peter's could hold at least 14,000 worshipers, and it remained the largest church in Christendom until the eleventh century.

SANTA SABINA. Old St. Peter's is gone, but the church of Santa Sabina in Rome, constructed by Bishop Peter of Illyria (a region in the Balkan peninsula) a century later, between about 422 and 432, appears much as it did in the fifth century **(FIGS. 7–8, 7–9)**. The basic elements of the Early Christian basilica church are clearly visible here, inside and out: a nave lit by clerestory windows, flanked by single side aisles, and ending in a rounded apse.

Santa Sabina's exterior is simple brickwork. In contrast, the church's interior displays a wealth of marble veneer and 24 fluted marble columns with Corinthian capitals reused from a second-century pagan building. (Material reused from earlier buildings is known as *spolia*, Latin for "spoils.") The columns support round arches, creating a nave arcade, in contrast to the straight rather than arching nave colonnade in Old St. Peter's. The spandrels—above the columns and between the arches—are inlaid with marble images of the chalice (wine cup) and paten (bread plate)—essential equipment for the Eucharistic rite that took place at the altar. In such basilicas, the blind wall between the arcade and the clerestory

typically had paintings or mosaics with biblical scenes, but here the decoration of the upper walls is lost.

SANTA COSTANZA. Central-plan Roman buildings, with vertical (rather than longitudinal) axes, served as models for Christian tombs, martyrs' churches, and baptisteries (see "Longitudinal-Plan and Central-Plan Churches," page 228). One of the earliest surviving central-plan Christian buildings is the mausoleum of Constantina, daughter of Constantine. Her tomb was built outside the walls of Rome just before 350 **(FIG. 7–10)**, and it was consecrated as a church

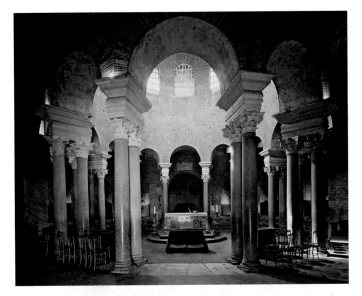

7-10 • CHURCH OF SANTA COSTANZA
Rome. c. 350. View from ambulatory into rotunda.

The forms of Early Christian buildings were based on two Roman prototypes: rectangular basilicas (SEE FIGS. 6–40, 6–59, 6–65) and circular or squared structures—including rotundas like the Pantheon (SEE FIGS. 6–46, 6–47). As in the basilica of Old St. Peter's in Rome (FIG. A), **longitudinal-plan** churches are characterized by a forecourt, the atrium, leading to an entrance porch, the **narthex**, which spans one of the building's short ends. Doorways—known collectively as the church's portals—lead from the narthex into a long, congregational area called a nave. Rows of columns separate the high-ceilinged nave from one or two lower **aisles** on either side. The nave can be lit by windows along its upper level just under the ceiling, called a **clerestory**, that rises above the side aisles' roofs. At the opposite end of the nave from the narthex is a semicircular projection, the **apse**. The apse functions as the building's focal point where the altar, raised on a platform, is located. Sometimes there is also a **transept**, a wing that

crosses the nave in front of the apse, making the building T-shape. When additional space (a liturgical choir) comes between the transept and the apse, the plan is known as a Latin cross.

Central-plan buildings were first used by Christians, like their pagan Roman forebears, as tombs. Central planning was also employed for baptisteries (where Christians "died"—giving up their old life—and were reborn as believers), and churches dedicated to martyrs (e.g. San Vitale, SEE FIG. 7–20), often built directly over their tombs. Like basilicas, central-plan churches can have an atrium, a narthex, and an apse. But instead of the longitudinal axis of basilican churches, which draws worshipers forward along a line from the entrance toward the apse, central-plan buildings, such as the Mausoleum of Constantina—rededicated in 1256 as the church of Santa Costanza (FIG. B)—have a more vertical axis, from the center up through the dome, which may have functioned as a symbolic "vault of heaven."

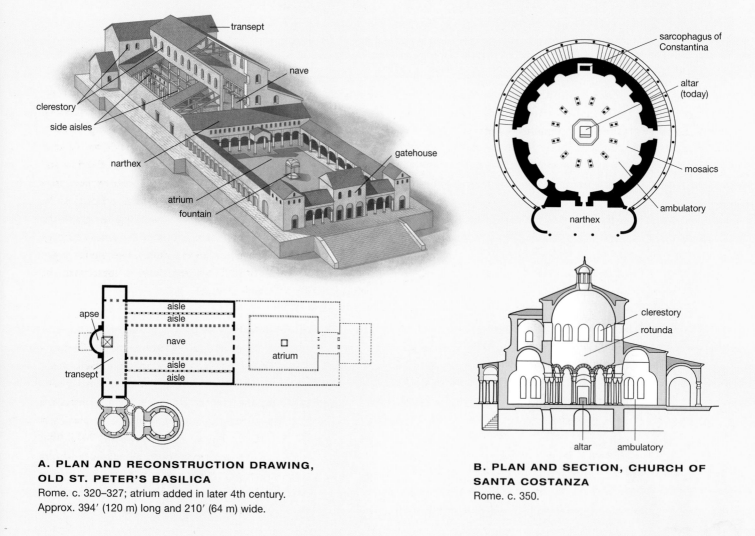

A. PLAN AND RECONSTRUCTION DRAWING, OLD ST. PETER'S BASILICA
Rome. c. 320–327; atrium added in later 4th century.
Approx. 394′ (120 m) long and 210′ (64 m) wide.

B. PLAN AND SECTION, CHURCH OF SANTA COSTANZA
Rome. c. 350.

in 1256, dedicated to Santa Costanza (the Italian form of Constantina, who was sanctified after her death). The building is a tall rotunda with an encircling barrel-vaulted passageway called an **ambulatory**. Paired columns with Composite capitals and richly molded

entablature blocks support the arcade and dome. Originally, the interior was entirely sheathed in mosaics and veneers of fine marble.

Mosaics still surviving in the ambulatory vault recall the syncretic images in the catacombs. In one section, for example, a

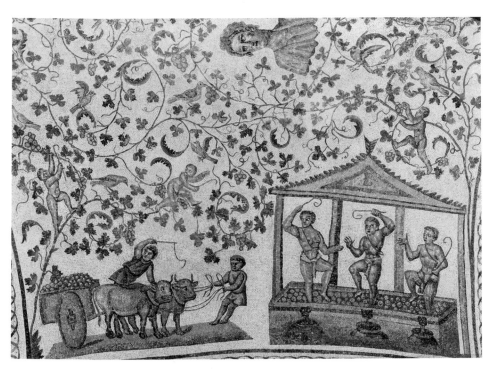

bust portrait of Constantina at the crest of the vault is surrounded by a tangle of grapevines filled with **putti**—naked cherubs, derived from pagan art—who vie with the birds to harvest the grapes (FIG. 7–11). Along the bottom edges on each side, other *putti* drive wagonloads of grapes toward pavilions housing large vats in which more *putti* trample the grapes into juice for the making of wine.

The technique, subject, and style are Roman and traditionally associated with Bacchus and his cult, but the meaning here is new. In a Christian context, the wine references the Eucharist and the trampling of grapes to transform them into wine becomes an image of death and resurrection. Constantina's pagan husband, however, may have appreciated the double allusion.

SCULPTURE

In sculpture, as in architecture, Christians adapted Roman forms for their own needs, especially monumental stone sarcophagi. For instance, within her mausoleum, Constantina (d. 354) was buried within a spectacularly huge porphyry sarcophagus (FIG. 7–12) that was installed across from the entrance on the other side of the ambulatory in a rectangular niche (visible on the plan on page 228, FIG. B; an in-place replica peeks over the altar in FIG. 7–10). The motifs are familiar. The same theme of *putti* making wine that we saw highlighted in the mosaics of the ambulatory vaults appears here as well, focused within areas framed by a huge, undulating grapevine, whose subsidiary shoots curl above and below over the flat sides of the box. Striding along its

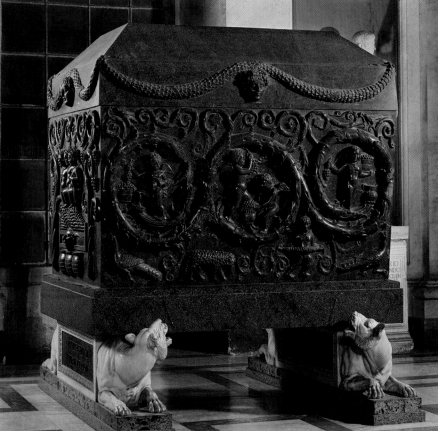

7–12 • SARCOPHAGUS OF CONSTANTINA
c. 350. Porphyry, height 7'5" (2.26 m). Musei Vaticani, Vatican, Rome.

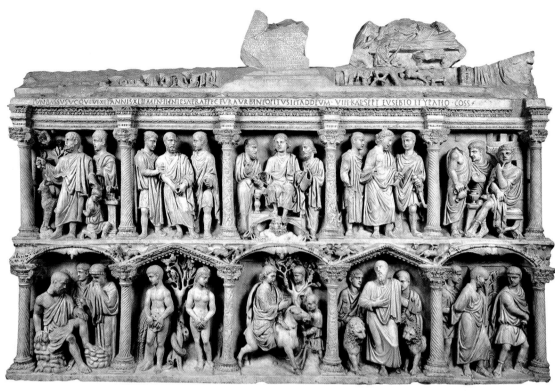

base, peacocks symbolize eternal life in paradise, while a lone sheep could represent a member of Jesus' flock, presumably Constantina herself.

The contemporary marble **SARCOPHAGUS OF JUNIUS BASSUS (FIG. 7–13)** is packed with elaborate figural scenes like the second-century CE Dionysiac Sarcophagus (see "A Closer Look," page 206), only here they are separated into two registers, where columns, entablatures, and gables divide the space into fields for individual scenes. Junius Bassus was a Roman official who, as the inscription here tells us, was "newly baptized" and died on August 25, 359, at the age of 42.

In the center of both registers is a triumphant Christ. Above, he appears as a Roman emperor, distributing legal authority in the form of scrolls to flanking figures of SS. Peter and Paul, and resting his feet on the head of Coelus, the pagan god of the heavens, here representing the cosmos to identify Christ as Cosmocrator (ruler of the cosmos). In the bottom register, the earthly Jesus makes his triumphal entry into Jerusalem, like a Roman emperor entering a conquered city. Jesus, however, rides on a humble ass rather than a powerful steed.

Even in the earliest Christian art, such as that in catacomb paintings and here on the *Sarcophagus of Junius Bassus*, artists employed episodes from the Hebrew Bible allegorically since Christians saw them as prefigurations of important events in the New Testament. At the top left, Abraham passes the test of faith and need not sacrifice his son Isaac. Christians saw in this story an allegory that foreshadowed God's sacrifice of his own son, Jesus, which culminates not in Jesus' death, but his resurrection. Under the triangular gable, second from the end at bottom right, the

Hebrew Bible story of Daniel saved by God from the lions prefigures Christ's emergence alive from his tomb. At bottom far left, God tests the faith of Job, who provides a model for the sufferings of Christian martyrs. Next to Job, Adam and Eve have sinned to set in motion the entire Christian redemption story. Lured by the serpent, they have eaten the forbidden fruit and, conscious of their nakedness, are trying to hide their genitals with leaves.

On the upper right side, spread over two compartments, Jesus appears before Pontius Pilate, who is about to wash his hands, symbolizing that he denies responsibility for Jesus' death. Jesus' position here, held captive between two soldiers, recalls (and perhaps could also be read as) his arrest in Gethsemane, especially since the composition of this panel is reflected in the arrests of the apostles Peter (top, second frame from the left) and Paul (bottom, far right).

RAVENNA

As Rome's political importance dwindled, that of the northern Italian city of Ravenna grew. In 395, Emperor Theodosius I split the Roman Empire into Eastern and Western divisions, each ruled by one of his sons. Heading the West, Honorius (r. 395–423) first established his capital at Milan, but in 402, to escape the siege of Germanic settlers, he moved his government to Ravenna on the east coast. Its naval base, Classis (present-day Classe), had been important since the early days of the empire. In addition to military security, Ravenna offered direct access by sea to Constantinople. When Italy fell in 476 to the Ostrogoths, Ravenna became one of their headquarters, but the beauty and richness of Early Christian buildings can still be experienced there in a remarkable group of well-preserved fifth- and sixth-century buildings.

The Life of Jesus

Episodes from the life of Jesus as recounted in the Gospels form the principal subject matter of Christian visual art. What follows is a list of main events in his life with parenthetical references citing their location in the Gospel texts.

INCARNATION AND CHILDHOOD OF JESUS

The Annunciation: The archangel Gabriel informs the Virgin Mary that God has chosen her to bear his Son. A dove often represents the **Incarnation**, her miraculous conception of Jesus through the Holy Spirit. (Lk 1:26–28)

The Visitation: The pregnant Mary visits her older cousin Elizabeth, pregnant with the future St. John the Baptist. (Lk 1:29–45)

The Nativity: Jesus is born in Bethlehem. The Holy Family—Jesus, Mary, and her husband, Joseph—is usually portrayed in a stable, or, in Byzantine art, a cave. (Lk 2:4–7)

Annunciation to and Adoration of the Shepherds: Angels announce Jesus's birth to shepherds, who hurry to Bethlehem to honor him. (Lk 2:8–20)

Adoration of the Magi: Wise men from the east follow a bright star to Bethlehem to honor Jesus as king of the Jews, presenting him with precious gifts. Eventually these Magi became identified as three kings, often differentiated through facial type as young, middle-aged, and old. (Mat 2:1–12)

Presentation in the Temple: Mary and Joseph bring the Infant Jesus to the Temple in Jerusalem, where he is presented to the high priest. (Lk 2:25–35)

Massacre of the Innocents and Flight into Egypt: An angel warns Joseph that King Herod—to eliminate the threat of a newborn rival king—plans to murder all male babies in Bethlehem. The Holy Family flees to Egypt. (Mat 2:13–16)

JESUS' MINISTRY

The Baptism: At age 30, Jesus is baptized by John the Baptist in the River Jordan. The Holy Spirit appears in the form of a dove and a heavenly voice proclaims Jesus as God's Son. (Mat 3:13–17, Mk 1:9–11, Lk 3:21–22)

Marriage at Cana: At his mother's request Jesus turns water into wine at a wedding feast, his first public miracle. (Jn 2:1–10)

Miracles of Healing: Throughout the Gospels, Jesus performs miracles of healing the blind, possessed (mentally ill), paralytic, and lepers; he also resurrects the dead.

Calling of Levi/Matthew: Jesus calls to Levi, a tax collector, "Follow me." Levi complies, becoming the disciple Matthew. (Mat 9:9, Mk 2:14)

Raising of Lazarus: Jesus brings his friend Lazarus back to life four days after his death. (Jn 11:1–44)

The Transfiguration: Jesus reveals his divinity in a dazzling vision on Mount Tabor as his closest disciples—Peter, James, and John—look on. (Mat 17:1–5, Mk 9:2–6, Lk 9:28–35)

Tribute Money: Challenged to pay the temple tax, Jesus sends Peter to catch a fish, which turns out to have the required coin in its mouth. (Mat 17:24–27, Lk 20:20–25)

JESUS' PASSION, DEATH, AND RESURRECTION

Entry into Jerusalem: Jesus, riding an ass and accompanied by his disciples, enters Jerusalem, while crowds honor him, spreading clothes and palm fronds in his path. (Mat 21:1–11, Mk 11:1–11, Lk 19:30–44, Jn 12:12–15)

The Last Supper: During the Jewish Passover seder, Jesus reveals his impending death to his disciples. Instructing them to drink wine (his blood) and eat bread (his body) in remembrance of him, he lays the foundation for the Christian Eucharist (Mass). (Mat 26:26–30, Mk 14:22–25, Lk 22:14–20)

Jesus Washing the Disciples' Feet: At the Last Supper, Jesus washes the disciples' feet, modeling humility. (Jn 13: 4–12)

The Agony in the Garden: In the Garden of Gethsemane on the Mount of Olives, Jesus struggles between his human fear of pain and death and his divine strength to overcome them. The apostles sleep nearby, oblivious. (Lk 22:40–45)

Betrayal (the Arrest): Judas Iscariot (a disciple) has accepted a bribe to indicate Jesus to an armed band of his enemies by kissing him. (Mat 26:46–49, Mk 14:43–46, Lk 22:47–48, Jn 18:3–5)

Jesus before Pilate: Jesus is taken to Pontius Pilate, Roman governor of Judaea, and charged with treason for calling himself king of the Jews. Pilate proposes freeing Jesus but is shouted down by the mob, which demands Jesus be crucified. (Mat 27:11–25, Mk 15:4–14, Lk 23:1–24, Jn 18:28–40)

The Crucifixion: Jesus is executed on a cross, often shown between two crucified criminals and accompanied by the Virgin Mary, John the Evangelist, Mary Magdalen, and other followers at the foot of the cross; Roman soldiers sometimes torment Jesus—one extending a sponge on a pole with vinegar instead of water for him to drink, another stabbing him in the side with a spear. A skull can identify the execution ground as **Golgotha**, "the place of the skull." (Mat 27:35–50, Mk 15:23–37, Lk 23:38–49, Jn 19:18–30)

Descent from the Cross (the Deposition): Jesus' followers take his body down from the cross. (Mat 27:55–59, Mk 15:40–46, Lk 23:50–56, Jn 19:38–40)

The Lamentation/Pietà and Entombment: Jesus' sorrowful followers gather around his body to mourn and then place his body in a tomb. An image of the grieving Virgin alone with Jesus across her lap is known as a **pietà** (from Latin *pietas*, "pity"). (Mat 27:60–61, Jn 19:41–42)

The Resurrection/Holy Women at the Tomb: Three days after his entombment, Christ rises from the dead, and his female followers—usually including Mary Magdalen—discover his empty tomb. An angel announces Christ's resurrection. (Mat 28, Mk 16, Lk 24:1–35, Jn 20)

Descent into Limbo (Harrowing of Hell or Anastasis): The resurrected Jesus descends into limbo, or hell, to free deserving predecessors, among them Adam, Eve, David, and Moses. (Not in the Gospels)

Noli Me Tangere ("Do Not Touch Me"): Christ appears to Mary Magdalen as she weeps at his tomb. When she reaches out to him, he warns her not to touch him. (Lk 24:34–53, Jn 20:11–31)

The Ascension: Christ ascends to heaven from the Mount of Olives, disappearing in a cloud, while his mother and apostles watch. (Acts 1)

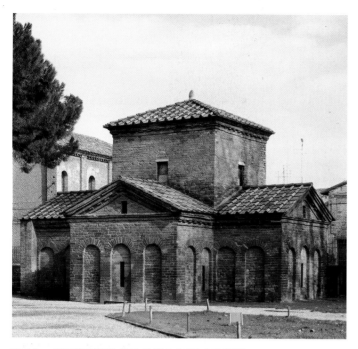

7-14 • ORATORY OF GALLA PLACIDIA
Ravenna. c. 425–426.

SEE MORE: Click the Google Earth link for the Oratory of Galla Placidia **www.myartslab.com**

THE ORATORY OF GALLA PLACIDIA. One of the earliest surviving Christian structures in Ravenna is an **oratory** (small chapel), attached about 425–426 to the narthex of the church of the imperial palace **(FIG. 7–14)**. It is named after Honorius' remarkable half-sister, Galla Placidia—daughter of the Western Roman emperor, wife of a Gothic king, and mother of Emperor Valentinian. As regent for her son after 425, she ruled the West until about 440. The oratory came to be called the Mausoleum of Galla Placidia because she and her family were once believed to be buried there.

This small building is **cruciform**, or cross-shape. A barrel vault covers each of its arms, and a pendentive dome—a dome continuous with its pendentives—covers the square space at the center (see "Pendentives and Squinches," page 236). The interior of the chapel contrasts markedly with the unadorned exterior, a transition seemingly designed to simulate the passage from the real world into the supernatural realm **(FIG. 7–15)**. The worshiper looking from the western entrance across to the eastern bay of the chapel sees brilliant mosaics in the vaults and panels of veined marble sheathing the walls below. Bands of luxuriant floral designs and geometric patterns cover the arches and barrel vaults. The upper walls of the central space are filled with the figures of standing

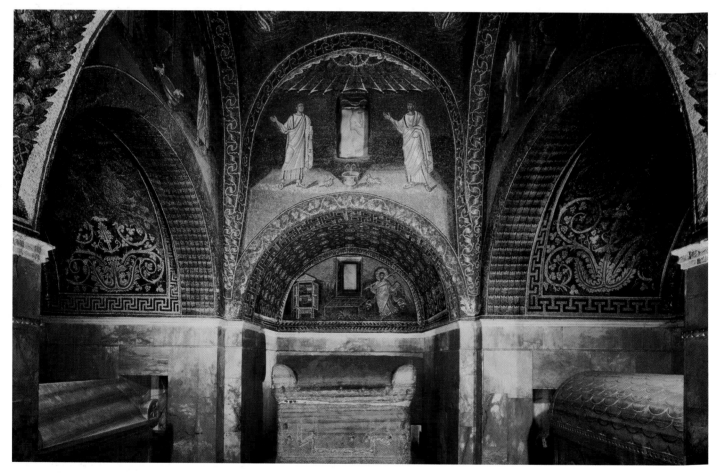

7-15 • ORATORY OF GALLA PLACIDIA
Ravenna. View from entrance, barrel-vaulted arms housing sarchophagi, lunette mosaic of the martyrdom of St. Lawrence. c. 425–426.

SEE MORE: View a panorama of the interior of the Oratory of Galla Placidia **www.myartslab.com**

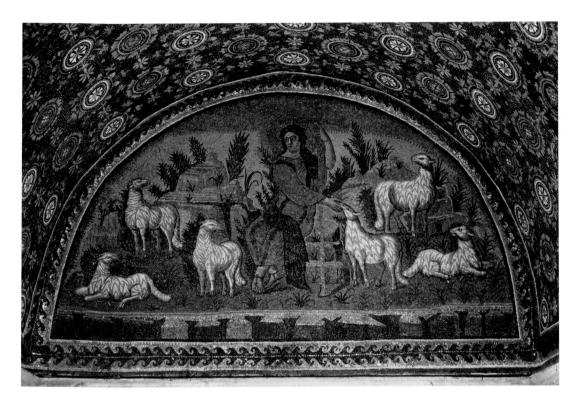

7–16 • THE GOOD SHEPHERD
Lunette over the entrance, Oratory of Galla Placidia. c. 425–426. Mosaic.

apostles, gesturing like orators. Doves flanking a small fountain between the apostles symbolize eternal life in heaven.

In the lunette at the end of the barrel vault opposite the entrance, a mosaic depicts the third-century St. Lawrence, to whom the building may have been dedicated. The triumphant martyr carries a cross over his shoulder like a trophy and gestures toward the fire-engulfed metal grill on which he was literally roasted in martyrdom. At the left stands a tall cabinet containing the Gospels, signifying the faith for which he gave his life. Opposite St. Lawrence, in a lunette over the entrance portal, is a mosaic of **THE GOOD SHEPHERD** (FIG. **7–16**). A comparison of this version with a fourth-century depiction of the same subject (SEE FIG. 7–5) reveals significant changes in content and design.

Jesus is no longer a boy in a simple tunic, but an adult emperor wearing purple and gold royal robes, his imperial majesty signaled by the golden halo surrounding his head and by a long golden staff that ends in a cross instead of a shepherd's crook. At the time this mosaic was made, Christianity had been the official state religion for 45 years, and nearly a century had past since the last official persecution of Christians. The artists and patrons of this mosaic chose to assert the glory of Jesus Christ in mosaic, the richest known medium of wall decoration, in an imperial image still imbued with pagan spirit but now signaling the triumph of a new faith.

EARLY BYZANTINE ART

Byzantine art can be thought of broadly as the art of Constantinople (whose ancient name, before Constantine renamed it after himself, was Byzantium) and the regions under its influence. In this chapter, we focus on Byzantine art's three "golden ages." The Early Byzantine period, most closely associated with the reign of Emperor Justinian I (527–565), began in the fifth century and ended in 726, at the onset of the iconoclast controversy that led to the destruction of religious images. The Middle Byzantine period began in 843, when Empress Theodora (c. 810–867) reinstated the veneration of icons. It lasted until 1204, when Christian crusaders from the west occupied Constantinople. The Late Byzantine period began with the restoration of Byzantine rule in 1261 and ended with the empire's fall to the Ottoman Turks in 1453, at which point Russia succeeded Constantinople as the "Third Rome" and the center of the Eastern Orthodox Church. Late Byzantine art continued to flourish into the eighteenth century in Ukraine, Russia, and much of southeastern Europe.

THE GOLDEN AGE OF JUSTINIAN

During the fifth and sixth centuries, while invasions and religious controversy wracked the Italian peninsula, the Eastern Empire prospered. Byzantium became the "New Rome." Constantine had chosen the site of his new capital city well. Constantinople lay at the crossroads of the overland trade routes between Asia and Europe and the sea route connecting the Black Sea and the Mediterranean. It was during the sixth century under Emperor Justinian I and his wife, Theodora, that Byzantine political power, wealth, and culture were at their peak. Imperial forces held northern Africa, Sicily, much of Italy, and part of Spain. Ravenna became the Eastern Empire's administrative capital in the west, and Rome remained under nominal Byzantine control until the eighth century.

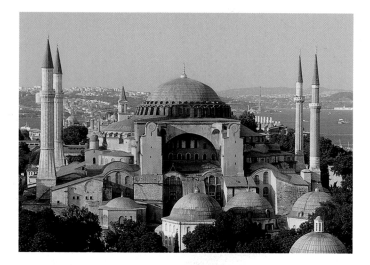

7-17 • Anthemius of Tralles and Isidorus of Miletus
CHURCH OF HAGIA SOPHIA
Istanbul. 532–537. View from the southwest.

The body of the original church is now surrounded by later additions, including the minarets built after 1453 by the Ottoman Turks. Today the building is a museum.

SEE MORE: Click the Google Earth link for Hagia Sophia **www.myartslab.com**

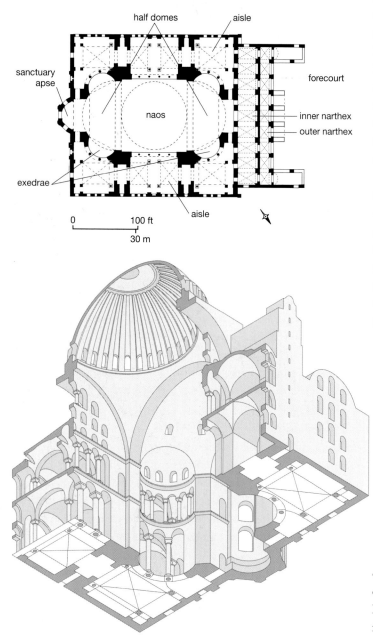

7-18 • **PLAN AND ISOMETRIC DRAWING OF THE CHURCH OF HAGIA SOPHIA**

HAGIA SOPHIA. In Constantinople, Justinian and Theodora embarked on a spectacular campaign of building and renovation, but little now remains of their architectural projects or of the old imperial capital itself. The church of Hagia Sophia, meaning "Holy Wisdom," is a spectacular exception (FIG. 7–17). It replaced a fourth-century church destroyed when crowds, spurred on by Justinian's foes during the devastating urban Nika Revolt in 532, set the old church on fire and cornered the emperor within his palace. Empress Theodora, a brilliant, politically shrewd woman, is said to have goaded Justinian, who was plotting an escape, not to flee the city, saying "Purple makes a fine shroud"—meaning that she would rather remain and die an empress (purple was the royal color) than retreat and preserve her life. Taking up her words as a battle cry, Justinian led the imperial forces in crushing the rebels and restoring order, reputedly slaughtering 30,000 of his subjects in the process.

To design a new church that embodied imperial power and Christian glory, Justinian chose two scholar-theoreticians, Anthemius of Tralles and Isidorus of Miletus. Anthemius was a specialist in geometry and optics, and Isidorus a specialist in physics who had also studied vaulting. They developed an audacious and awe-inspiring design, executed by builders who had refined their masonry techniques building the towers and domed rooms that were part of the city's defenses. So when Justinian ordered the construction of domed churches, and especially Hagia Sophia, master masons with a trained and experienced workforce stood ready to give permanent form to his architects' dreams.

The new Hagia Sophia was not constructed by the miraculous intervention of angels, as was rumored, but by mortal builders in only five years (532–537). Procopius of Caesarea, who chronicled Justinian's reign, claimed poetically that Hagia Sophia's gigantic dome seemed to hang suspended on a "golden chain from heaven." Legend has it that Justinian himself, aware that architecture can be a potent symbol of earthly power, compared his accomplishment with that of the legendary builder of the First Temple in Jerusalem, saying "Solomon, I have outdone you."

Hagia Sophia is an innovative hybrid of longitudinal and central architectural planning (FIG. 7–18). The building is clearly dominated by the hovering form of its gigantic dome (FIG. 7–19). But flanking **conches**—semidomes—extend the central space into a longitudinal nave that expands outward from the central dome to connect with the narthex on one end and the halfdome of the sanctuary apse on the other. This processional core, called

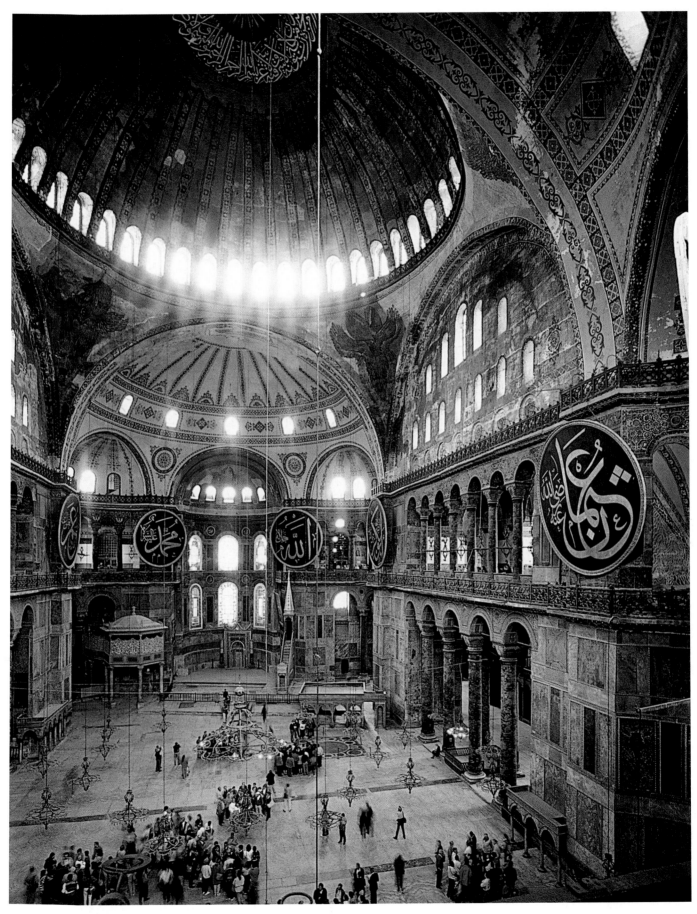

7-19 • INTERIOR OF THE CHURCH OF HAGIA SOPHIA

EXPLORE MORE: Gain insight from a primary source related to Hagia Sophia www.myartslab.com

Pendentives and squinches are two methods of supporting a round dome or its drum over a square space. **Pendentives** are concave, spherical triangles between arches that rise upward and inward to form a circular opening on which a dome rests. **Squinches** are diagonal lintels placed across the upper corner of the wall and supported by an arch or a series of corbeled arches that give it a nichelike shape. Because squinches create an octagon, which is close in shape to a circle, they provide a solid base around the perimeter of a dome, usually elevated on a drum (a circular wall), whereas pendentives project the dome slightly inside the square space it covers, making it seem to float. Byzantine builders preferred pendentives (as at Hagia Sophia, SEE FIG. 7–19), but elaborate, squinch-supported domes became a hallmark of Islamic architecture.

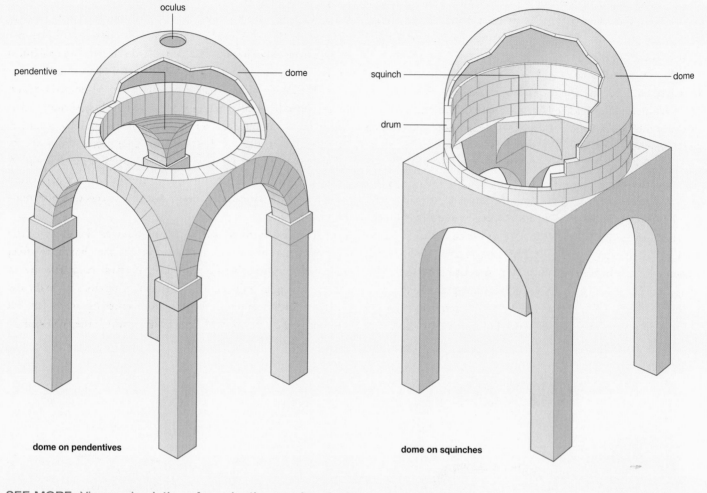

dome on pendentives

dome on squinches

the **naos** in Byzantine architecture, is flanked by side aisles and **galleries** above them overlooking the naos.

Since its idiosyncratic mixture of basilica and rotunda precludes a ring of masonry underneath the dome to provide support around its circumference (as in the Pantheon, SEE FIGS. 6–46, 6–47), the main dome of Hagia Sophia rests instead on four **pendentives** (triangular curving vault sections) that connect the base of the dome with the huge supporting piers at the four corners of the square area beneath it (see "Pendentives and Squinches," above). And since these piers are essentially submerged back into the darkness of the aisles, rather than expressed within the main space itself (SEE FIG. 7–18), the dome seems to float

mysteriously over a void. The miraculous, weightless effect was reinforced by the light-reflecting gold mosaic that covered the surfaces of dome and pendentives alike, as well as the band of 40 windows that perforate the base of the dome right where it meets its support. This daring move challenges architectural logic by seeming to weaken the integrity of the masonry at the very place where it needs to be strong, but the windows created the circle of light that helps the dome appear to hover, and a reinforcement of buttressing on the exterior made the solution sound as well as shimmering. The origin of the dome on pendentives is obscure, but its large-scale use at Hagia Sophia was totally unprecedented and represents one of the boldest experiments in the history of

architecture. It was to become the preferred method of supporting domes in Byzantine architecture.

The architects and builders of Hagia Sophia clearly stretched building materials to their physical limits, denying the physicality of the building in order to emphasize its spirituality. In fact, when the first dome fell in 558, it did so because a pier and pendentive shifted and because the dome was too shallow and exerted too much outward force at its base, not because the windows weakened the support. Confident of their revised technical methods, the architects designed a steeper dome that raised the summit 20 feet higher. They also added exterior buttressing. Although repairs had to be made in 869, 989, and 1346, the church has since withstood numerous earthquakes.

The liturgy used in Hagia Sophia in the sixth century has been lost, but it presumably resembled the rites described in detail for the church in the Middle Byzantine period. The celebration of the Mass took place behind a screen—at Hagia Sophia a crimson curtain embroidered in gold, in later churches an iconostasis, a wall hung with devotional paintings called **icons** (from the Greek *eikon*, meaning "image"). The emperor was the only layperson permitted to enter the sanctuary; men stood in the aisles and women in the galleries. Processions of clergy moved in a circular path from the sanctuary into the nave and back five or six times during the ritual. The focus of the congregation was on the iconostasis and the dome rather than the altar and apse. This upward focus reflects the interests of Byzantine philosophers, who viewed meditation as a way to rise from the material world to a spiritual state. Worshipers standing on the church floor must have felt just such a spiritual uplift as they gazed at the mosaics of saints, angels, and, in the golden central dome, heaven itself.

SAN VITALE. In 540, Byzantine forces captured Ravenna from the Arian Christian Ostrogoths who had themselves taken it from the Romans in 476. Much of our knowledge of the art of this turbulent period comes from the well-preserved monuments at Ravenna. In 526, Ecclesius, bishop of Ravenna, commissioned two new churches, one for the city and one for its port, Classis. Construction began on a central-plan church, a **martyrium** (church built over the grave of a martyr) dedicated to the fourth-century Roman martyr St. Vitalis (Vitale in Italian) in the 520s, but it was not finished until after Justinian had conquered Ravenna and established it as the administrative capital of Byzantine Italy (**FIG. 7–20**).

The design of San Vitale is basically a central-domed octagon surrounded by eight radiating exedrae (wall niches), surrounded in turn by an ambulatory and gallery, all covered by vaults. A rectangular sanctuary and semicircular apse project from one of the sides of the octagon, and circular rooms flank the apse. A separate oval narthex, set off-axis, joined church and palace and also led to cylindrical stair towers that gave access to the second-floor gallery.

The floor plan of San Vitale only hints at the effect of the complex, interpenetrating interior spaces of the church, an effect that was enhanced by the offset narthex, with its double sets of doors leading into the church. People entering from the right saw only arched openings, whereas those entering from the left approached on an axis with the sanctuary, which they saw straight

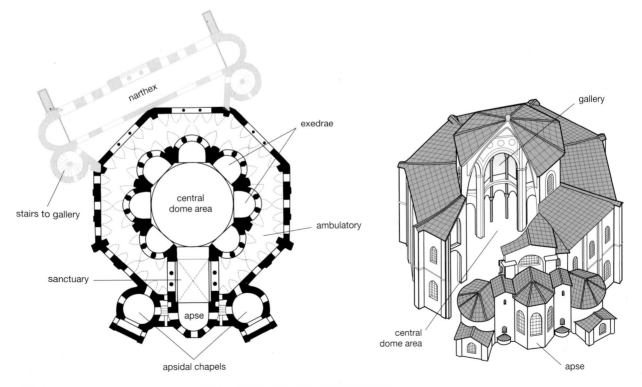

7-20 • PLAN AND CUTAWAY DRAWING, CHURCH OF SAN VITALE
Ravenna. Under construction from c. 520; consecrated 547; mosaics, c. 546–548.

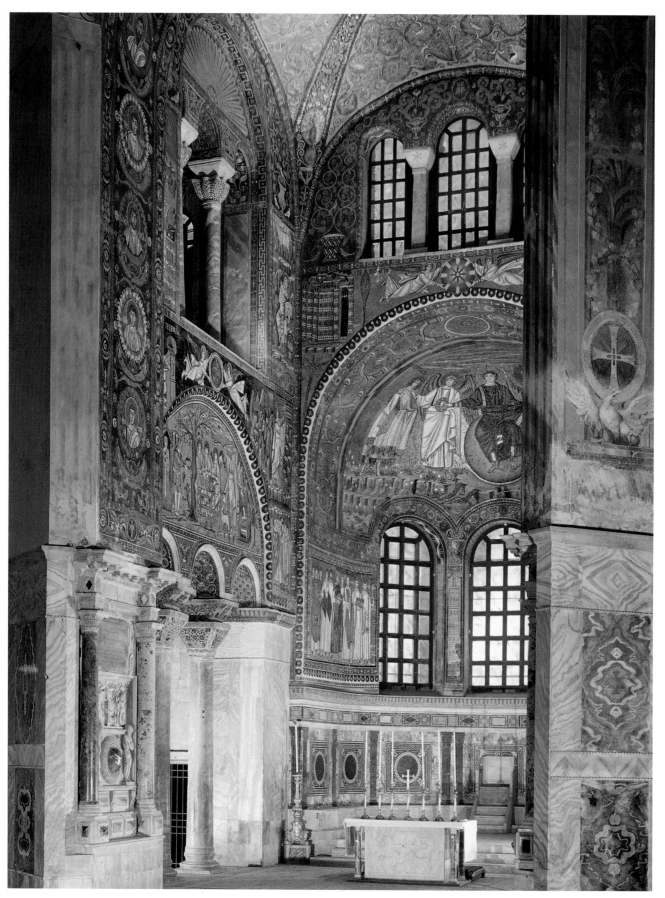

7–21 • CHURCH OF SAN VITALE
Ravenna. View into the sanctuary toward the northeast. Consecrated 547.

SEE MORE: View a panorama of San Vitale **www.myartslab.com**

Naming Christian Churches: Designation + Dedication + Location

Christian churches are identified by a three-part descriptive title combining (1) designation (or type), with (2) dedication (usually to a saint), and finally (3) geographic location, cited in that order.

DESIGNATION: There are various types of churches, fulfilling a variety of liturgical and administrative objectives, and the identification of a specific church often begins with an indication of its function within the system. For example, an **abbey church** is the place of worship within a monastery or convent; a **pilgrimage church** is a site that attracts visitors wishing to venerate **relics** (material remains or objects associated with a saint) as well as attend services. A cathedral is a bishop's primary church (the word derives from the Latin *cathedra*, meaning chair, since the chair or throne of a bishop is contained within his cathedral). A bishop's domain is called a diocese, and there can be only one church in the diocese designated as its bishop's cathedral, but the diocese is full of **parish churches** where local residents attend regular services.

DEDICATION: Christian churches are always dedicated to a saint or a sacred concept, for example St. Peter's Basilica or the Church of Hagia Sophia ("Holy Wisdom"). In short-hand identification, when we omit the church designation at the beginning, we always add an apostrophe and an *s* to the saint's name, as when using "St. Peter's" to refer to the Vatican Basilica of St. Peter in Rome

LOCATION: The final piece of information that clearly pinpoints the specific church referred to in a title is its geographic location, as in the Church of San Vitale in Ravenna or the Cathedral of Notre-Dame (French for "Our Lady," referring to the Virgin Mary) in Paris. "Notre-Dame" alone usually refers to this Parisian cathedral, in spite of the fact that many contemporary cathedrals elsewhere (e.g. at Chartres and Reims) were also dedicated to "Notre-Dame." Similarly, "St. Peter's" usually means the Vatican church of the pope in Rome.

ahead of them. The dome rests on eight large piers that frame the exedrae and the sanctuary. The undulating, two-story exedrae open through superimposed arcades into the outer aisles on the ground floor and into galleries on the second floor. They push out the circular central space and create an airy, floating sensation, reinforced by the liberal use of veined marble veneer and colored glass and gold mosaics in the surface decoration. The structure seems to dissolve into shimmering light and color.

In the halfdome of the sanctuary apse (**FIGS. 7–21, 7–22**), an image of **CHRIST ENTHRONED** is flanked by St. Vitalis and Bishop Ecclesius. The other sanctuary images relate to its use for the celebration of the Eucharist. The lunette on the north wall shows an altar table set for a meal that Abraham offers to three holy visitors, and next to it a portrayal of his near-sacrifice of Isaac. In the spandrels and other framed wall spaces appear prophets and evangelists, and the program is bristling with symbolic references to Jesus, but the focus of the sanctuary program is the courtly tableau in the semidome of the apse.

A youthful, classicizing Christ appears on axis, dressed in imperial purple and enthroned on a cosmic orb in paradise, the setting indicated by the four rivers that flow from the ground underneath him. Two winged angels flank him, like imperial bodyguards or attendants. In his left hand Christ holds a scroll with seven seals that he will open at his Second Coming at the end of time, proclaiming his authority not only over this age, but over the age to come. He extends his right hand to offer a crown of martyrdom to a figure on his right (our left) labeled as St. Vitalis, the saint to whom this church is dedicated. On

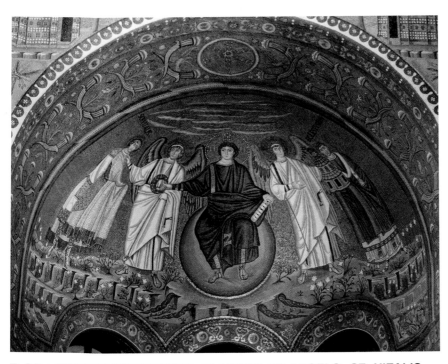

7-22 • CHRIST ENTHRONED, FLANKED BY ANGELS, ST. VITALIS AND BISHOP ECCLESIUS
Church of San Vitale, Ravenna. Consecrated 547. Mosaic.

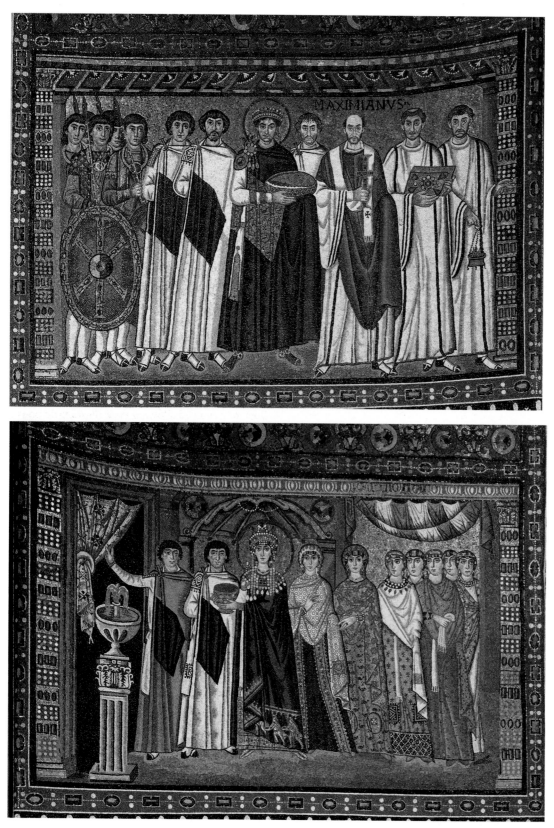

Church of San Vitale, Ravenna. Consecrated 547. Mosaic, 8'8" × 12' (2.64 × 3.65 m).

As head of state, the haloed Justinian wears a huge jeweled crown and a purple cloak; he carries a large golden paten (plate for Eucharistic bread) that he is donating to San Vitale for the celebration of the Eucharist. Bishop Maximianus at his left holds a jeweled cross and another churchman holds a jewel-covered book. Government officials stand at Justinian's right, followed by barbarian mercenary soldiers, one of whom wears a neck torc, another a Classical cameo cloak clasp.

7-24 • EMPRESS THEODORA AND HER ATTENDANTS, SOUTH WALL OF THE APSE
Church of San Vitale, Ravenna. Consecrated 547. Mosaic 8'8" × 12' (2.64 × 3.65 m).

Theodora and her ladies wear the rich textiles and jewelry of the Byzantine court. Both men and women are dressed in linen or silk tunics and cloaks. The men's cloaks are fastened on the right shoulder with a fibula (brooch) and are decorated with a rectangular embroidered panel (tablion). Women wore a second full, long-sleeved garment over their tunics and a large rectangular shawl. Like Justinian, Theodora has a halo and wears imperial purple. Her elaborate jewelry includes a wide collar of embroidered and jeweled cloth. A crown, hung with long strands of pearls (thought to protect the wearer from disease), frames her face.

the other side is the only un-nimbed figure in the tableau, labeled as Bishop Ecclesius, the founder of San Vitale, who holds forward a model of the church itself, offering it to Christ. The artist has imagined a scene of courtly protocol in paradise, where Christ, as emperor, gives a gift to, and receives a gift from, visiting luminaries.

Further visitors appear in separate, flanking rectangular compositions, along the curving wall of the apse underneath the scene in the semidome—Justinian and Theodora and their retinues (the former can be seen in FIG. 7–21). The royal couple did not attend the dedication ceremonies for the church of San Vitale, conducted by Archbishop Maximianus in 547. They may never actually have set foot in Ravenna, but these two large mosaic panels that face each other across its sanctuary picture their presence here in perpetuity. Justinian (FIG. 7–23), on the north wall, carries a large golden paten that will be used to hold the Eucharistic Host and stands next to Maximianus, who holds a golden, jewel-encrusted cross. The priestly celebrants at the right carry the Gospels, encased in a golden, jeweled book cover, symbolizing the coming of the Word, and a censer containing burning incense to purify the altar prior to the Eucharist.

On the south wall, Theodora, standing beneath a fluted shell canopy and singled out by a golden halo and elaborate crown, carries a huge golden chalice studded with jewels (FIG. 7–24). The rulers present these gifts as precious offerings to Christ—emulating most immediately Bishop Ecclesius, who offers a model of the church to Christ in the apse, but also the three Magi who brought valuable gifts to the infant Jesus, depicted in "embroidery" at the bottom of Theodora's purple cloak. In fact, the paten and chalice offered by the royal couple will be used by this church to offer Eucharistic bread and wine to the local Christian community during the liturgy. In this way the entire program of mosaic decoration revolves around themes of offering, extended into the theme of the Eucharist itself.

Theodora's group stands beside a fountain, presumably at the entrance to the women's gallery. The open doorway and curtain are Classical space-creating devices, but here the mosaicists have deliberately avoided allowing their illusionistic power to overwhelm their ability also to create flat surface patterns. Notice, too, that the figures cast no shadows, and, though modeled, their outlines as silhouetted shapes are more prominent than their sense of three-dimensionality. Still, especially in Justinian's panel, a complex and carefully controlled system of overlapping allows us to see these figures clearly and logically situated within a shallow space, moving in a stately procession from left to right toward the entrance to the church and the beginning of the liturgy. So the scenes portrayed in these mosaic paintings are both flattened and three-dimensional, abstract and representational, patterned and individualized. Like Justinian and Theodora, their images are both there and not there at the same time.

SANT'APOLLINARE IN CLASSE. At the same time that he was building the church of San Vitale, Bishop Ecclesius ordered a basilica church in the port of Classis dedicated to St. Apollinaris (Sant'Apollinare), the first bishop of Ravenna. The apse mosaic (FIG. 7–25) is a symbolic depiction of the Transfiguration (Matthew 17:1–5)—Jesus' revelation of his divinity. A narrative episode from the life of Christ has been transformed into an iconic embodiment of its underlying idea. One man and 15 sheep stand in a stylized, verdant landscape below a jeweled cross with the face of Christ at its center. The hand of God and the figures of Moses and Elijah from the Hebrew Bible

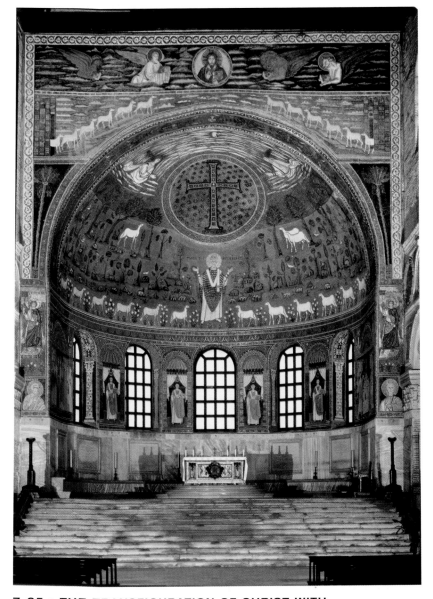

7-25 • THE TRANSFIGURATION OF CHRIST WITH SANT'APOLLINARE, FIRST BISHOP OF RAVENNA
Church of Sant'Apollinare in Classe. Consecrated 549. Mosaics: apse, 6th century; wall above apse, 7th and 9th centuries; side panels, 7th century.

appear in the heavens to authenticate the divinity of Christ. The apostles Peter, James, and John, who witness the event, are represented here by the three sheep with raised heads. Below the cross, Bishop Apollinaris raises his hands in an orant posture of prayer, flanked by 12 lambs who seem to represent the apostles.

This highly complicated work of symbolic narrative, like the mosaics of San Vitale, must have been aimed at a sophisticated population, prepared to appreciate its theological speculations and diagrammatic outlines of Christian doctrine. At this moment in its history, the Church is directing its message to an inside audience of faithful believers, who encounter its visualization within churches in their own community. Such an art could not have been conceived to educate an uninitiated public; rather it was developed to celebrate the values that hold Christian society together by representing them in a refined and urbane visual language.

OBJECTS OF VENERATION AND DEVOTION

The court workshops of Constantinople excelled in the production of luxurious, small-scale works in gold, ivory, and textiles. The Byzantine elite also sponsored vital **scriptoria** (writing centers for **scribes**—professional document writers) for the production of **manuscripts** (handwritten books).

THE ARCHANGEL MICHAEL DIPTYCH. Commemorative ivory diptychs—two carved panels hinged together—originated with Roman politicians elected to the post of consul. New consuls would send notices of their election to friends and colleagues by inscribing them in wax that filled a recessed rectangular area on the inner sides of a pair of ivory panels carved with elaborate decoration on the reverse. Christians adapted the practice for religious use, inscribing a diptych with the names of people to be remembered with prayers during the liturgy.

This large panel depicting the **ARCHANGEL MICHAEL**—the largest surviving Byzantine ivory—was half of such a diptych **(FIG. 7–26)**. In his classicizing beauty, imposing physical presence, and elegant architectural setting, the archangel is comparable to the (supposed) priestess of Bacchus in the fourth-century pagan Symmachus diptych panel (SEE FIG. 6–68). His relationship to the architectural space and the frame around him, however, is more complex. His heels rest on the top step of a stair that clearly lies behind the columns and pedestals, but the rest of his body projects in front of them—since it overlaps the architectural setting—creating a striking tension between this celestial figure and his terrestrial backdrop.

The angel is outfitted here as a divine messenger, holding a staff of authority in his left hand and a sphere symbolizing worldly power in his right. Within the arch is a similar cross-topped orb, framed by a wreath bound by a ribbon with long, rippling extensions, that is set against the background of a scallop shell. The lost half of this diptych would have completed the Greek inscription across the top, which reads: "Receive these gifts, and having learned the cause…." Perhaps the other panel contained a

7–26 • ARCHANGEL MICHAEL
Panel of a diptych, probably from the court workshop at Constantinople. Early 6th century. Ivory, 17 × 15½" (43.3 × 14 cm). British Museum, London.

Scroll and Codex

Since people began to write some 5,000 years ago, they have kept records on a variety of materials, including clay or wax tablets, pieces of broken pottery, papyrus, animal skins, and paper. Books have taken two forms: scroll and codex.

Scribes made **scrolls** from sheets of papyrus glued end to end or from thin sheets of cleaned, scraped, and trimmed sheepskin or calfskin, a material known as **parchment** or, when softer and lighter, **vellum**. Each end of the scroll was attached to a rod; the reader slowly unfurled the scroll from one rod to the other. Scrolls could be written to be read either horizontally or vertically.

At the end of the first century CE, the more practical and manageable **codex** (plural, codices)—sheets bound together like the modern book—replaced the scroll as the primary form of recording texts. The basic unit of the codex was the eight-leaf quire, made by folding a large sheet of parchment twice, cutting the edges free, then sewing the sheets together up the center. Heavy covers kept the sheets of a codex flat. The thickness and weight of parchment and vellum made it impractical to produce a very large manuscript, such as an entire Bible, in a single volume. As a result, individual sections were made into separate books.

Until the invention of printing in the fifteenth century, all books were **manuscripts**—that is, they were written by hand. Manuscripts often included illustrations, called **miniatures** (from *minium*, the Latin word for a reddish lead pigment). Manuscripts decorated with gold and colors were said to be illuminated.

portrait of the emperor—many think he would be Justinian—or of another high official who presented the panels as a gift to an important colleague, acquaintance, or family member. Nonetheless, the emphasis here is on the powerful celestial messenger who does not need to obey the laws of earthly scale or human perspective.

THE VIENNA GENESIS. Byzantine manuscripts were often made with very costly materials. For example, sheets of purple-dyed **vellum** (a fine writing surface made from calfskin) and gold and silver inks were used to produce a codex now known as the Vienna Genesis. It was probably made in Syria or Palestine, and the purple vellum indicates that it may have been created for an imperial patron (costly purple dye, made from the secretions of murex mollusks, was usually restricted to imperial use). The Vienna Genesis is written in Greek and illustrated with pictures that appear below the text at the bottom of the pages.

The story of **REBECCA AT THE WELL (FIG. 7–27)** (Genesis 24) appears here in a single composition, but the painter—clinging to the continuous narrative tradition that had characterized the illustration of scrolls—combines events that take place at different times in the story within a single narrative space. Rebecca, the heroine, appears at the left walking away from the walled city of Nahor with a large jug on her shoulder, going to fetch water. A colonnaded road leads toward a spring, personified by a reclining pagan water nymph who holds a flowing jar. In the foreground, Rebecca appears again. Her jug now full, she encounters a thirsty camel driver and offers him water to drink. Since he is Abraham's servant, Eliezer, in search of a bride for Abraham's son Isaac, Rebecca's generosity results in her marriage to Isaac. The lifelike poses and rounded, full-bodied figures of this narrative scene

7-27 • REBECCA AT THE WELL
Page from a codex featuring the book of Genesis (known as the Vienna Genesis). Syria or Palestine. Early 6th century. Tempera, gold, and silver paint on purple-dyed vellum, 13½ × 9⅞″ (33.7 × 25 cm). Österreichische Nationalbibliothek, Vienna.

7-28 • DAVID BATTLING GOLIATH

Detail of silver plate in FIG. 7–1. Made in Constantinople, 629–630. Metropolitan Museum of Art, New York.

conform to the conventions of traditional Roman painting. The sumptuous purple of the background and the glittering metallic letters of the text situate the book within the world of the privileged and powerful in Byzantine society.

LUXURY WORKS IN SILVER. The imperial court at Constantinople had a monopoly on the production of some luxury goods, especially those made of precious metals. It seems to have been the origin of a spectacular set of nine silver plates portraying events in the early life of the biblical King David, including the plate that we examined at the beginning of the chapter (SEE FIG. 7–1).

The plates would have been made by hammering a large silver ingot (the plate in FIG. 7–1 weighs 12 pounds 10 ounces) into a round shape and raising on it the rough semblance of the human figures and their environment. With finer chisels, silversmiths then refined these shapes, and at the end of their work, they punched ornamental motifs and incised fine details. The careful modeling,

lifelike postures, and intricate engraving characterizing the detail reproduced in **FIG. 7–28** document the highly refined artistry and stunning technical virtuosity of these cosmopolitan artists at the imperial court who still practiced a classicizing art that can be traced back to the traditions of ancient Greece.

ICONS AND ICONOCLASM

Christians in the Byzantine world prayed to Christ, Mary, and the saints while looking at images of them on independent painted panels known as icons. Church doctrine toward the veneration of icons was ambivalent. Christianity, like Judaism and Islam, has always been uneasy with the power of religious images. But key figures of the Eastern Church, such as Basil the Great of Cappadocia (c. 329–379) and John of Damascus (c. 675–749), distinguished between idolatry—the worship of images—and the veneration of an idea or holy person depicted in a work of art. Icons were thus accepted as aids to meditation and prayer, as intermediaries between

worshipers and the holy personages they depicted. Honor showed to the image was believed to transfer directly to its spiritual prototype. Icons were often displayed in Byzantine churches on a screen separating the congregation from the sanctuary called the **iconostasis**.

Surviving early icons are rare, but a few precious examples were preserved in the Monastery of St. Catherine on Mount Sinai, among them the **VIRGIN AND CHILD WITH SAINTS AND ANGELS (FIG. 7–29)**. As Theotokos (Greek for "bearer of God"), Jesus' earthly mother was viewed as the powerful, ever-forgiving intercessor, appealing to her divine son for mercy on behalf of repentant worshipers. She was also called the Seat of Wisdom, and many images of the Virgin and Child, like this one, show her holding Jesus on her lap in a way that suggests that she represents the throne of Solomon. Virgin and Child are flanked here by Christian warrior-saints Theodore (left) and George (right)— both legendary figures said to have slain dragons, representing the triumph of the Church over the "evil serpent" of paganism. Angels behind them twist upward to look heavenward. The artist has painted the Christ Child, the Virgin, and the angels in an illusionistic Roman manner that renders them lifelike and three-dimensional in appearance. But the warrior-saints are more stylized. The artist barely hints at bodily form beneath the richly patterned textiles of their cloaks, and their tense faces are frozen in frontal stares of gripping intensity.

In the eighth century, the veneration of icons sparked a major controversy in the Eastern Church, and in 726 Emperor Leo III launched a campaign of **iconoclasm** ("image breaking"), banning the use of icons in Christian worship and ordering the destruction of devotional pictures (see "Iconoclasm," page 246). Only a few early icons survived in isolated places like Mount Sinai, which was no longer a part of the Byzantine Empire at this time. But the iconoclasm did not last. In 843, Empress Theodora, widow of Theophilus, last of the iconoclastic emperors, reversed her husband's policy, and icons would play an increasingly important role as the history of Byzantine art developed.

7-29 • VIRGIN AND CHILD WITH SAINTS AND ANGELS
Icon. Second half of the 6th century.
Encaustic on wood, 27 × 18⅞″ (69 × 48 cm).
Monastery of St. Catherine, Mount Sinai, Egypt.

EXPLORE MORE: Gain insight from a primary source about painting icons **www.myartslab.com**

Iconoclasm

Iconoclasm (literally "image breaking," from the Greek words *eikon* for "image" and *klao* meaning "break" or "destroy") is the prohibition and destruction of works of visual art, usually because they are considered inappropriate in religious contexts.

During the eighth century, mounting discomfort with the place of icons in Christian devotion grew into a major controversy in the Byzantine world and, in 726, Emperor Leo III (r. 717–741) imposed iconoclasm, initiating the systematic destruction of images of saints and sacred stories on icons and in churches, as well as the persecution of those who made them and defended their use. His successor, Constantine V (r. 741–775), enforced these policies and practices with even greater fervor. Iconoclasm endured as imperial policy until 843, when the widowed Empress Theodora reversed her husband Theophilus' policy and reinstated the central place of images in Byzantine devotional practice.

A number of explanations have been proposed for this interlude of Byzantine iconoclasm. Some church leaders feared that the use of images in worship could lead to idolatry or at least distract worshipers from their spiritual exercises. Specifically there were questions surrounding the relationship between images and the Eucharist, the latter considered by iconoclasts as sufficient representation of the presence of Christ in the church. But there was also anxiety in Byzantium about the weakening state of the empire, especially in relation to the advances of Arab armies into Byzantine territory. It was easy to pin these hard times on God's displeasure with the idolatrous use of images. Coincidentally, Leo III's success fighting the Arabs could be interpreted as divine sanction of his iconoclastic position, and its very adoption might appease the iconoclastic Islamic enemy itself. Finally, since the production and promotion of icons was centered in monasteries—at that time rivaling the state in strength and wealth—attacking the use of images might check their growing power. Perhaps all these factors played a part, but at the triumph of the **iconophiles** (literally "lovers of images") in 843, the place of images in worship was again secure: Icons proclaimed Christ as God incarnate and facilitated Christian worship by acting as intermediaries between humans and saints. Those who had suppressed icons became heretics.

But iconoclasm is not restricted to Byzantine history. It reappears from time to time throughout the history of art. Protestant reformers in sixteenth-century Europe adopted what they saw as the iconoclastic position of the Hebrew Bible (Exodus 20:4), and many works of Catholic art were destroyed by zealous reformers and their followers.

Even more recently, in 2001, the Taliban rulers of Afghanistan dynamited two gigantic fifth-century CE statues of the Buddha carved into the rock cliffs of the Bamiyan Valley, specifically because they believed such "idols" violated Islamic law.

CRUCIFIXION AND ICONOCLASTS
From the Chludov Psalter. Mid 9th century. Tempera on vellum, 7¾ × 6" (19.5 × 15 cm). State Historical Museum, Moscow. MS D.29, fol. 67v

This page and its illustration of Psalm 21—made soon after the end of the iconoclastic controversy in 843—records the iconophiles' harsh judgment of the iconoclasts. Painted in the margin at the right, a scene of the Crucifixion shows a soldier tormenting Christ with a vinegar-soaked sponge. In a striking visual parallel, two named iconoclasts—identified by inscription—in the adjacent picture along the bottom margin employ a whitewash-soaked sponge to obliterate an icon portrait of Christ, thus linking their actions with those who had crucified him.

MIDDLE BYZANTINE ART

After the defeat of the iconoclasts, Byzantine art flourished once again, beginning in 867 under the leadership of an imperial dynasty from Macedonia. This support for the arts continued until Christian crusaders from the west, setting out on a holy war against Islam, diverted their efforts to conquering the wealthy Christian Byzantine Empire. The western crusaders who took Constantinople in 1204 looted the capital and set up a Latin dynasty of rulers to replace the Byzantine emperors.

Early Byzantine civilization had been centered in lands along

Greece. View from the east: Katholikon (left), early 11th century, and church of the Theotokos, late 10th century.

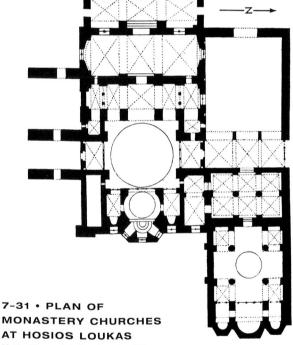

7-31 • PLAN OF MONASTERY CHURCHES AT HOSIOS LOUKAS

Katholikon at left, church of the Theotokos at right.

Under the Macedonian dynasty (867–1056) initiated by Basil I, the empire prospered and enjoyed a cultural rebirth. Middle Byzantine art and architecture, visually powerful and stylistically coherent, reflect the strongly spiritual focus of the period's autocratic, wealthy leadership. From the mid eleventh century, however, other powers entered Byzantine territory. The empire stabilized temporarily under the Comnenian dynasty (1081–1185), extending the Middle Byzantine period well into the time of the western Middle Ages.

ARCHITECTURE AND MOSAICS

Comparatively few Middle Byzantine churches in Constantinople have survived intact, but many central-plan domed churches, favored by Byzantine architects, survive in Greece to the southwest and Ukraine to the northeast, and are reflected in Venice within the Western medieval world. These structures reveal the Byzantine taste for a multiplicity of geometric forms, verticality, and rich decorative effects both inside and out.

HOSIOS LOUKAS. Although an outpost, Greece still lay within the Byzantine Empire, and the eleventh-century Katholikon of the Monastery of Hosios Loukas, built a few miles from the village of Stiris, Greece, is an excellent example of Middle Byzantine architecture. It stands next to the earlier church of the Theotokos (FIGS. 7–30, 7–31, 7–32). The church has a compact central plan with a dome, supported on squinches, rising over an octagonal core (see "Pendentives and Squinches," page 236). On the exterior, the rising forms of apses, walls, and roofs disguise the vaulting roofs of the interior. The Greek builders created a decorative effect

the rim of the Mediterranean Sea that had been within the Roman Empire. During the Middle Byzantine period, Constantinople's scope was reduced to present-day Turkey and other areas by the Black Sea, as well as the Balkan peninsula, including Greece, and southern Italy. The influence of Byzantine culture also extended into Russia and Ukraine, and to Venice, Constantinople's trading partner in northeastern Italy, at the head of the Adriatic Sea.

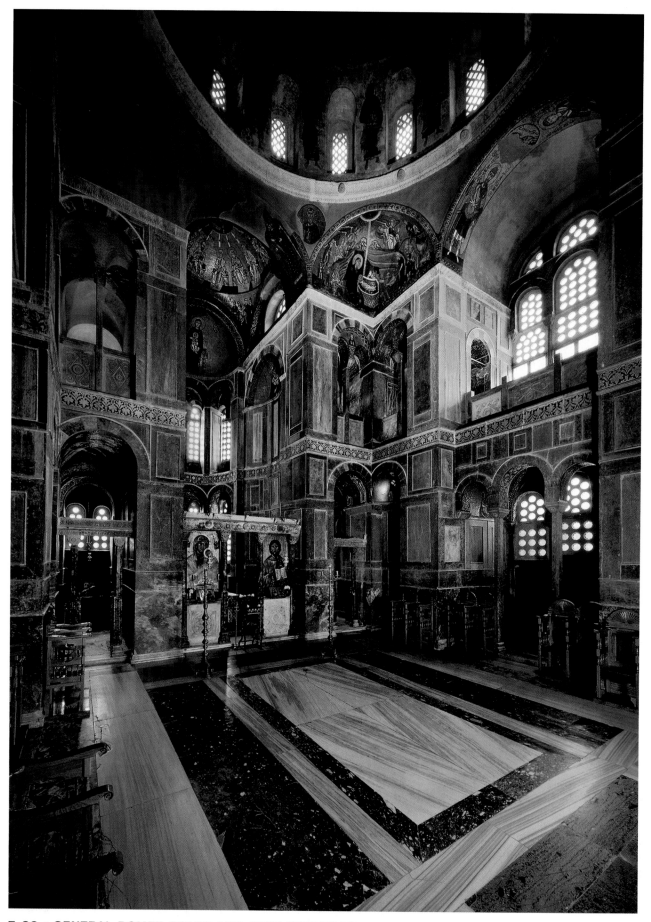

7-32 • CENTRAL DOMED SPACE AND APSE (THE NAOS), KATHOLIKON
Monastery of Hosios Loukas. Near Stiris, Greece. Early 11th century and later.

on the exterior, alternating stones with bricks set both vertically and horizontally and using diagonally set bricks to form saw-toothed moldings. Inside the churches, the high central space carries the eyes of worshipers upward into the main dome, which soars above a ring of tall arched openings.

Unlike Hagia Sophia, with its clear, sweeping geometric forms, the Katholikon has a complex variety of forms, including domes, groin vaults, barrel vaults, pendentives, and squinches, all built on a relatively small scale. The barrel vaults and tall sanctuary apse with flanking rooms further complicate the space. Single, double, and triple windows create intricate and unusual patterns of light that illuminated a mosaic of Christ Pantokrator (now lost) in the center of the main dome. The secondary, sanctuary dome is decorated with a mosaic of the Lamb of God surrounded by the Twelve Apostles at Pentecost, and the apse semi-dome has a mosaic of the Virgin and Child Enthroned. Biblical scenes (the Nativity appears on the squinch visible in FIG. 7–32) and figures of saints fill the interior with brilliant color and dramatic images. As at Hagia Sophia, the lower walls are faced with a multicolored stone veneer. An iconostasis separates the congregation from the sanctuary.

SANTA SOPHIA IN KIEV. During the ninth century, the rulers of Kievan Rus—Ukraine, Belarus, and Russia—adopted Orthodox Christianity and Byzantine culture. These lands had been settled by eastern Slavs in the fifth and sixth centuries, but later were ruled by Scandinavian Vikings who had sailed down the rivers from the Baltic to the Black Sea. In Constantinople, the Byzantine emperor hired the Vikings as his personal bodyguards, and Viking traders established a headquarters in the upper Volga region and in the city of Kiev, which became the capital of the area under their control.

The first Christian member of the Kievan ruling family was Princess Olga (c. 890–969), who was baptized in Constantinople by the patriarch himself, with the Byzantine emperor as her godfather. Her grandson Grand Prince Vladimir (r. 980–1015) established Orthodox Christianity as the state religion in 988. Vladimir sealed the pact with the Byzantines by accepting baptism and marrying Anna, the sister of the powerful Emperor Basil II (r. 976–1025).

Vladimir's son Grand Prince Yaroslav (r. 1036–1054) founded the **CATHEDRAL OF SANTA SOPHIA** in Kiev (**FIG. 7–33**). The church originally had a typical Byzantine multiple-domed cross design, but the building was expanded with double side aisles, leading to five apses. It culminated in a large central dome surrounded by 12 smaller domes. The small domes were said to stand for the 12 apostles gathered around the central dome, representing Christ Pantokrator, ruler of the universe. The central domed space of the crossing focuses attention on the nave and the main apse. Nonetheless, the many individual bays create a complicated and compartmentalized interior. The walls glow with lavish decoration: Mosaics glitter from the central dome, the apse, and the arches of the crossing. The remaining surfaces are frescoed with scenes from the lives of Christ, the Virgin, the apostles Peter and Paul, and the archangels.

The Kievan mosaics established a standard system of iconography used in Russian Orthodox churches. The Pantokrator fills the curving surface at the crest of the main dome (not visible above the window-pierced drum in FIG. 7–33). At a lower level, the apostles stand between the windows of the drum, with the four

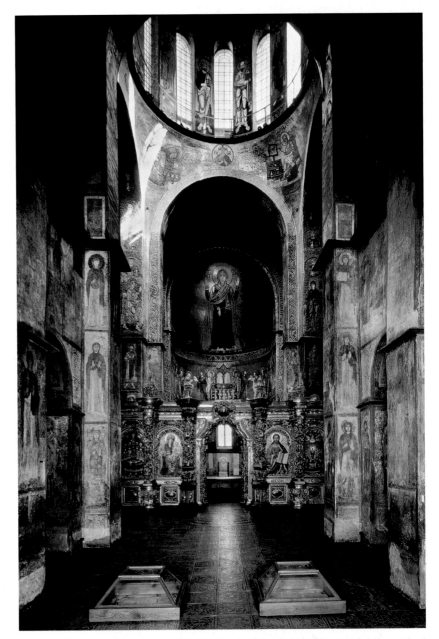

7-33 • INTERIOR, CATHEDRAL OF SANTA SOPHIA
Kiev. 1037–1046. Apse mosaics: Orant Virgin and Communion of the Apostles.

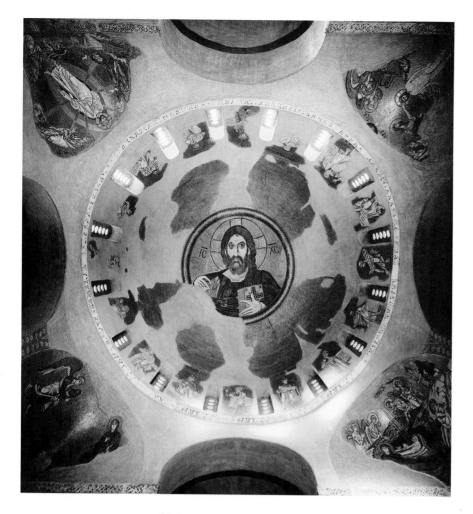

7-34 • CHRIST PANTOKRATOR AT CREST OF CENTRAL DOME, WITH SCENES FROM THE LIFE OF CHRIST IN THE PENDENTIVES
Church of the Dormition, Daphni, Greece. Late 11th century. Mosaic.

evangelists occupying the pendentives. An orant figure of the Virgin Mary seems to float in a golden heaven on the semidome and upper wall of the apse. In the mosaic on the wall below the Virgin is the Communion of the Apostles. Christ appears not once, but twice, in this scene, offering the Eucharistic bread and wine to the apostles, six on each side of the altar. With such extravagant use of costly mosaic, Prince Yaroslav made a powerful political declaration of his own power and wealth—and that of the Kievan Church as well.

CHURCH OF THE DORMITION AT DAPHNI. The refined mosaicists who worked at the church of the Dormition at Daphni, near Athens, conceived their compositions in relation to an intellectual ideal. They eliminated all "unnecessary" detail to focus on the essential elements of a narrative scene, conveying its mood and message in a moving but elegant style. The main dome of this church has maintained its riveting image of the Pantokrator, centered at the crest of the dome like a seal of divine sanction and surveillance (FIG. 7–34). This imposing figure manages to be elegant and awesome at the same time. Christ blesses or addresses the assembled congregation with one hand, while the slender, attenuated fingers of the other spread to clutch a massive book securely. In the squinches of the corner piers are four signal episodes from his life: Annunciation, Nativity, Baptism, and Transfiguration.

A mosaic of the **CRUCIFIXION** from the lower part of the church (FIG. 7–35) exemplifies the focus on emotional appeal to individuals that characterizes late eleventh-century Byzantine art. The figures inhabit an otherworldly space, a golden universe anchored to the material world by a few flowers, which suggest the promise of new life. A nearly nude Jesus is shown with bowed head and gently sagging body, his eyes closed in death. The witnesses have been reduced to two isolated mourning figures, Mary and the young apostle John, to whom Jesus had just entrusted the care of his mother. The elegant cut of the contours and the eloquent restraint of the gestures only intensify the emotional power of the

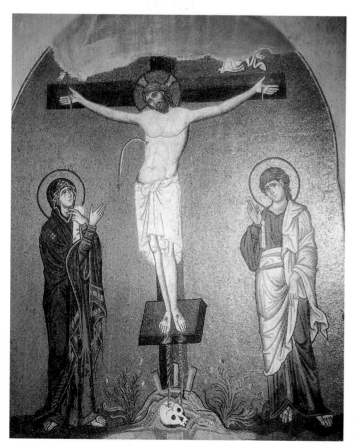

7-35 • CRUCIFIXION
Church of the Dormition, Daphni, Greece. East wall of the north arm. Late 11th century. Mosaic.

image. The nobility and suffering of these figures was meant to move worshipers toward a deeper involvement with their own meditation and worship.

This depiction of the Crucifixion has symbolic as well as emotional power. The mound of rocks and the skull at the bottom of the cross represent Golgotha, the "place of the skull," the hill outside ancient Jerusalem where Adam was thought to be buried and where the Crucifixion was said to have taken place. The faithful saw Jesus Christ as the new Adam, whose sacrifice on the cross saved humanity from the sins brought into the world by Adam and Eve. The arc of blood and water springing from Jesus' side refers to Eucharistic and baptismal rites. As Paul wrote in his First Letter to the Corinthians: "For just as in Adam all die, so too in Christ shall all be brought to life" (1 Corinthians 15:22). The timelessness and simplicity of this image were meant to aid the Christian worshiper seeking to achieve a mystical union with the divine through prayer and meditation, both intellectually and emotionally.

THE CATHEDRAL OF ST. MARK IN VENICE. The northeastern Italian city of Venice, set on the Adriatic at the crossroads of Europe and Asia Minor, was a major center of Byzantine art in Italy. Venice had been subject to Byzantine rule in the sixth and seventh centuries, and up to the tenth century, the city's ruler, the doge ("duke" in Venetian dialect), had to be ratified by the Byzantine emperor. At the end of the tenth century, Constantinople granted Venice a special trade status that allowed its merchants to control much of the commerce between east and west, and the city grew enormously wealthy.

Venetian architects looked to Byzantine domed churches for inspiration in 1063, when the doge commissioned a church to replace the palace chapel that had housed the relics of St. Mark the Apostle since they were brought to Venice from Alexandria in 828/29 (FIG. 7–36). The Cathedral of St. Mark has a Greek-cross plan, each square unit of which is covered by a dome, that is, five great domes in all, separated by barrel vaults and supported by pendentives. Unlike Hagia Sophia in Constantinople, where the space seems to flow from the narthex up into the dome and through the nave to the apse, St. Mark's domed compartments produce a complex space in which each dome maintains its own separate vertical axis. As we have seen elsewhere, marble veneer covers the lower walls, and golden mosaics glimmer above on the vaults, pendentives, and domes. The dome visible in FIG. 7–36 depicts Pentecost, the descent of the Holy Spirit on the apostles. A view of the exterior of St. Mark's as it would have appeared in early modern times can be seen in a painting by the fifteenth-century Venetian artist Gentile Bellini (SEE FIG. 19–36).

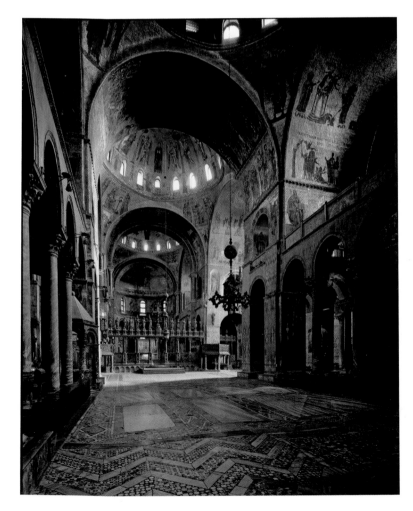

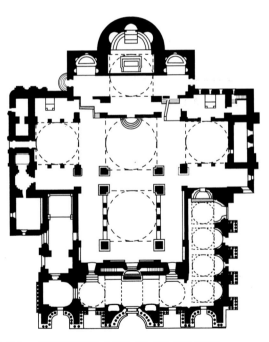

7-36 • INTERIOR AND PLAN OF THE CATHEDRAL OF ST. MARK
Venice. Begun 1063. View looking toward apse.

This church is the third one built on the site. It was both the palace chapel of the doge and the burial place for the bones of the patron of Venice, St. Mark. The church was consecrated as a cathedral in 1807. Mosaics have been reworked continually to the present day.

OBJECTS OF VENERATION AND DEVOTION

As in the Early Byzantine period, artists of great talent and high aesthetic sensibility produced small luxury items for members of the court as well as for the Church. Many of these items were commissioned by rulers and secular and Church functionaries as official gifts for one another. They had to be portable, sturdy, and exquisitely refined. These works often combined exceptional beauty and technical virtuosity with religious meaning. Icons, ivory carving, gold and enamel work, and fine books were especially prized.

THE VIRGIN OF VLADIMIR. The revered icon of Mary and Jesus known as the **VIRGIN OF VLADIMIR** (FIG. 7–37) was probably created in Constantinople but brought to Kiev. This distinctively humanized image suggests the growing desire for a more immediate and personal religion that we have already seen in the Crucifixion mosaic at Daphni, dating from about the same period. This exquisite icon employs an established iconographic type, known as the "Virgin of Compassion," showing Mary and the Christ Child pressing their cheeks together and gazing at each other with tender affection. It was widely believed that St. Luke had been the first to paint such a portrait of the Virgin and Child as they appeared to him in a vision.

Almost from its creation, the *Virgin of Vladimir* was thought to protect the people of the city where it resided. It arrived in Kiev sometime between 1131 and 1136 and was taken to the city of Suzdal and then to Vladimir in 1155. In 1480, it was moved to the Cathedral of the Dormition in the Moscow Kremlin. Today, even in a museum, it inspires prayer.

THE HARBAVILLE TRIPTYCH. Dating from the mid eleventh century, the small devotional ivory known as the **HARBAVILLE TRIPTYCH** features a tableau of Christ flanked by Mary and St. John the Baptist, a group known as the "Deësis" (FIG. 7–38). Deësis means "entreaty" in Greek, and here Mary and John intercede, presumably for the owner of this work, pleading with Christ for forgiveness and salvation. The emergence of the Deësis as an important theme is in keeping with an increasing personalization in Byzantine religious art. St. Peter stands directly under Christ, gesturing upward toward him. Inscriptions identify SS. James, John, Paul, and Andrew. The figures in the outer panels are military saints and martyrs. All these figures stand in a neutral space given definition only by the small bases under their feet, effectively removing them from the physical world. They are, however, fully realized human forms with rounded shoulders, thighs, and knees that suggest physical substance beneath their linear, decorative drapery.

THE PARIS PSALTER. The painters of luxuriously illustrated manuscripts matched the combination of intense religious expression, aristocratic elegance, and a heightened appreciation of rich decoration that we have experienced in monumental architectural painting.

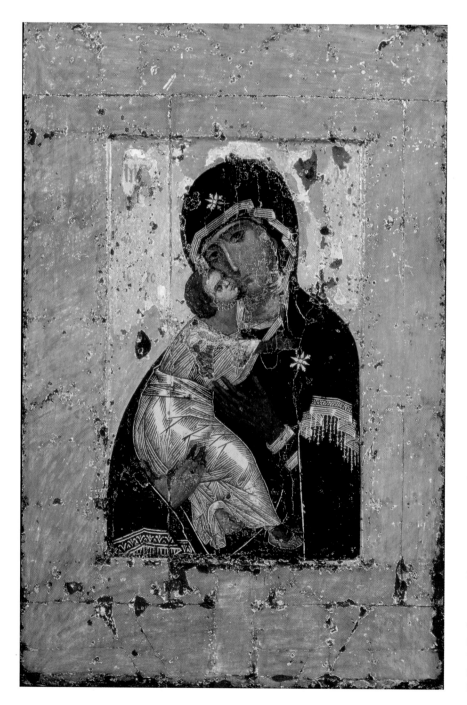

7-37 • VIRGIN OF VLADIMIR
Icon, probably from Constantinople. Faces, 11th–12th century; the figures have been retouched. Tempera on panel, height approx. 31″ (78 cm). Tretyakov Gallery, Moscow.

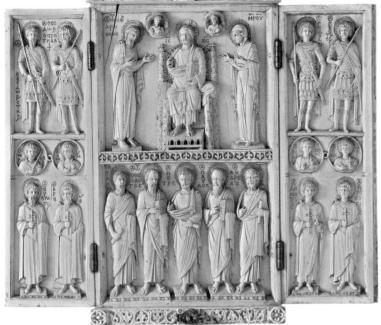

7-38 • HARBAVILLE TRIPTYCH
Mid 11th century. Ivory, closed 11 × 9½″ (28 × 24.1 cm);
open 11 × 19″ (28 × 48.2 cm). Musée du Louvre, Paris.

The luxurious Paris Psalter (named after its current library location), with 14 full-page paintings, was created for a Byzantine aristocrat during the second half of the tenth century. According to ancient tradition, the author of the Psalms was Israel's King David, who as a young shepherd and musician had saved the people of God by killing the giant Goliath (SEE FIG. 7–1). In Christian times, the Psalms were often extracted from the Bible and copied into a separate book called a **psalter**, used by wealthy Christians for private prayer and meditation.

The painters who worked on the Paris Psalter framed their scenes on full pages without text. The first of these depicts a seated David playing his harp **(FIG. 7–39)**. The monumental, idealized figures occupy a spacious landscape filled with lush foliage, a meandering stream, and a distant city. The image seems to have been transported directly from an ancient Roman wall painting. The ribbon-tied memorial column is a convention in Greek and Roman funerary art and, in the ancient manner, the illustrator has personified abstract ideas and landscape features: Melody, a female figure, leans casually on David's shoulder, while another woman, perhaps the nymph Echo, peeks out from behind the column. The swarthy reclining youth in

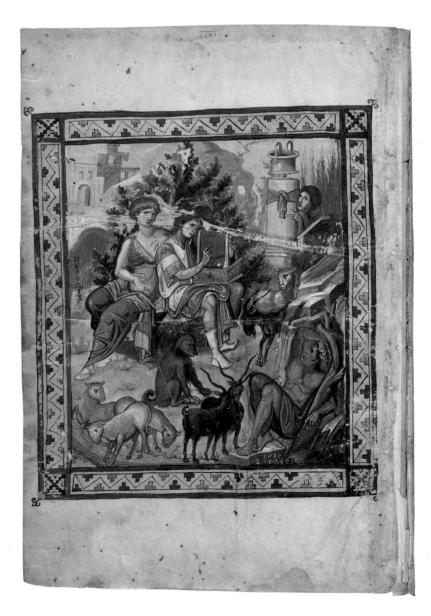

7-39 • DAVID THE PSALMIST
Page from the Paris Psalter. Second half of 10th century. Paint and gold on vellum, sheet size 14 × 10½″ (35.6 × 26 cm). Bibliothèque Nationale, Paris.

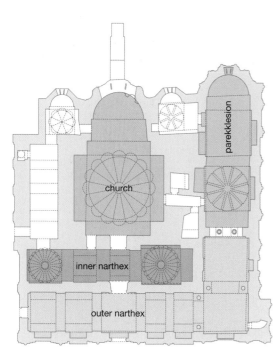

7-40 • PLAN OF THE MONASTERY CHURCH OF CHRIST IN CHORA

Constantinople. (Present-day Kariye Müzesi, Istanbul, Turkey.) 1077–1081, c. 1310–1321.

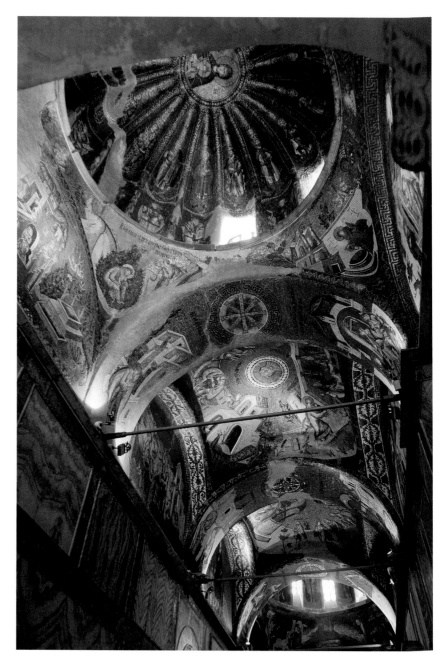

7-41 • MOSAICS IN THE VAULTING OF THE INNER NARTHEX

Church of Christ in Chora, Constantinople. (Present-day Kariye Müzesi, Istanbul, Turkey.) c. 1315–1321.

the lower foreground is a personification of Mount Bethlehem, as we learn from his inscription. The image of the dog watching over the sheep and goats while his master strums the harp suggests the Classical subject of Orpheus charming wild animals with music. The subtle modeling of forms, the integration of the figures into a three-dimensional space, and the use of atmospheric perspective all enhance the Classical flavor of the painting, in yet another example of the enduring vitality of pagan artistic traditions at the Christian court in Constantinople.

LATE BYZANTINE ART

The third great age of Byzantine art began in 1261, after the Byzantines expelled the Christian crusaders who had occupied Constantinople for nearly 60 years. Although the empire had been weakened and its realm decreased to small areas of the Balkans and Greece, its arts underwent a resurgence known as the Palaeologue Renaissance after the dynasty of emperors who ruled from Constantinople. The patronage of emperors, wealthy courtiers, and the Church stimulated renewed church building as well as the production of icons, books, and precious objects.

CONSTANTINOPLE: THE CHORA CHURCH

In Constantinople, many existing churches were renovated, redecorated, and expanded during the Palaeologue Renaissance. Among these is the church of the Monastery of Christ in Chora. The expansion of this church was one of several projects that Theodore Metochites (1270–1332), a humanist poet and scientist, and the administrator of the Imperial Treasury at Constantinople, sponsored between c. 1315 and 1321. He added a two-story annex

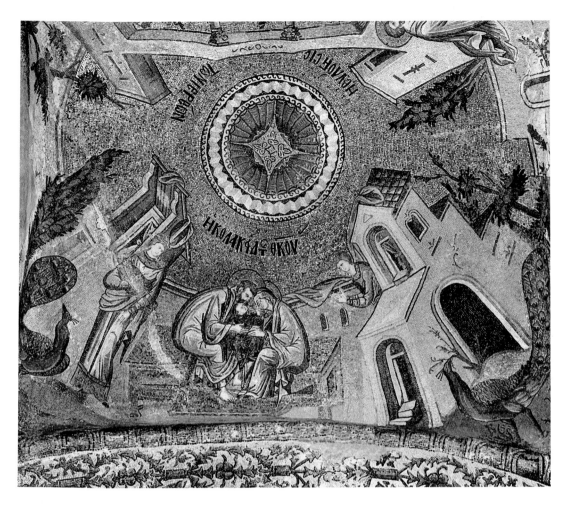

7-42 • THE INFANT VIRGIN MARY CARESSED BY HER PARENTS (JOACHIM AND ANNA)
Inner narthex, church of Christ in Chora, Constantinople. (Present-day Kariye Müzesi, Istanbul, Turkey.) c. 1315–1321. Mosaic.

The Greek inscription placed over the family group identifies this scene as the fondling of the Theotokos (bearer of God).

on the north side, two narthexes on the west, and a parekklesion (side chapel) used as a funerary chapel on the south (FIG. 7–40). These structures contain the most impressive interior decorations remaining in Constantinople from the Late Byzantine period, rivaling in splendor and technical sophistication the works of the age of Justinian, but on a more intimate scale. The walls and vaults of the parekklesion are covered with frescos (see "The Funerary Chapel of Theodore Metochites," pages 256–257), and the vaults of the narthexes are encrusted with mosaics.

In the new narthexes of the Chora church, above an expanse of traditional marble revetment on the lower walls, mosaics cover every surface—the domical groin vaults, the wall lunettes, even the undersides of arches—with narrative scenes and their ornamental framework (FIG. 7–41). The small-scale figures of these mosaics seem to dance with relentless enthusiasm through the narrative episodes they enact from the lives of Christ and his mother. Unlike the stripped-down narrative scenes of Daphni (SEE FIG. 7–35), here the artists have lavished special attention on the settings, composing their stories against backdrops of architectural fantasies and stylized plants. The architecture of the background is presented in an innovative system of perspective, charting its three-dimensionality not in relation to a point of convergence in the background—as will be the case in the linear, one-point perspective of fifteenth-century Florentine art (see "Renaissance Perspective," page 608)—but projecting forward in relationship to a point in the foreground, thereby drawing attention to the figural scenes themselves.

The Chora mosaics build on the growing Byzantine interest in the expression of emotions within religious narrative, but they broach a level of human tenderness that surpasses anything we have seen in Byzantine art thus far. The artists invite viewers to see the participants in these venerable sacred stories as human beings just like themselves, only wealthier and holier. For example, an entire narrative field in one vault is devoted to a scene where the infant Mary is cuddled between her adoring parents, Joachim and Anna (FIG. 7–42; part of the scene is visible lit up in FIG. 7–41). Servants on either side of the family look on with gestures and expressions of admiration and approval, perhaps modeling the response that is expected from viewers within the narthex itself. The human inter-action even extends to details, such as the nuzzling of Mary's head into the beard of her father as she leans back to look into his eyes, and her tentative reach toward her mother's face at the same time. In another scene, the young Jesus rides on the shoulders of Joseph, in a pose still familiar to fathers and children in our own time. The informality and believability that these anecdotal details bring to this sacred narrative recalls developments as far away as Italy, where at this same time Giotto and Duccio were using similar devices to bring their stories to life (see Chapter 17).

The Funerary Chapel of Theodore Metochites

Theodore Metochites (1270–1332) was one of the most fascinating personalities of the Late Byzantine world. Son of a disgraced intellectual cleric—condemned and exiled for championing the union of the Roman and Byzantine Churches—Metochites became a powerful intellectual figure in Constantinople. As a poet, philosopher, and astronomer who wrote scores of convoluted commentaries in an intentionally cultivated, arcane, and mannered literary style, he ridiculed a rival for his prose style of "excess clarity." In 1290, Emperor Andronicus II Palaeologus (r. 1282–1328) called Metochites to court service, where the prolific young scholar became an influential senior statesman, ascending to the highest levels of the government and amassing power and wealth second only to that of the emperor himself. Metochites' political and financial status fell when the emperor was overthrown by his grandson in 1328. Stripped of his wealth and sent into exile, he was allowed to return to the capital two years later, retiring to house arrest at the Chora monastery, where he died and was buried in 1332.

It is his association with this monastery that has become Theodore Metochites' greatest claim to enduring fame. Beginning in about 1315, at the peak of his power and wealth, he funded an expansion and restoration of the church of Christ in Chora (meaning "in the country"), part of an influential monastery on the outskirts of Constantinople. The mosaic decoration he commissioned for the church's expansive narthexes (SEE FIGS. 7–41, 7–42) may be the most sumptuous product of his beneficence, but the project probably revolved around a funerary chapel (or parekklesion) that he built adjacent to the main church (FIG. B), potentially motivated by a desire to create a location for his own funeral and tomb.

The extensive and highly integrative program of frescos covering every square inch of the walls and vaults of this jewel-box space focuses on funerary themes and expectations of salvation and its rewards. Above a dado of imitation marble stand a frieze of 34 stately saints ready to fulfill their roles as intercessors for the faithful. Above them, on the side walls of the main space, are stories from the Hebrew Bible interpreted as prefigurations of the Virgin Mary's own intercessory powers. A portrayal of Jacob's ladder (Genesis 28:11–19), for example, evokes her position between heaven and earth as a bridge from death to life. In the pendentives of the dome over the main space (two of which are seen in the foreground) sit famous Byzantine hymn writers, with quotations from their work. These carefully chosen passages highlight texts associated with funerals, including one that references the story of Jacob's ladder.

The climax of the decorative program, however, is the powerful rendering of the Anastasis that occupies the halfdome of the apse (FIG. A). In this popular Byzantine representation of the Resurrection—drawn not from the Bible but from the apocryphal Gospel of Nicodemus—Jesus demonstrates his powers of salvation by descending into hell after his death on the cross to save his righteous Hebrew forebears from Satan's grasp. Here a boldly striding Christ—brilliantly outfitted in a pure white that makes him shine to prominence within the fresco program—lunges to rescue Adam and Eve from their tombs, pulling them upward with such force that they seem to float airborne under the spell of his power. Satan lies tied into a useless bundle at his feet, and patriarchs, kings, and prophets to either side look on in admiration, perhaps waiting for their own turn to be rescued. During a funeral in this chapel, the head of the deceased would have been directed toward this engrossing tableau, closed eyes facing upward toward a painting of the Last Judgment, strategically positioned on the vault over the bier. In 1332, this was the location of Metochites' own dead body since this parekklesion was indeed the site of his funeral. He was buried in one of the niche tombs cut into the walls of the chapel itself.

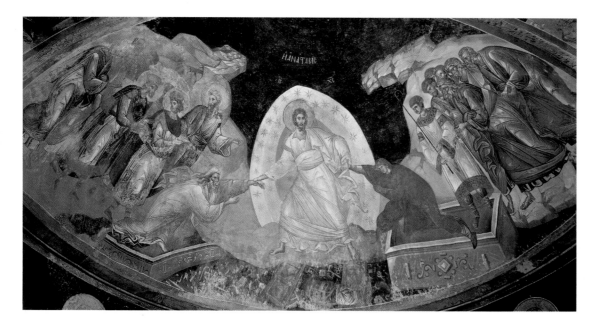

A. ANASTASIS
Apse of the funerary chapel, church of the Monastery of Christ in Chora. Fresco. Getty Research Library, Los Angeles. Wim Swaan Photograph Collection, 96.P.21

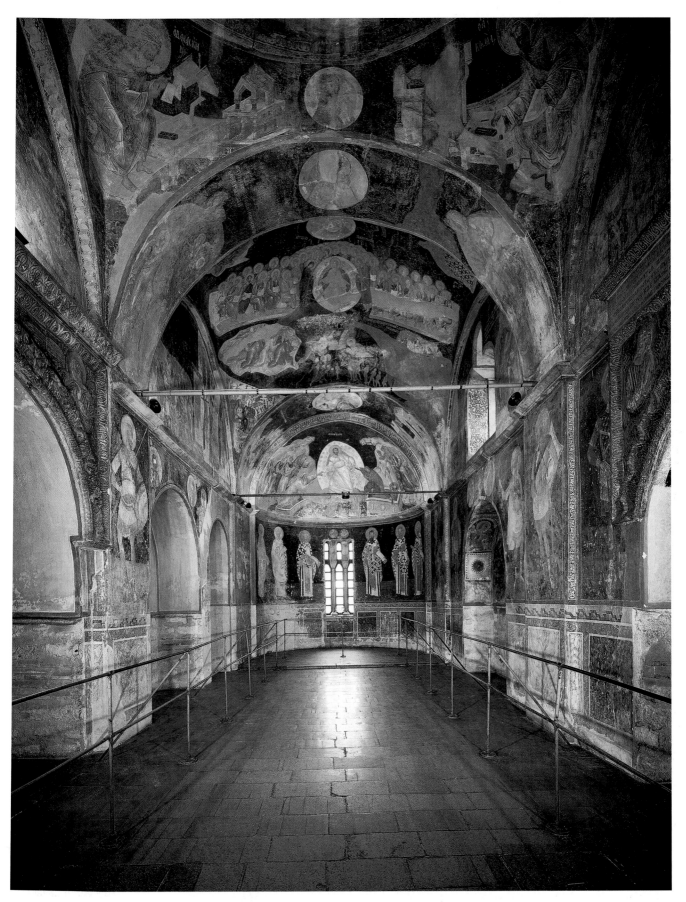

B. FUNERARY CHAPEL (PAREKKLESION), CHURCH OF THE MONASTERY OF CHRIST IN CHORA

Constantinople. (Present-day Kariye Müzesi, Istanbul, Turkey.) c. 1310–1321.

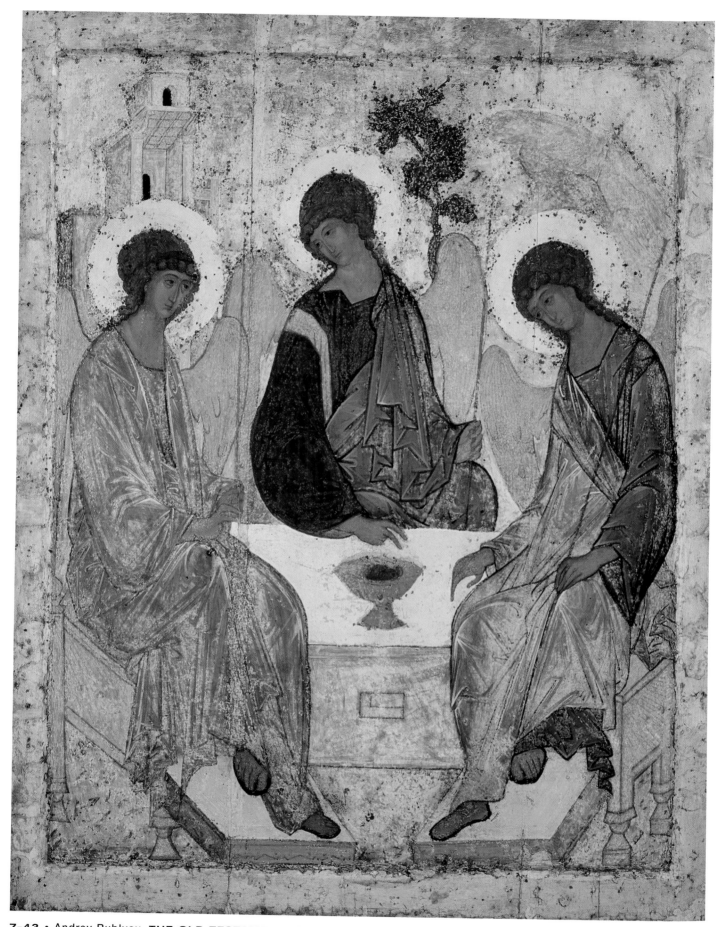

7-43 • Andrey Rublyov THE OLD TESTAMENT TRINITY (THREE ANGELS VISITING ABRAHAM)
Icon. c. 1410–1425. Tempera on panel, 55½ × 44½″ (141 × 113 cm).

MOSCOW: RUBLYOV

In the fifteenth and sixteenth centuries, architecture of the Late Byzantine style flourished outside the borders of the empire in regions that had adopted Eastern Orthodox Christianity. After Constantinople's fall to the Ottoman Turks in 1453, leadership of the Orthodox Church shifted to Russia, whose rulers declared Moscow to be the "Third Rome" and themselves the heirs of Caesar (the tsar).

The practice of venerating icons continued—perhaps even intensified—in Russia, where regional schools of icon painting flourished, fostering the work of remarkable artists. A magnificent icon from this time is **THE OLD TESTAMENT TRINITY (THREE ANGELS VISITING ABRAHAM)**, a large panel created sometime between about 1410 and 1425 by the renowned artist-monk Andrey Rublyov **(FIG. 7–43)**. It was commissioned in honor of Abbot Sergius of the Trinity-Sergius Monastery, near Moscow. The theme is the Trinity, always a challenge for artists. One late medieval solution was to show three identical divine individuals—here three angels—to suggest the idea of the Trinity. Rublyov's composition was inspired by a story in the Hebrew Bible of the patriarch Abraham and his wife Sarah, who entertained three strangers who were in fact God represented by three divine beings in human form (Genesis 18). Tiny images of Abraham and Sarah's home and the oak of Mamre can be seen above the angels. On the table, the food the couple offered to the strangers becomes a chalice on an altarlike table.

Rublyov's icon clearly illustrates how Late Byzantine artists relied on mathematical conventions to create ideal figures, as did the ancient Greeks, giving their works remarkable consistency. But unlike the Greeks, who based their formulas on close observation of nature, Byzantine artists invented an ideal geometry to evoke a spiritual realm and conformed their representations of human forms and features to it. Here, as is often the case, the circle—most apparent in the haloes—forms the basic underlying structure for the composition. Despite the formulaic approach, talented artists like Rublyov created a personal, expressive style working within it. Rublyov relied on typical Byzantine conventions—salient contours, elongation of the body, and a focus on a limited number of figures—to capture the sense of the spiritual in his work, yet he distinguished his art by imbuing it with a sweet, poetic ambience. In this master's hands, the Byzantine style took on a graceful and eloquent new life.

The Byzantine tradition would continue in the art of the Eastern Orthodox Church and is carried on to this day in Greek and Russian icon painting. In Constantinople, however, the three golden ages of Byzantine art—and the empire itself—came to an end in 1453. When the forces of the Ottoman sultan Mehmed II overran the capital, the Eastern Empire became part of the Islamic world. But the Turkish conquerors were so impressed with the splendor of the Byzantine art and architecture in the capital that they adopted its traditions and melded them with their own rich aesthetic heritage into a new, and now Islamic, artistic efflorescence.

THINK ABOUT IT

7.1 Discuss the Roman foundations of Early Christian sculpture, focusing your answer on the *Sarcophagus of Junius Bassus* (FIG. 7–13). Look back to Chapter 6 to help form your ideas.

7.2 Distinguish the "iconic" from the "narrative" in Early Christian and Byzantine art, locating one example of each in this chapter. How are these two traditions used by the Church and its members?

7.3 Distinguish the identifying features of basilicas and central-plan churches, and discuss how the forms of these early churches were geared toward specific types of Christian worship and devotional practice.

7.4 How were images used in Byzantine worship? Why were images suppressed during Iconoclasm?

7.5 Compare and contrast the mosaics of San Vitale in Ravenna with those in the Chora church in Constantinople. Consider, in particular, how figures are represented, what kinds of stories are told, and in what way.

PRACTICE MORE: Compose answers to these questions, get flashcards for images and terms, and review chapter material with quizzes **www.myartslab.com**

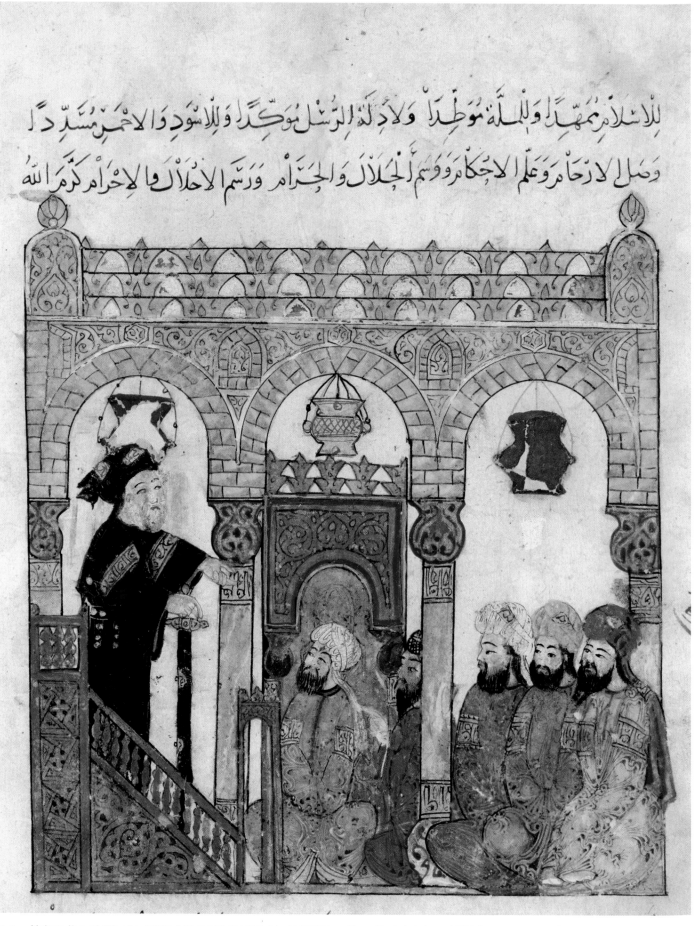

للإسلام ممهداً وللملة موطداً ولأدلة الرسل موكداً وللأسود والأحمر مسدداً

وصل الأرحام وعلم الأحكام وسم الجلال والحرام ورسم الأحلال والأحرام كرّم الله

8–1 • Yahya Ibn al-Wasiti THE *MAQAMAT* OF AL-HARIRI From Baghdad, Iraq. 1237. Paper. Bibliothèque Nationale, Paris. (Arabic MS. 5847, f. 18v)

ISLAMIC ART

The *Maqamat* ("*Assemblies*"), by al-Hariri (1054–1122), belongs to a popular literary genre of cautionary tales dating from the tenth century. The manuscript's vividly detailed scenes provide windows into ordinary Muslim life, here prayer in the congregational **mosque**, a religious and social institution central to Islam. Al-Hariri's stories revolve around a silver-tongued scoundrel named Abu Zayd, whose cunning inevitably triumphs over other people's naivety. His adventures take place in a world of colorful settings—desert camps, ships, pilgrim caravans, apothecary shops, mosques, gardens, libraries, cemeteries, and courts of law. Humans activate the scenes, pointing fingers, arguing, riding horses, stirring pots, and strumming musical instruments. These comic stories of trickery and theft would seem perfectly suited for illustration, but of the hundreds of surviving manuscript copies, only 13 have pictures.

This illustration **(FIG. 8–1)** shows a mosque with the congregation gathered to hear a sermon preached by the deceitful Abu Zayd, who plans to steal the alms collected from the congregation. The men sit directly on the ground, as is customary in mosques (and traditional dwellings). They look generally forward, but the listener in the front row tilts his chin upward to focus his gaze directly upon the speaker. He is framed and centered by the arch of the niche (**mihrab**) on the rear wall, his white turban contrasting noticeably with the darker background. To the extent that he represents any specific individual, he seems to stand in for the manuscript's reader who, perusing the illustrations of these captivating stories, pauses and perhaps projects himself or herself into the scene.

The columns of the arcades have ornamental capitals from which spring half-round arches. Glass mosque lamps filled with oil hang from the center of each arch. All the figures wear turbans and flowing, loose-sleeved robes with epigraphic borders (*tiraz*) embroidered in gold.

The sermon is delivered from a pulpit (**minbar**) of steps with an arched opening at the lowest level. This *minbar* and the arcades that form the backdrop to the scene and define the mosque's interior are unnaturally reduced in scale. The painter has manipulated the sizes so as to fit the maximum amount of detail into the scene, sacrificing natural space in order to make the painting more communicative. Likewise, although in an actual mosque the *minbar* would share the same wall as the niche in the center, here they have been separated to keep the niche from being hidden by the *minbar*. There is little modeling to represent volume: Instead depth of field is suggested by the overlapping of forms.

LEARN ABOUT IT

8.1 Discover Islamic art's eclecticism and embrace of other cultures.

8.2 Compare and contrast the variety of art and architecture in the disparate areas of the Islamic world.

8.3 Interpret art as a reflection of both religion and secular society.

8.4 Explore the use of ornament and inscription in Islamic art.

8.5 Recognize the role of trade routes and political ties in the creation of Islamic artistic unity.

HEAR MORE: Listen to an audio file of your chapter **www.myartslab.com**

ISLAM AND EARLY ISLAMIC SOCIETY

Islam arose in seventh-century Arabia, a land of desert oases with no cities of great size, sparsely inhabited by tribal nomads. Yet, under the leadership of its founder, the Prophet Muhammad (c. 570–632 CE), and his successors, Islam spread rapidly throughout northern Africa, southern and eastern Europe, and much of Asia, gaining territory and converts with astonishing speed. Because Islam encompassed geographical areas with a variety of long-established cultural traditions, and because it admitted diverse peoples among its converts, it absorbed and combined many different techniques and ideas about art and architecture. The result was a remarkable eclecticism and artistic sophistication.

In the desert outside of Mecca in 610, Muhammad received revelations that led him to found the religion called Islam ("submission to God's will"), whose adherents are Muslims ("those who have submitted to God"). Many powerful Meccans were hostile to the message of the young visionary, and in 622 he and his companions were forced to flee to Medina. There Muhammad built a house that became a gathering place for the converted and thus the first Islamic mosque. Muslims date their history as beginning with this *hijira* ("emigration").

In 630, Muhammad returned to Mecca with an army of 10,000, routed his enemies, and established the city as the spiritual capital of Islam. After his triumph, he went to the Kaaba (**FIG. 8–2**), a cubical, textile-draped shrine said to have been built for God by Ibrahim (Abraham) and Isma'il (Ishmael) and long the focus of pilgrimage and polytheistic worship. He emptied the shrine, repudiating its accumulated pagan idols, while preserving the enigmatic cubical structure itself and dedicating it to God.

The Kaaba is the symbolic center of the Islamic world, the place to which all Muslim prayer is directed and the ultimate destination of Islam's obligatory pilgrimage, the *hajj*. Each year, huge numbers of Muslims from all over the world travel to Mecca to circumambulate the Kaaba during the month of pilgrimage. The exchange of ideas that occurs during the intermingling of these diverse groups of pilgrims has contributed to Islam's cultural eclecticism.

Muhammad's act of emptying the Kaaba of its pagan idols instituted the fundamental concept of **aniconism** (avoidance of

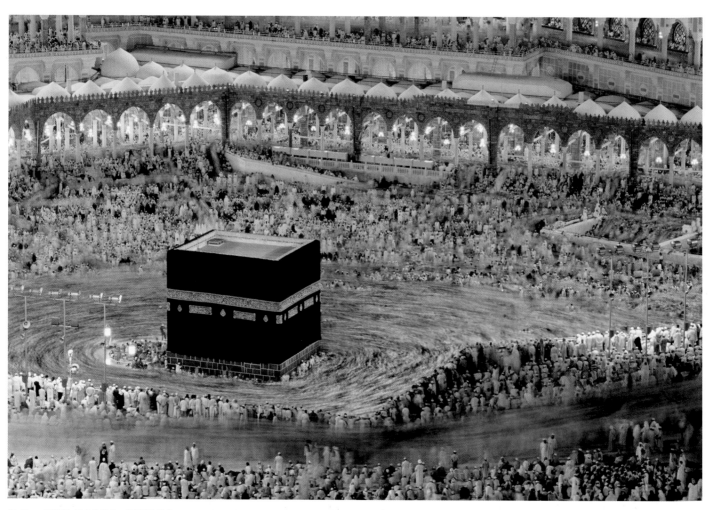

8-2 • THE KAABA, MECCA
The Kaaba represents the center of the Islamic world. Its cubical form is draped with a black textile that is embroidered with a few Qur'anic verses in gold.

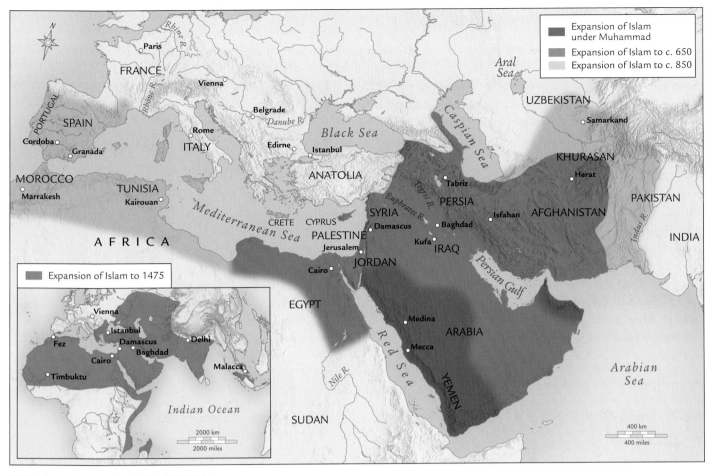

MAP 8–1 • THE ISLAMIC WORLD

Within 200 years after 622 CE, the Islamic world expanded from Mecca to India in the east, and to Morocco and Spain in the west.

figural imagery) in Islamic art. Following his example, the Muslim faith discourages the representation of figures in religious contexts (although such images abound in palaces and illustrated manuscripts). Instead, Islamic artists elaborated a rich vocabulary of nonfigural ornament, including complex geometric designs and scrolling vines sometimes known as **arabesques**. Islamic art revels in surface decoration, in manipulating line, color, and especially pattern, often highlighting the interplay of pure abstraction, organic form, and script.

According to tradition, the Qur'an assumed its final form during the time of the third caliph (successor to the Prophet), Uthman (r. 644–56). As the language of the Qur'an, the Arabic language and script have been a powerful unifying force within Islam. From the eighth through the eleventh centuries, it was the universal language among scholars in the Islamic world and in some Christian lands as well. Inscriptions frequently ornament works of art, sometimes written clearly to provide a readable message, but in other cases written as complex patterns simply to delight the eye.

The Prophet was succeeded by a series of caliphs. The accession of Ali as the fourth caliph (r. 656–61) provoked a power struggle that led to his assassination and resulted in enduring divisions within Islam. Followers of Ali, known as Shi'ites (referring

to the party or *shi'a* of Ali), regard him alone as the Prophet's rightful successor. Sunni Muslims, in contrast, recognize all of the first four caliphs as "rightly guided." Ali was succeeded by his rival Muawiya (r. 661–80), a close relative of Uthman and the founder of the first Muslim dynasty, the Umayyad dynasty (661–750).

Islam expanded dramatically. In just two decades, seemingly unstoppable Muslim armies conquered the Sasanian Persian Empire, Egypt, and the Byzantine provinces of Syria and Palestine. By the early eighth century, under the Umayyads, they had reached India, conquered northern Africa and Spain, and penetrated France before being turned back (MAP 8–1). In these newly conquered lands, the treatment of Christians and Jews who did not convert to Islam was not consistent, but in general, as "People of the Book"—followers of a monotheistic religion based on a revealed scripture—they enjoyed a protected status. However, they were also subject to a special tax and restrictions on dress and employment.

Muslims participate in congregational worship at a mosque (*masjid*, "place of prostration"). The Prophet Muhammad himself lived simply and instructed his followers in prayer at his house, now known as the Mosque of the Prophet, where he resided in Medina. This was a square enclosure that framed a large courtyard with rooms along the east wall where he and his family lived. Along the

Islamic art delights in complex ornament that sheathes surfaces, distracting the eye from the underlying structure or physical form.

ablaq masonry (*Madrasa*-Mausoleum-Mosque of Sultan Hasan, Cairo) juxtaposes stone of contrasting colors. The ornamental effect is enhanced here by the interlocking jigsaw shape of the blocks, called **joggled voussoirs**.

cut tile (Shah-i Zinda, Samarkand), made up of dozens of individually cut ceramic tile pieces fitted precisely together, emphasizes the clarity of the colored shapes.

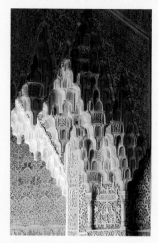

muqarnas (Court of the Lions, Alhambra, Granada) consists of small nichelike components, usually stacked in multiples as successive, nonload-bearing units in arches, cornices, and domes, hiding the transition from the vertical to the horizontal plane.

wooden strapwork (Kutubiya *Minbar*, Marrakesh) assembles finely cut wooden pieces to create the appearance of geometrically interlacing ribbons, often framing smaller panels of carved wood and inlaid ivory or mother-of-pearl (shell).

mosaic (Dome of the Rock, Jerusalem) is comprised of thousands of small glass or glazed ceramic tesserae set on a plaster ground. The luminous white circular shapes are mother-of-pearl.

water (Court of the Myrtles, Alhambra, Granada) is a fluid architectural element that reflects surrounding architecture, adds visual dynamism and sound, and, running in channels between halls, unites disparate spaces.

chini khana (Ali Qapu Pavilion, Isfahan)—literally "china cabinet"—is a panel of niches, sometimes providing actual shelving, but used here for its contrast of material and void which reverses the typical figure-ground relationship.

south wall, a thatched portico supported by palm-tree trunks sheltered both the faithful as they prayed and Muhammad as he spoke from a low platform. This simple arrangement inspired the design of later mosques. Lacking an architectural focus such as an altar, nave, or dome, the space of this prototypical **hypostyle** (multicolumned) mosque reflected the founding spirit of Islam in which the faithful pray as equals directly to God, led by an imam, but without the intermediary of a priesthood.

ART AND ARCHITECTURE THROUGH THE FOURTEENTH CENTURY

The caliphs of the Umayyad dynasty (661–750) ruled from Damascus in Syria, and throughout the Islamic Empire they built mosques and palaces that projected the authority of the new rulers and reflected the growing acceptance of Islam. In 750 the Abbasid clan replaced the Umayyads in a coup d'état, ruling as caliphs until 1258 from Baghdad, in Iraq, in the grand manner of the ancient Persian emperors. Their long and cosmopolitan reign saw achievements in medicine, mathematics, the natural sciences, philosophy, literature, music, and art. They were generally tolerant of the ethnically diverse populations in the territories they subjugated, and they admired the past achievements of Roman civilization and the living traditions of Byzantium, Persia, India, and China, freely borrowing artistic techniques and styles from all of them.

In the tenth century, the Islamic world split into separate kingdoms ruled by independent caliphs. In addition to the Abbasids of Iraq, there was a Fatimid Shi'ite caliph ruling Tunisia and Egypt, and a descendant of the Umayyads ruling Spain and Portugal (together then known as al-Andalus). The Islamic world did not reunite under the myriad dynasties who thereafter ruled from northern Africa to Asia, but the loss to unity was a gain to artistic diversity.

EARLY ARCHITECTURE

While Mecca and Medina remained the holiest Muslim cities, the political center shifted to the Syrian city of Damascus in 656. In the eastern Mediterranean, inspired by Roman and Byzantine architecture, the early Muslims became enthusiastic builders of shrines, mosques, and palaces. Although tombs were officially discouraged in Islam, they proliferated from the eleventh century onward, in part due to funerary practices imported from the Turkic northeast, and in part due to the rise of Shi'ism with its emphasis on genealogy and particularly ancestry through Muhammad's daughter, Fatima.

THE DOME OF THE ROCK. The Dome of the Rock is the first great monument of Islamic art. Built in Jerusalem, it is the third most holy site in Islam. In the center of the city rises the Haram al-Sharif ("Noble Sanctuary") **(FIG. 8–3)**, a rocky outcrop from which Muslims believe Muhammad ascended to the presence of God on the "Night Journey" described in the Qur'an. It is the site of the First and Second Jewish Temples, and Jews and Christians variously associate it with Solomon, the site of the creation of Adam, and the place where the patriarch Abraham prepared to sacrifice his son Isaac at the command of God. In 691–92, a shrine was built over the rock using artisans trained in the Byzantine tradition. By appropriating a site holy to the Jewish and Christian

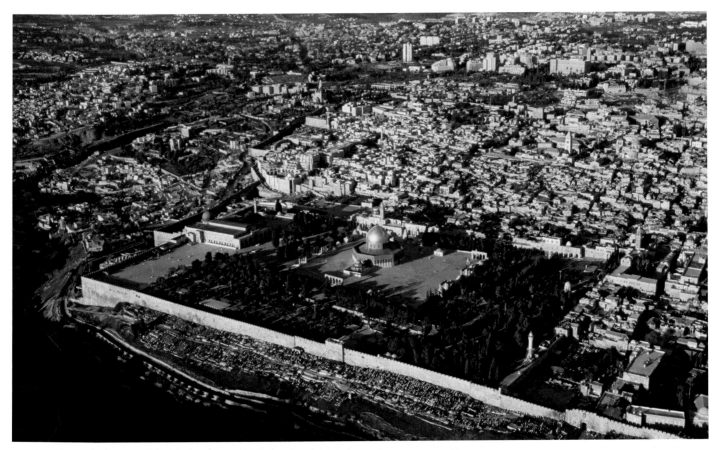

8-3 • AERIAL VIEW OF HARAM AL-SHARIF, JERUSALEM
The Dome of the Rock occupies a place of visual height and prominence in Jerusalem and, when first built, strikingly emphasized the arrival of Islam and its community of adherents in that ancient city.

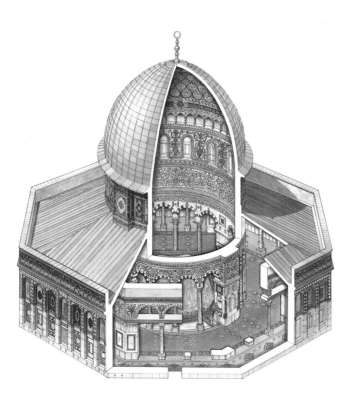

8-4 • CUTAWAY DRAWING OF THE DOME OF THE ROCK

faiths, the Dome of the Rock is the first architectural manifestation of Islam's view of itself as completing the prophecies of those faiths and superseding them.

Structurally, the Dome of the Rock imitates the centrally planned form of Early Christian and Byzantine martyria (SEE FIG. 7-20). However, unlike its models, with their plain exteriors, it is crowned by a golden dome that dominates the Jerusalem skyline. The ceramic tiles on the lower portion of the exterior were added later, but the opulent marble veneer and mosaics of the interior are original (see "Ornament," page 264). The dome, surmounting a circular drum pierced with windows and supported by arcades of alternating **piers** and **columns**, covers the central space containing the rock (**FIG. 8–4**). These arcades create concentric **aisles (ambulatories)** that permit devout visitors to circumambulate the rock. Inscriptions from the Qur'an interspersed with passages from other texts, including information about the building itself, form a frieze around the inner and outer arcades. As the pilgrim walks around the central space to read the inscriptions in brilliant gold mosaic on turquoise green ground, the building communicates both as a text and as a dazzling visual display (**FIG. 8–5**). These passages of text are especially notable because they are the oldest surviving written Qur'an verses and the first use of monumental Qur'anic inscriptions in architecture. Below are walls covered with pale marble, the veining of which creates abstract symmetrical patterns, and columns with shafts of gray marble and gilded capitals. Above the calligraphic frieze is another mosaic frieze depicting thick, symmetrical vine scrolls and trees in turquoise, blue, and green, embellished with imitation jewels, over a gold ground. The mosaics are variously

thought to represent the gardens of Paradise and trophies of Muslim victories offered to God. The decorative program is extraordinarily rich but, remarkably enough, the focus of the building is neither art nor architecture but the plain rock within it.

THE GREAT MOSQUE OF KAIROUAN. Muslim congregations gather on Fridays for regular worship in a mosque. The earliest mosque type was the hypostyle, following the model of the Prophet's own house. The Great Mosque of Kairouan, Tunisia (**FIG. 8–6**), built in the ninth century, reflects the early form of the mosque but is elaborated with later additions. The large rectangular space is divided between a courtyard and a flat-roofed hypostyle prayer hall oriented toward Mecca. The system of repeated bays and aisles can easily be extended as the congregation grows in size—

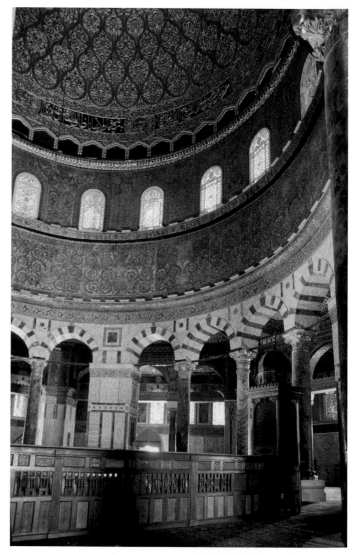

8-5 • DOME OF THE ROCK, JERUSALEM
691. Interior. The arches of the inner and outer face of the central arcade are encrusted with golden mosaics, a Byzantine technique adapted for Islamic use. The carpets and ceilings are modern but probably reflect the original patron's intention.

EXPLORE MORE: Click the Google Earth link for the Dome of the Rock **www.myartslab.com**

The Five Pillars of Islam

Islam emphasizes a direct, personal relationship with God. The Pillars of Islam, sometimes symbolized by an open hand with the five fingers extended, enumerate the duties required of Muslims by their faith.

- The first pillar (*shahadah*) is to proclaim that there is only one God and that Muhammad is his messenger. While monotheism is common to Judaism, Christianity, and Islam, and Muslims worship the god of Abraham, and also acknowledge Hebrew and Christian prophets such as Musa (Moses) and Isa (Jesus), Muslims deem the Christian Trinity polytheistic and assert that God was not born and did not give birth.
- The second pillar requires prayer (*salat*) to be performed by turning to face the Kaaba in Mecca five times daily: at dawn, noon, late afternoon, sunset, and nightfall. Prayer can occur almost anywhere, although the prayer on Fridays takes place in the congregational mosque. Because ritual ablutions are required for purity, mosque courtyards usually have fountains.
- The third pillar is the voluntary payment of annual tax or alms (*zakah*), equivalent to one-fortieth of one's assets. *Zakah* is used for charities such as feeding the poor, housing travelers, and paying the dowries of orphan girls. Among Shi'ites, an additional tithe is required to support the Shi'ite community specifically.

- The fourth pillar is the dawn-to-dusk fast (*sawm*) during Ramadan, the month when Muhammad received the revelations set down in the Qur'an. The fast of Ramadan is a communally shared sacrifice that imparts purification, self-control, and kinship with others. The end of Ramadan is celebrated with the feast day 'Id al-Fitr (Festival of the Breaking of the Fast).
- For those physically and financially able to do so, the fifth pillar is the pilgrimage to Mecca (*hajj*), which ideally is undertaken at least once in the life of each Muslim. Among the extensive pilgrimage rites are donning simple garments to remove distinctions of class and culture; collective circumambulations of the Kaaba; kissing the Black Stone inside the Kaaba (probably a meteorite that fell in pre-Islamic times); and the sacrificing of an animal, usually a sheep, in memory of Abraham's readiness to sacrifice his son at God's command. The end of the *hajj* is celebrated by the festival 'Id al-Adha (Festival of Sacrifice).

The directness and simplicity of Islam have made the Muslim religion readily adaptable to numerous varied cultural contexts throughout history. The Five Pillars instill not only faith and a sense of belonging, but also a commitment to Islam in the form of actual practice.

one of the hallmarks of the hypostyle plan. New is the large tower (the **minaret**, from which the faithful are called to prayer) that rises from one end of the courtyard and that stands as a powerful sign of Islam's presence in the city.

The **qibla** wall, marked by a centrally positioned *mihrab* niche, is the wall of the prayer hall that is closest to Mecca. Prayer is oriented towards this wall. In the Great Mosque of Kairouan, the *qibla* wall is given heightened importance by a raised roof, a dome over the *mihrab*, and a central aisle that marks the axis that extends from the minaret to the *mihrab* (for a fourteenth-century example of a *mihrab*, SEE FIG. 8–12). The *mihrab* belongs to the historical tradition of niches that signify a holy place—the shrine for the Torah scrolls in a synagogue, the frame for the sculpture of a god or ancestor in Roman architecture, the apse in a church.

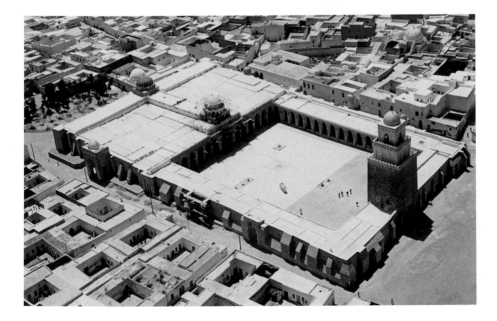

8-6 • THE GREAT MOSQUE, KAIROUAN, TUNISIA
836–875.

EXPLORE MORE: Click the Google Earth link for the Great Mosque of Kairouan **www.myartslab.com**

The Great Mosque of Cordoba

When the Umayyads were toppled in 750, a survivor of the dynasty, Abd al-Rahman I (r. 756–788), fled across north Africa into southern Spain (al-Andalus) where, with the support of Muslim settlers, he established himself as the provincial ruler, or emir. This newly transplanted Umayyad dynasty ruled in Spain from their capital in Cordoba (756–1031). The Hispano-Umayyads were noted patrons of the arts, and one of the finest surviving examples of Umayyad architecture is the Great Mosque of Cordoba.

In 785, the Umayyad conquerors began building the Cordoba mosque on the site of a Christian church built by the Visigoths, the pre-Islamic rulers of Spain. The choice of site was both practical—for the Muslims had already been renting space within the church—and symbolic, an appropriation of place (similar to the Dome of the Rock) that affirmed their presence. Later rulers expanded the building three times, and today the walls enclose an area of about 620 by 460 feet, about a third of which is the courtyard. This patio was planted with fruit trees, beginning in the early ninth century; today orange trees seasonally fill the space with color and sweet scent. Inside, the proliferation of pattern in the repeated columns and double flying arches is colorful and dramatic. The marble columns and capitals in the hypostyle prayer hall were recycled from the Christian church that had formerly occupied the site, as well as from classical buildings in the region, which had been a wealthy Roman province. The mosque's interior incorporates *spolia* (reused) columns of slightly varying heights. Two tiers of arches, one over the other, surmount these columns; the upper tier springs from rectangular posts that rise from the columns. This double-tiered design dramatically increases the height of the interior space, inspiring a sense of

monumentality and awe. The distinctively shaped **horseshoe arches**—a form known from Roman times and favored by the Visigoths—came to be closely associated with Islamic architecture in the West (see "Arches," page 271). Another distinctive feature of these arches, adopted from Roman and Byzantine precedents, is the alternation of white stone and red brick voussoirs forming the curved arch. This mixture of materials may have helped the building withstand earthquakes.

In the final century of Umayyad rule, Cordoba emerged as a major commercial and intellectual hub and a flourishing center for the arts, surpassing Christian European cities in science, literature, and philosophy. As a sign of this new wealth, prestige, and power, Abd al-Rahman III (r. 912–961) boldly reclaimed the title of caliph in 929. He and his son al-Hakam II (r. 961–976) made the Great Mosque a focus of patronage, commissioning costly and luxurious renovations such as a new *mihrab* with three bays in front of it. These capped the **maqsura**, an enclosure in front of the *mihrab* reserved for the ruler and other dignitaries, which became a feature of congregational

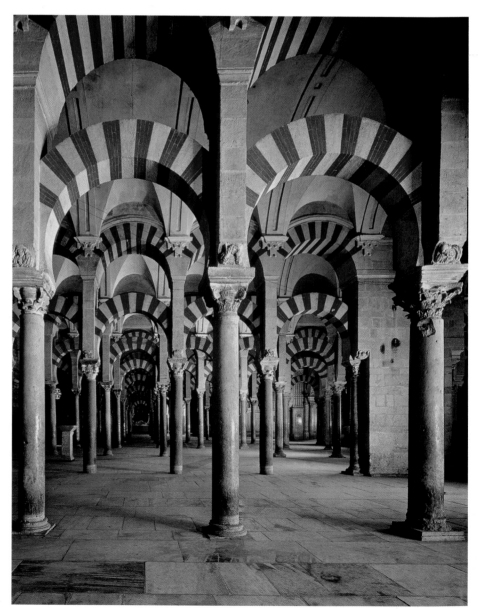

PRAYER HALL, GREAT MOSQUE, CORDOBA, SPAIN
Begun 785/786.

mosques after an assassination attempt on one of the Umayyad rulers. A *minbar* formerly stood by the *mihrab* as the place for the prayer leader and as a symbol of authority. The melon-shaped, ribbed dome over the central bay may be a metaphor for the celestial canopy. It seems to float upon a web of crisscrossing arches, the complexity of the design reflecting the Islamic interest in mathematics and geometry, not purely as abstract concepts but as sources for artistic inspiration. Lushly patterned mosaics with inscriptions, geometric motifs, and stylized vegetation clothe both this dome and the *mihrab* below in brilliant color and gold. These were installed by a Byzantine master who was sent by the emperor in Constantinople, bearing boxes of small glazed ceramic and glass pieces (*tesserae*). Such artistic exchange is emblematic of the interconnectedness of the medieval Mediterranean—through trade, diplomacy, and competition.

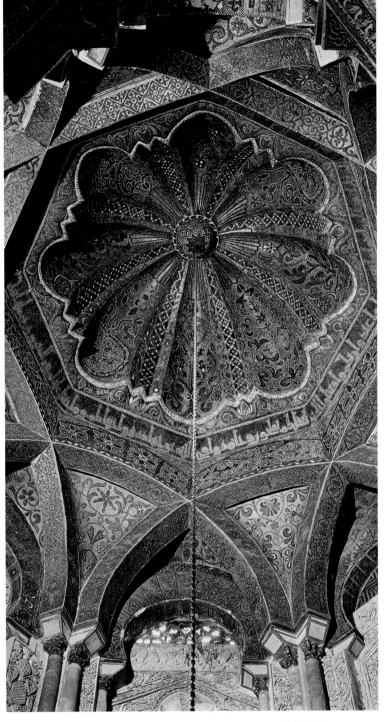

DOME IN FRONT OF THE MIHRAB, GREAT MOSQUE, CORDOBA
965.

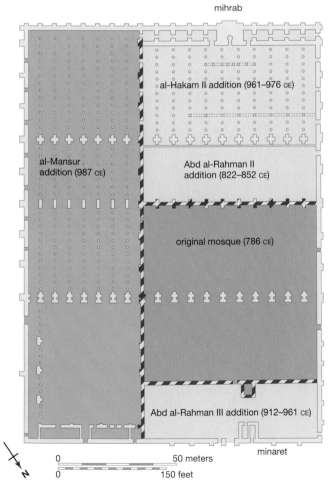

mihrab

al-Hakam II addition (961–976 CE)

al-Mansur addition (987 CE)

Abd al-Rahman II addition (822–852 CE)

original mosque (786 CE)

Abd al-Rahman III addition (912–961 CE)

minaret

0 50 meters
0 150 feet

PLAN, GREAT MOSQUE, CORDOBA

EXPLORE MORE: Click the Google Earth link for the Great Mosque at Cordoba **www.myartslab.com**

THE KUTUBIYA MOSQUE. In the Kutubiya Mosque, the principal mosque of Marrakesh, Morocco, an exceptionally exquisite wooden *minbar* survives from the twelfth century (**FIG. 8–7**). It consists of a staircase from which the weekly sermon was delivered to the congregation (for example, SEE FIG. 8–1). The sides are paneled in wooden marquetry with strapwork in a geometric pattern of eight-pointed stars and elongated hexagons inlaid with ivory (see "Ornament," page 264). The body of each figure is filled with wood carved in swirling vines. The risers of the stairs represent **horseshoe arches** resting on columns with ivory capitals and bases: Thus the pulpit (which had been made originally for the Booksellers' Mosque in Marrakesh) reflected the arcades of its surrounding architectural context. This *minbar* resembled others across the Islamic world, but those at the Kutubiya Mosque and the Great Mosque of Cordoba were the finest, according to Ibn Marzuq (1311–1379), a distinguished preacher who had given sermons from 48 such *minbars*.

THE LATER PERIOD

The Abbasid caliphate began a slow disintegration in the ninth century, and thereafter power in the Islamic world became fragmented among more or less independent regional rulers. During the eleventh century, the Saljuqs, a Turkic people, swept from north of the Caspian Sea into Khurasan and took Baghdad in

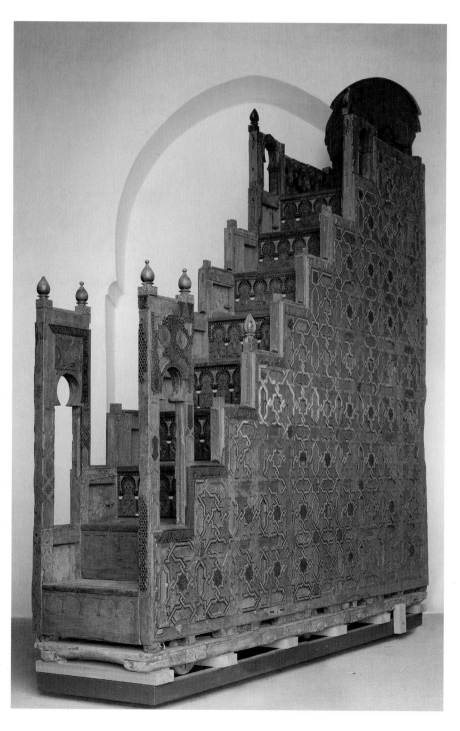

8-7 • MINBAR
From the Kutubiya Mosque, Marrakesh, Morocco. 1125–1130. Wood and ivory, 12′8″ × 11′4″ × 2′10″ (3.86 × 3.46 × 0.87 m). Badi Palace Museum, Marrakesh.

Islamic builders explored structure in innovative ways, using a variety of different arch types. The earliest is the simple semicircular arch, inherited from the Romans and Byzantines. It has a single center point that is level with the points from which the arch springs.

The horseshoe arch is a second type, which predates Islam but became the prevalent arch form in the Maghreb (see "The Great Mosque of Cordoba," page 268). The center point of this kind of arch is above the level of the arch's springing point, so that it pinches inward above the capital.

The pointed arch, introduced after the beginning of Islam, has two (sometimes four) center points, the points generating different circles that overlap (for a very slightly pointed arch, SEE FIG. 8–24).

A keel arch has flat sides, and slopes where other arches are curved. It culminates at a pointed apex (see "Ornament," cut tile, page 264).

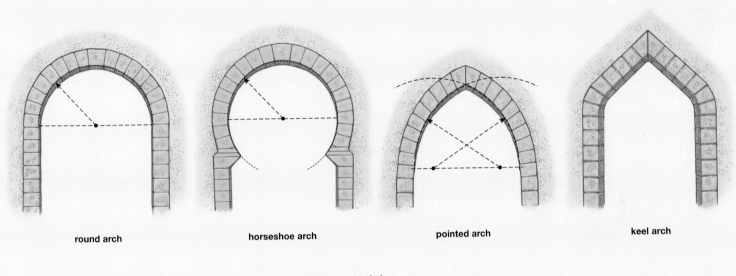

round arch horseshoe arch pointed arch keel arch

SEE MORE: View a simulation about arches **www.myartslab.com**

1055, becoming the virtual rulers of the Abbasid Empire. The Saljuqs united most of Iran and Iraq, establishing a dynasty that endured from 1037/38 to 1194. A branch of the dynasty, the Saljuqs of Rum, ruled much of Anatolia (Turkey) from the late eleventh to the beginning of the fourteenth century. The central and eastern Islamic world suffered a dramatic rift in the early thirteenth century when the nomadic Mongols—non-Muslims led by Genghiz Khan (r. 1206–1227) and his successors—attacked northern China, Central Asia, and ultimately Iran. The Mongols captured Baghdad in 1258, encountering weak resistance until they reached Egypt, where they were firmly defeated by the new **Mamluk** ruler. The Maghreb (Morocco, Spain, and Portugal) was ruled by various Arab and Berber dynasties. In Spain the borders of Islamic territory were gradually pushed southward by Christian forces until the rule of the last Muslim dynasty, the Nasrids (1230–1492), was ended. Morocco was ruled by the Berber Marinids (from the mid thirteenth century until 1465).

Although the religion of Islam remained a dominant and unifying force throughout these developments, the history of later Islamic society and culture reflects largely regional phenomena. Only a few works have been selected here and in Chapter 23 to characterize the art of Islam, and they by no means provide a comprehensive history of Islamic art.

ARCHITECTURE OF THE MEDITERRANEAN

The new dynasties built on a grand scale, expanding their patronage from mosques and palaces to include new functional buildings, such as tombs, **madrasas** (colleges for religious and legal studies), public fountains, urban hostels, and remote caravanserais (inns) for traveling merchants in order to encourage long-distance trade. A distinguishing characteristic of architecture in the later period is its complexity. Multiple building types were now combined in large and diverse complexes, supported by perpetual endowments (called *waqf*) that funded not only the building, but its administration and maintenance. Increasingly, these complexes included the patron's own tomb, thus giving visual prominence to the act of individual patronage and the expression of personal identity through commemoration. A new plan emerged, organized around a central courtyard framed by four large **iwans** (large vaulted halls with rectangular plans and monumental arched openings); this **four-iwan** plan was used for schools, palaces, and especially mosques.

THE *MADRASA*-MAUSOLEUM-MOSQUE IN CAIRO. Beginning in the eleventh century, Muslim rulers and wealthy individuals endowed hundreds of charitable complexes that displayed piety as well as personal wealth and status. The combined *madrasa*-mausoleum-mosque complex established in mid-fourteenth-century Cairo by

8–8 • *QIBLA* WALL WITH *MIHRAB* AND *MINBAR*, SULTAN HASAN *MADRASA*-MAUSOLEUM-MOSQUE COMPLEX
Main *iwan* (vaulted chamber) in the mosque, Cairo. 1356–1363.

EXPLORE MORE: Click the Google Earth link for the *Qibla* wall with *mihrab* and *minbar*,
Sultan Hasan *Madrasa*-Mausoleum-Mosque **www.myartslab.com**

the Mamluk Sultan Hasan **(FIGS. 8–8 and 8–9)** is such an example. A dark corridor—a deflected entrance that is askew from the building's orientation—leads from the street into a central, well-lit courtyard of majestic proportions. The complex has a classic four-*iwan* plan, each *iwan* serving as a classroom for a different branch of study, the students housed in a multi-storied cluster of tiny rooms around each one. The sumptuous *qibla iwan* served as the prayer hall for the complex. Its walls are ornamented with typically Mamluk panels of sharply contrasting marbles (*ablaq* masonry, see "Ornament," page 264) that culminate in a doubly recessed *mihrab* framed by slightly pointed arches on columns. The marble blocks of the arches are ingeniously joined in interlocking pieces called **joggled voussoirs**. The paneling is surmounted by a wide band of **Kufic** (an angular Arabic script) inscription in stucco set against a background of scrolling vines, both the text and the ornament

8–9 • THE SULTAN HASAN *MADRASA*-MAUSOLEUM-MOSQUE COMPLEX
The *qibla iwan* is visible in the top left face of the courtyard, and the domed tomb looms behind it.

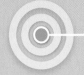
A Mamluk Glass Oil Lamp

from Cairo, Egypt. c. 1350–1355. Glass, polychrome enamel, and gold. Diameter of the top 10⅜" (26 cm), height 13⅝" (35 cm). British Museum, London.

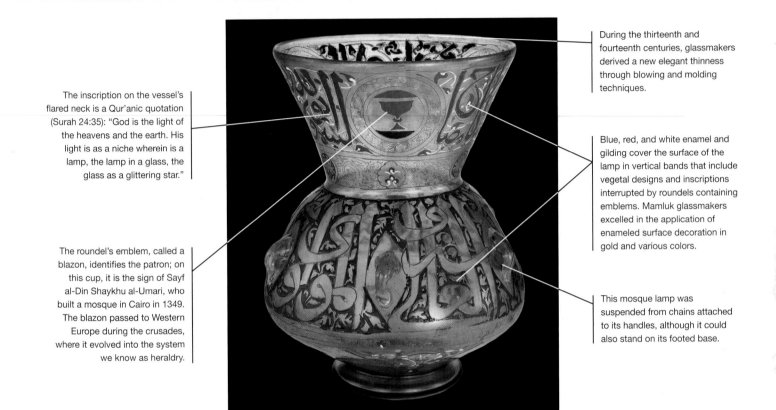

During the thirteenth and fourteenth centuries, glassmakers derived a new elegant thinness through blowing and molding techniques.

The inscription on the vessel's flared neck is a Qur'anic quotation (Surah 24:35): "God is the light of the heavens and the earth. His light is as a niche wherein is a lamp, the lamp in a glass, the glass as a glittering star."

Blue, red, and white enamel and gilding cover the surface of the lamp in vertical bands that include vegetal designs and inscriptions interrupted by roundels containing emblems. Mamluk glassmakers excelled in the application of enameled surface decoration in gold and various colors.

The roundel's emblem, called a blazon, identifies the patron; on this cup, it is the sign of Sayf al-Din Shaykhu al-Umari, who built a mosque in Cairo in 1349. The blazon passed to Western Europe during the crusades, where it evolved into the system we know as heraldry.

This mosque lamp was suspended from chains attached to its handles, although it could also stand on its footed base.

SEE MORE: View the Closer Look feature for the Mamluk Glass Oil Lamp **www.myartslab.com**

referring to the paradise that is promised to the faithful. Next to the *mihrab* stands an elaborate, thronelike *minbar*. A platform for reading the Qur'an is in the foreground. Standing just beyond the *qibla iwan*, the patron's monumental domed tomb attached his identity ostentatiously to the architectural complex. The Sultan Hasan complex is excessive in its vast scale and opulent decoration, but money was not an object: The project was financed by the estates of victims of the bubonic plague that had raged in Cairo from 1348 to 1350.

The mosque in the Sultan Hasan complex—and many smaller establishments—required hundreds of lamps, and glassmaking was a booming industry in Egypt and Syria. Made of ordinary sand and ash, glass is the most ethereal of materials. The Egyptians produced the first glassware during the second millennium BCE, yet the tools and techniques for making it have changed little since then.

Exquisite glass was also used for beakers and vases, but lamps, lit from within by oil and wick, glowed with special brilliance (see "A Closer Look," above).

THE ALHAMBRA. Muslim patrons also spent lavishly on luxurious palaces set in gardens. The Alhambra in Granada, in southeastern Spain, is an outstanding example of beautiful and refined Islamic palace architecture. Built on the hilltop site of an early Islamic fortress, this palace complex was the seat of the Nasrids (1232–1492), the last Spanish Muslim dynasty, by which time Islamic territory had shrunk from covering most of the Iberian Peninsula to the region around Granada. To the conquering Christians at the end of the fifteenth century, the Alhambra represented the epitome of luxury. Thereafter, they preserved the complex as much to commemorate the defeat of Islam as for its beauty. Essentially a

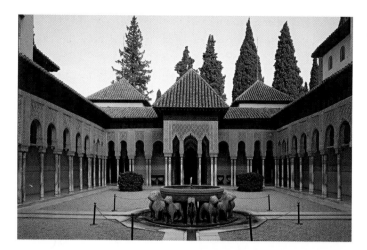

8-10 • COURT OF THE LIONS, ALHAMBRA, GRANADA, SPAIN
1354–1391.

EXPLORE MORE: Click the Google Earth link for the
Court of the Lions, Alhambra **www.myartslab.com**

small town extending for about half a mile along the crest of a high
hill overlooking Granada, it included government buildings, royal
residences, gates, mosques, baths, servants' quarters, barracks,
stables, a mint, workshops, and gardens. Much of what one sees at
the site today was built in the fourteenth century or by Christian
patrons in later centuries.

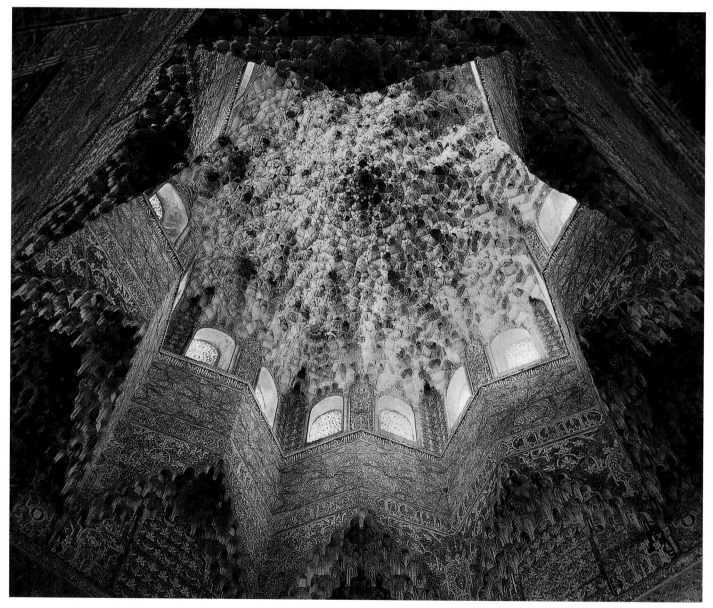

8-11 • *MUQARNAS* DOME, HALL OF THE ABENCERRAJES, PALACE OF THE LIONS, ALHAMBRA
1354–1391.

The stucco *muqarnas* (stalactite) ornament does not support the dome but is actually suspended from it, composed of some 5,000
individual plaster pieces. Of mesmerizing complexity, the vault's effect can be perceived but its structure cannot be fully comprehended.

SEE MORE: View a video about the Alhambra **www.myartslab.com**

The Alhambra offered dramatic views to the settled valley and snow-capped mountains around it, while enclosing gardens within its courtyards. One of these is the Court of the Lions which stood at the heart of the so-called Palace of the Lions, the private retreat of Sultan Muhammad V (r. 1354–1359 and 1362–1391). The Court of the Lions is divided into quadrants by cross-axial walkways—a garden form called a *chahar bagh*. The walkways carry channels that meet at a central marble fountain held aloft on the backs of 12 stone lions (FIG. 8–10). Water animates the fountain, filling the courtyard with the sound of its life-giving abundance. In an adjacent courtyard, the Court of the Myrtles, a basin's round shape responds to the naturally concentric ripples of the water that spouts from a central jet (see "Ornament," page 264). Water has a practical role in the irrigation of gardens, but here it is raised to the level of an art form.

The Court of the Lions is encircled by an arcade of stucco arches embellished with **muqarnas** (see "Ornament," page 264) and supported on single columns or clusters of two and three. Second-floor **miradors**—windows that frame specifically intentioned views—look over the courtyard, which was originally either gardened or more likely paved, with aromatic citrus confined to corner plantings. From these windows, protected by latticework screens, the women of the court, who did not appear in public, would watch the activities of the men below. At one end of the Palace of the Lions, a particularly magnificent *mirador* looks out onto a large, lower garden and the plain below. From here, the sultan literally oversaw the fertile valley that was his kingdom.

On the south side of the Court of the Lions, the lofty Hall of the Abencerrajes was designed as a winter reception hall and music room. In addition to having excellent acoustics, its ceiling exhibits dazzling geometrical complexity and exquisitely carved stucco (FIG. 8–11). The star-shaped vault is formed by a honeycomb of clustered *muqarnas* arches that alternate with corner **squinches** that are filled with more *muqarnas*. The square room thus rises to an eight-pointed star, pierced by 16 windows, that culminates in a burst of *muqarnas* floating high overhead, perceived and yet ultimately unknowable, like the heavens themselves.

ARCHITECTURE OF THE EAST

The Mongol invasions brought devastation and political instability but also renewal and artistic exchange that provided the foundation for successor dynasties with a decidedly eastern identity. One of the empires to emerge after the Mongols was the vast Timurid Empire (1370–1506), which conquered Iran, Central Asia, and the northern part of South Asia. Its founder, Timur (known in the West as Tamerlane), was a Mongol descendant, a lineage strengthened through marriage to a descendant of Genghiz Khan. Timur made his capital at Samarkand, which he embellished by means of the forcible relocation of expert artisans from the areas he subdued. Because the empire's compass was vast, Timurid art could integrate Chinese, Persian, Turkic, and Mediterranean artistic ideas into a Mongol base. Its architecture is characterized by axial symmetry, tall double-shelled domes (an inner dome capped by an outer shell

of much larger proportions), modular planning with rhythmically repeated elements, and brilliant cobalt blue, turquoise, and white glazed ceramics. Although the empire itself lasted only 100 years after the death of Timur, its legacy endured in the art of the later Safavid dynasty in Iran and the Mughals of South Asia.

A TILE MIHRAB. Made during a period of uncertainty as Iran shifted from Mongol to Timurid rule, this *mihrab* (1354), originally from a *madrasa* in Isfahan, is one of the finest examples of architectural ceramic decoration from this era (FIG. 8–12). More than 11 feet tall, it was made by painstakingly cutting each individual piece of tile, including the pieces making up the letters on the curving

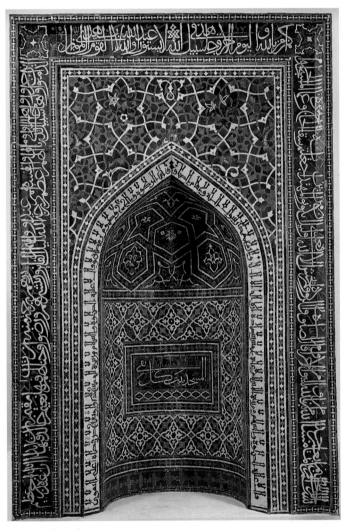

8-12 • TILE MOSAIC *MIHRAB*

From the Madrasa Imami, Isfahan, Iran. Founded 1354. Glazed and cut tiles, 11'3" × 7'6" (3.43 × 2.29 m). Metropolitan Museum of Art, New York. Harris Brisbane Dick Fund (39.20)

This *mihrab* has three inscriptions: the outer inscription, in cursive, contains Qur'anic verses (Surah 9) that describe the duties of believers and the Five Pillars of Islam. Framing the niche's pointed arch, a Kufic inscription contains sayings of the Prophet. In the center, a panel with a line in Kufic and another in cursive states: "The mosque is the house of every pious person."

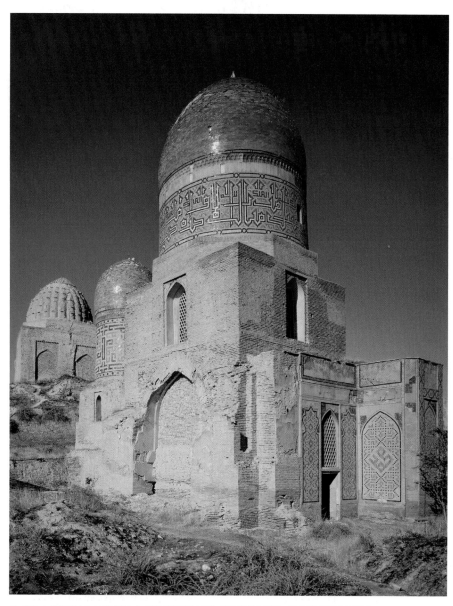

8-13 • SHAH-I ZINDA FUNERARY COMPLEX, SAMARKAND
Late 14th–15th century.

Timurid princesses were buried here and built many of the tombs. The lively experimentation in varied artistic motifs indicates that women were well versed in the arts and empowered to exercise personal taste.

(a cousin of the Prophet and a saint). The women sought burial in the vicinity of the holy man in order to gain *baraka* (blessing) from his presence. Like all Timurid architecture, the tombs reflect modular planning—noticeable in the repeated dome-on-square unit—and a preference for blue glazed tiles. The domes of the individual structures were double-shelled and, for exaggerated effect, stood on high drums inscribed with Qur'anic verses. The ornament adorning the exterior façades consists of an unusually exuberant array of patterns and techniques, from geometry to chinoiserie, and both painted and cut tiles (see "Ornament," page 264). The tombs reflect a range of individual taste and artistic experimentation that was possible precisely because they were private commissions that served the patrons themselves, rather than the city or state (as in a congregational mosque).

PORTABLE ARTS

Islamic society was cosmopolitan, with pilgrimage, trade, and a well-defined road network fostering the circulation of marketable goods. In addition to the import and export of basic foodstuffs and goods, luxury arts brought particular pleasure and status to their owners and were visible signs of cultural refinement. On objects made of ceramics, ivory, and metal, as well as textiles, calligraphy was prominently displayed. These art objects were eagerly exchanged and collected from one end of the Islamic world to the other, and despite their Arabic lettering—or perhaps precisely because of its artistic cachet—they were sought by European patrons as well.

surface of the keel-profiled niche. The color scheme—white against turquoise and cobalt blue with accents of dark yellow and green—was typical of this type of decoration, as were the harmonious, dense, contrasting patterns of organic and geometric forms. The cursive inscription of the outer frame is rendered in elegant white lettering on a blue ground, while the Kufic inscription bordering the pointed arch reverses these colors for a pleasing contrast.

THE SHAH-I ZINDA. Near Samarkand, the preexisting Shah-i Zinda (Living King) funerary complex was adopted for the tombs of Timurid family members, especially princesses, in the late fourteenth and fifteenth centuries **(FIG. 8–13)**. The mausolea are arrayed along a central avenue that descends from the tomb of Qutham b. Abbas

CERAMICS. Script was the sole decoration on a type of white pottery made from the tenth century onward in and around the region of Nishapur (in Khurasan, in present-day Iran) and Samarkand (in present-day Uzbekistan). These elegant pieces are characterized by the use of a clear lead glaze applied over a black inscription on a white slip-painted ground. In **FIGURE 8–14** the script's horizontals and verticals have been elongated to fill the bowl's rim. The fine quality of the lettering indicates that a calligrapher furnished the model. The inscription translates: "Knowledge [or magnanimity]: the beginning of it is bitter to taste, but the end is sweeter than honey," an apt choice for tableware and appealing to an educated patron. The inscriptions on Islamic ceramics provide a storehouse of such popular sayings.

8-14 • BOWL WITH KUFIC BORDER
Khurasan, 11th–12th century. Earthenware with slip, pigment, and lead glaze, diameter 14½″ (33.8 cm). Musée du Louvre, Paris.

The white ground of this piece imitated prized Chinese porcelains made of fine white kaolin clay. Khurasan was connected to the Silk Road, the great caravan route to China (Chapter 10), and was influenced by Chinese culture.

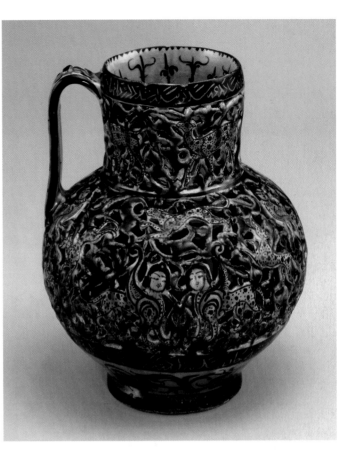

8-15 • THE MACY JUG
Iran. 1215/1216. Composite body glazed, painted fritware and incised (glaze partially stained with cobalt), with pierced outer shell, 6⅝ × 7¾″ (16.8 × 19.7 cm). Metropolitan Museum of Art, New York. Fletcher Fund, 1932 (32.52.1)

Fritware was used to make beads in ancient Egypt and may have been rediscovered there by Islamic potters searching for a substitute for Chinese porcelain. Its components were one part white clay, ten parts quartz, and one part quartz fused with soda, which produced a brittle white ware when fired. The colors on this double-walled ewer and others like it were produced by applying mineral glazes over black painted detailing. The deep blue comes from cobalt and the turquoise from copper. Luster—a thin, transparent glaze with a metallic sheen—was applied over the colored glazes.

In the ninth century, potters developed a technique to produce a lustrous metallic surface on their ceramics. They may have learned the technique from Islamic glassmakers who had produced luster-painted vessels a century earlier. First the potters applied a paint laced with silver, copper, or gold oxides to the surface of already fired and glazed tiles or vessels. In a second firing with relatively low heat and less oxygen, these oxides burned away to produce a reflective sheen. The finished **lusterware** resembled precious metal. At first the potters covered the entire surface with luster, but soon they began to use luster to paint dense, elaborate patterns using geometric design, foliage, and animals in golden brown, red, purple, and green. Lusterware tiles, dated 862/863, decorated the *mihrab* of the Great Mosque at Kairouan.

The most spectacular lusterware pieces are the double-shell fritware, in which an inner solid body is hidden beneath a densely decorated and perforated outer shell. A jar in the Metropolitan Museum known as the *Macy Jug* (after a previous owner) exemplifies this style **(FIG. 8–15)**. The black underglaze-painted decoration represents animals and pairs of harpies and sphinxes set into an elaborate "water-weed" pattern. The outer shell is covered with a turquoise glaze, enhanced by a deep cobalt-blue glaze on parts of the floral decoration and finally an overglaze that gives the entire surface its metallic luster. An inscription includes the date AH 612 (1215/1216 CE).

METAL. Islamic metalsmiths enlivened the surface of vessels with scrolls, interlacing designs, human and animal figures, and calligraphic inscriptions. A shortage of silver in the mid twelfth century prompted the development of inlaid brasswork that used the more precious metal sparingly, as in **FIGURE 8–16**. This basin, made in Mamluk Egypt in the late thirteenth or early fourteenth century, may be the finest work of metal produced by a Muslim artisan. Its dynamic surface is adorned with three bands, the upper and lower depicting running animals, and the center showing chivalric scenes of horsemen flanked by attendants, soldiers, and falcons. The surface is crowded with overlapping figures, in vigorous poses, that nevertheless remain distinct by means of hatching, modeling, and the framing device of the four roundels. The piece was made and signed (six times) by Muhammad Ibn al-Zain. The narrative band displays scenes of the princely art of

8-16 • Muhammad Ibn al-Zain
BAPTISTERY OF ST. LOUIS
Syria or Egypt. c. 1300. Brass inlaid
with silver and gold, 8⅝ × 19⅝"
(22.2 × 50.2 cm). Musée du Louvre,
Paris.

This beautifully crafted basir, with
its princely themes of hunting and
horsemanship, was made for an
unknown Mamluk patron, judging by its
emblems and coats of arms. However,
it became known as the *Baptistery of
St. Louis*, because it was acquired by
the French sometime before the end of
the fourteenth century (long after the
era of St. Louis) and used for royal
baptisms.

horsemanship and hunting, but in later metalwork such pictorial cycles were replaced by large-scale inscriptions.

TEXTILES. A Kufic inscription appears on a tenth-century piece of silk from Khurasan **(FIG. 8–17)**: "Glory and happiness to the Commander Abu Mansur Bukhtakin. May God prolong his prosperity." Such good wishes were common in Islamic art, appearing as generic blessings on ordinary goods sold in the marketplace or, as here, personalized for the patron. The woven bands of script are known as *tiraz* ("embroidered"), and they appear in textiles as well as illustrated manuscripts, such as the *Maqamat*, where the robes of figures have *tiraz* on their sleeves (SEE FIG. 8.1). Texts can sometimes help determine where and when a work was made, but they can be frustratingly uninformative when

little is known about the patron, and they are not always truthful. Stylistic comparisons—in this case with other textiles, with the way similar subjects appear in other media, and with other inscriptions—sometimes reveal more than the inscription alone.

This silk must have been brought from the Near East to France by knights at the time of the First Crusade. Known as the Shroud of St. Josse, it was preserved in the church of Saint-Josse-sur-Mer, near Caen in Normandy. Rich Islamic textiles of brilliantly hued silk, gold thread, brocade, and especially *tiraz* were prized by Christians and were often preserved in Christian burial chambers and church treasuries. Textiles were one of the most actively traded commodities in the medieval Mediterranean region and formed a significant portion of dowries and inheritances. For these reasons, they were an important means of disseminating

8-17 • TEXTILE WITH ELEPHANTS AND CAMELS
Known today as the Shroud of St. Josse. From Khurasan or Central Asia. Before 961. Dyed silk, largest fragment 20½ × 37" (52 × 94 cm). Musée du Louvre, Paris.

Silk textiles were both sought-after luxury items and a medium of economic exchange. Government-controlled factories, known as *dar al-tiraz*, produced cloth for the court as well as for official gifts and payments. A number of Islamic fabrics have been preserved in the treasuries of medieval European churches, where they were used for priests' ceremonial robes and as altar cloths, and to wrap the relics of Christian saints.

artistic styles and techniques. This fragment shows two elephants, themselves bearing highly ornamental coverings with Sasanian straps, facing each other on a dark red ground, each with a mythical griffin (a Chinese motif) between its feet. A caravan of two-humped Bactrian camels linked with rope moves up the elaborately patterned border along the left side. The inscription at the bottom is upside down, suggesting that the missing portion of the textile was a fragment from a larger and more complex composition. The technique and design derive from the sumptuous pattern-woven silks of Sasanian Iran (Persia). The Persian weavers had, in turn, adapted Chinese silk technology to the Sasanian taste for paired heraldic beasts and other Near Eastern imagery. The eclecticism of Islamic culture is demonstrated by the blending of Sasanian and Chinese sources in a textile made for a Turkic patron.

THE ARTS OF THE BOOK

The art of book production flourished from the first century of Islam because Islam's emphasis on the study of the Qur'an promoted a high level of literacy among both men and women. With the availability of paper, books on a wide range of religious as well as secular subjects were available, although hand-copied books always remained fairly costly. (Muslims did not adopt the printing press until the eighteenth and nineteenth centuries.) Libraries, often associated with *madrasas*, were endowed by members of the educated elite. Books made for royal patrons had luxurious bindings and highly embellished pages, the result of workshop collaboration between noted calligraphers and illustrators.

CALLIGRAPHY. Muslim society holds **calligraphy** (the art of fine hand lettering) in the highest esteem. Since the Qur'an is believed to reveal the word of God, its words must be written accurately, with devotion and embellishment. Writing was not limited to books and documents but—as we have seen—was displayed on the walls of buildings and on artwork. Since pictorial imagery developed relatively late in Islamic art (and there was no figural imagery at all in the religious context), text became a principal vehicle for visual communication. The written word thus played two roles: It could convey information about a building or object, describing its beauty or naming its patron, and it could delight the eye in an entirely aesthetic sense. Arabic script is written from right to left, and a letter's form varies depending on its position in a word. With its rhythmic interplay between verticals and horizontals, Arabic lends itself to many variations. Formal Kufic script (after Kufa, a city in Iraq) is blocky and angular, with strong upright strokes and long horizontals. It may have developed first for carved or woven inscriptions where clarity and practicality of execution were important.

Most early Qur'ans had large Kufic letters and only three to five lines per page, which had a horizontal orientation. The visual clarity was necessary because one book was often shared by multiple readers simultaneously. A page from a ninth-century Syrian Qur'an exemplifies the style common from the eighth to the tenth century (**FIG. 8–18**). Red diacritical marks (pronunciation guides) accent the dark brown ink; the *surah* ("chapter") title is embedded in the burnished ornament at the bottom of the sheet. Instead of

8-18 • PAGE FROM THE QUR'AN
Surah 2:286 and title of Surah 3 in Kufic script. Syria. 9th century. Black ink pigments, and gold on vellum, 8⅜ × 11⅛″ (21.8 × 29.2 cm). Metropolitan Museum of Art, New York. Rogers Fund, 1937 (37.99.2)

EXPLORE MORE: Gain insight from a primary source, the Qur'an
www.myartslab.com

8–19 • Attributed to Galinus ARABIC MANUSCRIPT PAGE

Iraq. 1199. Bibliothèque Nationale, Paris.

Headings are in ornamental Kufic script with a background of scrolling vines, while the text—a medical treatise—is written horizontally and vertically in *naskhi* script.

page numbers, the brilliant gold of the framed words and the knoblike projection in the left-hand margin are a distinctive means of marking chapter breaks.

Calligraphers enjoyed the highest status of all artists in Islamic society. Included in their number were princes and women. Apprentice scribes had to learn secret formulas for inks and paints; become skilled in the proper ways to sit, breathe, and manipulate their tools; and develop their individual specialties. They also had to absorb the complex literary traditions and number symbolism that had developed in Islamic culture. Their training was long and arduous, but unlike other artisans who were generally anonymous in the early centuries of Islam, outstanding calligraphers received public recognition.

By the tenth century, more than 20 cursive scripts had come into use. They were standardized by Ibn Muqla (d. 940), an Abbasid official who fixed the proportions of the letters in each script and devised a method for teaching calligraphy that is still in use today. The Qur'an was usually written on **parchment** (treated animal

skin) and **vellum** (calfskin or a fine parchment). Paper was first manufactured in Central Asia during the mid eighth century, having been introduced earlier by Buddhist monks. Muslims learned how to make high-quality, rag-based paper, and eventually established their own paper mills. By about 1000, paper had largely replaced the more costly parchment for everything but Qur'an manuscripts, which adopted the new medium much later. It was a change as momentous as that brought about by movable type or the internet, affecting not only the appearance of manuscripts but also their content. The inexpensive new medium sparked a surge in book production and the proliferation of increasingly elaborate and decorative cursive scripts which generally superseded Kufic by the thirteenth century. Of the major styles, one extraordinarily beautiful form, known as *naskhi*, was said to have been revealed and taught to scribes in a vision. In **FIGURE 8–19**, its beautifully flowing lines alternate with an eastern variety of Kufic set against a field of swirling vine scrolls.

MANUSCRIPT PAINTING

The manuscript illustrators of Mamluk Egypt (1250–1517) executed intricate nonfigural geometric designs for the Qur'ans they

8–20 • QUR'AN FRONTISPIECE (RIGHT HALF OF TWO-PAGE SPREAD)

Cairo. c. 1368. Ink, pigments, and gold on paper, 24 × 18″ (61 × 45.7 cm). National Library, Cairo. MS. 7

The Qur'an to which this page belonged was donated in 1369 by Sultan Shaban to the *madrasa* established by his mother. A close collaboration between illuminator and scribe can be seen here and throughout the manuscript.

produced. Geometric and botanical ornamentation contributed to unprecedented sumptuousness and complexity. As in architectural decoration, the exuberant ornament was underlaid by strict geometric organization. In an impressive frontispiece originally paired with its mirror image on the facing left page, the design radiates from a 16-pointed starburst, filling the central square (**FIG. 8–20**). The surrounding frames are filled with interlacing foliage and stylized flowers that embellish the holy scripture. The page's resemblance to court carpets was not coincidental. Designers worked in more than one medium, leaving the execution of their efforts to specialized artisans. In addition to religious works, scribes copied and recopied famous secular texts—scientific treatises, manuals of all kinds, stories, and especially poetry. Painters supplied illustrations for these books and also created individual small-scale paintings—miniatures—that were collected by the wealthy and placed in albums.

THE HERAT SCHOOL. One of the great royal centers of miniature painting was at Herat in western Afghanistan. A **school** of painting and calligraphy was founded there in the early fifteenth century under the highly cultured patronage of the Timurid dynasty (1370–1507). In the second half of the fifteenth century, the leader of the Herat School was Kamal al-Din Bihzad (c. 1450–1514). When the Safavids supplanted the Timurids in 1506/07 and established their capital at Tabriz in northwestern Iran, Bihzad moved to Tabriz and briefly resumed his career there. Bihzad's paintings, done around 1494 to illustrate the *Khamsa* (*Five Poems*), written by Nizami, demonstrate his ability to render human activity convincingly. He set his scenes within complex, stagelike architectural spaces that are stylized according to Timurid conventions, creating a visual balance between activity and architecture. In a scene depicting the caliph Harun al-Rashid's visit to a bath (**FIG. 8–21**), the bathhouse, its tiled entrance leading to a high-ceiling dressing room with brick walls, provides the structuring element. Attendants wash long, blue towels and hang them to dry on overhead clotheslines. A worker reaches for one of the towels with a long pole, and a client prepares to wrap himself discreetly in a towel before removing his outer garments. The blue door on the left leads to a room where a barber grooms the caliph while attendants bring water for his bath. The asymmetrical composition depends on a balanced placement of colors and architectural ornaments within each section.

8-21 • Attributed to Kamal al-Din Bihzad THE CALIPH HARUN AL-RASHID VISITS THE TURKISH BATH
From a copy of the 12th-century *Khamsa* (*Five Poems*) of Nizami. From Herat, Afghanistan. c. 1494. Ink and pigments on paper, approx. 7 × 6″ (17.8 × 15.3 cm). The British Library, London. Oriental and India Office Collections MS. Or. 6810, fol. 27v

Despite early warnings against it as a place for the dangerous indulgence of the pleasures of the flesh, the bathhouse (*hammam*), adapted from Roman and Hellenistic predecessors, became an important social center in much of the Islamic world. The remains of an eighth-century *hammam* still stand in Jordan, and a twelfth-century *hammam* is still in use in Damascus. *Hammam*s had a small entrance to keep in the heat, which was supplied by steam ducts running under the floors. The main room had pipes in the wall with steam vents. Unlike the Romans, who bathed and swam in pools of water, Muslims preferred to splash themselves from basins, and the floors were slanted for drainage. A *hammam* was frequently located near a mosque, part of the commercial complex provided by the patron to generate income for the mosque's upkeep.

ART AND ARCHITECTURE OF THE THREE EMPIRES

In the pre-modern era, three great powers emerged in the Islamic world. The introduction of gunpowder for use in cannons and guns caused a shift in military strategy because isolated lords in lone castles could not withstand gunpowder sieges. Power lay not in thick walls but in strong centralized governments that had the wherewithal to invest in fire power and train armies in its use. To the west was the Ottoman Empire (1342–1918), which grew from a small principality in Asia Minor. In spite of setbacks inflicted by the Mongols, the Ottomans ultimately created an empire that extended over Anatolia, western Iran, Iraq, Syria, Palestine, western Arabia (including Mecca and Medina), northern Africa (excepting Morocco), and part of eastern Europe. In 1453, their stunning capture of Constantinople (ultimately renamed Istanbul) brought the Byzantine Empire to an end. To the east of the Ottomans, Iran was ruled by the Safavid dynasty (1501–1732), distinguished for their Shi'ite branch of Islam. Their patronage of art and architecture favored the refinement of artistic ideas and techniques drawn from the Timurid period. The other heirs to the Timurids were the Mughals of South Asia (1526–1858). The first Mughal emperor, Babur, invaded Hindustan (India and Pakistan) from Afghanistan, bringing with him a taste for Timurid gardens, architectural symmetry, and modular planning.

THE OTTOMAN EMPIRE

Imperial Ottoman mosques were strongly influenced by Byzantine church plans and reflect a drive toward ever larger domes. The prayer hall interiors are dominated by a large domed space uninterrupted by structural supports. Worship is directed, as in other mosques, toward a *qibla* wall and *mihrab* opposite the entrance.

Upon conquering Constantinople, the rulers of the Ottoman Empire converted the great Byzantine church of Hagia Sophia into a mosque, framing it with two graceful Turkish-style minarets in the fifteenth century and two more in the sixteenth century (SEE FIG. 7–17). In conformance with Islamic aniconism, the church's mosaics were destroyed or whitewashed. Huge calligraphic disks with the names of God (Allah), Muhammad, and the early caliphs were added to the interior in the mid nineteenth century (SEE FIG. 7–19). At present, Hagia Sophia is neither a church nor a mosque but a state museum.

THE ARCHITECT SINAN. Ottoman architects had already developed the domed, centrally planned mosque, but the vast open interior and structural clarity of Hagia Sophia inspired them to strive for a more ambitious scale. For the architect Sinan (c. 1489–1588) the development of a monumental centrally planned mosque was a personal quest. Sinan began his career in the army and served as engineer in the Ottoman campaigns at Belgrade, Vienna, and Baghdad. He rose through the ranks to become, in 1528, chief architect for Suleyman "the Magnificent," the tenth Ottoman sultan (r. 1520–1566). Suleyman's reign marked the height of Ottoman power, and the sultan sponsored an ambitious building program on a scale not seen since the days of the Roman Empire. Serving Suleyman and his successor, Sinan is credited with more than 300 imperial commissions, including palaces, *madrasas* and Qur'an schools, tombs, public kitchens, hospitals, caravanserais, treasure houses, baths, bridges, viaducts, and 124 large and small mosques.

8-22 • Sinan MOSQUE OF SULTAN SELIM
Edirne, Turkey. 1568–1575.

The minarets that pierce the sky around the prayer hall of this mosque, their sleek, fluted walls and needle-nosed spires soaring to more than 295 feet, are only 12½ feet in diameter at the base, an impressive feat of engineering. Only royal Ottoman mosques were permitted multiple minarets, and having more than two was unusual.

EXPLORE MORE: Click the Google Earth link for the Mosque of Sultan Selim **www.myartslab.com**

8-23 • PLAN OF MOSQUE OF SULTAN SELIM

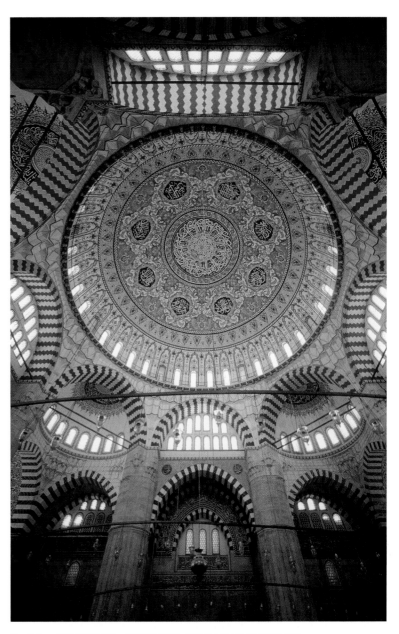

8-24 • INTERIOR, MOSQUE OF SULTAN SELIM

Sinan's crowning accomplishment, completed about 1579, when he was over 80, was a mosque he designed in the provincial capital of Edirne for Suleyman's son Selim II (r. 1566–1574) **(FIGS. 8–22, 8–23)**. The gigantic hemispheric dome that tops this structure is more than 102 feet in diameter, larger than the dome of Hagia Sophia, as Sinan proudly pointed out. It crowns a building of extraordinary architectural coherence. The transition from square base to the central dome is accomplished by corner half-domes that enhance the spatial plasticity and openness of the prayer hall's airy interior **(FIG. 8–24)**. The eight massive piers that bear the dome's weight are visible both within and without—on the exterior they resolve in pointed towers that encircle the main dome—revealing the structural logic of the building and clarifying its form. In the arches that support the dome and span from one pier to the next—and indeed at every level—light pours from windows into the interior, a space at once soaring and serene.

The interior was clearly influenced by Hagia Sophia—an open expanse under a vast dome floating on a ring of light—but it rejects Hagia Sophia's longitudinal pull from entrance to sanctuary. The Selimiye Mosque is truly a centrally planned structure. In addition to the mosque, the complex housed a *madrasa* and other educational buildings, a cemetery, a hospital, and charity kitchens, as well as the income-producing covered market and baths. Framed by the vertical lines of four minarets and raised on a platform at the city's edge, the Selimiye Mosque dominates the skyline.

The Topkapi, the Ottomans' enormous palace in Istanbul, was a city unto itself. Built and inhabited from 1473 to 1853, it consisted of enclosures within walled enclosures that mirrored the immense political bureaucracy of the state. Inside, the sultan was removed from virtually all contact with the public. At the end of the inner palace, a free-standing pavilion, the Baghdad Kiosk (1638), provided him with a sumptuous retreat **(FIG. 8–25)**. The kiosk consists of a low dome set above a cruciform hall with four alcoves. Each recess contains a low sofa (a Turkish word) laid with cushions and flanked by cabinets of wood inlaid with ivory and shell. Alternating with the cabinets are niches with ornate profiles: When stacked in profusion such niches—called *chini khana*— form decorative panels. On the walls, the blue and turquoise glazed tiles contain an inscription of the Throne Verse (2:255) which proclaims God's dominion "over the heavens and the earth," a reference to divine power that appears in many throne rooms and places associated with Muslim sovereigns. Light sparkles through the stained glass above.

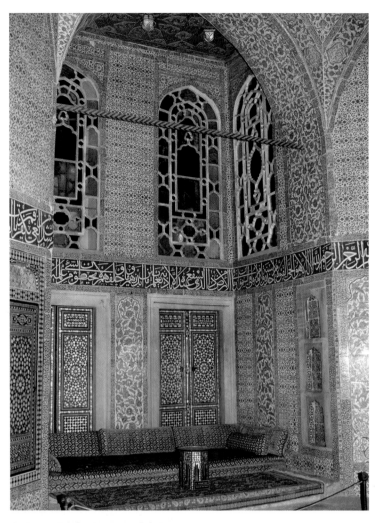

8-25 • BAGHDAD KIOSK
Topkapi Palace, Istanbul. 1638.

ILLUMINATED MANUSCRIPTS AND *TUGRAS*. A combination of abstract setting with realism in figures and details characterizes Ottoman painting. Ottoman painters adopted the style of the Herat School (influenced by Timurid conventions) for their miniatures, enhancing its decorative aspects with an intensity of religious feeling. At the Ottoman court of Sultan Suleyman in Istanbul, the imperial workshops produced remarkable illuminated manuscripts.

Following a practice begun by the Saljuqs and Mamluks, the Ottomans put calligraphy to political use, developing the design of imperial ciphers—**tugras**—into a specialized art form. Ottoman *tugras* combined the ruler's name and title with the motto "Eternally Victorious" into a monogram denoting the authority of the sultan and of those select officials who were also granted an emblem. *Tugras* appeared on seals, coins, and buildings, as well as on official documents called *firmans*, imperial edicts supplementing Muslim law. Suleyman issued hundreds of edicts, and a high court official supervised specialist calligraphers and illuminators who produced the documents with fancy *tugras* (**FIG. 8–26**).

Tugras were drawn in black or blue with three long, vertical strokes to the right of two concentric horizontal teardrops. Decorative foliage patterns fill the space. Fill decoration became more naturalistic by the 1550s and in later centuries spilled outside the emblems' boundary lines. The rare, oversized *tugra* below has a sweeping, fluid line drawn with perfect control according to set proportions. The color scheme of delicate floral interlace enclosed in the body of the *tugra* may have been inspired by Chinese blue-and-white ceramics; similar designs appear on Ottoman ceramics and textiles.

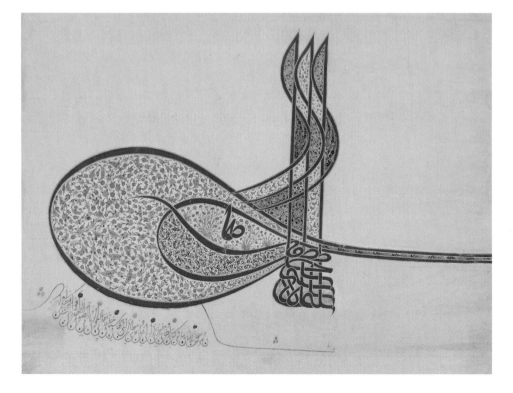

8-26 • ILLUMINATED *TUGRA* OF SULTAN SULEYMAN
From Istanbul, Turkey. c. 1555–1560. Ink, paint, and gold on paper, removed from a *firman* and trimmed to 20½ × 25⅜" (52 × 64.5 cm). Metropolitan Museum of Art, New York. Rogers Fund, 1938 (38.149.1)

The *tugra* shown here is from a document endowing an institution in Jerusalem that had been established by Suleyman's powerful wife, Hurrem.

THE SAFAVID DYNASTY

Whereas the Ottomans took their inspiration from regional cultures such as that of the Byzantine Empire, the Safavids looked to the Timurid architecture of tall, double-shell domes, sheathed in blue tiles. In the Safavid capital of Isfahan, the typically Timurid taste for modular construction re-emerged on a grand scale that extended well beyond works of architecture to include avenues, bridges, public spaces, and gardens. To the preexisting city of Isfahan, the Safavid Shah Abbas I (1588–1629) added an entirely new extension, planned around an immense central plaza (*maydan*) and a broad avenue, called the Chahar Bagh, that ran through a zone of imperial palace pavilions and gardens down to the river. The city's prosperity and beauty so amazed visitors who flocked from around the world to conduct trade and diplomacy that it led to the popular saying, "Isfahan is half the world."

With the Masjid-i Shah (1611–1638) in Isfahan, the four-*iwan* plan mosque reached its apogee (**FIGS. 8–27, 8–28**). Stately and huge, it anchors the south end of the city's *maydan*. Its 90-foot portal is aligned with the *maydan*, which is oriented astrologically,

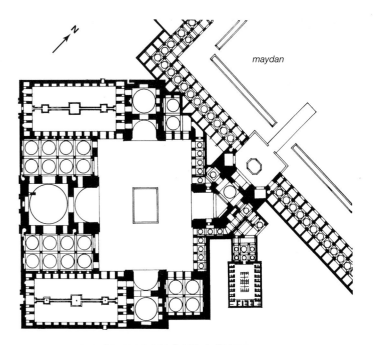

8-27 • PLAN OF THE MASJID-I SHAH

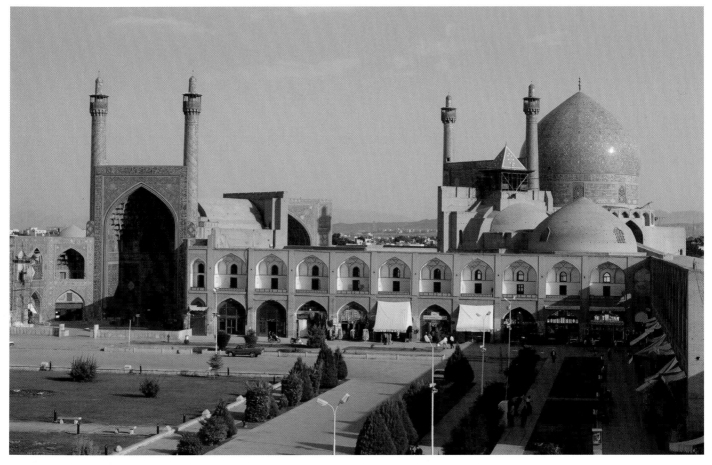

8-28 • MASJID-I SHAH, ISFAHAN
1611–1638.

Four *iwan*s with *pishtaq* frames face onto the courtyard, and a fifth faces the *maydan*. The tall bulbous dome behind the *qibla iwan* and the large *pishtaq*s are pronounced vertical elements that made royal patronage visible not only from the far end of the *maydan* but throughout the city and beyond.

SEE MORE: View a video about Masjid-i Shah **www.myartslab.com**

Because textiles are made of organic materials that are destroyed through use, very few carpets from before the sixteenth century have survived. There are two basic types of carpet: flat-weave carpets and pile, or knotted, carpets. Both can be made on either vertical or horizontal looms.

The best-known flat-weaves today are kilims, which are typically woven in wool with bold, geometric patterns and sometimes with brocaded details. Kilim weaving is done with a **tapestry** technique called slit tapestry (see a).

Knotted carpets are an ancient invention. The oldest known example, excavated in Siberia and dating to the fourth or fifth century BCE, has designs evocative of Achaemenid art, suggesting that the technique may have originated in Central Asia. In knotted carpets, the pile—the plush, thickly tufted surface—is made by tying colored strands of yarn, usually wool but occasionally silk for deluxe carpets, onto the vertical elements (the **warp**) of a yarn grid (see b and c).

These knotted loops are later trimmed and sheared to form the plush pile surface of the carpet. The **weft** strands (crosswise threads) are shot horizontally, usually twice, after each row of knots is tied, to hold the knots in place and to form the horizontal element common to all woven structures. The weft is usually an undyed yarn and is hidden by the colored knots of the warp. Two common knot tying techniques are the asymmetrical knot, used in many carpets from Iran, Egypt, and Central Asia (formerly termed the Sehna knot), and the symmetrical knot (formerly called the Gördes knot) more commonly used in Anatolian Turkish carpet weaving. The greater the number of knots, the shorter the pile. The finest carpets can have as many as 2,400 knots per square inch, each one tied separately by hand.

Although royal workshops produced luxurious carpets (SEE FIG. 8–29), most knotted rugs have traditionally been made in tents and homes. Depending on local custom, either women or men wove carpets.

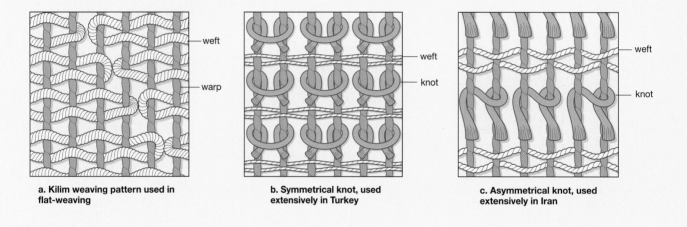

a. Kilim weaving pattern used in flat-weaving

b. Symmetrical knot, used extensively in Turkey

c. Asymmetrical knot, used extensively in Iran

but then turns to conform to the prayer hall, which is oriented to Mecca. The portal's great *iwan* is framed by a *pishtaq* (a rectangular panel framing an *iwan*) that rises above the surrounding walls, slender minarets enhancing its soaring verticality. The hood is filled with *muqarnas* and covered with glazed tiles with vine and flower motifs. The *iwan*'s profile is imitated and repeated by the double-tiered *iwan*s that parade across the façade of the mosque courtyard and the *maydan* as a whole. Achieving unity through the regular replication of a single element—the arch—is a hallmark of Safavid architecture. The Masjid-i Shah represents the culmination of Timurid aesthetics, but achieved on an unprecedented scale and integrated within a well-planned urban setting.

The Safavid period was also a golden age of carpet making (see "Carpet Making," above). Shah Abbas built workshops in Isfahan and Kashan that produced large, costly carpets that were often signed—indicating the weaver's growing prestige. Among the types produced were the medallion, centered around a sun or star, and the garden carpet, which represents Paradise as a shady garden with four rivers. Laid out on the floor of an open-air hall, and per-

haps set with bowls of ripe fruit and other delicacies, such carpets brought the beauty of nature indoors. Written accounts indicate that elaborate patterns appeared on Persian carpets as early as the seventh century. In one fabled royal carpet, garden paths were rendered in real gold, leaves were modeled with emeralds, and highlights on flowers, fruits, and birds were created from pearls and jewels. There were close parallels between carpet making and other arts: Many works of Islamic art represent flowers to evoke both garden and paradisiac associations.

The seventeenth-century *Wagner Carpet* is an extraordinarily sumptuous garden carpet made of wool pile (**FIG. 8–29**). It represents a dense field of trees (including cypresses) and flowers, populated with birds, animals, and even fish, and traversed by three large water channels that form an H with a central pool at the center. The carpet fascinates not only for the fact that so simple a technique as a knotted yarn can produce such complex, layered designs, but also for the combination of perspectives: From above, the carpet resembles a plan, but the trees are shown in profile, as if from ground level.

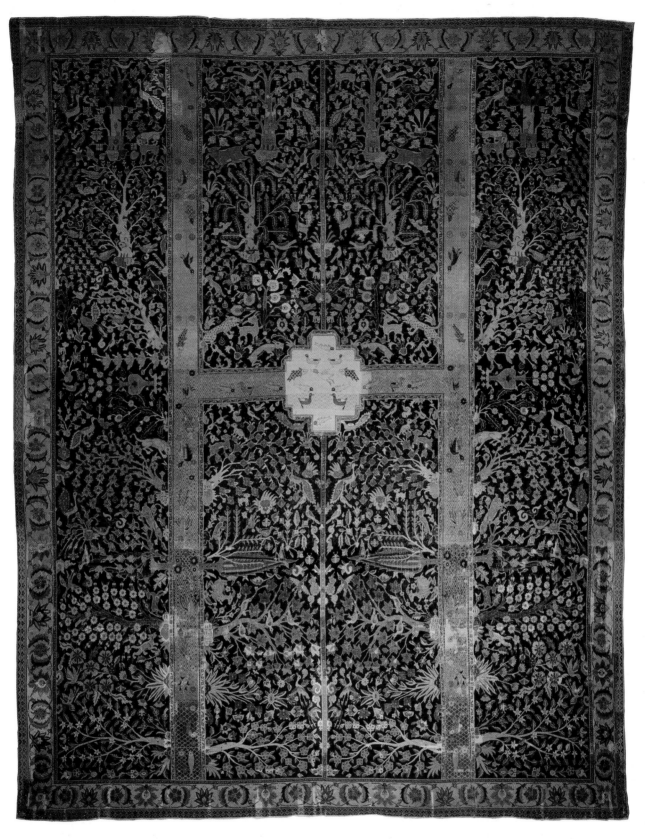

8-29 • WAGNER CARPET
From Iran. 17th century. Wool pile, cotton warp, cotton and wool weft, 17′5″ × 13′11″ (5.31 × 4.25 m). Burrell Collection, Glasgow.

When this extraordinarily detailed large carpet was laid on the floor of a palace or wealthy home, it gave the illusion of a garden underfoot. Natural motifs in carpets, textiles, and tiled walls, together with large windows and porches offering delightful vistas, invited the outdoors inside and blurred any distinction between them.

Rugs have long been used for Muslim prayer, which involves repeatedly kneeling and touching the forehead to the floor before God. While individuals often had their own small prayer rugs, with representations of niches to orient the faithful in prayer, many mosques were furnished with wool-pile rugs received as pious donations (the floor of the Selimiye Mosque would have had such rugs). In Islamic houses, people sat and slept on cushions, carpets, and thick mats laid directly on the floor, so cushions took the place of the fixed furnishings of Western domestic environments. From the late Middle Ages to today, carpets and textiles are one of the predominant Islamic arts and the Islamic art form best known in the West. Historically, rugs from Iran, Turkey, and elsewhere were highly valued by Westerners, who often displayed them on tables rather than floors.

MUGHAL DYNASTY

Like the Safavids in Iran, the Mughals brought Timurid models with them from Central Asia into Hindustan. Although Islam had flourished in the Delhi region from the early thirteenth century onward, the Mughals unified the Muslim- and Hindu-ruled states of north India into an empire (see Chapter 23). The illustrations of the emperor Babur's memoirs, the *Baburnama*, show his active patronage of forms such as the *chahar bagh* four-part garden plan. In **FIGURE 8–30**, Babur—in an orange robe and turban—oversees the construction of a walled garden in Kabul, teeming with fruit trees and flowers. Babur had been raised in an environment thoroughly saturated with the Timurid artistic legacy of *iwan*s with *pishtaq* frames, tall bulbous domes, modular planning, axial symmetry, and the *chahar bagh*. His introduction of such forms into South Asia culminated several generations later in the Taj Mahal (SEE FIG. 23–1).

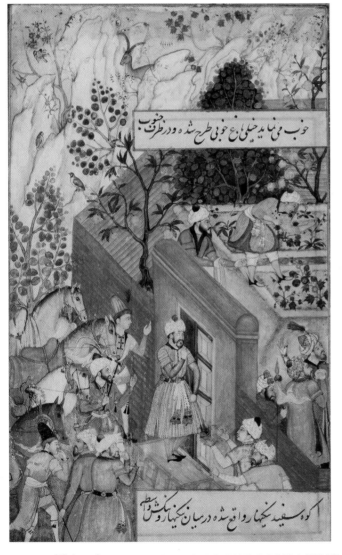
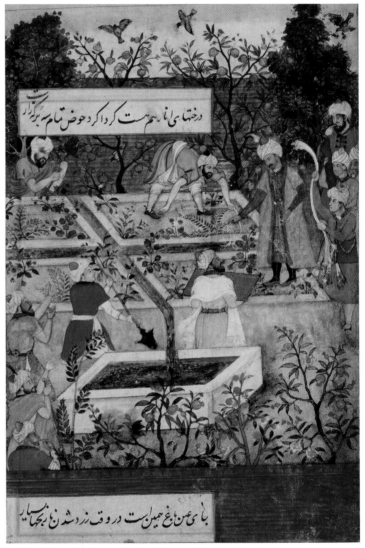

8-30 • Bishnadas "BABUR BUILDS THE BAGH-I WAFA," FROM THE *BABURNAMA*
India. c. 1590. Gouache and gold on paper, 8⅝ × 5⅝″ (21.9 × 14.4 cm). Victoria & Albert Museum, London. IM.276-1913, f. 276

The Mughal emperor Babur, on the right, gestures to his architect who holds a red board with grid lines—reflecting the legacy of Timurid modular planning—while workmen measure and shovel, their leggings rolled up to their knees.

8–31 • Paolo Portoghesi, Vittorio Gigliotti, and Sami Mousawi **ISLAMIC MOSQUE AND CULTURAL CENTRE, ROME** 1984–1992.

The prayer hall (197 × 13 feet/ 60 × 40 meters), which has an ablution area on the floor below, can accommodate a congregation of 2,500 on its main floor and balconies. The large central dome (65½ feet/ 20 meters in diameter) is surrounded by 16 smaller domes, all similarly articulated with concrete ribs.

THE MODERN ERA

The twentieth century saw the dissolution of the great Islamic empires and the formation of smaller nation-states in their place. The question of identity and its expression in art changed significantly as Muslim artists and architects sought training abroad and participated in an international movement that swept away many of the visible signs that formerly expressed their cultural character and difference. The abstract work of the architect Zaha Hadid (SEE FIG. 32–55), who was born in Baghdad and studied and practiced in London, is exemplary of the new internationalism. Other architects sought to reconcile modernity with an Islamic cultural identity that was distinct from the West. Thus the Iraqi architect Sami Mousawi and the Italian firm of Portoghesi-Gigliotti designed the Islamic Centre in Rome (completed 1992) with clean modern lines, exposing the structure while at the same time taking full advantage of opportunities for ornament (FIG. 8–31). The structural logic appears in the prayer hall's columns, made of concrete with an aggregate of crushed Carrara marble. These rise to meet abstract capitals in the form of plain rings, then spring upward to make a geometrically dazzling eight-pointed star supporting a dome of concentric circles. There are references here to the interlacing ribs of the *mihrab* dome in the Great Mosque of Cordoba, to the great domed spans of Sinan's prayer halls, and to the simple palm-tree trunks that supported the roof of the Mosque of the Prophet in Medina.

THINK ABOUT IT

8.1 The Islamic Empire rapidly spread east to India and west to Spain. Explain how the form of the mosque varies among the far-flung lands of the empire with reference to three examples. Despite the contrasts, what features do mosques typically have in common?

8.2 Select an Islamic structure discussed in this chapter that is influenced by Rome and/or Byzantium, and note which forms are borrowed and how, in their new Islamic context, they are transformed.

8.3 What is a *tugra*? Although it is a secular art form, how is it linked to Islamic religious art traditions?

8.4 Islamic art has no images of people in religious contexts. Instead, what decorative motifs and techniques are used?

8.5 Discuss the spread of carpet making within the rapidly growing Islamic Empire. Can you discern any geographical features that would have expedited the sharing of carpet-making techniques and specific styles? Use the map on page 263.

PRACTICE MORE: Compose answers to these questions, get flashcards for images and terms, and review chapter material with quizzes www.myartslab.com

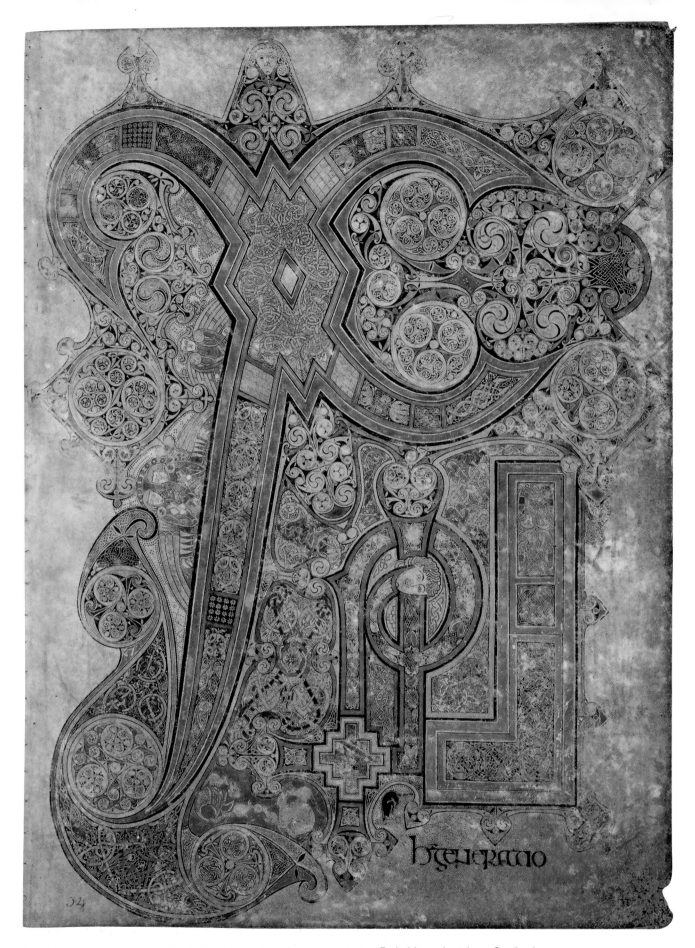

14-1 • CHI RHO IOTA PAGE FROM THE BOOK OF KELLS Probably made at Iona, Scotland.
Late 8th or early 9th century. Oxgall inks and pigments on vellum, 12¾ × 9½″ (32.5 × 24 cm).
The Board of Trinity College, Dublin. MS. 58, fol. 34r

EARLY MEDIEVAL ART IN EUROPE

The explosion of ornament surrounding—almost suffocating—the words on this page from an early medieval manuscript clearly indicates the importance of what is being expressed (FIG. 14–1). The large Greek letters *chi rho iota* (*XPI*) abbreviate the word *Christi* that starts the Latin phrase *Christi autem generatio*. The last word is written out fully and legibly at bottom right, clear of the decorative expanse. These words begin Matthew 1:18: "Now the birth of Jesus the Messiah took place in this way." So what is signaled here—not with a picture of the event but with an ornamental celebration of its initial mention in the text—is Christ's first appearance within this Gospel book. The book itself not only contains the four biblical accounts of Christ's life; it would also evoke Christ's presence on the altar of the monastery church where this lavish book was once housed. It is precisely the sort of ceremonial book that we have already seen carried in the hands of a deacon in Justinian's procession into San Vitale in Ravenna to begin the Mass (SEE FIG. 7–23).

There is nothing explicitly Christian about the ornamental motifs celebrating the first mention of the birth of Christ in this manuscript—the Book of Kells, produced in Ireland or Scotland sometime around the year 800. The swirling spirals and interlaced tangles of stylized animal forms have their roots in jewelry created by the migrating "barbarian" tribes that formed the "other" of the Greco-Roman world. But by this time, this ornamental repertory had been subsumed into the flourishing art of Irish monasteries. Irish monks became as famous for writing and copying books as for their intense spirituality and missionary fervor.

Wealthy, isolated, and undefended, Irish monasteries were easy victims to Viking attacks. In 806, fleeing Viking raids on the island of Iona (off the coast of modern Scotland), its monks established a refuge at Kells on the Irish mainland. They probably brought the Book of Kells with them. It was precious. Producing this illustrated version of the Gospels entailed lavish expenditure: Four scribes and three major painters worked on it (modern scribes take about a month to complete such a page), 185 calves were slaughtered to make the vellum, and colors for some of its paintings came from as far away as Afghanistan.

Throughout the Middle Ages and across Europe, monasteries were principal centers of art and learning. While prayer and acts of mercy represented their primary vocation, some talented monks and nuns also worked as painters, jewelers, carvers, weavers, and embroiderers. Few, however, could claim a work of art as splendid as this one.

LEARN ABOUT IT

14.1 Investigate how barbarian ornamental styles became the basis for illustrating Christian manuscripts in Ireland and Northumbria, and learn how these manuscripts were made and used.

14.2 Assess the Carolingian revival of Roman artistic traditions in relation to the political position of the rulers as emperors sanctioned by the pope.

14.3 Appreciate and understand the variety of styles used to illustrate early medieval sacred books.

14.4 Discover the distinctive style of manuscript painting developed by Christian artists in Spain.

14.5 Analyze the planning and function of monasteries in the early Middle Ages.

HEAR MORE: Listen to an audio file of your chapter **www.myartslab.com**

THE EARLY MIDDLE AGES

As Roman authority crumbled at the dissolution of the Western Empire in the fifth century, it was replaced by "barbarians," people from outside the Roman empire and cultural orbit who could only "barble" Greek or Latin (MAP 14–1). Thus far we have seen these "barbarians" as adversaries viewed through Greek and Roman eyes—the defeated Gauls at Pergamon (SEE FIG. 5–52), the captives on the *Gemma Augustea* (SEE FIG. 6–19), or the enemy beyond the Danube River on Trajan's Column (SEE FIG. 6–43). But by the fourth century many Germanic tribes were allies of Rome. In fact, most of Constantine's troops in the decisive battle with Maxentius at the Milvian Bridge were Germanic.

A century later the situation was entirely different. The adventures of the Roman princess Galla Placidia, whom we have already met as a patron of the arts (SEE FIG. 7–14), bring the situation vividly to life. She had the misfortune to be in Rome when Alaric and the Visigoths sacked the city in 410 (the emperor and pope were living safely in Ravenna). Carried off as a prize of war by the Goths, Galla Placidia had to join their migrations through France and Spain and eventually married the Gothic king, who was soon murdered. Back in Italy, married and widowed yet again, Galla Placidia ruled the Western Empire as regent for her son from 425 to 437/38. She died in 450, thus escaping yet another sack of Rome, this time by the Vandals, in 455. The fall of Rome shocked the Christian world, although the wounds were more psychological than physical. Bishop Augustine of Hippo (St. Augustine, d. 430) was inspired to write *The City of God*, a cornerstone of Christian philosophy, as an answer to people who claimed that the Goths represented the vengeance of the pagan gods on people who had abandoned them for Christianity.

Who were these people living outside the Mediterranean orbit? Their wooden architecture is lost to fire and decay, but their metalwork and its animal and geometric ornament has survived.

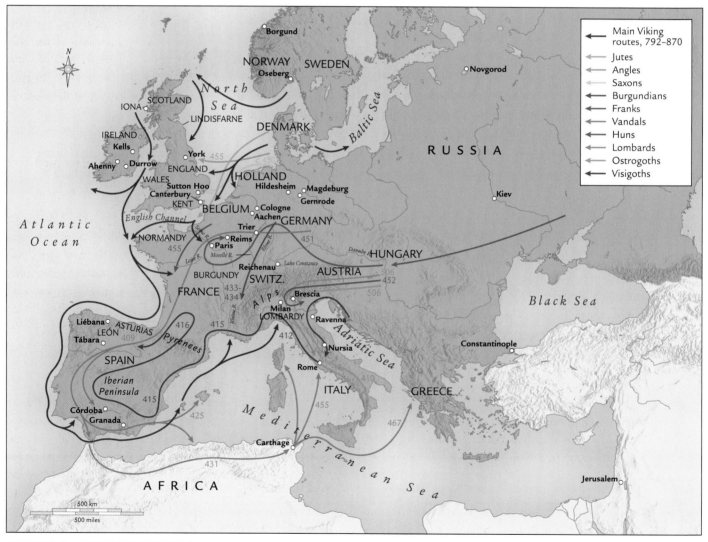

MAP 14–1 • EUROPE OF THE EARLY MIDDLE AGES

This map shows the routes taken by the groups of people who migrated into and through the western Roman world at the dawn of the Middle Ages. Modern country names have been used here for convenience, but at this time, these countries, as we know them, did not yet exist.

Defining the Middle Ages

The roughly 1,000 years of European history between the dissolution of the Western Roman Empire during the fifth century and the Florentine Renaissance in the fifteenth century are generally referred to as the Middle Ages, or the medieval period. These terms reflect the view of Renaissance humanists who regarded the period that preceded theirs as a "dark age" of ignorance, decline, and barbarism, standing in the middle and separating their own "golden age" from the golden ages of ancient Greece and Rome. Although scholars now acknowledge the ridiculousness of this self-serving formulation and recognize the millennium of the "Middle Ages" as a period of great richness, complexity, creativity, and innovation, the term has endured.

Art historians commonly divide the Middle Ages into three periods: early medieval (ending c. 1000), Romanesque (eleventh and twelfth centuries), and Gothic (beginning in the mid-twelfth and extending into the fifteenth century). In this chapter we can look at only a few of the many cultures that flourished during the early medieval period. For convenience, we will use modern geographic names as familiar points of reference (SEE MAP 14–1), but, in fact, European nations as we know them today did not yet exist.

They were hunters and fishermen, shepherds and farmers living in villages with a social organization based on extended families and tribal loyalties. They engaged in the practical crafts—pottery, weaving, woodwork—and they fashioned metals into weapons, tools, and jewelry.

The Celts controlled most of western Europe (see "The Celts," page 152), and the Germanic people—Goths and others—lived around the Baltic Sea. Increasing population evidently forced the Goths to begin to move south, into better lands and climate around the Mediterranean and Black Seas, but the Romans had extended the borders of their empire across the Rhine and Danube rivers. Seeking the relative security and higher standard of living they saw in the Roman Empire, the Germanic people crossed the borders and settled within the Roman world.

The tempo of migration speeded up in the fifth century when the Huns from Central Asia swept down on western Europe; the Ostrogoths (Eastern Goths) moved into Italy and deposed the last Western Roman emperor in 476; the Visigoths (Western Goths) ended their wanderings in Spain; the Burgundians settled in Switzerland and eastern France; the Franks in Germany, France, and Belgium; and the Vandals crossed over into Africa, making Carthage their headquarters before circling back to Italy, sacking Rome in 455.

As these barbarian groups gradually converted to Christianity, the Church served to unify Europe's heterogeneous population. As early as 345, the Goths adopted Arian Christianity, beliefs considered heretical by the Church in Rome. (Arian Christians did not believe that Christ was divine or co-equal with God the Father.) Not until 589 did they accept Roman Christianity. But the Franks under Clovis (r. 481–511), influenced by his Burgundian wife Clotilda, converted to Roman Christianity in 496, beginning a fruitful alliance between French rulers and the popes. Kings and nobles defended the claims of the Roman Church, and the pope, in turn, validated their authority. As its wealth and influence increased throughout Europe, the Church emerged as the principal patron of the arts to fulfill growing needs for buildings and liturgical equipment, including altars, altar vessels, crosses, candlesticks, containers for the remains of saints (reliquaries), vestments (ritual garments), images of Christian figures and stories, and copies of sacred texts such as the Gospels. (See "Defining the Middle Ages," above.)

THE ART OF THE "BARBARIANS" IN EUROPE

Out of a tangled web of themes and styles originating from inside and out of the empire, from pagan and Christian beliefs, from urban and rural settlements, brilliant new artistic styles were born across Europe as barbarian people settled within the former Western Roman Empire. Many of the migratory groups were superb metalworkers and created magnificent colorful jewelry, both with precious metals and with inlays of gems. Most of the motifs were geometric or highly abstracted from natural forms.

THE MEROVINGIANS

One of the barbarian groups that moved into the Western Roman world during the fifth century was the Franks, who migrated westward from what is now Belgium and settled in the northern part of Roman Gaul (modern France). There they were soon ruled by a succession of leaders from a dynasty named "Merovingian" after its legendary founder, Merovech. The Merovingians established a powerful kingdom during the reigns of Childeric I (c. 457–481) and his son Clovis I (481–511), whose conversion to Christianity in 496 connected the Franks to the larger European world through an ecclesiastical network of communication and affiliation.

Though some early **illuminated** books (books that include not only text but pictures and decoration in color and gold) have

14-2 • JEWELRY OF QUEEN ARNEGUNDE
Discovered in her tomb, excavated at the Abbey of Saint-Denis, Paris. Burial c. 580–590. Gold, silver, garnets, and glass beads; length of pin 10³/₈″ (26.4 cm). Musée des Antiquités Nationales, Saint-Germain-en-Laye, France.

been associated with the dynasty, our knowledge of Merovingian art is based primarily on the jewelry that has been uncovered in the graves of kings, queens, and aristocrats, indicating that both men and women expressed their wealth (in death, as presumably in life) by wearing earrings, necklaces, finger rings, bracelets, and weighty leather belts, from which they suspended even more ornamental metalwork. One of the most spectacular royal tombs was that of Queen Arnegunde, unearthed during excavations in 1959 at the Abbey of Saint-Denis, near Paris, which was a significant center of Merovingian patronage.

Arnegunde was discovered within a stone sarcophagus— undisturbed since her burial in c. 580–590. From her bodily remains, archaeologists determined that she was slight and blond, 5 feet tall, and about 70 years old at the time of her death. The inscription of her name on a gold ring on her left thumb provided

the first clue to her identity, and her royal pedigree was confirmed by the sumptuousness of her clothing. She was outfitted in a short, purple silk tunic, cinched at the waist by a substantial leather belt from which was suspended ornamental metalwork. The stockings that covered her legs were supported by leather garters with silver strap tongues and dangling ornaments. Over this ensemble was a dark red gown embroidered in gold thread. This overgarment was opened up the front, but clasped at neck and waist by round brooches and a massive buckle **(FIG. 14–2)**. These impressive objects were made by casting their general shape in two-piece molds, refining and chasing them with tools, and inlaying within reserved and framed areas carefully cut garnets to provide color and sparkle. Not long after Arnegunde's interment, Merovingian royalty ceased the practice of burying such precious items with the dead—encouraged by the Church to donate them instead to

religious institutions in honor of the saints—but we are fortunate to have a few early examples that presumably document the way these royal figures presented themselves on state occasions.

THE NORSE

In Scandinavia (present-day Denmark, Norway, and Sweden), which was never part of the Roman Empire, people spoke variants of the Norse language and shared a rich mythology with other Germanic peoples. Scandinavian artists had exhibited a fondness for abstract patterning from early prehistoric times. During the first millennium BCE, trade, warfare, and migration had brought a variety of jewelry, coins, textiles, and other portable objects into northern Europe. The artists incorporated the solar disks and stylized animals on these objects into their already rich artistic vocabulary.

By the fifth century CE, the so-called **animal style** dominated the arts, displaying an impressive array of serpents, four-legged beasts, and squat human figures, as can be seen in their metalwork. The **GUMMERSMARK BROOCH (FIG. 14–3)**, for example, is a large silver-gilt pin dating from the sixth century in Denmark. This elegant ornament consists of a large, rectangular panel and a medallionlike plate covering the safety pin's catch connected by an arched bow. The surface of the pin seethes with human, animal, and geometric forms. An eye-and-beak motif frames the rectangular panel, a man is compressed between dragons just below the bow, and a pair of monster heads and crouching dogs with spiraling tongues frame the covering of the catch.

Certain underlying principles govern works with animal style design: The compositions are generally symmetrical, and artists depict animals in their entirety either in profile or from above. Ribs and spinal columns are exposed as if they had been x-rayed; hip and shoulder joints are pear-shape; tongues and jaws extend and curl; and legs end in large claws.

The northern jewelers carefully crafted their molds to produce a glittering surface on the cast metal, turning a process intended to speed production into an art form of great refinement.

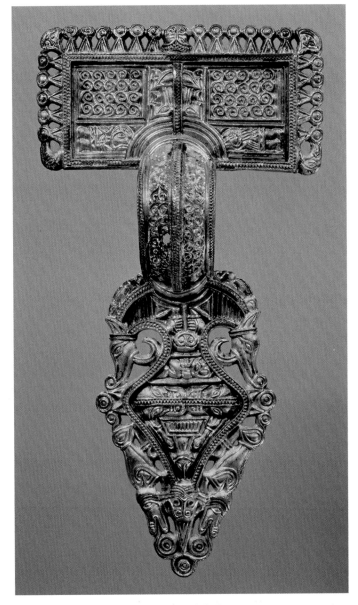

14-3 • GUMMERSMARK BROOCH
Denmark. 6th century. Silver gilt, height 5¾″ (14.6 cm). Nationalmuseet, Copenhagen.

THE CELTS AND ANGLO-SAXONS IN BRITAIN

After the Romans departed Britain at the beginning of the fifth century, Angles and Saxons from Germany and the Low Lands, and Jutes from Denmark, crossed the sea to occupy southeastern Britain. Gradually they extended their control northwest across the island. Over the next 200 years, the arts experienced a spectacular efflorescence. A fusion of Celtic, Roman, Germanic, and Norse cultures generated a new style of art, sometimes known as Hiberno-Saxon (from the Roman name for Ireland, Hibernia). Anglo-Saxon literature is filled with references to sumptuous jewelry and weapons made of or decorated with gold and silver, and fortunately, some of it has survived to this day.

The Anglo-Saxon epic *Beowulf*, composed perhaps as early as the seventh century, describes its hero's burial with a hoard of treasure in a grave mound near the sea. Such a burial site was discovered near the North Sea coast in Suffolk at a site called Sutton Hoo (*hoo* means "hill"). The grave's occupant had been buried in a ship—90 feet long and designed for rowing, not sailing—whose traces in the earth were recovered by careful excavators. The wood—and the hero's body—had disintegrated, and no inscriptions record his name. He has sometimes been identified with the ruler Raedwald, who died about 625. Whoever he was, the treasures buried with him prove that he was a wealthy and powerful man. They include weapons, armor, other equipment to provide for the ruler's afterlife, and many luxury items. The objects from Sutton Hoo represent the broad multicultural heritage characterizing Britain, Ireland, and Scotland at this time—Celtic, Scandinavian, and classical Roman, as well as Anglo-Saxon. There was even a Byzantine silver bowl at Sutton Hoo.

The story of the discovery of Sutton Hoo—unquestionably one of the most important archaeological discoveries in Britain—begins with Edith May Pretty, who decided late in her life to explore the burial mounds that were located on her estate in southeast Suffolk, securing the services of a local amateur archaeologist, Basil Brown. Excavations began in 1938 as a collaborative effort between the two of them, and in the following year they encountered the famous ship burial. As rumors spread of the importance of the find, its excavation was gradually taken over by renowned experts and archaeologists who moved from the remains of the ship to the treasures of the burial chamber for which Sutton Hoo is most famous. Police officers were posted to guard the site, and the treasures were sent for safekeeping to the British Museum in London, although, since Sutton Hoo was determined not to be "Treasure Trove" (buried objects meant to be retrieved by their original owners and now considered property of the Crown—see "The Mildenhall Treasure," page 214), it was the legal property of Mrs. Pretty. She, however, decided to donate the entire contents of the burial mound to the British Museum.

Excavation of Sutton Hoo was interrupted by World War II, but in 1945 Rupert Bruce-Mitford of the British Museum began a scholarly study of its treasures that would become his life work. He not only subjected each piece to detailed scrutiny; he proposed reconstructions of objects that were only partially preserved, such at the harp, helmet, and drinking horns. Using the evidence that had been gathered in a famous murder case, he proposed that Sutton Hoo was actually a burial, even though no evidence of human remains were ever found, since they could have disappeared completely in the notably acidic soil of the mound. Other scholars used radiocarbon dating of timber fragments and close analysis of coins to focus the dating of the burial to c. 625, which happened to coincide with the death date of King Raedwald of East Anglia, the most popular candidate for the identity of the person buried at Sutton Hoo.

After heated discussions and considerable controversy, new excavations were carried out in the area of Sutton Hoo during the 1980s and 1990s. These revealed a series of other discoveries in what emerged as an important early medieval burial ground and proved that the area had been inhabited since the Neolithic period, but they uncovered nothing to rival the collection of treasures that were preserved at Sutton Hoo.

One of the most exquisite finds was a clasp of pure gold that once secured over his shoulder the leather body armor of its distinguished owner **(FIG. 14–4)**. The two sides of the clasp—essentially identical in design—were connected when a long gold pin, attached to one half by a delicate but strong gold chain, was inserted through a series of aligned channels on the back side of the inner edge of each. The superb decoration of this work is created by thin pieces of garnet and blue-checkered glass (known as **millefiori**, from the Italian for "a thousand flowers") cut into precisely stepped geometric shapes or to follow the sinuous contours of stylized animal forms. The cut shapes were then inserted into channels and supplemented by granulation (the use of minute granules of gold fused to the surface; see also "Aegean Metalwork," page 87). Under the stepped geometric pieces that form a rectangular patterned field on each side, jewelers placed gold foil stamped with incised motifs that reflect light back up through the transparent garnet to spectacular effect. Around these carpetlike rectangles are borders of interlacing snakes, and in the curving compartments to the outside stand pairs of semi-transparent, overlapping boars stylized in ways that reflect the traditions of Scandinavian jewelry. Their curly pig's tails overlap their strong rumps at the outer edges on each side of the clasp, and following the visible vertebrae along the arched forms of their backs, we arrive at their heads, with floppy ears and extended tusks. Boars represented strength and bravery, important virtues in warlike Anglo-Saxon society.

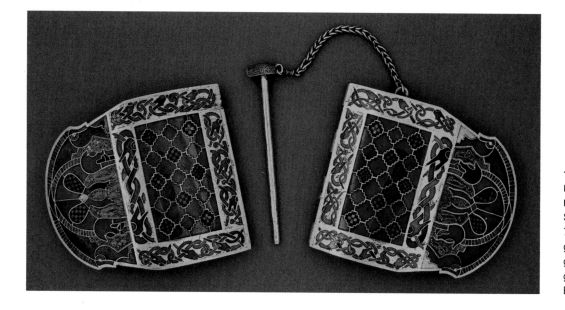

14-4 • HINGED CLASP, FROM THE SUTTON HOO BURIAL SHIP
Suffolk, England. First half of 7th century. Gold plaques with granulation and inlays of garnet and checked millefiori glass, length 5″ (12.7 cm). British Museum, London.

THE EARLY CHRISTIAN ART OF THE BRITISH ISLES

Although the Anglo-Saxons who settled in Britain had their own gods and myths, Christianity survived. Monasteries flourished in the Celtic north and west, and Christians from Ireland founded influential missions in Scotland and northern England. Cut off from Rome, these Celtic Christians developed their own liturgical practices, church calendar, and distinctive artistic traditions. Then, in 597, Pope Gregory the Great (pontificate 590–604) dispatched missionaries from Rome to the Anglo-Saxon king Ethelbert of Kent, whose Christian wife, Bertha, was sympathetic to their cause. The head of this successful mission, the monk Augustine (St. Augustine of Canterbury, d. 604), became the first archbishop of Canterbury in 601. The Roman Christian authorities and the Irish monasteries, although allied in the effort to Christianize Britain, came into conflict over their divergent practices. The Roman Church eventually triumphed and brought British Christians under its authority. Local traditions, however, continued to influence their art.

ILLUSTRATED BOOKS

Among the richest surviving artworks of the period are the lavishly decorated Gospel books, not only essential for spiritual and liturgical life within established monasteries, but also critical for the missionary activities of the Church, since a Gospel book was required in each new foundation. Often bound in gold and jeweled covers, they were placed on the altars of churches, carried in processions, and even thought to protect parishioners from enemies, predators, diseases, and all kinds of misfortune. Such sumptuous books were produced by monks in local monastic workshops called **scriptoria** (see "The Medieval Scriptorium," page 432).

THE BOOK OF DURROW. One of the earliest surviving decorated Gospels of the period is the **BOOK OF DURROW**, dating to the second half of the seventh century (**FIG. 14–5**). The book's format reflects Roman Christian models, but its paintings are an encyclopedia of Hiberno-Saxon design. Each of the four Gospels is introduced by a three-part decorative sequence: a page with the symbol of its evangelist author, followed by a page of pure ornament, and finally elaborate decoration highlighting the initial words of the text (the *incipit*).

The Gospel of Matthew is preceded by his symbol, the man, but what a difference there is from the way humans were represented in the Greco-Roman tradition. The armless body is formed by a colorful checkered pattern recalling the rectangular panels of the Sutton Hoo clasp (SEE FIG. 14–4). Set on the body's rounded shoulders, a schematic, symmetrical, frontal face stares directly out at the viewer, and the tiny feet that emerge at its other end are seen from a contrasting profile view, as if to deny any hint of lifelike form or earth-based spatial placement. Equally prominent is the bold band of complicated but coherent interlacing ornament that borders the figure's field.

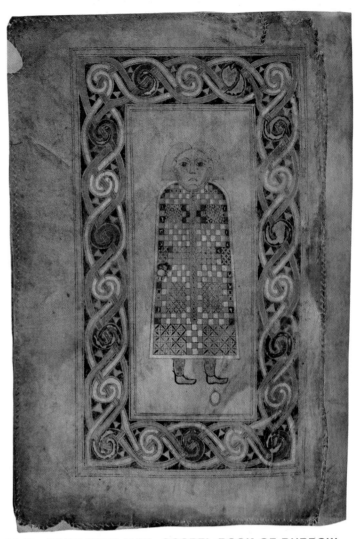

14-5 • PAGE WITH MAN, GOSPEL BOOK OF DURROW
Gospel of Matthew. Probably made at Iona, Scotland, or in northern England. Second half of 7th century. Ink and tempera on parchment, 9⅝ × 6⅛″ (24.4 × 15.5 cm). The Board of Trinity College, Dublin. MS. 57 fol. 21v

THE BOOK OF KELLS. The monastic scribes and artists of England, Scotland, and Ireland developed and expanded this artistic tradition in works of breathtaking virtuosity like the Lindisfarne Gospels (see "The Lindisfarne Gospels," pages 430–431) and the Book of Kells. This chapter began with a close look at the most celebrated page in the Book of Kells—the page introducing Matthew's account of Jesus' birth (SEE FIG. 14–1). At first this appears to be a dense thicket of spiral and interlace patterns derived from metalworking traditions embellishing—in fact practically overwhelming—the Chi Rho monogram of Christ. The illuminators outlined each letter in the Chi Rho monogram, and then they subdivided the letters into panels filled with interlaced animals and snakes, as well as extraordinary spiral and knot motifs. The spaces between the letters form a whirling ornamental field, dominated by spirals.

In the midst of these abstractions, the painters inserted numerous pictorial and symbolic references to Christ—a fish (the

The Lindisfarne Gospels

The Lindisfarne Gospels is one of the most extraordinary books ever created, admired for the astonishing beauty of its words and pictures (SEE FIGS. A, B, and the first Closer Look in the Introduction, FIG. A), but also notable for the wealth of information we have about its history. Two and a half centuries after it was made, a priest named Aldred added a colophon to the book, outlining with rare precision the book's history, as he knew it—that it was written by Eadfrith, bishop of Lindisfarne (698–721), and bound by Ethelwald, his successor. Producing this stupendous example of book art was an expensive and laborious proposition—requiring 300 calfskins to make the vellum and using pigments imported from as far away as the Himalayas for the decoration. Preliminary outlines were made for each of the pictures, using compasses, dividers, and straight edges to produce precise underdrawings with a sharp point of silver or lead, forerunner to our pencils.

The full pages of ornament set within cross-shape frameworks (see example in the Introduction) are breathtakingly complex, like visual puzzles that require patient and extended viewing. Hybrid animal forms tangle in acrobatic interlacing, disciplined by strict symmetry and sharp framing. Some have speculated that members of the religious community at Lindisfarne might have deciphered the patterns as a spiritual exercise. But principally the book was carried in processions and displayed on the altar, not shelved in the library to be consulted as a part of intellectual life. The text is heavily ornamented and abbreviated, difficult to read. The words that begin the Gospel of Matthew (FIG. A)—*Liber generationis ihu xpi filii david filii abraham* (The book of the generation of Jesus Christ, son of David, son of Abraham)—are jammed together, even stacked on top of each other. They are also framed, subsumed, and surrounded by a proliferation of the decorative forms, ultimately deriving from barbarian visual traditions, that we have already seen moving from jewelry into books in the Durrow Gospels (SEE FIG. 14–5) and the Book of Kells (SEE FIG. 14–1).

But the paintings in the Lindisfarne Gospels document more than the developing sophistication of an abstract artistic tradition. Roman influence is evident here as well. Instead of beginning each Gospel with a symbol of its author, the designer of this book introduced portraits of the evangelists writing their texts, drawing on a Roman tradition (FIG. B). The monastic library at Wearmouth-Jarrow, not far from Lindisfarne, is known to have had a collection of Roman books, and an author portrait in one of them seems to have provided the model for an artist there, who portrayed *Ezra Restoring the Sacred Scriptures* within a huge Bible (FIG. C).

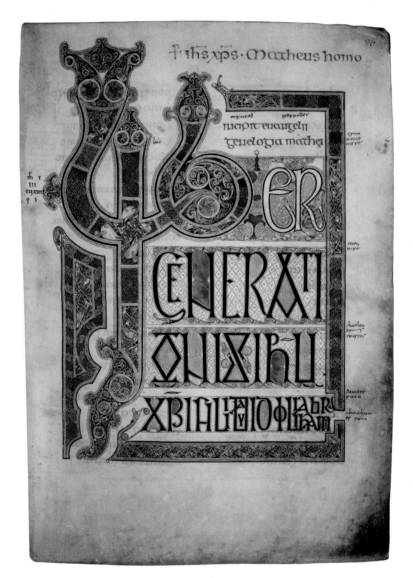

A. PAGE WITH THE BEGINNING OF THE TEXT OF MATTHEW'S GOSPEL, LINDISFARNE GOSPEL BOOK
Lindisfarne, c. 715–720. Ink and tempera on vellum, 13⅜ × 9⁷⁄₁₆″ (34 × 24 cm). The British Library, London. Cotton MS. Nero D.IV fol. 27r

The words written in the right margin, just beside the frame, are an Old English gloss translating the Latin text, added here in the middle of the tenth century by the same Aldred who added the colophon. They represent the earliest surviving English text of the Gospels.

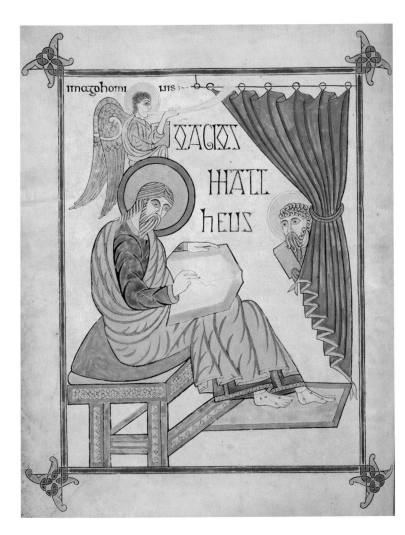

B. MATTHEW WRITING HIS GOSPEL, LINDISFARNE GOSPEL BOOK

Lindisfarne. c. 715–720. Ink and tempera on vellum, 13⅜ × 9⁷⁄₁₆″ (34 × 24 cm). The British Library, London. Cotton MS. Nero D.IV fol. 25v

The identity of the haloed figure peeking from behind the curtain is still a topic of debate. Some see him as Christ confronting us directly around the veil that separated the holy of holies from worshipers in the Jewish Temple; others think he is Moses, holding the closed book of the law that was meant to be seen in contrast to the open book into which Matthew writes his Gospel. Also curious here is the Greek form of "saint" in Matthew's title ("O Agios" or "the holy"), written, however, with letters from the Latin alphabet.

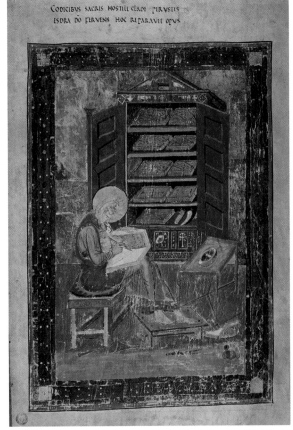

C. EZRA RESTORING THE SACRED SCRIPTURES, IN THE BIBLE KNOWN AS THE CODEX AMIATINUS

Wearmouth-Jarrow. c. 700–715. Ink and tempera on vellum, 20 × 13½″ (50.5 × 34.3 cm). Biblioteca Medicea Laurenziana, Florence. Cod. Amiat. I, fol. 5r

This huge manuscript (at over 2,000 pages, it weighs more than 75 pounds) is the earliest surviving complete text of the Bible in the Latin Vulgate translation of St. Jerome.

This painter worked to emulate the illusionistic traditions of the Greco-Roman world. Ezra is a modeled, three-dimensional form, sitting on a foreshortened bench and stool, both drawn in perspective to make them appear to recede into the distance. In the background, the obliquely placed books on the shelves of a cabinet seem to occupy the depth of its interior space.

Interestingly, the artist of the Matthew portrait in the Lindisfarne Gospels worked with the same Roman prototype, judging from the number of details these two portraits share, especially the figures' poses. But instead of striving to capture the lifelike features of his Roman model, the Lindisfarne artist sought to undermine them. Matthew appears against a blank background. All indications of modeling have been stripped from his clothing to foreground the decorative pattern and contrasting color created by the drapery "folds." By carefully arranging the ornament on the legs of Matthew's bench, the three-dimensional shading and perspective evident in the portrait of Ezra have been successfully suppressed. The footstool has been liberated from its support to float freely on the surface, while still resting under the evangelist's silhouetted feet. Playing freely with an acknowledged and clearly understood alien tradition, the painter situates an enigmatic figure in the "background" at upper right behind a gathered drape—suspended from a curtain rod hanging from a screw eye sunk into the upper frame—that is not long enough to conceal the rest of his figure. Clearly there were important cultural reasons for such divergent reactions to a Mediterranean model—Wearmouth-Jarrow seeking to emphasize its Roman connections and Lindisfarne its indigenous roots. We are extremely fortunate to have two surviving works of art that visualize the contrast so clearly.

The Medieval Scriptorium

Today books are made with the aid of computer software that can lay out pages, set type, and insert and prepare illustrations. Modern presses can produce hundreds of thousands of identical copies in full color. In medieval Europe, however, before the invention of printing from movable type in the mid 1400s, books were made by hand, one at a time, with ink, pen, brush, and paint. Each one was a time-consuming and expensive undertaking. No two were exactly the same.

At first, medieval books were usually made by monks and nuns in a workshop called a **scriptorium** (plural, scriptoria) within the monastery. As the demand for books increased, rulers set up palace workshops employing both religious and lay scribes and artists, supervised by scholars. Books were written on carefully prepared animal skin—either **vellum**, which was fine and soft, or **parchment**, which was heavier

and shinier. Ink and water-based paints also required time and experience to prepare, and many pigments—particularly blues and greens—were prepared from costly semiprecious stones. In very rich books, artists also used gold leaf or gold paint.

Work on a book was often divided between scribes, who copied the text, and artists, who painted or drew illustrations, large initials, and other decorations. Occasionally, scribes and artists signed and dated their work on the last page, in what was called the **colophon**. One scribe even took the opportunity to warn: "O reader, turn the leaves gently, and keep your fingers away from the letters, for, as the hailstorm ruins the harvest of the land, so does the injurious reader destroy the book and the writing" (cited in Dodwell, p. 247).

Greek word for "fish," *ichthus*, comprises in its spelling the first letters of Jesus Christ, Son of God, Savior), moths (symbols of rebirth), the cross-inscribed wafer of the Eucharist, and numerous chalices and goblets. In a particularly intriguing image at bottom left, two cats pounce on a pair of mice nibbling the Eucharistic wafer, and two more mice torment the vigilant cats. Is this a metaphor for the struggle between good (cats) and evil (mice), or an acknowledgment of the perennial problem of keeping the sacred Host safe from rodents? Perhaps it is both.

IRISH HIGH CROSSES. Metalworking traditions influenced not only manuscript decoration, but also the monumental stone crosses erected in Ireland during the eighth century. The **SOUTH CROSS** of Ahenny, in County Tipperary, is an especially well-preserved example (**FIG. 14–6**). It seems to have been modeled on metal ceremonial or reliquary crosses, that is, cross-shape containers for holy relics. It is outlined with ropelike, convex moldings and covered with spirals and interlace. The large bosses (broochlike projections), which form a cross within this cross, resemble the jewels that were similarly placed on metal crosses. The circle enclosing the arms of such Irish high crosses—so called because of their size—has been interpreted as a ring of heavenly light or as a purely practical means of supporting the projecting arms.

MOZARABIC ART IN SPAIN

In 711, Islamic invaders conquered Spain, ending Visigothic rule. Bypassing the small Christian kingdom of Asturias on the north coast, they crossed the Pyrenees Mountains into France, but in 732 Charles Martel and the Frankish army stopped them before they

14–6 • SOUTH CROSS, AHENNY
County Tipperary, Ireland. 8th century. Stone.

reached Paris. The Moors, as they were known in Spain, remained in the Iberian peninsula (Spain and Portugal) for nearly 800 years, until the fall of Granada to the Christians in 1492.

With some exceptions, Christians and Jews who acknowledged the authority of the Islamic rulers and paid the taxes required of non-Muslims were left free to follow their own religious practices. The Iberian peninsula became a melting pot of cultures in which Muslims, Christians, and Jews lived and worked together, all the while officially and firmly separated. Christians in the Muslim territories were called Mozarabs (from the Arabic *mustarib*, meaning "would-be Arab"). In a rich exchange of artistic influences, Christian artists incorporated some features of Islamic art into a colorful new style known as **Mozarabic**. When the Mozarabic communities migrated to northern Spain, which returned to Christian rule not long after the initial Islamic invasion, they took this Mozarabic style with them.

BEATUS MANUSCRIPTS

One of the most influential books of the eighth century was the Commentary on the Apocalypse, compiled by Beatus, abbot of the Monastery of San Martín at Liébana in the northern kingdom of Asturias. Beatus described the end of the world and the Last Judgment of the Apocalypse, rooted in the Revelation to John at the end of the New Testament, which vividly describes Christ's final, fiery triumph.

A lavishly illustrated copy of Beatus' Commentary called the Morgan Beatus was produced c. 940–945, probably at the Monastery of San Salvator at Tábara, by an artist named Maius (d. 968), who both wrote the text and painted the illustrations. His gripping portrayal of the *Woman Clothed with the Sun*, based on the biblical text of Apocalypse (Revelation) 12:1–18, extends over two pages to cover an entire opening of the book (**FIG. 14–7**). Maius has stayed close to the text in composing his tableau, which is

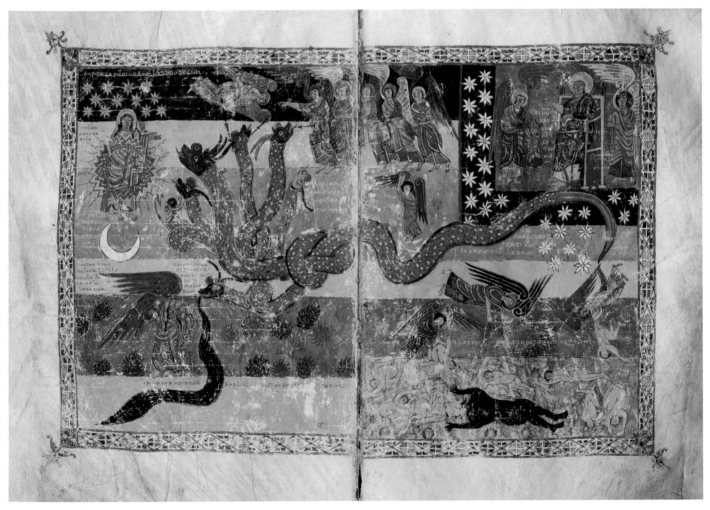

14–7 • Maius WOMAN CLOTHED WITH THE SUN, THE MORGAN BEATUS
Monastery of San Salvador at Tábara, León, Spain. 940–945. Tempera on vellum, 15⅛ × 22⅙″ (38.5 × 56 cm).
The Pierpont Morgan Library, New York. MS. M644, fols. 152v–153r

When the modern abstract French painter Fernand Léger (1881–1955; SEE FIG. 31–21) was visiting the great art historian Meyer Schapiro (1904–1996) in New York during World War II, the artist asked the scholar to suggest the single work of art that was most important for him to see while there. Schapiro took him to the Morgan Library to leaf through this manuscript, and the strong impact it had on Léger can be clearly seen in the boldness of his later paintings.

dominated by the long, seven-headed, red dragon that slithers across practically the entire width of the picture to threaten at top left the "woman clothed with the sun, with the moon under her feet, and on her head a crown of twelve stars" (12:1). With his tail, at upper right, he sweeps a third of heaven's stars toward Earth while the woman's male child appears before the throne of God. Maius presents this complex allegory of the triumph of the Church over its enemies with a forceful, abstract, ornamental style that accentuates the dramatic, nightmarish qualities of the events outlined in the text. The background has been distilled into horizontal strips of color; the figures become striped bundles of drapery capped with faces dominated by staring eyes and silhouetted, framing haloes. Momentous apocalyptic events have been transformed by Maius into exotic abstractions that still maintain their power to captivate our attention.

Another copy of Beatus' Commentary was produced about 30 years later for Abbot Dominicus of San Salvator at Tábara. A colophon identifies Senior as the scribe for this project. Emeterius and a woman named Ende (or simply En), who signed herself "painter and servant of God," shared the task of illustration. For the first time in the West, a woman artist is identified by name with a specific surviving work of art. In an allegory of the triumph of Christ over Satan **(FIG. 14–8)**, the painters show a peacock grasping a red-and-orange snake in its beak. The text explains that a bird with a powerful beak and beautiful plumage (Christ) covers itself with mud to trick the snake (Satan). Just when the snake decides the bird is harmless, the bird swiftly attacks and kills it. "So Christ in his Incarnation clothed himself in the impurity of our [human] flesh that through a pious trick he might fool the evil deceiver…. [W]ith the word of his mouth [he] slew the venomous killer, the devil" (cited in Williams, page 95).

14-8 • Emeterius and Ende, with the scribe Senior BATTLE OF THE BIRD AND THE SERPENT, COMMENTARY ON THE APOCALYPSE BY BEATUS AND COMMENTARY ON DANIEL BY JEROME (DETAIL)
Made for Abbot Dominicus, probably at the Monastery of San Salvador at Tábara, León, Spain. Completed July 6, 975. Tempera on parchment, 15¾ × 10¼" (40 × 26 cm). Cathedral Library, Gerona, Spain. MS. 7[11], fol. 18v

THE VIKING ERA

In the eighth century, seafaring bands of Norse seamen known as Vikings (*viken*, "people from the coves") descended on the rest of Europe. Setting off in flotillas of as many as 350 ships, they explored, plundered, traded with, and colonized a vast area during the ninth and tenth centuries. The earliest recorded Viking incursions were two devastating attacks on wealthy isolated Christian monasteries: one in 793, on the religious community on Lindisfarne, an island off the northeast coast of England; and another in 795, at Iona, off Scotland's west coast.

Norwegian and Danish Vikings raided a vast territory stretching from Iceland and Greenland, where they settled in 870 and 985, respectively, to Ireland, England, Scotland, and France. The Viking Leif Eriksson reached North America in 1000. In good weather a Viking ship could sail 200 miles in a day. In the early tenth century, the rulers of France bought off Scandinavian raiders (the Normans, or "northmen") with a large grant of land that became the duchy of Normandy. Swedish Vikings turned eastward and traveled down the Russian rivers to the Black Sea and Constantinople, where the Byzantine emperor recruitedthem to form an elite personal guard. Others, known as Rus, established settlements around Novgorod, one of the earliest cities in what would become Russia. They settled in Kiev in the tenth century and by 988 had become became Orthodox Christians (see Chapter 7).

THE OSEBERG SHIP

Since prehistoric times Northerners had represented their ships as sleek sea serpents, and, as we saw at Sutton Hoo, they used them for burials as well as sea journeys. The ship of a dead warrior symbolized his passage to Valhalla (a legendary great hall that welcomed fallen warriors), and Viking chiefs were sometimes cremated in a ship in the belief that this hastened their journey. Women as well as men were honored by ship burials. A 75-foot-long ship, discovered in Oseberg, Norway, and dated 815–820, served as the vessel for two women on their journey to eternity in 834, a queen and her companion or servant. Although the burial chamber was long ago looted of jewelry and precious objects, the ship itself and its equipment attest to the wealth and prominence of the ship's owner. A cart and four sleds, all made of wood with beautifully carved decorations, were stored on board. At least 12 horses, several dogs, and an ox had been sacrificed to accompany these women on their last journey.

This Oseberg ship itself, propelled by both sail and oars, was designed for travel in the relatively calm waters of fjords (narrow coastal inlets), not for voyages in the open sea. The rising prow spirals into a tiny serpent's head, and bands of interlaced animals carved in low relief run along the edges (**FIG. 14–9**). Viking beasts are grotesque, broad-bodied creatures with bulging eyes, short muzzles, snarling mouths, and large teeth who clutch each other with sharp claws. Images of these strange beasts adorned all sorts of

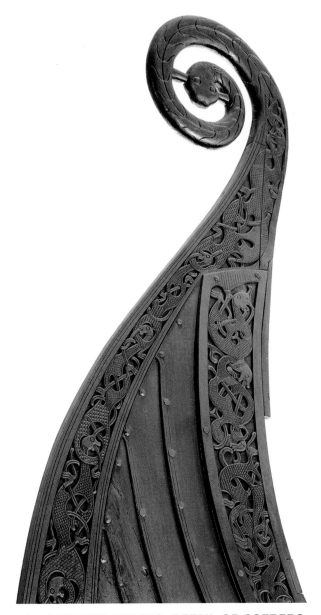

14-9 • GRIPPING BEASTS, DETAIL OF OSEBERG SHIP
c. 815–820. Wood. Vikingskiphuset, Universitets Oldsaksamling, Oslo, Norway.

Viking belongings—jewelry, houses, tent poles, beds, wagons, and sleds. Traces of color—black, white, red, brown, and yellow—indicate that the carved wood was originally painted.

All women, including the most elite, worked in the fiber arts. The Oseberg queen took her spindles, a frame for sprang (braiding), and tablets for tablet-weaving, as well as two upright looms, with her to the grave. Her cabin walls had been hung with tapestries, fragments of which survive. Women not only produced clothing and embroidered garments and wall hangings, but also wove the huge sails of waterproof unwashed wool that gave the ships a long-distance capability. The entire community—men and women—worked to create these ships, which represent the Vikings' most important surviving contribution to world architecture.

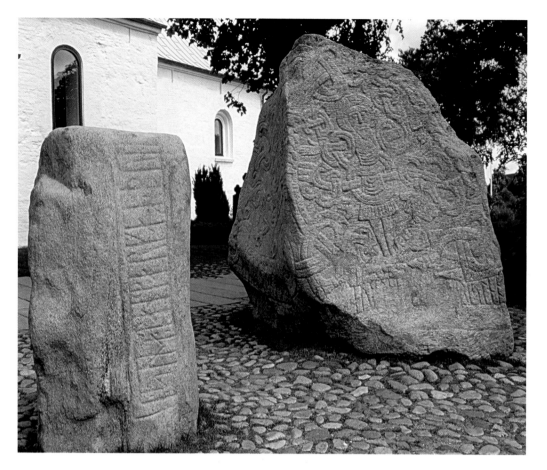

14–10 • ROYAL RUNE STONES, RIGHT-HAND STONE ORDERED BY KING HARALD BLUETOOTH
Jelling, Denmark. 983–985. Granite, 3-sided, height about 8′ (2.44 m).

PICTURE STONES AT JELLING

Both at home and abroad, the Vikings erected large memorial stones. Those covered mostly with inscriptions are called **rune stones** (runes are twiglike letters of an early Germanic alphabet). Those with figural decoration are called **picture stones**. Traces of pigments suggest that the memorial stones were originally painted in bright colors.

About 980, the Danish king Harald Bluetooth (c. 940–987) ordered a picture stone to be placed near an old, smaller rune stone and the family burial mounds at Jelling **(FIG. 14–10)**. Carved in runes on a boulder 8 feet high is the inscription "King Harald had this memorial made for Gorm his father and Thyra his mother: that Harald who won for himself all Denmark and Norway and made the Danes Christians." Harald and the Danes had accepted Christianity in c. 960, but Norway did not become Christian until 1015.

During the tenth century, a new style emerged in Scandinavia and the British Isles, one that combined interlacing foliage and ribbons with animals that are more recognizable than the gripping beasts of the Oseberg ship. On one face of the larger Jelling stone the sculptor carved the image of Christ robed in the Byzantine manner, with arms outstretched as if crucified. He is entangled in a double-ribbon interlace instead of nailed to a cross. A second side holds runic inscriptions, and a third, a striding creature resembling a lion fighting a snake. The loosely twisting double-ribbon interlace covering the surface of the stone could have been inspired by Hiberno-Saxon art.

TIMBER ARCHITECTURE

The vast forests of Scandinavia provided the materials for timber buildings of many kinds. Two forms of timber construction evolved: one that stacked horizontal logs, notched at the ends, to form a rectangular building (the still-popular log cabin); and the other that stood the wood on end to form a palisade or vertical plank wall, with timbers set directly in the ground or into a sill (a horizontal beam). More modest buildings consisted of wooden frames filled with wattle-and-daub (woven branches covered with mud or other substances). Typical buildings had a turf or thatched roof supported on interior posts. The same basic structure was used for almost all building types—feasting and assembly halls, family homes (which were usually shared with domestic animals), workshops, barns, and sheds. The great hall had a central open hearth (smoke escaped through a louver in the roof) and an off-center door designed to reduce drafts. People secured their residences and trading centers by building massive circular earthworks topped with wooden palisades.

THE BORGUND STAVE CHURCH. Subject to decay and fire, early timber buildings have largely disappeared, leaving only postholes and other traces in the soil. In rural Norway, however, a few timber **stave churches** survive—named for the four huge timbers (staves) that form their structural core. Borgund church, from about 1125–1150 **(FIG. 14–11)**, has four corner staves supporting the central roof, with additional interior posts that create the effect of

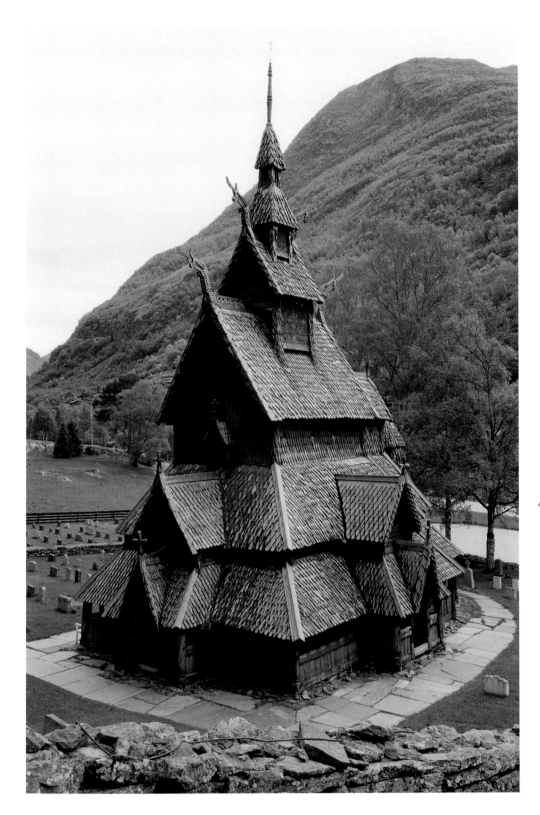

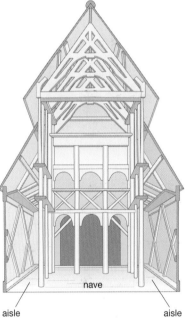

aisle nave aisle

14-11 • EXTERIOR AND CUTAWAY DRAWING OF STAVE CHURCH, BORGUND, NORWAY

c. 1125–1150.

SEE MORE: View a simulation of stave church construction

www.myartslab.com

a nave and side aisles, narthex, and choir. A rounded apse covered with a timber tower is attached to the choir. Steeply pitched roofs covered with wooden shingles protect the walls—planks slotted into the sills—from the rain and snow. Openwork timber stages set on the roof ridge create a tower and give the church a steep pyramidal shape. On all the gables either crosses or dragon heads protect the church and its congregation from trolls and demons.

The Vikings were not always victorious. Their colonies in Iceland and the Faeroe Islands survived, but in North America their trading posts eventually had to be abandoned. In Europe, south of the Baltic Sea, a new German dynasty challenged and then defeated the Vikings. By the end of the eleventh century the Viking era came to an end.

THE CAROLINGIAN EMPIRE

During the second half of the eighth century, while Christians and Muslims were creating a rich multicultural art in Spain and the Vikings were surging through Europe, a new force emerged on the Continent. Charlemagne (the French form of *Carolus Magnus*, Latin for "Charles the Great") established a dynasty and an empire known today as the Carolingian. He descended from a family that had succeeded the Merovingians in the late seventh century as rulers of the Franks in northern Gaul (parts of present-day France and Germany). Under Charlemagne (r. 768–814), the Carolingian realm reached its greatest extent, encompassing western Germany, France, the Lombard kingdom in Italy, and the Low Countries (present-day Belgium and Holland). Charlemagne imposed Christianity throughout this territory, and in 800, Pope Leo III (pontificate 795–816) crowned Charlemagne emperor in a ceremony in St. Peter's Basilica in Rome, declaring him the rightful successor to Constantine, the first Christian emperor. This endorsement reinforced Charlemagne's authority and strengthened the bonds between the papacy and secular government in the West.

The Carolingian rulers' ascent to the Roman *imperium*, and the political pretensions it implied, are clearly signaled in a small bronze equestrian statue—once thought to be a portrait of Charlemagne himself but now usually identified with his grandson **CHARLES THE BALD** (FIG. 14–12). The idea of representing an emperor as a proud equestrian figure recalls the much larger image of Marcus Aurelius (SEE FIG. 6–52) that was believed during the Middle Ages to portray Constantine, the first Christian emperor and an ideal prototype for the ruler of the Franks, newly legitimized by the pope. But unlike the bearded Roman, this Carolingian king sports a mustache, a Frankish sign of nobility that had also been common among the Celts (SEE FIG. 5–52). Works of art such as this are not the result of a slavish mimicking of Roman prototypes, but of a creative appropriation of Roman imperial typology to glorify manifestly Carolingian rulers.

Charlemagne sought to restore the Western Empire as a Christian state and to revive the arts and learning. As inscribed on his official seal, Charlemagne's ambition was "the Renewal of the Roman Empire." To lead this revival, Charlemagne turned to Benedictine monks and nuns. By the early Middle Ages, monastic communities had spread across Europe. In the early sixth century, Benedict of Nursia (c. 480–547) wrote his *Rule for Monasteries*, and this set of guidelines for a secluded life of monastic work and prayer became the model for Benedictine monasticism, soon the dominant form throughout Europe. The Benedictines became Charlemagne's "cultural army," and the imperial court at Aachen, Germany, one of the leading intellectual centers of western Europe.

CAROLINGIAN ARCHITECTURE

To proclaim the glory of the new empire in monumental form, Charlemagne's architects turned to the two former Western imperial capitals, Rome and Ravenna, for inspiration. Charlemagne's biographer Einhard reported that the ruler, "beyond all sacred and venerable places... loved the church of the holy apostle Peter in Rome." Not surprisingly, Constantine's basilica of St. Peter, with its long nave and side aisles ending in a transept and projecting apse (see page 228, FIG. A), served as a model for many important churches in Charlemagne's empire. The basilican plan, which had fallen out of favor since the Early Christian period, emerged again as the principal arrangement of large congregational churches and would remain so throughout the Middle Ages and beyond.

14-12 • EQUESTRIAN PORTRAIT OF CHARLES THE BALD (?)
9th century. Bronze, height 9½" (24.4 cm). Musée du Louvre, Paris.

Extensive renovations took place in the nineteenth century, when the chapel was reconsecrated as the Cathedral of Aachen, and in the twentieth century, after it was damaged in World War II.

SEE MORE: View a video about the Palace Chapel of Charlemagne www.myartslab.com

clerestory

tribune

aisle

14-14 • SECTION DRAWING OF THE PALACE CHAPEL OF CHARLEMAGNE

CHARLEMAGNE'S PALACE AT AACHEN. Charlemagne's palace complex provides an example of the Carolingian synthesis of Roman, Early Christian, and northern styles. Charlemagne, who enjoyed hunting and swimming, built a headquarters and palace complex amid the forests and natural hot springs of Aachen in the northern part of his empire and installed his court there about 794. The palace complex included a large masonry audience hall and chapel facing each other across a large square (reminiscent of a Roman forum), and a monumental gateway supporting a hall of judgment. Other administrative buildings, a palace school, homes for his circle of advisors and his large family, and workshops supplying all the needs of Church and state, were mostly constructed using the wooden building traditions indigenous to this part of Europe.

The **PALACE CHAPEL (FIGS. 14–13, 14–14)** functioned as Charlemagne's private place of worship, the church of his imperial court, a place for precious relics, and, after the emperor's death, the imperial mausoleum. The central, octagonal plan recalls the church of San Vitale in Ravenna (SEE FIG. 7–20), but the Carolingian architects have added a monumental western entrance block. Known as a **westwork**, this structure combined a ground-floor narthex (vestibule) and an upper-story throne room which opened onto the chapel interior, allowing the emperor an unobstructed view of the liturgy at the high altar, and at the same time assuring his privacy and safety. The room also opened outside into a large walled forecourt where the emperor could make public appearances and speak to the assembled crowd.

14–15 • WESTWORK, ABBEY CHURCH OF CORVEY
Germany. Late 9th century
(upper stories mid 12th century).

The soaring core of the chapel is an octagon, surrounded at the ground level by an ambulatory (curving aisle passageway) and on the second floor by a gallery (upper-story passageway overlooking the main space), and rising to a clerestory above the gallery level and under the octagonal dome. Two tiers of paired Corinthian columns and railings at the gallery level form a screen that re-emphasizes the flat, pierced walls of the octagon and enhances the clarity and planar geometry of its design. The effect is quite different from the dynamic spatial play and undulating exedrae of San Vitale, but the veneer of richly patterned and multicolored stone—some imported from Italy—on the walls and the mosaics covering the dome at Aachen were clearly inspired by Byzantine architecture.

THE WESTWORK AT CORVEY. Originally designed to answer practical requirements of protection and display in buildings such as Charlemagne's palace chapel, the soaring multitowered westwork came to function symbolically as the outward and very visible sign of an important building and is one of the hallmarks of Carolingian architecture. A particularly well-preserved example is the late ninth-century westwork at the **ABBEY CHURCH OF CORVEY (FIG. 14–15).** Even discounting the pierced upper story and towers that were added in the middle of the twelfth century, this is a broad and imposing block of masonry construction. The strong, austere exterior is a symmetrical arrangement of towers flanking a central core punched with a regular pattern of windows and doors, devoid of elaborate carving or decoration. In addition to providing private spaces for local or visiting dignitaries, the interiors of westworks may have been used for choirs—medieval musical graffiti have been discovered in the interior of this westwork—and they were the starting point for important liturgical processions.

THE SAINT GALL PLAN. Monastic life centered on prayer and work, and since it also demanded seclusion, it required a special type of architectural planning. While contemplating how best to house a monastic community, Abbot Haito of Reichenau developed, at the request of his colleague Abbot Gozbert of Saint Gall, a conceptual plan for the layout of monasteries. This extraordinary ninth-century drawing survives in the library of the Abbey of Saint Gall in modern Switzerland and is known as the

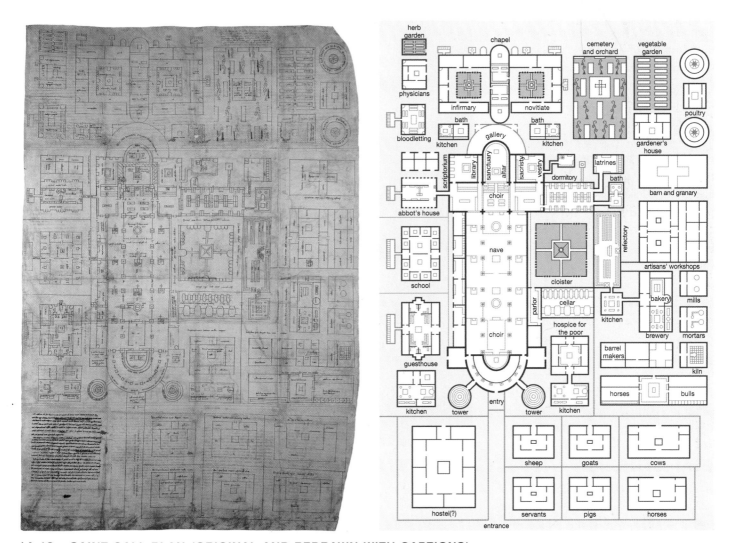

14-16 • SAINT GALL PLAN (ORIGINAL AND REDRAWN WITH CAPTIONS)
c. 817. Original in red ink on parchment, 28 × 44⅛″ (71.1 × 112.1 cm). Stiftsbibliothek, Saint Gall, Switzerland. Cod. Sang. 1092

SAINT GALL PLAN (FIG. 14–16). This is not a "blueprint" in the modern sense, prepared to guide the construction of an actual monastery, but an intellectual record of Carolingian meditations on the nature of monastic life. It does, however, reflect the basic design used in the layout of medieval monasteries, an efficient and functional arrangement that continues to be used by Benedictine monasteries to this day.

At the center of the Saint Gall plan is the **cloister**, an enclosed courtyard around which open all the buildings that are most central to the lives of monks. Most prominent is a large basilican church north of the cloister, with towers and multiple altars in nave and aisles as well as in the sanctuary at the east end, where monks would gather for communal prayer throughout the day and night. On the north side of the church were public buildings such as the abbot's house, the school, and the guesthouse. The monks' living quarters lie off the southern and eastern sides of the cloister, with dormitory, refectory (dining room), and work rooms. For night services the monks could enter the church directly from their dormitory. The kitchen, brewery, and bakery were attached to the refectory, and a huge cellar (indicated on the plan by giant barrels) was on the west side. Along the east edge of the plan are the cemetery, hospital, and an educational center for novices (monks in training).

The Saint Gall plan indicates beds for 77 monks in the dormitory. Practical considerations for group living include latrines attached to every unit—dormitory, guesthouse, and abbot's house. Six beds and places in the refectory were reserved for visiting monks. In the surrounding buildings were special spaces for scribes and painters, who spent much of their day in the scriptorium studying and copying books, and teachers who staffed the monastery's schools and library. St. Benedict had directed that monks extend hospitality to all visitors, and the plan includes a hospice for the poor. South and west of the central core were the workshops, farm buildings, and housing for the lay community of support staff.

ILLUSTRATED BOOKS

Books played a central role in the efforts of Carolingian rulers to promote learning, propagate Christianity, and standardize church law and practice. Imperial workshops produced authoritative copies of key religious texts, weeding out the errors that had inevitably crept into books over centuries of copying them by hand. The scrupulously edited versions of ancient and biblical texts that emerged are among the lasting achievements of the Carolingian period. For example, the Anglo-Saxon scholar Alcuin of York, whom Charlemagne called to his court, spent the last eight years of his life producing a corrected copy of the Latin Vulgate Bible. His revision served as the standard text of the Bible for the remainder of the medieval period and is still in use.

Carolingian scribes also worked on standardizing script. Capitals (majuscules) based on ancient Roman inscriptions continued to be used for very formal writing, titles and headings, and luxury manuscripts. But they also developed a new, clear script called Carolingian minuscule, based on Roman forms but with a

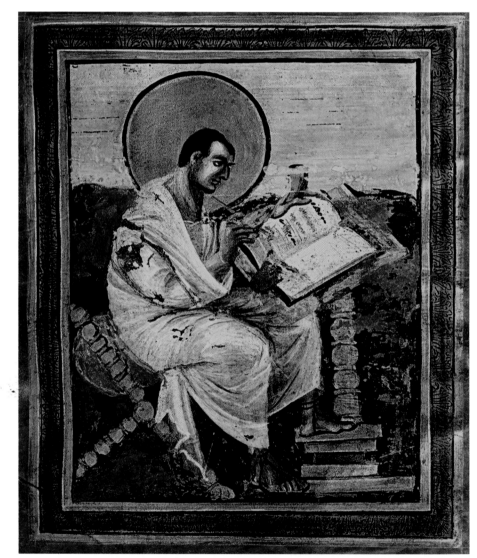

14-17 • PAGE WITH ST. MATTHEW THE EVANGELIST, CORONATION GOSPELS
Gospel of Matthew. Early 9th century. 12¾ × 9⅞" (36.3 × 25 cm). Kunsthistorische Museum, Vienna.

Tradition holds that this Gospel book was buried with Charlemagne in 814, and that in the year 1000 Emperor Otto III removed it from his tomb. Its title derives from its use in the coronation ceremonies of later German emperors.

uniform lowercase alphabet that increased legibility and streamlined production. So like those who transformed revived Roman types—such as basilicas, central-plan churches, or equestrian Roman portraits—into creative new works, scribes and illuminators revived, reformed, and revitalized established traditions of book production. Notably, they returned the representation of lifelike human figures to a central position. For example, portraits of the evangelists (the authors of the Gospels)—as opposed to the symbols used to represent them in the Book of Durrow (SEE FIG. 14–5)—began to look like pictures of Roman authors.

THE CORONATION GOSPELS.

The portait of Matthew (FIG. 14–17) in the early ninth-century Coronation Gospels of Charlemagne conforms to principles of idealized, lifelike representation quite consistent with the Greco-Roman Classical tradition.

The full-bodied, white-robed figure is modeled in brilliant white and subtle shading and seated on the cushion of a folding chair set within a freely painted landscape. The way his foot lifts up to rest on the solid base of his writing desk emphasizes his three-dimensional placement within an outdoor setting, and the frame enhances the Classical effect of a view seen through a window. Conventions for creating the illusion of solid figures in space may have been learned from Byzantine manuscripts in a monastic library, or from artists fleeing Byzantium as a result of the iconoclastic controversy (see "Iconoclasm," page 246).

THE EBBO GOSPELS.

The incorporation of the Roman tradition in manuscript painting was not an exercise in blind copying. It became the basis for a series of creative Carolingian variations. One of the most innovative and engaging is a Gospel book made for Archbishop Ebbo of Reims (archbishop 816–835, 840–841) at the nearby Abbey of Hautevillers (FIG. 14–18). The calm, carefully painted grandeur characterizing Matthew's portrait in the Coronation Gospels (SEE FIG. 14–17) has given way here to spontaneous, calligraphic painting suffused with energetic abandon. The passion may be most immediately apparent in the intensity of Matthew's gaze, but the whole composition is charged with energy, from the evangelist's wiry hairdo and rippling drapery, to the rapidly sketched landscape, and even extending into the windblown acanthus leaves of the frame. These forms are related to content since the marked expressionism evokes the evangelist's spiritual excitement as he hastens to transcribe the Word of God delivered by the angel (also serving as Matthew's symbol), who is almost lost in the upper right corner. As if swept up in the saint's turbulent emotions, the footstool tilts precariously, and the top of the desk seems about to detach itself from the pedestal.

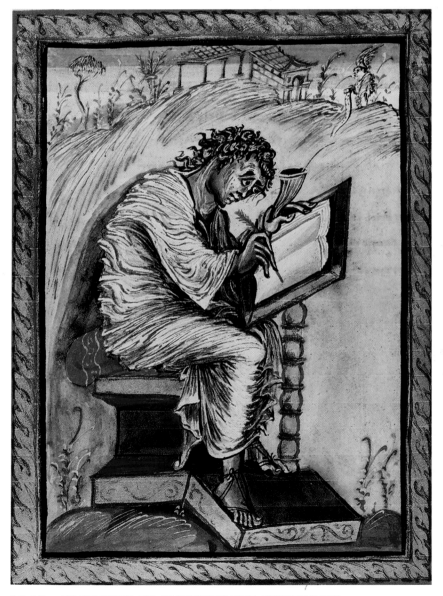

14–18 • PAGE WITH ST. MATTHEW THE EVANGELIST, EBBO GOSPELS
Gospel of Matthew. Second quarter of 9th century. Ink, gold, and colors on vellum, 10¼ × 8¾″ (26 × 22.2 cm). Bibliothèque Municipale, Épernay, France. MS. 1, fol. 18v

THE UTRECHT PSALTER.

One of the most famous Carolingian manuscripts, the Utrecht Psalter, is illustrated with ink drawings that match the nervous linear vitality encountered in Ebbo's Gospel book. Psalms do not tell straightforward stories but use metaphor and allegory in poems of prayer; they are exceptionally difficult to illustrate. Some psalters bypass this situation by illustrating scenes from the life of the presumed author (SEE FIG. 7–39), but the artists of the Utrecht Psalter decided to interpret the words and images of individual psalms literally (see "A Closer Look," page 444). Sometimes the words are acted out, as in a game of charades.

Psalm 23 in the Utrecht Psalter

Second quarter of 9th century. Ink on vellum or parchment, 13 × 9⅞″ (33 × 25 cm). Universiteitsbibliotheek, Utrecht, Holland. MS. 32, fol. 13r

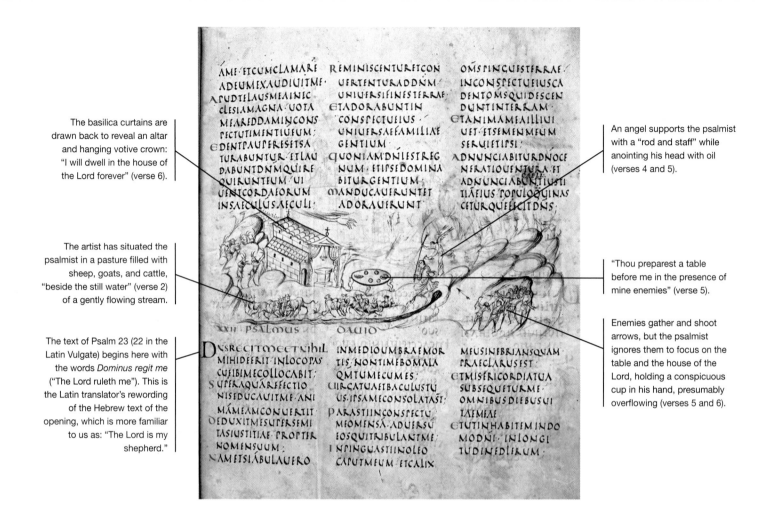

The basilica curtains are drawn back to reveal an altar and hanging votive crown: "I will dwell in the house of the Lord forever" (verse 6).

The artist has situated the psalmist in a pasture filled with sheep, goats, and cattle, "beside the still water" (verse 2) of a gently flowing stream.

The text of Psalm 23 (22 in the Latin Vulgate) begins here with the words *Dominus regit me* ("The Lord ruleth me"). This is the Latin translator's rewording of the Hebrew text of the opening, which is more familiar to us as: "The Lord is my shepherd."

An angel supports the psalmist with a "rod and staff" while anointing his head with oil (verses 4 and 5).

"Thou preparest a table before me in the presence of mine enemies" (verse 5).

Enemies gather and shoot arrows, but the psalmist ignores them to focus on the table and the house of the Lord, holding a conspicuous cup in his hand, presumably overflowing (verses 5 and 6).

SEE MORE: View the Closer Look feature for Psalm 23 in the Utrecht Psalter **www.myartslab.com**

CAROLINGIAN METALWORK

The sumptuously illustrated manuscripts of the medieval period represented an enormous investment of time, talent, and materials, so it is not surprising that they were often protected with equally sumptuous covers. But because these covers were themselves made of valuable materials—ivory, enamelwork, precious metals, and jewels—they were frequently recycled or stolen. The elaborate book cover of gold and jewels, now on the Carolingian manuscript known as the **LINDAU GOSPELS** (FIG. 14–19), was probably made between 870 and 880 at one of the monastic workshops of Charlemagne's grandson, Charles the Bald (r. 840–877), but not for this book. Sometime before the sixteenth century it was reused on a late ninth-century manuscript from the Monastery of Saint Gall.

The cross and the Crucifixion were common themes for medieval book covers. This one is crafted in pure gold with figures in repoussé (low relief produced by pushing or hammering up from the back of a panel of metal to produce raised forms on the front) surrounded by heavily jeweled frames. The jewels are raised on miniature arcades to allow reflected light to pass through them from beneath, imparting a lustrous glow, and also to allow light traveling in the other direction to reflect from the shiny surface of the gold.

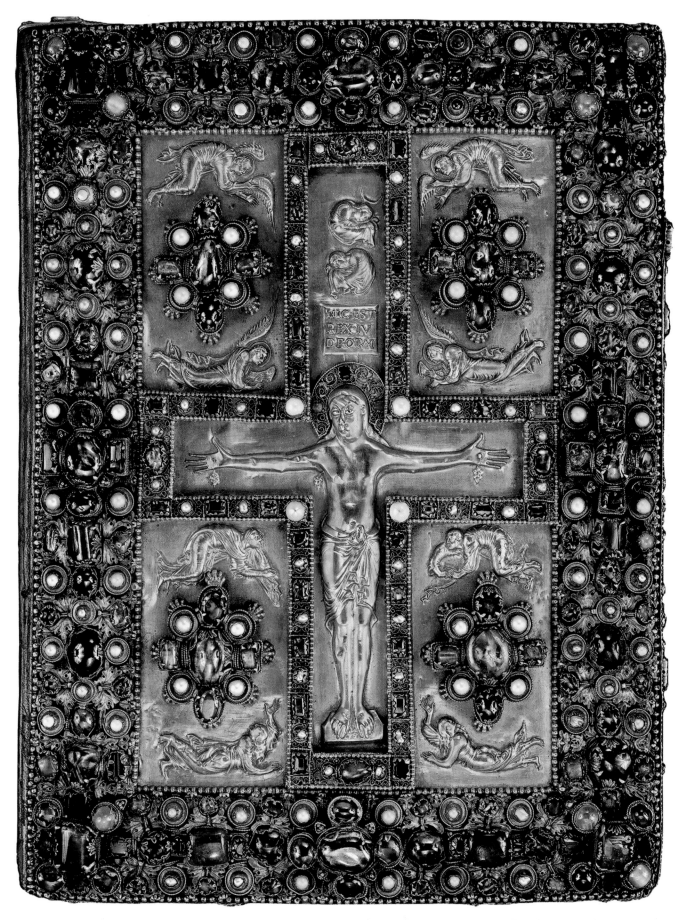

14–19 • CRUCIFIXION WITH ANGELS AND MOURNING FIGURES, LINDAU GOSPELS
Outer cover. c. 870–880. Gold, pearls, sapphires, garnets, and emeralds, 13¾ × 10⅜″ (36.9 × 26.7 cm).
The Pierpont Morgan Library, New York. MS. 1

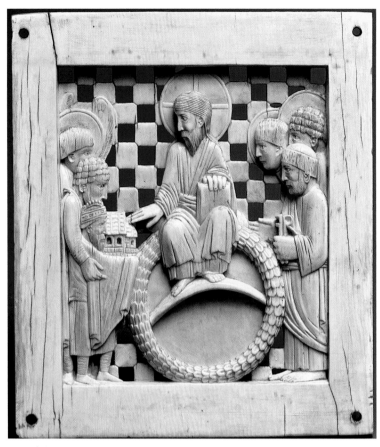

14-20 • OTTO I PRESENTING MAGDEBURG CATHEDRAL TO CHRIST

One of a series of 17 ivory plaques known as the Magdeburg Ivories, possibly carved in Milan. c. 962–968. Ivory, 5 × 4½″ (12.7 × 11.4 cm). Metropolitan Museum of Art, New York. Bequest of George Blumenthal, 1941 (41.100.157)

Grieving angels hover above the arms of the cross, and earthbound mourners twist in agony below. Over Jesus' head personifications of the sun and the moon hide their faces in anguish. The gracefully animated poses of these figures, who seem to float around the jeweled bosses in the compartments framed by the arms of the cross, extend the expressive style of the Utrecht Psalter illustrations into another medium and a later moment. Jesus, on the other hand, has been modeled in a more rounded and calmer Classical style. He seems almost to be standing in front of the cross—straight, wide-eyed, with outstretched arms, as if to prefigure his ultimate triumph over death. The flourishes of blood that emerge from his wounds are almost decorative. There is little, if any, sense of his suffering.

OTTONIAN EUROPE

In 843, the Carolingian Empire was divided into three parts, ruled by three grandsons of Charlemagne. One of them was Charles the Bald, whom we have already encountered (SEE FIG. 14–12). Another, Louis the German, took the eastern portion, and when his family died out at the beginning of the tenth century, a new

Saxon dynasty came to power in lands corresponding roughly to present-day Germany and Austria. We call this dynasty Ottonian after its three principal rulers—Otto I (r. 936–973), Otto II (r. 973–983), and Otto III (r. 994–1002; queens Adelaide and Theophanu had ruled as regents for him, 983–994). After the Ottonian armies defeated the Vikings in the north and the Magyars (Hungarians) on the eastern frontiers, the resulting peace permitted increased trade and the growth of towns, making the tenth century a period of economic recovery. Then, in 951, Otto I added northern Italy to his domain by marrying the widowed Lombard Queen Adelaide. He also re-established Charlemagne's Christian Roman Empire by being crowned emperor by the pope in 962. The Ottonians and their successors so dominated the papacy and appointments to other high church offices that in the twelfth century this union of Germany and Italy under a German ruler came to be known as the Holy Roman Empire. The empire survived in modified form as the Habsburg Empire into the early twentieth century.

The Ottonian ideology, rooted in unity of Church and state, takes visual form on an ivory plaque, one of several that may once have been part of the decoration of an altar or pulpit presented to Magdeburg Cathedral at the time of its dedication in 968 (FIG. 14–20). Otto I presents a model of the cathedral to Christ and St. Peter. Hieratic scale demands that the mighty emperor be represented as a tiny, doll-like figure, and that the saints and angels, in turn, be taller than Otto but smaller than Christ. Otto is embraced by the patron saint of this church, St. Maurice, who was a third-century military commander martyred for refusing to worship pagan gods. The cathedral Otto holds is a basilica with prominent clerestory windows and a rounded apse that, like the character of the Carolingian basilicas before it, was intended to recall the churches of Rome.

OTTONIAN ARCHITECTURE

As we have just seen, Ottonian rulers, in keeping with their imperial status, sought to replicate the splendors both of the Christian architecture of Rome and of the Christian empire of their Carolingian predecessors. German officials knew Roman basilicas well, since the German court in Rome was located near the Early Christian church of Santa Sabina (SEE FIGS. 7–8, 7–9). The buildings of Byzantium were another important influence, especially after Otto II married a Byzantine princess, cementing a tie with the East. But large timber-roofed basilicas were terribly vulnerable to fire. Magdeburg Cathedral burned down in 1008, only 40 years after its dedication; it was rebuilt in 1049, burned down again in 1207, and was rebuilt yet again. In 1009, the Cathedral of Mainz burned down on the day of its consecration. The church of St. Michael at Hildesheim was destroyed in World War II. Luckily the convent church of St. Cyriakus at Gernrode, Germany, still survives.

THE CONVENT CHURCH OF ST. CYRIAKUS IN GERNRODE.
During the Ottonian Empire, aristocratic women often held positions of authority, especially as leaders of religious communities. When, in 961, the provincial military governor Gero founded the convent and church of St. Cyriakus, he made his widowed daughter-in-law the convent's first abbess. The church was designed as a basilica with a westwork flanked by circular towers **(FIG. 14–21)**. At the eastern end of the church a transept with chapels led to a choir with an apse built over a crypt.

Like an Early Christian or Carolingian basilica, the interior of St. Cyriakus **(FIG. 14–22)** has a nave flanked by side aisles. But the design of the three-level wall elevation—nave arcade, gallery, and clerestory—creates a rhythmic effect distinct from the uniformity that had characterized earlier basilicas. Rectangular piers alternate with round columns in the two levels of arcades, and at gallery level, pairs of openings are framed by larger arches and then grouped in threes. The central rectangular piers, aligned on the two levels, bisect the walls vertically into two units, each composed of two broad arches of the nave arcade surmounted by three pairs of arches at the gallery level. This seemingly simple design, with its rhythmic alternation of heavy and light supports, its balance of rectangular and rounded forms, and its combination of horizontal and vertical movements, seems to prefigure the aesthetic exploration of wall design that will characterize the Romanesque architecture of the next two centuries.

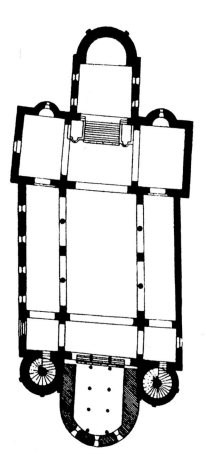

14-21 • PLAN OF THE CHURCH OF ST. CYRIAKUS, GERNRODE
Germany. Begun 961; consecrated 973.

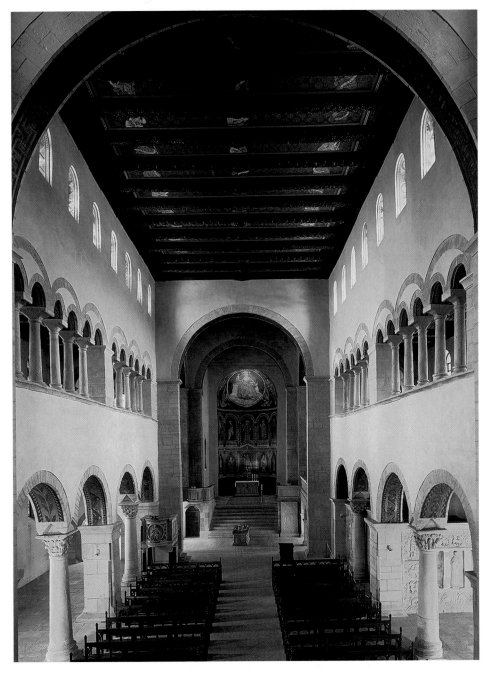

14-22 • NAVE, CHURCH OF ST. CYRIAKUS, GERNRODE

OTTONIAN SCULPTURE

Ottonian sculptors worked in ivory, bronze, wood, and other materials rather than stone. Like their Early Christian and Byzantine predecessors, they and their patrons focused on church furnishings and portable art rather than architectural sculpture. Drawing on Roman, Early Christian, Byzantine, and Carolingian models, they created large works in wood and bronze that would have a significant influence on later medieval art.

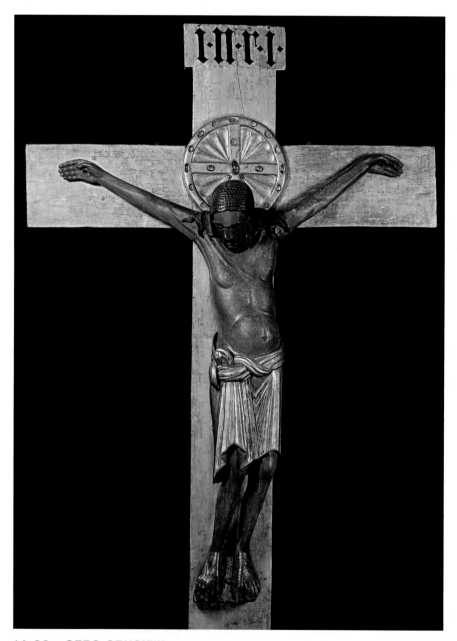

14-23 • GERO CRUCIFIX
Cologne Cathedral, Germany. c. 970. Painted and gilded wood, height of figure 6′2″ (1.88 m).

This life-size sculpture is both a crucifix to be suspended over an altar and a special kind of reliquary. A cavity in the back of the head was made to hold a piece of the Host, or communion bread, already consecrated by the priest. Consequently, the figure not only represents the body of the dying Jesus but also contains a "relic" of the Eucharistic body of Christ. In fact, the Ottonian chronicle of Thietmar of Meresburg (written 1012–1018) claims that Gero himself placed a consecrated Host, as well as a fragment of the true cross, in a crack that formed within the head of this crucifix and prayed that it be closed, which it was.

THE GERO CRUCIFIX. The **GERO CRUCIFIX** is one of the few large works of carved wood to survive from the early Middle Ages **(FIG. 14–23)**. Archbishop Gero of Cologne (archbishop 969–976) commissioned the sculpture for his cathedral about 970. The figure of Christ is life-size and made of painted and gilded oak. The focus here is on Jesus' human suffering. He is shown as a tortured martyr, not as the triumphant hero of the Lindau Gospels cover (SEE FIG. 14–19). Jesus' broken body sags on the cross and his head falls forward, eyes closed. The straight, linear fall of his golden drapery heightens the impact of his drawn face, emaciated arms and legs, sagging torso, and limp, bloodied hands. This is a poignant image of distilled anguish, meant to inspire pity and awe in the empathetic responses of its viewers.

THE HILDESHEIM DOORS. Under the last of the Ottonian rulers, Henry II and Queen Kunigunde (r. 1002–1024), Bishop Bernward of Hildesheim emerged as an important patron. His biographer, the monk Thangmar, described Bernward as a skillful goldsmith who closely supervised the artisans working for him. Bronze doors made under his direction for the abbey church of St. Michael in Hildesheim—and installed by him, according to the doors' inscription, in 1015—represented the most ambitious and complex bronze-casting project undertaken since antiquity **(FIG. 14–24)**. Each door, including the impressive lion heads holding the ring handle, was cast as a single piece in the lost-wax process (see page 413) and later detailed and reworked with chisels and fine tools. Rounded and animated figures populate spacious backgrounds. Architectural elements and features of the landscape are depicted in lower relief, so that the figures stand out prominently, with their heads fully modeled in three dimensions. The result is lively, visually stimulating, and remarkably spontaneous for so monumental an undertaking.

The doors, standing more than 16 feet tall, portray scenes from the Hebrew Bible on the left (reading down from the creation of Eve at the top to Cain's murder of Abel at the bottom) and New Testament scenes on the right (reading upward from the Annunciation at the bottom to the *Noli me tangere* at the top). In each pair of scenes across from each other, the Hebrew Bible event is meant to present a prefiguration of or complement to the adjacent

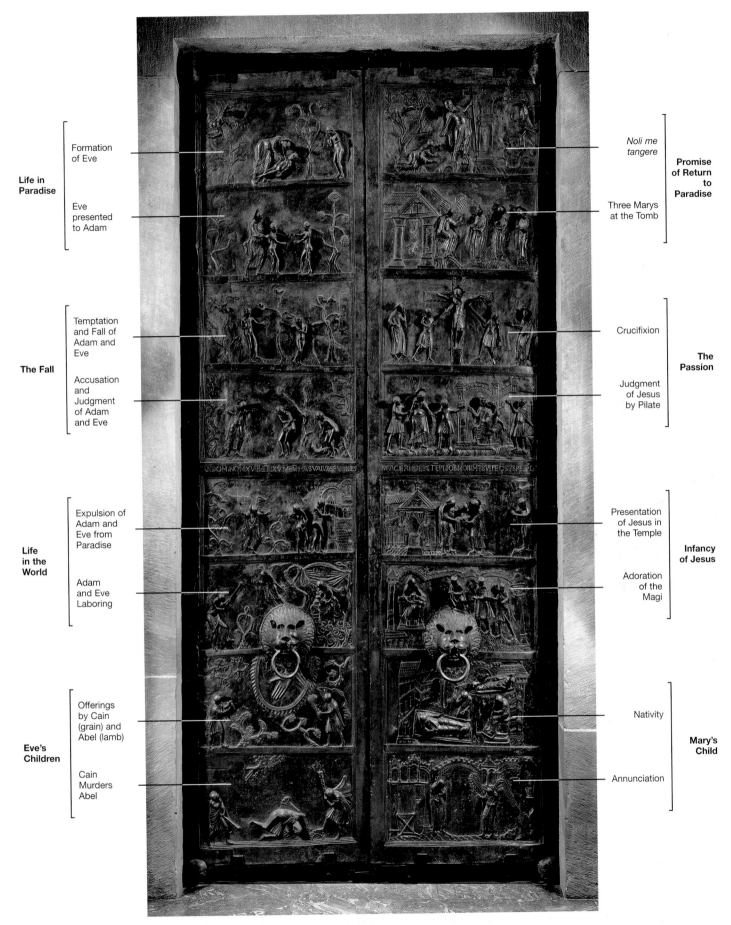

Life in Paradise
Formation of Eve
Eve presented to Adam

The Fall
Temptation and Fall of Adam and Eve
Accusation and Judgment of Adam and Eve

Life in the World
Expulsion of Adam and Eve from Paradise
Adam and Eve Laboring

Eve's Children
Offerings by Cain (grain) and Abel (lamb)
Cain Murders Abel

Promise of Return to Paradise
Noli me tangere
Three Marys at the Tomb

The Passion
Crucifixion
Judgment of Jesus by Pilate

Infancy of Jesus
Presentation of Jesus in the Temple
Adoration of the Magi

Mary's Child
Nativity
Annunciation

14-24 • DOORS OF BISHOP BERNWARD
Abbey church of St. Michael, Hildesheim, Germany. 1015. Bronze, height 16′6″ (5 m).

New Testament event. For instance, the third panel down on the left shows Adam and Eve picking the forbidden fruit of knowledge in the Garden of Eden, believed by Christians to be the source of human sin, suffering, and death. This paired scene on the right shows the Crucifixion of Jesus, whose sacrifice was believed to have atoned for Adam and Eve's original sin, bringing the promise of eternal life. At the center of the doors, six panels down—between the door pulls—Eve (left) and Mary (right) sit side by side, holding their sons. Cain (who murdered his brother) and Jesus (who was unjustly executed) signify the opposition of evil and good, damnation and salvation. Other telling pairs are the murder of Abel (the first sin) with the Annunciation (the advent of salvation) at the bottom, and, fourth from the top, the passing of blame from Adam and Eve to the serpent paired with Pilate washing his hands of any responsibility in the execution of Jesus.

ILLUSTRATED BOOKS

Like their Carolingian predecessors, Ottonian monks and nuns created richly illuminated manuscripts, often funded by secular rulers. Styles varied from place to place, depending on the traditions of the particular scriptorium and the models available in its library.

THE HITDA GOSPELS. The presentation page of a Gospel book made in the early eleventh century for Abbess Hitda (d. 1041) of Meschede, near Cologne (FIG. 14–25) represents one of the most distinctive local styles. The abbess herself appears here, offering the book to St. Walpurga, her convent's patron saint. The artist has angled the buildings of the sprawling convent in the background to frame the figures and draw attention to their interaction. The size of the architectural complex underscores the abbess's position of authority. The foreground setting—a rocky, undulating strip of landscape—is meant to be understood as holy ground, separated from the rest of the world by golden trees and the huge

arch-shape aura that silhouettes St. Walpurga. The energetic spontaneity of the painting style suffuses the scene with a sense of religious fervor appropriate to the visionary saintly encounter.

THE GOSPELS OF OTTO III. This Gospel book, made in a German monastery near Reichenau about 1000, shows another Ottonian painting style, in this case inspired by Byzantine art in the use of sharply outlined drawing and lavish fields of gold (FIG. 14–26). Backed by a more controlled and balanced architectural canopy than that sheltering Hitda and St. Walpurga, these tall, slender men gesture dramatically with long, thin fingers. The scene captures the moment when Jesus washes the feet of his disciples during their final meal together (John 13:1–17). Peter, who had tried to stop his Savior from performing this ancient ritual of hospitality, appears at left, one leg reluctantly poised over the basin,

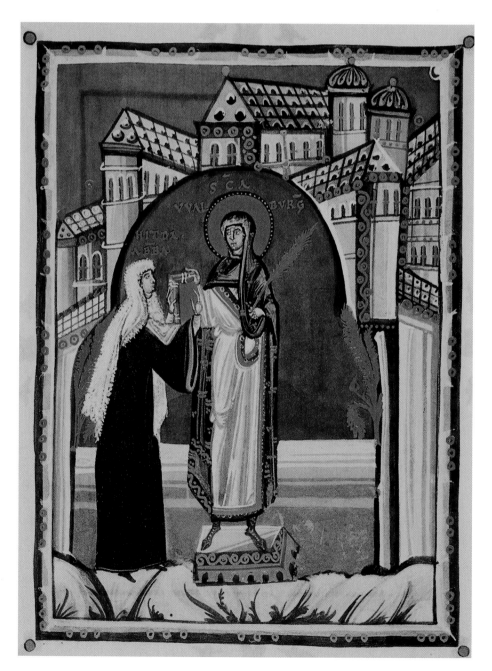

14-25 • PRESENTATION PAGE WITH ABBESS HITDA AND ST. WALPURGA, HITDA GOSPELS
Early 11th century. Ink and colors on vellum, 11⅜ × 5⅝″ (29 × 14.2 cm). Hessische Lanesund Hochschulbibliothek, Darmstadt, Germany.

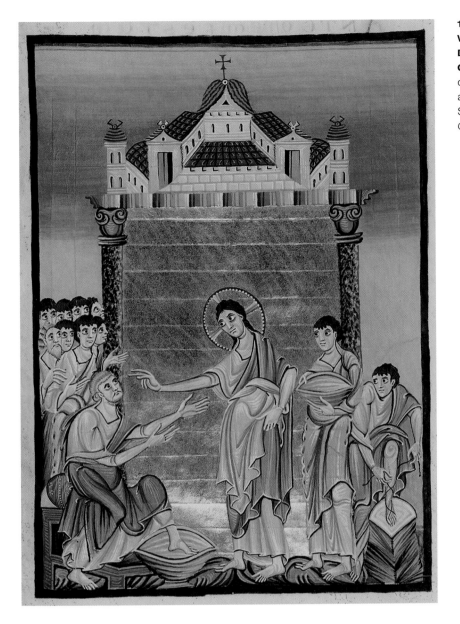

14–26 • PAGE WITH CHRIST WASHING THE FEET OF HIS DISCIPLES, AACHEN GOSPELS OF OTTO III

c. 1000. Ink, gold, and colors on vellum, approx. 8 × 6″ (20.5 × 14.5 cm). Staatsbibliothek, Munich. Nr. 15131, Clm 4453, fol. 237r

while a centrally silhouetted and slightly overscale Jesus gestures emphatically to underscore the necessity and significance of the act. Another disciple, at far right, enthusiastically lifts his leg to untie his sandals so he can be next in line. Selective stylization has allowed the artist of this picture to transform the received Classical tradition into a style of stunning expressiveness and narrative power, features that will also characterize the figural styles associated with the Romanesque.

THINK ABOUT IT

14.1 Briefly outline how illuminated manuscripts were made and used in the early medieval period. Then trace the source of two motifs in the Chi Rho page of the Book of Kells (FIG. 14–1) in pre-Christian ornamental styles.

14.2 Explain the reference to ancient Roman tradition in the small bronze portrait of a Carolingian emperor in FIG. 14–12.

14.3 Compare and contrast representations of the Gospel author Matthew in two books covered in this chapter.

14.4 Characterize the style of painting that developed in Spain for the illustration of commentaries on the Apocalypse. Focus your answer on a specific example discussed in this chapter.

14.5 How does the Saint Gall Plan represent the organization of the medieval monastery in relation to its function as a retreat from the secular world as well as in relationship to the secular world?

PRACTICE MORE: Compose answers to these questions, get flashcards for images and terms, and review chapter material with quizzes **www.myartslab.com**

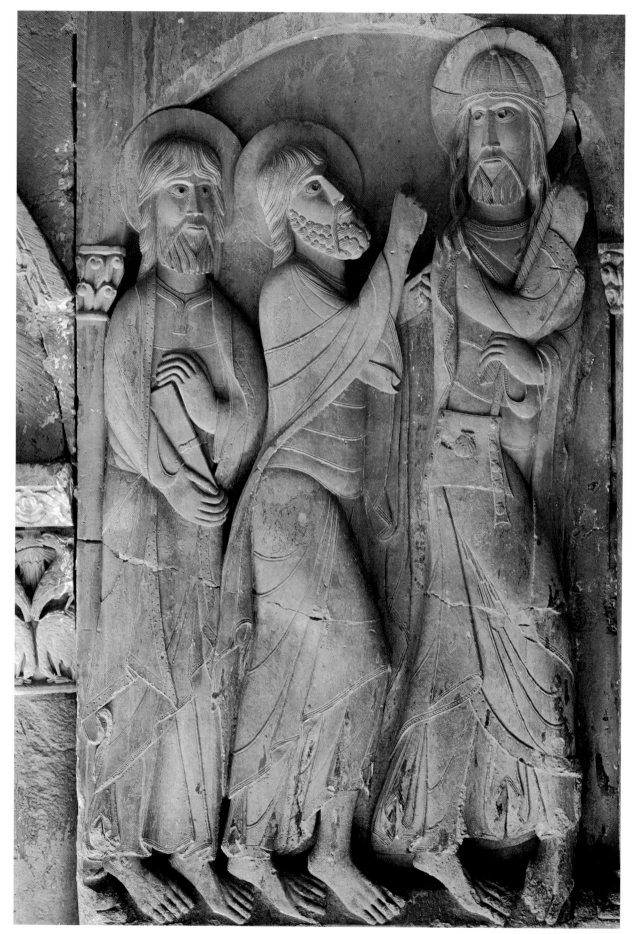

15-1 • CHRIST AND DISCIPLES ON THE ROAD TO EMMAUS
Cloister of the Abbey of Santo Domingo, Silos, Castile, Spain. Pier relief, figures nearly life-size. c. 1100.

ROMANESQUE ART

These three men seem to glide forward on tiptoe as their leader turns back, reversing their forward movement (FIG. 15–1). Their bodies are sleek; legs cross in languid curves rather than vigorous strides; their shoulders, elbows, and finger joints seem to melt; draperies delicately delineate curving contours; bearded faces stare out with large, wide eyes under strong, arched brows. The figures interrelate and interlock, pushing against the limits of the architectural frame.

Medieval viewers would have quickly identified the leader as Christ, not only by his commanding size, but specifically by his cruciform halo. The sanctity of his companions is signified by their own haloes. The scene recalls to faithful Christians the story of the resurrected Christ and two of his disciples on the road from Jerusalem to Emmaus (Luke 24:13–35). Christ has the distinctive attributes of a medieval pilgrim—a hat, a satchel, and a walking stick. Even the scallop shell on his satchel is the badge worn by pilgrims to a specific site: the shrine of St. James at Santiago de Compostela. Early pilgrims reaching this destination in the far northwestern corner of the Iberian peninsula continued to the coast to pick up a shell as evidence of their journey. Soon shells were gathered (or fabricated from metal as brooches) and sold to the pilgrims—a lucrative business for both the sellers and the church. On the return journey home, the shell became the pilgrims' passport, a badge attesting to their piety and accomplishment. Other distinctive badges were adopted at other pilgrimage sites.

This relief was carved on a corner pier in the cloister of the Monastery of Santo Domingo in Silos, a major eleventh- and twelfth-century center of religious and artistic life south of the pilgrimage road across Spain (see "The Pilgrim's Journey," page 458). It engaged an audience of monks and religious pilgrims—who were well versed in the meaning of Christian images—through a new sculptural style that we call Romanesque. Not since the art of ancient Rome half a millennium earlier had sculptors carved monumental figures in stone within an architectural fabric. During the early Middle Ages, sculpture was small-scale, independent, and created from precious materials—a highlighted object within a sacred space rather than a part of its architectural envelope. But during the Romanesque period, narrative and iconic figural imagery in deeply carved ornamental frameworks would collect around the entrances to churches, focusing attention on their compelling portal complexes. These public displays of Christian doctrine and moral teaching would have been part of the cultural landscape surveyed by pilgrims journeying along the road to Santiago. Travel as a pilgrim opened the mind to a world beyond the familiar towns and agricultural villages of home, signaling a new era in the social, economic, and artistic life of Europe.

LEARN ABOUT IT

15.1 Explore the emergence of Romanesque architecture—with its emphasis on the aesthetic qualities of a sculptural wall—out of early masonry construction techniques.

15.2 Assess the impact of pilgrimage as a cultural phenomenon on the design and embellishment of church architecture.

15.3 Compare and contrast Romanesque architectural styles in different regions of Europe.

15.4 Investigate the integration of painting and sculpture within the Romanesque building, and consider the implications of placing art on the church exterior and what theological themes were emphasized.

15.5 Explore the eleventh- and twelfth-century interest in telling stories of human frailty and sanctity in sculpture, textiles, and manuscript painting—stories that were meant to appeal to the feelings as well as to the minds of the viewers.

HEAR MORE: Listen to an audio file of your chapter **www.myartslab.com**

EUROPE IN THE ROMANESQUE PERIOD

At the beginning of the eleventh century, Europe was still divided into many small political and economic units ruled by powerful families, such as the Ottonians in Germany (MAP 15–1). The nations we know today did not exist, although for convenience we shall use present-day names of countries. The king of France ruled only a small area around Paris known as the Île-de-France. The southern part of modern France had close linguistic and cultural ties to northern Spain; in the north the duke of Normandy (heir of the Vikings) and in the east the duke of Burgundy paid the French king only token homage.

When in 1066 Duke William II of Normandy (r. 1035–1087) invaded England and, as William the Conqueror, became that country's new king, Norman nobles replaced the Anglo-Saxon nobility there, and England became politically and culturally allied with Normandy. As astute and skillful administrators, the Normans formed a close alliance with the Church, supporting it with grants of land and gaining in return the allegiance of abbots and bishops. Normandy became one of Europe's most powerful feudal domains. During this period, the Holy Roman Empire, re-established by the Ottonians, encompassed much of Germany and northern Italy, while the Iberian peninsula remained divided between Muslim rulers in the south and Christian rulers in the north. By 1085, Alfonso VI of Castile and León (r. 1065–1109) had conquered the Muslim stronghold of Toledo, a center of Islamic and Jewish culture in the kingdom of Castile. Catalunya (Catalonia) emerged as a power along the Mediterranean coast.

By the end of the twelfth century, however, a few exceptionally intelligent and aggressive rulers had begun to create national states. The Capetians in France and the Plantagenets in England were especially successful. In Germany and northern Italy, the power of local rulers and towns prevailed, and Germany and Italy remained politically fragmented until the nineteenth century.

POLITICAL AND ECONOMIC LIFE

Although towns and cities with artisans and merchants grew in importance, Europe remained an agricultural society, with land the primary source of wealth and power for a hereditary aristocracy. In France and England in particular, social, economic, and political relations were governed by a system commonly referred to as "feudalism." Arrangements varied considerably from place to place, but typically a landowning lord granted property and protection to a subordinate, called a vassal. In return, the vassal pledged allegiance and military service to the lord. Peasants worked the land in exchange for a place to live, military protection, and other services from the lord. Allegiances and obligations among lords, vassals, and peasants were largely inherited but constantly shifting.

THE CHURCH

In the early Middle Ages, Church and state had forged some fruitful alliances. Christian rulers helped ensure the spread of Christianity throughout Europe and supported monastic communities with grants of land. Bishops and abbots were often royal relatives, younger brothers and cousins, who supplied crucial social and spiritual support and a cadre of educated administrators. As a result, secular and religious authority became tightly intertwined, and this continued through the Romanesque period. Monasteries continued to sit at the center of European culture, but there were two new cultural forces fostered by the Church: pilgrimages and crusades.

MONASTICISM. Although the first universities were established in the eleventh and twelfth centuries in the growing cities of Bologna, Paris, Oxford, and Cambridge, monastic communities continued to play a major role in intellectual life. Monks and nuns also provided valuable social services, including caring for the sick and destitute, housing travelers, and educating the elite. Because monasteries were major landholders, abbots and priors were part of the feudal power structure. The children of aristocratic families joined religious orders, helping forge links between monastic communities and the ruling elite.

As life in Benedictine communities grew increasingly comfortable and intertwined with the secular world, reform movements arose. Reformers sought a return to earlier monastic austerity and spirituality. The most important groups of reformers for the arts were the Burgundian congregation of Cluny, established in the tenth century, and later the Cistercians, who sought reform of what they saw as Cluniac decadence and corruption of monastic values.

PILGRIMAGES. Pilgrimages to the holy places of Christendom—Jerusalem, Rome, and Santiago de Compostela—increased, despite the great physical hardships they entailed (see "The Pilgrim's Journey," page 458). As difficult and dangerous as these journeys were, rewards awaited courageous travelers along the routes. Pilgrims could venerate the relics of local saints during the journey, and artists and architects were commissioned to create spectacular and enticing new buildings and works of art to capture their attention.

CRUSADES. In the eleventh and twelfth centuries, Christian Europe, previously on the defensive against the expanding forces of Islam, became the aggressor. In Spain, Christian armies of the north were increasingly successful against the Islamic south. At the same time, the Byzantine emperor asked the pope for help in his war with the Muslims surrounding his domain. The Western Church responded in 1095 by launching a series of holy wars, military offensives against Islamic powers known collectively as the crusades (from the Latin *crux*, referring to the cross crusaders wore).

This First Crusade was preached by Pope Urban II (pontificate 1088–1099) and fought by the lesser nobility of France, who had economic and political as well as spiritual objectives. The crusaders

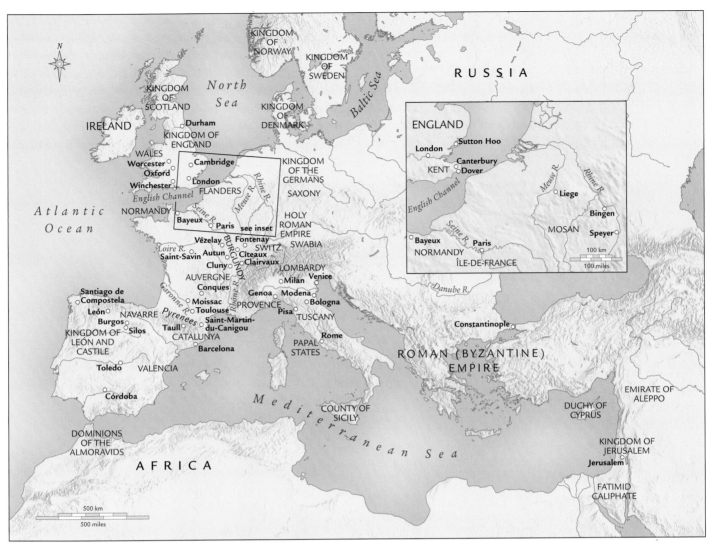

MAP 15–1 • EUROPE IN THE ROMANESQUE PERIOD

Although a few large political entities began to emerge in places like England and Normandy, Burgundy, and León/Castile, Europe remained a land of small economic entities. Pilgrimages and crusades acted as unifying international forces.

captured Jerusalem in 1099 and established a short-lived kingdom. The Second Crusade in 1147, preached by St. Bernard and led by France and Germany, accomplished nothing. The Muslim leader Saladin united the Muslim forces and captured Jerusalem in 1187, inspiring the Third Crusade, led by German, French, and English kings. The Christians recaptured some territory, but not Jerusalem, and in 1192 they concluded a truce with the Muslims, permitting the Christians access to the shrines in Jerusalem. Although the crusades were brutal military failures, the movement had far-reaching cultural and economic consequences, providing western Europeans with direct encounters with the more sophisticated material culture of the Islamic world and the Byzantine Empire. This in turn helped stimulate trade, and with trade came the development of an increasingly urban society during the eleventh and twelfth centuries.

ROMANESQUE ART

The word "Romanesque," meaning "in the Roman manner," was coined in the early nineteenth century to describe early medieval European church architecture, which often displayed the solid masonry walls and rounded arches and vaults characteristic of imperial Roman buildings. Soon the term was applied to all the arts of the period from roughly the mid-eleventh century to the second half of the twelfth century, even though that art derives from a variety of sources and reflects a multitude of influences, not just Roman.

This was a period of great building activity in Europe. New castles, manor houses, churches, and monasteries arose everywhere. As one eleventh-century monk put it, the Christian faithful were so relieved to have passed through the apocalyptic anxiety that had gripped their world at the millennial change around the year 1000,

that, in gratitude, "Each people of Christendom rivaled with the other, to see which should worship in the finest buildings. The world shook herself, clothed everywhere in a white garment of churches" (Radulphus Glaber, cited in Holt, vol. I, p. 18) (SEE FIG. 15–2). The desire to glorify the house of the Lord and his saints (whose earthly remains in the form of relics kept their presence alive in the minds of the people) increased throughout Christendom. There was a veritable building boom.

ARCHITECTURE

Romanesque architecture and art is a trans-European phenomenon, but it is inflected regionally, and the style varies in character from place to place. Although timber remained common in construction, Romanesque builders used stone masonry whenever possible. Masonry vaults were stronger and more durable, and they enhanced the acoustical effect of the Gregorian chants (plainsong, named after

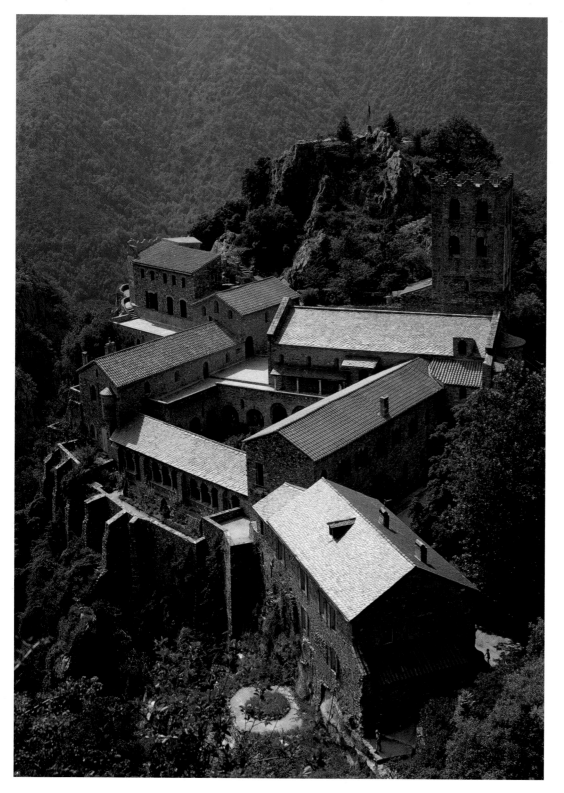

15–2 • SAINT-MARTIN-DU-CANIGOU
French Pyrenees. 1001–1026.

Pope Gregory the Great, pontificate 590–604) sung inside. Tall stone towers, at times flanking the main entrance portal, marked the church as the most important building in the community. The portals themselves were often encrusted with sculpture that broadcast the moral and theological messages of the Church to a wide public audience.

"FIRST ROMANESQUE"

Soon after the year 1000—while Radulphus Glaber was commenting on the rise of church building across the land—patrons and builders in Catalunya (northeast Spain), southern France, and northern Italy were already constructing all-masonry churches, employing the methods of late Roman builders. The picturesque Benedictine monastery of **SAINT-MARTIN-DU-CANIGOU**, nestled into the Pyrenees on a building platform stabilized by strongly buttressed retaining walls, is a typical example **(FIG. 15–2)**. Patronized by the local Count Guifred, who took refuge in the monastery and died here in 1049, the complex is capped by a massive stone tower sitting next to the sanctuary of the two-story church. Art historians call such early stone-vaulted buildings "First Romanesque," employing the term that Catalan architect and theorist Josep Puig I Cadafalch first associated with them in 1928.

THE CHURCH OF SANT VINCENC, CARDONA. One of the finest examples of "First Romanesque" is the **CHURCH OF SANT VINCENC** (St. Vincent) in the Catalan castle of Cardona **(FIG. 15–3)**. Begun in the 1020s, it was consecrated in 1040. Castle residents entered the church through a two-story narthex into a nave with low narrow side aisles that permitted clerestory windows in the nave wall. The sanctuary was raised dramatically over an aisled crypt. The Catalan masons used local materials—small split stones, bricks, even river pebbles, and very strong mortar—to raise plain walls and round barrel or groin vaults. Today we can admire their skillful stonework both inside and out, but the builders originally covered their masonry with a facing of stucco.

To strengthen the walls and vaults, the masons added vertical bands of masonry (called strip buttresses) joined by arches and additional courses of masonry to counter the outward thrust of the vault and to enrich the sculptural quality of the wall. On the interior these masonry strips project from the piers and continue up and over the vault, creating a **transverse arch**. Additional projecting bands line the underside of the arches of the nave arcade. The result is a compound pier that works in concert with the transverse arches to divide the nave into a series of bays. This system of bay division became standard in Romanesque architecture. It is a marked contrast to the flat-wall continuity and undivided space within a pre-Romanesque church like Gernrode (SEE FIG. 14–22).

PILGRIMAGE CHURCHES

The growth of a cult of relics and the desire to visit shrines such as St. Peter's in Rome or St. James's in Spain increasingly inspired the Christians of western Europe to travel on pilgrimages (see

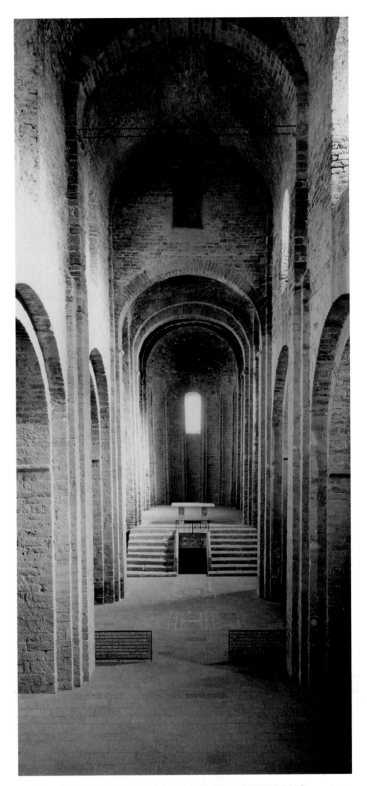

15-3 • INTERIOR, CHURCH OF SANT VINCENC, CARDONA
1020s–1030s.

"The Pilgrim's Journey," page 458). To accommodate the faithful and proclaim church doctrine, many monasteries on the major pilgrimage routes built large new churches, filled them with sumptuous altars and reliquaries, and encrusted them with elaborate stone sculpture on the exterior around entrances.

The Pilgrim's Journey

Western Europe in the eleventh and twelfth centuries saw an explosive growth in the popularity of religious pilgrimage. The rough roads that led to the most popular destinations—the tomb of St. Peter and other martyrs in Rome, the church of the Holy Sepulcher in Jerusalem, and the Cathedral of St. James in Santiago de Compostela in the northwest corner of Spain—were often crowded with pilgrims. Their journeys could last a year or more; church officials going to Compostela were given 16 weeks' leave of absence. Along the way the pilgrims had to contend with bad food and poisoned water, as well as bandits and dishonest innkeepers and merchants.

In the twelfth century, the priest Aymery Picaud wrote a guidebook for pilgrims on their way to Santiago through what is now France. Like travel guides today, Picaud's book provided advice on local customs, comments on food and the safety of drinking water, and a list of useful words in the Basque language. In Picaud's time, four main pilgrimage routes crossed France, merging into a single road in Spain at Puente la Reina and leading on from there through Burgos and León to Compostela. Conveniently spaced monasteries and churches offered food and lodging, as well as relics to venerate. Roads and bridges were maintained by a guild of bridge builders and guarded by the Knights of Santiago.

Picaud described the best-traveled routes and most important shrines to visit along the way. Chartres, for example, housed the tunic that the Virgin was said to have worn when she gave birth to Jesus. The monks of Vézelay had the bones of St. Mary Magdalen, and at Conques, the skull of Sainte Foy was to be found. Churches associated with miraculous cures—Autun, for example, which claimed to house the relics of Lazarus, raised by Jesus from the dead—were filled with the sick and injured praying to be healed.

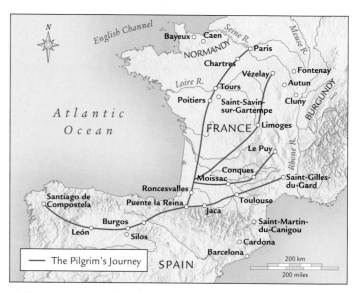

MAP 15-2 • THE PILGRIMAGE ROUTES TO SANTIAGO DE COMPOSTELA

THE CATHEDRAL OF ST. JAMES IN SANTIAGO DE COMPOSTELA. One major goal of pilgrimage was the **CATHEDRAL OF ST. JAMES IN SANTIAGO DE COMPOSTELA** (FIG. 15–4), which held the body of St. James, the apostle to the Iberian peninsula. Builders of this and other major churches along the roads leading through France to the shrine developed a distinctive plan designed to accommodate the crowds of pilgrims and allow them to move easily from chapel to chapel in their desire to venerate relics (see "Relics and Reliquaries," page 462). This "pilgrimage plan" is a model of functional planning and traffic control. To the aisled nave the builders added aisled transepts with eastern chapels leading to an ambulatory (curving walkway) with additional radiating chapels around the apse (FIGS. 15–5, 15–6). This expansion of the basilican plan allowed worshipers to circulate freely around the church's perimeter, visiting chapels and venerating relics without disrupting services within the main space.

At Santiago, pilgrims entered the church through the large double doors at the ends of the transepts rather than through the western portal, which served ceremonial processions. Pilgrims from France entered the north transept portal; the approach from the town was through the south portal. All found themselves in a transept in which the design exactly mirrored the nave in height and structure. Both nave and transept have two stories—an arcade and a gallery. Compound piers with attached half-columns on all four sides support the immense barrel vault and are projected over it vertically through a rhythmic series of transverse arches. They give sculptural form to the interior walls and also mark off individual vaulted bays in which the sequence is as clear and regular as the ambulatory chapels of the choir. Three different kinds of vaults are used here: barrel vaults with transverse arches cover the nave, groin vaults span the side aisles, and halfbarrel or quadrant vaults cover the galleries and strengthen the building by countering the outward thrust of the high nave vaults and transferring it to the outer walls and buttresses. Without a clerestory, light enters the nave only indirectly, through windows in the outer walls of the aisles and upper-level galleries that overlook the nave. Light from the choir clerestory and the large windows of an octagonal **lantern** tower (a structure built above the height of the main ceiling with windows that illuminate the space below) over the crossing would therefore spotlight the

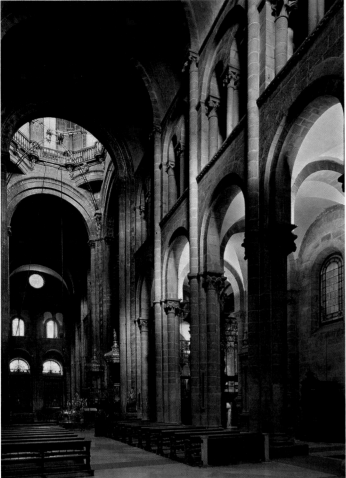

Galicia, Spain. 1078–1122. View toward the crossing.

SEE MORE: Click the Google Earth link for the Cathedral of Saint James, Santiago de Compostela www.myartslab.com

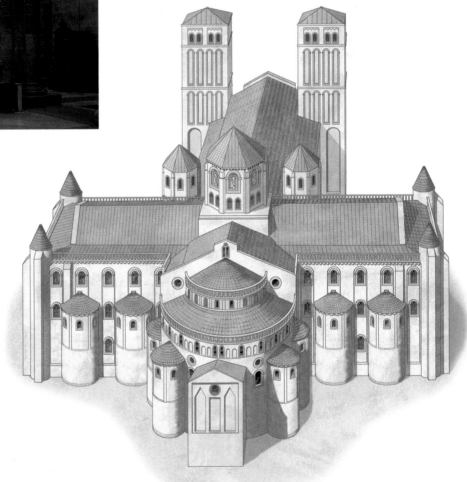

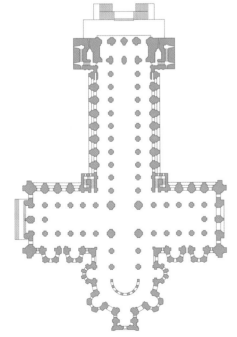

15-5 • PLAN OF CATHEDRAL OF ST. JAMES, SANTIAGO DE COMPOSTELA

SEE MORE: View a video about the Cathedral of Saint James, Santiago de Compostela www.myartslab.com

15-6 • RECONSTRUCTION DRAWING (AFTER CONANT) OF CATHEDRAL OF ST. JAMES, SANTIAGO DE COMPOSTELA
1078–1122; western portions later. View from the east.

EXPLORE MORE: Gain insight from primary sources related to the Cathedral of Saint James, Santiago de Compostela www.myartslab.com

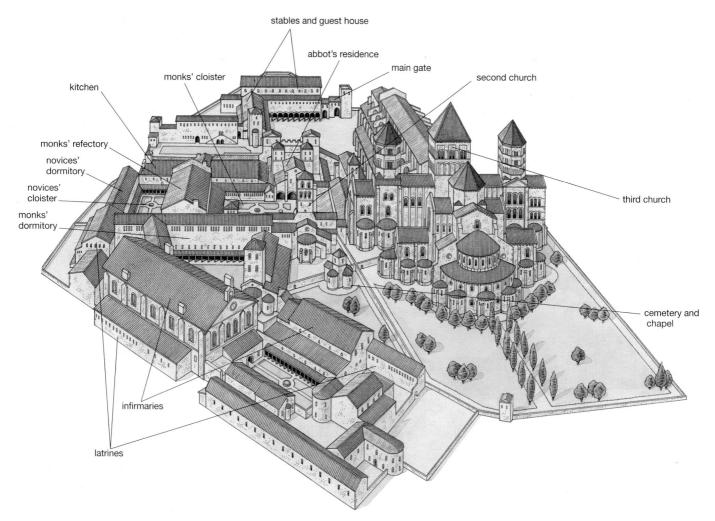

stables and guest house

abbot's residence

monks' cloister

main gate

second church

kitchen

monks' refectory

novices' dormitory

novices' cloister

monks' dormitory

third church

cemetery and chapel

infirmaries

latrines

15-7 • RECONSTRUCTION DRAWING OF THE ABBEY AT CLUNY
Burgundy, France. 1088–1130. View from the east.

EXPLORE MORE: Gain insight from a primary source related to the abbey at Cluny **www.myartslab.com**

glittering gold and jeweled shrine of the principal relic at the high altar.

In its own time, Santiago was admired for the excellence of its construction—"not a single crack is to be found," according to the twelfth-century pilgrims' guide—"admirable and beautiful in execution…large, spacious, well-lighted, of fitting size, harmonious in width, length, and height…." Pilgrims arrived at Santiago de Compostela weary after weeks of difficult travel through dense woods and mountains. Grateful to St. James for his protection along the way, they entered a church that welcomed them with open portals, encrusted with the dynamic moralizing sculpture that characterized Romanesque churches. The cathedral had no doors to close—it was open day and night.

CLUNY

In 909, the duke of Burgundy gave land for a monastery to Benedictine monks intent on strict adherence to the original rules of St. Benedict. They established the reformed congregation of Cluny. From its foundation, Cluny had a special independent status; its abbot answered directly to the pope in Rome rather than to the local bishop or feudal lord. This unique freedom, jealously safeguarded by a series of long-lived and astute abbots, enabled Cluny to keep the profits from extensive gifts of land and treasure. Independent, wealthy, and a center of culture and learning, Cluny and its affiliates became important patrons of architecture and art.

The monastery of Cluny was a city unto itself. By the second half of the eleventh century, there were some 200 monks in residence, supplemented by troops of laymen on whom they depended for material support. As we have seen in the Saint Gall plan of the Carolingian period (SEE FIG. 14–16), the cloister lay at the center of the monastic community, joining the church with domestic buildings and workshops (FIG. 15–7). In wealthy monasteries like this, the arcaded galleries of the cloister had elaborate carved capitals as well as relief sculpture on piers (SEE FIG. 15–1). The capitals may have served as memory devices or visualized theology to direct and inspire the monks' thoughts and prayers.

Cluniac monks observed the traditional eight Hours of the Divine Office (including prayers, scripture readings, psalms, and hymns) spread over the course of each day and night. Mass was celebrated after the third hour (terce), and the Cluniac liturgy was especially elaborate. During the height of its power, plainsong (or Gregorian chant) filled the church with music 24 hours a day.

The hallmark of Cluny—and the Cluniac churches of its host of dependent monasteries—was careful and elegant design that combined the needs of the monks with the desires of pilgrims to visit shrines and relics. They were also notable for their fine stone masonry with rich sculptured and painted decoration. In their homeland of Burgundy, the churches were distinguished by their use of classicizing elements from Roman art, such as fluted pilasters and Corinthian capitals. Cluniac monasteries elsewhere, however, were free—and perhaps even encouraged—to follow regional traditions and styles.

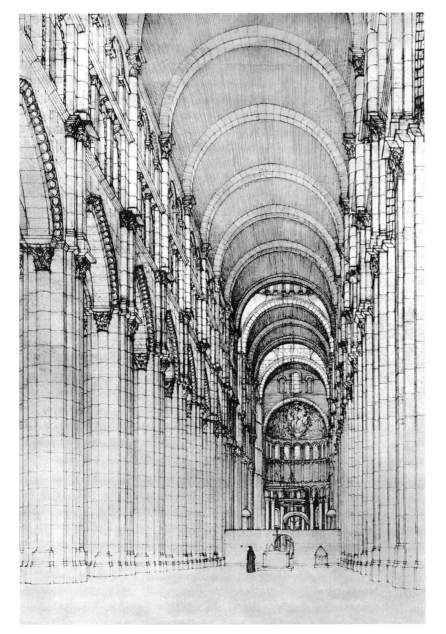

THE THIRD CHURCH AT CLUNY. The original church at Cluny, a small barnlike building, was soon replaced by a basilica with two towers and narthex at the west and a choir with tower and chapels at the east. Hugh de Semur, abbot of Cluny for 60 years (1049–1109), began rebuilding the abbey church for the third time in 1088 (**FIGS. 15–7, 15–8**). Money paid in tribute by Muslims to victorious Christians in Spain financed the building. When King Alfonso VI of León and Castile captured Toledo in 1085, he sent 10,000 pieces of gold to Cluny. The church (known to art historians as Cluny III because it was the third building at the site) was the largest in Europe when it was completed in 1130: 550 feet long, with five aisles like Old St. Peter's in Rome. Built with superbly cut masonry, and richly carved, painted, and furnished, Cluny III was a worthy home for the relics of St. Peter and St. Paul, which the monks had acquired from the church of St. Paul's Outside the Walls in Rome. It was also a fitting headquarters for a monastic order that had become so powerful within Europe that popes were chosen from its ranks.

In simple terms, the church was a basilica with five aisles, double transepts with chapels, and an ambulatory and radiating chapels around the high altar. The large number of chapels was necessary so that each monk-priest had an altar at which to perform the services of daily Mass. Octagonal towers over the two crossings and additional towers over the transept arms created a dramatic pyramidal design at the east end. The nave had a three-part elevation. A nave arcade with tall compound piers, faced by pilasters to the inside and engaged columns at the sides, supported pointed arches lined by Classical ornament. At the next level a blind arcade and pilasters created a continuous sculptural strip that could have been modeled on an imperial Roman triumphal monument. Finally, triple clerestory windows in each bay let sunlight directly into the church around its perimeter. The pointed barrel vault with transverse arches rose to a daring height of 98 feet with a span of about 40 feet, made possible by giving the vaults a steep profile, rather than the weaker round profile used at Santiago de Compostela.

The church was consecrated in 1130, but it no longer exists. The monastery was suppressed during the French Revolution, and this grandest of French Romanesque churches was sold stone by stone, transformed into a quarry for building materials. Today the site is an archaeological park, with only one transept arm from the original church still standing.

15-8 • RECONSTRUCTION DRAWING OF THE THIRD ABBEY CHURCH AT CLUNY LOOKING EAST
1088–1130.

Relics and Reliquaries

Christians turned to the heroes of the Church, the martyrs who had died for their faith, to answer their prayers and to intercede with Christ on their behalf. In the Byzantine Church, the faithful venerated icons, that is, pictures of the saints, but Western Christians wanted to be close to the saints' actual earthly remains. Scholars in the Church assured the people that the veneration of icons or relics was not idol worship. Bodies of saints, parts of bodies, and things associated with the Holy Family or the saints were kept in richly decorated containers called reliquaries. Reliquaries could be simple boxes, but they might also be given the shape of the relic—the arm of St. John the Baptist, the rib of St. Peter, the sandal of St. Andrew. By the eleventh century, many different arrangements of crypts, chapels, and passageways gave people access to the relics kept in churches. When the Church decided that every altar required a relic, the saints' bodies and possessions were subdivided. In this way relics were multiplied; for example, hundreds of churches held relics of the true cross.

Owning and displaying these relics so enhanced the prestige and wealth of a community that people went to great lengths to acquire them, not only by purchase but also by theft. In the ninth century, for example, the monks of Conques stole the relics of the child martyr Sainte Foy (St. Faith) from her shrine at Agen. Such a theft was called "holy robbery," for the new owners insisted that it had been sanctioned by the saint who had communicated to them her desire to move. In the late ninth or tenth century, the monks of Conques encased their new relic—the skull of Sainte Foy—in a gold and jewel statue whose unusually large head was made from a reused late Roman work. During the eleventh century, they added the crown and more jeweled banding, and, over subsequent centuries, jewels, cameos, and other gifts added by pilgrims continued to enhance the splendor of the statue.

This type of reliquary—taking the form of a statue of the saint—was quite popular in the region around Conques, but not everyone was comfortable with the way these works functioned as cult images. Early in the eleventh century, the learned Bernard of Angers prefaces his tendentious account of miracles associated with the cult of Sainte Foy by confessing his initial misgivings about such reliquaries, specifically the way simple folks adored them. Bernard thought it smacked of idolatry: "To learned people this may seem to be full of superstition, if not unlawful, for it seems as if the rites of the gods of ancient cultures, or that the rites of demons, are being observed" (*Book of Sainte Foy*, p. 77). But when he witnessed firsthand the interaction of the reliquary statue with the faithful, he altered his position: "For the holy image is consulted not as an idol that requires sacrifices, but because it commemorates a martyr. Since reverence to her honors God on high, it was despicable of me to compare her statue to statues of Venus or Diana. Afterwards I was very sorry that I had acted so foolishly toward God's saint." (ibid., p. 78)

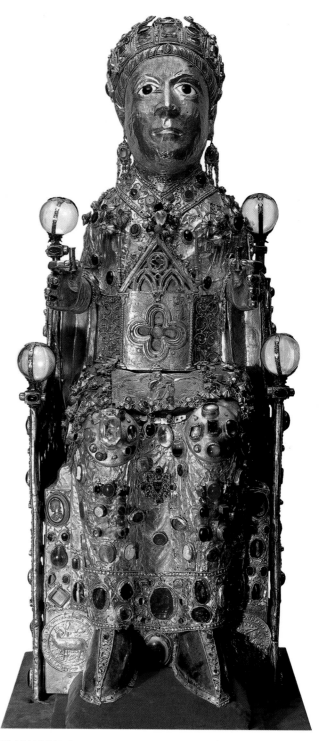

RELIQUARY STATUE OF SAINTE FOY (ST. FAITH)
Abbey church of Conques, Conques, France. Late 9th or 10th century with later additions. Silver gilt over a wood core, with added gems and cameos of various dates. Height 33″ (85 cm). Church Treasury, Conques.

THE CISTERCIANS

New religious orders devoted to an austere spirituality arose in the late eleventh and early twelfth centuries. Among these were the Cistercians, who spurned Cluny's elaborate liturgical practices and emphasis on the arts, especially sculpture in cloisters (see "St. Bernard and Theophilus: The Monastic Controversy over the Visual Arts," page 464). The Cistercian reform began in 1098 with the founding of the abbey of Cîteaux (Cistercium in Latin, hence the order's name). Led in the twelfth century by the commanding figure of Abbot Bernard of Clairvaux, the Cistercians advocated strict mental and physical discipline and a life devoted to prayer and intellectual pursuits combined with shared manual labor. Like the Cluniacs, however, they did depend on the work of laypeople. To seclude themselves as much as possible from the outside world, the Cistercians settled and reclaimed swamps and forests in the wilderness, where they then farmed and raised sheep. In time, their monasteries could be found from Russia to Ireland.

FONTENAY. Cistercian architecture embodies the ideals of the order—simplicity, austerity, and purity. Always practical, the Cistercians made a significant change to the already very efficient monastery plan. They placed key buildings such as the refectory at right angles to the cloister walk so that the building could easily be extended should the community grow. The cloister fountain was relocated from the center of the cloister to the side, conveniently in front of the refectory, where the monks could wash when coming from their work in the fields for communal meals. For easy access to the sanctuary during their prayers at night, monks entered the church directly from the cloister into the south transept or from the dormitory by way of the "night stairs."

The **ABBEY OF FONTENAY** in Burgundy is among the best-preserved early Cistercian monasteries. The abbey church, begun in 1139, has a simple geometric plan (FIGS. **15–9, 15–10**) with a long bay-divided nave, rectangular chapels off the square-ended transept arms, and a shallow choir with a straight east wall. One of its characteristic features is the use of pointed barrel vaults over the nave and pointed arches in the nave arcade and side-aisle bays. Although pointed arches are usually associated with Gothic architecture, they are actually common in the Romanesque buildings of some regions, including Burgundy (we have already seen them at Cluny). Pointed arches are structurally more stable than round ones, directing more weight down into the floor instead of outward to the walls. Consequently, they can span greater distances at greater heights without collapsing.

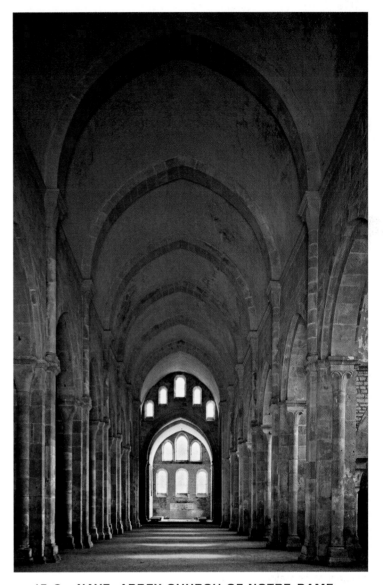

15-9 • NAVE, ABBEY CHURCH OF NOTRE-DAME, FONTENAY
1139–1147.

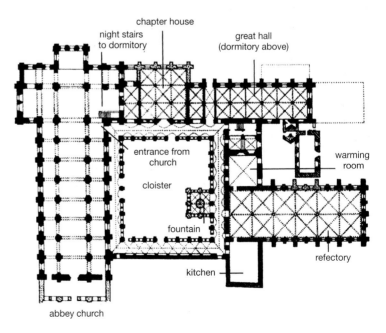

15-10 • PLAN OF THE ABBEY OF NOTRE-DAME, FONTENAY
Burgundy, France. 1139–1147.

St. Bernard and Theophilus: The Monastic Controversy over the Visual Arts

The twelfth century saw a heated controversy over the place and appropriateness of lavish art in monasteries. In a letter to William of Saint-Thierry, Bernard of Clairvaux wrote:

> What excuse can there be for these ridiculous monstrosities in the cloisters where the monks do their reading, extraordinary things at once beautiful and ugly? Here we find filthy monkeys and fierce lions, fearful centaurs, harpies, and striped tigers, soldiers at war, and hunters blowing their horns. Here is one head with many bodies, there is one body with many heads. Over there is a beast with a serpent for its tail, a fish with an animal's head, and a creature that is horse in front and goat behind, and a second beast with horns and the rear of a horse. All round there is such an amazing variety of shapes that one could easily prefer to take one's reading from the walls instead of a book. One could spend the whole day gazing fascinated at these things, one by one, instead of meditating on the law of God. Good Lord, even if the foolishness of it all occasion no shame, a least one might balk at the expense.
>
> (Bernard, "Apologia to Abbot William," p. 66)

"Theophilus" is the pseudonym used by a monk who wrote a book during the first half of the twelfth century on the practice of artistic craft, voiced as a defense of the place of the visual arts within the monastic traditions of work and prayer. The book gives detailed instructions for panel painting, **stained glass** (colored glass assembled into ornamental or pictorial windows), and goldsmithing. In contrast to the stern warnings of Bernard, perhaps even in response to them, "Theophilus" assured artists that "God delights in embellishments" and that artists worked "under the direction and authority of the Holy Spirit."

He wrote:

> Therefore, most beloved son, you should not doubt but should believe in full faith that the Spirit of God has filled your heart when you have embellished His house with such great beauty and variety of workmanship …
>
> … do not hide away the talent given to you by God, but, working and teaching openly and with humility, you faithfully reveal it to those who desire to learn.
>
> … if a faithful soul should see a representation of the Lord's crucifixion expressed in the strokes of an artist, it is itself pierced; if it sees how great are the tortures that the saints have endured in their bodies and how great the rewards of eternal life that they have received, it grasps at the observance of a better life; if it contemplates how great are the joys in heaven and how great are the torments in the flames of hell, it is inspired with hope because of its good deeds and shaken with fear on considering its sins.
>
> (Theophilus, *On Divers Arts*, pp. 78–79)

As we will see in the next chapter, Abbot Suger of Saint-Denis shared the position of Theophilus, rather than that of Bernard, and from this standpoint would sponsor a reconstruction of his abbey church that gave birth to the Gothic style.

Although Fontenay and other early Cistercian monasteries fully reflect the architectural developments of their time in masonry construction, vaulting, and planning, the Cistercians relied on harmonious proportions and superbly refined stonework, not elaborately carved and painted figural decoration, to achieve beauty in their architecture. Church furnishings included little other than altars with crosses and candles. The large windows in the end wall, rather than a clerestory, provided light, concentrated here as at Santiago, on the sanctuary. The sets of triple windows may have reminded the monks of the Trinity. Some scholars have suggested that the numerical and proportional systems guiding the design of such seemingly simple buildings are saturated with the sacred numerical systems outlined by such eminent early theologians as St. Augustine of Hippo. The streamlined but sophisticated architecture favored by the Cistercians spread from their homeland in Burgundy to become an international style. From Scotland and Poland to Spain and Italy, Cistercian designs and building techniques varied only slightly in relation to local building traditions. Cistercian experiments with masonry vaulting and harmonious proportions influenced the development of the French Gothic style in the middle of the twelfth century.

REGIONAL STYLES IN ROMANESQUE ARCHITECTURE

The Cathedral of Santiago de Compostela and the abbey church at Cluny reflect the cultural exchanges along the pilgrimage roads and the international connections fostered by powerful monastic orders, but Europe remained a land divided by competing kingdoms, regions, and factions. Romanesque architecture reflects this regionalism in the wide variety of its styles, traditions, and building techniques. Only a few examples can be examined here.

THE CATHEDRAL OF ST. MARY OF THE ASSUMPTION IN PISA. Throughout Italy artists looked to the still-standing remains of imperial Rome and Early Christianity. The influence remained especially strong in Pisa, on the west coast of Tuscany. Pisa became a maritime power, competing with Barcelona and Genoa as well as the Muslims for control of trade in the western Mediterranean. In 1063, after a decisive victory over the Muslims, the jubilant

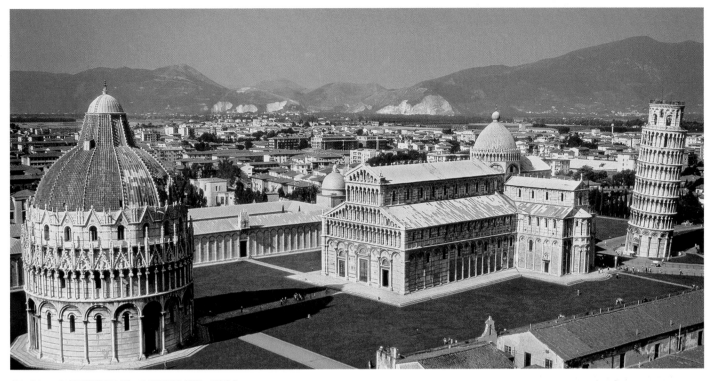

15–11 • CATHEDRAL COMPLEX, PISA

Tuscany, Italy. Cathedral, begun 1063; baptistery, begun 1153; campanile, begun 1174; Campo Santo, 13th century.

When finished in 1350, the Leaning Tower of Pisa stood 179 feet high. The campanile had begun to tilt while still under construction, and today it leans about 13 feet off the perpendicular. In the latest effort to keep it from toppling, engineers filled the base with tons of lead.

SEE MORE: Click the Google Earth link for the Cathedral complex, Pisa
www.myartslab.com

Pisans began an imposing new cathedral dedicated to the Virgin Mary **(FIG. 15–11)**. The cathedral was designed as a cruciform basilica by the master builder Busketos. A long nave with double side aisles (usually an homage to Old St. Peter's) is crossed by projecting transepts, designed like basilicas with their own aisles and apses. The builders added galleries above the side aisles, and a dome covers the crossing. Unlike Early Christian basilicas, the exteriors of Tuscan churches were richly decorated with marble— either panels of green and white marble or arcades. At Pisa, pilasters, applied arcades, and narrow galleries in white marble adorn the five-story façade.

In addition to the cathedral itself, the complex eventually included a baptistery, a campanile, and the later Gothic Campo Santo, a walled burial ground. The baptistery, begun in 1153, has arcading and galleries on the lower levels of its exterior that match those on the cathedral (the baptistery's present exterior dome and ornate upper levels were built later). The campanile (a free-standing bell tower—now known for obvious reasons as "the Leaning Tower of Pisa") was begun in 1174 by master builder Bonanno Pisano. Built on inadequate foundations, it began to lean almost immediately. The cylindrical tower is encased in tier upon tier of marble columns. This creative reuse of the Classical theme of

the colonnade, turning it into a decorative arcade, is characteristic of Tuscan Romanesque art.

THE BENEDICTINE CHURCH OF SAN CLEMENTE IN ROME. The Benedictine church of San Clemente in Rome was rebuilt beginning in the eleventh century (it was consecrated in 1128) on top of the previous church (which had itself been built over a Roman sanctuary of Mithras). The architecture and decoration reflect a conscious effort to reclaim the artistic and spiritual legacy of the early church **(FIG. 15–12)**. As with the columns of Santa Sabina (SEE FIG. 7–9), the columns in San Clemente are **spolia**: that is, they were reused from ancient Roman buildings. The church originally had a timber roof (now disguised by an ornate eighteenth-century ceiling). Even given the Romanesque emphasis on stone vaulting, the construction of timber-roofed buildings continued throughout the Middle Ages.

At San Clemente, the nave ends in a semicircular apse opening directly off the rectangular hall without a sanctuary extension or transept crossing. To accommodate the increased number of participants in the twelfth-century liturgy, the liturgical choir for the monks was extended into the nave itself, defined by a low barrier made up of ninth-century relief panels reused from the earlier

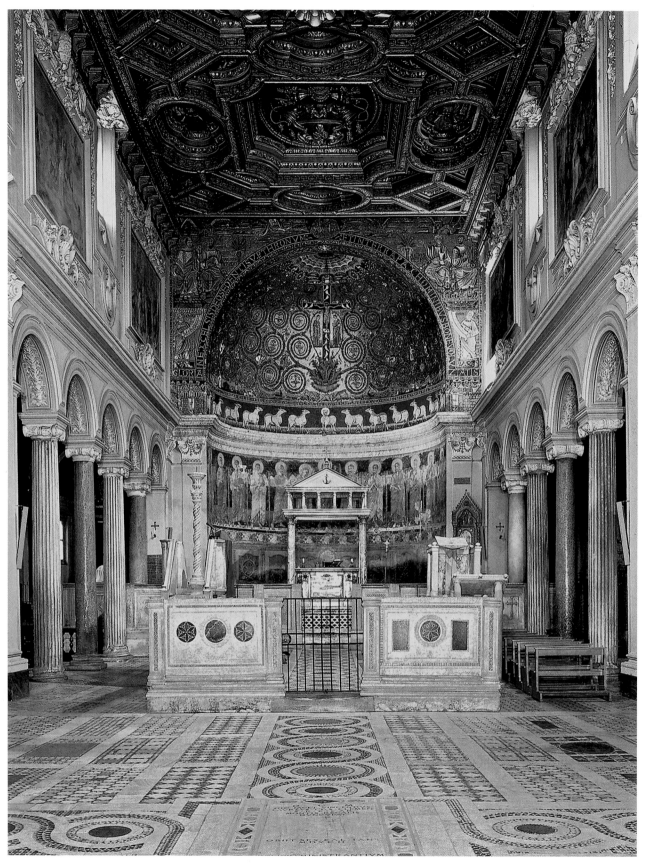

15-12 • NAVE, CHURCH OF SAN CLEMENTE, ROME
Consecrated 1128.

San Clemente contains one of the finest surviving collections of early church furniture: choir stalls, pulpit, lectern, candlestick, and also the twelfth-century inlaid floor pavement. Ninth-century choir screen panels were reused from the earlier church on the site. The upper wall and ceiling decoration date from the eighteenth century.

church. In Early Christian basilicas, the area in front of the altar had been similarly enclosed by a low stone parapet (SEE FIG. 7–9), and the Romanesque builders may have wanted to revive what they considered a glorious Early Christian tradition. A **baldachin** (a canopy suspended over a sacred space, also called a ciborium), symbolizing the Holy Sepulcher, covers the main altar in the apse.

The apse of San Clemente is richly decorated with marble revetment on the curving walls and mosaic in the semidome, in a system familiar from the Early Christian and Byzantine world (SEE FIGS. 7–15, 7–21, 7–25). The mosaics attempt to recapture this past glory, portraying the trees and rivers of paradise, a lavish vine scroll inhabited by figures, in the midst of which emerges the crucified Christ flanked by Mary and St. John. Twelve doves on the cross and the 12 sheep that march in single file below represent the apostles. Stags drink from streams flowing from the base of the cross, evocation of the tree of life in paradise (**FIG. 15–13**). An inscription running along the base of the apse explains, "We liken the Church of Christ to this vine that the law causes to wither and the Cross causes to bloom," a statement that recalls Jesus' reference to himself as the true vine and his followers as the branches (John 15:1–11), The learned monks of San Clemente would have been prepared to derive these and other meanings from the evocative symbols within this elaborate and arresting composition.

Although the subject of the mosaic recalls Early Christian art, the style and technique are clearly Romanesque. The artists have suppressed the sense of lifelike illusionism that characterized earlier mosaics in favor of ornamental patterns and schemas typical of the twelfth century. The doves silhouetted on the dark blue cross, the symmetrical repetition of circular vine scrolls, even the animals, birds, and humans among their leaves conform to an overriding formal design. By an irregular setting of mosaic tesserae in visibly rough plaster, the artists are able to heighten color and increase the glitter of the pervasive gold field, allowing the mosaic to sparkle.

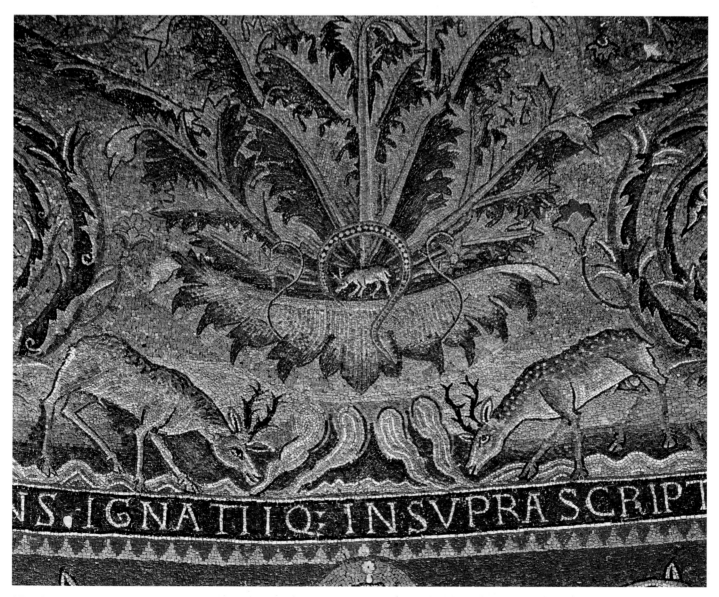

15-13 • STAGS DRINKING FROM STREAMS FLOWING UNDER THE CRUCIFIED CHRIST
Detail of mosaics in the apse of the church of San Clemente, Rome. Consecrated 1128.

The Paintings of San Climent in Taull: Mozarabic Meets Byzantine

As we see at San Clemente in Rome and at Saint-Savin-sur-Gartempe (SEE FIGS. 15–12, 15–14), Romanesque church interiors were not bare expanses of stone, but were often covered with images that glowed in flickering candlelight amid clouds of incense. Outside Rome during the Romanesque period, murals largely replaced mosaics on the walls of churches. Wall painting was subject to the same influences as the other visual arts: that is, the mural painters could be inspired by illuminated manuscripts, or ivories, or enamels in their treasuries or libraries. Some artists must have seen examples of Byzantine art; others had Carolingian or even Early Christian models.

Artists in Catalunya brilliantly combined the Byzantine style with their own Mozarabic and Classical heritage in the apse paintings of the church of San Climent in the mountain village of Taull (Tahull), consecrated in 1123, just a few years before the church of San Clemente in Rome. The curve of the semi-dome of the apse contains a magnificently expressive Christ in Majesty holding an open book inscribed *Ego sum lux mundi* ("I am the light of the world," John 8:12)—recalling in his commanding presence the imposing Byzantine depictions of Christ Pantocrator, ruler and judge of the world, in Middle Byzantine churches (SEE FIG. 7–34). The San Climent artist was one of the finest painters of the Romanesque period, but where he came from and where he learned his art is unknown. His use of elongated oval faces, large staring eyes, and long noses, as well as the placement of figures against flat bands of color and his use of heavy outlines, reflect the Mozarabic past (SEE FIG. 14–7). At the same time his work betrays the influence of Byzantine art in his painting technique of modeling from light to dark through repeated colored lines of varying width in three shades—dark, medium, and light. Instead of blending the colors, he delights in the striped effect, as he also does in the patterning potential in details of faces, hair, hands, and muscles.

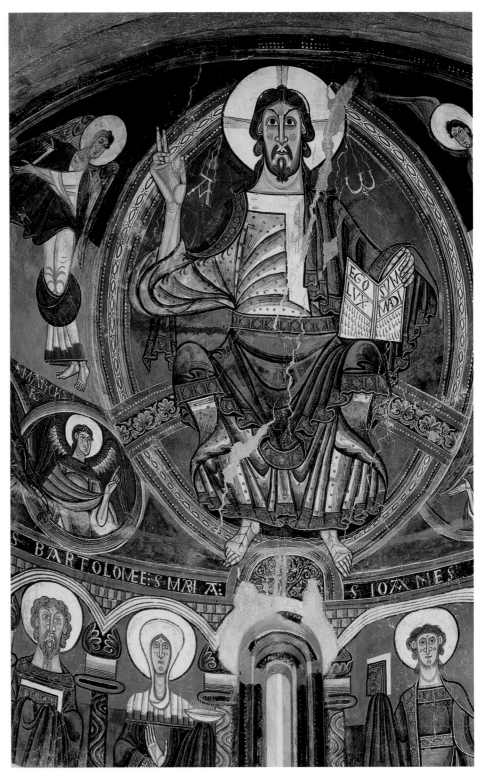

CHRIST IN MAJESTY
Detail of apse, church of San Climent, Taull, Catalunya, Spain.
Consecrated 1123. Museu Nacional d'Art de Catalunya, Barcelona.

15-14 • ABBEY CHURCH OF SAINT-SAVIN-SUR-GARTEMPE, POITOU
France. Choir c. 1060–1075; nave c. 1095–1115.

THE ABBEY CHURCH OF SAINT-SAVIN-SUR-GARTEMPE. At the Benedictine abbey church in Saint-Savin-sur-Gartempe in western France, a tunnel-like barrel vault runs the length of the nave and choir (FIG. 15–14). Without galleries or clerestory windows, the nave at Saint-Savin approaches the form of a "hall church," where the nave and aisles rise to an equal height. And unlike other churches we have seen (SEE, FOR EXAMPLE, FIG. 15–4), at Saint-Savin the barrel vault is unbroken by projecting transverse arches, making it ideally suited for paintings.

The paintings on the high vaults of Saint-Savin survive almost intact, presenting scenes from the Hebrew Bible and New Testament. The nave was built c. 1095–1115, and the painters seem to have followed the masons immediately, probably using the same scaffolding. Perhaps their intimate involvement with the building process accounts for the vividness with which they portrayed the biblical story of the **TOWER OF BABEL** (FIG. 15–15).

According to the account in Genesis (11:1–9), God (represented here by a striding figure of Christ on the left) punished the prideful people who had tried to reach heaven by means of their own architectural ingenuity by scattering them and making their languages mutually unintelligible. The tower in the painting is a medieval structure, reflecting the medieval practice of visualizing all stories in contemporary settings, thereby underlining their relevance for the contemporary audience. Workers haul heavy stone blocks toward the tower, presumably intending to lift them to masons on the top with the same hoist that has been used to haul up a bucket of mortar. The giant Nimrod, on the far right, simply hands over the blocks. These paintings embody the energy

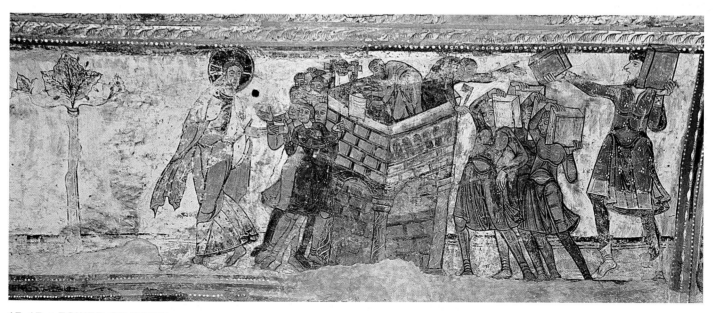

15-15 • TOWER OF BABEL
Detail of painting in nave vault, abbey church of Saint-Savin-sur-Gartempe, Poitou, France. c. 1115.

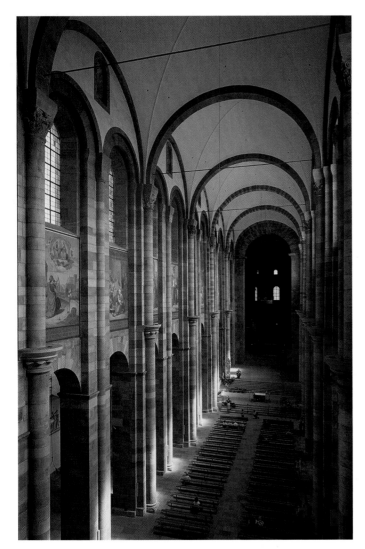

15-16 • INTERIOR, SPEYER CATHEDRAL
Germany. As remodeled c. 1080–1106.

with smaller piers supporting the vaults of the aisle bays. This rhythmic, alternating pattern of heavy and light elements, first suggested for aesthetic reasons in Ottonian wooden-roofed architecture (SEE FIG. 14–22), became an important design element in Speyer. Since groin vaults concentrate the weight and thrust of the vault on the four corners of the bay, they relieve the stress on the side walls of the building. Windows can be safely inserted in each bay to flood the building with light.

The exterior of Speyer Cathedral emphasizes its Ottonian and Carolingian background. Soaring towers and wide transepts mark both ends of the building, although a narthex, not an apse, stands at the west. A large apse housing the high altar abuts the flat wall of the choir; transept arms project at each side; a large octagonal tower rises over the crossing; and a pair of tall slender towers flanks the choir **(FIG. 15–17)**. A horizontal arcade forms an exterior gallery at the top of the apse and transept wall, recalling the Italian practice we saw at Pisa (SEE FIG. 15–11).

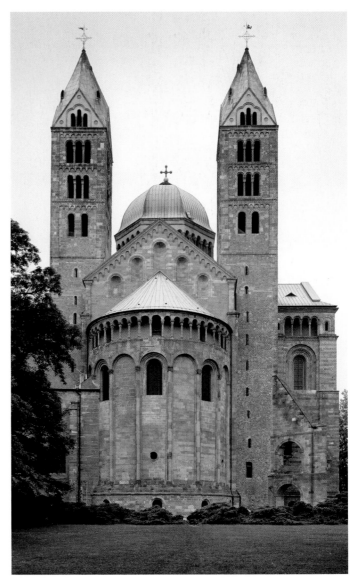

15-17 • EXTERIOR, SPEYER CATHEDRAL
c. 1080–1106 and second half of the 12th century.

and narrative vigor that characterizes Romanesque art. A dynamic figure of God confronts the wayward people, stepping away from them even as he turns back, presumably to scold them. The dramatic movement, monumental figures, bold outlines, broad areas of color, and patterned drapery all promote the legibility of these pictures to viewers looking up in the dim light from far below. The team of painters working here did not use the *buon fresco* technique favored in Italy for its durability, but they did moisten the walls before painting, which allowed some absorption of pigments into the plaster, making them more permanent than paint applied to a dry surface.

THE CATHEDRAL OF THE VIRGIN AND ST. STEPHEN AT SPEYER. The imperial cathedral at Speyer in the Rhine River Valley was a colossal structure rivaled only by Cluny III. An Ottonian, wooden-roofed church built between 1030 and 1060 was given a masonry vault c. 1080–1106 **(FIG. 15–16)**. Massive compound piers mark each nave bay and support the transverse ribs of a groin vault that rises to a height of over 100 feet. These compound piers alternate

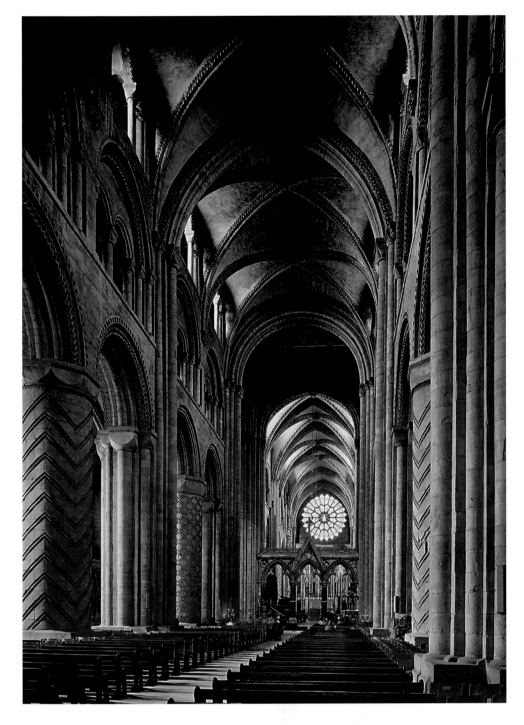

England. 1087–1133. Original east
end replaced by a Gothic choir,
1242–c. 1280. Vault height about 73′
(22.2 m).

SEE MORE: View a panorama
of Durham Cathedral
www.myartslab.com

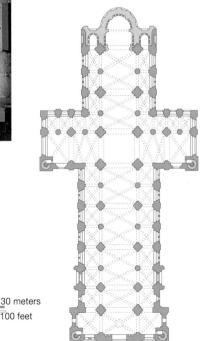

0 30 meters
0 100 feet

15-19 • PLAN OF DURHAM CATHEDRAL
Showing original east end.

DURHAM CATHEDRAL. In Durham, an English military outpost
near the Scottish border, a prince-bishop held both secular and
religious authority. For his headquarters he chose a natural defensive
site where the bend in the River Wear formed a natural moat.
Durham grew into a powerful fortified complex including a castle, a
monastery, and a cathedral. The great tower of the castle defended
against attack from the land, and an open space between buildings
served as the courtyard of the castle and the cathedral green.

DURHAM CATHEDRAL, begun in 1087 and vaulting
constructed from 1093, is an impressive example of Norman
Romanesque, but like most buildings that have been in continuous
use, it has been altered several times **(FIGS. 15–18, 15–19)**. The

nave retains its Norman character, but the huge circular window lighting the choir is a later Gothic addition. The cathedral's size and décor are ambitious. Enormous compound piers and robust columnar piers form the nave arcade and establish a rhythmic alternation. The columnar piers are carved with chevrons, spiral fluting, and diamond patterns, and some have scalloped, cushion-shape capitals. The richly carved arches that sit on them have multiple round moldings and chevron ornaments. All this carved ornamentation was originally painted.

Above the cathedral's massive piers and walls rises a new system of ribbed groin vaults. Romanesque masons in Santiago de Compostela, Cluny, Fontenay, Speyer, and Durham were all experimenting with stone vaulting—and reaching different conclusions. The Durham builders divided each bay with two pairs of diagonal crisscrossing rounded ribs and so kept the crowns of the vaults close in height to the keystones of the pointed transverse arches (SEE FIG. 15–18). Although this allows the eye to run smoothly down the length of the vault, and from vault to vault down the expanse of the nave, the richly carved zigzagging moldings on the

ribs themselves invite us to linger over each bay, acknowledging traditional Romanesque bay division. This new system of ribbed groin vaulting will become a hallmark of Gothic architecture, though there it will create a very different aesthetic effect.

SECULAR ARCHITECTURE: DOVER CASTLE, ENGLAND

The need to provide for personal security in a time of periodic local warfare and political upheaval, as well as the desire to glorify the house of Christ and his saints, meant that communities used much of their resources to build castles and churches. Fully garrisoned, castles were sometimes as large as cities. In the twelfth century, **DOVER CASTLE**, safeguarding the coast of England from invasion, was a bold manifestation of military power (**FIG. 15–20**). It illustrates the way in which a key defensive position developed over the centuries.

The Romans had built a lighthouse on the point where the English Channel separating England and France narrows. The Anglo-Saxons added a church (both lighthouse and church can be seen in FIG. 15–20 behind the tower, surrounded by the remains of

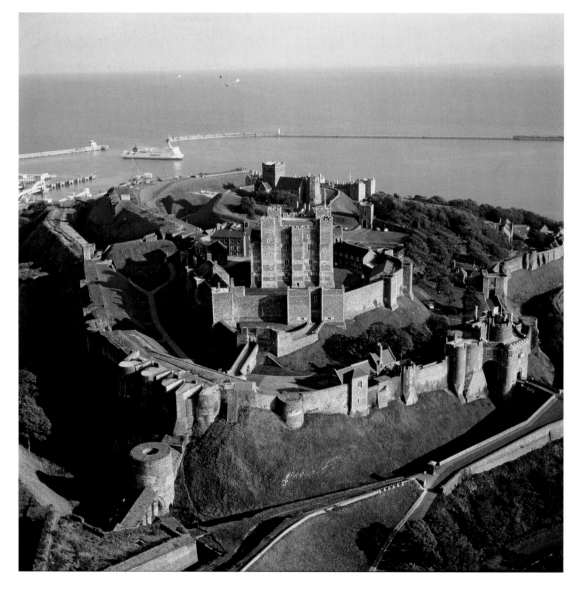

15–20 • DOVER CASTLE
England

Aerial view overlooking the harbor and the English Channel. Center distance: Roman lighthouse tower, rebuilt Anglo-Saxon church, earthworks. Center: Norman Great Tower, surrounding earthworks and wall, twelfth century. Outer walls, thirteenth century. Modern buildings have red tile roofs. The castle was used in World War II and is now a museum.

The most important imagery on a Romanesque portal appears on the semicircular **tympanum** directly over the door—often a hieratically scaled image of abstract grandeur such as Christ in Majesty or Christ presiding over the Last Judgment—as well as on the **lintel** beneath it. **Archivolts**—curved moldings composed of the wedge-shape stone voussoirs of the arch—frame the tympanum. On both sides of the doors, the **jambs** (vertical elements) and occasionally a central pier (called the **trumeau**), support the lintel and archivolts, providing further fields for figures, columns, or narrative friezes. The jambs can extend forward to form a porch.

SEE MORE: View a simulation of a Romanesque church portal **www.myartslab.com**

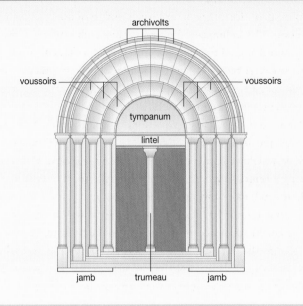

earthen walls). In the early Middle Ages, earthworks topped by wooden walls provided a measure of security, and a wooden tower signified an important administrative building and residence. The advantage of fire-resistant walls was obvious, and in the twelfth and thirteenth centuries, military engineers replaced the timber tower and palisades with stone walls. They added the massive stone towers we see today.

The Great Tower, as it was called in the Middle Ages (but later known as a **keep** in England, and donjon in France), stood in a courtyard (called the **bailey**) surrounded by additional walls. Ditches outside the walls added to the height of the walls. In some castles, ditches were filled with water to form moats. A gate-house—perhaps with a drawbridge—controlled the entrance. In all castles, the bailey was filled with buildings, the most important of which was the lord's hall; it was used to hold court and for feasts and ceremonial occasions. Timber buildings housed troops, servants, and animals. Barns and workshops, ovens and wells were also needed since the castle had to be self-sufficient.

If enemies broke through the outer walls, the castle's defenders retreated to the Great Tower. In the thirteenth century, the builders at Dover doubled the walls and strengthened them with towers, even though the castle's position on cliffs overlooking the sea made scaling the walls nearly impossible. The garrison could be forced to surrender only by starving its occupants.

During Dover Castle's heyday, improvements in farming and growing prosperity provided the resources for increased building activity across Europe. Churches, castles, halls, houses, barns, and monasteries proliferated. The buildings that still stand—despite the ravages of weather, vandalism, neglect, and war—testify to the technical skills and creative ingenuity of the builders and the power, local pride, and faith of the patrons.

ARCHITECTURAL SCULPTURE

Architecture dominated the arts in the Romanesque period—not only because it required the material and human resources of entire communities, but because it provided the physical context for a revival of the art of monumental stone sculpture, an art that had been dormant in European art for 500 years. The "mute" façades used in early medieval buildings (SEE FIG. 14–15) were transformed by Romanesque sculptors into "speaking" façades with richly carved portals projecting bold symbolic and didactic programs to the outside world (SEE FIG. 15–22). Christ Enthroned in Majesty might be carved over the entrance, and increasing importance is accorded to the Virgin Mary. The prophets, kings, and queens of the Hebrew Bible were seen by medieval Christians as precursors of people and events in the New Testament, so these were depicted, and we can also find representations of contemporary bishops, abbots, other noble patrons, and even ordinary folk. A profusion of monsters, animals, plants, geometric ornament, allegorical figures such as Lust and Greed, and depictions of real and imagined buildings surround the sculpture within its architectural setting. The elect rejoice in heaven with the angels; the damned suffer in hell, tormented by demons; biblical and historical tales come alive. All these events seem to take place in a contemporary medieval setting, and they are juxtaposed with scenes drawn from the viewer's everyday life.

These innovative portals are among the greatest artistic achievements of Romanesque art, taking the central messages of the Christian Church out of the sanctuary (SEE FIGS. 7–21, 7–25) and into the public spaces of medieval towns. And figural sculpture appeared not only at entrances, but on the capitals of interior as well as exterior piers and columns, and occasionally spread all over

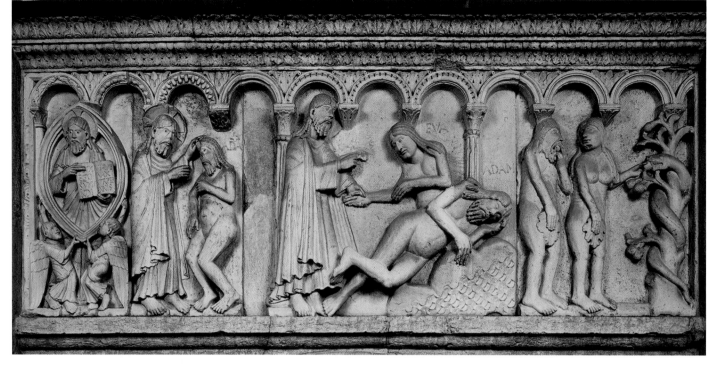

15–21 • Wiligelmo CREATION AND FALL, WEST FAÇADE, MODENA CATHEDRAL
Emilia, Italy. Building begun 1099; sculpture c. 1099. Height approx. 3′ (92 cm).

the building in friezes, on corbels, even peeking around cornices or from behind moldings. There was plenty of work for stone sculptors on Romanesque building sites.

WILIGELMO AT THE CATHEDRAL OF MODENA

The spirit of ancient Rome pervades the sculpture of Romanesque Italy, and the sculptor Wiligelmo may have been inspired by Roman sarcophagi still visible in cemeteries when he carved horizontal reliefs across the west façade of Modena Cathedral, c. 1099. Wiligelmo took his subjects here from Genesis, focusing on events from the **CREATION AND FALL OF ADAM AND EVE (FIG. 15–21)**. On the far left, God, in a **mandorla** (body halo) supported by angels, appears in two persons as both Creator and Christ, identified by a cruciform halo. Following this iconic image, the narrative of creation unfolds in three scenes, from left to right: God brings Adam to life, then brings forth Eve from Adam's side, and finally Adam and Eve cover their genitals in shame as they greedily eat fruit from the forbidden tree, around which the wily serpent twists.

Wiligelmo's deft carving gives these figures a strong three-dimensionality. The framing arcade establishes a stagelike setting, with the rocks on which Adam lies and the tempting tree of paradise serving as stage props. Wiligelmo's figures exude life and personality. They convey an emotional connection with the narrative they enact, and bright paint, now almost all lost, must have increased their lifelike impact still further. An inscription at Modena proclaims, "Among sculptors, your work shines forth, Wiligelmo." This self-confidence turned out to be justified.

Wiligelmo's influence can be traced throughout Italy and as far away as Lincoln Cathedral in England.

THE PRIORY CHURCH OF SAINT-PIERRE AT MOISSAC

The Cluniac priory of Saint-Pierre at Moissac was a major stop on the pilgrimage route to Santiago de Compostela. The shrine at the site dates back to the Carolingian period, and after affiliating with Cluny in 1047, the monastery prospered from the donations of pilgrims and local nobility, as well as from its control of shipping on the nearby Garonne River. During the twelfth century, Moissac's monks launched an ambitious building campaign, and much of the sculpture from the cloister (c. 1100, under Abbot Ansquetil) and the church portal and porch (1100–1130, under Abbot Roger) has survived. The quantity and quality of the carving here are outstanding.

A flattened figure of **CHRIST IN MAJESTY** dominates the huge tympanum **(FIG. 15–22)**, visualizing a description of the Second Coming in Chapters 4 and 5 of Revelation. This gigantic Christ is an imposing, iconic image of enduring grandeur. He is enclosed by a mandorla; a cruciform halo rings his head. Although Christ is stable, even static, in this apocalyptic appearance, the four winged creatures symbolizing the evangelists—Matthew the man (upper left), Mark the lion (lower left), Luke the ox (lower right), and John the eagle (upper right)—who frame him on either side move with dynamic force, as if activated by the power of his unchanging majesty. Rippling bands extending across the tympanum at Christ's sides and under him—perhaps representing waves in the "sea of glass like crystal" (Revelation 4:6)—delineate three registers in

which 24 elders with "gold crowns on their heads" and either a harp or a gold bowl of incense (Revelation 4:4 and 5:8) twist nervously to catch a glimpse of Christ's majestic arrival. Each of them takes an individually conceived pose and gesture, as if the sculptors were demonstrating their ability to represent three-dimensional human figures turning in space in a variety of postures, some quite challengingly contorted. Foliate and geometric ornament covers every surface surrounding this tableau. Monstrous heads in the lower corners of the tympanum spew ribbon scrolls, and other creatures appear at each end of the lintel, their tongues growing into ropes encircling acanthus rosettes.

Two side jambs and a trumeau (central portal pier) support the weight of the lintel and tympanum. These elements have scalloped profiles that playfully undermine the ability of the colonettes on the door jambs to perform their architectural function and give a sense of instability to the lower part of the portal, as if to underline the ability of the stable figure of Christ in Majesty to provide his own means of support. St. Peter and the prophet Isaiah flank the doorway on the jambs. Peter, a tall, thin saint, steps away from the door but twists back to look through it.

The **TRUMEAU** (**FIG. 15–23**) is faced by a crisscrossing pair of lions. On the side visible here, a prophet, usually identified as

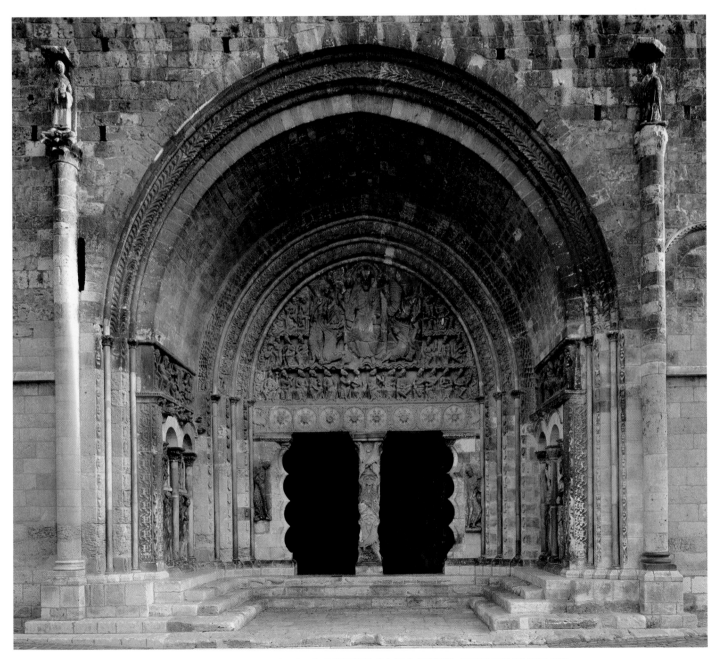

15–22 • SOUTH PORTAL AND PORCH, SHOWING CHRIST IN MAJESTY, PRIORY CHURCH OF SAINT-PIERRE, MOISSAC
France. c. 1115.

Jeremiah, twists toward the viewer, with legs crossed in a pose that would challenge his ability to stand, much less move. The sculptors placed him in skillful conformity with the constraints of the scalloped trumeau; his head, pelvis, knees, and feet moving into the pointed cusps. This decorative scalloping, as well as the trumeau lions and lintel rosettes, may reveal influence from Islamic art. Moissac was under construction shortly after the First Crusade, when many Europeans first encountered the Islamic art and architecture of the Holy Land. People from the region around Moissac participated in the crusade; perhaps they brought Islamic objects and ideas home with them.

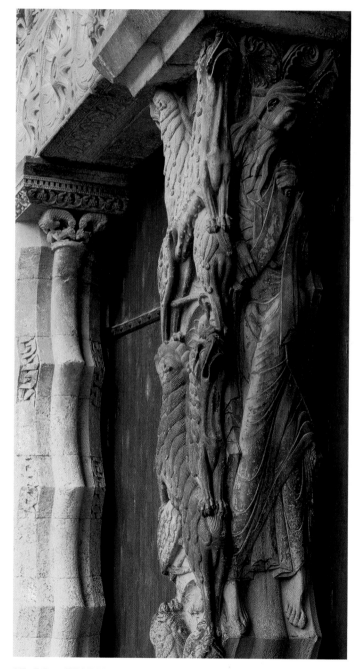

15-23 • TRUMEAU, SOUTH PORTAL, PRIORY CHURCH OF SAINT-PIERRE, MOISSAC
France. c. 1115.

A porch covering the area in front of the portal at Moissac provided a sheltered space for pilgrims to congregate and view the sculpture during their stopover along the way to Santiago. The side walls are filled with yet more figural sculptural (**FIG. 15–24**), but the style of presentation changes here with the nature of the subject matter and the response that was sought from the audience. Instead of the stylized and agitated figures on the tympanum and its supports, here sculptors have substituted more lifelike and approachable human beings. Rather than embodying unchanging theological notions or awe-inspiring apocalyptic appearances, these figures convey human frailties and torments in order to persuade viewers to follow the Church's moral teachings.

Behind the double arcade framework of the lower part of the wall are hair-raising portrayals of the torments of those who fall prey to the two sins that particularly preoccupied twelfth-century moralists: avarice (greed and the hoarding of money) and lust (sexual misconduct). At bottom left, a greedy man is attacked by demons while the money bags around his neck weigh him down, strangling him. On the other side of the column, his counterpart, the female personification of lust (*luxuria*), is confronted by a pot-bellied devil while snakes bite at her breasts and another predator attacks her pubic area. In the scene that extends behind the column and across the wall above them, *luxuria* reappears, kneeling beside the deathbed of the miser, as devils make off with his money and conspire to make his final moments miserable. These scenes are made as graphic as possible so that medieval viewers could identify with these situations, perhaps even feel the pain in their own bodies as a warning to avoid the behaviors that lead to such gruesome consequences.

In the strip of relief running across the top of the wall, the mood is calmer, but the moral message remains strong and clear, at least for those who know the story. The sculpture recounts the tale of Lazarus and Dives (Luke 16:19–31), the most popular parable of Jesus in Romanesque art. The broad scene to the right shows the greedy, rich Dives, relishing the feast that is being laid before him by his servants and refusing even to give his table scraps to the leprous beggar Lazarus, spread out at lower left. Under the table, dogs—unsatisfied by leftovers from Dives' feast—turn to lick the pus from Lazarus' sores as the poor man draws his last breath. The angel above Lazarus, however, transfers his soul (represented as a naked baby, now missing) to the lap of Abraham (a common image of paradise), where he is cuddled by the patriarch, the eternal reward for a pious life. The fate of Dives is not portrayed here, but it is certainly evoked on the lower section of this very wall in the torments of the greedy man, whom we can now identify with Dives himself. Clearly some knowledge is necessary to recognize the characters and story of this sculpture, and a "guide" may have been present to aid those viewers who did not readily understand. Nonetheless, the moral of sin and its consequences can be read easily and directly from the narrative presentation. This is not scripture for an ignorant illiterate population. It is a sermon sculpted in stone.

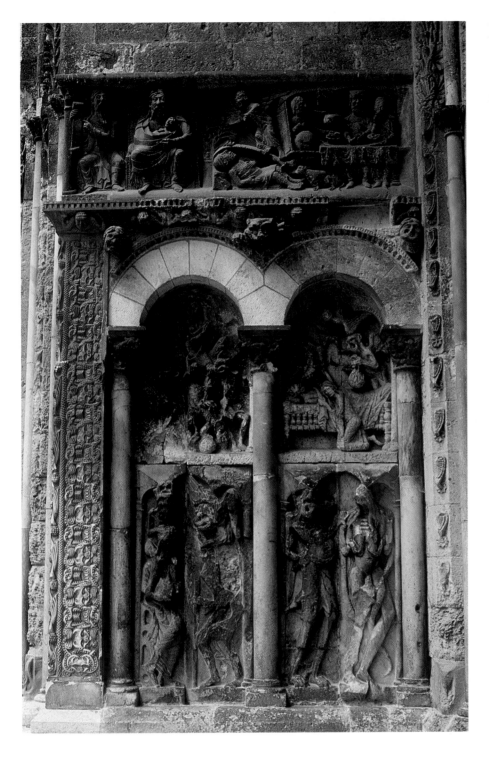

The parable of Lazarus and Dives that runs across the top of this wall retains its moral power to our own day. This was the text of Martin Luther King's last Sunday sermon, preached only a few days before his assassination in Memphis, where he was supporting a strike by sanitation workers. Perhaps he saw the parable's image of the table scraps of the rich and greedy as particularly appropriate to his context. Just as in this portal, in Dr. King's sermon the story is juxtaposed with other stories and ideas to craft its interpretive message in a way that is clear and compelling for the audience addressed.

THE CHURCH OF SAINT-LAZARE AT AUTUN

A different sculptural style and another subject appear at Autun on the main portal of the abbey church (now cathedral) of Saint-Lazare (see "A Closer Look," page 478). This is the Last Judgment, in which Christ—enclosed in a mandorla held by two svelte angels—has returned at the end of time to judge the cowering, naked humans whose bodies rise from their sarcophagi along the lintel at his feet. The damned writhe in torment at Christ's left (our right), while on the opposite side the saved savor serene bliss. The inscribed message on the side of the damned reads: "Here let fear strike those whom earthly error binds, for their fate is shown by the horror of these figures," and under the blessed: "Thus shall rise again everyone who does not lead an impious life, and endless light of day shall shine for him" (translations from Grivot and Zarnecki).

Another text, right under the feet of Christ, ascribes the Autun tympanum to a man named Gislebertus—*Gislebertus hoc fecit* ("Gislebertus made this"). Traditionally art historians have interpreted this inscription as a rare instance of a twelfth-century artist's signature, assigning this façade and related sculpture to an

The Last Judgment Tympanum at Autun

by Gislebertus (?), west portal, Cathedral (originally abbey church) of Saint-Lazare. Autun, Burgundy, France. c. 1120–1130 or 1130–1145.

In one of the most endearing vignettes, an angel pushes one of the saved up through an open archway and into the glorious architectural vision of heaven. Another figure at the angel's side reaches up, impatient for his turn to be hoisted up into paradise.

Christ's mother, Mary, is enthroned as queen of heaven. Below, St. Peter—identified by the large keys slung over his shoulder—performs his duties as heavenly gatekeeper, clasping the hands of someone waiting to gain entrance.

This inscription proclaims "I alone dispose of all things and crown the just. Those who follow crime I judge and punish." Clearly, some of the viewers could read Latin.

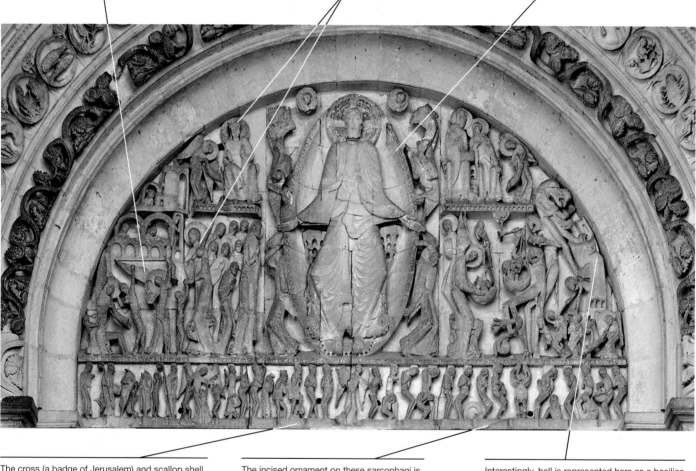

The cross (a badge of Jerusalem) and scallop shell (a badge of Santiago de Compostela) identify these two figures as former pilgrims. The clear message is that participation in pilgrimage will be a factor in their favor at the Last Judgment.

The incised ornament on these sarcophagi is quite similar to that on ancient Roman sarcophagi, one of many indications that the Autun sculptors and masons knew the ancient art created when Autun was a Roman city.

Interestingly, hell is represented here as a basilica, with a devil emerging from the toothy maw that serves as a side entrance, capturing sinners for eternal torment. The devil uses a sharp hook to grab *luxuria*, the female personification of lust.

SEE MORE: View the Closer Look feature for the Last Judgment Tympanum at Autun **www.myartslab.com**

individual named Gislebertus, who was at the head of a large workshop of sculptors. Recently, however, art historian Linda Seidel has challenged this reading, arguing that Gislebertus was actually a late Carolingian count who had made significant donations to local churches. Like the names inscribed on many academic buildings of American universities, this legendary donor's name would have been evoked here as a reminder of the long and rich history of secular financial support in Autun, and perhaps also

as a challenge to those currently in power to respect and continue that venerable tradition of patronage themselves.

Thinner and taller than their counterparts at Moissac, stretched out and bent at sharp angles, the stylized figures at Autun are powerfully expressive and hauntingly beautiful. As at Moissac, a huge, hieratic figure of Christ dominates the composition at the center of the tympanum, but the surrounding figures are not arranged here in regular compartmentalized tiers. Their posture and placement conform to their involvement in the story they enact. Since that story is filled with human interest and anecdotal narrative detail, viewers can easily project themselves into what is going on. On the lintel, angels physically assist the resurrected bodies rising from their tombs, guiding them to line up and await their turn at being judged. Ominously, a pair of giant, pincer-like hands descends aggressively to snatch one of the damned on the right side of the lintel. Above these hands, the archangel Michael competes with devils over the fate of someone whose judgment is being weighed on the scales of good and evil. The man himself perches on the top of the scale, hands cupped to his mouth to project his pleas for help toward the Savior. Another man hides nervously in the folds of Michael's robe, perhaps hoping to escape judgment or cowering from the loathsome prospect of possible damnation.

By far the most riveting players in this drama are the frenzied, grotesque, screaming demons who grab and torment the damned and even try, in vain, to cheat by yanking the scales to favor damnation. The fear they inspire, as well as the poignant portrayal of the psychological state of those whom they torment, would have been moving reminders to medieval viewers to examine the way they were leading their own lives, or perhaps to seek the benefits of entering the doors in front of them to participate in the community of the Church.

The creation of lively narrative scenes within the geometric confines of capitals (called **historiated capitals**) was an important Romanesque innovation in architectural sculpture. The same sculptors who worked on the Autun tympanum carved historiated capitals for pier pilasters inside the church. Two capitals **(FIG. 15–25)** depict scenes from the childhood of Jesus drawn from Matthew 2:1–18. In one capital, the Magi—who have previously adored and offered gifts to the child Jesus—are interrupted in their sleep by an angel who warns them not to inform King Herod of the location of the newborn king of the Jews. In an ingenious compositional device, the sculptor has shown the reclining Magi and the head of their bed as if viewed from above, whereas the angel and the foot of the bed are viewed from the side. This allows us to see clearly the angel—who is appearing to them in a dream—as he touches the hand of the upper Magus, whose eyes have suddenly popped open. As on the façade, the sculptor has conceived this scene in ways that emphasize the human qualities of its story, not its deep theological significance. With its charming, doll-like figures, the other capital shows an event that occurred just after the Magi's dream: Joseph, Mary, and Jesus are journeying toward Egypt to escape King Herod's order to murder all young boys so as to eliminate the newborn royal rival the Magi had journeyed to venerate.

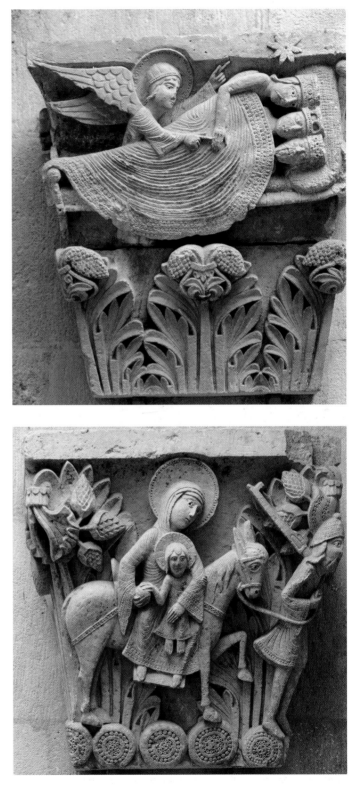

15-25 • THE MAGI ASLEEP AND THE FLIGHT INTO EGYPT
Capitals from the choir, Cathedral of Saint-Lazare, Autun, Burgundy, France. c. 1125.

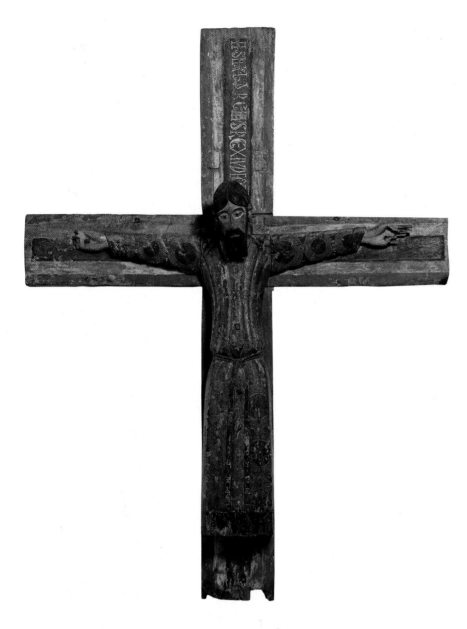

15-26 • CRUCIFIX (MAJESTAT BATLLÓ)
Catalunya, Spain. Mid-12th century. Polychromed wood, height approx. 37¾″ (96 cm).
Museu Nacional d'Art de Catalunya, Barcelona.

CHRIST ON THE CROSS (MAJESTAT BATLLÓ)

This mid-twelfth-century painted wooden crucifix from Catalunya, known as the **MAJESTAT BATLLÓ (FIG. 15–26)**, presents a clothed, triumphant Christ, rather than the seminude figure we have seen at Byzantine Daphni (SEE FIG. 7–35) or on the Ottonian Gero Crucifix (SEE FIG. 14–23). This Christ's royal robes emphasize his kingship, although his bowed head, downturned mouth, and heavy-lidded eyes convey a quiet sense of sadness or introspection. The hem of his long, medallion-patterned tunic has pseudo-kufic inscriptions—designs meant to resemble Arabic script—a reminder that silks from Islamic Spain were highly prized in Europe at this time. Islamic textiles were widely used as cloths of honor hung behind thrones and around altars to designate royal and sacred places. They were used to wrap relics and to cover altars with apparently no concern for their Muslim source.

MARY AS THE THRONE OF WISDOM

Any Romanesque image of Mary seated on a throne and holding the Christ Child on her lap is known as "The Throne of Wisdom." In a well-preserved example in painted wood dating from the second half of the twelfth century **(FIG. 15–27)**, Mother and Child are frontal and regal. Mary's thronelike bench symbolized the lion-throne of Solomon, the Hebrew Bible king who represented earthly wisdom in the Middle Ages. Mary, as Mother and "God-bearer" (the Byzantine *Theotokos*), gave Jesus his human nature. She forms a throne on which he sits in majesty, but she also represents the Church. Although the Child's hands are missing, we can assume that the young Jesus held a book—the Word of God—in his left hand and raised his right hand in blessing.

Such statues of the Virgin and Child served as cult objects on the altars of many churches during the twelfth century. They also sometimes took part in the liturgical dramas being added to church services at that time. At the feast of the Epiphany, celebrating the arrival of the Magi to pay homage to the young Jesus, townspeople representing the Magi acted out their journey by searching through the church for the newborn king. The roles of Mary and Jesus were "acted" by the sculpture, which the Magi discovered on the altar. On one of the capitals from Autun in FIG. 15–25, the Virgin and Child who sit on the donkey in the Flight to Egypt may record the theatrical use of a wooden statue, strapped to the back of a wooden donkey that would have been rolled into the church on wheels, possibly referenced by the round forms at the base of the capital.

SCULPTURE IN WOOD AND BRONZE

Painted wood was commonly used when abbey and parish churches of limited means commissioned statues. Wood was not only cheap; it was lightweight, a significant consideration since these devotional images were frequently carried in processions. Whereas wood seems to have been a sculptural medium that spread across Europe, three geographic areas—the Rhineland, the Meuse River Valley, and German Saxony—were the principal metalworking centers. Bronze sculpture was produced only for wealthy aristocratic and ecclesiastical patrons. It drew on a variety of stylistic sources, including the work of contemporary Byzantine and Italian artists, as well as Classical precedents as reinterpreted by the sculptors' Carolingian and Ottonian forebears.

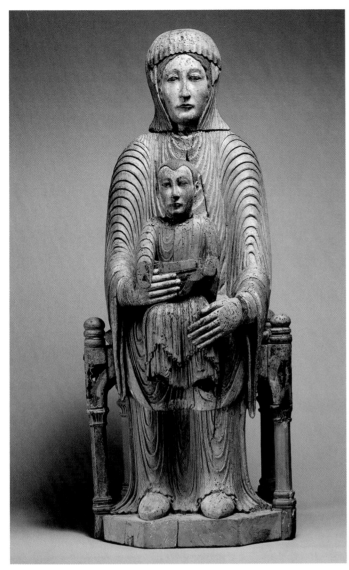

15-27 • VIRGIN AND CHILD
Auvergne region, France. Late 12th century. Oak with polychromy, height 31″ (78.7 cm). Metropolitan Museum of Art, New York.
Gift of J. Pierpont Morgan, 1916 (16.32.194)

TOMB OF RUDOLF OF SWABIA

The oldest known bronze tomb effigy (recumbent portraits of the deceased) is that of **KING RUDOLF OF SWABIA (FIG. 15–28)**, who died in battle in 1080. The spurs on his oversized feet identify him as a heroic warrior, and he holds a scepter and cross-surmounted orb, emblems of Christian kingship. Although the tomb is in the Cathedral of Merseburg, in Saxony, the effigy has been attributed to an artist originally from the Rhine Valley. Nearly life-size, it was cast in one piece and gilt, though few traces of the gilding survive. The inscription around the frame was incised after casting, and glass paste or semiprecious stones may have originally been set into the eyes and crown. We know that during the battle that ultimately led to Rudolph's death he lost a hand—which was mummified separately and kept in a leather case—but the sculptor of his effigy presents him idealized and whole.

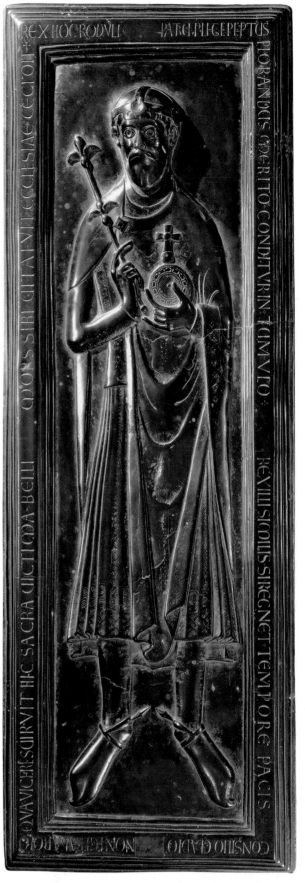

15-28 • TOMB COVER WITH EFFIGY OF KING RUDOLF OF SWABIA
Saxony, Germany. c. 1080. Bronze with niello, approx. 6′5½″ × 2′2½″ (1.97 × 0.68 m). Cathedral of Merseburg, Germany.

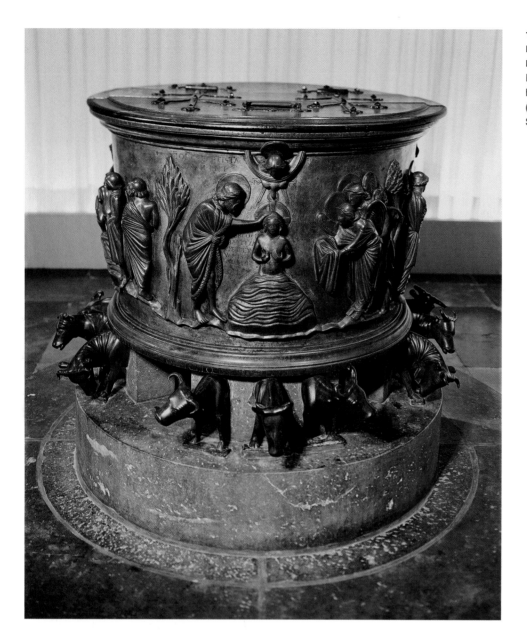

15–29 • Renier of Huy
BAPTISMAL FONT,
NOTRE-DAME-AUX-FONTS
Liège, France. 1107–1118. Bronze,
height 23⅝″ (60 cm); diameter 31¼″
(79 cm). Now in the church of
St. Barthelemy, Liège.

RENIER OF HUY

Bronze sculptor Renier of Huy (Huy is near Liège in present-day Belgium) worked in the Mosan region under the profound influence of classicizing early medieval works of art, as well as the humanistic learning of church scholars. Hellinus of Notre-Dame-aux-Fonts in Liège (abbot 1107–1118) commissioned a bronze baptismal font from Renier **(FIG. 15–29)** that was inspired by the basin carried by 12 oxen in Solomon's Temple in Jerusalem (I Kings 7:23–24). Christian commentators identified the 12 oxen as the 12 apostles and the basin as the baptismal font, and their interpretive thought is given visual form in Renier's work. On the sides of the font are images of St. John the Baptist preaching and baptizing Christ, St. Peter baptizing Cornelius, and St. John the Evangelist baptizing the philosopher Crato. Renier models sturdy but idealized bodies—nude or with clinging drapery—that move and gesture with lifelike conviction, infused with dignity, simplicity, and harmony. His understanding of human anatomy and movement must derive from his close observation of the people around him. He placed these figures within defined landscape settings, standing on an undulating ground line, and separated into scenes by miniature trees. Water rises in a mound of rippling waves (in Byzantine fashion) to cover nude figures discreetly.

TEXTILES AND BOOKS

Among the most admired arts during the Middle Ages are those that later critics patronized as the "minor" or "decorative" arts. Although small in scale, these works are often produced with very precious materials, and they were vital to the Christian mission and devotion of the institutions that housed them.

Artists in the eleventh and twelfth centuries were still often monks and nuns. They labored within monasteries as calligraphers and painters in the scriptorium to produce books and as

metalworkers to craft the enamel- and jewel-encrusted works used in liturgical services. They also embroidered the vestments, altar coverings, and wall hangings that clothed both celebrants and settings in the Mass. Increasingly, however, secular urban workshops supplied the aristocratic and royal courts with textiles, tableware, books, and weapons, as well as occasional donations to religious institutions.

CHRONICLING HISTORY

Romanesque artists were commissioned not only to illlustrate engaging stories and embody important theological ideas within the context of sacred buildings and sacred books. They also created visual accounts of secular history, although here as well moralizing was one of the principal objectives of pictorial narrative.

THE BAYEUX EMBROIDERY. Elaborate textiles, including embroideries and tapestries, enhanced a noble's status and were thus necessary features in castles and palaces. The Bayeux Embroidery (see pages 484–485) is one of the earliest examples to have survived. This long narrative strip chronicles the events leading to Duke William of Normandy's conquest of England in 1066. The images depicted on this long embroidered band may have been drawn by a Norman designer since there is a clear Norman bias in the telling of the story, but style suggests that it may have been Anglo-Saxons who did the actual needlework. This represents the kind of secular art that must once have been part of most royal courts. It could be rolled up and transported from residence to residence as the noble Norman owner traveled throughout his domain, and some have speculated that it may have been the backdrop at banquets for stories sung by professional performers who could have received their cues from the identifying descriptions that accompany most scenes. Eventually the embroidery was given to Bayeux Cathedral, perhaps by Bishop Odo, William's brother; we know it was displayed around the walls of the cathedral on the feast of the relics.

THE WORCESTER CHRONICLE. Another Romanesque chronicle is the earliest known illustrated history book: the **WORCESTER CHRONICLE** (FIG. 15–30), written in the twelfth century by a monk named John. The pages shown here concern Henry I (r. 1100–1135), the second of William the Conqueror's sons to sit on the English throne. The text relates a series of nightmares the

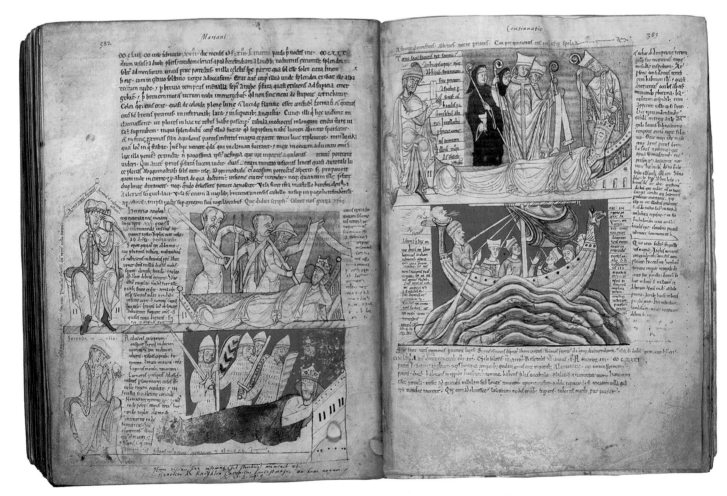

15-30 • John of Worcester **THOSE WHO WORK; THOSE WHO FIGHT; THOSE WHO PRAY— THE DREAM OF HENRY I, WORCESTER CHRONICLE**
Worcester, England. c. 1140. Ink and tempera on vellum, each page 12¾ × 9⅜" (32.5 × 23.7 cm).
Corpus Christi College, Oxford. CCC MS. 157, pages 382–383

The Bayeux Embroidery

Rarely has art spoken more vividly than in the Bayeux Embroidery, a strip of embroidered linen that recounts the history of the Norman Conquest of England. Its designer was a skillful storyteller who used a staggering number of images to chronicle this history. In the 50 surviving scenes there are more than 600 human figures; 700 horses, dogs, and other creatures; and 2,000 inch-high letters.

On October 14, 1066, William, Duke of Normandy, after a hard day of fighting, became William the Conqueror, king of England. The story told in embroidery seeks to justify his action, with the intensity of an eyewitness account: The Anglo-Saxon nobleman Harold initially swears his feudal allegiance to William, but later betrays his feudal vows, accepting the crown of England for himself. Unworthy to be king, he dies in battle at the hands of William and the Normans.

Harold is a heroic figure at the beginning of the story, but then events overtake him. After his coronation, cheering crowds celebrate—until Halley's Comet crosses the sky (FIG. A). The Anglo-Saxons, seeing the comet as a portent of disaster, cringe and point at this brilliant ball of fire with a flaming

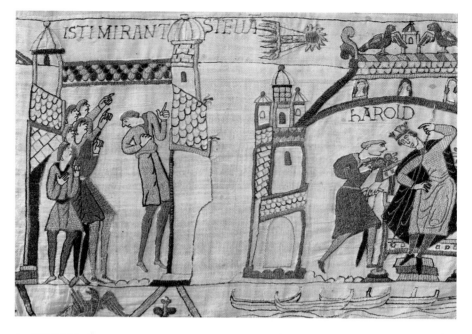

A. MESSENGERS SIGNAL THE APPEARANCE OF A COMET (HALLEY'S COMET), THE BAYEUX EMBROIDERY

tail, and a man rushes to inform the new king. Harold slumps on his throne in the Palace of Westminster. He foresees what is to come: Below his feet is his vision of a ghostly fleet of Norman ships already riding the waves.

Duke William has assembled the last great Viking flotilla on the Normandy coast.

The tragedy of this drama has spoken movingly to audiences over the centuries. It is the story of a good man who, like

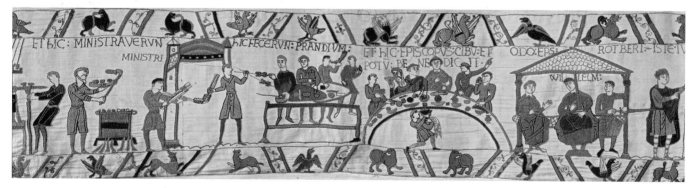

B. BISHOP ODO BLESSING THE FEAST, THE BAYEUX EMBROIDERY
Norman–Anglo-Saxon embroidery from Canterbury, Kent, England, or Bayeux, Normandy, France. c. 1066–1082. Linen with wool, height 20″ (50.8 cm). Centre Guillaume le Conquérant, Bayeux, France.

Odo and William are feasting before the battle. Attendants bring in roasted birds on skewers, placing them on a makeshift table made of the knights' shields set on trestles. The diners, summoned by the blowing of a horn, gather at a curved table laden with food and drink. Bishop Odo— seated at the center, head and shoulders above William to his right—blesses the meal while others eat. The kneeling servant in the middle proffers a basin and towel so that the diners may wash their hands. The man on Odo's left points impatiently to the next event, a council of war between William (now the central and tallest figure), Odo, and a third man labeled "Rotbert," probably Robert of Mortain, another of William's halfbrothers. Translation of text: "and here the servants (*ministra*) perform their duty. / Here they prepare the meal (*prandium*) / and here the bishop blesses the food and drink (*cibu et potu*). Bishop Odo. William. Robert."

— stem stitching

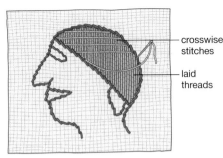

— crosswise stitches

— laid threads

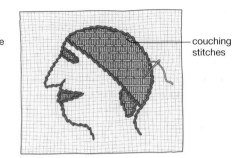

— couching stitches

Shakespeare's Macbeth, is overcome by his lust for power and so betrays his lord. The images of this Norman invasion also spoke to people during the darkest days of World War II. When the Allies invaded Nazi-occupied Europe in June 1944, they took the same route in reverse from England to beaches on the coast of Normandy. The Bayeux Embroidery still speaks to us of the folly of human greed and ambition and of two battles that changed the course of history.

Although traditionally referred to as the "Bayeux Tapestry," this work is really an embroidery. In tapestry, colored threads that form the images or patterns are woven in during the process of making the fabric itself; **embroidery** consists of stitches applied on top of an already woven fabric ground. The embroiderers, probably Anglo-Saxon women, worked in tightly twisted wool that was dyed in eight colors. They used only two stitches: the quick, overlapping stem stitch that produced a slightly jagged line or outline, and the time-consuming laid-and-couched work used to form blocks of color. For the latter, the embroiderer first "laid" a series of long, parallel covering threads; then anchored them with a second layer of regularly spaced crosswise stitches; and finally tacked all the strands down with tiny "couching" stitches. Some of the laid-and-couched work was done in contrasting colors to achieve particular effects. The creative coloring is often fanciful: for example, some horses have legs in four different colors. Skin and other light-toned areas are represented by the bare linen cloth that formed the ground of the work.

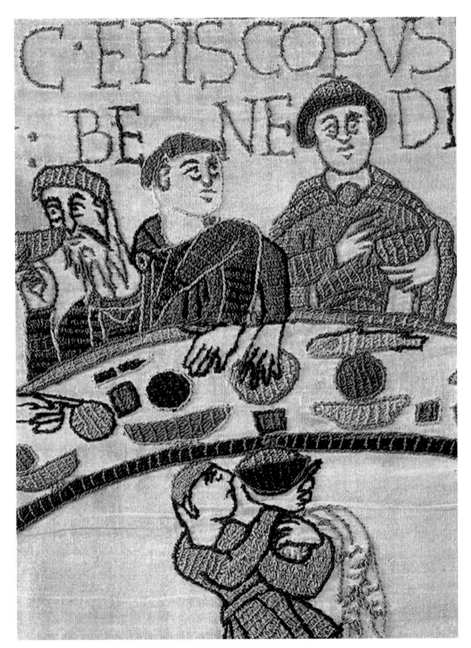

C. DETAIL OF BISHOP ODO BLESSING THE FEAST, THE BAYEUX EMBROIDERY

king had in 1130, in which his subjects demanded tax relief. The artist depicts the dreams with energetic directness. On the first night, angry farmers confront the sleeping king; on the second, armed knights surround his bed; and on the third, monks, abbots, and bishops present their case. In the fourth illustration, the king travels in a storm-tossed ship and saves himself by promising God that he will rescind the tax increase for seven years. The author of the Worcester Chronicle assured his readers that this story came from a reliable source, the royal physician Grimbald, who appears in the margins next to three of the scenes. The angry farmers capture our attention today because we seldom see working men with their equipment and simple clothing depicted in painting from this time.

SACRED BOOKS

Illustrated books played a key role in the transmission of artistic styles from one region to another. Monastic scriptoria continued to be the centers of production, which increased dramatically during the twelfth century. But the scriptoria sometimes employed lay scribes and artists who traveled from place to place. In addition to the books needed for the church services, scribes produced copies of sacred texts, scholarly commentaries, visionary devotional works, lives of saints, and collections of letters and sermons.

THE CODEX COLBERTINUS. The portrait of **ST. MATTHEW FROM THE CODEX COLBERTINUS (FIG. 15–31)** is an entirely Romanesque conception, quite different from Hiberno-Saxon and Carolingian author portraits. Like the sculptured pier figures of Silos (SEE FIG. 15–1), he stands within an architectural frame that completely surrounds him. He blesses and holds his book—rather than writing it—within the compact silhouette of his body. His dangling feet bear no weight, and his body has little sense of three-dimensionality, with solid blocks of color filling its strong outlines. The evangelist is almost part of the text—the opening lines of *Liber generationis*.

The text of Matthew's Gospel begins with a complementary block of ornament left of the evangelist. The "L" of *Liber generationis* ("The book of the generation") is a framed picture formed of plants and animals—called a historiated initial. Dogs or catlike creatures and long-necked birds twist, claw, and bite each other and themselves while, in the center, two humans—one dressed and one nude—clamber up the letter. This manuscript was made in the region of Moissac at about the same time that sculptors were working on the abbey church, and the stacking of intertwined animals here recalls the outer face of the Moissac trumeau (SEE FIG. 15–23).

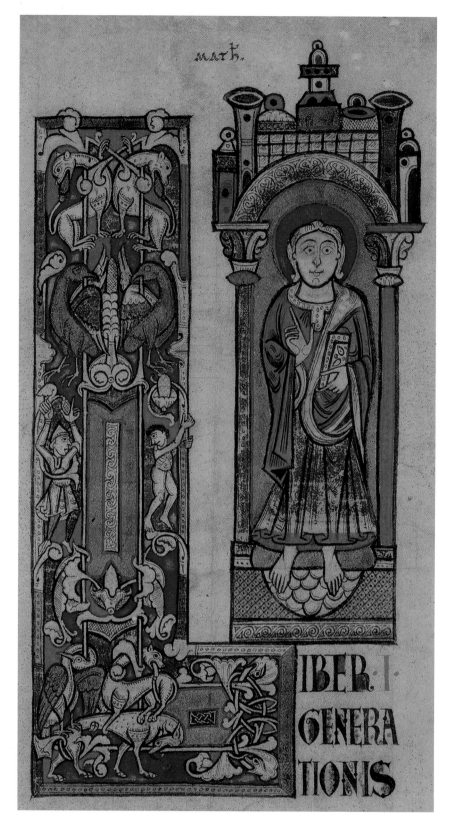

15–31 • ST. MATTHEW, FROM THE CODEX COLBERTINUS
c. 1100. Tempera on vellum, 7½ × 4″ (19 × 10.16 cm). Bibliothèque Nationale, Paris.

Hildegard of Bingen

We might expect women to have a subordinate position in the hierarchical and militaristic society of the twelfth century. On the contrary, aristocratic women took responsibility for managing estates during their male relatives' frequent absences in wars or while serving at court. And women also achieved positions of authority and influence as the heads of religious communities. Notable among them was Hildegard of Bingen (1098–1179).

Born into an aristocratic German family, Hildegard transcended the barriers that limited most medieval women. She began serving as leader of her convent in 1136, and about 1147 she founded a new convent near Bingen. Hildegard also wrote important treatises on medicine and natural science, invented an alternate alphabet, and was one of the most gifted and innovative composers of her age, writing not only motets and liturgical settings, but also a musical drama that is considered by many to be the first opera. Clearly a major, multitalented figure in the intellectual and artistic life of her time—comparison with the later Leonardo da Vinci comes to mind—she also corresponded with emperors, popes, and the powerful abbots Bernard of Clairvaux and Suger of Saint-Denis.

Following a command she claimed to have received from God in 1141, and with the assistance of her nuns and the monk Volmar, Hildegard began to record the mystical visions she had been experiencing since she was 5 years old. The resulting book, called the *Scivias* (from the Latin *scite vias lucis*, "know the ways of the light"), is filled not only with words but with striking images of the strange and wonderful visions themselves (FIG. A). The opening page (FIG. B) shows Hildegard receiving a flash of divine insight, represented by the tongues of flame encircling her head—she said, "a fiery light, flashing intensely, came from the open vault of heaven and poured through my whole brain"—while her scribe Volmar writes to her dictation. But was she also responsible for the arresting pictures that accompany the text in this book? Art historian Madeline Caviness thinks so, both because of their unconventional

A. Hildegard of Bingen
THE UNIVERSE
1927–1933 facsimile of Part I, Vision 3 of the *Liber Scivias* of Hildegard of Bingen. Original, 1150–1175.

Hildegard begins her description of this vision with these words: "After this I saw a vast instrument, round and shadowed, in the shape of an egg, small at the top, large in the middle, and narrowed at the bottom; outside it, surrounding its circumference, there was a bright fire with, as it were, a shadowy zone under it. And in that fire there was a globe of sparkling flame so great that the whole instrument was illuminated by it."

nature and because they conform in several ways to the "visionary" effects experienced by many people during migraines, which plagued Hildegard throughout her life but especially during her forties while she was composing the *Scivias*. She said of her visions, "My outward eyes are open. So I have never fallen prey to ecstacy in the visions, but I see them wide awake, day and night. And I am constantly fettered by sickness, and often in the grip of pain so intense that it threatens to kill me." (Translated in Newman, p. 16.)

Perhaps in this miniature Hildegard is using the large stylus to sketch on the wax tablets in her lap the pictures of her visions that were meant to accompany the verbal descriptions she dictates to Volmar, who sits at the right with a book in his hand, ready to write them down.

B. HILDEGARD AND VOLMAR
From a 1927–1933 facsimile of the frontispiece of the *Liber Scivias* of Hildegard of Bingen. Original, 1150–1175.

This author portrait was once part of a manuscript of Hildegard's *Scivias* that many believe was made in her own lifetime, but it was lost in World War II. Today we can study its images only from prewar black-and-white photographs or from a full-color facsimile that was lovingly hand-painted by the nuns of the Abbey of St. Hildegard in Eigingen under the direction of Joesepha Krips between 1927 and 1933, the source of both pictures reproduced here.

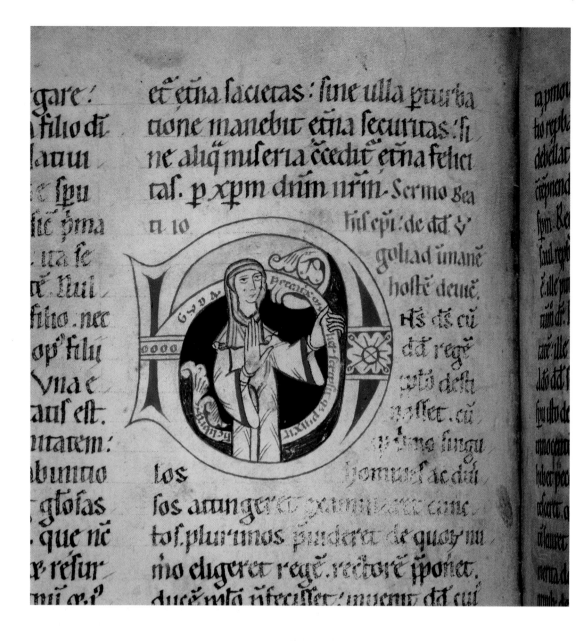

15-32 • The Nun Guda
BOOK OF HOMILIES
Westphalia, Germany.
Early 12th century. Ink
on parchment. Stadtund
Universitäts-Bibliothek,
Frankfurt, Germany. MS.
Barth. 42, fol. 110v

THE GERMAN NUN GUDA. In another historiated initial, this one from Westphalia in Germany, the nun Guda has a more modest presentation. In a **BOOK OF HOMILIES** (sermons), she inserted her self-portrait into the letter *D* and signed it as scribe and painter, "Guda, the sinful woman, wrote and illuminated this book" **(FIG. 15–32)**. This is a simple colored drawing with darker blocks of color in the background, but Guda and her monastic sisters played an important role in the production of books in the twelfth century, and not all of them remain anonymous. Guda's image is the earliest signed self-portrait by a woman in western Europe. Throughout the Middle Ages, women were involved in the production of books as authors, scribes, painters, and patrons (see "Hildegard of Bingen," page 487).

A CISTERCIAN TREE OF JESSE. The Cistercians were particularly devoted to the Virgin Mary and are also credited with popularizing themes such as the Tree of Jesse as a device for showing her position as the last link in the genealogy connecting Jesus to King David. (Jesse, the father of King David, was an ancestor of Mary and, through her, of Jesus.) A manuscript of St. Jerome's Commentary on Isaiah, made in the scriptorium of the Cistercian mother house of Cîteaux in Burgundy about 1125, contains an image of an abbreviated **TREE OF JESSE** (FIG. 15–33).

A monumental Mary, with the Christ Child sitting on her veiled arm, stands over the forking branches of the tree, dwarfing the sleeping patriarch, Jesse, from whose body a small tree trunk grows. The long, vertical folds of Mary's voluminous drapery—especially the flourish at lower right, where a piece of her garment billows up, as if caught in an updraft—recall the treatment of drapery in the portal at Autun (see "A Closer Look," page 478), also from Burgundy. The manuscript artist has drawn, rather than painted, with soft colors, using subtle tints that seem somehow in keeping with Cistercian restraint. Christ embraces his mother's neck, pressing his cheek against hers in a display of tender affection that recalls Byzantine icons of the period, like the Virgin of Vladimir (SEE FIG. 7–37). The foliate form Mary holds in her hands

15-33 • PAGE WITH THE TREE OF JESSE, EXPLANATIO IN ISAIAM (ST. JEROME'S COMMENTARY ON ISAIAH)

Abbey of Cîteaux, Burgundy, France. c. 1125. Ink and tempera on vellum, 15 × 4¾″ (38 × 12 cm). Bibliothèque Municipale, Dijon, France. MS. 129, fol. 4v

could be a flowering sprig from the Jesse Tree, or it could be a lily symbolizing her purity.

The building held by the angel on the left equates Mary with the Church, and the crown held by the angel on the right is hers as queen of heaven. The dove above her halo represents the Holy Spirit; Jesse Trees often have doves sitting in the uppermost branches. In the early decades of the twelfth century, church doctrine came increasingly to stress the role of the Virgin Mary and the saints as intercessors who could plead for mercy on behalf of repentant sinners, and devotional images of Mary became increasingly popular during the later Romanesque period. As we will see, this popularity would continue into the Gothic period.

THINK ABOUT IT

15.1 Discuss what is meant by the term "Romanesque" and distinguish some of the key stylistic features associated with architecture in this style.

15.2 What is a pilgrimage site? How did pilgrimage sites function for medieval Christians? Ground your answer in a discussion of Santiago de Compostela (FIGS. 15–4, 15–5, 15–6), focusing on specific features that were geared towards pilgrims.

15.3 Compare and contrast two Romanesque churches from different regions of Europe. Explain the key aspects of each regional style.

15.4 Discuss the sculpture that was integrated into the exteriors of Romanesque churches. Why was it there? Whom did it address? What were the prominent messages? Make reference to at least one church discussed in this chapter.

15.5 Analyze one example of a Romanesque work of art in this chapter that tells a story of human frailty and a second work that focuses on an exemplary, holy life. Compare and contrast their styles and messages.

PRACTICE MORE: Compose answers to these questions, get flashcards for images and terms, and review chapter material with quizzes www.myartslab.com

16-1 • SCENES FROM GENESIS From the Good Samaritan Window, nave aisle, Cathedral of Notre-Dame, Chartres, France. Stained and painted glass. c. 1200–1210.

GOTHIC ART OF THE TWELFTH AND THIRTEENTH CENTURIES

The Gothic style—originating in the powerful monasteries of the Paris region—dominated much of European art and architecture for 400 years. By the mid 12th century, advances in building technology, increasing financial resources, and new intellectual and spiritual aspirations led to the development of a new art and architecture that expressed the religious and political values of cloistered Christian communities. Soon bishops and rulers, as well as abbots, vied to build the largest and most elaborate churches. Just as residents of twentieth-century American cities raced to erect higher and higher skyscrapers, so too the patrons of western Europe competed during the Middle Ages in the building of cathedrals and churches with ever-taller naves and towers, diaphanous walls of glowing glass, and breathtakingly airy interiors that seemed to open in all directions.

The light captured in stained-glass windows created luminous pictures that must have captivated a faithful population whose everyday existence included little color, outside the glories of the natural world. And the light that passed through these windows transformed interior spaces into a many-colored haze. Walls, objects, and even people seemed to dissolve—dematerializing into color. Truly, Gothic churches became the glorious jeweled houses of God, evocations of the heavenly Jerusalem. They were also glowing manifestations of Christian doctrine, and invitations to faithful living, encouraging worshipers to follow in the footsteps of the saints whose lives were frequently featured in the windows of Gothic churches. Stained glass soon became the major medium of monumental painting.

This detail from the **GOOD SAMARITAN WINDOW** at Chartres Cathedral (FIG. 16–1), created in the early years of the thirteenth century, well into the development of French Gothic architecture, includes scenes from Genesis, the first book of the Bible. The window portrays God's creation of Adam and Eve, and continues with their subsequent temptation, fall into sin, and expulsion from the paradise of the Garden of Eden to lead a life of work and woe. Adam and Eve's story is used here to interpret the meaning of the parable of the Good Samaritan for medieval viewers, reminding them that Christ saves them from the original sin of Adam and Eve just as the Good Samaritan saves the injured and abused traveler (SEE FIG. 16–12). The stained-glass windows of Gothic cathedrals were more than glowing walls activated by color and light; they were also luminous sermons, preached with pictures rather than with words. These radiant pictures were directed at a diverse audience of worshipers, drawn from a broad spectrum of medieval society, who derived multiple meanings from gloriously complicated works of art.

LEARN ABOUT IT

16.1 Investigate the ideas, events, and technical innovations that led to the development of Gothic architecture.

16.2 Contrast English and German styles of Gothic with their French prototypes.

16.3 Trace the development of stained glass as the major medium of monumental Gothic painting.

16.4 Appreciate how artists were able to communicate complex theological ideas in stained glass, sculpture, and illustrated books.

16.5 Analyze the relationship between the Franciscan ideals of empathy and the emotional appeals of sacred narrative painting and sculpture in Italy.

HEAR MORE: Listen to an audio file of your chapter www.myartslab.com

THE EMERGENCE OF THE GOTHIC STYLE

In the middle of the twelfth century, a distinctive new architecture known today as Gothic emerged in the Île-de-France, the French royal domain around Paris (MAP 16–1). The appearance there of a new style and technique of building coincided with the emergence of the monarchy as a powerful centralizing force. Within 100 years, an estimated 2,700 Gothic churches, shimmering with stained glass and encrusted with sculpture, were built in the Île-de-France region alone.

Advances in building technology allowed progressively larger windows and even loftier vaults supported by more and more streamlined skeletal exterior buttressing. Soon, the Gothic style spread throughout western Europe, gradually displacing Romanesque forms while taking on regional characteristics inspired by them. Gothic prevailed until about 1400, lingering even longer in some regions. It was adapted to all types of structures, including town halls and residences, as well as Christian churches and synagogues.

The term "Gothic" was popularized by the sixteenth-century Italian artist and historian Giorgio Vasari, who disparagingly attributed the by-then-old-fashioned style to the Goths, Germanic invaders who had "destroyed" the Classical civilization of the Roman Empire that Vasari preferred. In its own day the Gothic style was simply called "modern art" or the "French style."

THE RISE OF URBAN AND INTELLECTUAL LIFE

The Gothic period was an era of both communal achievement and social change. Although Europe remained rural, towns gained increasing prominence. They became important centers of artistic patronage, fostering strong communal identity by public projects and ceremonies. Intellectual life was also stimulated by the inter-action of so many people living side by side. Universities in Bologna, Padua, Paris, Cambridge, and Oxford supplanted monastic

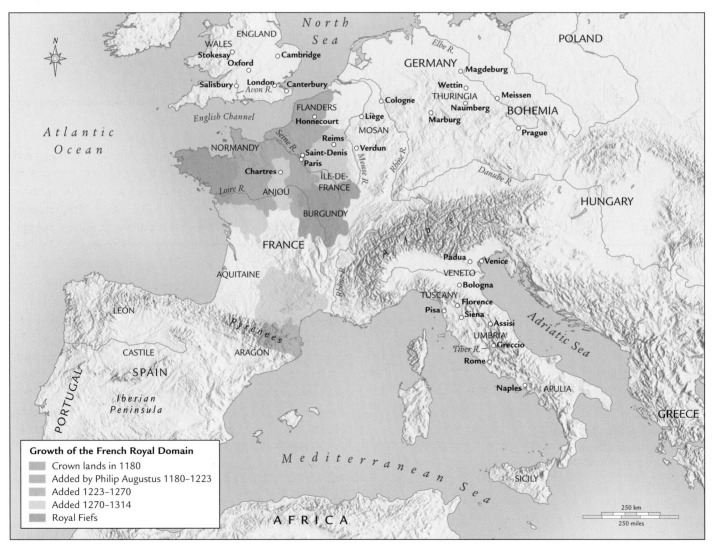

MAP 16–1 • EUROPE IN THE GOTHIC ERA

The color changes on this map chart the gradual expansion of territory ruled by the king of France during the period when Gothic was developing as a modern French style.

Abbot Suger on the Value of Art in Monasteries

Suger, who masterminded the reconstruction of the abbey church at Saint-Denis while he was its abbot (1122–1151), weighed in on the twelfth-century monastic debate concerning the appropriateness of elaborate art in monasteries (see "St. Bernard and Theophilus," page 464) both through the magnificence of the new church he built and by the way he described and discussed the project in the account he wrote of his administration of the abbey.

These are his comments on the bronze doors (destroyed in 1794):

Bronze casters having been summoned and sculptors chosen, we set up the main doors on which are represented the Passion of the Saviour and His Resurrection, or rather Ascension, with great cost and much expenditure for their gilding as was fitting for the noble porch...

The verses on the door are these:

Whoever thou art, if thou seekest to extol the glory of these doors,
Marvel not at the gold and the expense but at the craftsmanship of the work,
Bright is the noble work; but being nobly bright, the work
Should lighten the minds, so that they may travel, through the true lights,
To the True Light where Christ is the true door,
In what manner it be inherent in this world the golden door defines:
The dull mind rises to truth through that which is material
And, in seeing this light, is resurrected from its former subversion.

On the lintel, just under the large figure of Christ at the Last Judgment on the tympanum, Suger had inscribed:

Receive, O stern Judge, the prayers of Thy Suger; grant that I be mercifully numbered among Thy own sheep.

(Translations from Panofsky, pp. 47, 49)

EXPLORE MORE: Gain insight from another primary source by Abbot Suger **www.myartslab.com**

and cathedral schools as centers of learning. Brilliant teachers like Peter Abelard (1079–1142) drew crowds of students, and in the thirteenth century an Italian theologian, Thomas Aquinas (1225–1274), made Paris the intellectual center of Europe.

A system of reasoned analysis known as scholasticism emerged from these universities, intent on reconciling Christian theology with Classical philosophy. Scholastic thinkers used a question-and-answer method of argument and arranged their ideas into logical outlines. Thomas Aquinas, the foremost Scholastic, applied Aristotelian logic to comprehend religion's supernatural aspects, setting up the foundation on which Catholic thought rests to this day. Some have seen a relationship between the development of these new ways of thinking and the geometrical order that permeates the design of Gothic cathedrals, as well as with the new interest in describing the appearance of the natural world in sculpture and painting.

THE AGE OF CATHEDRALS

Urban cathedrals, the seats of the ruling bishops, superseded rural monasteries as centers of religious culture and patronage. So many cathedrals were rebuilt between 1150 and 1400—often to replace earlier churches destroyed in the fires that were an unfortunate byproduct of population growth and housing density within cities—that some have dubbed the period the "Age of Cathedrals." Cathedral precincts functioned almost as towns within towns—

containing a palace for the bishop, housing for the clergy, and workshops for the multitude of artists and laborers necessary to support building campaigns. These gigantic churches certainly dominated their urban surroundings. But even if their grandeur inspired admiration, their enormous expense and some bishops' intrusive displays of power inspired resentment, even urban rioting.

GOTHIC ART IN FRANCE

The invention and initial flowering of the Gothic style in France took place against the backdrop of the growing power of the Capetian monarchy. Louis VII (r. 1137–1180) and Philip Augustus (r. 1180–1223) consolidated royal authority in the Île-de-France and began to exert more control over powerful nobles in other regions. Louis VII's queen, Eleanor of Aquitaine, brought southwestern France into the royal domain, but when their marriage was annulled, Eleanor reclaimed her lands and married Henry Plantagenet—count of Anjou, duke of Normandy—who became King Henry II of England. The resulting tangle of conflicting claims kept France and England at odds for centuries.

As French kings continued to consolidate royal authority and to increase their domains and privileges, they also sparked a building boom with the growing centralization of their government in Paris, which developed from a small provincial town into a thriving urban center beginning in the middle of the twelfth

century. Concentrated architectural activity in the capital may have provided the impetus—or perhaps simply the opportunity—for the developments in architectural technology and the new ways of planning and thinking about buildings that ultimately led to the birth of a new style.

THE BIRTH OF GOTHIC AT THE ABBEY CHURCH OF SAINT-DENIS

The first Gothic building was the church of the Benedictine abbey of Saint-Denis, just north of Paris. This monastery had been founded in the fifth century over the tomb of St. Denis, the Early Christian martyr who had been sent from Rome to convert the local pagan population and was considered the first bishop of Paris. Early on, the abbey developed special royal significance. It housed tombs of the kings of France, the regalia of the French crown, and the relics of St. Denis, patron saint of France.

Construction began in the 1130s of a new church that was to replace the early medieval church at the abbey, under the supervision of Abbot Suger (abbot 1122–1151). In a written account of his administration of the abbey, Suger discusses the building of the church, a rare first-hand chronicle and justification of a medieval building program. Suger prized magnificence, precious materials, and especially fine workmanship (see "Abbot Suger on the Value of Art in Monasteries," page 493). He invited an international team of masons, sculptors, metalworkers, and glass painters, making this building site a major center of artistic exchange. Such a massive undertaking was extraordinarily expensive. The abbey received substantial annual revenues from the town's inhabitants, and Suger was not above forging documents to increase the abbey's landholdings, which constituted its principal source of income.

Suger began building c. 1135, with a new west façade and narthex attached to the old church, but it was in the new choir—completed in three years and three months between July 13, 1140, and June 14, 1144—where the fully formed Gothic architectural style first appeared. In his account of the reconstruction, Suger argues that that older building was inadequate to accommodate the crowds of pilgrims who arrived on feast days to venerate the body of St. Denis, and too modest to express the importance of the saint himself. In working with builders to conceive a radically new church design, he turned for inspiration to texts that were attributed erroneously to a follower of St. Paul named Dionysius (the Greek form of Denis), who considered radiant light a physical manifestation of God. Through the centuries, this Pseudo-Dionysius

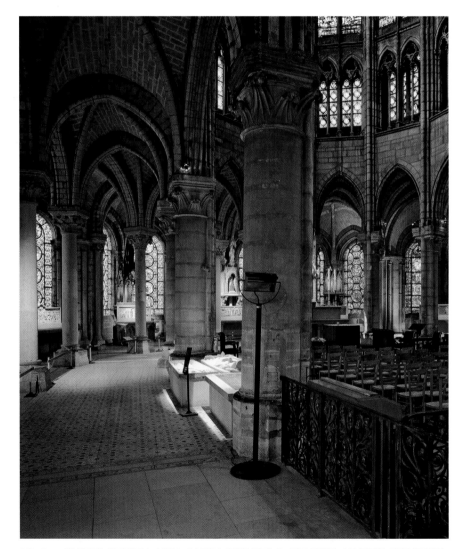

16-3 • AMBULATORY AND APSE CHAPELS OF THE ABBEY CHURCH OF SAINT-DENIS
France. 1140–1144.

Envisioning the completion of the abbey church with a transept, and presumably also a nave, Abbot Suger had the following inscription placed in the church to commemorate the 1144 dedication of the choir: "Once the new rear part is joined to the part in front, the church shines with its middle part brightened. For bright is that which is brightly coupled with the bright, and bright is the noble edifice which is pervaded by the new light." (Panofsky, p. 51).

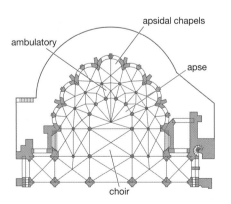

16-2 • PLAN OF THE CHOIR OF THE ABBEY CHURCH OF SAINT-DENIS
France. 1140–1144.

(labels in figure 16-2: apsidal chapels, ambulatory, apse, choir)

An important innovation of Romanesque and Gothic builders was **rib vaulting**. Rib vaults are a form of groin vault (see "Roman Vaulting," page 188), in which the diagonal ridges (groins) rest on and are covered by curved moldings called ribs. After the walls and piers of the building reached the desired height, timber scaffolding to support these masonry ribs was constructed. When the mortar of the ribs was set, the web of the vault was then laid on forms built on the ribs themselves. After all the temporary forms were removed, the ribs may have provided strength at the intersections of the webbing to channel the vaults' thrust outward and downward to the foundations; they certainly add decorative interest. In short, ribs formed the "skeleton" of the vault; the webbing, a lighter masonry "skin." In Late Gothic buildings, additional, decorative ribs give vaults a lacelike appearance.

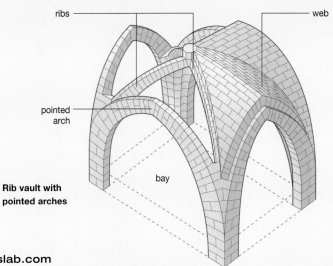

Rib vault with pointed arches

SEE MORE: View a simulation about rib vaulting **www.myartslab.com**

also became identified with the martyred Denis whose body was venerated at the abbey, so Suger was adapting what he believed was the patron saint's concept of divine luminosity in designing the new abbey church with walls composed essentially of stained-glass windows. In inscriptions he composed for the bronze doors (now lost), he was specific about the motivations for the church's new architectural style: "being nobly bright, the work should lighten the minds, so that they may travel, through the true lights, to the True Light where Christ is the true door" (Panofsky, p. 49).

The **PLAN OF THE CHOIR (FIG. 16–2)** retains key features of the Romanesque pilgrimage church (SEE FIG. 15–6), with a semicircular apse surrounded by an ambulatory, around which radiate seven chapels of uniform size. And the structural elements of the choir had already appeared in Romanesque buildings, including pointed arches, ribbed groin vaults, and external buttressing that relieves stress on the walls. The most dramatic achievement of Suger's builders was the coordinated use of these features to create an architectural whole that emphasized open, flowing space, enclosed by non-load-bearing walls of colorful, glowing stained glass **(FIG. 16–3)**. As Suger himself put it, the church becomes "a circular string of chapels by virtue of which the whole would shine with the wonderful and uninterrupted light of most luminous windows, pervading the interior beauty" (Panofsky, p. 101). And since Suger saw the contemplation of light as a means of illuminating the soul and uniting it with God, he was providing his monks with an environment especially conducive to their primary vocation of prayer and meditation.

The revolutionary stained-glass windows of Suger's Saint-Denis were almost lost in the wake of the French Revolution, when this royal abbey represented everything the new leaders were intent on suppressing. Thanks to an enterprising antiquarian named Alexandre Lenoir, however, the twelfth-century windows,

though removed from their architectural setting, were saved from destruction. During the nineteenth century, parts of them returned to the abbey, but many panels are now in museums. One of the best-preserved panels—from a window that narrated Jesus' childhood—portrays **THE FLIGHT INTO EGYPT (FIG. 16–4)**. The crisp elegance of the delineation of faces, foliage, and drapery—painted with vitreous enamel on the vibrantly colored pieces of glass that make up the panel (see "Stained-Glass Windows," page 497)— is almost as clear today as it was when the windows were new. One unusual detail—the Virgin reaching to pick a date from a palm tree that has bent down at the infant Jesus' command to accommodate her hungry grasp—is based on an apocryphal Gospel that was not included in the canonical Christian scriptures but that was a very popular source for twelfth-century artists.

Louis VII and Eleanor of Aquitaine attended the consecration of the new choir in June 1144, along with a constellation of secular and sacred dignitaries. Since the bishops and archbishops of France were assembled at the consecration—celebrating Mass simultaneously at altars throughout the choir and crypt—they had the opportunity to experience firsthand this new Gothic style of building. The history of French architecture over the next few centuries indicates that they were quite impressed.

GOTHIC CATHEDRALS

The abbey church of Saint-Denis became the prototype for a new architecture of space and light based on a highly adaptable skeletal framework that supported rib vaulting on the points of slender piers—rather than massive Romanesque walls—reinforced by external buttress systems. It initiated a period of competitive experimentation in France that resulted in ever-larger churches— principally cathedrals—enclosing increasingly taller interior spaces, walled with ever-greater expanses of stained glass.

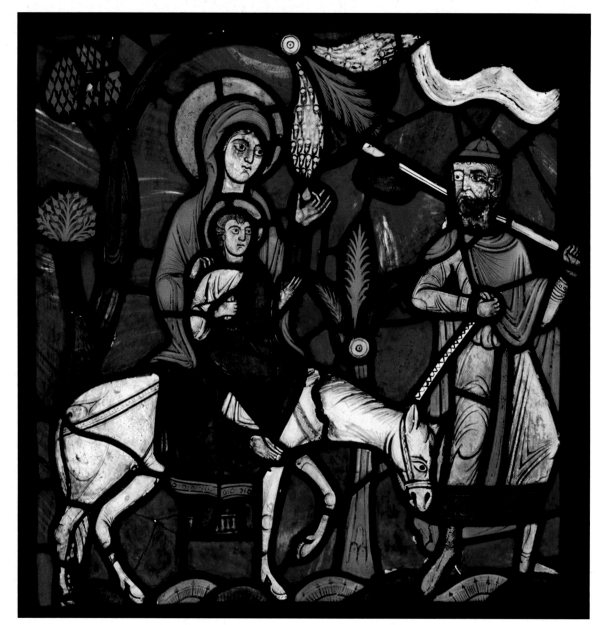

THE CATHEDRAL OF NOTRE-DAME IN PARIS. The **CATHEDRAL OF NOTRE-DAME** ("Our Lady," the Virgin Mary) in Paris—known today simply as Notre-Dame—bridges the period between Abbot Suger's rebuilding of his abbey church and the High Gothic cathedrals of the thirteenth century **(FIG. 16–5)**. The building was begun in the 1160s with the choir, and it was essentially complete by the middle of the thirteenth century with the achievement of the façade. To increase the window size and secure the soaring 115-foot-high vault, builders here employed the first true flying buttresses, probably during the 1180s. The **flying buttress**, a gracefully arched, skeletal exterior support, counters the lateral thrust of the nave vault and transfers its weight outward, over the side aisles, where it is resolved into and supported by a vertical external buttress, rising from the ground. During the thirteenth century, builders modernized Notre-Dame by reworking the two upper levels into the large clerestory windows we see today. The huge, spiderlike flying buttress system visible to modern visitors is the result of even later remodeling. The original flying buttresses were more modest quadrant arches, but they represented a structural innovation that would become central to the future development of Gothic architecture.

THE CATHEDRAL OF NOTRE-DAME IN CHARTRES. The new conceptions of space and wall, and the structural techniques that made them possible, initiated at Saint-Denis and expanded at Notre-Dame in Paris, were developed further at Chartres. The great cathedral dominates this town southwest of Paris and, for many people, is a near-perfect embodiment of the Gothic style in stone and glass. Constructed in several stages beginning in the mid twelfth century and extending into the mid thirteenth, with additions such as the north spire as late as the sixteenth century, Chartres Cathedral reflects the transition from an experimental twelfth-century architecture to a mature thirteenth-century style.

The "wonderful and uninterrupted light" that Suger sought in the reconstruction of the choir of Saint-Denis in the 1140s was provided by stained-glass artists that—as he tells us—he called in from many nations to create glowing walls for the radiating chapels, perhaps the clerestory as well. As a result of their exquisite work, this influential building program not only constituted a new architectural style; it catapulted what had been a minor curiosity among pictorial techniques into the major medium of monumental European painting. For several centuries, stained glass would be integral to architectural design, not decoration added subsequently to a completed building. Windows were produced at the same time as masons were building walls and carving capitals and moldings.

Our knowledge about the medieval art of stained glass is based on a precious twelfth-century text—*De Diversis Artibus* (*On the Various Arts*)—written by a German monk who called himself Theophilus Presbyter (see "St. Bernard and Theophilus," page 464). In fact, the basic procedures of producing a stained-glass window have changed little since the Middle Ages. It is not a lost art, but it is a complex and costly process. The glass itself was made by bringing sand and ash to the molten state under intense heat, and "staining" it with color through the addition of metallic oxides. This molten material was then blown and flattened into sheets. Using a **cartoon** (full-scale drawing) painted on a whitewashed board as a guide, the glass painter would cut from these sheets the individual shapes of color that would make up a figural scene or ornamental passage. This was done with a hot iron that would crack the glass into a rough approximation that could be refined by chipping away at the edges carefully with an iron tool—a process called **grozing**—to achieve the precise shape needed in the composition.

The artists used a vitreous paint (made, Theophilus tells us, of iron filings and ground glass suspended in wine or urine) at full strength to block light and delineate features such as facial expressions or drapery folds. It could also be diluted to create modeling washes. Once painted, the pieces of glass would be fired in a kiln to fuse the painting with the glass surface. Only then did the artists assemble these shapes of color—like pieces of a complex compositional puzzle—with strips of lead (called **cames**), and subsequently mount a series of these individual panels on an iron framework within the architectural opening to form an ensemble we call a stained-glass window. Lead was used in the assembly process because it was strong enough to hold the glass pieces together but flexible enough to bend around their complex shapes and—perhaps more critically—to absorb the impact from gusts of wind and prevent the glass itself from cracking under pressure.

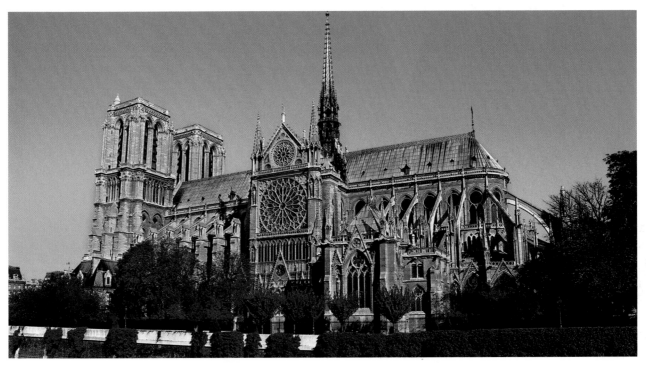

16–5 • CATHEDRAL OF NOTRE-DAME, PARIS
Begun 1163; choir chapels, 1270s; crossing spire, 19th-century. View from the south.

For all its spiritual and technological glory, Notre-Dame barely survived the French Revolution. The revolutionaries decapitated the statues associated with deposed nobility and their "superstitious" religion, and transformed the cathedral into a secular "Temple of Reason" (1793–1795). But it would not be long until Notre-Dame was returned to religious use. Napoleon crowned himself emperor at its altar in 1804, and Parisians gathered there to celebrate the liberation of Paris from the Nazis in August 1944. Today, boats filled with tourists glide under bridges that link the island where the cathedral stands with the Left Bank, the traditional students' and artists' quarter. Notre-Dame so resonates with the life and history of the city that it has become more than a house of worship and work of art; it is a symbol of Paris itself.

SEE MORE: View panoramas of the Cathedral of Notre-Dame, Paris **www.myartslab.com**

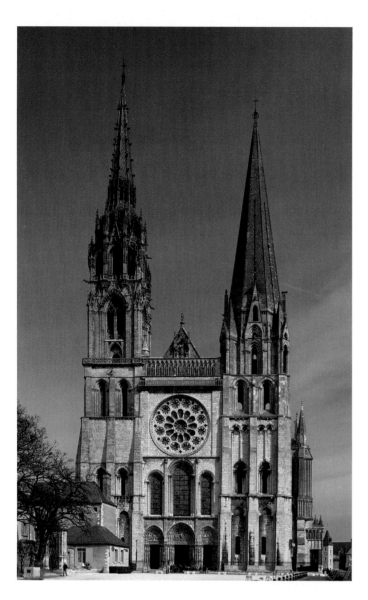

16-6 • WEST FAÇADE, CHARTRES CATHEDRAL (THE CATHEDRAL OF NOTRE-DAME)
France. West façade begun c. 1134; cathedral rebuilt after a fire in 1194; building continued to 1260; north spire 1507–1513.

SEE MORE: View panoramas of Chartres Cathedral
www.myartslab.com

Chartres was the site of a pre-Christian virgin-goddess cult, and later, dedicated to the Virgin Mary, it became one of the oldest and most important Christian shrines in France. Its main treasure was a piece of linen believed to have been worn by the Virgin Mary when she gave birth to Jesus. This relic was a gift from the Byzantine empress Irene to Charlemagne, whose grandson Charles the Bald donated it to Chartres in 876. It was kept below the high altar in a huge basement crypt. The healing powers attributed to the cloth made Chartres a major pilgrimage destination, especially as the cult of the Virgin grew in popularity in the twelfth and thirteenth centuries. Its association with important market fairs—especially cloth markets—held at Chartres on the feast days of the Virgin put the textile relic at the intersection of local prestige and the local economy, increasing the income of the cathedral not only through pilgrimage but also through tax revenue it received from the markets.

The west façade of Chartres preserves an early sculptural program created within a decade of the reconstruction of Saint-Denis (**FIG. 16–6**). Surrounding these three doors—the so-called Royal Portal, used not by the general public but only for important ceremonial entrances of the bishop and his retinue—sculpted figures calmly and comfortably fill their architectural settings. On the central tympanum, Christ is enthroned in majesty, returning at the end of time surrounded by the four evangelists (**FIG. 16–7**).

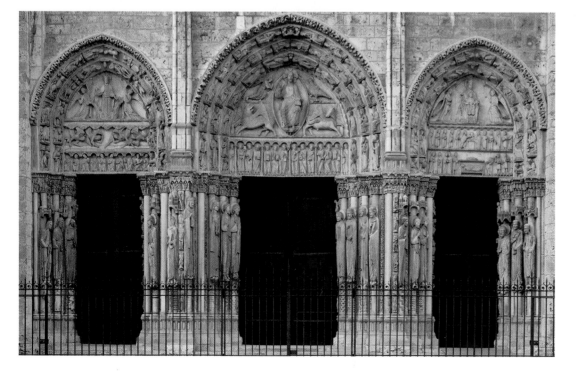

16-7 • ROYAL PORTAL, WEST FAÇADE, CHARTRES CATHEDRAL
c. 1145–1155.

EXPLORE MORE: Gain insight from a primary source related to the building of Chartres Cathedral
www.myartslab.com

Most large Gothic churches in western Europe were built on the Latin cross plan, with a projecting transept marking the transition from nave to choir, an arrangement that derives ultimately from the fourth-century, Constantinian basilica of Old St. Peter's (see page 228, FIG. A). The main entrance portal was generally on the west, with the choir and its apse on the east. A western narthex could precede the entrance to the nave and side aisles. An ambulatory with radiating chapels circled the apse and facilitated the movement of worshipers through the church. Many Gothic churches have a three-story elevation, with a triforium sandwiched between the nave arcade and a glazed clerestory. Rib vaulting usually covered all spaces. **Flying buttresses** helped support the soaring nave vaults by transferring their outward thrust over the aisles to massive, free-standing, upright external buttresses. Church walls were decorated inside and out with arcades of round or pointed arches, engaged columns and colonnettes, an applied filigree of tracery, and horizontal moldings called **stringcourses**. The pitched roofs above the vaults—necessary to evacuate rainwater from the building—were supported by wooden frameworks. A spire or crossing tower above the junction of the transept and nave was usually planned, though often never finished. Portal façades were also customarily marked by high, flanking towers or gabled porches ornamented with **pinnacles** and finials. Architectural sculpture proliferated on each portal's tympanum, archivolts, and jambs, and in France a magnificent rose window typically formed the centerpiece of the flat portal façades.

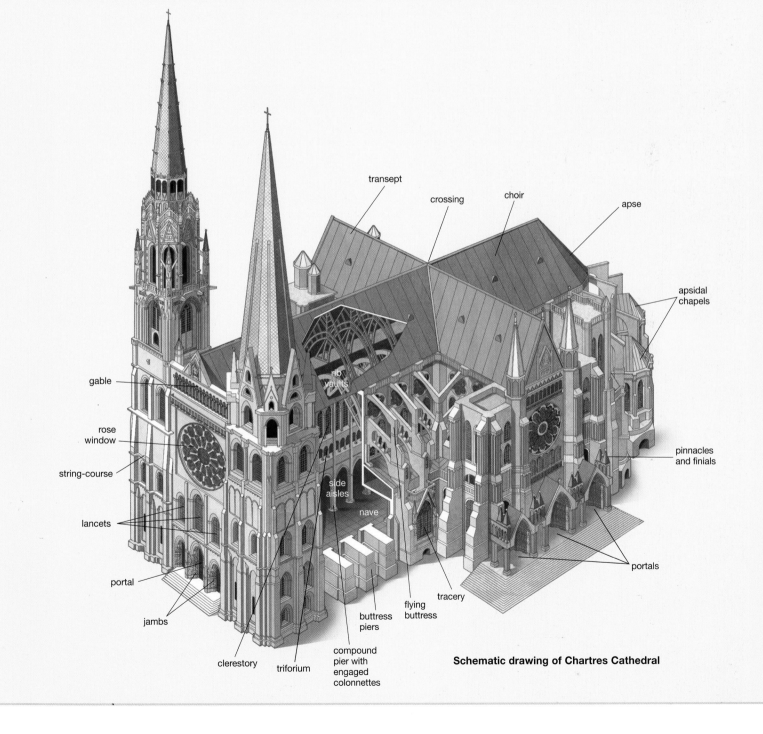

Schematic drawing of Chartres Cathedral

Although imposing, he seems more serene and more human than in the hieratic and stylized portrayal of the same subject at Moissac (SEE FIG. 15–22). The apostles, organized into four groups of three fill the lintel, and the 24 Elders of the Apocalypse line the archivolts.

The right portal is dedicated to the Incarnation (God's first earthly appearance), highlighting the role of Mary in the early life of Christ, from the Annunciation to the Presentation in the Temple. On the left portal is the Ascension (the Incarnate God's return from earth to heaven). Jesus floats heavenward in a cloud, supported by angels. Running across all three portals, historiated capitals, on the top of the jambs just underneath the level of the lintels, depict Jesus' life on Earth in a series of small, lively narrative scenes.

Flanking all three openings on the jambs are serenely calm column statues (FIG. 16–8)—kings, queens, and prophets from the Hebrew Bible, evocations of Christ's royal and spiritual ancestry, as well as a reminder of the close ties between the Church and the French royal house. The prominence of kings and queens here is what has given the Royal Portal its name. The elegantly elongated proportions and linear, but lifelike, drapery of these column statues echo the cylindrical shafts behind them. Their meticulously carved, idealized heads radiate a sense of beatified calm. In fact, tranquility and order prevail in the overall design as well as in the individual components of this portal, a striking contrast to the dynamic configurations and energized figures on the portals of Romanesque churches.

The bulk of Chartres Cathedral was constructed after a fire in 1194 destroyed an earlier Romanesque church but spared the Royal Portal, the windows above it, and the crypt with its precious relics. A papal representative convinced reluctant local church officials to rebuild. He argued that the Virgin had permitted the fire because she wanted a new and more beautiful church to be built in her honor. Between 1194 and about 1260 that new cathedral was built (see "The Gothic Church," page 499).

Such a project required vast resources—money, raw materials, and skilled labor (see "Master Masons," opposite). A contemporary painting shows a building site with the masons at work (FIG. 16–9). Carpenters have built scaffolds, platforms, and a lifting machine. Master stonecutters measure and cut the stones; workers carry and hoist the blocks by hand or with a lifting wheel. Thousands of stone had to be accurately cut and placed. In the illustration a laborer carries mortar up a ladder to men working on the top of the wall, where the lifting wheel delivers cut stones. To support this work, the bishop and cathedral officials usually pledged all

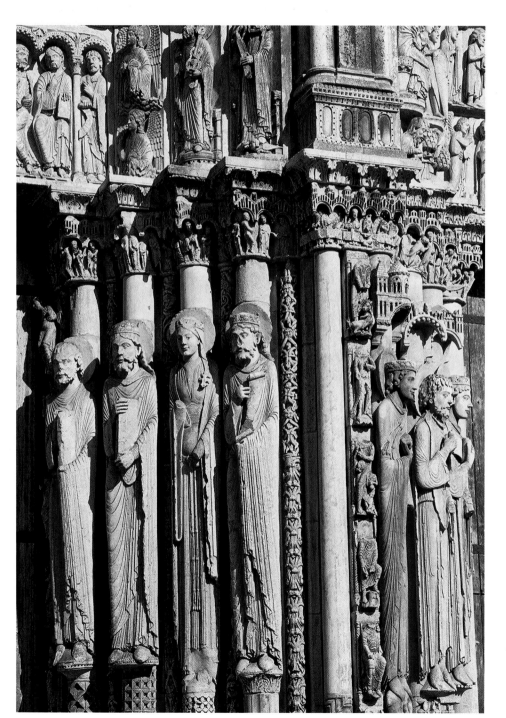

16-8 • ROYAL PORTAL, WEST FAÇADE, CHARTRES CATHEDRAL
Detail: prophets and ancestors of Christ (kings and queens of Judea). Right side, Central Portal. c. 1145–1155.

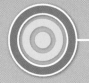

ART AND ITS CONTEXTS

Master Masons

Master masons oversaw all aspects of church construction in the Middle Ages, from design and structural engineering to construction and decoration. The master mason at Chartres coordinated the work of roughly 400 people scattered, with their equipment and supplies, across many locations, from distant stone quarries to high scaffolding. It has been estimated that this workforce set in place some 200 blocks of stone each day.

Funding shortages and technical delays, such as the need to let mortar harden for three to six months, made construction sporadic, so master masons and their crews moved constantly from job to job, with several masters and many teams of masons often contributing to the construction of a single building. Fewer than 100 master builders are estimated to have been responsible for all the major architectural projects around Paris during the century-long building boom there, some of them working on parts of as many as 40 churches. This was dangerous work. Masons were always at risk of injury, which could cut short a career in its prime. King Louis IX of France actually provided sick pay to a mason injured in the construction of Royaumont Abbey in 1234, but not all workers were this lucky. Master mason William of Sens, who supervised construction at Canterbury Cathedral, fell from a scaffold. His grave injuries forced him to return to France in 1178 because of his inability to work. Evidence suggests that some medieval contracts had pension arrangements or provisions that took potential injury or illness into account, but some did not.

Today the names of more than 3,000 master masons are known to us, and the close study of differences in construction techniques often discloses the participation of specific masters. Master masons gained in prestige during the thirteenth century as they increasingly differentiated themselves from the laborers they supervised. In some cases their names were prominently inscribed in the labyrinths on cathedral floors. From the thirteenth century on, in what was then an exceptional honor, masters were buried, along with patrons and bishops, in the cathedrals they built.

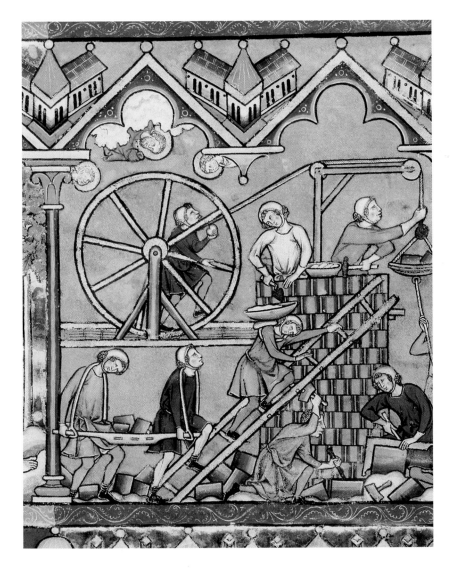

or part of their incomes for three to five, even ten years. Royal and aristocratic patrons joined in the effort. In an ingenious scheme that seems very modern, the churchmen at Chartres solicited contributions by sending the cathedral relics, including the Virgin's tunic, on tour as far away as England.

As the new structure rose higher during the 1220s, the work grew more costly and funds dwindled. But when the bishop and the cathedral clergy tried to make up the deficit by raising feudal and commercial taxes, the townspeople drove them into exile for four years. This action in Chartres was not unique; people often opposed the building of cathedrals because of the burden of new taxes. The economic privileges claimed by the Church for the cathedral sparked intermittent uprisings by townspeople and the local nobility throughout the thirteenth century.

Building on the principles pioneered at Saint-Denis—a glass-filled masonry skeleton enclosing a large open space—the masons at Chartres erected a church over 45 feet wide with vaults that soar approximately 120 feet above the floor. As at Saint-Denis, the plan is rooted in the Romanesque

16-9 • MASONS AT WORK
Detail of a miniature from a Picture Bible made in Paris during the 1240s. Pierpont Morgan Library, New York. Ms. M638, fol. 3r

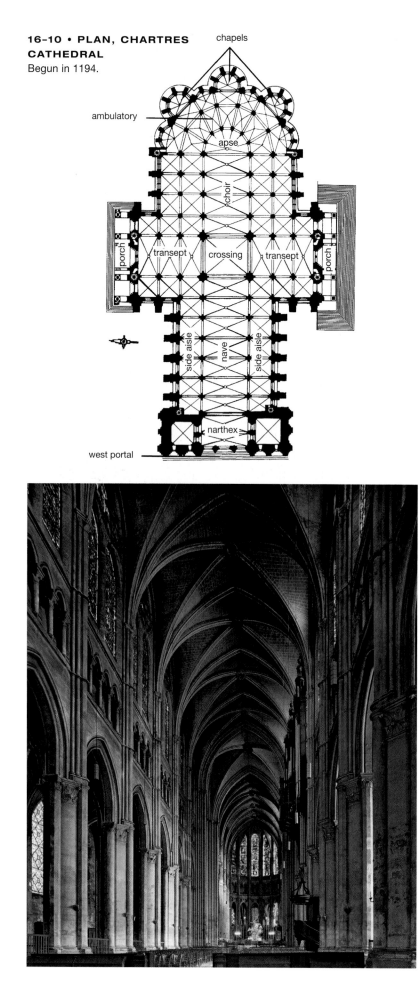

16–10 • PLAN, CHARTRES CATHEDRAL
Begun in 1194.

chapels

ambulatory

apse

choir

transept crossing transept

porch porch

side aisle nave side aisle

narthex

west portal

16–11 • NAVE, CHARTRES CATHEDRAL
c. 1194–1220.

pilgrimage plan, but with a significantly enlarged sanctuary occupying a full third of the building (**FIG. 16–10**). The Chartres builders codified what were to become the typical Gothic structural devices: pointed arches and ribbed groin vaults rising from compound piers over rectangular bays, supported by exterior flying buttresses (**FIG. 16–11**). The skillful use of the newly discovered flying buttress system permitted much larger clerestory windows, nearly equal in height to the nave arcade; the band between upper and lower stories was now occupied by a **triforium** (arcaded wall passageway) rather than a tall gallery. The alternating heavy and light piers typical of Romanesque naves such as those at Speyer and Durham cathedrals (SEE FIGS. 15–16, 15–18) become a very subtle alternation at Chartres between round and octagonal compound pier cores.

In Romanesque churches, worshipers are mainly drawn forward toward the apse, which is often more brilliantly illuminated than the nave. But at Chartres, visitors are drawn upward as well, to the glowing clerestory windows flanking the soaring vaults. The large and luminous clerestory is formed by paired **lancets** (tall openings with pointed tops), surmounted by small circular rose windows. The technique used is known as **plate tracery**—holes are cut into the stone wall and nearly half the wall surface is filled with stained glass.

Chartres is unusual among French Gothic buildings in that most of its stained-glass windows have survived. Stained glass is an enormously expensive and complicated medium of painting, but its effect on the senses and emotions made the effort worthwhile for medieval patrons and builders. By 1260, glass painters had installed about 22,000 square feet of stained glass in 176 windows (see "Stained-Glass Windows," page 497). Most of the glass dates from between about 1200 and 1250, but a few earlier windows, from the 1150s—comparable in style to the windows of Suger's Saint-Denis—survived the fire of 1194 and were maintained in the west wall above the Royal Portal.

In the aisles and chapels, where the windows were low enough to be easily seen, were elaborate multi-scene narratives, with small figures composed into individual episodes within the irregularly shaped compartments of windows designed as stacked medallions set against dense, multicolored fields of ornament. Art historians refer to these as cluster medallion windows. The **GOOD SAMARITAN WINDOW**

of c. 1200–1210 in the nave aisle is a typical example of the design **(FIG. 16–12)**. Its learned allegory on sin and salvation also typifies the complexity of Gothic narrative art.

The principal subject is a parable Jesus told his followers to teach a moral truth (Luke 10:25–37). The protagonist is a traveling Samaritan who cares for a stranger, beaten, robbed, and left for dead by thieves on the side of a road. Jesus' parable is an allegory for his imminent redemption of humanity's sins, and within this window a story from Genesis is juxtaposed with the parable to underscore that association (SEE FIG. 16–1). Adam and Eve's fall introduced sin into the world, but Christ (the Good Samaritan) rescues humanity (the traveler) from sin (the thieves) and ministers to them within the Church, just as the Good Samaritan takes the wounded traveler for refuge and healing to an inn (bottom scene, FIG. 16–1). Stylistically, these willowy, expressive figures avoid the classicizing stockiness in Wiligelmo's folksy Romanesque rendering of the Genesis narrative at Modena (SEE FIG. 15–21). Instead they take the dancelike postures that will come to characterize Gothic figures as the style spreads across Europe in ensuing centuries.

In the clerestory windows, the Chartres glaziers mainly used not multiscene narratives, but large-scale single figures that could be seen at a distance because of their size, bold drawing, and strong colors. Iconic ensembles were easier to "read" in lofty openings more removed from viewers, such as the huge north transept rose window (over 42 feet in diameter) with five lancets beneath it **(FIG. 16–13)**, which proclaims the royal and priestly heritage of Mary and Jesus, and through them of the Church itself. In the central lancet, St. Anne holds her daughter, the baby Mary, flanked left to right by statuesque figures of Hebrew Bible leaders Melchizedek, David, Solomon, and Aaron. Above, in the very center of the rose window itself, Mary and Jesus are enthroned, surrounded by a radiating array of doves, angels, and kings and prophets from the Hebrew Bible.

This vast wall of glass was a gift from the young King Louis IX (r. 1226–1270), perhaps arranged by his powerful mother, Queen Blanche of Castile (1188–1252), who ruled as regent 1226–1234 during Louis's minority. Royal heraldic emblems secure the window's association with the king. The arms of France—golden *fleurs-de-lis* on a blue ground—fill a prominent shield under St. Anne at the bottom of the central lancet. *Fleurs-de-lis* also appear in the graduated lancets bracketing the base of the rose window and in a series of **quatrefoils** (four-lobed designs) within the rose itself. But also prominent is the Castilian device of golden castles on a red ground, a reference to the royal lineage of Louis' powerful

16–12 • GOOD SAMARITAN WINDOW
South nave aisle, Chartres Cathedral. Stained and painted glass.
c. 1200–1210.

SEE MORE: View a video about the stained glass at Chartres Cathedral **www.myartslab.com**

16–13 • ROSE WINDOW AND LANCETS, NORTH TRANSEPT, CHARTRES CATHEDRAL
France. Stained and painted glass. c. 1230–1235.

EXPLORE MORE: Gain insight from a primary source related to the stained glass at Chartres Cathedral **www.myartslab.com**

mother. Light radiating from the deep blues and reds creates a hazy purple atmosphere in the soft light of the north side of the building. On a sunny day the masonry may seem to dissolve in color, but the bold theological and political messages of the rose window remain clear.

THE CATHEDRAL OF NOTRE-DAME IN REIMS. Reims Cathedral, northeast of Paris in the region of Champagne, was the coronation church of the kings of France and, like Saint-Denis, had been a cultural and educational center since Carolingian times. When, in 1210, fire destroyed this historic building, the community at Reims began to erect a new Gothic structure, planned as a large basilica (FIG. 16–14) similar to the model set earlier at the Cathedral of Chartres (SEE FIG. 16–10), only at Reims priority is given to an extended nave rather than an expanded choir, perhaps a reference to the processional emphasis of the coronation ceremony. The cornerstone of the cathedral was laid in 1211, and work continued throughout the century. The expense of the project sparked such local opposition that twice in the 1230s revolts drove the archbishop and canons into exile. At Reims, five master masons directed the work on the cathedral over the course of a century—Jean d'Orbais, Jean le Loup, Gaucher de Reims, Bernard de Soissons, and Robert de Coucy.

The west front of the Cathedral of Reims is a magnificent ensemble, in which almost every square inch of stone surface seems encrusted with sculptural decoration (FIG. 16–15). Its tall gabled portals form a broad horizontal base and project forward to display an expanse of sculpture, while the tympana they enclose

16–14 • PLAN, CATHEDRAL OF NOTRE-DAME, REIMS
France. Begun in 1211.

16–15 • WEST FAÇADE, CATHEDRAL OF NOTRE-DAME, REIMS
France. Rebuilding begun 1211; façade begun c. 1225; to the height of rose window by 1260; finished for the coronation of Philip the Fair in 1286; towers left unfinished 1311; additional work 1406–1428.

SEE MORE: View panoramas of Reims Cathedral www.myartslab.com

are filled with stained-glass windows rather than stone carvings. Their soaring peaks—the middle one reaching to the center of the dominating rose window—unify the façade vertically. In a departure from tradition, Mary rather than Christ is featured in the central portal, a reflection of the growing popularity of her cult. Christ crowns her as queen of heaven in the central gable. The towers were later additions, as was the row of carved figures that runs from the base of one tower to the other above the rose window. This "gallery of kings" is the only strictly horizontal element of the façade.

The sheer magnitude of sculpture envisioned for this elaborate cathedral front required the skills of many sculptors, working in an impressive variety of styles over several decades. Four figures from the right jamb of the central portal illustrate the rich stylistic diversity (FIG. 16–16). The pair on the right portrays the Visitation, in which Mary (left), pregnant with Jesus, visits her older cousin, Elizabeth (right), pregnant with St. John the Baptist. The sculptor of these figures, active in Reims about 1230–1235, drew heavily on ancient sources. Reims had been a major Roman city, and there were remaining Roman works at the disposal of medieval sculptors. The bulky bodies show the same solidity seen in Roman sculpture (see "Roman Portraiture," page 170), and the women's full faces, wavy hair, and heavy mantles recall imperial portrait statuary, even in their use of the two imperial facial ideals of unblemished youth (Mary) and aged accomplishment (Elizabeth) (compare FIGS. 6–36, 6–37). The figures shift their weight to one leg in contrapposto as they turn toward each other in conversation.

The pair to the left of the Visitation enacts the Annunciation, in which the archangel Gabriel announces to Mary that she will bear Jesus. This Mary's slight body, broad planes of simple drapery, restrained gesture, inward focus, and delicate features contrast markedly with the bold tangibility of the Mary in the Visitation next to her. She is clearly the work of a second sculptor. The archangel Gabriel (at the far left) represents a third artist, active at the middle of the century. This sculptor created tall, gracefully swaying figures with small, fine-featured heads, whose

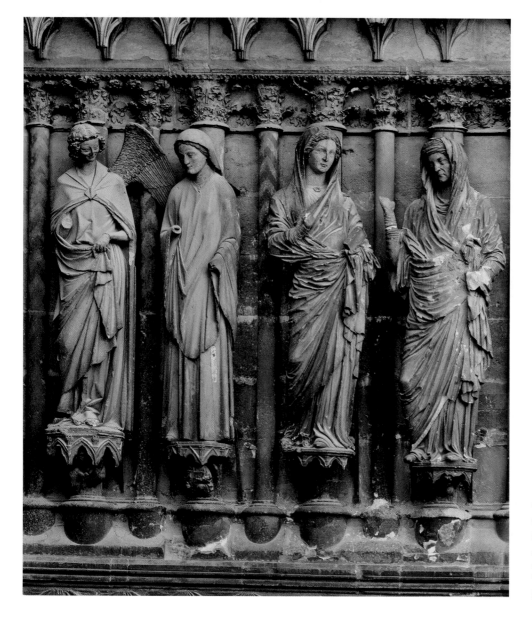

16–16 • WEST FAÇADE, CENTRAL PORTAL, RIGHT SIDE, REIMS CATHEDRAL
Annunciation (left pair: Mary [right] c. 1240, angel [left] c. 1250) and Visitation (right pair: Mary [left] and Elizabeth [right] c. 1230).

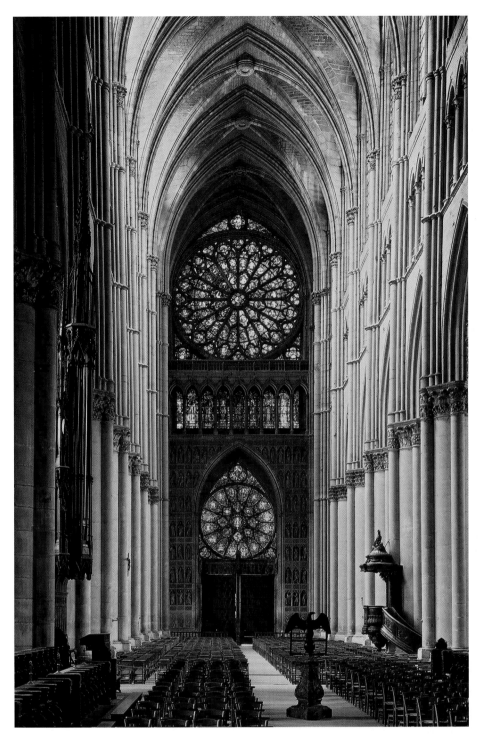

enlarged colonnette at the middle of the triforium. This design feature was certainly noticed by one contemporary viewer, since it is (over)emphasized in the drawings Villard de Honnecourt made during a visit to Reims Cathedral c. 1230 (see "Villard de Honnecourt," page 510). Villard also highlighted one of the principal innovations at Reims: the development of **bar tracery**, in which thin stone bars, called **mullions**, are inserted into an expansive opening in the wall to form a lacy framework for the stained glass (see rose window in FIG. 16–17). Bar tracery replaced the older plate tracery—still used at Chartres—and made possible even larger areas of stained glass in relation to wall surface.

A remarkable ensemble of sculpture and stained glass fills the interior west wall at Reims, which visually "dissolves" in the glow of colored light within delicate mullions of bar tracery. A great rose window fills the clerestory level; a row of lancets illuminates the triforium; and a smaller rose window replaces the stone of the portal tympanum. The lower level is anchored visually by an expanse of sculpture covering the inner wall of the façade. Here ranks of carved prophets and royal ancestors represent moral guides for the newly crowned monarchs who faced them while processing down the elongated nave and out of the cathedral following the coronation ceremony as they began the job of ruling France.

precious expressions, carefully crafted hairdos, and mannered poses of aristocratic refinement grew increasingly to characterize the figural arts in later Gothic sculpture and painting. These characteristics became the basis for what is called the International Gothic Style, fashionable across Europe well into the fifteenth century.

Inside the church **(FIG. 16–17)**, the wall is designed, as at Chartres, as a three-story elevation with nave arcade and clerestory of equal height divided by the continuous arcade of a narrow triforium passageway. The designer at Reims gives a subtle emphasis to the center of each bay in the wall elevation, coordinating the central division of the clerestory into two lancets with a slightly

ART IN THE AGE OF ST. LOUIS

During the time of Louis IX (r. 1226–1270; canonized as St. Louis in 1297), Paris became the artistic center of Europe. Artists from all over France were lured to the capital, responding to the growing local demand for new and remodeled buildings, as well as to the international demand for the extraordinary works of art that were the specialty of Parisian commercial workshops. Especially valued were small-scale objects in precious materials and richly illuminated manuscripts. The Parisian style of this period is often called the "Court Style," since its association with the court of St. Louis was one reason it spread beyond the capital to the courts of

The Sainte-Chapelle in Paris

In 1237, Baldwin II, Latin ruler of Constantinople—descendant of the crusaders who had snatched the Byzantine capital from Emperor Alexius III Angelus in 1204—was in Paris, offering to sell the relic of Christ's crown of thorns to his cousin, King Louis IX of France. The relic was at that time hocked in Venice, securing a loan to the cash-poor Baldwin, who had decided, rather than redeeming it, to sell it to the highest bidder. Louis purchased the relic in 1239, and on August 18, when the newly acquired treasure arrived at the edge of Paris, the humble, barefoot king carried it through the streets of his capital to the royal palace. Soon after its arrival, plans were under way to construct a glorious new palace building to house it—the Sainte-Chapelle, completed for its ceremonial consecration on April 26, 1248. In the 1244 charter establishing services in the Sainte-Chapelle, Pope Innocent IV claimed that Christ had crowned Louis with his own crown, strong confirmation for Louis's own sense of the sacred underpinnings of his kingship.

The Sainte-Chapelle is an extraordinary manifestation of the Gothic style. The two-story building (FIG. A)—there is both a lower and an upper liturgical space—is large for a chapel, and though it is now swallowed up into modern Paris, when it was built it was one of the tallest and most elaborately decorated buildings in the capital. The upper chapel is a completely open interior space surrounded by walls composed almost entirely of stained glass (FIG. B), presenting viewers with a glittering, multicolored expanse. Not only the king and his court experienced this chapel; members of the public came to venerate

and celebrate the relic, as well as to receive the indulgences offered to pious visitors. The Sainte-Chapelle resembles a reliquary made of painted stone and glass instead of gold and gems, turned inside out so that we experience it from within. But this arresting visual impression is only part of the story.

The stained-glass windows present extensive narrative cycles related to the special function of this chapel. Since they are painted in a bold, energetic style, the stories are easily legible, in spite of their breadth and complexity. Around the sanctuary's **hemicycle** (apse or semicircular interior space) are standard themes relating to the celebration of the Mass. But along

the straight side walls are broader, four-lancet windows whose narrative expanse is dominated by the exploits of the sacred kings and queens of the Hebrew Bible, heroes Louis claimed as his own royal ancestors. Above the recessed niche where Louis himself sat at Mass was a window filled with biblical kings, whereas in the corresponding niche on the other side of the chapel, his mother, Queen Blanche of Castile, and his wife, Queen Marguerite of Provence, sat under windows devoted to the lives of Judith and Esther, alternatively appropriate role models for medieval queens. Everywhere we look we see kings being crowned, leading soldiers into holy warfare, or performing royal duties, all framed with heraldic

A. SCHEMATIC DRAWING OF THE SAINTE-CHAPELLE
Paris. 1239–1248.

references to Louis and the French royal house. There is even a window that includes scenes from the life of Louis IX himself.

After the French Revolution, the Sainte-Chapelle was transformed into an archive, and some stained glass was removed to allow more light into the building. Deleted panels made their way onto the art market, and, in 1803, wealthy Philadelphia merchant William Powell bought three medallions from the Judith Window during a European tour, returning home to add them to his collection, the first in America to concentrate on medieval art. One portrays the armies of Holofernes crossing the Euphrates River (FIG. C). A compact crowd of equestrian warriors to the right conforms to a traditional system of representing crowds as a measured, overlapping mass of essentially identical figures, but the warrior at the rear of the battalion breaks the pattern, turning to acknowledge a knight behind him. The foreshortened rump of this soldier's horse projects out into our space, as if he were marching from our real world into the fictive world of the window—an avant-garde touch from a major artist working in the progressive climate of the mid-thirteenth-century Parisian art world.

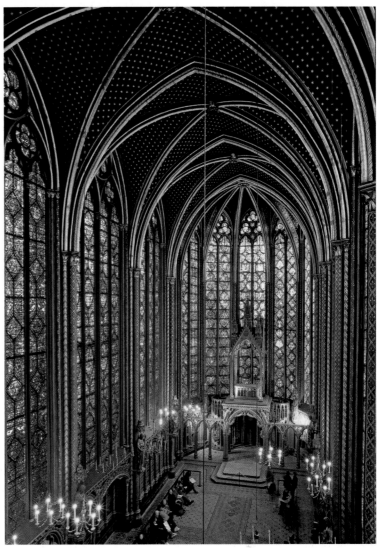

B. UPPER CHAPEL, THE SAINTE-CHAPELLE
Paris. 1239–1248.

C. HOLOFERNES' ARMY CROSSING THE EUPHRATES RIVER
From the Judith Window, the Sainte-Chapelle, Paris. c. 1245. Stained, painted, and leaded glass, diameter 23⁵/₁₆″ (59.2 cm). Philadelphia Museum of Art.

Villard de Honnecourt

One of the most fascinating and enigmatic works surviving from Gothic France is a set of 33 sheets of parchment covered with about 250 drawings in leadpoint and ink, signed by a man named Villard from the Picardy town of Honnecourt, and now bound into a book housed in the French National Library. Villard seems to have made these drawings in the 1220s and 1230s judging from the identifiable buildings that he recorded, during what seem to have been extensive travels, made for unknown reasons, mainly in France—where he recorded plans or individual details of the cathedrals of Cambrai, Chartres, Laon, and especially Reims—but also in Switzerland and Poland.

Villard seems simply to have drawn those things that interested him—animals, insects, human beings, church furnishings, buildings, and construction devices. Although the majority of his drawings have nothing to do with architecture, his renderings of aspects of Gothic buildings have received the most attention since the book was rediscovered in the mid nineteenth century, and led to a widespread belief that he was an architect or master mason. There is no evidence for this. In fact, the evidence we have argues against it, since the architectural drawings actually suggest the work of someone passionately interested in, but without a great deal of knowledge of, the structural systems and design priorities of Gothic builders. This in no way diminishes the value of this amazing document, which allows us rare access into the mind of a curious, well-traveled thirteenth-century amateur, who drew the things that caught his fancy in the extraordinary world around him.

A. Villard de Honnecourt **SHEET OF DRAWINGS WITH GEOMETRIC FIGURES**
c. 1230. Ink on vellum, 9¼ × 6″ (23.5 × 15.2 cm). Bibliothèque Nationale, Paris. MS. fr. 19093

This page, labeled "help in drawing figures according to the lessons taught by the art of geometry," demonstrates how geometric configurations underlie the shapes of natural forms and the designs of architectural features. They seem to give insight into the design process of Gothic artists, but could they also represent the fertile doodlings of a passionate amateur?

B. Villard de Honnecourt **DRAWINGS OF THE INTERIOR AND EXTERIOR ELEVATION OF THE NAVE OF REIMS CATHEDRAL**
c. 1230. Ink on vellum, 9¼ × 6″ (23.5 × 15.2 cm). Bibliothèque Nationale, Paris. MS. fr. 19093

Scholars still debate whether Villard's drawings of Reims Cathedral—the church he documented most extensively, with five leaves showing views and two containing details—were made from observing the building itself, during construction, or copied from construction drawings that had been prepared to guide the work of the masons. But in either case, what Villard documents here are those aspects of Reims that distinguish it from other works of Gothic architecture, such as the use of bar tracery, the enlarged central colonettes of the triforium, the broad bands of foliate carving on the pier capitals, or the statues of angels that perch on exterior buttresses. He seems to have grasped what it was that separated this building from the other cathedrals rising across France at this time.

EXPLORE MORE: Gain insight from a primary source related to Villard de Honnecourt **www.myartslab.com**

other European rulers. Parisian works became trans-European benchmarks of artistic quality and sophistication.

THE SAINTE-CHAPELLE IN PARIS. The masterpiece of the mid-thirteenth-century Parisian style is the Sainte-Chapelle (Holy Chapel) of the royal palace, commissioned by Louis IX to house his collection of relics of Christ's Passion, especially the crown of thorns (see "The Sainte-Chapelle in Paris," pages 508–509). In many ways this huge chapel can be seen as the culmination of the Gothic style that emerged from Suger's pioneering choir at Saint-Denis. The interior walls have been reduced to a series of slender piers and mullions that act as skeletal support for a vast skin of stained glass. The structure itself is stabilized by external buttressing that projects from the piers around the exterior of the building. Interlocking iron bars between the piers and concealed within the windows themselves run around the entire building, adding further stabilization. The viewer inside is unaware of these systems of support, being focused instead on the kaleidoscopic nature of this jewelbox reliquary and the themes of sacred kingship that dominate the program of stained-glass windows.

ILLUMINATED MANUSCRIPTS. Paris gained renown in the thirteenth century not only for its new architecture and sculpture but also for the production of books. Manuscript painters flocked to Paris from other regions to join workshops supervised by university officials who controlled the production and distribution of books. These works ranged from small Bibles used as textbooks by university students to extravagant devotional and theological works filled with exquisite miniatures for the use of wealthy patrons.

A particularly sumptuous Parisian book from the time of St. Louis is a three-volume Moralized Bible from c. 1230, in which selected scriptural passages are paired with allegorical or moralized interpretations, using pictures as well as words to convey the message. The dedication page **(FIG. 16–18)** shows the teenage King Louis IX and his mother, Queen Blanche of Castile, who served as regent of France (1226–1234) until he came of age. The royal pair—emphasized by their elaborate thrones and slightly oversized heads—appear against a solid gold background under a multicolored

architectural framework. Below them, a clerical scholar (left) dictates to a scribe, who seems to be working on a page from this very manuscript, with a column of roundels already outlined for paintings.

This design of stacked medallions—forming the layout for most of this monumental manuscript **(FIG. 16–19)**—clearly derives from stained-glass lancets with their columns of superimposed images (SEE FIG. 16–12). In the book, however, the schema combines pictures with words. Each page has two vertical strips of painted scenes set against a mosaiclike repeated pattern and filled out by half-quatrefoils in the interstices—the standard format of mid-thirteenth-century windows. Adjacent to each

16–18 • QUEEN BLANCHE OF CASTILE AND KING LOUIS IX
From a Moralized Bible made in Paris. 1226–1234. Ink, tempera, and gold leaf on vellum, 15 × 10½″ (38 × 26.6 cm). The Pierpont Morgan Library, New York. MS. M. 240, fol. 8r

16-19 • MORALIZATIONS FROM THE APOCALYPSE
From a Moralized Bible made in Paris. 1226–1234. Ink, tempera, and gold leaf on vellum, each page 15 × 10½" (38 × 26.6 cm). The Pierpont Morgan Library, New York. MS. M. 240, fol. 6r

people continued to live in rural villages and bustling market towns. Textile production dominated manufacture and trade, and fine embroidery continued to be an English specialty. The French Gothic style influenced English architecture and manuscript illumination, but these influences were tempered by local materials and methods, traditions and tastes. Notable is a continuing interest in using expressive line to enliven surface decoration.

MANUSCRIPT ILLUMINATION

The universities of Oxford and Cambridge dominated intellectual life, but monasteries continued to house active scriptoria, in contrast to France, where book production became centralized in the professional workshops of Paris. By the end of the thirteenth century, secular workshops became increasingly active in England, meeting demands for books from students as well as from royal and noble patrons.

MATTHEW PARIS. The monastic tradition of history writing that we saw in the Romanesque Worcester Chronicle (SEE FIG. 15–30) flourished into the Gothic period at the Benedictine monastery of St. Albans, where monk Matthew Paris (d. 1259) compiled a series of historical works. Paris wrote the texts of his chronicles, and he also added hundreds of marginal pictures that were integral to his history writing. The tinted drawings have a freshness that reveals the artist as someone working outside the rigid strictures of compositional conventions—or at least pushing against them. In one of his books, Paris included an almost full-page, framed image of the Virgin and Child in a tender embrace (FIG. 16–20). Under this picture, outside the sacred space of Mary and Jesus, Paris drew a picture of himself—identified not by likeness but by a label with his name, strung out in alternating red and blue capital letters behind him. He looks not at the holy couple, but at the words in front of him. These offer his commentary on the image, pointing to the affection shown in the playful Christ Child's movement toward his earthly mother, but emphasizing the authority he has as the divine incarnation of his godly father. Matthew Paris seems almost to hold his words in his hands, pushing them upward toward the object of his devotion.

THE WINDMILL PSALTER. The dazzling artistry and delight in ambiguity and contradiction that had marked early medieval manuscripts in the British Isles (SEE FIG. 14–1) also survived into the Gothic period in the Windmill Psalter of c. 1270–1280 (see "A Closer Look," page 514). The letter *B*—the first letter of

medallion is an excerpt of text, either a summary of a scriptural passage or a terse contemporary interpretation or allegory. Both painted miniatures and texts alternate between scriptural summaries and their moralizing explications, outlined in words and visualized with pictures. This adds up to a very learned and complicated compilation, perhaps devised by clerical scholars at the University of Paris, but certainly painted by some of the most important professional artists in the cosmopolitan French capital.

GOTHIC ART IN ENGLAND

Plantagenet kings ruled England from the time of Henry II and Eleanor of Aquitaine until 1485. Many were great patrons of the arts. During this period, London grew into a large city, but most

16–20 • Matthew Paris
SELF-PORTRAIT KNEELING BEFORE THE VIRGIN AND CHILD
From the *Historia Anglorum*, made in St. Albans, England. 1250–1259. Ink and color on parchment, 14 × 9¾" (35.8 × 25 cm). The British Library, London. Royal MS. 14.c.vii, fol. 6r

Psalm 1, which begins with the words *Beatus vir qui non abit in consilio impiorum* ("Happy are those who do not follow the advice of the wicked")—fills an entire left-hand page and outlines a densely interlaced thicket of tendrils and figures. This is a Tree of Jesse, a genealogical diagram of Jesus' royal and spiritual ancestors in the Hebrew Bible based on a prophesy in Isaiah 11:1–3. An oversized, semi-reclining figure of Jesse, father of King David, appears sheathed in a red mantle, with the blue trunk of a vinelike tree emerging from his side. Above him is his majestically enthroned royal son, who, as an ancestor of Mary (shown just above him), is also an ancestor of Jesus, who appears at the top of the sequence. In the circling foliage flanking this sacred royal family tree are a series of prophets, representing Jesus' spiritual heritage.

E, the second letter of the psalm's first word, appears at the top of the right-hand page and is formed from large tendrils emerging from delicate background vegetation to support characters in the story of the Judgment of Solomon portrayed within it (I Kings 3:16–27). Two women (one above the other at the right) claiming the same baby appear before King Solomon (enthroned on the crossbar) to settle their dispute. The king orders a guard to slice the baby in half with his sword and give each woman her share. This trick exposed the real mother, who hastened to give up her claim in order to save the baby's life. It has been suggested that the positioning of this story within the letter *E* may have made a subtle association between Solomon and the reigning King Edward I. The rest of the psalm's five opening words appear on a banner carried by an angel who swoops down at the bottom of the *E*.

The Opening of Psalm 1 in the Windmill Psalter

Psalm 1 (Beatus Vir). London, c. 1270–1280. Ink, pigments, and gold on vellum, each page 12¾ × 8¾" (32.3 × 22.2 cm). The Pierpont Morgan Library, New York. MS. 102, fols. Iv–2r

Although this page initially seems to have been trimmed at left, the flattened outside edge of the roundels marks the original end of the page. What might have started as an independent Jesse Tree may later have been expanded into the initial *B*, widening the pictorial composition farther than originally planned.

The four evangelists appear in the corner roundels as personified symbols writing at desks.

The windmill that has given this psalter its name seems to be a religious symbol based on the fourth verse of this Psalm: "Not so the wicked, not so: but like the dust, which the wind driveth from the face of the earth."

Tucked within the surrounds of the letter *B* are scenes from God's creation of the world, culminating in the forming of Adam and Eve. Medieval viewers would meditate on how the new Adam (Christ) and Eve (Mary)—featured in the Jesse Tree—had redeemed humankind from the sin of the first man and woman. Similarly, Solomon's choice of the true mother would recall Christ's choice of the true Church. Medieval manuscripts are full of cross-references and multiple meanings, intended to stimulate extended reflection and meditation, not embody a single truth or tell a single story.

Participants in this scene of the Judgment of Solomon here have been creatively distributed within the unusual narrative setting of the letter *E*. Solomon sits on the crossbar; the two mothers are stacked one above the other; and the knight balancing the baby has to hook his toe under the curling extension of the crossbar to maintain his balance.

SEE MORE: View the Closer Look feature for The Opening of Psalm I in the Windmill Psalter **www.myartslab.com**

ARCHITECTURE

The Gothic style in architecture appeared early in England, introduced by Cistercian and Norman builders and by traveling master masons. But in England there was less emphasis on height than in France. English churches have long, broad naves and screenlike façades.

SALISBURY CATHEDRAL. The thirteenth-century cathedral in Salisbury is an excellent example of English Gothic. It has unusual origins. The first cathedral in this diocese had been built within the castle complex of the local lord. In 1217, Bishop Richard Poore petitioned the pope to relocate the church, claiming the wind on the hilltop howled so loudly that the clergy could not hear themselves sing the Mass. A more pressing concern was probably his desire to escape the lord's control. As soon as he moved, the bishop established a new town, called Salisbury. Material from the old church was carted down the hill and used in the new cathedral, along with dark, fossil-filled Purbeck stone from quarries in southern England and limestone imported from Caen. Building began in 1220, and most of the cathedral was finished by 1258, an unusually short period for such an undertaking **(FIG. 16–21)**.

The west façade, however, was not completed until 1265. The small flanking towers project beyond the side walls and buttresses, giving the façade an increased width, underscored by tier upon tier of blind tracery and arcaded niches. Instead of a western rose window floating over triple portals (as seen in France), the English

16–21 • SALISBURY CATHEDRAL
England. Church building 1220–1258; west façade finished 1265; spire c. 1320–1330; cloister and chapter house 1263–1284.

SEE MORE: Click the Google Earth link for Salisbury Cathedral **www.myartslab.com**

16-22 • PLAN OF SALISBURY CATHEDRAL

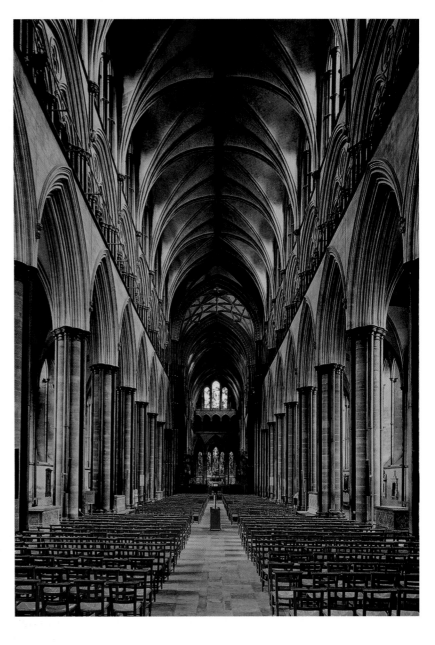

16-23 • NAVE OF SALISBURY CATHEDRAL

In the eighteenth century, the English architect James Wyatt subjected the building to radical renovations, during which the remaining stained glass and figure sculpture were removed or rearranged. Similar campaigns to refurbish medieval churches were common at the time. The motives of the restorers were complex and their results far from our notions of historical authenticity today.

master masons placed tall lancet windows above rather insignificant doorways. A mighty crossing tower (the French preferred a slender spire) became the focal point of the building. (The huge crossing tower and its 400-foot spire are a fourteenth-century addition at Salisbury, as are the flying buttresses, which were added to stabilize the tower.) The slightly later cloister and chapter house provided for the cathedral's clergy.

Salisbury has an equally distinctive plan (FIG. 16–22), with wide projecting double transepts, a square east end with a single chapel, and a spacious sanctuary—more like a monastic church. The nave interior reflects the Norman building tradition of heavy walls and a tall nave arcade surmounted by a gallery and a clerestory with simple lancet windows (FIG. 16–23). The walls alone are substantial enough to buttress the four-part ribbed vault. The emphasis on the horizontal movement of the arcades, unbroken by continuous vertical colonnettes extending from the compound piers, directs worshipers' attention forward toward the

altar behind the choir screen, rather than upward into the vaults, as preferred in France (SEE FIG. 16–17). The use of color in the stonework is reminiscent of the decorative effects in Romanesque interiors. The shafts supporting the four-part rib vaults are made of dark Purbeck stone that contrasts with the lighter limestone of the rest of the interior. The original painting and gilding of the stonework would have enhanced the effect.

MILITARY AND DOMESTIC ARCHITECTURE. Cathedrals were not the only buildings constructed during the Early and High Gothic periods. Western European knights who traveled east during the crusades were inspired by the architectural forms they saw in Muslim castles and Byzantine fortifications. When they returned home, Europeans built their own versions of these fortifications. Castle gateways now became complex, nearly independent fortifications, often guarded by twin towers rather than just one. New D-shape and round towers eliminated the corners that had

16-24 • EXTERIOR OF THE GREAT HALL, STOKESAY CASTLE
England. Late 13th century.

made earlier square towers vulnerable to battering rams, and crenellations (notches) were added to tower tops in order to provide stone shields for more effective defense. The outer, enclosing walls of the castles were strengthened. The open, interior space was enlarged and filled with more comfortable living quarters for the lord and wooden buildings to house the garrison and the staff necessary to repair armor and other equipment. Barns and stables for animals, including the extremely valuable war horses, were also erected within the enclosure.

STOKESAY CASTLE. Military structures were not the only secular buildings outfitted for defense. In uncertain times, the manor (a landed estate), which continued to be an important economic unit in the thirteenth century, also had to fortify its buildings. A country house that was equipped with a tower and crenellated rooflines became a status symbol as well as a necessity. Stokesay Castle, a remarkable fortified manor house, survives in England near the Welsh border. In 1291, a wool merchant, Lawrence of Ludlow, acquired the property of Stokesay and secured permission from King Edward I to fortify his dwelling—officially known as a "license to crenellate" **(FIG. 16–24)**. He built two towers, including a massive crenellated south tower and a great hall that still survive.

Life in the Middle Ages revolved around the hall. Windows on each side of Stokesay's hall open both toward the courtyard and out across a moat toward the countryside. By the thirteenth century, people began to expect some privacy as well as security; therefore at both ends of the hall are two-story additions that provided retiring rooms for the family and workrooms where women could spin and weave. Rooms on the north end could be reached from the hall, but the upper chamber at the south was accessible only by means of an exterior stairway. A tiny window—a peephole—let women and members of the household observe the often rowdy activities in the hall below. In layout, there was essentially no difference between this manor far from the London court and the mansions built by the nobility in the city. A palace followed the same pattern of hall and retiring rooms; it was simply larger than a manor.

GOTHIC ART IN GERMANY AND THE HOLY ROMAN EMPIRE

The Holy Roman Empire, weakened by internal strife and a prolonged struggle with the papacy, ceased to be a significant power in the thirteenth century. England and France were becoming strong nation-states, and the empire's hold on southern Italy and Sicily ended at mid century with the death of Emperor Frederick II. Subsequent emperors—who were elected—had only nominal authority over a loose conglomeration of independent principalities, bishoprics, and free cities. As in England, the French Gothic style, avidly embraced in the western Germanic territories, shows regional adaptations and innovations.

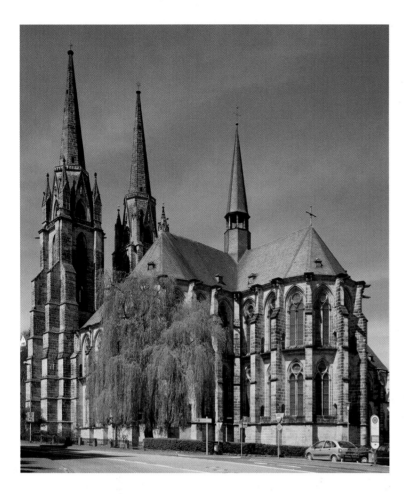

of windows suggest a two-story building, which is not the case. Inside, the closely spaced piers of the nave support the ribbed vault and, as with the buttresses, give the building a vertical, linear quality (FIG. 16–26). Light from the two stories of tall windows fills the interior, unimpeded by walls, galleries, or triforia (plural of triforium, arcaded wall passageways). The hall-church design was adopted widely for civic and residential buildings in Germanic lands and also for Jewish architecture.

THE ALTNEUSCHUL. Built in the third quarter of the thirteenth century, Prague's **ALTNEUSCHUL** ("Old-New Synagogue") is the oldest functioning synagogue in Europe and one of two principal synagogues serving the Jews of Prague (FIG. 16–27). The Altneuschul demonstrates the adaptability of the Gothic hall-church design for non-Christian use. Like a hall church, the vaults of the synagogue are all the same height. Unlike a basilican church, however, with its division into nave and side aisles, the Altneuschul has only two aisles, each with three bays supported by the

ARCHITECTURE

In the thirteenth century, the increasing importance of the sermon in church services led architects in Germany to develop the **hall church**, a type of open, light-filled interior space that appeared in Europe in the early Middle Ages, characterized by a nave and side aisles of equal height. The spacious and well-lit design of the hall church provided accommodation for the large crowds drawn by charismatic preachers.

CHURCH OF ST. ELIZABETH OF HUNGARY IN MARBURG. Perhaps the first true Gothic hall church, and one of the earliest Gothic buildings in Germany, was the **CHURCH OF ST. ELIZABETH OF HUNGARY** in Marburg (FIG. 16–25). The Hungarian princess Elizabeth (1207–1231) had been sent to Germany at age 4 to marry the ruler of Thuringia. He soon died of the plague, and she devoted herself to caring for people with incurable diseases. It was said that she died at age 24 from exhaustion, and she was canonized in 1235. Between 1235 and 1283, the knights of the Teutonic Order (who had moved to Germany from Jerusalem) built a church to serve as her mausoleum and a center of pilgrimage.

The plan of the church is an early German form, a **trefoil** (three-lobed design) with choir and transepts of equal size. The elevation of the building, however, is new—the nave and aisles are of equal height. On the exterior wall, buttresses run the full height of the building and emphasize its verticality. The two rows

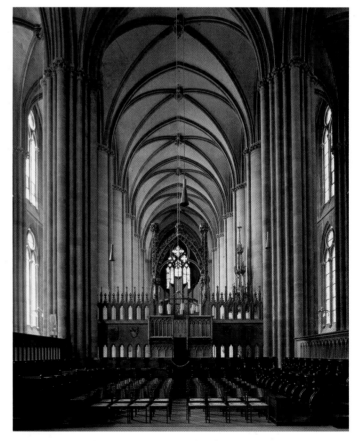

16-26 • INTERIOR, CHURCH OF ST. ELIZABETH OF HUNGARY Marburg, Germany. 1235–1283.

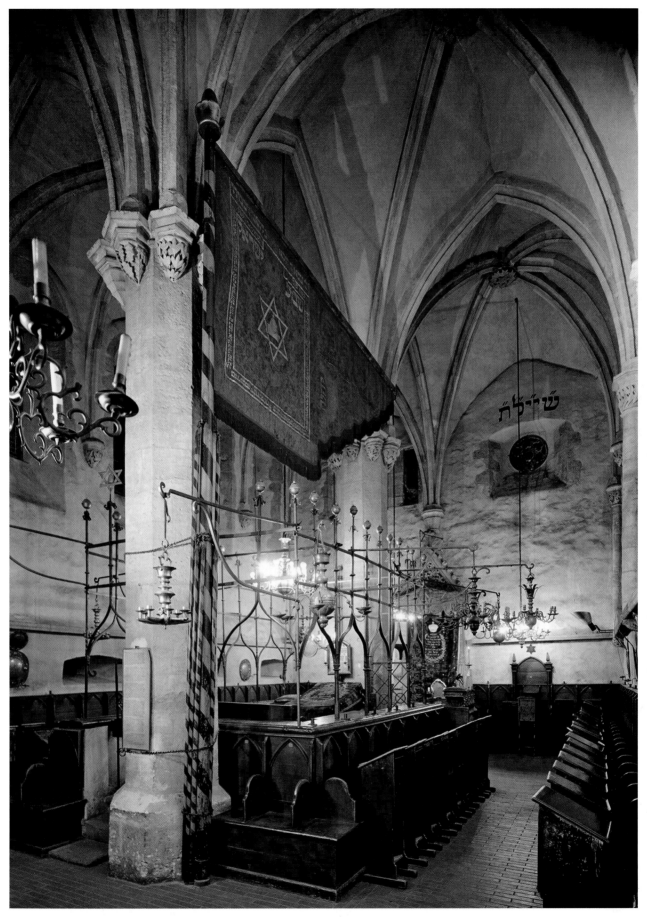

16-27 • INTERIOR, ALTNEUSCHUL
Prague, Bohemia (Czech Republic). c. late 13th century; *bimah* after 1483.

walls and two octagonal piers. The bays have Gothic four-part ribbed vaulting to which a nonfunctional fifth rib has been added. Some say that this fifth rib was added to undermine the cross form made by the intersecting diagonal ribs.

The medieval synagogue was both a place of prayer and a communal center of learning and inspiration where men gathered to read and discuss the Torah. The synagogue had two focal points, the *aron*, or shrine for the Torah scrolls, and a raised reading platform called the *bimah*. The congregation faced the *aron*, which was located on the east wall, in the direction of Jerusalem. The *bimah* stood in the center of the hall, straddling the two center bays, and in Prague it was surrounded by an ironwork open screen. The single entrance was placed off-center in a corner bay at the west end. Men worshiped and studied in the main space; women had to worship in annexes on the north and west sides.

SCULPTURE

One of the most creative centers of European sculpture since the eleventh century had been the Rhine River Valley and the region known as the Mosan (from the Meuse River, in present-day Belgium), with centers in Liège and Verdun. Ancient Romans had built camps and cities in this area, and Classical influence lingered on through the Middle Ages. Nicholas of Verdun and his fellow goldsmiths inspired a new classicizing style in the arts.

SHRINE OF THE THREE KINGS. For the archbishop of Cologne, Nicholas created the magnificent **SHRINE OF THE THREE KINGS** (c. 1190–c. 1205/10), a reliquary for what were believed to be relics of the three Magi. Shaped in the form of a basilican church (**FIG. 16–28**), it is made of gilded bronze and silver, set with gemstones and dark blue enamel plaques that accentuate its architectural details. Like his fellow Mosan artists, Nicholas was inspired by ancient Roman art still found in the region, as well as classicizing Byzantine works. The figures are lifelike, fully modeled, and swathed in voluminous but revealing drapery. The three Magi and the Virgin fill the front gable end, and prophets and apostles sit in the niches in the two levels of arcading on the sides. The work combines robust, expressively mobile sculptural forms with a jeweler's exquisitely ornamental detailing to create an opulent, monumental setting for its precious contents.

ST. MAURICE. A powerful current of realism runs through German Gothic sculpture. Some works seem to be carved after a living model. Among them is an arresting mid-thirteenth-century statue of **ST. MAURICE** in Magdeburg Cathedral (**FIG. 16–29**), the location of his relics since 968. The Egyptian Maurice, a commander in the Roman army, was martyred in 286 together with his Christian battalion while they were stationed in Germany. As patron saint of Magdeburg, he was revered by Ottonian

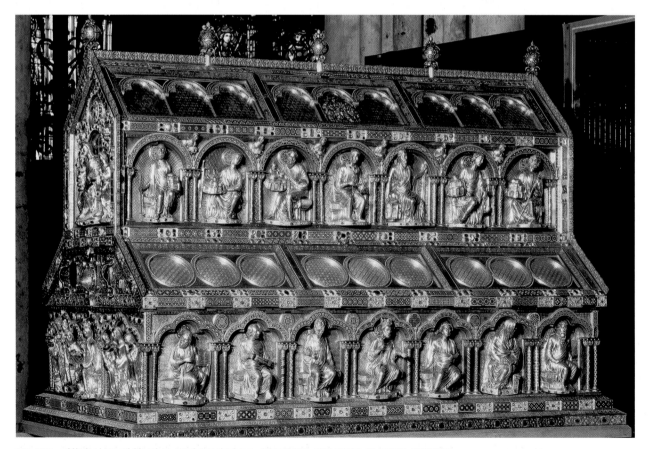

16-28 • Nicholas of Verdun and workshop SHRINE OF THE THREE KINGS
Cologne (Köln) Cathedral, Germany. c. 1190–c. 1205/10. Silver and gilded bronze with enamel and gemstones, 5′8″ × 6′ × 3′8″ (1.73 × 1.83 × 1.12 m).

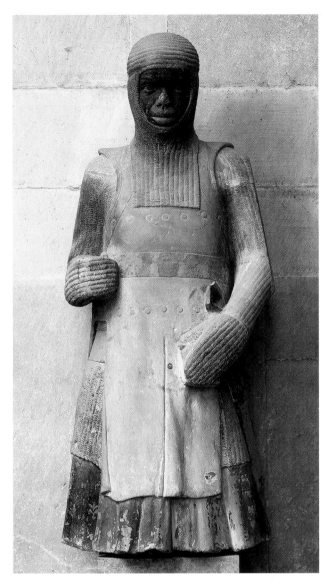

16-29 • ST. MAURICE
Magdeburg Cathedral, Magdeburg, Germany. c. 1240–1250.
Dark sandstone with traces of polychromy.

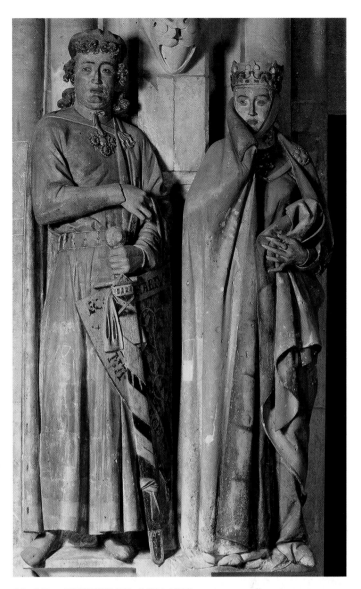

16-30 • EKKEHARD AND UTA
West chapel, Naumburg Cathedral, Germany. c. 1245–1260.
Stone with polychromy, height approx. 6′2″ (1.88 m).

emperors, who were anointed in St. Peter's in Rome at the altar of St. Maurice. He remained a favorite saint of military aristocrats. This is the first surviving representation of Maurice as a black African, an acknowledgment of his Egyptian origins and an aspect of the growing German interest in realism, which extends here to the detailed rendering of his costume of chain mail and riveted leather.

EKKEHARD AND UTA. Equally portraitlike is the depiction of this couple, commissioned about 1245 by Dietrich II, bishop of Wettin, for the family funeral chapel, built at the west end of Naumburg Cathedral. Bishop Dietrich ordered life-size statues of 12 of his ancestors, who had been patrons of the church, to be placed on pedestals mounted at window level around the chapel.

In the representations of Margrave Ekkehard of Meissen (a margrave—count of the march or border—was a territorial governor whose duty it was to defend the frontier) and his Polish-born wife, Uta **(FIG. 16–30)**, the sculptor created highly individualized figures and faces. Since these are eleventh-century people, sculpted in the thirteenth century, we are not looking at portrait likenesses of Ekkehard and Uta themselves, but it is still possible that live models were used to heighten the sense of a living presence in their portraits. But more than their faces contribute to this liveliness. The margrave nervously fingers the strap of the shield that is looped over his arm, and the coolly elegant Uta pulls her cloak around her neck as if to protect herself from the cold, while the extraordinary spread of her left hand is necessary to control the voluminous, thick cloth. The survival of original **polychromy** (multicolored painting on the surface of sculpture or architecture) indicates that color added to the impact of the figures. The impetus toward descriptive realism and psychological presence, initiated in the thirteenth century, will expand in the art of northern Europe into the fifteenth century and beyond.

GOTHIC ART IN ITALY

The thirteenth century was a period of political division and economic expansion for the Italian peninsula. Part of southern Italy and Sicily was controlled by Frederick II von Hohenstaufen (1194–1250), Holy Roman emperor from 1220. Frederick was a politically unsettling force. He fought with a league of north Italian cities and briefly controlled the Papal States. On his death, however, Germany and the Holy Roman Empire ceased to be an important factor in Italian politics and culture.

In northern Italy, in particular, organizations of successful merchants created communal governments in their prosperous and independent city-states and struggled against powerful families for political control. Artists began to emerge as independent agents, working directly with wealthy clients and with civic and religious institutions.

It was during this time that new religious orders known as the mendicants (begging monks) arose to meet the needs of the growing urban population. They espoused an ideal of poverty, charity, and love, and they dedicated themselves to teaching and preaching, while living among the urban poor. Most notable in the beginning were the Franciscans, founded by St. Francis of Assisi (1182–1226; canonized in 1228). This son of a wealthy merchant gave away his possessions and devoted his life to God and the poor. As others began to join him, he wrote a simple rule for his followers, who were called brothers, or friars (from the Latin *frater*, meaning "brother"), and the pope approved the new order in 1209–1210.

SCULPTURE: THE PISANO FAMILY

During his lifetime, the culturally enlightened Frederick II had fostered a Classical revival. He was a talented poet, artist, and naturalist, and an active patron of the arts and sciences. In the Romanesque period, artists in southern Italy had already turned to ancient sculpture for inspiration, but Frederick, mindful of his imperial status as Holy Roman emperor, encouraged this tendency to help communicate a message of power. He also encouraged artists to emulate the natural world around them. Nicola Pisano (active in Tuscany c. 1258–1278), who moved from the southern region of Apulia to Tuscany at mid century, became the leading exponent of this classicizing and naturalistic style.

NICOLA PISANO'S PULPIT AT PISA. In an inscription on a free-standing marble pulpit in the Pisa Baptistery **(FIG. 16–31)**, Nicola identifies himself as a supremely self-confident sculptor: "In the year 1260 Nicola Pisano carved this noble work. May so gifted a hand be praised as it deserves." Columns topped with leafy Corinthian capitals support standing figures and Gothic trefoil arches, which in turn provide a platform for the six-sided pulpit. The columns rest on high bases carved with crouching figures, domestic

16-31 • Nicola Pisano PULPIT
Baptistery, Pisa, Italy. 1260. Marble, height approx. 15′ (4.6 m).

On the morning of September 27, 1997, tragedy struck. An earthquake convulsed the small town of Assisi, shaking the church of St. Francis and damaging architecture and frescos. Where the vault collapsed, priceless frescos crumbled and plunged to the floor. The photographer Ghigo Roli had just finished recording every painted surface of the interior when the sound of the first earthquake was heard in the basilica. As the building shook and the paintings fell, "I wanted to cry," he later wrote.

When such disasters happen, the whole world seems to respond. Volunteers immediately raised money to restore the frescos, with the hope and intention of paying the costs of repairing and strengthening the basilica, reassembling the paintings from millions of tiny pieces, and finally reinstalling the restored treasures. So successful was the effort that visitors today would not guess that an earthquake had brought down the vault shown here scarcely more than a decade ago. But in other parts of the church the remains are insufficient to reconstruct entire paintings, and computers work to match the fragments and bring together at least sections of them.

CHURCH OF ST. FRANCIS, ASSISI, ITALY: RESTORED
Painting dating 1228–1253.

CHURCH OF ST. FRANCIS, ASSISI, ITALY: DURING THE 1997 EARTHQUAKE
Caught by a television camera during the quake, some of the vaults and archivolts in the upper church plunged to the floor, killing four people. The camera operator eventually emerged, covered with the fine dust of the shattered brickwork and plaster, as a "white, dumbfounded phantom."

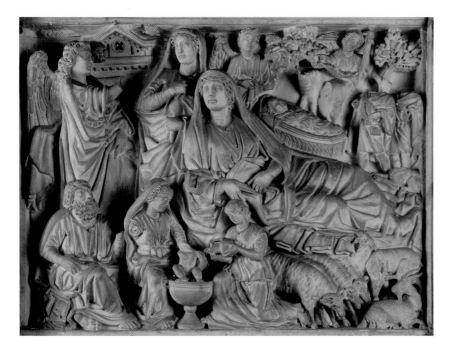

animals, and shaggy-maned lions. Panels forming the pulpit enclosure illustrate New Testament subjects, each framed as an independent composition.

Each panel illustrates several scenes in a continuous narrative; FIG. **16–32** depicts the Annunciation, Nativity, and Adoration of the Shepherds. The Virgin reclines in the middle of the composition after having given birth to Jesus, who below receives his first bath from midwives. The upper left-hand corner holds the Annunciation—the moment of Christ's conception, as announced by the archangel Gabriel. The scene in the upper right combines the Annunciation to the Shepherds with their Adoration of the Child. The viewer's attention moves from group to group within the shallow space, always returning to the regally detached mother of God. The format, style, and technique of Roman sarcophagus reliefs—readily accessible in the burial ground near the baptistery—may have provided Nicola's models for this carving. The sculptural treatment of the deeply cut, full-bodied forms is certainly Classical in inspiration, as are the heavy, placid faces.

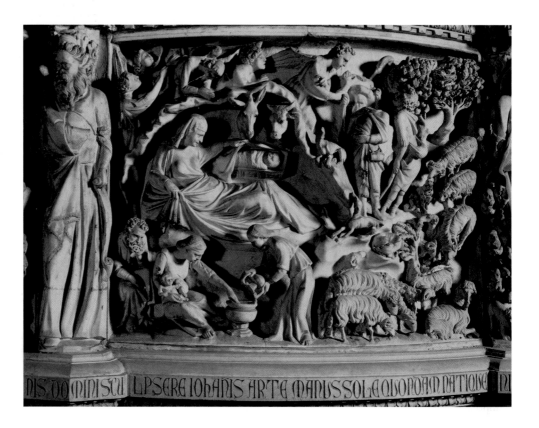

16–33 • Giovanni Pisano
NATIVITY
Detail of pulpit, Cathedral, Pisa. 1302–1310. Marble, 34⅜ × 43″ (87.2 × 109.2 cm).

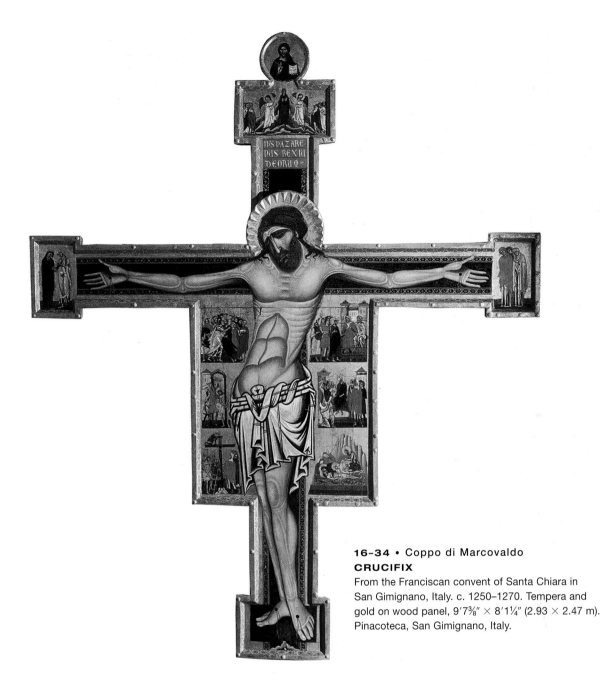

16-34 • Coppo di Marcovaldo
CRUCIFIX
From the Franciscan convent of Santa Chiara in San Gimignano, Italy. c. 1250–1270. Tempera and gold on wood panel, 9'7⅜" × 8'1¼" (2.93 × 2.47 m). Pinacoteca, San Gimignano, Italy.

GIOVANNI PISANO'S PULPIT AT PISA. Nicola's son Giovanni (active c. 1265–1314) assisted his father while learning from him, and he may also have worked or studied in France. By the end of the thirteenth century, he had emerged as a versatile artist in his own right. Between 1302 and 1310, he and his workshop carved a huge pulpit for Pisa Cathedral that is similar to his father's in conception but significantly different in style and execution. In his rendering of the **NATIVITY**, Giovanni places graceful, animated figures in an uptilted, deeply carved setting (FIG. 16–33). He replaces Nicola's imperious Roman matron with a lithe, younger Mary who, sheltered by a shell-like cave, gazes delightedly at her baby. Below her, a midwife who had doubted the virgin birth has her withered hand restored while preparing the baby's bath water. Sheep, shepherds, and angels spiral up through the trees at the right and more angelic onlookers replace the Annunciation. Giovanni's sculpture is as dynamic as Nicola's is static.

PAINTING

The capture of Constantinople by crusaders in 1204 brought an influx of Byzantine art and artists to Italy. The imported style of painting, the *maniera greca* ("the Greek manner"), influenced thirteenth- and fourteenth-century Italian painting in style and technique and introduced a new emphasis on pathos and emotion.

PAINTED CRUCIFIXES. One example, a large wooden crucifix attributed to the thirteenth-century Florentine painter Coppo di Marcovaldo (FIG. 16–34), represents an image of a suffering Christ on the cross, a Byzantine type with closed eyes and bleeding, sagging body that encourages viewers to respond emotionally and empathetically to the image (SEE FIGS. 7–35, 14–23). This is a "historiated crucifix," meaning that narrative scenes flank Christ's body, in this case episodes from the story of his Passion. Such monumental crosses—this one is almost 10 feet

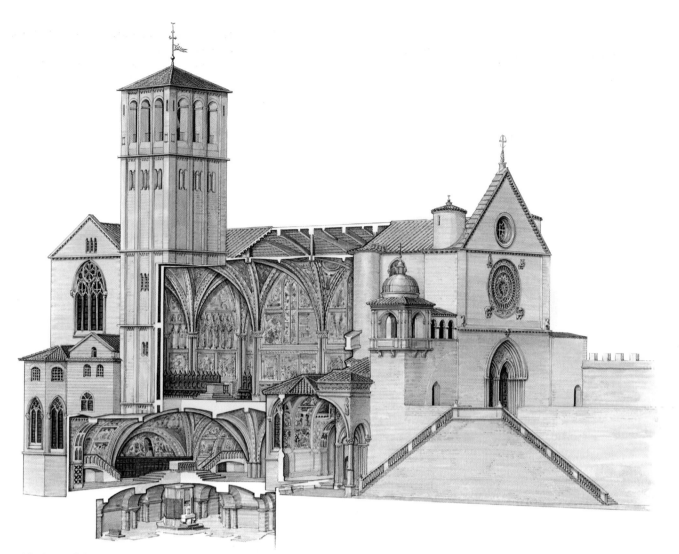

16-35 • SCHEMATIC DRAWING OF THE CHURCH OF ST. FRANCIS
Assisi, Italy. 1228–1253.

high—were mounted on the choir screens that separated the clergy in the sanctuary from the lay people in the nave, especially in the churches of the Italian mendicants. One such cross can be seen from behind with its wooden bracing in FIG. 16–36, tilted out to lean toward the worshiper's line of vision and increase the emotional impact.

THE CHURCH OF ST. FRANCIS AT ASSISI. Two years after St. Francis's death in 1226, the church in his birthplace, Assisi, was begun. It was nearly finished in 1239 but was not dedicated until 1253. This building was unusually elaborate in its design, with upper and lower churches on two stories and a crypt at the choir end underneath both (FIG. 16–35). Both upper and lower churches have a single nave of four square vaulted bays, and both end in a transept and a single apse. The lower church has massive walls and a narrow nave flanked by side chapels. The upper church is a spacious, well-lit hall with excellent visibility and acoustics, designed to accommodate the crowds of pilgrims who came to see and hear the friars preach as well as to participate in church rituals and venerate the tomb of the saint. The church walls

presented expanses of uninterrupted wall surface where sacred stories could unfold in murals. In the wall paintings of the upper church, the focus was on the story of Francis himself, presented as a model Christian life to which pilgrims as well as resident friars might aspire.

Scholars differ over whether the murals of the upper church were painted as early as 1290, but they agree on their striking narrative effectiveness. Like most Franciscan paintings, these scenes were designed to engage with viewers by appealing to their memories of their own life experiences, evoked by the inclusion of recognizable anecdotal details and emotionally expressive figures. A good example is **THE MIRACLE OF THE CRIB AT GRECCIO** (FIG. 16–36), portraying St. Francis making the first Christmas manger scene in the church at Greccio.

The scene—like all Gothic visual narratives, set in the pres-ent even though the event portrayed took place in the past—unfolds within a Gothic church that would have looked very familiar to late thirteenth-century viewers. A large wooden crucifix, similar to the one by Coppo di Marcovaldo (SEE FIG. 16–34), has been suspended from a stand on top of a screen

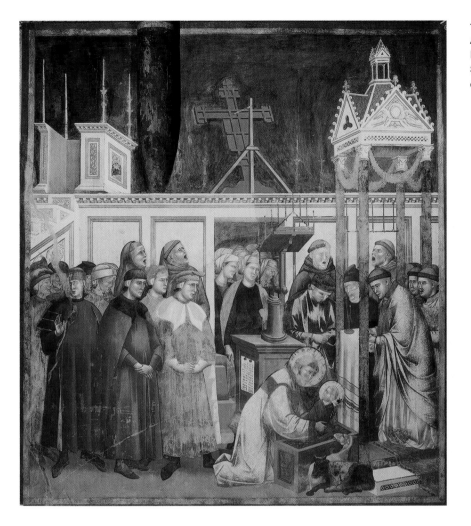

16-36 • THE MIRACLE OF THE CRIB AT GRECCIO

From a cycle of the Life of St. Francis, church of St. Francis, Assisi, Italy. Late 13th or early 14th century. Fresco.

separating the sanctuary from the nave. The cross has been reinforced on the back and tilted forward to hover over people in the nave, whom we see crowding behind an open door in the choir screen. A pulpit, with stairs leading up to its entrance and candlesticks at its corners, rises above the screen at the left. An elaborate carved baldacchino (canopy) surmounts the altar at the right, and an adjustable wooden lectern stands in front of the altar. Other small but telling touches include a seasonal liturgical calendar posted on the lectern, foliage swags decorating the baldacchino, and an embroidered altar cloth. And sound as well as sight is referenced here in the figures of the friars who throw their heads back, mouths wide open, to provide the liturgical soundtrack to this cinematic tableau.

The focus on the sacred narrative is confined to a small area at lower right, where St. Francis reverently holds the Holy Infant above a plain, boxlike crib next to miniature representations of various animals that might have been present at the Nativity, capturing the miraculous moment when, it was said, the Christ Child himself appeared in the manger. But even if the story is about a miracle, it takes place in a setting rich in worldly references that allowed contemporary viewers to imagine themselves as part of the scene, either as worshipers kneeling in front of the altar or as spectators pushing toward the doorway to get a better view.

THINK ABOUT IT

16.1 What are the most important technological innovations and sociocultural formations that made the "Age of the Cathedrals" possible?

16.2 Analyze Salisbury Cathedral in England and the German church of St. Elizabeth of Hungary in Marburg. How does each reflect characteristics of French Gothic style, and how does each depart from that style and express architectural features characteristic of its region?

16.3 Explain the process for making medieval stained glass, and trace its development as the key pictorial medium in France during the Gothic period from the abbey church of Saint-Denis to the Parisian Sainte-Chapelle. What are the similarities and differences when comparing windows from these two sites?

16.4 Explain how manuscript illumination was used to convey complex theological ideas during the Gothic period. Analyze the iconography of one manuscript discussed in the chapter.

16.5 How was St. Francis of Assisi's message of empathy conveyed in the church of St. Francis?

PRACTICE MORE: Compose answers to these questions, get flashcards for images and terms, and review chapter material with quizzes
www.myartslab.com

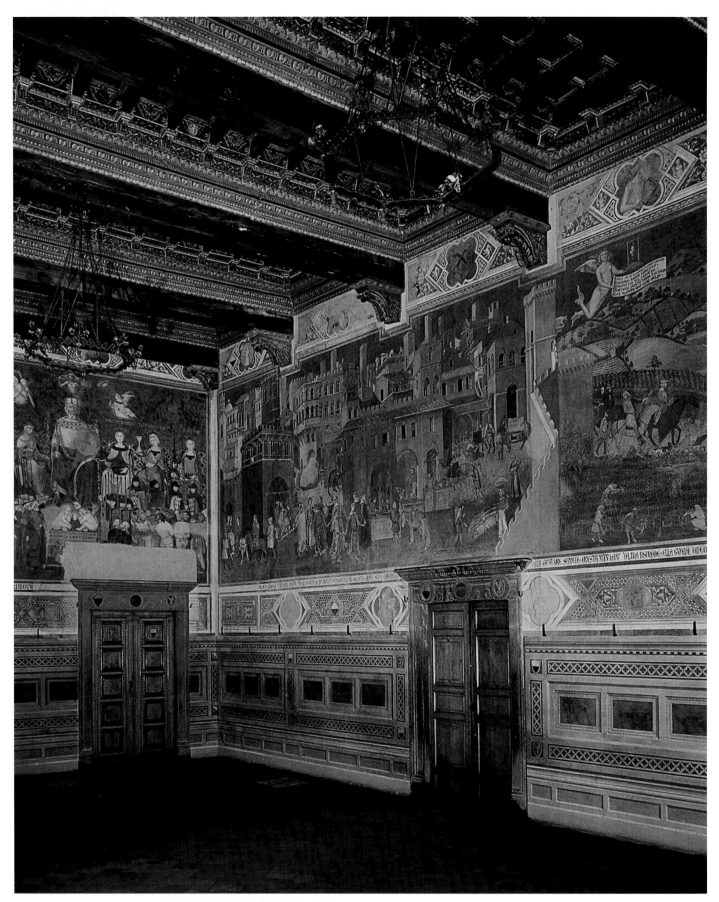

17–1 • Ambrogio Lorenzetti FRESCOS OF THE SALA DEI NOVE (OR SALA DELLA PACE)
Palazzo Pubblico, Siena, Italy. 1338–1339. Length of long wall about 46′ (14 m).

EXPLORE MORE: Gain insight from a primary source related to the frescos in the Palazzo Pubblico
www.myartslab.com

FOURTEENTH-CENTURY ART IN EUROPE

In 1338, the Nine—a council of merchants and bankers that governed Siena as an oligarchy—commissioned frescos from renowned Sienese painter Ambrogio Lorenzetti (c. 1295–c. 1348) for three walls in the chamber within the Palazzo Pubblico where they met to conduct city business. This commission came at the moment of greatest prosperity and security since the establishment of their government in 1287.

Lorenzetti's frescos combine allegory with panoramic landscapes and cityscapes, communicating ideology to visualize the justification for and positive effects of Sienese government. The moral foundation of the rule of the Nine is outlined in a complicated allegory in which seated personifications (far left in **FIG. 17–1**) of Concord, Justice, Peace, Strength, Prudence, Temperance, and Magnanimity not only diagram good governance but actually reference the Last Judgment in a bold assertion of the relationship between secular rule and divine authority. This tableau contrasts with a similar presentation of bad government, where Tyranny is flanked by the personified forces that keep tyrants in power—Cruelty, Treason, Fraud, Fury, Division, and War. A group of scholars would have devised this complex program of symbols and meanings; it is unlikely that Lorenzetti would have known the philosophical works that underlie them.

Lorenzetti's fame, however, and the wall paintings' secure position among the most remarkable surviving mural programs of the period, rests on the other part of this ensemble—the effects of good and bad government in city and country life (SEE FIG. 17–15).

Unlike the tableau showing the perils of life under tyrannical rule, the panoramic view of life under good government—which in this work of propaganda means life under the rule of the Nine—is well preserved. A vista of fourteenth-century Siena—identifiable by the cathedral dome and tower peeking over the rooftops in the background—details carefree life within shops, schools, taverns, and worksites, as the city streets bustle with human activity. Outside, an expansive landscape highlights agricultural productivity.

Unfortunately, within a decade of the frescos' completion, life in Siena was no longer as stable and carefree. The devastating bubonic plague visited in 1348—Ambrogio Lorenzetti himself was probably one of the victims—and the rule of the Nine collapsed in 1355. But this glorious vision of joyful prosperity preserves the dreams and aspirations of a stable government, using some of the most progressive and creative ideas in fourteenth-century Italian art, ideas whose development we will trace over the next two centuries.

LEARN ABOUT IT

17.1 Assess the close connections between works of art and their patrons in fourteenth-century Europe.

17.2 Compare and contrast the Florentine and Sienese narrative painting traditions as exemplified by Giotto and Duccio.

17.3 Discover the rich references to everyday life and human emotions that begin to permeate figural art in this period.

17.4 Explore the production of small-scale works, often made of precious materials and highlighting extraordinary technical virtuosity, that continues from the earlier Gothic period.

17.5 Evaluate the regional manifestations of the fourteenth-century Gothic architectural style.

HEAR MORE: Listen to an audio file of your chapter **www.myartslab.com**

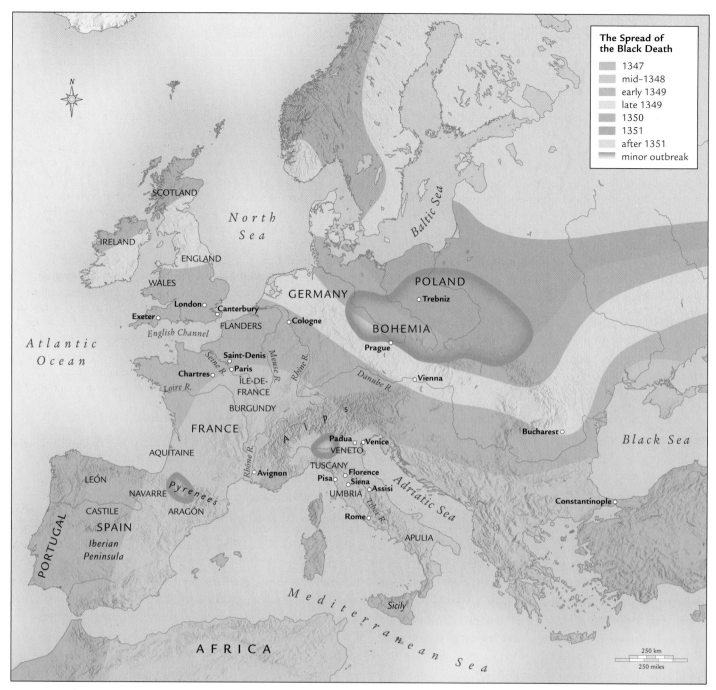

MAP 17-1 • EUROPE IN THE FOURTEENTH CENTURY

From its outbreak in the Mediterranean the Black Death in 1347 swept across the European mainland over the next four years.

FOURTEENTH-CENTURY EUROPE

Literary luminaries Dante, Petrarch, Boccaccio, Chaucer, and Christine de Pizan (see "A New Spirit in Fourteenth-Century Literature," opposite) and the visionary painters Cimabue, Duccio, Jean Pucelle, and Giotto participated in a cultural explosion that swept through fourteenth-century Europe, and especially Italy. The poet Petrarch (1304–1374) was a towering figure in this change, writing his love lyrics in Italian, the language of everyday life, rather than Latin, the language of ceremony and high art. Similarly the deeply moving murals of Florentine painter Giotto di Bondone (c. 1277–1337) were rooted in his observation of the people around him, giving the participants in sacred narratives both great dignity and striking humanity, thus making them familiar, yet new, to the audiences that originally experienced them. Even in Paris—still the artistic center of Europe as far as refined taste and technical

A New Spirit in Fourteenth-Century Literature

For Petrarch and his contemporaries, the essential qualifications for a writer were an appreciation of Greek and Roman authors and an ability to observe the people living around them. Although fluent in Latin, they chose to write in the language of their own time and place—Italian, English, French. Leading the way was Dante Alighieri (1265–1321), who wrote *The Divine Comedy*, his great summation of human virtue and vice, and ultimately human destiny, in Italian, establishing his daily vernacular as worthy to express great literary themes.

Francesco Petrarca, called simply Petrarch (1304–1374), raised the status of secular literature with his sonnets to his unobtainable beloved, Laura, his histories and biographies, and his writings on the joys of country life in the Roman manner. Petrarch's imaginative updating of Classical themes in a work called *The Triumphs*—which examines the themes of Chastity triumphant over Love, Death over Chastity, Fame over Death, Time over Fame, and Eternity over Time—provided later Renaissance poets and painters with a wealth of allegorical subject matter.

More earthy, Giovanni Boccaccio (1313–1375) perfected the art of the short story in *The Decameron*, a collection of amusing and moralizing tales told by a group of young Florentines who moved to the countryside to escape the Black Death. With wit and sympathy, Boccaccio presents the full spectrum of daily life in Italy. Such secular literature, written in Italian as it was then spoken in Tuscany, provided a foundation for fifteenth-century Renaissance writers.

In England, Geoffrey Chaucer (c. 1342–1400) was inspired by Boccaccio to write his own series of stories, *The Canterbury Tales*, told by pilgrims traveling to the shrine of St. Thomas à Becket (1118?–1170) in Canterbury. Observant and witty, Chaucer depicted the pretensions and foibles, as well as the virtues, of humanity.

Christine de Pizan (1364–c. 1431), born in Venice but living and writing at the French court, became an author out of necessity when she was left a widow with three young children and an aged mother to support. Among her many works are a poem in praise of Joan of Arc and a history of famous women—including artists—from antiquity to her own time. In *The Book of the City of Ladies*, she defended women's abilities and argued for women's rights and status.

These writers, as surely as Giotto, Duccio, Peter Parler, and Master Theodoric, led the way into a new era.

sophistication were concerned—the painter Jean Pucelle began to show an interest in experimenting with established conventions.

Changes in the way that society was organized were also under way, and an expanding class of wealthy merchants supported the arts as patrons. Artisan guilds—organized by occupation—exerted quality control among members and supervised education through an apprenticeship system. Admission to the guild came after examination and the creation of a "masterpiece"—literally, a piece fine enough to achieve master status. The major guilds included cloth finishers, wool merchants, and silk manufacturers, as well as pharmacists and doctors. Painters belonged to the pharmacy guild, perhaps because they used mortars and pestles to grind their colors. Their patron saint, Luke, who was believed to have painted the first image of the Virgin Mary, was also a physician—or so they thought. Sculptors who worked in wood and stone had their own guild, while those who worked in metals belonged to another. Guilds provided social services for their members, including care of the sick and funerals for the deceased. Each guild had its patron saint, maintained a chapel, and participated in religious and civic festivals.

Despite the cultural flourishing and economic growth of the early decades, by the middle of the fourteenth century much of Europe was in crisis. Prosperity had fostered population growth, which began to exceed food production. A series of bad harvests compounded this problem with famine. To make matters worse, a prolonged conflict known as the Hundred Years' War (1337–1453) erupted between France and England. Then, in mid century, a lethal plague known as the Black Death swept across Europe (**MAP 17–1**), wiping out as much as 40 percent of the population. In spite of these catastrophic events, however, the strong current of cultural change still managed to persist through to the end of the century and beyond.

ITALY

As great wealth promoted patronage of art in fourteenth-century Italy, artists began to emerge as individuals, in the modern sense, both in their own eyes and in the eyes of patrons. Although their methods and working conditions remained largely unchanged from the Middle Ages, artists in Italy contracted freely with wealthy townspeople and nobles as well as with civic and religious bodies. Perhaps it was their economic and social freedom that encouraged ambition and self-confidence, individuality and innovation.

FLORENTINE ARCHITECTURE AND METALWORK

The typical medieval Italian city was a walled citadel on a hilltop. Houses clustered around the church and an open city square. Powerful families added towers to their houses, both for defense

17-2 • PIAZZA DELLA SIGNORIA WITH PALAZZO DELLA SIGNORIA (TOWN HALL) 1299-1310, AND LOGGIA DEI LANZI (LOGGIA OF THE LANCERS), 1376-1382
Florence.

SEE MORE: Click the Google Earth link for the Palazzo della Signoria www.myartslab.com

and as expressions of family pride. In Florence, by contrast, the ancient Roman city—with its axial rectangular plan and open city squares—formed the basis for civic layout. The cathedral stood northeast of the ancient forum and a street following the Roman plan connected it with the Piazza della Signoria, the seat of the government.

THE PALAZZO DELLA SIGNORIA. The Signoria (ruling body, from *signore*, meaning "Lord") that governed Florence met in the **PALAZZO DELLA SIGNORIA**, a massive fortified building with a tall bell tower 300 feet high **(FIG. 17–2)**. The building faces a large square, or piazza, which became the true center of Florence. The town houses around the piazza often had benches along their walls to provide convenient public seating. Between 1376 and 1382,

master builders Benci di Cione and Simone Talenti constructed a huge **loggia** or covered open-air corridor at one side—now known as the Loggi dei Lanzi (Loggia of the Lancers)—to provide a sheltered locale for ceremonies and speeches.

THE BAPTISTERY DOORS. In 1330, Andrea Pisano (c. 1290–1348) was awarded the prestigious commission for a pair of gilded bronze doors for the Florentine Baptistery of San Giovanni, situated directly in front of the cathedral. (Andrea's "last" name means "from Pisa;" he was not related to Nicola and Giovanni Pisano.) The doors were completed within six years and display 20 scenes from the **LIFE OF JOHN THE BAPTIST** (the San Giovanni to whom the baptistery is dedicated) set above eight personifications of the Virtues **(FIG. 17–3)**. The overall effect is two-dimensional and

17–3 • Andrea Pisano LIFE OF JOHN THE BAPTIST
South doors, Baptistery of San Giovanni, Florence. 1330–1336. Gilded bronze, each panel 19¼ × 17″
(48 × 43 cm). Frame, Ghiberti workshop, mid-15th century.

The bronze vine scrolls filled with flowers, fruits, and birds on the lintel and jambs framing the door
were added in the mid fifteenth century.

17–4 • Andrea Pisano
THE BAPTISM OF THE
MULTITUDE
From the south doors, Baptistery
of San Giovanni, Florence.
1330–1336. Gilded bronze,
19¼ × 17″ (48 × 43 cm).

decorative: a grid of 28 rectangles with repeated quatrefoils filled by the graceful, patterned poses of delicate human figures. Within the quatrefoil frames, however, the figural compositions create the illusion of three-dimensional forms moving within the described spaces of natural and architectural worlds.

The scene of John baptizing a multitude **(FIG. 17–4)** takes place on a shelflike stage created by a forward extension of the rocky natural setting, which also expands back behind the figures into a corner of the quatrefoil frame. Composed as a rectangular group, the gilded figures present an independent mass of modeled forms. The illusion of three-dimensionality is enhanced by the way the curving folds of their clothing wrap around their bodies. At the same time, their graceful gestures and the elegant fall of their drapery reflect the soft curves and courtly postures of French Gothic art. Their quiet dignity, however, seems particular to the work of Andrea himself.

FLORENTINE PAINTING

Florence and Siena, rivals in so many ways, each supported a flourishing school of painting in the fourteenth century. Both grew out of thirteenth-century painting traditions and engendered individual artists who became famous in their own time. The Byzantine influence—the *maniera greca* ("Greek style")— continued to provide models of dramatic pathos and narrative iconography, as well as stylized features including the use of gold for drapery folds and striking contrasts of highlights and shadows in the modeling of individual forms. By the end of the fourteenth century, the painter and commentator Cennino Cennini (see "Cennino Cennini on Panel Painting," page 544) would be struck by the accessibility and modernity of Giotto's art, which, though it retained traces of the *maniera greca*, was moving toward the depiction of a lifelike, contemporary world anchored in three-dimensional forms.

CIMABUE. In Florence, this transformation to a more modern style began a little earlier than in Siena. About 1280, a painter named Cenni di Pepi (active c. 1272–1302), better known by his nickname "Cimabue," painted a panel portraying the **VIRGIN AND CHILD ENTHRONED (FIG. 17–5)**, perhaps for the main altar of the church of Santa Trinità in Florence. At over 12 feet tall, this enormous painting set a new precedent for monumental altarpieces. Cimabue surrounds the Virgin and Child with angels and places a row of Hebrew Bible prophets beneath them. The hieratically scaled figure of Mary holds the infant Jesus in her lap. Looking out at the viewer while gesturing toward her son as the path to salvation, she adopts a formula popular in Byzantine iconography since at least the seventh century (SEE FIG. 7–29).

Mary's huge throne, painted to resemble gilded bronze with inset enamels and gems, provides an architectural framework for the figures. Cimabue creates highlights on the drapery of Mary, Jesus, and the angels with thin lines of gold, as if to capture their divine radiance. The viewer seems suspended in space in front of the image, simultaneously looking down on the projecting elements of the throne and Mary's lap, while looking straight ahead at the prophets at the base of the throne and the angels at each side. These spatial ambiguities, the subtle asymmetries within the

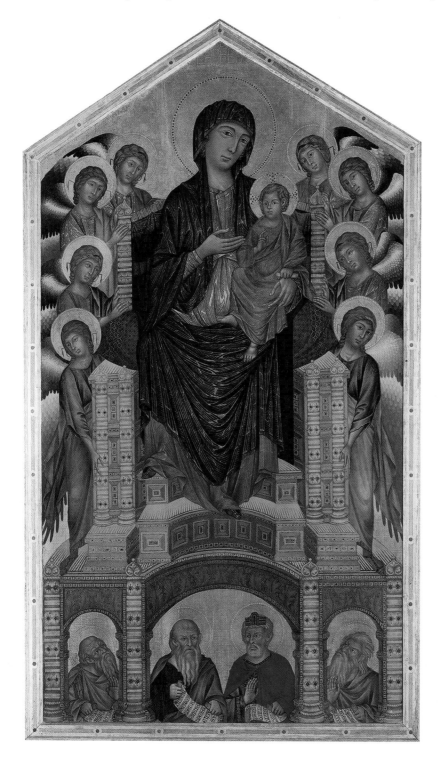

17-5 • Cimabue VIRGIN AND CHILD ENTHRONED
Most likely painted for the high altar of the church of Santa Trinità, Florence. c. 1280. Tempera and gold on wood panel, 12′7″ × 7′4″ (3.53 × 2.2 m). Galleria degli Uffizi, Florence.

SEE MORE: See a video about the egg tempera process
www.myartslab.com

centralized composition, the Virgin's engaging gaze, and the individually conceived faces of the old men give the picture a sense of life and the figures a sense of presence. Cimabue's ambitious attention to spatial volumes, his use of delicate modeling in light and shade to simulate three-dimensional form, and his efforts to give naturalistic warmth to human figures had an impact on the future development of Italian painting.

GIOTTO DI BONDONE. According to the sixteenth-century chronicler Giorgio Vasari, Cimabue discovered a talented shepherd boy, Giotto di Bondone, and taught him to paint—and "not only did the young boy equal the style of his master, but he became such an excellent imitator of nature that he completely banished that crude Greek [i.e., Byzantine] style and revived the modern and excellent art of painting, introducing good drawing from live natural models, something which had not been done for more than two hundred years" (Vasari, translated by Bondanella and Bondanella, p. 16). After his training, Giotto may have collaborated on murals at the prestigious church of St. Francis in Assisi. We know he worked for the Franciscans in Florence and absorbed facets of their teaching. St. Francis's message of simple, humble devotion, direct experience of God, and love for all creatures was

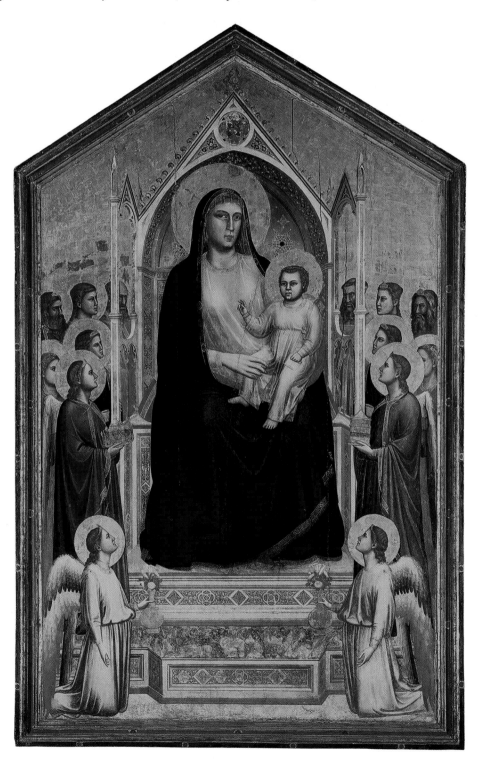

17-6 • Giotto di Bondone VIRGIN AND CHILD ENTHRONED
Most likely painted for the high altar of the church of the Ognissanti (All Saints), Florence. 1305–1310. Tempera and gold on wood panel, 10′8″ × 6′8¼″ (3.53 × 2.05 m). Galleria degli Uffizi, Florence.

EXPLORE MORE: Gain insight from a primary source by Dante Alighieri that references Giotto di Bondone
www.myartslab.com

The two techniques used in mural painting are *buon* ("true") *fresco* ("fresh"), in which paint is applied with water-based paints on wet plaster, and *fresco secco* ("dry"), in which paint is applied to a dry plastered wall. The two methods can be used on the same wall painting.

The advantage of *buon fresco* is its durability. A chemical reaction occurs as the painted plaster dries, which bonds the pigments into the wall surface. In *fresco secco*, by contrast, the color does not become part of the wall and tends to flake off over time. The chief disadvantage of *buon fresco* is that it must be done quickly without mistakes. The painter plasters and paints only as much as can be completed in a day, which explains the Italian term for each of these sections: **giornata**, or a day's work. The size of a *giornata* varies according to the complexity of the painting within it. A face, for instance, might take an entire day, whereas large areas of sky can be painted quite rapidly. In Giotto's Scrovegni Chapel, scholars have identified 852 separate *giornate*, some worked on concurrently within a single day by assistants in Giotto's workshop.

In medieval and Renaissance Italy, a wall to be frescoed was first prepared with a rough, thick undercoat of plaster known as the *arriccio*. When this was dry, assistants copied the master painter's composition onto it with reddish-brown pigment or charcoal. The artist made any necessary adjustments. These underdrawings, known as **sinopia**, have an immediacy and freshness lost in the finished painting. Work proceeded in irregularly shaped *giornate* conforming to the contours of major figures and objects. Assistants covered one section at a time with a fresh, thin coat of very fine plaster—the *intonaco*—

over the *sinopia*, and when this was "set" but not dry, the artist worked with pigments mixed with water, painting from the top down so that drips fell on unfinished portions. Some areas requiring pigments such as ultramarine blue (which was unstable in *buon fresco*), as well as areas requiring gilding, would be added after the wall was dry using the *fresco secco* technique.

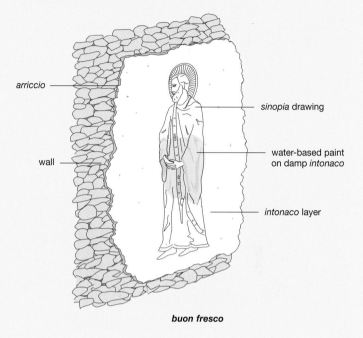

arriccio

sinopia drawing

wall

water-based paint on damp *intonaco*

intonaco layer

buon fresco

gaining followers throughout western Europe, and it had a powerful impact on thirteenth- and fourteenth-century Italian literature and art.

Compared to Cimabue's *Virgin and Child Enthroned*, Giotto's panel of the same subject (**FIG. 17–6**), painted about 30 years later for the church of the Ognissanti (All Saints) in Florence, exhibits greater spatial consistency and sculptural solidity while retaining some of Cimabue's conventions. The position of the figures within a symmetrical composition reflects Cimabue's influence. Gone, however, are Mary's modestly inclined head and the delicate gold folds in her drapery. Instead, light and shadow play gently across her stocky form, and her action—holding her child's leg instead of pointing him out to us—seems less contrived. This colossal Mary overwhelms her slender Gothic tabernacle of a throne, where figures peer through openings and haloes overlap faces. In spite of the hieratic scale and the formal, enthroned image and flat, gold background, Giotto has created the sense that these are fully three-dimensional beings, whose plainly draped, bulky bodies inhabit real space. The Virgin's solid torso is revealed by her thin tunic, and Giotto's angels are substantial solids whose foreshortened postures project from the foreground toward us, unlike those of Cimabue, which stay on the surface along lateral strips composed of overlapping screens of color.

Although he was trained in the Florentine tradition, many of Giotto's principal works were produced elsewhere. After a sojourn in Rome during the last years of the thirteenth century, he was called to Padua in northern Italy soon after 1300 to paint frescos (see "Buon Fresco," above) for a new chapel being constructed at the site of an ancient Roman arena—explaining why it is usually referred to as the Arena Chapel. The chapel was commissioned by Enrico Scrovegni, whose family fortune was made through the practice of usury—which at this time meant charging interest when loaning money, a sin so grave that it resulted in exclusion from the Christian sacraments. Enrico's father, Regibaldo, was a particularly egregious case (he appears in Dante's *Inferno* as the prototypical usurer), but evidence suggests that Enrico followed in his father's footsteps, and the building of the Arena Chapel next to his new palatial residence seems to have been conceived at least in part as a penitential act, part of Enrico's campaign not only to atone for his father's sins, but also to seek absolution for his own. He was pardoned by Pope Benedict XI (pontificate 1303–1304).

That Scrovegni called two of the most famous artists of the time—Giotto and Giovanni Pisano (SEE FIG. 16–33)—to decorate his chapel indicates that his goals were to express his power, sophistication, and prestige, as well as to atone for his sins. The building itself has little architectural distinction. It is a simple,

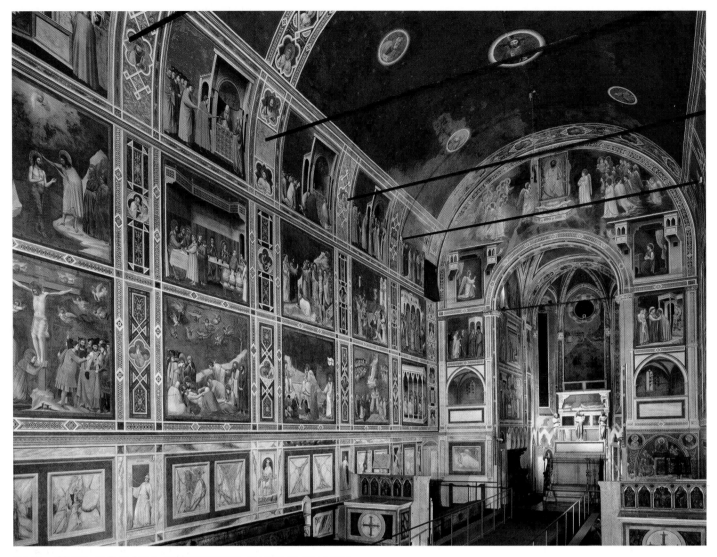

17-7 • Giotto di Bondone SCROVEGNI (ARENA) CHAPEL
Padua. 1305–1306. Frescos. View toward east wall.

barrel-vaulted room that provides broad walls, a boxlike space to showcase Giotto's paintings **(FIG. 17–7)**. Giotto covered the entrance wall with the *Last Judgment* (not visible here), and the sanctuary wall with three highlighted scenes from the life of Christ. The Annunciation spreads over the two painted architectural frameworks on either side of the high arched opening into the sanctuary itself. Below this are, to the left, the scene of Judas receiving payment for betraying Jesus, and, to the right, the scene of the Visitation, where the Virgin, pregnant with God incarnate, embraces her cousin Elizabeth, pregnant with John the Baptist. The compositions and color arrangement of these two scenes create a symmetrical pairing that encourages viewers to relate them, comparing the ill-gotten financial gains of Judas (a rather clear reference to Scrovegni usury) to the miraculous pregnancy that brought the promise of salvation.

Giotto subdivided the side walls of the chapel into framed pictures. A dado of faux-marble and allegorical **grisaille** (monochrome paintings in shades of gray) paintings of the Virtues and Vices support vertical bands painted to resemble marble inlay into which are inserted painted imitations of carved medallions. The central band of medallions spans the vault, crossing a brilliant, lapis-blue, star-spangled sky in which large portrait disks float like glowing moons. Set into this framework are three horizontal bands of rectangular narrative scenes from the life of the Virgin and her parents at the top, and Jesus along the middle and lower registers, constituting together the primary religious program of the chapel.

Both the individual scenes and the overall program display Giotto's genius for distilling complex stories into a series of compelling moments. He concentrates on the human dimensions of the unfolding drama—from touches of anecdotal humor to expressions of profound anguish—rather than on its symbolic or theological weight. His prodigious narrative skills are apparent in a set of scenes from Christ's life on the north wall **(FIG. 17–8)**. At top left Jesus performs his first miracle, changing water into wine at the wedding feast at Cana. The wine steward—looking very much like the jars of new wine himself—sips the results. To the right is the

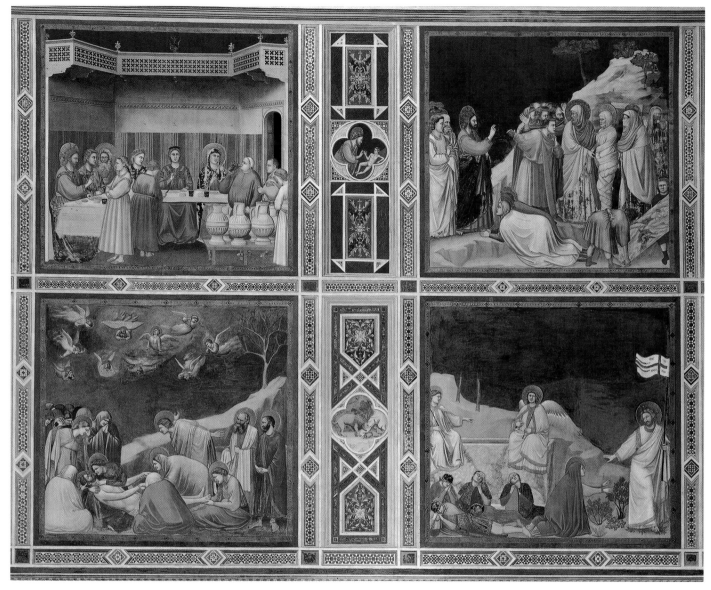

17-8 • Giotto di Bondone MARRIAGE AT CANA, RAISING OF LAZARUS, LAMENTATION, AND RESURRECTION / NOLI ME TANGERE
North wall of Scrovegni (Arena) Chapel, Padua. 1305–1306. Fresco, each scene approx. 6′5″ × 6′ (2 × 1.85 m).

Raising of Lazarus, where boldly modeled and individualized figures twist in space. Through their postures and gestures they react to the human drama by pleading for Jesus' help, or by expressing either astonishment at the miracle or revulsion at the smell of death. Jesus is separated from the crowd. His transforming gesture is highlighted against the dark blue of the background, his profile face locked in communication with the similarly isolated Lazarus, whose eyes—still fixed in death—let us know that the miracle is just about to happen.

On the lower register, where Jesus' grief-stricken followers lament over his dead body, Giotto conveys palpable human suffering, drawing viewers into a circle of personal grief. The stricken Virgin pulls close to her dead son, communing with mute intensity, while John the Evangelist flings his arms back in convulsive despair and others hunch over the corpse. Giotto has

linked this somber scene—much as he linked the scene of Judas' pact and the Visitation across the sanctuary arch—to the mourning of Lazarus on the register above through the seemingly continuous diagonal implied by the sharply angled hillside behind both scenes and by the rhyming repetition of mourners in each scene—facing in opposite directions—who throw back their arms to express their emotional state. Viewers would know that the mourning in both scenes is resolved by resurrection, portrayed in the last picture in this set.

Following traditional medieval practice, the fresco program is full of scenes and symbols like these that are intended to be contemplated as coordinated or contrasting juxtapositions. What is new here is the way Giotto draws us into the experience of these events. This direct emotional appeal not only allows viewers to imagine these scenes in relation to their own life experiences; it

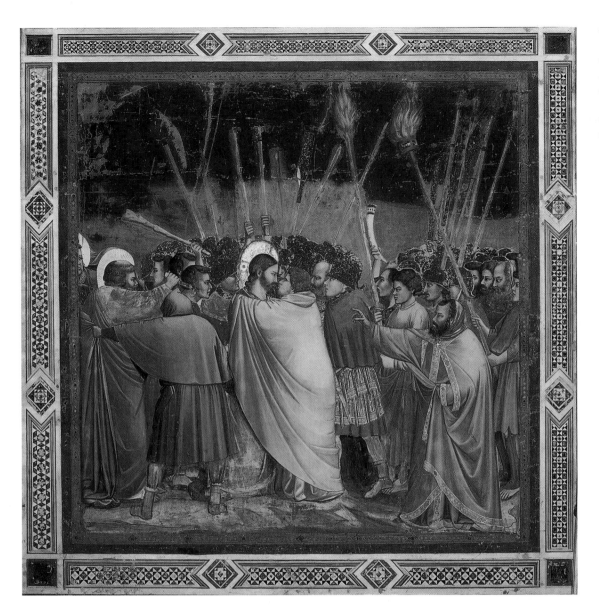

17-9 • Giotto di Bondone KISS OF JUDAS
South wall of Scrovegni (Arena) Chapel, Padua. 1305–1306. Fresco, 6′6¾″ × 6′7⅞″ (2 × 1.85 m).

also embodies the new Franciscan emphasis on personal devotion rooted in empathetic responses to sacred stories.

One of the most gripping paintings in the chapel is Giotto's portrayal of the **KISS OF JUDAS**, the moment of betrayal that represents the first step on Jesus' road to the Crucifixion **(FIG. 17–9)**. Savior and traitor are slightly off-center in the near foreground. The expansive sweep of Judas' strident yellow cloak—the same outfit he wore at the scene of his payment for the betrayal on the strip of wall to the left of the sanctuary arch—almost completely swallows Christ's body. Surrounding them, faces glare from all directions. A bristling array of weapons radiating from the confrontation draws attention to the encounter between Christ and Judas and documents the militarism of the arresting battalion. Jesus stands solid, a model of calm resolve that recalls his visual characterization in the Resurrection of Lazarus, and forms a striking foil to the noisy and chaotic aggression that engulfs him. Judas, in simian profile, purses his lips for the treacherous kiss that will betray Jesus to his captors, setting up a mythic confrontation of good and evil. In a subplot to the left, Peter lunges forward to sever the ear of a member of the arresting retinue. They are behind another broad sweep of fabric, this one extended by an ominous figure seen from behind and completely concealed except for the clenched hand that pulls at Peter's mantle. Indeed, a broad expanse of cloth and lateral gestures creates a barrier along the picture plane—as if to protect viewers from the compressed chaos of the scene itself. Rarely has this poignant event been visualized with such riveting power.

SIENESE PAINTING

Like their Florentine rivals, Sienese painters were rooted in thirteenth-century pictorial traditions, especially those of Byzantine art. Sienese painting emphasized the decorative potential of narrative painting, with brilliant, jewel-like colors and elegantly posed figures. For this reason, some art historians consider Sienese art more conservative than Florentine art, but we will see that it has its own charm, and its own narrative strategy.

DUCCIO DI BUONINSEGNA. Siena's foremost painter was Duccio di Buoninsegna (active 1278–1318), whose creative synthesis of Byzantine and French Gothic sources transformed the tradition in which he worked. The format of a large altarpiece he painted for the church of Santa Maria Novella in Florence after 1285 **(FIG. 17–10)** is already familiar from the Florentine altarpieces of Cimabue and Giotto (SEE FIGS. 17-5 and 17-6). A monumental Virgin and Child sit on an elaborate throne, set against a gold ground and seemingly supported by flanking angels. But in striking contrast both with Cimabue's Byzantine drapery stylizations and sense of three-dimensional form and space, and with Giotto's matter-of-fact emphasis on weightiness and references to an earthly setting, Duccio's figural composition foregrounds gracefulness of pose and gesture and a color scheme rich in luminous pastels. Drapery not only models his figures into convincing forms; it also falls into graceful lines and patterns, especially apparent in the sinuous golden edge of the Virgin's deep blue mantle and the ornamental extravagance of the brocade hangings on her throne.

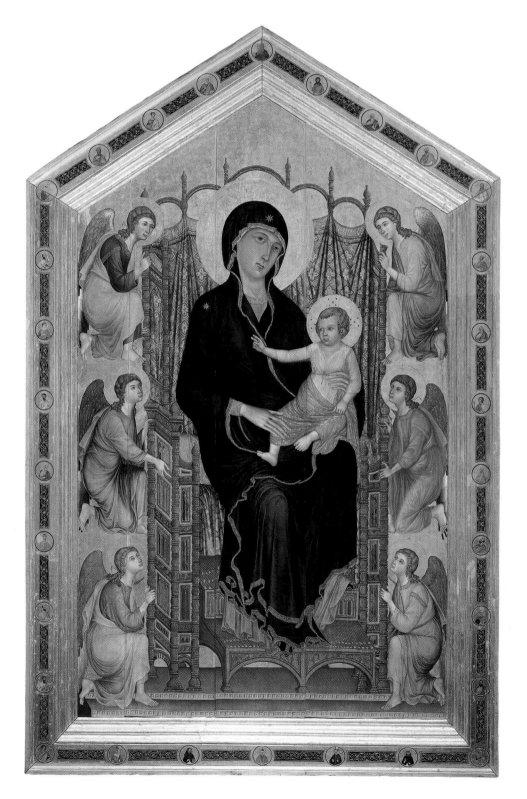

17–10 • Duccio di Buoninsegna
VIRGIN AND CHILD ENTHRONED (RUCELLAI MADONNA)
Commissioned in 1285. Tempera and gold on wood panel, 14′9⅛″ × 9′6⅛″ (4.5 × 2.9 m). Galleria degli Uffizi, Florence.

This altarpiece, commissioned in 1285 for the church of Santa Maria Novella in Florence by the Society of the Virgin Mary, is now known as the *Rucellai Madonna* because it was installed at one time in the Rucellai family's chapel within the church.

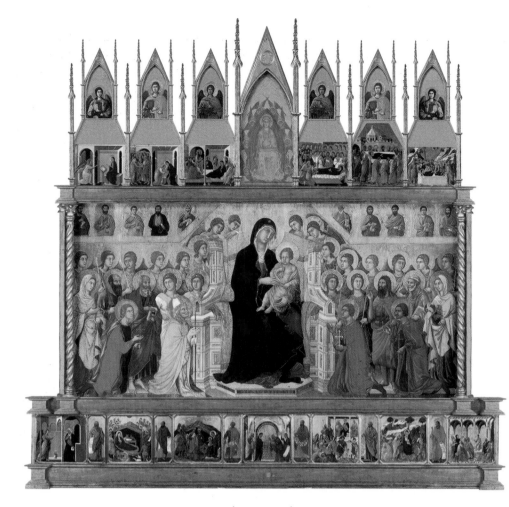

17–11a • Duccio di Buoninsegna
CONJECTURAL RECONSTRUCTION OF THE FRONT OF THE MAESTÀ ALTARPIECE
Made for Siena Cathedral. 1308–1311. Tempera and gold on wood, main front panel 7 × 13′ (2.13 × 4.12 m).

EXPLORE MORE: Gain insight from a primary source related to Duccio's *Maestà*
www.myartslab.com

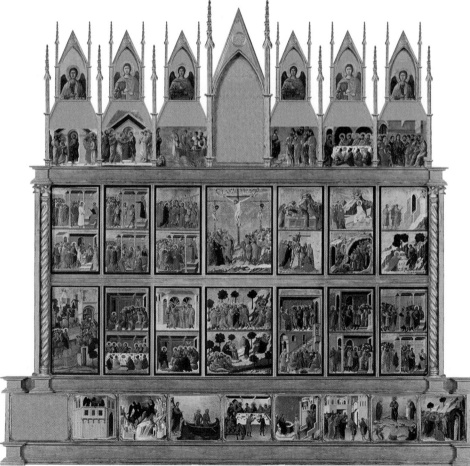

17–11b • Duccio di Buoninsegna
CONJECTURAL RECONSTRUCTION OF THE BACK OF THE MAESTÀ ALTARPIECE

Between 1308 and 1311, Duccio and his workshop painted a huge altarpiece commissioned by Siena Cathedral and known as the *Maestà* ("Majesty") **(FIG. 17–11)**. Creating this altarpiece—assembled from many wood panels bonded together before painting—was an arduous undertaking. The work was not only large—the central panel alone was 7 by 13 feet—but it had to be painted on both sides since it could be seen from all directions when installed on the main altar at the center of the sanctuary.

Because the *Maestà* was dismantled in 1771, its power and beauty can only be imagined from scattered parts, some still in Siena but others elsewhere. **FIG. 17–11a** is a reconstruction of how the front of the original altarpiece might have looked. It is dominated by a large representation of the Virgin and Child in Majesty (thus its title of *Maestà*), flanked by 20 angels and ten saints, including the four patron saints of Siena kneeling in the foreground. Above and below this lateral tableau were small narrative scenes from the last days of the life of the Virgin (above) and the infancy of Christ (spread across the predella). An inscription running around the base of Mary's majestic throne places the artist's signature within an optimistic framework: "Holy Mother of God, be thou the cause of peace for Siena and life to Duccio because he painted thee thus." This was not Duccio's first work for the cathedral. In 1288 he had designed a stunning stained-glass window portraying the Death, Assumption, and Coronation of the Virgin for the huge circular opening in the east wall of the sanctuary. It would have hovered over the installed *Maestà* when it was placed on the altar in 1311.

On the back of the *Maestà* **(FIG. 17–11b)** were episodes from the life of Christ, focusing on his Passion. Sacred narrative unfolds in elegant episodes enacted by graceful figures who seem to dance their way through these stories while still conveying emotional content. Characteristic of Duccio's narrative style is the scene of the **RAISING OF LAZARUS (FIG. 17–12)**. Lyrical figures enact the event with graceful decorum, but their highly charged glances and expressive gestures—especially the bold reach of Christ—convey a strong sense of dramatic urgency that contrasts with the tense stillness that we saw in Giotto's rendering of this same moment of confrontation (SEE FIG. 17–8). Duccio's shading of drapery, like his modeling of faces, faithfully describes the figures' three-dimensionality, but the crisp outlines of the jewel-colored shapes created by their drapery, as well as the sinuous continuity of folds and gestures, generate rhythmic patterns across the surface. Experimentation with the portrayal of space extends from the receding rocks of the mountainous landscape to carefully studied interiors, here the tomb of Lazarus whose heavy door was removed by the straining hug of a bystander to reveal the shrouded figure of Jesus' resurrected friend, propped up against the door jamb.

The enthusiasm with which citizens greeted a great painting or altarpiece like the *Maestà* demonstrates the power of images as

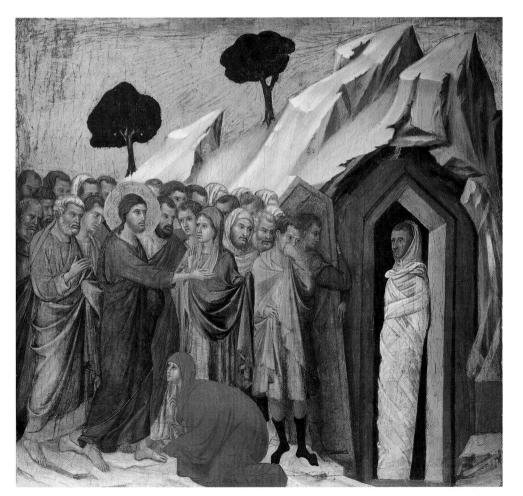

17–12 • Duccio di Buoninsegna
RAISING OF LAZARUS
From the back of the *Maestà* altarpiece (lower right corner of FIG. 17–9b), made for Siena Cathedral. 1308–1311. Tempera and gold on wood, 17⅛ × 18¼″ (43.5 × 46.4 cm). Kimbell Art Museum, Fort Worth, Texas.

Il Libro dell' Arte (*The Book of Art*) of Cennino Cennini (c. 1370–1440) is a compendium of Florentine painting techniques from about 1400 that includes step-by-step instructions for making panel paintings, a process also used in Sienese paintings of the same period.

The wood for the panels, he explains, should be fine-grained, free of blemishes, and thoroughly seasoned by slow drying. The first step in preparing such a panel for painting was to cover its surface with clean white linen strips soaked in a **gesso** made from gypsum, a task, he tells us, best done on a dry, windy day. Gesso provided a ground, or surface, on which to paint, and Cennini specified that at least nine layers should be applied. The gessoed surface should then be burnished until it resembles ivory. Only then could the artist sketch the composition of the work with charcoal made from burned willow twigs. At this point, advised Cennini, "When you have finished drawing your figure, especially if it is in a very valuable [altarpiece], so that you are counting on profit and reputation from it, leave it alone for a few days, going back to it now and then to look it over and improve it wherever it still needs something. When it seems to you about right (and bear in mind that you may copy and examine things done by other good masters; that it is no shame to you) when the figure is satisfactory, take the feather and rub it over the drawing very lightly, until the drawing is practically effaced" (Cennini, trans. Thompson, p. 75). At this point, the final design would be inked in with a fine squirrel-hair brush. Gold leaf, he advises, should be affixed on a humid day, the tissue-thin sheets carefully glued down with a mixture of fine powdered clay and egg white on the reddish clay ground called bole. Then the gold is burnished with a gemstone or the tooth of a carnivorous animal. Punched and incised patterning should be added to the gold leaf later.

Fourteenth- and fifteenth-century Italian painters worked principally in tempera paint, powdered pigments mixed with egg yolk, a little water, and an occasional touch of glue. Apprentices were kept busy grinding pigments and mixing paints, setting them out for more senior painters in wooden bowls or shell dishes.

Cennini outlined a detailed and highly formulaic painting process. Faces, for example, were always to be done last, with flesh tones applied over two coats of a light greenish pigment and highlighted with touches of red and white. The finished painting was to be given a layer of varnish to protect it and intensify its colors.

EXPLORE MORE: Gain insight from a primary source by Cennino Cennini **www.myartslab.com**

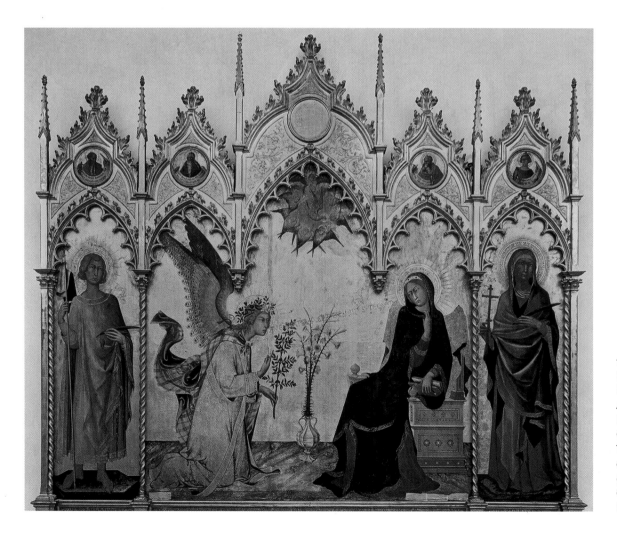

17–13 • Simone Martini and Lippo Memmi ANNUNCIATION
Made for Siena Cathedral. 1333. Tempera and gold on wood, 10′ × 8′9″ (3 × 2.67 m). Galleria degli Uffizi, Florence.

17–14 • AERIAL VIEW OF THE CAMPO IN SIENA WITH THE PALAZZO PUBBLICO (CITY HALL INCLUDING ITS TOWER) FACING ITS STRAIGHT SIDE
Siena. Palazzo Pubblico 1297–c. 1315; tower 1320s–1340s.

well as the association of such magnificent works with the glory of the city itself. According to a contemporary account, on December 20, 1311, the day that Duccio's altarpiece was carried from his workshop to the cathedral, all the shops were shut, and everyone in the city participated in the procession, with "bells ringing joyously, out of reverence for so noble a picture as is this" (Holt, p. 69).

SIMONE MARTINI. The generation of painters who followed Duccio continued to paint in the elegant style he established, combining the evocation of three-dimensional form with a graceful continuity of linear pattern. One of Duccio's most successful and innovative followers was Simone Martini (c. 1284–1344), whose paintings were in high demand throughout Italy, including in Assisi where he covered the walls of the St. Martin Chapel with frescos between 1312 and 1319. His most famous work, however, was commissioned in 1333 for the cathedral of his native Siena, an altarpiece of the **ANNUNCIATION** flanked by two saints **(FIG. 17–13)** that he painted in collaboration with his brother-in-law, Lippo Memmi.

The smartly dressed figure of Gabriel—the extended flourish of his drapery behind him suggesting he has just arrived, and with some speed—raises his hand to address the Virgin. The words of his message are actually incised into the gold-leafed gesso of the background, running from his opened mouth toward the Virgin's ear: *Ave gratia plena dominus tecum* (Luke 1:28: "Hail, full of grace, the Lord is with thee"). Seemingly frightened—at the very least startled—by this forceful and unexpected celestial messenger, Mary recoils into her lavish throne, her thumb inserted into the book she had been reading to safeguard her place, while her other hand pulls at her clothing in an elegant gesture of nobility ultimately deriving from the courtly art of thirteenth-century Paris (see Solomon, second lancet from the right in FIG. 16–13).

AMBROGIO LORENZETTI. The most important civic structure in Siena was the **PALAZZO PUBBLICO (FIG. 17–14)**, the town hall which served as the seat of government, just as the Palazzo della Signoria did in rival Florence. There are similarities between these two buildings. Both are designed as strong, fortified structures sitting on the edge of a public piazza; both have a tall tower,

making them visible signs of the city from a considerable distance. The Palazzo Pubblico was constructed from 1297 to 1310, but the tower was not completed until 1348, when the bronze bell, which rang to signal meetings of the ruling council, was installed.

The interior of the Palazzo Pubblico was the site of important commissions by some of Siena's most famous artists. In c. 1315, Simone Martini painted a large mural of the Virgin in Majesty surrounded by saints—clearly based on Duccio's recently installed *Maestà*. Then, in 1338, the Siena city council commissioned Ambrogio Lorenzetti to paint frescos for the council room of the Palazzo known as the Sala della Pace (Chamber of Peace) on the theme of the contrast between good and bad government (SEE FIG. 17–1).

Ambrogio painted the results of both good and bad government on the two long walls. For the expansive scene of the **EFFECTS OF GOOD GOVERNMENT IN THE CITY AND IN THE COUNTRY**, and in tribute to his patrons, Ambrogio created an idealized but recognizable portrait of the city of Siena and its immediate environs (**FIG. 17–15**). The cathedral dome and the distinctive striped campanile are visible in the upper left-hand corner; the streets are filled with the bustling activity of productive citi-zens who also have time for leisurely diversions. Ambrogio shows the city from shifting viewpoints so we can see as much as possible, and renders its inhabitants larger in scale than the buildings around them so as to highlight their activity. Featured in the foreground is a circle of dancers—probably a professional troupe of male entertainers masquerading as women as part of a spring festival—and above them, at the top of the painting, a band of masons stand on exterior scaffolding constructing the wall of a new building.

The Porta Romana, Siena's gateway leading to Rome, divides the thriving city from its surrounding countryside. In this panoramic landscape painting, Ambrogio describes a natural world marked by agricultural productivity, showing activities of all seasons simultaneously—sowing, hoeing, and harvesting. Hovering above the gate that separates city life and country life is a woman clad in a wisp of transparent drapery, a scroll in one hand and a miniature gallows complete with a hanged man in the other. She represents Security, and her scroll bids those coming to the city to enter without fear because she has taken away the power of the guilty who would harm them.

The world of the Italian city-states—which had seemed so full of promise in Ambrogio Lorenzetti's *Good Government* fresco—was transformed as the middle of the century approached into uncertainty and desolation by a series of natural and societal disasters—in 1333, a flood devastated Florence, followed by banking failures in the 1340s, famine in 1346–1347, and epidemics of the bubonic plague, especially virulent in the summer of 1348, just a few years after Ambrogio's frescos were completed. Some art historians have traced the influence of these calamities on the visual arts at the middle of the fourteenth century (see "The Black Death," page 548). Yet as dark as those days must have seemed to the men and women living through them, the strong currents of cultural and artistic change initiated earlier in the century would persist. In a relatively short span of time, the European Middle Ages gave way in Florence to a new movement that would blossom in the Italian Renaissance.

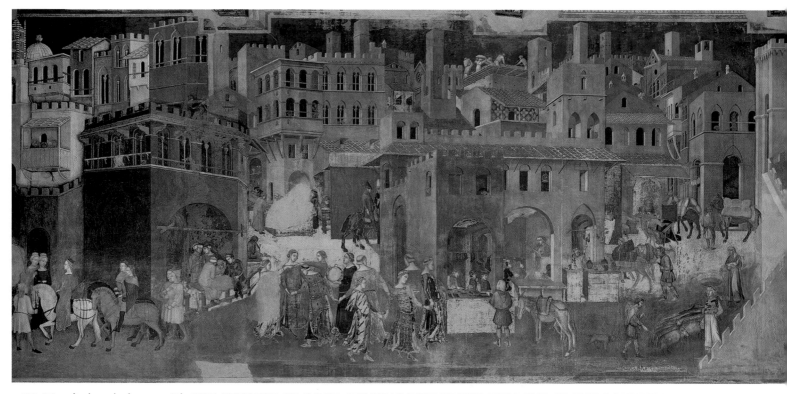

17-15 • Ambrogio Lorenzetti THE EFFECTS OF GOOD GOVERNMENT IN THE CITY AND IN THE COUNTRY
Sala dei Nove (also known as Sala della Pace), Palazzo Pubblico, Siena, Italy. 1338–1339. Fresco, total length about 46′ (14 m).

FRANCE

At the beginning of the fourteenth century, the royal court in Paris was still the arbiter of taste in western Europe, as it had been in the days of King Louis IX (St. Louis). During the Hundred Years' War, however, the French countryside was ravaged by armed struggles and civil strife. The power of the old feudal nobility, weakened significantly by warfare, was challenged by townsmen, who took advantage of new economic opportunities that opened up in the wake of the conflict. As centers of art and architecture, the duchy of Burgundy, England, and, for a brief golden moment, the court of Prague began to rival Paris.

French sculptors found lucrative new outlets for their work—not only in stone, but in wood, ivory, and precious metals, often decorated with enamel and gemstones—in the growing demand among wealthy patrons for religious art intended for homes as well as churches. Manuscript painters likewise created lavishly illustrated books for the personal devotions of the wealthy and powerful. And architectural commissions focused on smaller, exquisitely detailed chapels or small churches, often under private patronage, rather than on the building of cathedrals funded by church institutions.

MANUSCRIPT ILLUMINATION

By the late thirteenth century, private prayer books became popular among wealthy patrons. Because they contained special prayers to be recited at the eight canonical devotional "hours" between morning and night, an individual copy of one of these books came to be called a **Book of Hours**. Such a book included everything the lay person needed for pious practice—psalms, prayers to and offices of the Virgin and other saints (like the owner's patron or the patron of their home church), a calendar of feast days, and sometimes prayers for the dead. During the fourteenth century, a richly decorated Book of Hours was worn or carried like jewelry, counting among a noble person's most important portable possessions.

THE BOOK OF HOURS OF JEANNE D'ÉVREUX. Perhaps at their marriage in 1324, King Charles IV gave his 14-year-old queen, Jeanne d'Évreux, a tiny Book of Hours—it fits easily when open within one hand—illuminated by Parisian painter Jean Pucelle (see "A Closer Look," page 550). This book was so precious to the queen that she mentioned it and its illuminator specifically in her will, leaving this royal treasure to King Charles V. Pucelle painted the book's pictures in *grisaille*—monochromatic painting in shades of gray with only delicate touches of color. His style clearly derives from the courtly mode established in Paris at the time of St. Louis, with its softly modeled, voluminous draperies gathered loosely and falling in projecting diagonal folds around tall, elegantly posed figures with carefully coiffed curly hair, broad foreheads, and delicate features. But his conception of space, with figures placed within coherent, discrete architectural settings, suggests a firsthand knowledge of contemporary Sienese art.

Jeanne appears in the initial *D* below the Annunciation, kneeling in prayer before a lectern, perhaps using this Book of Hours to guide her meditations, beginning with the words written

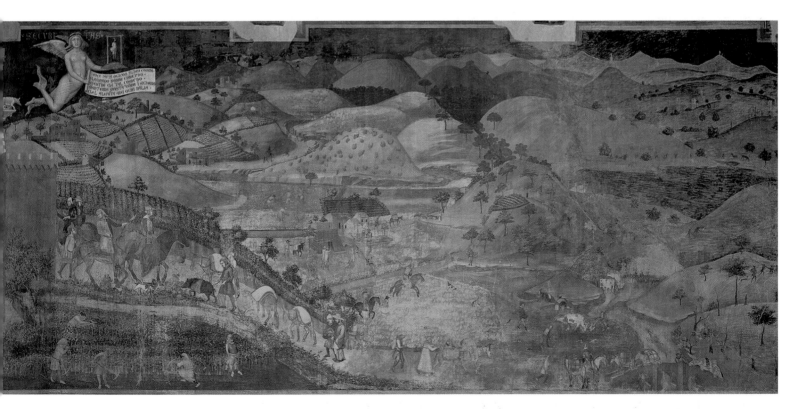

The Black Death

A deadly outbreak of the bubonic plague, known as the Black Death after the dark sores that developed on the bodies of its victims, spread to Europe from Asia, both by land and by sea, in the middle of the fourteenth century. At least half the urban population of Florence and Siena—some estimate 80 percent—died during the summer of 1348, probably including the artists Andrea Pisano and Ambrogio Lorenzetti. Death was so quick and widespread that basic social structures crumbled in the resulting chaos; people did not know where the disease came from, what caused it, or how long the pandemic would last.

Mid-twentieth-century art historian Millard Meiss proposed that the Black Death had a significant impact on the development of Italian art in the middle of the fourteenth century. Pointing to what he saw as a reactionary return to hieratic linearity in religious art, Meiss theorized that artists had retreated from the rounded forms that had characterized the work of Giotto to old-fashioned styles, and that this artistic change reflected a growing reliance on traditional religious values in the wake of a disaster that some interpreted as God's punishment of a world in moral decline.

An altarpiece painted in 1354–1357 by Andrea di Cione, nicknamed Orcagna ("Archangel"), under the patronage of Tommasso Strozzi—the so-called *Strozzi Altarpiece*—is an example of the sort of paintings that led Meiss to his interpretation. The painting's otherworldly vision is dominated by a central figure of Christ, presumably enthroned, but without any hint of an actual seat, evoking the image of the judge at the Last Judgment, outside time and space. The silhouetted outlines of the standing and kneeling saints emphasize surface over depth; the gold expanse of floor beneath them does not offer any reassuring sense of spatial recession to contain them and their activity. Throughout, line and color are more prominent than form.

Recent art historians have stepped back from Meiss's theory of stylistic change in mid-fourteenth-century Italy. Some have pointed out logical relationships between style and subject in the works Meiss cites; others have seen in them a mannered outgrowth of current style rather than a reversion to an earlier style; still others have discounted the underlying notion that stylistic change is connected with social situations. But there is no denying the relationship of works such as the *Strozzi Altarpiece* with death and judgment, sanctity and the promise of salvation. These themes are suggested in the narrative scenes on the **predella** (the lower zone of the altarpiece): Thomas Aquinas's ecstasy during Mass, Christ's miraculous walk on water to rescue Peter, and the salvation of Emperor Henry II because of his donation of a chalice to a religious institution. While these are not uncommon scenes in sacred art, it is difficult not see a relationship between their choice as subject matter here and the specter cast by the Black Death over a world that had just imagined its prosperity in path-breaking works of visual art firmly rooted in references to everyday life.

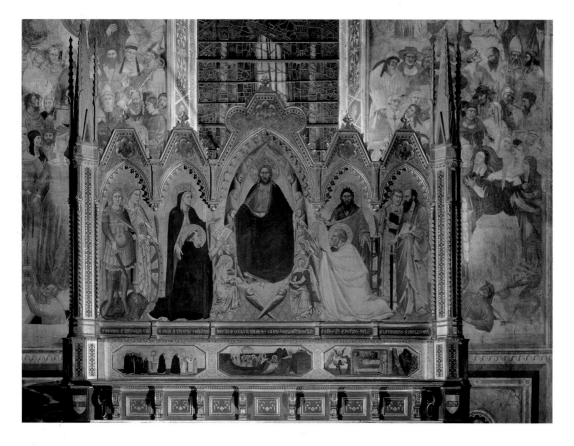

Andrea di Cione
(nicknamed Orcagna)
**ENTHRONED CHRIST
WITH SAINTS,
FROM THE STROZZI
ALTARPIECE**
Strozzi Chapel, Santa Maria
Novella, Florence.
1354–1357. Tempera and
gold on wood, 9′ × 9′8″
(2.74 × 2.95 m).

EXPLORE MORE: Gain insight from a primary source related to the Black Death
www.myartslab.com

on this page: *Domine labia mea aperies* (Psalm 51:15: "O Lord, open thou my lips"). The juxtaposition of the praying Jeanne's portrait with a scene from the life of the Virgin Mary suggests that the sacred scene is actually a vision inspired by Jeanne's meditations. The young queen might have identified with and sought to feel within herself Mary's joy at Gabriel's message. Given what we know of Jeanne's own life story and her royal husband's predicament, it might also have directed the queen's prayers toward the fulfillment of his wish for a male heir.

In the Annunciation, Mary is shown receiving the archangel Gabriel in a Gothic building that seems to project outward from the page toward the viewer, while rejoicing angels look on from windows under the eaves. The group of romping children at the bottom of the page at first glance seems to echo the angelic jubilation. Folklorists have suggested, however, that the children are playing "froggy in the middle" or "hot cockles," games in which one child was tagged by the others. To the medieval viewer, if the game symbolized the mocking of Christ or the betrayal of Judas, who "tags" his friend, it would have evoked a darker mood by referring to the picture on the other page of this opening, foreshadowing Jesus' imminent death even as his life is beginning.

METALWORK AND IVORY

Fourteenth-century French sculpture is intimate in character. Religious subjects became more emotionally expressive; objects became smaller and demanded closer scrutiny from the viewer. In the secular realm, tales of love and valor were carved on luxury items to delight the rich (see "An Ivory Chest with Scenes of Romance," pages 552–553). Precious materials—gold, silver, and ivory—were preferred.

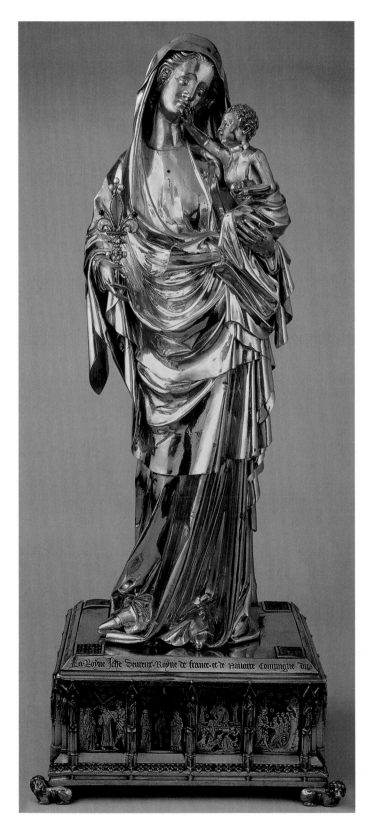

THE VIRGIN AND CHILD FROM SAINT-DENIS. A silver-gilt image of a standing **VIRGIN AND CHILD** (**FIG. 17–16**) is a rare survivor that verifies the acclaim that was accorded Parisian fourteenth-century goldsmiths. An inscription on the base documents the statue's donation to the abbey church of Saint-Denis in 1339 and the donor's name, the same Queen Jeanne d'Évreux whose Book of Hours we have just examined. In a style that recalls the work of artist Jean Pucelle in that Book of Hours, the Virgin holds Jesus in her left arm with her weight on her left leg, standing in a graceful, characteristically Gothic S-curve pose. Mary originally wore a crown, and she still holds a large enameled and jeweled *fleur-de-lis*—the heraldic symbol of royal France—which served as a reliquary container for strands of Mary's hair. The Christ Child, reaching out tenderly to caress his mother's face, is babylike in both form and posture. On the base, minuscule statues of prophets stand on projecting piers to separate 14 enameled scenes from Christ's Infancy and Passion, reminding us of the suffering to come. The apple in the baby's hand carries the theme further with its reference to Christ's role as the new Adam, whose sacrifice on the cross—medieval Christians believed—redeemed humanity from the first couple's fall into sin when Eve bit into the forbidden fruit.

17-16 • VIRGIN AND CHILD
c. 1324–1339. Silver gilt and enamel, height 27⅛" (69 cm).
Musée du Louvre, Paris.

The Hours of Jeanne d'Évreux

by Jean Pucelle, Two-Page Opening with the Kiss of Judas and the Annunciation. Paris. c. 1325–1328. *Grisaille* and color on vellum, each page 3½ × 2¼" (8.9 × 6.2 cm). Metropolitan Museum of Art, New York. The Cloisters Collection (54.1.2), fols. 15v–16r

In this opening Pucelle juxtaposes complementary scenes drawn from the Infancy and Passion of Christ, placed on opposing pages, in a scheme known as the Joys and Sorrows of the Virgin. The "joy" of the Annunciation on the right is paired with the "sorrow" of the betrayal and arrest of Christ on the left.

Christ sways back gracefully as Judas betrays him with a kiss. The S-curve of his body mirrors the Virgin's pose on the opposite page, as both accept their fate with courtly decorum.

The prominent lamp held aloft by a member of the arresting battalion informs the viewer that this scene takes place at night, in the dark.

The angel who holds up the boxlike enclosure where the Annunciation takes place is an allusion to the legend of the miraculous transportation of this building from Nazareth to Loreto in 1294.

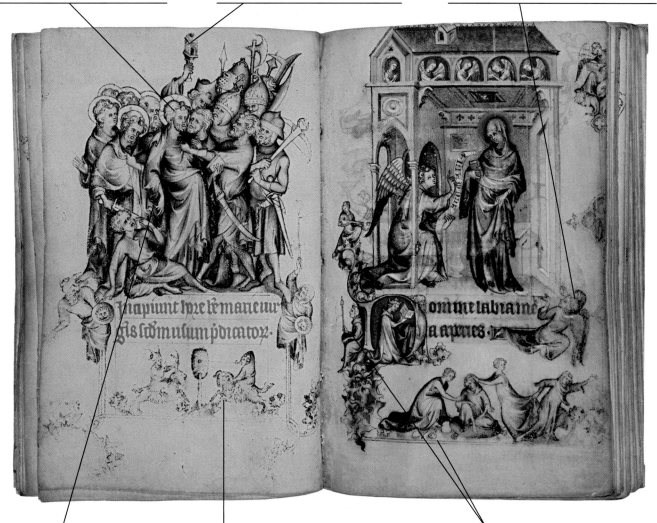

Christ reaches casually down to heal Malchus, the assistant of the high priest whose ear Peter had just cut off in angry retaliation for his participation in the arrest of Jesus.

Scenes of secular amusements from everyday life, visual puns, and off-color jokes appear at the bottom of many pages of this book. Sometimes they relate to the themes of the sacred scenes above them. These comic knights riding goats may be a commentary on the lack of valor shown by the soldiers assaulting Jesus, especially if this wine barrel conjured up for Jeanne an association with the Eucharist.

The candle held by the cleric who guards the "door" to Jeanne's devotional retreat, as well as the rabbit emerging from its burrow in the marginal scene, are sexually charged symbols of fertility that seem directly related to the focused prayers of a child bride required to produce a male heir.

SEE MORE: View the Closer Look feature for The Hours of Jeanne d'Évreux **www.myartslab.com**

ENGLAND

Fourteenth-century England prospered in spite of the ravages of the Black Death and the Hundred Years' War with France. English life at this time is described in the brilliant social commentary of Geoffrey Chaucer in the *Canterbury Tales* (see "A New Spirit in Fourteenth-Century Literature," page 531). The royal family, especially Edward I (r. 1272–1307)—the castle builder—and many of the nobles and bishops were generous patrons of the arts.

EMBROIDERY: OPUS ANGLICANUM

Since the thirteenth century, the English had been renowned for pictorial needlework, using colored silk and gold thread to create images as detailed as contemporary painters produced in manuscripts. Popular throughout Europe, the art came to be called *opus anglicanum* ("English work"). The popes had more than 100 pieces in the Vatican treasury. The names of several prominent embroiderers are known, but in the thirteenth century no one surpassed Mabel of Bury St. Edmunds, who created both religious and secular articles for King Henry III (r. 1216–1272).

THE CHICHESTER-CONSTABLE CHASUBLE. This *opus anglicanum* liturgical vestment worn by a priest during Mass **(FIG. 17–17)** was embroidered c. 1330–1350 with images formed by subtle gradations of colored silk. Where gold threads were laid and couched (tacked down with colored silk), the effect resembles the burnished gold-leaf backgrounds of manuscript illuminations. The Annunciation, the Adoration of the Magi, and the Coronation of the Virgin are set in cusped, crocketed **ogee** (S-shape) arches, supported on animal-head corbels and twisting branches sprouting oak leaves with seed-pearl acorns. Because the star and crescent moon in the Coronation of the Virgin scene are heraldic emblems of Edward III (r. 1327–1377), perhaps he or a family member commissioned this luxurious vestment.

During the celebration of the Mass, especially as the priest moved, *opus anglicanum* would have glinted in the candlelight amid treasures on the altar. Court dress was just as rich and colorful, and at court such embroidered garments proclaimed the rank and status of the wearer. So heavy did such gold and bejeweled garments become that their wearers often needed help to move.

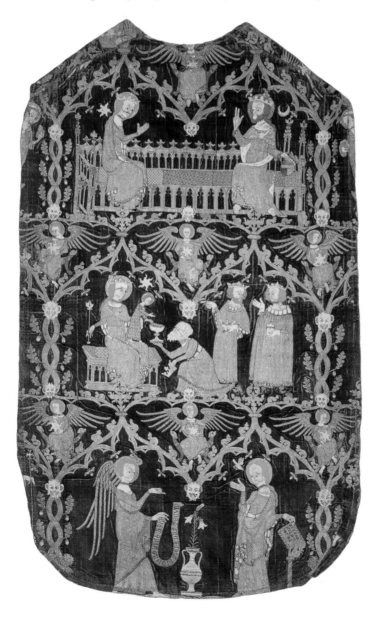

17–17 • LIFE OF THE VIRGIN, BACK OF THE CHICHESTER-CONSTABLE CHASUBLE

From a set of vestments embroidered in *opus anglicanum* from southern England. c. 1330–1350. Red velvet with silk and metallic thread and seed pearls, length 4′3″ (129.5 cm), width 30″ (76 cm). Metropolitan Museum of Art, New York.
Fletcher Fund, 1927 (27 162.1)

An Ivory Chest with Scenes of Romance

Fourteenth-century Paris was renowned for more than its goldsmiths (SEE FIG. 17–16). Among the most sumptuous and sought-after Parisian luxury products were small chests assembled from carved ivory plaques that were used by wealthy women to store jewelry or other personal treasures. The entirely secular subject matter of these chests was romantic love. Indeed, they seem to have been courtship gifts from smitten men to desired women, or wedding presents offered by grooms to their brides.

A chest from around 1330–1350, now in the Walters Museum (SEE FIG. A), is one of seven that have survived intact; there are fragments of a dozen more. It is a delightful and typical example. Figural relief covers five exterior sides of the box: around the perimeter and on the hinged top. The assembled panels were joined by metal hardware—strips, brackets, hinges, handles, and locks—originally wrought in silver. Although some chests tell a single romantic story in sequential episodes, most, like this one, anthologize scenes drawn from a group of stories, combining courtly romance, secular allegory, and ancient fables.

On the lid of the Walters casket (SEE FIG. B), jousting is the theme. Spread over the central two panels, a single scene catches two charging knights in the heat of a tournament, while trumpeting heralds call the attention of spectators, lined up above in a gallery to observe this public display of virility. The panel at right mocks the very ritual showcased in the middle panels by pitting a woman against a knight, battling not with lances but with a long-stemmed rose (symbolizing sexual surrender) and an oak bough (symbolizing fertility). Instead of observing these silly goings-on, however, the spectators tucked into the upper architecture pursue their own amorous flirtations. Finally, in the scene on the left, knights use crossbows and a catapult to hurl roses at the Castle of Love, while Cupid returns fire with his seductive arrows.

On the front of the chest (SEE FIG. A), generalized romantic allegory gives way to vignettes from a specific story. At left, the long-bearded Aristotle teaches the young Alexander the Great, using exaggerated gestures and an authoritative text to emphasize his point. Today's lesson is a stern warning not to allow the seductive power of women to distract the young prince from his studies. The subsequent scene, however, pokes fun at his eminent teacher, who has become so smitten by the wiles of a young beauty named Phyllis that he lets

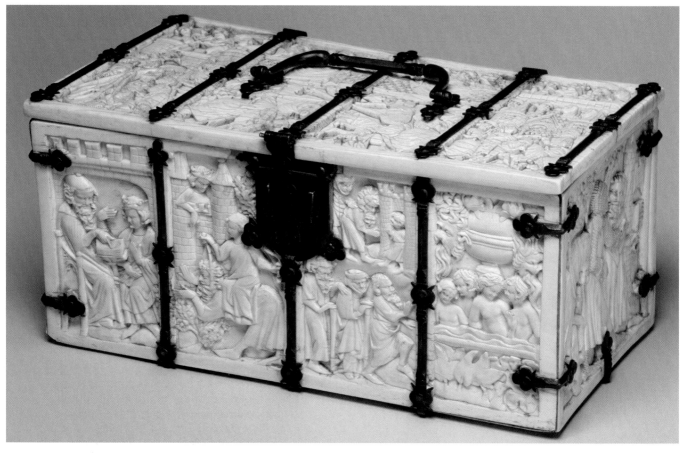

A. SMALL IVORY CHEST WITH SCENES FROM COURTLY ROMANCES
Made in Paris. c. 1330–1350. Elephant ivory with modern iron mounts, height 4½″ (11.5 cm), width 9¹¹⁄₁₆″ (24.6 cm), depth 4⅞″ (12.4 cm). The Walters Art Museum, Baltimore.

her ride him around like a horse, while his student observes this farce, peering out of the castle in the background. The two scenes at right relate to an eastern legend of the fountain of youth, popular in medieval Europe. A line of bearded elders approaches the fountain from the left, steadied by their canes. But after having partaken of its transforming effects, two newly rejuvenated couples, now nude, bathe and flirt within the fountain's basin. The man first in line for treatment, stepping up to climb into the fountain, looks suspiciously like the figure of the aging Aristotle, forming a link between the two stories on the casket front.

Unlike royal marriages of the time, which were essentially business contracts based on political or financial exigencies, the romantic love of the aristocratic wealthy involved passionate devotion. Images of gallant knights and their coy paramours, who could bring intoxicating bliss or cruelly withhold their love on a whim, captured the popular Gothic imagination. They formed the principal subject matter on personal luxury objects, not only chests like this, but mirror backs, combs, writing tablets, even ceremonial saddles. And these stories evoke themes that still captivate us since they reflect notions of desire and betrayal, cruel rejection and blissful folly, at play in our own romantic conquests and relationships to this day. In this way they allow us some access to the lives of the people who commissioned and owned these precious objects, even if we ourselves are unable to afford them.

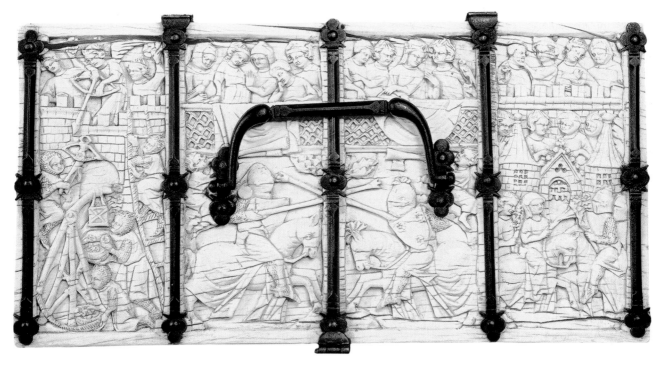

B. ATTACK ON THE CASTLE OF LOVE
Top of the chest.

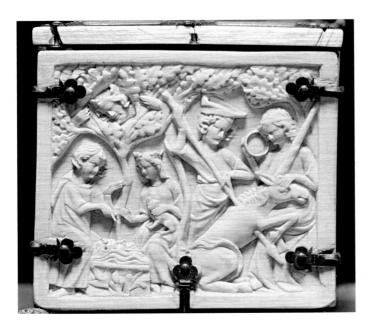

C. TRISTAN AND ISEULT AT THE FOUNTAIN; CAPTURE OF THE UNICORN
Left short side of the chest.

Two other well-known medieval themes are juxtaposed on this plaque from the short side of the ivory chest. At left, Tristan and Iseult have met secretly for an illicit romantic tryst, while Iseult's husband, King Mark, tipped off by an informant, observes them from a tree. But when they see his reflection in a fountain between them, they alter their behavior accordingly, and the king believes them innocent of the adultery he had (rightly) suspected. The medieval bestiary ("book of beasts") claimed that only a virgin could capture the mythical unicorn, which at right lays his head, with its aggressively phallic horn, into the lap of just such a pure maiden so that the hunter can take advantage of her alluring powers over the animal to kill it with his phallic counterpart of its horn, a large spear.

ARCHITECTURE

In the later years of the thirteenth century and early years of the fourteenth, a distinctive and influential Gothic architectural style, popularly known as the "Decorated style," developed in England. This change in taste has been credited to Henry III's ambition to surpass St. Louis, who was his brother-in-law, as a royal patron of the arts.

THE DECORATED STYLE AT EXETER. One of the most complete Decorated-style buildings is **EXETER CATHEDRAL**. Thomas of Witney began construction in 1313 and remained master mason from 1316 to 1342. He supervised construction of the nave and redesigned upper parts of the choir. He left the towers of the original Norman cathedral but turned the interior into a dazzling stone forest of colonnettes, moldings, and vault ribs (FIG. 17–18). From piers formed by a cluster of colonnettes rise multiple moldings that make the arcade seem to ripple. Bundled colonnettes spring from sculptured foliate **corbels** (brackets that project from a wall) between the arches and rise up the wall to support conical clusters of 13 ribs that meet at the summit of the vault, a modest 69 feet above the floor. The basic structure here is the four-part vault with intersecting cross-ribs, but the designer added additional ribs, called **tiercerons**, to create a richer linear pattern. Elaborately carved **bosses** (decorative knoblike elements) signal the point where ribs meet along the ridge of the vault. Large bar-tracery clerestory windows illuminate the 300-foot-long nave. Unpolished gray marble shafts, yellow sandstone arches, and a white French stone, shipped from Caen, add subtle gradations of color to the upper wall.

Detailed records survive for the building of Exeter Cathedral, documenting work over the period from 1279 to 1514, with only two short breaks. They record where masons and carpenters were housed (in a hostel near the cathedral) and how they were paid (some by the day with extra for drinks, some by the week, some for each finished piece); how materials were acquired and transported (payments for horseshoes and fodder for the horses); and, of course, payments for the building materials (not only stone and wood but rope for measuring and parchment on which to draw forms for the masons). The bishops contributed generously to the building funds. This was not a labor only of love.

Thomas of Witney also designed the intricate, 57-foot-high bishop's throne (at right in FIG. 17–18), constructed by Richard de Galmeton and Walter of Memburg, who led a team of a dozen carpenters. The canopy resembles embroidery translated into wood, with its maze of pinnacles, bursting with leafy crockets and tiny carved animals and

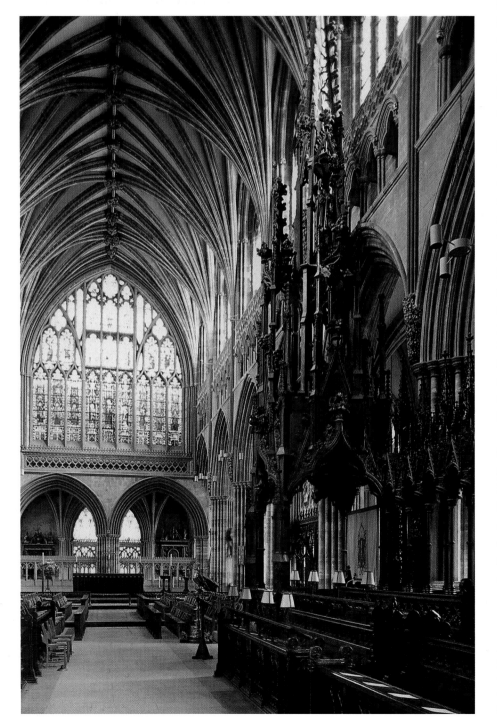

17–18 • EXETER CATHEDRAL
Devon, England. Thomas of Witney, choir, 14th century and bishop's throne, 1313–1317; Robert Lesyngham, east window, 1389–1390.

heads. To finish the throne in splendor, Master Nicolas painted and gilded the wood. When the bishop was seated on his throne wearing embroidered vestments like the Chichester-Constable Chasuble (SEE FIG. 17–17), he must have resembled a golden image in a shrine—more a symbol of the power and authority of the Church than a specific human being.

THE PERPENDICULAR STYLE AT EXETER. During years following the Black Death, work at Exeter Cathedral came to a standstill. The nave had been roofed but not vaulted, and the windows had no glass. When work could be resumed, tastes had changed. The exuberance of the Decorated style gave way to an austere style in which rectilinear patterns and sharp angular shapes replaced intricate curves, and luxuriant foliage gave way to simple stripped-down patterns. This phase is known as the Perpendicular style.

In 1389–1390, well-paid master mason Robert Lesyngham rebuilt the great east window (SEE FIG. 17–18), and he designed the window tracery in the new Perpendicular style. The window fills the east wall of the choir like a glowing altarpiece. A single figure in each light stands under a tall painted canopy that flows into and blends with the stone tracery. The Virgin with the Christ Child stands in the center over the high altar, with four female saints at the left and four male saints on the right, including St. Peter, to whom the church is dedicated. At a distance the colorful figures silhouetted against the silver *grisaille* glass become a band of color, conforming to and thus reinforcing the rectangular pattern of the mullions and transoms. The combination of *grisaille*, silver-oxide stain (staining clear glass with shades of yellow or gold), and colored glass produces a glowing wall, and casts a cool, silvery light over the nearby stonework.

Perpendicular architecture heralds the Renaissance style in its regularity, its balanced horizontal and vertical lines, and its plain wall or window surfaces. When Tudor monarchs introduced Renaissance art into the British Isles, builders were not forced to rethink the form and structure of their buildings; they simply changed the ornament from the pointed cusps and crocketed arches of the Gothic style to the round arches and columns and capitals of Roman Classicism. The Perpendicular style itself became an English architectural vernacular. It remains popular today in the United States for churches and college buildings.

THE HOLY ROMAN EMPIRE

By the fourteenth century, the Holy Roman Empire existed more as an ideal fiction than a fact. The Italian territories had established their independence, and in contrast to England and France, Germany had become further divided into multiple states with powerful regional associations and princes. The Holy Roman emperors, now elected by Germans, concentrated on securing the fortunes of their families. They continued to be patrons of the arts, promoting local styles.

MYSTICISM AND SUFFERING

The by-now-familiar ordeals of the fourteenth century—famines, wars, and plagues—helped inspire a mystical religiosity in Germany that emphasized both ecstatic joy and extreme suffering. Devotional images, known as *Andachtsbilder* in German, inspired worshipers to contemplate Jesus' first and last hours, especially during evening prayers, or vespers, giving rise to the term *Vesperbild* for the image of Mary mourning her son. Through such religious exercises, worshipers hoped to achieve understanding of the divine and union with God.

VESPERBILD. In this well-known example (FIG. 17–19), blood gushes from the hideous **rosettes** that form the wounds of an emaciated and lifeless Jesus who teeters improbably on the lap of his hunched-over mother. The Virgin's face conveys the intensity

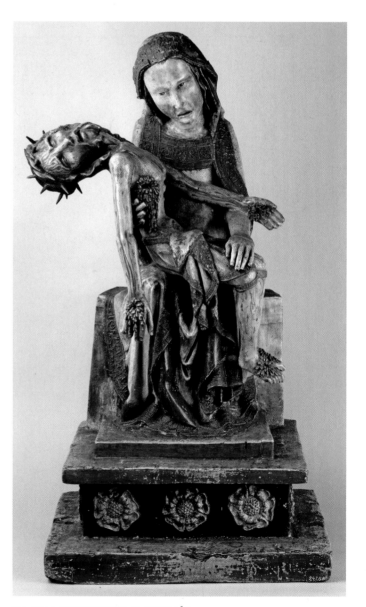

17–19 • VESPERBILD (PIETÀ)
From the Middle Rhine region, Germany. c. 1330. Wood and polychromy, height 34½″ (88.4 cm). Landesmuseum, Bonn.

of her ordeal, mingling horror, shock, pity, and grief. Such images took on greater poignancy since they would have been compared, in the worshiper's mind, to the familiar, almost ubiquitous images of the young Virgin mother holding her innocent and loving baby Jesus.

THE HEDWIG CODEX. The extreme physicality and emotionalism of the *Vesperbild* finds parallels in the actual lives of some medieval saints in northern Europe. St. Hedwig (1174–1243), married at age 12 to Duke Henry I of Silesia and mother of his seven children, entered the Cistercian convent of Trebniz (in modern Poland) on her husband's death in 1238. She devoted the rest of her life to caring for the poor and seeking to emulate the suffering of Christ by walking barefoot in the snow. As described in her *vita*, she had a

particular affection for a small ivory statue of the Virgin and Child, which she carried with her at all times, and which "she often took up in her hands to envelop it in love, so that out of passion she could see it more often and through the seeing could prove herself more devout, inciting her to even greater love of the glorious Virgin. When she once blessed the sick with this image they were cured immediately" (translation from Schleif, p. 22). Hedwig was buried clutching the statue, and when her tomb was opened after her canonization in 1267, it was said that although most of her body had deteriorated, the fingers that still gripped the beloved object had miraculously not decayed.

A picture of Hedwig serves as the frontispiece **(FIG. 17–20)** of a manuscript of her *vita* (biography) known as the Hedwig Codex, commissioned in 1353 by one her descendants, Ludwig I of

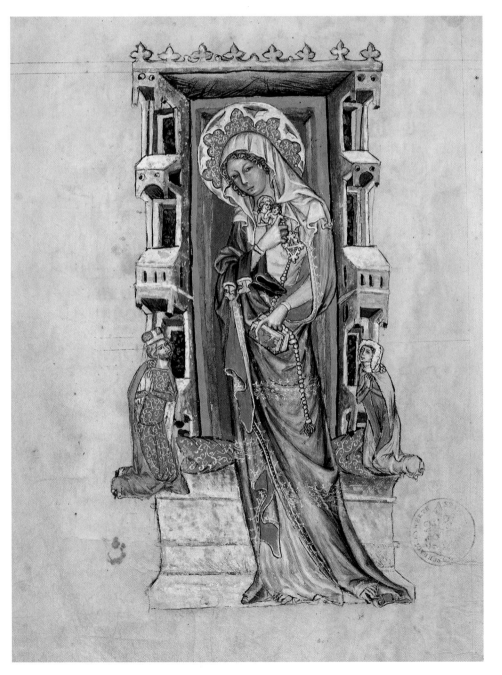

17–20 • ST. HEDWIG OF SILESIA WITH DUKE LUDWIG I OF LIEGNITZ-BRIEG AND DUCHESS AGNES
Dedication page of the Hedwig Codex. 1353. Ink and paint on parchment. 13⁷⁄₁₆ × 9¾″ (115 × 94 cm). J. Paul Getty Museum, Los Angeles. MS. Ludwig XI 7, fol. 12v

Liegnitz-Brieg. Duke Ludwig and his wife, Agnes, are shown here kneeling on either side of St. Hedwig, dwarfed by the saint's architectural throne and her own imposing scale. With her prominent, spidery hands, she clutches the famous ivory statue, as well as a rosary and a prayer book, inserting her fingers within it to maintain her place as if our arrival had interrupted her devotions. She has draped her leather boots over her right wrist in a reference to her practice of removing them to walk in the snow. Hedwig's highly volumetric figure stands in a swaying pose of courtly elegance derived from French Gothic, but the fierce intensity of her gaze and posture are far removed from the mannered graciousness of the smiling angel of Reims (see statue at far left in FIG. 16–16), whose similar gesture and extended finger are employed simply to grasp his drapery and assure its elegant display.

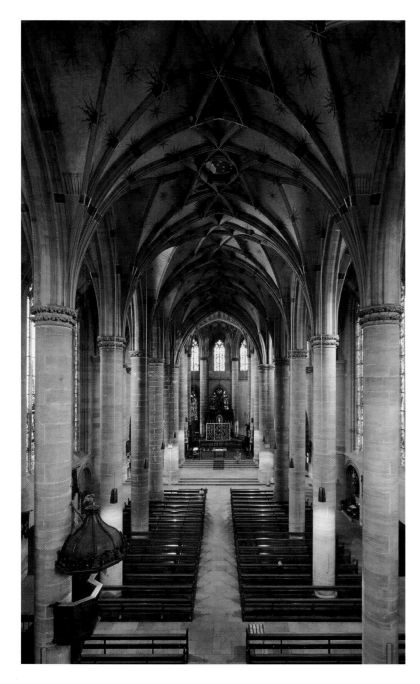

THE SUPREMACY OF PRAGUE

Charles IV of Bohemia (r. 1346–1375) was raised in France, and his admiration for the French king Charles IV was such that he changed his own name from Wenceslas to Charles. He was officially crowned king of Bohemia in 1347 and Holy Roman Emperor in 1355. He established his capital in Prague, which, in the view of its contemporaries, replaced Constantinople as the "New Rome." Prague had a great university, a castle, and a cathedral overlooking a town that spread on both sides of a river joined by a stone bridge, a remarkable structure itself.

When Pope Clement VI made Prague an archbishopric in 1344, construction began on a new cathedral in the Gothic style—to be named for St. Vitus. It would also serve as the coronation church and royal pantheon. But the choir was not finished for Charles's first coronation, so he brought Peter Parler from Swabia to complete it.

THE PARLER FAMILY. In 1317, Heinrich Parler, a former master of works on Cologne Cathedral, designed and began building the church of the Holy Cross in Schwäbisch Gmünd, in southwest Germany. In 1351, his son Peter (c. 1330–1399), the most brilliant architect of this talented family, joined the workshop. Peter designed the choir (FIG. 17–21) in the manner of a hall church whose triple-aisled form was enlarged by a ring of deep

17–21 • Heinrich and Peter Parler PLAN AND INTERIOR OF CHURCH OF THE HOLY CROSS
Schwäbisch Gmünd, Germany. Begun in 1317 by Henrich Parler; choir by Peter Parler begun in 1351; vaulting completed 16th century.

17–22 • Master Theodoric ST. LUKE
Holy Cross Chapel, Karlstejn Castle, near Prague. 1360–1364. Paint and gold on panel. 45¼ × 37″ (115 × 94 cm).

chapels between the buttresses. The contrast between Heinrich's nave and Peter's choir (seen clearly in the plan of FIG. 17–21) illustrates the increasing complexity of rib patterns covering the vaults, which emphasizes the unity of interior space rather than its division into bays.

Called by Charles IV to Prague in 1353, Peter turned the unfinished St. Vitus Cathedral into a "glass house," adding a vast clerestory and glazed triforium supported by double flying buttresses, all covered by net vaults that created a continuous canopy over the space. Because of the success of projects such as this, Peter and his family became the most successful architects in the Holy Roman Empire. Their concept of space, luxurious decoration, and intricate vaulting dominated central European architecture for three generations.

MASTER THEODORIC. At Karlstejn Castle, a day's ride from Prague, Charles IV built another chapel, covering the walls with gold and precious stones as well as with paintings. There were 130 paintings of the saints serving as reliquaries, with relics inserted into their frames. Master Theodoric, the court painter, provided drawings on the wood panels, and he painted about 30 images himself. Figures are crowded into—even extend over—their frames, emphasizing their size and power. Master Theodoric was head of the Brotherhood of St. Luke, and the way that his painting of **ST. LUKE (FIG. 17–22)**, patron saint of painters, looks out at the viewer has suggested to scholars that this may be a self-portrait. His personal style combined a preference for substantial bodies, oversized heads and hands, dour and haunted faces, and soft, deeply modeled drapery, with a touch of grace derived from the French Gothic style. The chapel, consecrated in 1365, so pleased the emperor that in 1367 he gave the artist a farm in appreciation of his work.

Prague and the Holy Roman Empire under Charles IV had become a multicultural empire where people of different religions (Christians and Jews) and ethnic heritages (German and Slav) lived side by side. Charles died in 1378, and without his strong central government, political and religious dissent overtook the empire. Jan Hus, dean of the philosophy faculty at Prague University and a powerful reforming preacher, denounced the immorality he saw in the Church. He was burned at the stake, becoming a martyr and Czech national hero. The Hussite Revolution in the fifteenth century ended Prague's—and Bohemia's—leadership in the arts.

THINK ABOUT IT

17.1 Discuss the circumstances surrounding the construction and decoration of the Scrovegni (Arena) Chapel, with special attention to its relationship to the life and aspirations of its patron.

17.2 Compare and contrast Giotto's and Duccio's renderings of the biblical story of Christ's Raising of Lazarus (FIGS. 17–8, 17–12).

17.3 Discuss Ambrogio Lorenzetti's engagement with secular subject matter in his frescos for Siena's Palazzo Pubblico (FIG. 17–15). How did these paintings relate to their sociopolitical context?

17.4 Choose one small work of art in this chapter that is crafted from precious materials with exceptional technical skill. Explain how it was made and how it was used. How does the work of art relate to its cultural and social context?

17.5 Analyze how the Decorated Gothic style of Exeter Cathedral (FIG. 17–18) preserves certain traditions from the thirteenth-century Gothic that you learned about in Chapter 16, and assess how it departs from the traditional Gothic style.

PRACTICE MORE: Compose answers to these questions, get flashcards for images and terms, and review chapter material with quizzes
www.myartslab.com

GLOSSARY

abacus (p. 108) The flat slab at the top of a **capital**, directly under the **entablature**.

abbey church (p. 239) An abbey is a religious community headed by an abbot or abbess. An abbey church often has an especially large choir to provide space for the monks or nuns.

absolute dating (p. 12) A method of assigning a precise historical date to periods and objects, based on known and recorded events in the region, as well as technically extracted physical evidence (such as carbon-14 disintegration). See also **radiometric dating**, **relative dating**.

abstract, abstraction (p. 8) Any art that does not represent observed aspects of nature or transforms visible forms into a stylized image. Also: the **formal** qualities of this process.

academy (p. 924) A place of study, the word coming from the Greek name of a garden near Athens where Plato and, later, Platonic philosophers held discussions. Academies of fine arts, such as the Academy of Drawing or the Royal Academy of Painting, were created to foster the arts by teaching, by discussion, by exhibitions, and occasionally by financial aid.

acanthus (p. 110) A Mediterranean plant whose leaves are reproduced in architectural ornament used on **moldings**, **friezes**, and **Corinthian capitals**.

acropolis (p. 129) The citadel of an ancient Greek city, located at its highest point and housing temples, a treasury, and sometimes a royal palace. The most famous is the Acropolis in Athens.

acroterion (acroteria) (p. 110) An ornament at the corner or peak of a roof.

adobe (p. 393) Sun-baked blocks made of clay mixed with straw. Also: the buildings made with this material.

aedicula (p. 609) A decorative architectural frame, usually found around a niche, door, or window. An aedicula is made up of a **pediment** and **entablature** supported by **columns** or **pilasters**.

agora (p. 138) An open space in a Greek town used as a central gathering place or market. See also **forum**.

aisle (p. 228) Passage or open corridor of a church, hall, or other building that parallels the main space, usually on both sides, and is delineated by a row, or **arcade**, of **columns** or **piers**. Called side aisles when they flank the **nave** of a church.

album (p. 795) A book consisting of a series of painting or prints (album leaves) mounted into book form.

allegory (p. 625) In a work of art, an image (or images) that symbolizes an idea, concept, or principle, often moral or religious.

alloy (p. 23) A mixture of metals; different metals melted together.

amalaka (p. 301) In Hindu architecture, the circular or square-shaped element on top of a spire (**shikhara**), often crowned with a **finial**, symbolizing the cosmos.

ambulatory (p. 228) The passage (walkway) around the **apse** in a **basilican** church or around the central space in a **central-plan building**.

amphora (p. 101) An ancient Greek jar for storing oil or wine, with an egg-shaped body and two curved handles.

aniconic (p. 262) A symbolic representation without images of human figures, very often found in Islamic art.

animal interlace or style (p. 427) Decoration made of interwoven animals or serpents, often found in Celtic and early medieval Northern European art.

ankh (p. 51) A looped cross signifying life, used by ancient Egyptians.

appropriation (p. 1102) Term used to describe the practice of some postmodern artists of adopting images in their entirety from other works of art or from visual culture for use in their own art. The act of recontextualizing the appropriated image allows the artist to critique both it and the time and place in which it was created.

apse, apsidal (p. 192) A large semicircular or polygonal (and usually **vaulted**) niche protruding from the end wall of a building. In the Christian church, it contains the altar. Apsidal is an adjective describing the condition of having such a space.

arabesque (p. 263) A type of linear surface decoration based on foliage and **calligraphic** forms, usually characterized by flowing lines and swirling shapes.

arcade (p. 172) A series of **arches**, carried by **columns** or **piers** and supporting a common wall or **lintel**. In a **blind arcade**, the arches and supports are **engaged** (attached to the wall) and have a decorative function.

arch (p. 271) In architecture, a curved structural element that spans an open space. Built from wedge-shaped stone blocks called **voussoirs**, which, when placed together and held at the top by a trapezoidal **keystone**, form an effective space-spanning and weight-bearing unit. Requires **buttresses** at each side to contain the outward **thrust** caused by the weight of the structure. **Corbel arch** (p. 16): an arch or **vault** formed by **courses** of stones, each of which projects beyond the lower course until the space is enclosed; usually finished with a **capstone**. **Horseshoe arch** (p. 268): an arch of more than a half-circle; typical of western Islamic architecture. **Round arch** (p. 271): arch that displaces most of its weight, or downward thrust along its curving sides, transmitting that weight to adjacent supporting uprights (door or window jambs, columns, or piers). Ogival arch: a pointed arch created by S-curves. Relieving arch: an arch built into a heavy wall just above a **post-and-lintel** structure (such as a gate, door, or window) to help support the **lintel** by transferring the load to the side walls. **Transverse arch** (p. 457): an arch that connects the wall **piers** on both sides of an interior space, and up and over a stone vault.

Archaic smile (p. 114) The curved lips of an ancient Greek statue, usually interpreted as a way of animating facial features.

architrave (p. 108) The bottom element in an **entablature**, beneath the **frieze** and the **cornice**.

archivolt (p. 473) A **molded** band framing an **arch**, or a series of stone blocks that rest directly on the **columns**.

ashlar (p. 99) Highly finished, precisely cut block of stone. When laid in even courses, ashlar masonry creates a uniform face with fine joints. Often used as a facing on the visible exterior of a building, especially as a veneer for the **façade**. Also called **dressed stone**.

assemblage (p. 1026) Artwork created by gathering and manipulating two- and/or three-dimensional found objects.

astragal (p. 110) A thin convex decorative **molding**, often found on Classical **entablatures**, and usually decorated with a continuous row of beadlike circles.

atelier (p. 944) The studio or workshop of a master artist or craftsperson, often including junior associates and apprentices.

atmospheric perspective (p. 562) See **perspective**.

atrial cross (p. 941) The cross placed in the **atrium** of a church. In Colonial America, used to mark a gathering and teaching place.

atrium (p. 160) An unroofed interior courtyard or room in a Roman house, sometimes having a pool or garden, sometimes surrounded by **columns**. Also: the open courtyard in front of a Christian church; or an entrance area in modern architecture.

automatism (p. 1056) A technique whereby the usual intellectual control of the artist over his or her brush or pencil is foregone. The artist's aim is to allow the subconscious to create the artwork without rational interference.

avant-garde (p. 971) Term derived from the French military word meaning "before the group," or "vanguard." Avant-garde denotes those artists or concepts of a strikingly new, experimental, or radical nature for their time.

axis (p. xxxii) An implied line around which the elements of a picture are organized.

axis-mundi (p. 297) A concept of an "axis of the world," which marks sacred sites and denotes a link between the human and celestial realms. For example, in Buddhist art, the *axis mundi* can be marked by monumental freestanding decorative **pillars**.

bailey (p. 473) The outermost walled courtyard of a castle.

baldachin (p. 467) A canopy (whether suspended from the ceiling, projecting from a wall, or supported by **columns**) placed over an honorific or sacred space such as a throne or church altar.

bar tracery (p. 507) See **tracery**.

barbarian (p. 151) A term used by the ancient Greeks and Romans to label all foreigners outside their cultural orbit (e.g., Celts, Goths, Vikings). The word derives from an imitation of what the "barblings" of their language sounded like to those who could not understand it.

bargeboards (p. 870) Boards covering the rafters at the gable end of a building; bargeboards are often carved or painted.

barrel vault (p. 188) See **vault**.

base (p. 110) Any support. Also: masonry supporting a statue or the shaft of a **column**.

basilica (p. 192) A large rectangular building. Often built with a **clerestory**, side **aisles** separated from the center **nave** by **colonnades**, and an **apse** at one or both ends. Roman centers for administration, later adapted to Christian church use.

battered (p. 418) An architectural design whereby walls are sloped inward toward the top to increase stability.

bay (p. 172) A unit of space defined by architectural elements such as **columns, piers**, and walls.

beehive tomb (p. 98) A **corbel-vaulted** tomb, conical in shape like a beehive, and covered by an earthen mound.

Benday dots (p. 1093) In modern printing and typesetting, the individual dots that, together with many others, make up lettering and images. Often machine- or computer-generated, the dots are very small and closely spaced to give the effect of density and richness of tone.

bi (p. 333) A jade disk with a hole in the center.

bilum (p. 863) Netted bags made mainly by women throughout the central highlands of New Guinea. The bags can be used for everyday purposes or even to carry the bones of the recently deceased as a sign of mourning.

biomorphic (p. 1057) A term used in the early twentieth century to denote the biologically or organically inspired shapes and forms that were routinely included in abstracted Modern art.

black-figure (p. 105) A style or technique of ancient Greek pottery in which black figures are painted on a red clay ground. See also **red-figure**.

blackware (p. 853) A **ceramic** technique that produces pottery with a primarily black surface with **matte** and glossy patterns on the surface.

blind arcade (p. 780) See **arcade**.

bodhisattva (p. 297) In Buddhism, a being who has attained enlightenment but chooses to remain in this world in order to help others advance spiritually. Also defined as a potential Buddha.

Book of Hours (p. 547) A private prayer book, containing a calendar, services for the canonical hours, and sometimes special prayers.

boss (p. 554) A decorative knoblike element that can be found in many places, such as at the intersection of a Gothic **rib vault** or in the buttonlike projections of metalwork.

bracket, bracketing (p. 335) An architectural element that projects from a wall to support a horizontal part of a building, such as beams or the eaves of a roof.

buon fresco (p. 87) See **fresco**.

burin (p. 590) A metal instrument used in **engraving** to cut lines into the metal plate. The sharp end of the burin is trimmed to give a diamond-shaped cutting point, while the other end is finished with a wooden handle that fits into the engraver's palm.

buttress, buttressing p. 172) A projecting support built against an external wall, usually to counteract the lateral **thrust** of a **vault** or **arch** within. In Gothic architecture, a **flying buttress** is an arched bridge above the **aisle** roof that extends from the upper **nave** wall, where the lateral thrust of the main vault is greatest, down to a solid **pier**.

cairn (p.17) A pile of stones or earth and stones that served both as a prehistoric burial site and as a marker of underground tombs.

calligraphy (p. 279) Handwriting as an art form.

calotype (p. 968) The first photographic process utilizing negatives and paper positives. It was invented by William Henry Fox Talbot in the late 1830s.

calyx krater (p. 118) See **krater**.

came (cames) (p. 497) A lead strip used in the making of leaded or **stained-glass windows**. Cames have an indented groove on the sides into which the separate pieces of glass are fitted to hold the composition together.

cameo (p. 178) Gemstone, clay, glass, or shell having layers of color, carved in **low relief** to create an image and ground of different colors.

camera obscura (p. 967) An early cameralike device used in the Renaissance and later for recording images of nature. Made from a dark box (or room) with a hole in one side (sometimes fitted with a lens), the camera obscura operates when bright light shines through the hole, casting an upside-down image of an object outside onto the inside wall of the box.

canon of proportions (p. 65) A set of ideal mathematical ratios in art based on measurements, as in the proportional relationships among the basic elements of the human body.

canopic jar (p. 56) Special jars used to store the major organs of a body before embalming, found in ancient Egyptian culture.

capital (p. 110) The sculpted block that tops a **column**. According to the **conventions** of the **orders**, capitals include different decorative elements. See **order**. A **historiated capital** is one displaying a figural composition of a **narrative** scene.

capriccio (p. 912) A painting or print of a fantastic, imaginary landscape, usually with architecture.

capstone (p. 99) The final, topmost stone in a **corbel arch** or **vault**, which joins the sides and completes the structure.

cartoon (p. 497) A full-scale drawing used to transfer or guide a design onto a surface (such as a wall, canvas, panel, or **tapestry**) to be painted, carved, or woven.

cartouche (p. 189) A frame for a **hieroglyphic** inscription formed by a rope design surrounding an oval space. Used to signify a sacred or honored name. Also: in architecture, a decorative device or plaque, usually with a plain center used for inscriptions or epitaphs.

caryatid (p. 107) A sculpture of a draped female figure acting as a **column** supporting an **entablature**.

cassone (cassoni) (p. 616) An Italian dowry chest often highly decorated with carvings, paintings, **inlaid** designs, and gilt embellishments.

catacomb (p. 219) A subterranean burial ground consisting of tunnels on different levels, having niches for urns and **sarcophagi** and often incorporating rooms (**cubiculae**).

cathedral (p. 222) The principal Christian church in a diocese, the bishop's administrative center and housing his throne (*cathedra*).

celadon (p. 352) A high-fired, transparent glaze of pale bluish-green hue whose principal coloring agent is an oxide of iron. In China and Korea, such glazes typically were applied over a pale gray **stoneware** body, though Chinese potters sometimes applied them over **porcelain** bodies during the Ming (1368–1644) and Qing (1644–1911) dynasties. Chinese potters invented celadon glazes and initiated the continuous production of celadon-glazed wares as early as the third century CE.

cella (p. 108) The principal interior room at the center of a Greek or Roman temple within which the cult statue was usually housed. Also called the **naos**.

celt (p. 377) A smooth, oblong stone or metal object, shaped like an axe-head.

cenotaph (p. 771) A funerary monument commemorating an individual or group buried elsewhere.

centering (p. 172) A temporary structure that supports a masonry **arch** and **vault** or **dome** during construction until the mortar is fully dried and the masonry is self-sustaining.

central-plan building (p. 228) Any structure designed with a primary central space surrounded by symmetrical areas on each side. For example, a **rotunda** or a Greek-cross plan (equal-armed cross).

ceramics (p. 22) A general term covering all types of wares made from fired clay, including **porcelain** and **terra cotta**.

chacmool (p. 390) In Mayan sculpture, a half-reclining figure probably representing an offering bearer.

chaitya (p. 302) A type of Buddhist temple found in India. Built in the form of a hall or **basilica**, a *chaitya* hall is highly decorated with sculpture and usually is carved from a cave or natural rock location. It houses a sacred shrine or **stupa** for worship.

chamfer (p. 780) The slanted surface produced when an angle is trimmed or beveled, common in building and metalwork.

chasing (p. 776) Ornamentation made on metal by **incising** or hammering the surface.

château (châteaux) (p. 691) A French country house or residential castle. A *château fort*, is a military castle incorporating defensive works such as towers and battlements.

chattri (chattris) (p. 779) A decorative pavilion with an umbrella-shaped **dome** in Indian architecture.

chevron (p. 350) A decorative or heraldic motif of repeated Vs; a zigzag pattern.

chiaroscuro (p. 634) An Italian word designating the contrast of dark and light in a painting, drawing, or print. *Chiaroscuro* creates spatial depth and volumetric forms through gradations in the intensity of light and shadow.

cista (cistae) (p. 166) **Cylindrical** containers used by wealthy women as a case for toiletry articles such as a mirror.

clerestory (p. 58) The topmost zone of a wall with windows in a **basilica** extending above the aisle roofs. Provides direct light into the central interior space (the **nave**).

cloister (p. 442) An open space within a monastery, surrounded by an **arcaded** or colonnaded walkway, often having a fountain and garden. The most important monastic buildings (e.g., dormitory, refectory) open off of it. Since members of a cloistered order do not leave the monastery or interact with outsiders, the cloister represents the center of their enclosed world.

codex (codices) (p. 243) A book, or a group of **manuscript** pages (folios), held together by stitching or other binding on one side.

coffer (p. 197) A recessed decorative panel that is used to reduce the weight of and to decorate ceilings or **vaults**. The use of coffers is called coffering.

coiling (p. 845) A technique in basketry. In coiled baskets a spiraling structure is held in place by another material.

collage (p. 1026) A composition made of cut and pasted scraps of materials, sometimes with lines or forms added by the artist.

colonnade (p. 69) A row of **columns**, supporting a straight **lintel** (as in a **porch** or **portico**) or a series of **arches** (an **arcade**).

colophon (p. 432) The data placed at the end of a book listing the book's author, publisher, **illuminator**, and other information related to its production. In East Asian **handscrolls**, the inscriptions which follow the painting are also called colophons.

column (p. 110) An architectural element used for support and/or decoration. Consists of a rounded or polygonal vertical **shaft** placed on a **base** and topped by a decorative **capital**. In Classical architecture, built in accordance with the rules of one of the architectural **orders**. Columns can be free-standing or attached to a background wall (**engaged**).

combine (p. 1085) Combinations of painting and sculpture using nontraditional art materials.

complementary color (p. 993) The primary and secondary colors across from each other on the color wheel (red and green, blue and orange, yellow and purple). When juxtaposed, the intensity of both colors increases. When mixed together, they negate each other to make a neutral gray-brown.

composite order (p. 163) See **order**.

composite pose or **image (p. 9)** Combining different viewpoints within a single representation of a subject.

composition (p. xxix) The overall arrangement, organizing design, or structure of a work of art.

conch (p. 234) A half-**dome**.

cong (p. 328) A square or octagonal jade tube with a cylindrical hole in the center. A symbol of the earth, it was used for ritual worship and astronomical observations in ancient China.

connoisseurship (p. 741) A term derived from the French word connoisseur, meaning "an expert," and signifying the study and evaluation of art based primarily on **formal**, visual, and stylistic analysis. A connoisseur studies the style and technique of an object to assess its relative quality and identify its maker through visual comparison with other works of secure authorship. See also **contextualism; formalism**.

contrapposto (p. 121) An Italian term meaning "set against," used to describe the pose that results from setting parts of the body in opposition to each other around a central **axis**.

convention (p. 51) A traditional way of representing forms.

corbel, corbeling (p. 16) An early roofing and arching technique in which each **course** of stone projects slightly beyond the previous layer (a corbel) until the

uppermost corbels meet. Results in a high, almost pointed **arch** or **vault**.

corbeled vault (p. 99) See **vault**.

Corinthian order (p. 108) See **order**.

cornice (p. 110) The uppermost section of a Classical **entablature**. More generally, a horizontally projecting element found at the top of a building wall or **pedestal**. A raking cornice is formed by the junction of two slanted cornices, most often found in **pediments**.

course (p. 99) A horizontal layer of stone used in building.

crenellation (p. 44) Alternating higher and lower sections along the top of a defensive wall, giving a stepped appearance and forming a permanent shield for defenders on top of a fortified building.

crocket (p. 585) A stylized leaf used as decoration along the outer angle of spires, pinnacles, gables, and around **capitals** in Gothic architecture.

cruciform (p. 232) A term describing anything that is cross-shaped, as in the cruciform plan of a church.

cubiculum (cubicula) (p. 224) A small private room for burials in the **catacombs**.

cuneiform (p. 28) An early form of writing with wedge-shaped marks impressed into wet clay with a **stylus**, primarily used by ancient Mesopotamians.

curtain wall (p. 1045) A wall in a building that does not support any of the weight of the structure.

cyclopean construction (p. 93) A method of building using huge blocks of rough-hewn stone. Any large-scale, monumental building project that impresses by sheer size. Named after the Cyclopes (sing. Cyclops) one-eyed giants of legendary strength in Greek myths.

cylinder seal (p. 32) A small cylindrical stone decorated with **incised** patterns. When rolled across soft clay or wax, the resulting raised pattern or design (**relief**) served in Mesopotamian and Indus Valley cultures as an identifying signature.

dado (dadoes) (p. 163) The lower part of a wall, differentiated in some way (by a molding or different coloring or paneling) from the upper section.

daguerreotype (p. 967) An early photographic process that makes a positive print on a light-sensitized copperplate; invented and marketed in 1839 by Louis-Jacques-Mandé Daguerre.

demotic writing (p. 77) The simplified form of ancient Egyptian **hieratic writing**, used primarily for administrative and private texts.

dendrochronology (p. xxxvi) The dating of wood based on the patterns of the growth rings.

desert varnish (p. 400) In southwestern North America, a substance that turned cliff faces into dark surfaces. Neolithic artists would draw images by scraping through the dark surface.

diptych (p. 215) Two panels of equal size (usually decorated with paintings or **reliefs**) hinged together.

dogu (p. 356) Small human figurines made in Japan during the Jomon period. Shaped from clay, the figures have exaggerated expressions and are in contorted poses. They were probably used in religious rituals.

dolmen (p. 17) A prehistoric structure made up of two or more large upright stones supporting a large, flat, horizontal slab or slabs.

dome (p. 188) A rounded **vault**, usually over a circular space. Consists of curved masonry and can vary in shape from hemispherical to bulbous to ovoidal. May use a supporting vertical wall (**drum**), from which the vault springs, and may be crowned by an open space (**oculus**) and/or an exterior **lantern**. When a dome is built over a square space, an intermediate element is required to make the transition to a circular drum. There are two systems: A dome on **pendentives** (spherical triangles) incorporates **arched**, sloping intermediate sections of wall that carry the weight and **thrust** of the dome to

heavily **buttressed** supporting **piers**. A dome on **squinches** uses an arch built into the wall (squinch) in the upper corners of the space to carry the weight of the dome across the corners of the square space below. A half-dome or **conch** may cover a semicircular space.

domino construction (p. 1045) System of building construction introduced by the architect Le Corbusier in which reinforced concrete floor slabs are floated on six free-standing posts placed as if at the positions of the six dots on a domino playing piece.

Doric order (p. 108) See **order**.

dressed stone (p. 85) See **ashlar**.

drillwork (p. 190) The technique of using a drill for the creation of certain effects in sculpture.

drum (p. 110) The wall that supports a **dome**. Also: a segment of the circular **shaft** of a **column**.

drypoint (p. 748) An **intaglio** printmaking process by which a metal (usually copper) plate is directly inscribed with a pointed instrument (**stylus**). The resulting design of scratched lines is inked, wiped, and printed. Also: the print made by this process.

earthenware (p. 22) A low-fired, opaque **ceramic** ware that is fired in the range of 800 to 900 degrees Celsius. Earthenware employs humble clays that are naturally heat resistant; the finished wares remain porous after firing unless glazed. Earthenware occurs in a range of earth-toned colors, from white and tan to gray and black, with tan predominating.

earthwork (p. 1102) Usually very large scale, outdoor artwork that is produced by altering the natural environment.

echinus (p. 110) A cushionlike circular element found below the **abacus** of a **Doric capital**. Also: a similarly shaped molding (usually with egg-and-dart motifs) underneath the **volutes** of an **Ionic** capital.

electronic spin resonance (p. 12) Method that uses magnetic field and microwave irradiation to date material such as tooth enamel and its surrounding soil.

elevation (p. 108) The arrangement, proportions, and details of any vertical side or face of a building. Also: an architectural drawing showing an exterior or interior wall of a building.

emblema (emblemata) (p. 202) In a **mosaic**, the elaborate central motif on a floor, usually a self-contained unit done in a more refined manner, with smaller **tesserae** of both marble and semiprecious stones.

embroidery (p. 484) Stitches applied on top of an already-woven fabric ground.

encaustic (p. 79) A painting medium using pigments mixed with hot wax.

engaged column (p. 173) A column attached to a wall. See also **column**.

engraving (p. 590) An **intaglio** printmaking process of inscribing an image, design, or letters onto a metal or wood surface from which a print is made. An engraving is usually drawn with a sharp implement (**burin**) directly onto the surface of the plate. Also: the print made from this process.

entablature (p. 108) In the Classical **orders**, the horizontal elements above the **columns** and **capitals**. The entablature consists of, from bottom to top, an **architrave**, a **frieze**, and a **cornice**.

entasis (p. 108) A slight swelling of the **shaft** of a Greek **column**. The optical illusion of entasis makes the column appear from afar to be straight.

etching (p. 748) An **intaglio** printmaking process in which a metal plate is coated with acid-resistant resin and then inscribed with a **stylus** in a design, revealing the plate below. The plate is then immersed in acid, and the design of exposed metal is eaten away by the acid. The resin is removed, leaving the design etched permanently into the metal and the plate ready to be inked, wiped, and printed.

Eucharist (p. 222) The central rite of the Christian Church, from the Greek word "thanksgiving." Also known as the Mass or Holy Communion, it is based on the Last Supper. According to traditional Catholic Christian belief, consecrated bread and wine become the body and blood of Christ; in Protestant belief, bread and wine symbolize the body and blood.

exedra (exedrae) (p. 199) In architecture, a semicircular niche. On a small scale, often used as decoration, whereas larger exedrae can form interior spaces (such as an **apse**).

expressionism (p. 151) Terms describing a work of art in which forms are created primarily to evoke subjective emotions rather than a rational response.

façade (p. 52) The face or front wall of a building.

faience (p. 87) Type of **ceramic** covered with colorful, opaque glazes that form a smooth, impermeable surface. First developed in ancient Egypt.

fang ding (p. 328) A square or rectangular bronze vessel with four legs. The *fang ding* was used for ritual offerings in ancient China during the Shang dynasty.

femmage (p. 1101) From "female" and "**collage**," the incorporation of fabric into painting.

fête galante (p. 908) A subject in painting depicting well-dressed people at leisure in a park or country setting. It is most often associated with eighteenth-century French Rococo painting.

filigree (p. 87) Delicate, lacelike ornamental work.

fillet (p. 110) The flat ridge between the carved out **flutes** of a **column shaft**. See also fluting.

finial (p. 308) A knoblike architectural decoration usually found at the top point of a spire, pinnacle, canopy, or gable. Also found on furniture; also the ornamental top of a staff.

flutes, fluted (p. 110) In architecture, evenly spaced, rounded parallel vertical grooves incised on **shafts** of **columns** or columnar elements (such as **pilasters**).

flying buttress (p. 496) See **buttress**.

flying gallop (p. 87) Animals posed off the ground with legs fully extended backwards and forwards to signify that they are running.

foreshortening (p. 119) The illusion created on a flat surface in which figures and objects appear to recede or project sharply into space. Accomplished according to the rules of perspective.

formal analysis (p. xxix) An exploration of the visual character that artists bring to their works through the expressive use of elements such as line, form, color, and light, and through its overall structure or composition.

Formalism, formalist (p. 1073) An approach to the understanding, appreciation, and valuation of art based almost solely on considerations of form. This approach tends to regard an artwork as independent of its time and place of making. In the 1940s, Formalism was most ardently proposed by critic Clement Greenberg. See also **connoisseurship**.

forum (p. 178) A Roman town center; site of temples and administrative buildings and used as a market or gathering area for the citizens.

four-iwan mosque (p. 271) See **iwan** and **mosque**.

fresco (p. 87) A painting technique in which water-based pigments are applied to a surface of wet plaster (called **buon fresco**). The color is absorbed by the plaster, becoming a permanent part of the wall. **Fresco secco** is created by painting on dried plaster, and the color may flake off. Murals made by both these techniques are called frescoes.

fresco secco (p. 87) See **fresco**.

frieze (p. 108) The middle element of an **entablature**, between the **architrave** and the cornice. Usually decorated with sculpture, painting, or moldings. Also: any continuous flat band with **relief sculpture** or painted decorations.

frottage (p. 1056) A design produced by laying a piece of paper over a textured surface and rubbing with charcoal or other soft medium.

fusuma (p. 818) Sliding doors covered with paper, used in traditional Japanese construction. *Fusuma* are often highly decorated with paintings and colored backgrounds.

gallery (p. 236) In church architecture, the story found above the side **aisles** of a church, usually open to and overlooking the **nave**. Also: in secular architecture, a long room, usually above the ground floor in a private house or a public building used for entertaining, exhibiting pictures, or promenading. Also: a building or hall in which art is displayed or sold. Also: *galleria*.

garbhagriha (p. 301) From the Sanskrit word meaning "womb chamber," a small room or shrine in a Hindu temple containing a holy image.

genre painting (p. 712) A term used to loosely categorize paintings depicting scenes of everyday life, including (among others) domestic interiors, parties, inn scenes, and street scenes.

geoglyphs (p. 392) Earthen designs on a colossal scale, often created in a landscape as if to be seen from an aerial viewpoint.

gesso (p. 544) A ground made from glue, gypsum, and/or chalk forming the ground of a wood panel or the priming layer of a canvas. Provides a smooth surface for painting.

gilding (p. 87) The application of paper-thin **gold leaf** or gold pigment to an object made from another medium (for example, a sculpture or painting). Usually used as a decorative finishing detail.

giornata (giornate) (p. 537) Adopted from the Italian term meaning "a day's work," a giornata is the section of a **fresco** plastered and painted in a single day.

gold leaf (p. 47) Paper-thin sheets of hammered gold that are used in **gilding**. In some cases (such as Byzantine **icons**), also used as a ground for paintings.

gold foil (p. 87) A thin sheet of gold.

gopura (p. 775) The towering gateway to an Indian Hindu temple complex. A temple complex can have several different *gopuras*.

Grand Manner (p. 922) An elevated style of painting popular in the eighteenth century in which the artist looked to the ancients and to the Renaissance for inspiration; for portraits as well as history painting, the artist would adopt the poses, compositions, and attitudes of Renaissance and antique models.

Grand Tour (p. 911) Popular during the eighteenth and nineteenth centuries, an extended tour of cultural sites in France and Italy intended to finish the education of a young upper-class person primarily from Britain or North America.

granulation (p. 87) A technique of decoration in which metal granules, or tiny metal balls, are fused onto a metal surface.

graphic arts (p. xxiv) A term referring to those arts that are drawn or printed and that utilize paper as primary support.

grattage (p. 1056) A pattern created by scraping off layers of paint from a canvas laid over a textured surface. See also **frottage**.

grid (p. 64) A system of regularly spaced horizontally and vertically crossed lines that gives regularity to an architectural plan or in the composition of a work of art. Also: in painting, a grid is used to allow designs to be enlarged or transferred easily.

grisaille (p. 538) A style of monochromatic painting in shades of gray. Also: a painting made in this style.

groin vault (p. 188) See **vault**.

grozing (p. 497) In **stained-glass** windows, chipping away at the edges of a piece of glass to achieve the precise shape needed for inclusion in the composition.

hall church (p. 518) A church with a **nave** and **aisles** of the same height, giving the impression of a large, open hall.

handscroll (p. 337) A long, narrow, horizontal painting or text (or combination thereof) common in Chinese and Japanese art and of a size intended for individual use. A handscroll is stored wrapped tightly around a wooden pin and is unrolled for viewing or reading.

hanging scroll (p. 795) In Chinese and Japanese art, a vertical painting or text mounted within sections of silk. At the top is a semicircular rod; at the bottom is a round dowel. Hanging scrolls are kept rolled and tied except for special occasions, when they are hung for display, contemplation, or commemoration.

haniwa (p. 356) Pottery forms, including cylinders, buildings, and human figures, that were placed on top of Japanese tombs or burial mounds.

Happening (p. 1085) An art form developed by Allan Kaprow in the 1960s incorporating performance, theater, and visual images. A Happening was organized without a specific narrative or intent; with audience participation, the event proceeded according to chance and individual improvisation.

hemicycle (p. 508) A semicircular interior space or structure.

henge (p. 18) A circular area enclosed by stones or wood posts set up by Neolithic peoples. It is usually bounded by a ditch and raised embankment.

hieratic scale (p. 27) The use of different sizes for powerful or holy figures and for ordinary people to indicate relative importance. The larger the figure, the greater the importance.

hieroglyph (p. 52) Picture writing; words and ideas rendered in the form of pictorial symbols.

high relief (p. 304) See **relief sculpture**.

historiated capital (p. 479) See **capital**.

historicism (p. 963) The strong consciousness of and attention to the institutions, themes, styles, and forms of the past, made accessible by historical research, textual study, and archaeology.

history paintings (p. 924) Paintings based on historical, mythological, or biblical narratives. Once considered the noblest form of art, history paintings generally convey a high moral or intellectual idea and are often painted in a grand pictorial style.

horizon line A horizontal "line" formed by the implied meeting point of earth and sky. In **linear perspective**, the **vanishing point** or points are located on this "line."

horseshoe arch (p. 268) See **arch**.

hue (p. xxii) Pure color. The saturation or intensity of the hue depends on the purity of the color. Its value depends on its lightness or darkness.

hydria (p. 139) A large ancient Greek and Roman jar with three handles (horizontal ones at both sides and one vertical at the back), used for storing water.

hypostyle hall (p. 66) A large interior room characterized by many closely spaced columns that support its roof.

icon (p. 237) An image representing a sacred figure or event in the Byzantine, and later in the Orthodox, Church. Icons were venerated by the faithful, who believed them to have miraculous powers to transmit messages to God.

iconic image (p. 224) A picture that expresses or embodies an intangible concept or idea.

iconoclasm (p. 245) The banning or destruction of images, especially **icons** and religious art. Iconoclasm in eighth- and ninth-century Byzantium and sixteenth- and seventeenth-century Protestant territories arose from differing beliefs about the power, meaning, function, and purpose of imagery in religion.

iconography (p. xxxiii) Identifying and studying the subject matter and conventional motifs or symbols in works of art.

iconology (p. xxxv) Interpreting works of art as embodiments of cultural situation by placing them within broad social, political, religious, and intellectual contexts.

iconophile (p. 246) From the Greek for "lovers of images." In Byzantine art, iconophiles advocated for the continued use of **iconic images** in art.

iconostasis (p. 245) The partition screen in a Byzantine or Orthodox church between the **sanctuary** (where the Mass is performed) and the body of the church (where the congregation assembles). The iconostasis displays **icons**.

idealization (p. xxiv) A process in art through which artists strive to make their forms and figures attain perfection, based on pervading cultural values and/or their own personal ideals.

ideograph (p. 331) A written character or symbol representing an idea or object. Many Chinese characters are ideographs.

ignudi (p. 645) Heroic figures of nude young men.

illumination (p. 425) A painting on paper or parchment used as an illustration and/or decoration in **manuscripts** or **albums**. Usually richly colored, often supplemented by gold and other precious materials. The artists are referred to as illuminators. Also: the technique of decorating manuscripts with such paintings.

impasto (p. 748) Thick applications of pigment that give a painting a palpable surface texture.

impost block (p. 600) A block, serving to concentrate the weight above, imposed between the **capital** of a **column** and the springing of an **arch** above.

incising (p. 32) A technique in which a design or inscription is cut into a hard surface with a sharp instrument. Such a surface is said to be incised.

ink painting (p. 810) A monochromatic style of painting developed in China using black ink with gray washes.

inlay (p. 30) To set pieces of a material or materials into a surface to form a design. Also: material used in or decoration formed by this technique.

installation (p. 1087) Contemporary art created for a specific site, especially a gallery or outdoor area, that creates a complete and controlled environment.

intaglio (p. 590) Term used for a technique in which the design is carved out of the surface of an object, such as an **engraved seal** stone. In the **graphic arts**, intaglio includes **engraving**, **etching**, and **drypoint**—all processes in which ink transfers to paper from **incised**, ink-filled lines cut into a metal plate.

intarsia (p. 617) Decoration formed through wood **inlay**.

intuitive perspective (p. 184) See **perspective**.

Ionic order (p. 108) See **order**.

iwan (p. 71) A large, **vaulted** chamber in a **mosque** with a monumental **arched** opening on one side.

jamb (p. 473) In architecture, the vertical element found on both sides of an opening in a wall, and supporting an **arch** or **lintel**.

japonisme (p. 994) A style in French and American nineteenth-century art that was highly influenced by Japanese art, especially prints.

jasperware (p. 917) A fine-grained, unglazed, white **ceramic** developed by Josiah Wedgwood, often colored by metallic oxides with the raised designs remaining white.

jataka tales (p. 300) In Buddhism, stories associated with the previous lives of Shakyamuni, the historical Buddha.

joggled voussoirs (p. 272) Interlocking **voussoirs** in an **arch** or **lintel**, often of contrasting materials for colorful effect.

joined-block sculpture (p. 367) A method of constructing large-scale wooden sculpture developed in

Japan. The entire work is constructed from smaller hollow blocks, each individually carved, and assembled when complete. The joined-block technique allowed the production of larger sculpture, as the multiple joints alleviate the problems of drying and cracking found with sculpture carved from a single block.

kantharos (p. 117) A type of Greek vase or goblet with two large handles and a wide mouth.

keep (p. 473) The innermost and strongest structure or central tower of a medieval castle, sometimes used as living quarters, as well as for defense. Also called a donjon.

kente (p. 892) A woven cloth made by the Ashanti peoples of Africa. Kente cloth is woven in long, narrow pieces in complex and colorful patterns, which are then sewn together.

key block (p. 826) A key block is the master block in the production of a colored **woodblock print**, which requires different blocks for each color. The key block is a flat piece of wood upon which the outlines for the entire design of the print were first drawn on its surface and then all but these outlines were carved away with a knife. These outlines serve as a guide for the accurate **registration** or alignment of the other blocks needed to add colors to specific parts of a print.

keystone (p. 172) The topmost **voussoir** at the center of an **arch**, and the last block to be placed. The pressure of this block holds the arch together. Often of a larger size and/or decorated.

kiln (p. 22) An oven designed to produce enough heat for the baking, or firing, of clay.

kiva (p. 398) A ceremonial enclosure, usually wholly or partly underground, used for ritual purposes by modern Pueblo peoples and Ancestral Puebloans. *Kivas* may be round or square, made of **adobe** or stone, and they usually feature a hearth and a small indentation in the floor behind it.

kondo (p. 360) The main hall inside a Japanese Buddhist temple where the images of Buddha are housed.

korambo (p. 863) A ceremonial or spirit house in Pacific cultures, reserved for the men of a village and used as a meeting place as well as to hide religious artifacts from the uninitiated.

kore (kourai) (p. 114) An Archaic Greek statue of a young woman.

koru (p. 870) A design depicting a curling stalk with a bulb at the end that resembles a young tree fern, and often found in Maori art.

kouros (kouroi) (p. 114) An Archaic Greek statue of a young man or boy.

kowhaiwhai (p. 870) Painted curvilinear patterns often found in Maori art.

krater (p. 99) An ancient Greek vessel for mixing wine and water, with many subtypes that each have a distinctive shape. **Calyx krater**: a bell-shaped vessel with handles near the base that resemble a flower calyx. **Volute krater**: a type of krater with handles shaped like scrolls.

Kufic (p. 272) An ornamental, angular Arabic script.

kylix (p. 124) A shallow Greek cup, used for drinking, with a wide mouth and small handles near the rim.

lacquer (p. 22) A type of hard, glossy surface varnish used on objects in East Asian cultures, made from the sap of the Asian sumac or from shellac, a resinous secretion from the lac insect. Lacquer can be layered and manipulated or combined with pigments and other materials for various decorative effects.

lakshana (p. 303) Term used to designate the thirty-two marks of the historical Buddha. The *lakshana* include, among others, the Buddha's golden body, his long arms, the wheel impressed on his palms and the soles of his feet, and his elongated earlobes.

lamassu (p. 42) Supernatural guardian-protector of ancient Near Eastern palaces and throne rooms, often represented sculpturally as a combination of the bearded

head of a man, powerful body of a lion or bull, wings of an eagle, and the horned headdress of a god, usually possessing five legs.

lancet (p. 502) A tall, narrow window crowned by a sharply pointed **arch**, typically found in Gothic architecture.

lantern (p. 458) A turretlike structure situated on a roof, **vault**, or **dome**, with windows that allow light into the space below.

leythos (lekythoi) (p. 141) A slim Greek oil vase with one handle and a narrow mouth.

linear perspective (p. 593) See **perspective**.

linga shrine (p. 310) A place of worship centered on an object or representation in the form of a phallus (the lingam), which symbolizes the power of the Hindu god Shiva.

lintel (p. 473) A horizontal element of any material carried by two or more vertical supports to form an opening.

literati (p. 337) The English word used for the Chinese *wenren* or the Japanese *bunjin*, referring to well educated artists who enjoyed literature, **calligraphy**, and painting as a pastime. Their paintings are termed **literati painting**.

literati painting (p. 791) A style of painting that reflects the taste of the educated class of East Asian intellectuals and scholars. Aspects include an appreciation for the antique, small scale, and an intimate connection between maker and audience.

lithography (p. 951) Process of making a print (lithograph) from a design drawn on a flat stone block with greasy crayon. Ink is applied to the wet stone and adheres only to the greasy areas of the design.

loggia (p. 532) Italian term for a covered open-air **gallery**. Often used as a corridor between buildings or around a courtyard, loggias usually have **arcades** or **colonnades**.

logosyllabic (p. 385) A writing system consisting of both logograms (symbols that represent words) and phonetic signs (symbols that represent sounds, in this case syllables). Cuneiform, Maya, and Japanese are examples of logosyllabic scripts.

longitudinal-plan building (p. 228) Any structure designed with a rectangular shape. If a cross-shaped building, the main arm of the building would be longer then any arms that cross it. For example, **basilicas** or Latin-cross plan churches.

lost-wax casting (p. 413) A method of casting metal, such as bronze, by a process in which a wax mold is covered with clay and plaster, then fired, melting the wax and leaving a hollow form. Molten metal is then poured into the hollow space and slowly cooled. When the hardened clay and plaster exterior shell is removed, a solid metal form remains to be smoothed and polished.

low relief (p. 39) See **relief sculpture**.

lunette (p. 223) A semicircular wall area, framed by an **arch** over a door or window. Can be either plain or decorated.

lusterware (p. 277) **Ceramic** pottery decorated with metallic glazes.

madrasa (p. 271) An Islamic institution of higher learning, where teaching is focused on theology and law.

maenad (p. 104) In ancient Greece, a female devotee of the wine god Dionysos who participated in orgiastic rituals. She is often depicted with swirling drapery to indicate wild movement or dance. (Also called a Bacchante, after Bacchus, the Roman name of Dionysos.)

majolica (p. 571) Pottery painted with a tin glaze that, when fired, gives a lustrous and colorful surface.

mandala (p. 299) An image of the cosmos represented by an arrangement of circles or concentric geometric shapes containing diagrams or images. Used for meditation and contemplation by Buddhists.

mandapa (p. 301) In a Hindu temple, an open hall dedicated to ritual worship.

mandorla (p. 474) Light encircling, or emanating from, the entire figure of a sacred person.

manuscript (p. 242) A handwritten book or document.

maqsura (p. 268) An enclosure in a Muslim **mosque**, near the **mihrab**, designated for dignitaries.

martyrium (martyria) (p. 237) In Christian architecture, a church, chapel, or shrine built over the grave of a martyr or the site of a great miracle.

mastaba (p. 53) A flat-topped, one-story structure with slanted walls over an ancient Egyptian underground tomb.

matte (p. 571) Term describing a smooth surface that is without shine or luster.

mausoleum (p. 177) A monumental building used as a tomb. Named after the tomb of Mausolos erected at Halikarnassos around 350 BCE.

medallion (p. 225) Any round ornament or decoration. Also: a large medal.

megalith (p. 17) A large stone used in prehistoric building. Megalithic architecture employs such stones.

megaron (p. 93) The main hall of a Mycenaean palace or grand house, having a columnar **porch** and a room with central fireplace surrounded by four **columns**.

memento mori (p. 907) From Latin for "remember that you must die." An object, such as a skull or extinguished candle, typically found in a **vanitas** image, symbolizing the transience of life.

memory image (p. 8) An image that relies on the generic shapes and relationships that readily spring to mind at the mention of an object.

menorah (p. 219) A Jewish lamp-stand with seven or nine branches; the nine-branched menorah is used during the celebration of Hanukkah. Representations of the seven-branched menorah, once used in the Temple of Jerusalem, became a symbol of Judaism.

metope (p. 110) The carved or painted rectangular panel between the **triglyphs** of a **Doric frieze**.

mihrab (p. 261) A recess or niche that distinguishes the wall oriented toward Mecca (**qibla**) in a **mosque**.

millefiori (p. 428) A term derived from the Italian for "a thousand flowers" that refers to a glass-making technique in which rods of differently-colored glass are fused in a long bundle that is subsequently sliced to produce disks or beads with small-scale, multicolor patterns.

minaret (p. 267) A tower on or near a **mosque**, varying extensively in form throughout the Islamic world, from which the faithful are called to prayer five times a day.

minbar (p. 261) A high platform or pulpit in a **mosque**.

miniature (p. 243) Anything small. In painting, miniatures may be illustrations within **albums** or **manuscripts** or intimate portraits.

mirador (p. 275) In Spanish and Islamic palace architecture, a very large window or room with windows, and sometimes balconies, providing views to interior courtyards or the exterior landscape.

mithuna (p. 302) The amorous male and female couples in Buddhist sculpture, usually found at the entrance to a sacred building. The *mithuna* symbolize the harmony and fertility of life.

moai (p. 859) Statues found in Polynesia, carved from tufa, a yellowish brown volcanic stone, and depicting the human form. Nearly 1,000 of these statues have been found on the island of Rapa Nui but their significance has been a matter of speculation.

mobile (p. 1059) A sculpture made with parts suspended in such a way that they move in a current of air.

modeling (p. xxix) In painting, the process of creating the illusion of three-dimensionality on a two-dimensional surface by use of light and shade. In sculpture, the process of molding a three-dimensional form out of a malleable substance.

module (p. 341) A segment or portion of a repeated design. Also: a basic building block.

molding (p. 315) A shaped or sculpted strip with varying contours and patterns. Used as decoration on architecture, furniture, frames, and other objects.

mortise-and-tenon (p. 19) A method of joining two elements. A projecting pin (tenon) on one element fits snugly into a hole designed for it (mortise) on the other. Such joints are very strong and flexible.

mosaic (p. 146) Images formed by small colored stone or glass pieces (**tesserae**), affixed to a hard, stable surface.

mosque (p. 261) An edifice used for communal Islamic worship.

Mozarabic (p. 433) An eclectic style practiced in Christian medieval Spain while much of the Iberian peninsula was ruled by Muslim dynasties.

mudra (p. 304) A symbolic hand gesture in Buddhist art that denotes certain behaviors, actions, or feelings.

mullion (p. 507) A slender vertical element or colonnette that divides a window into subsidiary sections.

muqarna (p. 275) Small nichelike components stacked in tiers to fill the transition between differing vertical and horizontal planes.

naos (p. 236) The principal room in a temple or church. In ancient architecture, the **cella**. In a Byzantine church, the **nave** and **sanctuary**.

narrative image (p. 224) A picture that recounts an event drawn from a story, either factual (e.g., biographical) or fictional.

narthex (p. 222) The vestibule or entrance **porch** of a church.

nave (p. 192) The central space of a **basilica**, two or three stories high and usually flanked by aisles.

necking (p. 110) The molding at the top of the **shaft** of the **column**.

necropolis (p. 53) A large cemetery or burial area; literally a "city of the dead."

negative space (p. 120) Empty space, surrounded and shaped so that it acquires a sense of form or volume.

nemes headdress (p. 51) The royal headdress of Egypt.

niello (p. 87) A metal technique in which a black sulfur alloy is rubbed into fine lines **engraved** into metal (usually gold or silver). When heated, the **alloy** becomes fused with the surrounding metal and provides contrasting detail.

nishiki-e (p. 813) A multicolored and ornate Japanese print.

oculus (p. 188) In architecture, a circular opening. Oculi are usually found either as windows or at the apex of a **dome**. When at the top of a dome, an oculus is either open to the sky or covered by a decorative exterior **lantern**.

odalisque (p. 950) Turkish word for "harem slave girl" or "concubine."

ogee (p. 551) An S-shaped curve. See **arch**.

oinochoe (p. 128) A Greek jug used for wine.

olpe (p. 105) Any Greek vase or jug without a spout.

one-point perspective See **perspective**.

orant (p. 222) The representation of a standing figure praying with outstretched and upraised arms.

oratory (p. 232) A small chapel.

order (p. 110) A system of proportions in Classical architecture that includes every aspect of the building's plan, elevation, and decorative system. **Composite**: a combination of the **Ionic** and the **Corinthian** orders.

The **capital** combines **acanthus** leaves with **volute** scrolls. **Corinthian**: the most ornate of the orders, the Corinthian includes a **base**, a **fluted column shaft** with a capital elaborately decorated with acanthus leaf carvings. Its **entablature** consists of an **architrave** decorated with **moldings**, a **frieze** often containing sculptured **reliefs**, and a **cornice** with dentils. **Doric**: the column shaft of the Doric order can be fluted or smooth-surfaced and has no base. The Doric capital consists of an undecorated **echinus** and **abacus**. The Doric entablature has a plain architrave, a frieze with **metopes** and **triglyphs**, and a simple cornice. **Ionic**: the column of the Ionic order has a base, a fluted shaft, and a capital decorated with volutes. The Ionic entablature consists of an architrave of three panels and moldings, a frieze usually containing sculpted relief ornament, and a cornice with dentils. **Tuscan**: a variation of Doric characterized by a smooth-surfaced column shaft with a base, a plain architrave, and an undecorated frieze. A colossal order is any of the above built on a large scale, rising through several stories in height and often raised from the ground by a **pedestal**.

orientalism (p. 966) The fascination with Middle Eastern cultures.

orthogonal (p. 140) Any line running back into the represented space of a picture perpendicular to the imagined picture plane. In **linear perspective**, all orthogonals converge at a single **vanishing point** in the picture and are the basis for a **grid** that maps out the internal space of the image. An orthogonal plan is any plan for a building or city that is based exclusively on right angles, such as the grid plan of many major cities.

pagoda (p. 341) An East Asian **reliquary** tower built with successively smaller, repeated stories. Each story is usually marked by an elaborate projecting roof.

painterly (p. xxiv) A style of painting which emphasizes the techniques and surface effects of brushwork (also color, light, and shade).

palace complex (p. 41) A group of buildings used for living and governing by a ruler and his or her supporters, usually fortified.

palazzo (p. 600) Italian term for palace, used for any large urban dwelling.

palmette (p. 139) A fan-shaped ornament with radiating leaves.

panel painting Any painting executed on a wood support. The wood is usually planed to provide a smooth surface. A panel can consist of several boards joined together.

parapet (p. 138) A low wall at the edge of a balcony, bridge, roof, or other place from which there is a steep drop, built for safety. A parapet walk is the passageway, usually open, immediately behind the uppermost exterior wall or battlement of a fortified building.

parchment (p. 243) A writing surface made from treated skins of animals. Very fine parchment is known as **vellum**.

parish church (p. 239) Church where local residents attend regular services.

parterre (p. 760) An ornamental, highly regimented flowerbed. An element of the ornate gardens of seventeenth-century palaces and **châteaux**.

passage grave (p. 17) A prehistoric tomb under a **cairn**, reached by a long, narrow, slab-lined access passageway or passageways.

pastel (p. 912) Dry pigment, chalk, and gum in stick or crayon form. Also: a work of art made with pastels.

pedestal (p. 107) A platform or **base** supporting a sculpture or other monument. Also: the block found below the base of a Classical **column** (or **colonnade**), serving to raise the entire element off the ground.

pediment (p. 108) A triangular gable found over major architectural elements such as Classical Greek **porticoes**, windows, or doors. Formed by an **entablature** and the ends of a sloping roof or a raking **cornice**. A similar architectural element is often used decoratively

above a door or window, sometimes with a curved upper **molding**. A broken pediment is a variation on the traditional pediment, with an open space at the center of the topmost angle and/or the horizontal cornice.

pendentive (p. 236) The concave triangular section of a **vault** that forms the transition between a square or polygonal space and the circular **base** of a **dome**.

peplos (p. 115) A loose outer garment worn by women of ancient Greece. A cloth rectangle fastened on the shoulders and belted below the bust or at the waist.

Performance art (p. 1085) An artwork based on a live, sometimes theatrical performance by the artist.

peristyle (p. 66) A surrounding **colonnade** in Greek architecture. A peristyle building is surrounded on the exterior by a colonnade. Also: a peristyle court is an open colonnaded courtyard, often having a pool and garden.

perspective (p. 184) A system for representing three-dimensional space on a two-dimensional surface. **Atmospheric perspective**: A method of rendering the effect of spatial distance by subtle variations in color and clarity of representation. **Intuitive perspective**: A method of giving the impression of recession by visual instinct, not by the use of an overall system or program. Oblique perspective: An intuitive spatial system in which a building or room is placed with one corner in the picture plane, and the other parts of the structure recede to an imaginary vanishing point on its other side. Oblique perspective is not a comprehensive, mathematical system. **One-point** and multiple-point perspective (also called **linear**, scientific or mathematical): A method of creating the illusion of three-dimensional space on a two-dimensional surface by delineating a horizon line and multiple **orthogonal** lines. These recede to meet at one or more points on the horizon (called **vanishing points**), giving the appearance of spatial depth. Called scientific or mathematical because its use requires some knowledge of geometry and mathematics, as well as optics. Reverse perspective: A Byzantine perspective theory in which the orthogonals or rays of sight do not converge on a vanishing point in the picture, but are thought to originate in the viewer's eye in front of the picture. Thus, in reverse perspective the image is constructed with orthogonals that diverge, giving a slightly tipped aspect to objects.

photomontage (p. 1039) A photographic work created from many smaller photographs arranged (and often overlapping) in a composition, which is then rephotographed.

pictograph (p. 331) A highly stylized depiction serving as a symbol for a person or object. Also: a type of writing utilizing such symbols.

picture plane (p. 573) The theoretical plane corresponding with the actual surface of a painting, separating the spatial world evoked in the painting from the spatial world occupied by the viewer.

picture stone (p. 436) A medieval northern European memorial stone covered with figural decoration. See also **rune stone**.

picturesque (p. 917) A term describing the taste for the familiar, the pleasant, and the agreeable, popular in the eighteenth and nineteenth centuries in Europe. Originally used to describe the "picture like" qualities of some landscape scenes. When contrasted with the **sublime**, the picturesque stood for the interesting but ordinary domestic landscape.

piece-mold casting (p. 328) A casting technique in which the mold consists of several sections that are connected during the pouring of molten metal, usually bronze. After the cast form has hardened, the pieces of the mold are disassembled, leaving the completed object.

pier (p. 266) A masonry support made up of many stones, or rubble and concrete (in contrast to a column **shaft** which is formed from a single stone or a series of **drums**), often square or rectangular in plan, and capable of carrying very heavy architectural loads.

pietà (p. 231) A devotional subject in Christian religious art. After the Crucifixion the body of Jesus was laid across the lap of his grieving mother, Mary. When others are present the subject is called the Lamentation.

pietra dura (p. 781) Italian for "hard stone." Semiprecious stones selected for color, variation, and cut in shapes to form ornamental designs such as flowers or fruit.

pietra serena (p. 600) A gray Tuscan limestone used in Florence.

pilaster (p. 160) An **engaged column**-like element that is rectangular in format and used for decoration in architecture.

pilgrimage church (p. 239) A site that attracts visitors wishing to venerate **relics** as well as attend services.

pillar (p. 219) In architecture, any large, free-standing vertical element. Usually functions as an important weight-bearing unit in buildings.

pilotis (p. 1045) Free-standing posts.

pinnacle (p. 499) In Gothic architecture, a steep pyramid decorating the top of another element such as a **buttress**. Also: the highest point.

plate tracery (p. 502) See **tracery**.

plinth (p. 163) The slablike base or **pedestal** of a **column**, statue, wall, building, or piece of furniture.

pluralism (p. 1106) A social structure or goal that allows members of diverse ethnic, racial, or other groups to exist peacefully within the society while continuing to practice the customs of their own divergent cultures, thus providing to artists a variety of valid contemporary styles.

podium (p. 138) A raised platform that acts as the foundation for a building, or as a platform for a speaker.

polychrome, polychromy (p. 521) The multi-colored painting decoration applied to any part of a building, sculpture, or piece of furniture.

polyptych (p. 564) An altarpiece constructed from multiple panels, sometimes with hinges to allow for movable wings.

porcelain (p. 22) A high-fired, vitrified, translucent, white **ceramic** ware that employs two specific clays—kaolin and petuntse—and is fired in the range of 1,300 to 1,400 degrees Celsius. The relatively high proportion of silica in the body clays renders the finished porcelains translucent. Like **stonewares**, porcelains are glazed to enhance their aesthetic appeal and to aid in keeping them clean. By definition, porcelain is white, though it may be covered with a glaze of bright color or subtle hue. Chinese potters were the first in the world to produce porcelain, which they were able to make as early as the eighth century.

porch (p. 108) The covered entrance on the exterior of a building. With a row of **columns** or **colonnade**, also called a **portico**.

portal (p. 39) A grand entrance, door, or gate, usually to an important public building, and often decorated with sculpture.

portico (p. 62) In architecture, a projecting roof or porch supported by **columns**, often marking an entrance. See also **porch**.

post-and-lintel (p. 16) An architectural system of construction with two or more vertical elements (posts) supporting a horizontal element (**lintel**).

potassium-argon dating (p. 12) Technique used to measure the decay of a radioactive potassium isotope into a stable isotope of argon, and inert gas.

potsherd (p. 22) A broken piece of **ceramic** ware.

poupou (p. 871) A house panel, often carved with designs and found in Pacific cultures.

Prairie Style (p. 1046) Style developed by a group of midwestern architects who worked together using the aesthetic of the Prairie and indigenous prairie plants for landscape design to design mostly domestic homes and small public buildings mostly in the midwest.

predella (p. 548) The base of an altarpiece, often decorated with small scenes that are related in subject to that of the main panel or panels.

primitivism (p. 1022) The borrowing of subjects or forms usually from non-European or prehistoric sources by Western artists. Originally practiced by Western artists as an attempt to infuse their work with the naturalistic and expressive qualities attributed to other cultures, especially colonized cultures.

pronaos (p. 108) The enclosed vestibule of a Greek or Roman temple, found in front of the **cella** and marked by a row of **columns** at the entrance.

proscenium (p. 150) The stage of an ancient Greek or Roman theater. In modern theater, the area of the stage in front of the curtain. Also: the framing **arch** that separates a stage from the audience.

psalter (p. 253) In Jewish and Christian scripture, a book containing the psalms, or songs, attributed to King David.

psykter (p. 127) A Greek vessel with an extended bottom allowing it to float in a larger krater; used to chill wine.

putto (putti) (p. 229) A plump, naked little boy, often winged. In Classical art, called a cupid; in Christian art, a cherub.

pylon (p. 66) A massive gateway formed by a pair of tapering walls of oblong shape. Erected by ancient Egyptians to mark the entrance to a temple complex.

qibla (p. 267) The **mosque** wall oriented toward Mecca indicated by the **mihrab**.

quatrefoil (p. 503) A four-lobed decorative pattern common in Gothic art and architecture.

quillwork (p. 845) A Native American decorative craft technique. The quills of porcupines and bird feathers are dyed and attached to materials in patterns.

radiometric dating (p. 12) A method of dating prehistoric works of art made from organic materials, based on the rate of degeneration of radiocarbons in these materials. See also **relative dating**, **absolute dating**.

raigo (p. 372) A painted image that depicts the Amida Buddha and other Buddhist deities welcoming the soul of a dying worshiper to paradise.

raku (p. 821) A type of **ceramic** pottery made by hand, coated with a thick, dark glaze, and fired at a low heat. The resulting vessels are irregularly shaped and glazed, and are highly prized for use in the Japanese tea ceremony.

readymade (p. 1037) An object from popular or material culture presented without further manipulation as an artwork by the artist.

red-figure (p. 118) A style and technique of ancient Greek vase painting characterized by red clay-colored figures on a black background. (The figures are reserved against a painted ground and details are drawn, not engraved, as in **black-figure style**.)

register (p. 30) A device used in systems of spatial definition. In painting, a register indicates the use of differing groundlines to differentiate layers of space within an image. In sculpture, the placement of self-contained bands of **reliefs** in a vertical arrangement. See **registration marks**.

registration marks (p. 826) In Japanese **woodblock printing**, these were two marks carved on the blocks to indicate proper alignment of the paper during the printing process. In multicolor printing, which used a separate block for each color, these marks were essential for achieving the proper position or registration of the colors.

relative dating (p. 12) See **radiometric dating**.

relic (p. 239) A venerated object associated with a saint or martyr.

relief sculpture (p. 5) A three-dimensional image or design whose flat background surface is carved away to a certain depth, setting off the figure. Called **high** or **low (bas) relief** depending upon the extent of projection of the image from the background. Called **sunken relief** when the image is carved below the original surface of the background, which is not cut away.

reliquary (p. 299) A container, often made of precious materials, used as a repository to protect and display sacred **relics**.

repoussé (p. 87) A technique of hammering metal from the back to create a protruding image. Elaborate **reliefs** are created with wooden armatures against which the metal sheets are pressed and hammered.

rhyton (p. 88) A vessel in the shape of a figure or an animal, used for drinking or pouring liquids on special occasions.

rib vault (p. 495) See **vault**.

ridgepole (p. 16) A longitudinal timber at the apex of a roof that supports the upper ends of the rafters.

roof comb (p. 386) In a Mayan building, a masonry wall along the apex of a roof that is built above the level of the roof proper. Roof combs support the highly decorated false façades that rise above the height of the building at the front.

rosettes (p. 105) A round or oval ornament resembling a rose.

rotunda (p. 197) Any building (or part thereof) constructed in a circular (or sometimes polygonal) shape, usually producing a large open space crowned by a **dome**.

round arch (p. 172) See **arch**.

roundel (p. 160) Any element with a circular format, often placed as a decoration on the exterior of architecture.

rune stone (p. 436) A stone used in early medieval northern Europe as a commemorative monument, which is carved or inscribed with runes, a writing system used by early Germanic peoples.

rustication (p. 600) In building, the rough, irregular, and unfinished effect deliberately given to the exterior facing of a stone edifice. Rusticated stones are often large and used for decorative emphasis around doors or windows, or across the entire lower floors of a building. Also, masonry construction with conspicuous, often beveled joints.

salon (p. 905) A large room for entertaining guests; a periodic social or intellectual gathering, often of prominent people; a hall or **gallery** for exhibiting works of art.

sanctuary (p. 102) A sacred or holy enclosure used for worship. In ancient Greece and Rome, consisted of one or more temples and an altar. In Christian architecture, the space around the altar in a church called the chancel or presbytery.

sarcophagus (p. 49) A stone coffin. Often rectangular and decorated with **relief sculpture**.

scarab (p. 51) In Egypt, a stylized dung beetle associated with the sun and the god Amun.

scarification (p. 403) Ornamental decoration applied to the surface of the body by cutting the skin for cultural and/or aesthetic reasons.

school of artists (p. 281) An art historical term describing a group of artists, usually working at the same time and sharing similar styles, influences, and ideals. The artists in a particular school may not necessarily be directly associated with one another, unlike those in a workshop or **atelier**.

scribe (p. 242) A writer; a person who copies texts.

scriptorium (scriptoria) (p. 242) A room in a monastery for writing or copying **manuscripts**.

scroll painting (p. 243) A painting executed on a rolled support. Rollers at each end permit the horizontal scroll to be unrolled as it is studied or the vertical scroll to be hung for contemplation or decoration.

sculpture in the round (p. 5) Three-dimensional sculpture that is carved free of any background or block.

seals (p. 338) Personal emblems usually carved of stone in **intaglio** or **relief** and used to stamp a name or legend onto paper or silk. In China, they traditionally employ the archaic characters appropriately known as "seal script," of the Zhou or Qin. Cut in stone, a seal may state a formal given name, or it may state any of the numerous personal names that China's painters and writers adopted throughout their lives. A treasured work of art often bears not only the seal of its maker but also those of collectors and admirers through the centuries. In the Chinese view, these do not disfigure the work but add another layer of interest.

serdab (p. 53) In Egyptian tombs, the small room in which the *ka* statue was placed.

sfumato (p. 634) Italian term meaning "smoky," soft, and mellow. In painting, the effect of haze in an image. Resembling the color of the atmosphere at dusk, *sfumato* gives a smoky effect.

sgraffito (p. 602) Decoration made by **incising** or cutting away a surface layer of material to reveal a different color beneath.

shaft (p. 110) The main vertical section of a **column** between the **capital** and the **base**, usually circular in cross section.

shaft grave (p. 98) A deep pit used for burial.

shikhara (p. 301) In the architecture of northern India, a conical (or pyramidal) spire found atop a Hindu temple and often crowned with an **amalaka**.

shoin (p. 819) A term used to describe the various features found in the most formal room of upper-class Japanese residential architecture.

shoji (p. 819) A standing Japanese screen covered in translucent rice paper and used in interiors.

siapo (p. 874) A type of **tapa** cloth found in Samoa and still used as an important gift for ceremonial occasions.

silkscreen printing (p. 1091) A technique of printing in which paint or ink is pressed through a stencil and specially prepared cloth to produce a previously designed image. Also called serigraphy.

sinopia (sinopie) (p. 537) Italian word taken from "Sinope," the ancient city in Asia Minor that was famous for its red-brick pigment. In **fresco** paintings, a full-sized, preliminary sketch done in this color on the first rough coat of plaster or *arriccio*.

site-specific sculpture (p. 1102) A sculpture commissioned and/or designed for a particular location.

slip (p. 120) A mixture of clay and water applied to a ceramic object as a final decorative coat. Also: a solution that binds different parts of a vessel together, such as the handle and the main body.

spandrel (p. 172) The area of wall adjoining the exterior curve of an **arch** between its springing and the **keystone**, or the area between two arches, as in an **arcade**.

spolia (p. 465) Latin for "hide stripped from an animal." Term used for fragments of older architecture or sculpture reused in a secondary context.

springing (p. 172) The point at which the curve of an **arch** or **vault** meets with and rises from its support.

squinch (p. 236) An **arch** or **lintel** built across the upper corners of a square space, allowing a circular or polygonal dome to be more securely set above the walls.

stained glass (p. 464) Molten glass stained with color using metallic oxides. Stained glass is most often used in windows, for which small pieces of different colors are precisely cut and assembled into a design, held together by lead **cames**. Additional details may be added with vitreous paint.

stave church (p. 436) A Scandinavian wooden structure with four huge timbers (staves) at its core.

stele (stelae) (p. 27) A stone slab placed vertically and decorated with inscriptions or reliefs. Used as a grave marker or memorial.

stereobate (p. 110) A foundation upon which a Classical temple stands.

still life (p. xxxv) A type of painting that has as its subject inanimate objects (such as food, dishes, fruit, or flowers).

stoa (p. 107) In Greek architecture, a long roofed walk-way, usually having **columns** on one long side and a wall on the other.

stoneware (p. 22) A high-fired, vitrified, but opaque **ceramic** ware that is fired in the range of 1,100 to 1,200 degrees Celsius. At that temperature, particles of silica in the clay bodies fuse together so that the finished vessels are impervious to liquids, even without glaze. Stoneware pieces are glazed to enhance their aesthetic appeal and to aid in keeping them clean (since unglazed ceramics are easily soiled). Stoneware occurs in a range of earth-toned colors, from white and tan to gray and black, with light gray predominating. Chinese potters were the first in the world to produce stoneware, which they were able to make as early as the Shang dynasty.

stringcourse (p. 499) A continuous horizontal band, such as a **molding**, decorating the face of a wall.

studiolo (p. 617) A room for private conversation and the collection of fine books and art objects. Also known as a study.

stupa (p. 298) In Buddhist architecture, a bell-shaped or pyramidal religious monument, made of piled earth or stone, and containing sacred **relics**.

stylobate (p. 110) In Classical architecture, the stone foundation on which a temple **colonnade** stands.

stylus (p. 28) An instrument with a pointed end (used for writing and printmaking), which makes a delicate line or scratch. Also: a special writing tool for **cuneiform** writing with one pointed end and one triangular.

sublime (p. 955) djective describing a concept, thing, or state of greatness or vastness with high spiritual, moral, intellectual or emotional value; or something awe-inspiring. The sublime was a goal to which many nineteenth-century artists aspired in their artworks.

sunken relief (p. 71) See **relief sculpture**.

symposium (p. 118) An elite gathering of wealthy and powerful men in ancient Greece that focused principally on wine, music, poetry, conversation, games, and love making.

syncretism (p. 222) A process whereby artists assimilate images and ideas from other traditions or cultures and give them new meanings.

taotie (p. 328) A mask with a dragon or animal-like face common as a decorative motif in Chinese art.

tapa (p. 874) A type of cloth used for various purposes in Pacific cultures, made from tree bark stripped and beaten, and often bearing subtle designs from the mallets used to work the bark.

tapestry (p. 484) Multicolored pictorial or decorative weaving meant to be hung on a wall or placed on furniture. Pictorial or decorative motifs are woven directly into the fabric of the cloth itself.

tatami (p. 819) Mats of woven straw used in Japanese houses as a floor covering.

tempera (p. 141) A painting medium made by blending egg yolks with water, pigments, and occasionally other materials, such as glue.

tenebrism (p. 724) The use of strong **chiaroscuro** and artificially illuminated areas to create a dramatic contrast of light and dark in a painting.

terra cotta (p. 114) A medium made from clay fired over a low heat and sometimes left unglazed. Also: the orange-brown color typical of this medium.

tessera (tesserae) (p. 146) The small piece of stone, glass, or other object that is pieced together with many others to create a **mosaic**.

tetrarchy (p. 204) Four-man rule, as in the late Roman Empire, when four emperors shared power.

thatch (p. 17) Plant material such as reeds or straw tied over a framework of poles.

thermo-luminescence dating (p. 12) A technique that measures the irradiation of the crystal structure of material such as flint or pottery and the soil in which it is found, determined by luminescence produced when a sample is heated.

tholos (p. 138) A small, round building. Sometimes built underground, as in a Mycenaean tomb.

tholos tomb (p. 98) See **tholos**.

thrust (p. 172) The outward pressure caused by the weight of a **vault** and supported by **buttressing**. See **arch**.

tierceron (p. 554) In vault construction, a secondary rib that arcs from a **springing** point to the rib that runs lengthwise through the **vault**, called the ridge rib.

tondo (p. 128) A painting or **relief sculpture** of circular shape.

torana (p. 300) In Indian architecture, an ornamented gateway **arch** in a temple, usually leading to the **stupa**.

torc (p. 151) A circular neck ring worn by Celtic warriors.

toron (p. 417) In West African **mosque** architecture, the wooden beams that project from the walls. Torons are used as support for the scaffolding erected annually for the replastering of the building.

tracery (p. 502) Stonework or woodwork applied to wall surfaces or filling the open space of windows. In **plate tracery**, openings are cut through the wall. In **bar tracery**, **mullions** divide the space into vertical segments and form decorative patterns at the top of the opening or panel.

transept (p. 228) The arm of a **cruciform** church, perpendicular to the **nave**. The point where the nave and transept cross is called the crossing. Beyond the crossing lies the **sanctuary**, whether **apse**, choir, or chevet.

transverse arch (p. 457) An **arch** that connects the wall **piers** on both sides of an interior space, up and over a stone **vault**.

trefoil (p. 294) An ornamental design made up of three rounded lobes placed adjacent to one another.

triforium (p. 502) The element of the interior elevation of a church, found directly below the **clerestory** and consisting of a series of **arched** openings. The triforium can be made up of openings from a narrow wall passageway, or it can be attached directly to the wall.

triglyph (p. 110) Rectangular block between the **metopes** of a **Doric frieze**. Identified by the three carved vertical grooves, which approximate the appearance of the end of a wooden beam.

triptych (p. 564) An artwork made up of three panels. The panels may be hinged together so the side segments (wings) fold over the central area.

trompe l'oeil (p. 617) A manner of representation in which the appearance of natural space and objects is re-created with the express intention of fooling the eye of the viewer, who may be convinced that the subject actually exists as three-dimensional reality.

trumeau (p. 473) A **column**, **pier**, or post found at the center of a large **portal** or doorway, supporting the **lintel**.

tugra (p. 284) A **calligraphic** imperial monogram used in Ottoman courts.

tukutuku (p. 871) Lattice panels created by women from the Maori culture and used in architecture.

Tuscan order (p. 161) See **order**.

twining (p. 845) A basketry technique in which short rods are sewn together vertically. The panels are then joined together to form a vessel.

tympanum (p. 473) In Classical architecture, the vertical panel of the **pediment**. In medieval and later architecture, the area over a door enclosed by an **arch** and a **lintel**, often decorated with sculpture or **mosaic**.

ukiyo-e (p. 994) A Japanese term for a type of popular art that was favored from the sixteenth century, particularly in the form of color **woodblock prints**. *Ukiyo-e* prints often depicted the world of the common people in Japan, such as courtesans and actors, as well as landscapes and myths.

undercutting (p. 214) A technique in sculpture by which the material is cut back under the edges so that the remaining form projects strongly forward, casting deep shadows.

underglaze (p. 799) Color or decoration applied to a ceramic piece before glazing.

upeti (p. 874) A carved wooden design tablet, used to create patterns in cloth by dragging the fabric across it, and found in Pacific cultures.

urna (p. 303) In Buddhist art, the curl of hair on the forehead that is a characteristic mark of a buddha. The *urna* is a symbol of divine wisdom.

ushnisha (p. 303) In Asian art, a round turban or tiara symbolizing royalty and, when worn by a buddha, enlightenment.

vanishing point (p. 608) In a **perspective** system, the point on the **horizon line** at which orthogonals meet. A complex system can have multiple vanishing points.

vanitas (p. 751) An image, especially popular in Europe during the seventeenth century, in which all the objects symbolize the transience of life. *Vanitas* paintings are usually of still lifes or genre subjects.

vault (p. 17) An arched masonry structure that spans an interior space. **Barrel** or tunnel vault: an elongated or continuous semicircular vault, shaped like a half-cylinder.

Corbeled vault: a vault made by projecting **courses** of stone. **Groin** or cross vault: a vault created by the intersection of two barrel vaults of equal size which creates four side compartments of identical size and shape. Quadrant or half-barrel vault: as the name suggests a half-barrel vault. **Rib vault**: ribs (extra masonry) demarcate the junctions of a groin vault. Ribs may function to reinforce the groins or may be purely decorative. See also **corbeling**.

veduta (p. 913) Italian for "vista" or "view." Paintings, drawings, or prints often of expansive city scenes or of harbors.

vellum (p. 243) A fine animal skin prepared for writing and painting. See also **parchment**.

verism (p. 170) style in which artists concern themselves with describing the exterior likeness of an object or person, usually by rendering its visible details in a finely executed, meticulous manner.

vihara (p. 301) From the Sanskrit term meaning "for wanderers." A *vihara* is, in general, a Buddhist monastery in India. It also signifies monks' cells and gathering places in such a monastery.

volute (p. 110) A spiral scroll, as seen on an **Ionic capital**.

votive figure (p. 31) An image created as a devotional offering to a god or other deity.

voussoir (p. 172) The oblong, wedge-shaped stone blocks used to build an arch. The topmost voussoir is called a **keystone**.

warp (p. 286) The vertical threads in a weaver's loom. Warp threads make up a fixed framework that provides the structure for the entire piece of cloth, and are thus often thicker than weft threads. See also **weft**.

wattle and daub (p. 17) A wall construction method combining upright branches, woven with twigs (wattles) and plastered or filled with clay or mud (daub).

weft (p. 286) The horizontal threads in a woven piece of cloth. Weft threads are woven at right angles to and through the warp threads to make up the bulk of the decorative pattern. In carpets, the weft is often completely covered or formed by the rows of trimmed knots that form the carpet's soft surface. See also **warp**.

westwork (p. 439) The monumental, west-facing entrance section of a Carolignian, Ottonian, or Romanesque church. The exterior consists of multiple stories between two towers; the interior includes an entrance vestibule, a chapel, and a series of **galleries** overlooking the nave.

white-ground (p. 141) A type of ancient Greek pottery in which the background color of the object was painted with a **slip** that turns white in the firing process. Figures and details were added by painting on or **incising** into this slip. White-ground wares were popular in the Classical period as funerary objects.

woodblock print (p. 589) A print made from one or more carved wooden blocks. In Japan, woodblock prints were made using multiple blocks carved in **relief**, usually with a block for each color in the finished print. See also **woodcut**.

woodcut (p. 590) A type of print made by carving a design into a wooden block. The ink is applied to the block with a roller. As the ink remains only on the raised areas between the carved-away lines, these carved-away areas and lines provide the white areas of the print. Also: the process by which the woodcut is made.

yaksha, yakshi (p. 296) The male (*yaksha*) and female (*yakshi*) nature spirits that act as agents of the Hindu gods. Their sculpted images are often found on Hindu temples and other sacred places, particularly at the entrances.

ziggurat (p. 28) In Mesopotamia, a tall stepped tower of earthen materials, often supporting a shrine.

BIBLIOGRAPHY

Susan V. Craig, updated by Carrie L. McDade

This bibliography is composed of books in English that are appropriate "further reading" titles. Most items on this list are available in good libraries, whether college, university, or public institutions. Recently published works have been emphasized so that the research information would be current. There are three classifications of listings: general surveys and art history reference tools, including journals and Internet directories; surveys of large periods that encompass multiple chapters (ancient art in the Western tradition, European medieval art, European Renaissance through eighteenth-century art, modern art in the West, Asian art, and African and Oceanic art, and art of the Americas); and books for individual Chapters 1 through 32.

General Art History Surveys and Reference Tools

Adams, Laurie Schneider. *Art across Time.* 4th ed. New York: McGraw-Hill, 2011.

Barnet, Sylvan. *A Short Guide to Writing about Art.* 10th ed. Upper Saddle River, NJ: Pearson/Prentice Hall, 2010.

Bony, Anne. *Design: History, Main Trends, Main Figures.* Edinburgh: Chambers, 2005.

Boström, Antonia. *Encyclopedia of Sculpture.* 3 vols. New York: Fitzroy Dearborn, 2004.

Broude, Norma, and Mary D. Garrard, eds. *Feminism and Art History: Questioning the Litany.* Icon Editions. New York: Harper & Row, 1982.

Chadwick, Whitney. *Women, Art, and Society.* 4th ed. New York: Thames & Hudson, 2007.

Chilvers, Ian, ed. *The Oxford Dictionary of Art.* 4th ed. New York: Oxford Univ. Press, 2009.

Curl, James Stevens. *A Dictionary of Architecture and Landscape Architecture.* 2nd ed. Oxford: Oxford Univ. Press, 2006.

Davies, Penelope J. E., et al. *Janson's History of Art: The Western Tradition.* 8th ed. Upper Saddle River, NJ: Prentice Hall, 2010.

The Dictionary of Art. Ed. Jane Turner. 34 vols. New York: Grove's Dictionaries, 1996.

Encyclopedia of World Art. 17 vols. New York: McGraw-Hill, 1959–84.

Frank, Patrick, Duane Preble, and Sarah Preble. *Prebles' Artforms.* 10th ed. Upper Saddle River, NJ: Pearson/Prentice Hall, 2008.

Gaze, Delia, ed. *Dictionary of Women Artists.* 2 vols. London: Fitzroy Dearborn, 1997.

Griffiths, Antony. *Prints and Printmaking: An Introduction to the History and Techniques.* 2nd ed. London: British Museum Press, 1996.

Hadden, Peggy. *The Quotable Artist.* New York: Allworth Press, 2002.

Hall, James. *Dictionary of Subjects and Symbols in Art.* 2nd ed. Boulder, CO: Westview Press, 2008.

Holt, Elizabeth Gilmore, ed. *A Documentary History of Art.* 3 vols. New Haven: Yale Univ. Press, 1986.

Honour, Hugh, and John Fleming. *The Visual Arts: A History.* 7th ed. rev. Upper Saddle River, NJ: Pearson/Prentice Hall, 2010.

Johnson, Paul. *Art: A New History.* New York: HarperCollins, 2003.

Kemp, Martin, ed. *The Oxford History of Western Art.* Oxford: Oxford Univ. Press, 2000.

Kleiner, Fred S. *Gardner's Art through the Ages.* Enhanced 13th ed. Belmont, CA: Thomson/Wadsworth, 2011.

Kostof, Spiro. *A History of Architecture: Settings and Rituals.* 2nd ed. Revised. Greg Castillo. New York: Oxford Univ. Press, 1995.

Mackenzie, Lynn. *Non-Western Art: A Brief Guide.* 2nd ed. Upper Saddle River, NJ: Pearson/Prentice Hall, 2001.

Marmor, Max, and Alex Ross, eds. *Guide to the Literature of Art History 2.* Chicago: American Library Association, 2005.

Onians, John, ed. *Atlas of World Art.* New York: Oxford Univ. Press, 2004.

Sayre, Henry M. *Writing about Art.* 6th ed. Upper Saddle River, NJ: Pearson/Prentice Hall, 2009.

Sed-Rajna, Gabrielle. *Jewish Art.* Trans. Sara Friedman and Mira Reich. New York: Abrams, 1997.

Slatkin, Wendy. *Women Artists in History: From Antiquity to the Present.* 4th ed. Upper Saddle River, NJ: Pearson/Prentice Hall, 2001.

Sutton, Ian. *Western Architecture: From Ancient Greece to the Present.* World of Art. New York: Thames & Hudson, 1999.

Trachtenberg, Marvin, and Isabelle Hyman. *Architecture, from Prehistory to Postmodernity.* 2nd ed. Upper Saddle River, NJ: Pearson/Prentice Hall, 2002.

Watkin, David. *A History of Western Architecture.* 4th ed. New York: Watson-Guptill, 2005.

Art History Journals: A Select List of Current Titles

African Arts. Quarterly. Los Angeles: Univ. of California at Los Angeles, James S. Coleman African Studies Center, 1967–.

American Art: The Journal of the Smithsonian American Art Museum. 3/year. Chicago: Univ. of Chicago Press, 1987–.

American Indian Art Magazine. Quarterly. Scottsdale, AZ: American Indian Art Inc., 1975–.

American Journal of Archaeology. Quarterly. Boston: Archaeological Institute of America, 1885–.

Antiquity: A Periodical of Archaeology. Quarterly. Cambridge: Antiquity Publications Ltd., 1927–.

Apollo: The International Magazine of the Arts. Monthly. London: Apollo Magazine Ltd., 1925–.

Architectural History. Annually. Farnham, UK: Society of Architectural Historians of Great Britain, 1958–.

Archives of American Art Journal. Quarterly. Washington, DC: Archives of American Art, Smithsonian Institution, 1960–.

Archives of Asian Art. Annually. New York: Asia Society, 1945–.

Ars Orientalis: The Arts of Asia, Southeast Asia, and Islam. Annually. Ann Arbor: Univ. of Michigan Dept. of Art History, 1954–.

Art Bulletin. Quarterly. New York: College Art Association, 1913–.

Art History: Journal of the Association of Art Historians. 5/year. Oxford: Blackwell Publishing Ltd., 1978–.

Art in America. Monthly. New York: Brant Publications Inc., 1913–.

Art Journal. Quarterly. New York: College Art Association, 1960–.

Art Nexus. Quarterly. Bogata, Colombia: Arte en Colombia Ltda., 1976–.

Art Papers Magazine. Bimonthly. Atlanta: Atlanta Art Papers Inc., 1976–.

Artforum International. 10/year. New York: Artforum International Magazine Inc., 1962–.

Artnews. 11/year. New York: Artnews LLC, 1902–.

Bulletin of the Metropolitan Museum of Art. Quarterly. New York: Metropolitan Museum of Art, 1905–.

Burlington Magazine. Monthly. London: Burlington Magazine Publications Ltd., 1903–.

Dumbarton Oaks Papers. Annually. Locust Valley, NY: J. J. Augustin Inc., 1940–.

Flash Art International. Bimonthly. Trevi, Italy: Giancarlo Politi Editore, 1980–.

Gesta. Semiannually. New York: International Center of Medieval Art, 1963–.

History of Photography. Quarterly. Abingdon, UK: Taylor & Francis Ltd., 1976–.

International Review of African American Art. Quarterly. Hampton, VA: International Review of African American Art, 1976–.

Journal of Design History. Quarterly. Oxford: Oxford Univ. Press, 1988–.

Journal of Egyptian Archaeology. Annually. London: Egypt Exploration Society, 1914–.

Journal of Hellenic Studies. Annually. London: Society for the Promotion of Hellenic Studies, 1880–.

Journal of Roman Archaeology. Annually. Portsmouth, RI: Journal of Roman Archaeology LLC, 1988–.

Journal of the Society of Architectural Historians. Quarterly. Chicago: Society of Architectural Historians, 1940–.

Journal of the Warburg and Courtauld Institutes. Annually. London: Warburg Institute, 1937–.

Leonardo: Art, Science and Technology. 6/year. Cambridge, MA: MIT Press, 1968–.

Marg. Quarterly. Mumbai, India: Scientific Publishers, 1946–.

Master Drawings. Quarterly. New York: Master Drawings Association, 1963–.

October. Cambridge, MA: MIT Press, 1976–.

Oxford Art Journal. 3/year. Oxford: Oxford Univ. Press, 1978–.

Parkett. 3/year. Zürich, Switzerland: Parkett Verlag AG, 1984–.

Print Quarterly. Quarterly. London: Print Quarterly Publications, 1984–.

Simiolus: Netherlands Quarterly for the History of Art. Quarterly. Apeldoorn, Netherlands: Stichting voor Nederlandse Kunsthistorische Publicaties, 1966–.

Woman's Art Journal. Semiannually. Philadelphia: Old City Publishing Inc., 1980–.

Internet Directories for Art History Information: A Selected List

ARCHITECTURE AND BUILDING,
http://www.library.unlv.edu/arch/rsrce/webresources/
A directory of architecture websites collected by Jeanne Brown at the Univ. of Nevada at Las Vegas. Topical lists include architecture, building and construction, design, history, housing, planning, preservation, and landscape architecture. Most entries include a brief annotation and the last date the link was accessed by the compiler.

ART HISTORY RESOURCES ON THE WEB,
http://witcombe.sbc.edu/ARTHLinks.html
Authored by Professor Christopher L. C. E. Witcombe of Sweet Briar College in Virginia, since 1995, the site includes an impressive number of links for various art historical eras as well as links to research resources, museums, and galleries. The content is frequently updated.

ART IN FLUX: A DIRECTORY OF RESOURCES FOR RESEARCH IN CONTEMPORARY ART,
http://www.boisestate.edu/art/artinflux/intro.html
Cheryl K. Shurtleff of Boise State Univ. in Idaho, has authored this directory, which includes sites selected according to their relevance to the study of national or international contemporary art and artists. The subsections include artists, museums, theory, reference, and links.

ARTCYCLOPEDIA: THE GUIDE TO GREAT ART ON THE INTERNET
http://www.artcyclopedia.com
With more than 2,100 art sites and 75,000 links, this is one of the most comprehensive web directories for artists and art topics. The primary search is by artist's name but access is also available by title of artwork, artistic movement, museums and galleries, nationality, period, and medium.

MOTHER OF ALL ART AND ART HISTORY LINKS PAGES
http://umich.edu/~motherha
Maintained by the Dept. of the History of Art at the Univ. of Michigan, this directory covers art history departments, art museums, fine arts schools and departments as well as links to research resources. Each entry includes annotations.

VOICE OF THE SHUTTLE,
http://vos.ucsb.edu
Sponsored by Univ. of California, Santa Barbara, this directory includes more than 70 pages of links to humanities and humanities-related resources on the Internet. The structured guide includes specific subsections on architecture, on art (modern and contemporary), and on art history. Links usually include a one-sentence explanation and the resource is frequently updated with new information.

ARTBABBLE
http://www.artbabble.org/
An online community created by staff at the Indianapolis Museum of Art to showcase art-based video content, including interviews with artists and curators, original documentaries, and art installation videos. Partners and contributors to the project include Art21, Los Angeles County Museum of Art, The Museum of Modern Art, The New York Public Library, San Francisco Museum of Modern Art, and Smithsonian American Art Museum.

YAHOO! ARTS>ART HISTORY,
http://dir.yahoo.com/Arts/Art_History/
Another extensive directory of art links organized into subdivisions with one of the most extensive being "Periods and

Movements." Links include the name of the site as well as a few words of explanation.

European Medieval Art, General

Backman, Clifford R. *The Worlds of Medieval Europe*. 2nd ed. New York: Oxford Univ. Press, 2009.

Bennett, Adelaide Louise, et al. *Medieval Mastery: Book Illumination from Charlemagne to Charles the Bold: 800–1475*. Trans. Lee Preedy and Greta Arblaster-Holmer. Turnhout: Brepols, 2002.

Benton, Janetta R. *Art of the Middle Ages*. World of Art. New York: Thames & Hudson, 2002.

Binski, Paul. *Painters*. Medieval Craftsmen. London: British Museum Press, 1991.

Brown, Sarah, and David O'Connor. *Glass-painters*. Medieval Craftsmen. London: British Museum Press, 1991.

Calkins, Robert G. *Medieval Architecture in Western Europe: From a.d. 300 to 1500*. New York: Oxford Univ. Press, 1998.

Cherry, John F. *Goldsmiths*. Medieval Craftsmen. London: British Museum Press, 1992.

Clark, William W. *The Medieval Cathedrals*. Westport, CT: Greenwood Press, 2006.

Coldstream, Nicola. *Masons and Sculptors*. Medieval Craftsmen. London: British Museum Press, 1991.

———. *Medieval Architecture*. Oxford History of Art. Oxford: Oxford Univ. Press, 2002.

De Hamel, Christopher. *Scribes and Illuminators*. Medieval Craftsmen. London: British Museum Press, 1992.

Duby, Georges. *Art and Society in the Middle Ages*. Trans. Jean Birrell. Malden, MA: Blackwell, 2000.

Fossier, Robert, ed. *The Cambridge Illustrated History of the Middle Ages*. Trans. Janet Sondheimer and Sarah Hanbury Tenison. 3 vols. Cambridge: Cambridge Univ. Press, 1986–97.

Hürlimann, Martin, and Jean Bony. *French Cathedrals*. Rev. & enlarged ed. London: Thames & Hudson, 1967.

Jotischky, Andrew, and Caroline Susan Hull. *The Penguin Historical Atlas of the Medieval World*. New York: Penguin, 2005.

Kenyon, John. *Medieval Fortifications*. Leicester: Leicester Univ. Press, 1990.

Pfaffenbichler, Matthias. *Armourers*. Medieval Craftsmen. London: British Museum Press, 1992.

Rebold Benton, Janetta. *Art of the Middle Ages*. World of Art. New York: Thames & Hudson, 2002.

Rudolph, Conran, ed. *A Companion to Medieval Art*. Blackwell Companions to Art History. Oxford: Blackwell, 2006.

Sekules, Veronica. *Medieval Art*. Oxford History of Art. New York: Oxford Univ. Press, 2001.

Snyder, James, Henry Luttikhuizen, and Dorothy Verkerk. *Art of the Middle Ages*. 2nd ed. Upper Saddle River, NJ: Pearson/Prentice Hall, 2006.

Staniland, Kay. *Embroiderers*. Medieval Craftsmen. London: British Museum Press, 1991.

Stokstad, Marilyn. *Medieval Art*. 2nd ed. Boulder, CO: Westview Press, 2004.

———. *Medieval Castles*. Greenwood Guides to Historic Events of the Medieval World. Westport, CT: Greenwood Press, 2005.

Chapter 7 Jewish, Early Christian, and Byzantine Art

Age of Spirituality: Late Antique and Early Christian Art, Third to Seventh Century. New York: Metropolitan Museum of Art, 1979.

Beckwith, John. *Early Christian and Byzantine Art*. 2nd ed. Pelican History of Art. New Haven: Yale Univ. Press, 1979.

Bleiberg, Edward, ed. *Tree of Paradise: Jewish Mosaics from the Roman Empire*. Brooklyn: Brooklyn Museum, 2005.

Cioffarelli, Ada. *Guide to the Catacombs of Rome and Its Surroundings*. Rome: Bonsignori, 2000.

Cormack, Robin, and Maria Vassilaki, eds. *Byzantium, 330–1453*. London: Royal Academy of Arts, 2008.

Cutler, Anthony. *The Hand of the Master: Craftsmanship, Ivory, and Society in Byzantium 9th–11th Centuries*. Princeton: Princeton Univ. Press, 1994.

Durand, Jannic. *Byzantine Art*. Paris: Terrail, 1999.

Eastmond, Antony, and Liz James, eds. *Icon and Word : The Power of Images in Byzantium: Studies Presented to Robin Cormack*. Burlington, VT: Ashgate, 2003.

Evans, Helen C., ed. *Byzantium: Faith and Power (1261–1557)*. New York: Metropolitan Museum of Art, 2004.

———, and William D. Wixom, eds. *The Glory of Byzantium: Art and Culture of the Middle Byzantine era, a.d. 843–1261*. New York: Abrams, 1997.

Fine, Steven. *Art and Judaism in the Greco–Roman World: Toward a New Jewish Archaeology*. New York: Cambridge Univ. Press, 2005.

Freely, John. *Byzantine Monuments of Istanbul*. Cambridge: New York: Cambridge Univ. Press, 2004.

Grabar, André. *Byzantine Painting: Historical and Critical Study*. Trans. Stuart Gilbert. New York: Rizzoli, 1979.

Hachlili, Rachel. *Ancient Mosaic Pavements: Themes, Issues, and Trends*. Leiden: Brill, 2009.

Jensen, Robin Margaret. *Understanding Early Christian Art*. New York: Routledge, 2000.

Kitzinger, Ernst. *The Art of Byzantium and the Medieval West: Selected Studies*. Ed. W. Eugene Kleinbauer. Bloomington: Indiana Univ. Press, 1976.

———. *Byzantine Art in the Making: Main Lines of Stylistic Development in Mediterranean Art, 3rd–7th Century*. Cambridge, MA: Harvard Univ. Press, 1977.

Kleinbauer, W. Eugene. *Hagia Sophia*. London: Scala, 2004.

Krautheimer, Richard, and Slobodan Curcic. *Early Christian and Byzantine Architecture*. 4th ed. Pelican History of Art. New Haven: Yale Univ. Press, 1992.

Levine, Lee I., and Zeev Weiss, eds. *From Dura to Sepphoris: Studies in Jewish Art and Society in Late Antiquity*. Journal of Roman Archaeology: Supplementary Series, no. 40. Portsmouth, R.I.: Journal of Roman Archaeology, 2000.

Lowden, John. *Early Christian and Byzantine Art*. Art & Ideas. London: Phaidon Press, 1997.

Maguire, Henry. *The Icons of Their Bodies: Saints and Their Images in Byzantium*. Princeton: Princeton Univ. Press, 1996.

Mainstone, Rowland J. *Hagia Sophia: Architecture, Structure and Liturgy of Justinian's Great Church*. 2nd ed. New York: Thames & Hudson, 2001.

Mango, Cyril. *Art of the Byzantine Empire, 312–1453: Sources and Documents*. Upper Saddle River, NJ: Pearson/Prentice Hall, 1972.

Mathew, Gervase. *Byzantine Aesthetics*. London: John Murray, 1963.

Mathews, Thomas F. *Byzantium: From Antiquity to the Renaissance*. Perspectives. New York: Abrams, 1998.

———. *The Clash of Gods: A Reinterpretation of Early Christian Art*. Rev. ed. Princeton: Princeton Univ. Press, 1999.

Olin, Margaret. *The Nation without Art: Examining Modern Discourses on Jewish Art*. Lincoln: Univ. of Nebraska Press, 2001.

Olsson, Birger, and Magnus Zetterholm, eds. *The Ancient Synagogue from Its Origins until 200 c.e.: Papers Presented at an International Conference at Lund University, October 14–17, 2001*. Coniectanea Biblica: New Testament Series, 39. Stockholm: Almqvist & Wiksell International, 2003.

Ousterhout, Robert. *Master Builders of Byzantium*. Princeton: Princeton Univ. Press, 1999.

Rodley, Lyn. *Byzantine Art and Architecture: An Introduction*. Cambridge: Cambridge Univ. Press, 1994.

Rutgers, Leonard V. *Subterranean Rome: In Search of the Roots of Christianity in the Catacombs of the Eternal City*. Leuven: Peeters, 2000.

Sed-Rajna, Gabrielle. *Jewish Art*. Trans. Sara Friedman and Mira Reich. New York: Abrams, 1997.

Spier, Jeffrey, ed. *Picturing the Bible: The Earliest Christian Art*. New Haven: Yale Univ. Press, 2007.

Tadgell, Christopher. *Imperial Space: Rome, Constantinople and the Early Church*. New York: Whitney Library of Design, 1998.

Vio, Ettore. *St. Mark's: The Art and Architecture of Church and State in Venice*. New ed. New York: Riverside Book, 2003.

Webb, Matilda. *The Churches and Catacombs of Early Christian Rome: A Comprehensive Guide*. Brighton, UK: Sussex Academic Press, 2001.

Weitzmann, Kurt. *Late Antique and Early Christian Book Illumination*. New York: Braziller, 1977.

———. *Place of Book Illumination in Byzantine Art*. Princeton: Art Museum, Princeton Univ., 1975.

Wharton, Annabel Jane. *Refiguring the Post-Classical City: Dura Europos, Jerash, Jerusalem and Ravenna*. Cambridge: Cambridge Univ. Press, 1995.

White, L. Michael. *The Social Origins of Christian Architecture*. 2 vols. Baltimore, MD: Johns Hopkins Univ. Press, 1990.

Chapter 8 Islamic Art

Al-Faruqi, Isma'il R., and Lois Ibsen Al Faruqi. *Cultural Atlas of Islam*. New York: Macmillan, 1986.

Atil, Esin. *The Age of Sultan Suleyman the Magnificent*. Washington, DC: National Gallery of Art, 1987.

Baker, Patricia L. *Islam and the Religious Arts*. London: Continuum, 2004.

Barry, Michael A. *Figurative Art in Medieval Islam and the Riddle of Bihzâd of Herât (1465–1535)*. Paris: Flammarion, 2004.

Blair, Sheila S., and Jonathan Bloom. *The Art and Architecture of Islam 1250–1800*. Pelican History of Art. New Haven: Yale Univ. Press, 1995.

Denny, Walter B. *Iznik: The Artistry of Ottoman Ceramics*. New York: Thames & Hudson, 2004.

Dodds, Jerrilynn D., ed. *Al-Andalus: The Art of Islamic Spain*. New York: Metropolitan Museum of Art, 1992.

Ecker, Heather. *Caliphs and Kings: The Art and Influence of Islamic Spain*. Washington, DC: Arthur M. Sackler Gallery, Smithsonian Institution, 2004.

Ettinghausen, Richard, Oleg Grabar, and Marilyn Jenkins-Madina. *Islamic Art and Architecture, 650–1250*. 2nd ed. Pelican History of Art. New Haven: Yale Univ. Press, 2001.

Frishman, Martin, and Hasan-Uddin Khan. *The Mosque: History, Architectural Development and Regional Diversity*. London: Thames & Hudson, 1994.

Grabar, Oleg. *The Formation of Islamic Art*. Rev. and enlarged. New Haven: Yale Univ. Press, 1987.

———. *The Great Mosque of Isfahan*. New York: New York Univ. Press, 1990.

———. *Islamic Visual Culture, 1100–1800*. Burlington, VT: Ashgate, 2006.

———. *Mostly Miniatures: An Introduction to Persian Painting*. Princeton: Princeton Univ. Press, 2000.

———, Mohammad Al-Asad, Abeer Audeh, and Said Nuseibeh. *The Shape of the Holy: Early Islamic Jerusalem*. Princeton: Princeton Univ. Press, 1996.

Hillenbrand, Robert. *Islamic Art and Architecture*. World of Art. London: Thames & Hudson, 1999.

Irwin, Robert. *The Alhambra*. Cambridge, MA: Harvard Univ. Press, 2004.

Khalili, Nasser D. *Visions of Splendour in Islamic Art and Culture*. London: Worth Press, 2008.

Komaroff, Linda, and Stefano Carboni, eds. *The Legacy of Genghis Khan: Courtly Art and Culture in Western Asia, 1256–1353*. New York: Metropolitan Museum of Art, 2002.

Lentz, Thomas W., and Glenn D. Lowry. *Timur and the Princely Vision: Persian Art and Culture in the Fifteenth Century*. Los Angeles: Los Angeles County Museum of Art, 1989.

Necipolu, Gülru. *The Age of Sinan: Architectural Culture in the Ottoman Empire*. Princeton: Princeton Univ. Press, 2005.

Petruccioli, Attilio, and Khalil K. Pirani, eds. *Understanding Islamic Architecture*. New York: Routledge Curzon, 2002.

Roxburgh, David J., ed. *Turks: A Journey of a Thousand Years, 600–1600*. London: Royal Academy of Arts, 2005.

Sims, Eleanor, B. I. Marshak, and Ernst J. Grube. *Peerless Images: Persian Painting and Its Sources*. New Haven: Yale Univ. Press, 2002.

Stanley, Tim, Mariam Rosser-Owen, and Stephen Vernoit. *Palace and Mosque: Islamic Art from the Middle East*. London: V&A Publications, 2004.

Stierlin, Henri. *Islamic Art and Architecture*. New York: Thames & Hudson, 2002.

Tadgell, Christopher. *Four Caliphates: The Formation and Development of the Islamic Tradition*. London: Ellipsis, 1998.

Ward, R. M. *Islamic Metalwork*. New York: Thames & Hudson, 1993.

Watson, Oliver. *Ceramics from Islamic Lands*. New York: Thames & Hudson in assoc. with the al-Sabah Collection, Dar al-Athar al-Islamiyyah, Kuwait National Museum, 2004.

Chapter 14 Early Medieval Art in Europe

Alexander, J. J. G. *Medieval Illuminators and Their Methods of Work*. New ed. New Haven: Yale Univ. Press, 1994.

The Art of Medieval Spain, a.d. 500–1200. New York: Metropolitan Museum of Art, 1993.

Backhouse, Janet, D. H. Turner, and Leslie Webster, eds. *The Golden Age of Anglo-Saxon Art, 966–1066*. Bloomington: Indiana Univ. Press, 1984.

Bandmann, Günter. *Early Medieval Architecture as Bearer of Meaning*. New York: Columbia Univ. Press, 2005.

Brown, Michelle P. *The Lindisfarne Gospels: Society, Spirituality and the Scribe*. Toronto: Univ. of Toronto Press, 2003.

Calkins, Robert G. *Illuminated Books of the Middle Ages*. Ithaca, NY: Cornell Univ. Press, 1983.

Carver, Martin. *Sutton Hoo: A Seventh-Century Princely Burial Ground and Its Context*. London: British Museum Press, 2005.

Davis-Weyer, Caecilia. *Early Medieval Art, 300–1150: Sources and Documents*. Upper Saddle River, NJ: Pearson/Prentice Hall, l971.

Diebold, William J. *Word and Image: An Introduction to Early Medieval Art*. Boulder, CO: Westview Press, 2000.

Dodwell, C. R. *Pictorial Arts of the West, 800–1200*. Pelican History of Art. New Haven: Yale Univ. Press, 1993.

Farr, Carol. *The Book of Kells: Its Function and Audience*. London: British Library, 1997.

Fitzhugh, William W., and Elisabeth I. Ward, eds. *Vikings: The North Atlantic Saga*. Washington, DC: Smithsonian Institution Press, 2000.

Harbison, Peter. *The Golden Age of Irish Art: The Medieval Achievement, 600–1200*. London: Thames & Hudson, 1999.

Henderson, George. *From Durrow to Kells: The Insular Gospel-Books, 650–800*. London: Thames & Hudson, 1987.

Horn, Walter W., and Ernest Born. *Plan of Saint Gall: A Study of the Architecture and Economy of and Life in a Paradigmatic Carolingian Monastery*. California Studies in the History of Art, 19. 3 vols. Berkeley: Univ. of California Press, 1979.

Lasko, Peter. *Ars Sacra, 800–1200*. 2nd ed. Pelican History of Art. New Haven: Yale Univ. Press, 1994.

McClendon, Charles B. *The Origins of Medieval Architecture: Building in Europe, a.d 600–900*. New Haven: Yale Univ. Press, 2005.

Mayr-Harting, Henry. *Ottonian Book Illumination: An Historical Study*. 2nd rev. ed. 2 vols. London: Harvey Miller, 1999.

Mentré, Mireille. *Illuminated Manuscripts of Medieval Spain*. New York: Thames & Hudson, 1996.

Nees, Lawrence. *Early Medieval Art*. Oxford History of Art. Oxford: Oxford Univ. Press, 2002.

Richardson, Hilary, and John Scarry. *An Introduction to Irish High Crosses*. Dublin: Mercier, 1990.

Schapiro, Meyer. *Language of Forms: Lectures on Insular Manuscript Art*. Ed. Jane Rosenthal. New York: Pierpont Morgan Library, 2006.

Stalley, R. A. *Early Medieval Architecture*. Oxford History of Art. Oxford: Oxford Univ. Press, 1999.

Wickham, Chris. *Framing the Early Middle Ages: Europe and the Mediterranean 400–800*. New York: Oxford Univ. Press, 2005.

Williams, John. *Early Spanish Manuscript Illumination*. New York: Braziller, 1977.

Wilson, David M. *Anglo-Saxon Art: From the Seventh Century to the Norman Conquest*. London: Thames & Hudson, 1984.

———, and Ole Klindt-Jensen. *Viking Art*. 2nd ed. Minneapolis: Univ. of Minnesota Press, 1980.

Chapter 15 Romanesque Art

Barral i Altet, Xavier. *The Romanesque: Towns, Cathedrals and Monasteries*. Taschen's World Architecture. New York: Taschen, 1998.

Bernard of Clairvaux. *"Apologia to Abbot William."* In *Treatises I*. The Work of Bernard of Clairvaux, 1: Cistercian Fathers Series, 1. Shannon, Ireland: Irish Univ. Press, 1970: 33–69.

The Book of Sainte Foy. Ed. and trans. Pamela Sheingorn. Philadelphia: Univ. of Pennsylvania Press, 1995.

Cahn, Walter. *Romanesque Manuscripts: The Twelfth Century*. 2nd ed. 2 vols. A Survey of Manuscripts Illuminated in France. London: Harvey Miller, 1996.

Caviness, Madeline H. *"Hildegard as Designer of the Illustrations to her Works."* In *Hildegard of Bingen: The Context of her Thought and Art*, edited by Charles Burnett and Peter Dronke. London: Warburg Institute, 1998: 29–63.

Davis-Weyer, Caecilia. *Early Medieval Art, 300–1150. Sources and Documents*. Upper Saddle River, NJ: Pearson/Prentice Hall, 1971.

Dimier, Anselme. *Stones Laid before the Lord: A History of Monastic Architecture*. Trans. Gilchrist Lavigne. Cistercian Studies Series, no. 152. Kalamazoo, MI: Cistercian Publications, 1999.

Fergusson, Peter. *Architecture of Solitude: Cistercian Abbeys in Twelfth-Century England*. Princeton: Princeton Univ. Press, 1984.

Forsyth, Ilene H. *The Throne of Wisdom: Wood Sculptures of the Madonna in Romanesque France*. Princeton: Princeton Univ. Press, 1972.

Gaud, Henri, and Jean-François Leroux-Dhuys. *Cistercian Abbeys: History and Architecture*. Köln: Könemann, 1998.

Gerson, Paula, ed. *The Pilgrim's Guide to Santiago de Compostela: A Critical Edition*. 2 vols. London: Harvey Miller, 1998.

Grivot, Denis, and George Zarnecki. *Gislebertus: Sculptor of Autun*. New York: Orion Press, 1961.

Hearn, M. F. *Romanesque Sculpture: The Revival of Monumental Stone Sculptures in the Eleventh and Twelfth Centuries*. Ithaca, NY: Cornell Univ. Press, 1981.

Hicks, Carola. *The Bayeux Tapestry: The Life Story of a Masterpiece*. London: Chatto & Windus, 2006.

Hourihane, Colum, ed. *Romanesque Art and Thought in the Twelfth Century: Essays in Honor of Walter Cahn*. The Index of Christian Art Occasional Papers 10. University Park, PA: Penn State Press, 2008.

Kubach, Hans E. *Romanesque Architecture*. History of World Architecture. New York: Electa/Rizzoli, 1988.

Minne-Sève, Viviane, and Hervé Kergall. *Romanesque and Gothic France: Architecture and Sculpture*. Trans. Jack Hawkes and Lory Frankel. New York: Abrams, 2000.

Newman, Barbara. *Sister of Wisdom: St. Hildegard's Theology of the Feminine*. 2nd ed. Berkeley: Univ. of California Press, 1997.

Schapiro, Meyer. *Romanesque Art: Selected Papers*. New York: George Braziller, 1977.

———. *The Romanesque Sculpture of Moissac*. New York: Braziller, 1985.

———. *Romanesque Architectural Sculpture: The Charles Eliot Norton Lectures*. Ed. Linda Seidel. Chicago: Univ. of Chicago Press, 2006.

Seidel, Linda. *Legends in Limestone: Lazarus, Gislebertus, and the Cathedral of Autun*. Chicago: Univ. of Chicago Press, 1999.

Sundell, Michael G. *Mosaics in the Eternal City*. Tempe: Arizona Center for Medieval and Renaissance Studies, 2007.

Swanson, R. N. *The Twelfth-Century Renaissance*. Manchester: Manchester Univ. Press, 1999.

Theophilus. *On Divers Arts: The Foremost Medieval Treatise on Painting, Glassmaking, and Metalwork*. Trans. John G. Hawthorne and Cyril Stanley Smith. New York: Dover, 1979.

Toman, Rolf, ed. *Romanesque: Architecture, Sculpture, Painting*. Trans. Fiona Hulse and Ian Macmillan. Köln: Könemann, 1997.

Wilson, David M. *The Bayeux Tapestry: The Complete Tapestry in Color*. London: Thames & Hudson and New York: Knopf, 2004.

Zarnecki, George, Janet Holt, and Tristam Holland, eds. *English Romanesque Art, 1066–1200*. London: Weidenfeld and Nicolson, 1984.

Chapter 16 Gothic Art of the Twelfth and Thirteenth Centuries

Barnes, Carl F. *The Portfolio of Villard de Honnecourt: A New Critical Edition and Color Facsimile*. Burlington, VT: Ashgate, 2009.

Binding, Günther. *High Gothic: The Age of the Great Cathedrals*. Taschen's World Architecture. London: Taschen, 1999.

Binski, Paul. *Becket's Crown: Art and Imagination in Gothic England, 1170–1300*. New Haven: Yale Univ. Press, 2004.

Bony, Jean. *French Gothic Architecture of the 12th and 13th Centuries*. California Studies in the History of Art, 20. Berkeley: Univ. of California Press, 1983.

Camille, Michael. *Gothic Art: Glorious Visions*. Perspectives. New York: Abrams, 1996.

Cennini, Cennino. *The Craftsman's Handbook "Il libro dell'arte"*. Trans. D.V. Thompson, Jr. New York: Dover, 1960.

Coldstream, Nicola. *Masons and Sculptors*. Toronto and Buffalo, NY: Univ. of Toronto Press, 1991.

Crosby, Sumner M. *The Royal Abbey of Saint-Denis from Its Beginnings to the Death of Suger, 475–1151*. Yale Publications in the History of Art, 37. New Haven: Yale Univ. Press, 1987.

Erlande-Brandenburg, Alain. *Gothic Art*. Trans. I. Mark Paris. New York: Abrams, 1989.

Favier, Jean. *The World of Chartres*. Trans. Francisca Garvie. New York: Abrams, 1990.

Frankl, Paul. *Gothic Architecture*. Revised. Paul Crossley. Pelican History of Art. New Haven: Yale Univ. Press, 2000.

Frisch, Teresa G. *Gothic Art, 1140–c. 1450: Sources and Documents*. Upper Saddle River, NJ: Pearson/Prentice Hall, 1971.

Grodecki, Louis, and Catherine Brisac. *Gothic Stained Glass, 1200–1300*. Ithaca, NY: Cornell Univ. Press, 1985.

Jordan, Alyce A. *Visualizing Kingship in the Windows of the Sainte-Chapelle*. Turnhout: Brepols, 2002.

Moskowitz, Anita Fiderer. *Nicola & Giovanni Pisano: The Pulpits: Pious Devotion, Pious Diversion*. London: Harvey Miller, 2005.

Nussbaum, Norbert. *German Gothic Church Architecture*. Trans. Scott Kleager. New Haven: Yale Univ. Press, 2000.

Panofsky, Erwin. *Abbot Suger on the Abbey Church of St.-Denis and Its Art Treasures*. 2nd ed. Ed. Gerda Panofsky-Soergel. Princeton: Princeton Univ. Press, 1979.

Parry, Stan. *Great Gothic Cathedrals of France*. New York: Viking Studio, 2001.

Sauerländer, Willibald. *Gothic Sculpture in France, 1140–1270*. Trans. Janet Sandheimer. London: Thames & Hudson, 1972.

Scott, Robert A. *The Gothic Enterprise: A Guide to Understanding the Medieval Cathedral*. Berkeley: Univ. of California Press, 2003.

Simsom, Otto Georg von. *The Gothic Cathedral: Origins of Gothic Architecture and the Medieval Concept of Order*. 3rd ed. exp. Bollingen Series. Princeton: Princeton Univ. Press, 1988.

Suckale, Robert, and Matthias Weniger. *Painting of the Gothic Era*. Ed. Ingo F. Walther. New York: Taschen, 1999.

Wieck, Roger S. *Time Sanctified: The Book of Hours in Medieval Art and Life*. 2nd ed. New York: Braziller, 2001.

Williamson, Paul. *Gothic Sculpture, 1140–1300*. Pelican History of Art. New Haven: Yale Univ. Press, 1995.

Chapter 17 Fourteenth-Century Art in Europe

Alexander, Jonathan, and Paul Binski, eds. *Age of Chivalry: Art in Plantagenet England, 1200–1400*. London: Royal Academy of Arts, 1987.

Backhouse, Janet. *Illumination from Books of Hours*. London: British Library, 2004.

Boehm, Barbara Drake, and Jiří Fajt, eds. *Prague: The Crown of Bohemia, 1347–1437*. New York: Metropolitan Museum of Art, 2005.

Bony, Jean. *The English Decorated Style: Gothic Architecture Transformed, 1250–1350*. The Wrightsman Lectures 10th. Oxford: Phaidon Press, 1979.

Borsook, Eve. *The Mural Painters of Tuscany: From Cimabue to Andrea del Sarto*. 2nd ed. rev. & enlarged. Oxford Studies in the History of Art and Architecture. Oxford: Clarendon Press 1980.

Derbes, Anne, and Mark Sandona, eds. *The Cambridge Companion to Giotto*. Cambridge and New York: Cambridge Univ. Press, 2003.

Fajt, Jiří, ed. *Magister Theodoricus, Court Painter to Emperor Charles IV: The Pictorial Decoration of the Shrines at Karlstejn Castle*. Prague: National Gallery, 1998.

Holt, Elizabeth Gilmore, ed. *A Documentary History of Art*. 2 vols. Princeton, Princeton Univ. Press, 1982–86.

Ladis, Andrew. ed, *The Arena Chapel and the Genius of Giotto: Padua. Giotto and the World of Early Italian Art*, 2. New York: Garland, 1998.

Meiss, Millard. *Painting in Florence and Siena after the Black Death: The Arts, Religion, and Society in the Mid-Fourteenth Century*. 2nd ed. Princeton: Princeton Univ. Press, 1978.

Moskowitz, Anita Fiderer. *Italian Gothic Sculpture: c. 1250– c. 1400*. New York: Cambridge Univ. Press, 2001.

Norman, Diana, ed. *Siena, Florence, and Padua: Art, Society, and Religion 1280–1400*. 2 vols. New Haven: Yale Univ. Press, 1995.

Poeschke, Joachim. *Italian Frescoes, the Age of Giotto, 1280–1400*. New York: Abbeville Press, 2005.

Schleif, Corine. "St. Hedwig's Personal Ivory Madonna: Women's Agency and the Powers of Possessing Portable Figures." In *The Four Modes of Seeing: Approaches to Medieval Imagery in Honor of Madeline Harrison Caviness*, edited by Evelyn Staudinger Lane, Elizabeth Carson Paston, and Ellen M. Shortell. Farnham, Surrey: Ashgate, 2009: 282–403.

Vasari, Giorgio. *The Lives of the Artists*. Trans. Julia Conaway Bondanella and Peter Bondanella. Oxford World's Classics. New York: Oxford Univ. Press, 2008.

Welch, Evelyn S. *Art in Renaissance Italy, 1350–1500*. New ed. Oxford History of Art. Oxford: Oxford Univ. Press, 2000.

White, John. *Art and Architecture in Italy, 1250 to 1400*. 3rd ed. Pelican History of Art. Harmondsworth, UK: Penguin, 1993.

INDEX

W

Y

Buried Lies

True Tales and Tall Stories
from the PGA Tour

PETER JACOBSEN

with Jack Sheehan

Penguin Books

PENGUIN BOOKS
Published by the Penguin Group
Penguin Books USA Inc., 375 Hudson Street, New York, New York 10014, U.S.A.
Penguin Books Ltd, 27 Wrights Lane, London W8 5TZ, England
Penguin Books Australia Ltd, Ringwood, Victoria, Australia
Penguin Books Canada Ltd, 10 Alcorn Avenue, Toronto, Ontario, Canada M4V 3B2
Penguin Books (N.Z.) Ltd, 182–190 Wairau Road, Auckland 10, New Zealand

Penguin Books Ltd, Registered Offices: Harmondsworth, Middlesex, England

First published in the United States of America by G.P. Putnam's Sons 1993
Reprinted by arrangement with G.P. Putnam's Sons
Published in Penguin Books 1994

10 9 8 7 6 5 4 3 2 1

THE LIBRARY OF CONGRESS HAS CATALOGUED THE HARDCOVER AS
FOLLOWS:
Jacobsen, Peter.
Buried lies: true tales and tall stories from the PGA tour/Peter Jacobsen
with Jack Sheehan
p. cm.
ISBN 0-399-13810-2 (hc.)
ISBN 0 14 02.3578 7 (pbk.)
1. Jacobsen, Peter. 2. Golfers—United States—Biography. 3. Golf—Tournaments.
4. PGA Tour (Association). I. Sheehan, Jack.
GV964.J33A3 1993 796.352′092—dc20 92–42827 [B]

Printed in the United States of America
Set in Bembo

Contents

INTRODUCTION

"Fore-Mative Years": The Family Jacobsen

IN MY SEVENTEEN YEARS on the PGA Tour, I've done hundreds of newspaper and magazine interviews, and because I enjoy telling a good anecdote, and usually have a lot of things to get off my chest, I've often been told that I should consider doing a book someday.

I decided to do it not because of my playing record—I certainly have not stamped my place in golf history the way many of the champions in these pages have—but I have had some great experiences, many funny moments, and done a few things a professional golfer normally wouldn't do. So, of course, I chose one of the most hectic years of my life to undertake this project.

As this book was being written, my father, Erling, was approaching the end of an eight-year battle with cancer, but he remained a great cheerleader and a wonderful inspiration for us all. After his surgery in 1990, for instance, he

insisted on being with his family in a downtown Portland warehouse to pose with me for an Apollo golf shaft ad campaign. Dad's golf swing and posture in the pictures are perfect. No one would know that we had to stop the session every few minutes so that Dad could sit down. He still had his stitches in.

Later, my brother, David, and sister, Susie, and I would sit down with Dad, and I would read him aloud many of the early chapter drafts from this book. He would laugh and nod approvingly.

A couple of days before he died, I picked up a golf club leaning against the wall and handed it to him. His hands went on the club like he'd been born with it, and it occurred to me to ask him one final question.

"Dad," I said, "what's the most important part of golf?"

He looked at me through his kind blue eyes and said, "A sense of humor."

I've tried to keep that in mind in the telling of these stories. It is to the spirit, courage, and humor of Erling Jacobsen that this book is dedicated.

I have wonderful memories of growing up in the golfing Jacobsen family. We not only all loved golf, but we were pretty competitive. At one point several years ago, the combined handicap of all the Jacobsens was 27. I was a plus-three, my brothers David and Paul were a plus-one and an eight, Dad was a five, and Mom and Susie were nines. If there had been a *Family Feud* golf tournament, the Jacobsens could have held their own.

How avid were we? We even built a putting green in our backyard. Dad and David did most of the work, because David was basically the family greenskeeper and maintenance man (fittingly, he owns a turf equipment

business today), and when it was finally finished, it was darned good, better than many I've played on the Tour.

We had regular family putting tournaments, and I'd pretend that those testy five-footers were for more than family honor—they were always to win the Masters or the U.S. Open. I had no idea that I would actually get to play in those tournaments one day.

It was in the backyard that I also began to develop my impersonations of other players' swings—something I'm well known for today. Of course, I did Arnie and Jack, but I also did Sam Snead, George Knudson, Miller Barber, Don January—all the players that I watched on *Shell's Wonderful World of Golf* and the *CBS Golf Classic*. The prime motivation was to get the approval of my mother. She'd laugh really hard and tell me I was good at it, and so I'd spend even more time practicing in front of a mirror to make them better. I guess you could say I got hooked on golf and entertaining at about the same time.

I got my sense of humor from my dad, too. Dad loved practical jokes, especially in the morning. One time, our family rented a condominium at Black Butte Ranch, in eastern Oregon, for a week of golf and relaxation. The condo sat on the shore of a lake that was home to several large geese. On this particular morning, Dad was down feeding them bread crumbs when he got a wonderful idea: he'd employ the geese to wake us up. So he lured them up to the house with the old Hansel-and-Gretel routine. He sprinkled a trail of breadcrumbs all the way up to the deck, through the sliding-glass door into the condo, and right up to the door of the bedroom where David and I were dead to the world.

Dad then opened the door and threw the rest of the bread onto our beds. I woke up to a gaggle of long-necked

geese snapping at bread bits all over me. It was like Alfred Hitchcock's *The Birds* . . . only the birds were on steroids. David and I jumped out of bed screaming, and this in turn scared the hell out of the geese, who went honking back out into the living room. They flew toward the light of day, which was right into the glass door. They weren't hurt, only stunned, but after another second they freaked out and started flapping and squawking and got themselves tangled in the curtains. This made them even more panicky, and their bowels came totally uncorked. Instantly, goose crap was everywhere, and Mom was having a fit, and David and Dad and I were laughing hysterically. We finally got them outside without any major injuries, but over the next few days there was some serious carpet-and-drape cleaning going on.

One of the great things about learning golf from my father is that he appreciated how important the game was in shaping personality. He would always take one or more of us kids to the course with him, and would often include us in his foursome. I played several times with Mr. Bill Knight, the father of Nike founder Phil Knight, and Mr. Peter Murphy, of the Murphy lumber family in Portland. You notice I still call them *Mister*—it's the only way I can think of them. They were older than my father, almost two generations removed from me, and they were classy, distinguished gentlemen. I was able to form different attitudes and thoughts about the world by playing with them, rather than just with kids my own age. I felt I really had to have my act together when I was with these men, because they had such respect for the game. They also showed *me* respect, and at my age that was special.

My father was a stickler for golf course etiquette. Not only did he always replace his divots, but on par-three holes he'd always pick up four or five others and meticulously lay them down and step on them. He'd fit in each divot as if it was the most important piece of a jigsaw puzzle. He didn't care if it was just a little nip of grass or a pelt that looked like it came from Sy Sperling's Hair Club for Men; Dad would carefully replace it and sometimes even secure it by sticking a tee in it.

One time, I was scolded by a close family friend, Mr. R. S. Miller, after hitting three or four shots to a green at Waverley Country Club, my home club. Mr. Miller made the point emphatically that practice was for the driving range, not the golf course. When I got home, I assumed Dad would give me sympathy and support, but he didn't. He said that Mr. Miller was right, and that I should have known better. It taught me something about conviction. I realized that Dad had greater respect for the etiquette of the game than for my damaged pride.

Then when I got a little older, about twelve, I perfected this great tantrum move. I'd tee the ball up, give one waggle, take my backswing, pause at the top, swing as hard as I could, and if it was a bad shot I'd instantly reverse the swing and bury the club back into the ground with a loud *Whop*. This was most effective on tee-shots, because the driver would leave an impression in the ground like a muddy horseshoe print. My patented reverse slam would put such stress on the shaft that once or twice the club ended up looking like a damn hockey stick.

I'd usually accompany this move with a chorus of four-letter action verbs, most of which I didn't understand, and all of which I was years away from performing. If I were to make an analogy, I was like Spalding, the spoiled nephew in *Caddyshack*—you know, the fat kid who burps,

passes gas, picks his nose, and uses foul language. It's the difficult adolescent zone into which some kids fall, when you're incorrigible and you don't know why.

Finally, my horrible golf etiquette caught up with me—and taught me a valuable lesson. I was playing with my father and David and another friend at the Astoria Country Club. We were on the tee of the 7th hole, a par-four. I followed my normal routine of waggle, swing, follow-through, bad-shot, *Whop*. My driver embedded in the ground and I screamed an obscenity.

"That's it, Peter!" my dad said. "If you cannot act like a gentleman, you can't play any more golf today."

He took my clubs and told me to go back and sit in the car while they finished the round as a threesome.

So I stomped off and said, "Fine, fine!" It was a long walk back to the clubhouse, and it took me over hill and dale, over a sand dune, through a fairway, over another dune, and through another fairway.

By the time I got to the car, I was even more angry and frustrated, and hating life. I remember sitting there in the car in a stunned silence, thinking how I had embarrassed myself.

I couldn't go into the clubhouse because the guys would have asked why I wasn't still playing, so I didn't have much choice but to sit there and let it all sink in. At that age, kids think that their parents are put on earth only to serve their needs, and that their parents don't have feelings and don't have sex, and . . . well . . . that incident put a few things in perspective for me. Here was this beautiful day, on a wonderful course near the ocean, and my behavior had forced me to stop playing and sit all by myself in a hot car for two hours.

The fact that I remember the incident so vividly reveals what an important lesson it was. (Note: I have not repeated

the *Whop* move since that day, but I have muttered a few choice words. Under my breath, of course.)

I got another lesson at about the same time, when I played in a pro-junior tournament at Tualatin Country Club, paired with Jon Peterson, the assistant pro at Waverley.

I was about twelve or thirteen, and I'd never broken 40 for nine holes, but this day I shot a 46 on the front nine—and on the back nine drained everything: I had ten putts for the nine holes and shot 39. I won Low Net for the tournament, and Jon raved about what a great putter and clutch player I was—he talked about my performance as though he were describing Chip Beck shooting his 59.

On the drive back to Astoria, where we were spending the summer, I couldn't wait to show the trophy to my parents. We stopped somewhere along the way for dinner, and all the kids were still talking about my great round, and I was jamming food in my mouth as fast as I could and lapping up the praise like a pack mule at a water trough.

Then disaster struck: we got in the car to finish the ride and I realized I'd lost my bite plate for my braces, that horrendous-looking slab of membrane that always had fuzz and bits of ol' Life Savers stuck to it from being in my pocket all day rather than in my mouth. We stopped and turned on the interior lights and searched the car, but it was nowhere to be found. The defining moment of my youth suddenly turned to ashes, and I ended up crying in my brother David's arms, fearful I was going to get my butt kicked for losing yet another in a series of elusive, thirty-eight-dollar bite plates.

But this was the lesson: when we got home, my parents were more interested in my personal-best 39 than in the tooth-straightener. They were as excited for me as I had

been. As I said, the Jacobsen family loves golf . . . far more than orthodontics. It was then that I got the notion in the back of my mind that maybe I could go somewhere in this game, and I've never looked back.

It was after that first bath of adoration that I got almost ritualistic about golf, going so far as to clean the grooves of my clubs meticulously each night before a tournament round. I'd run a metal fingernail file carefully through the groove of each iron, and even in the numbers on the bottom of the club. Then I'd run hot water over the face of the irons until steam filled the room. I'd make sure the water was scalding when I did the putter, so that the blade would stay "hot" the next day and hole everything.

In *Wayne's World,* they would call me "mental." Personally, I think it's standard behavior for all golfers once they catch the bug.

One last lesson from my younger days.

I'm often asked by parents of junior golfers such things as what handicap their son should be at age fifteen, and how many junior tournaments I had won by the age of thirteen. I explain that timetables like that are pointless. What is important is that the girl or boy enjoy the game and learn the character-building lessons that golf can impart. Twelve-year-olds who have competed in a heavy tournament schedule since they were seven or eight often burn out early, which is a shame. And I frequently hear of parents who are greatly disappointed when their children don't live up to their unrealistic expectations. This is even more shameful. Golf is a recreation that can and should last a lifetime, regardless of the skill level of the participant.

When I talk with these parents, I point out that I hadn't won *any* tournaments by the time I was thirteen—and I

was never the least bit upset about it. That's because, thanks to the influence of my father and men like him, I always placed as much importance on the enjoyment aspect of golf as on the competition. My father always asked me two things after a round of golf: "Did you have fun?" and "What did you learn out there?" As a result, I've tried never to get too solemn "out there," even when I'm competing at my hardest.

I've sometimes wondered whether that attitude hasn't hurt me at times, because I don't have quite the win-at-all-cost ethic of some other players. There's always that prankster side of me looking for the humor of every situation. But if my personality has cost me a title or two, I feel I've more than made up for it with laughter.

And I'd like to share some of that laughter with you now . . .

CHAPTER I

Across the Pond

I'VE PLAYED IN THREE major championships at the Old Course at St. Andrews, and each has been filled with wonder and excitement. They've had a mystical aura to them because of my feelings about the essence of golf and the game's rich history.

My first visit was in 1976 to play in the British Amateur championship. My decision to play had been based solely on the venue. I wanted to experience the Old Course before I turned professional, while I was still what the British call a "simon pure."

The trip didn't make sense economically, because I knew I was going to be married later in the year, but I've never based important decisions on money. I reasoned that competing at St. Andrews was tremendously important to my growth as a player and as a person, and therefore would make me a better husband once I was married (which shows we can rationalize almost anything if we want to do it badly enough).

I arrived in Scotland early in the morning. I was so

excited, and wired from jet lag, that when I got to the town of St. Andrews I walked around to soak up the atmosphere. I had an immediate sense of history, from the cobblestone streets to a tour through St. Andrews Castle. It was a whole other world to me.

For an Oregon college kid used to McDonald's and Dunkin' Donuts for breakfast, it was neat to see a horse-drawn milk wagon making its morning rounds. I stopped the driver and bought a quart from him. The bottle didn't even have a top on it, just a thick layer of cream. Then I went to a bakery and introduced myself to several towns-people, who were friendly and warm. I told them why I was there, and they were impressed that I had come all that way to play in their amateur championship. While I didn't sense that any of them were golfers, it was obvious they had a great deal of civic pride over the fact that their hometown was a shrine to all who loved the game. The owner gave me warm donuts and pastries, and wouldn't take any money for them. Others gave me tips on local customs and—something I found delightfully surprising—they all had their own ideas about how to play the infamous 17th hole at St. Andrews, known as the Road Hole. More about that later.

Later in the morning, I checked into the bed-and-breakfast near the golf course, the kind with shared bathroom quarters. It was no big deal after the fraternity at the University of Oregon. Any notion of privacy is abandoned after you've hung with the "brothers" a few years.

When I checked in at the Old Course, I was pleased to learn I had been assigned Michael Bonallack's regular caddy. Michael is a highly esteemed player, and the current secretary of the Royal and Ancient Golf Club. A five-time winner of the British Amateur, he's also made many Walker Cup appearances.

My caddy's name was Sydney B. Rutherford, and he was seventy years old and came up to about my armpit. A spryer, wittier leprechaun you'll never find. His brogue was thicker than the heather that blooms in the St. Andrews rough, and nearly everything he said made me laugh. When we were first introduced, he said, "Hae na fair, wee Syd is hair."

"Excuse me?" I said, and leaned closer to try to decipher his message. When he repeated the line, I realized he was saying "Have no fear, wee Syd is here."

And so it went all week. Although everything Sydney B. Rutherford said was difficult to understand, it was well worth bending an ear for.

In the first practice round, for instance, I hit my drive off the first tee, and when we reached the ball I started pacing all around. After a moment, wee Syd said, "What ur ya luckin' fer, Pee-air?"

I told him a sprinkler head, so I could walk off a yardage (I didn't know then there was no irrigation system at St. Andrews). He looked at me, set the bag down, and said, "Yardage? Nay, you donna wan no yardage on the ol' gurl. If ya need ta know how fer it is, I'll tell ya."

Later that day, on the 13th hole, a long and difficult par-four, the wind was at our back and Syd had me hit an eight-iron from 175 yards, which ended up pin-high. The next morning, on the same hole, the wind was dead in our face and I had about 200 yards to the flag. Now, on the back nine at St. Andrews, all the holes head into the clubhouse, and because many of the shots are blind the golfer must aim at various buildings in the town or landmarks on the horizon. So Syd told me to aim at the steeple of the church. Then he pulled the sock off my three-wood and handed it to me. I thought it was way too much club and told him so.

He glared back at me. "Pee-air, I tell ya it's a three-wood," he said, "and donna leave nonuv it hair."

I laughed and ripped it, and sure enough when we came over the rise and could see the green, the ball was pin-high, 15 feet away. I remember thinking, this guy is a national treasure. I'm gonna tuck him into the ball pocket of my golf bag and smuggle him back to the States. The only drawback was that I would have had to put a set of head-phones on like they use at the United Nations, so an interpreter could tell me what the hell he was saying.

Another day, at the 15th hole, wee Syd did something unusual, and I realized that he'd done it the previous day as well. He left my side and walked to the right, taking an unnecessarily long route to the green. So I asked him why, and he said, "Aye, Laddie, I want to pae tribute to Madame Graziano."

He told me that the two mounds on the side of the fairway are called—ready?—Madame Graziano's Tits, and that respectful golfers always walk between them to get to the green. Now I don't know whether Madame Graziano was a woman for whom he had caddied, or someone he knew from a sport played in darker quarters than golf, but she must have been quite a gal, judging by the size of those mounds.

Each time I've returned to St. Andrews, I look up wee Sydney. He's in his eighties now, but he still has all the wit and charm he possessed when I first met him.

My next competition at St. Andrews was in the 1984 British Open, and once again I was tremendously excited to be there. I was so pumped up that I shot a 67 in the first round, and held a share of the lead with Greg Norman and British professional Bill Longmuir. That was the year that

a bad bounce on the infamous 17th hole, the Road Hole, cost Tom Watson a chance at the title, which went to Seve Ballesteros. Little did I know the spectrum of emotions I would go through the next time I played that hole, in 1990. But I'll arrive at that in a jiffy, as Sydney would say.

I remember having a lot of fun in the press conference following the opening round in '84. It was my first time in front of most of the British writers, and recognizing their appreciation of wit and irony, I wanted to give them something a little different from the routine post-round re-hash of a good score: driver, six-iron, 15-footer, yawn, snooze . . .

I had recently read the book *Golf in the Kingdom,* by writer Michael Murphy. It's the story of a young American golfer named Michael, who travels through Great Britain on his way to India to study philosophy and religion. While in Britain, he plays a round of golf at a course called Burningbush, patterned after St. Andrews, and meets an enchanting older professional named Shivas Irons, who astounds Michael with his golfing ability and wisdom. The story contains elements of Zen, magic, psychology, and history, and is an irresistible read for anyone who loves the game of golf. I had been introduced to the brilliance of the book by Chuck Hogan, a friend and golf educator who founded Sports Enhancement Associates, and has been a marvelous teacher to me through the years.

The characters in *Golf in the Kingdom* reaffirm everything I believe about the beauty of the sport and its interplay of mind, soul, and body. It also contains many poetic descriptions that have stayed with me long afterward, such as: "The thrill of seeing a ball fly over the countryside, over obstacles—especially over a stretch of water—and then onto the green and into the hole has a mystic quality. What is it but the flight of the alone to the alone?"

Or "Ye're makin' a mistake if ye think the gemme [game] is meant for the shots. The gemme is for walkin' . . . Tis a rotten shame, for if ye can enjoy the walkin' ye can probably enjoy the other times in yer life when ye're *in between*. And that's most o' the time, wouldn't ye say?"

Anyway, it was as though a window of awareness had been opened to me when I read the book, so I was eager to discuss its influence in the press room at St. Andrews. In talking about my 67, I quoted Shivas Irons and his teacher, Seamus Macduff. I was also so overcome by the venerability of the course, and the spirits of all those who had played there before me, that I alluded to the movie *Ghostbusters,* which was a big hit at the time. "I saw so many ghosts floating over the landscape out there," I said, "that I was afraid I was going to get 'slimed.' "

Some of the writers laughed, but the others looked at me like my porchlight had burned out. Then the ghosts themselves decided to teach me a lesson for taking them so lightly.

First, they fixed me for the rest of the tournament: I closed with three straight 73s. I still finished 22nd and enjoyed the week tremendously, but the British press was probably relieved that they could get back to reporting birdies and bogies instead of Zen masters and apparitions.

Then the spirits lay in wait for my return . . .

I was more than normally pumped up for the British Open when it returned to St. Andrews in 1990. I was in the midst of my best-ever season in the U.S., with a win at the Bob Hope Desert Classic, third-place finishes at the L.A. Open and Western Open, and two other top-tens, so when I arrived in Scotland I was brimming with confidence.

For the first 54 holes, my game plan was working per-

fectly. I was eight under par after the third round, and although not about to catch Nick Faldo, who was running away with the tournament at 17 under, I was in solid contention for a top-five finish. Plus, I was really enjoying the experience. Playing a great course in a major championship is a thrill all its own, but to play well to boot is the best feeling you can have as a professional golfer.

It got even more fun through 10 holes of the final round, as I made four birdies and an eagle going out, and worked myself into third place at 14 under par. With the wind whipping harder by the minute, I bogied three of the next six holes, but others were dropping strokes to par also, so I was still tied for fourth as I came to the Road Hole.

I'm willing to relive that hole for you now because I think what happened to me there epitomizes the fickleness of golf, and how the golfing gods can spit in your eye at a moment's notice.

I should further preface the impending horror by reporting that I had birdied the Road Hole the previous day, holing a meandering putt of about 95 feet. When the putt finally dissolved into the cup, I darted across the green like Neon Deion Sanders returning a punt for a touchdown. The exhibition of glee was caught by BBC cameras and beamed back to the U.S. on ABC. Perhaps, in retrospect, I should have been more subdued, because I obviously insulted Harry Vardon and Old Tom Morris and all those other hovering presences that lurked in the gorse at St. Andrews.

Anyway, there I was on Sunday afternoon, about to finish my best-ever British Open as I stood on the 17th tee. Now, there's just no way to emphasize how difficult that hole is. The tee-shot, for starters, is totally blind. Your target is over a replica of an ancient railway shed, over the hotel grounds, and into a fairway that makes an extreme

dogleg to the right. You just pray your ball lands in the fairway, because the out-of-bounds wall is close by and the rough is potluck: sometimes you can play out of it, other times your ball sinks deeper than the Titanic. The hole plays to 480 yards, and while it's a par-four, it's tougher than three-quarters of all the par-fives in the U.S. I believe it's the hardest hole in golf, tougher even than the 16th at Cypress Point, simply because there are so many different hazards that can grab you by the throat and choke the life out of you.

Off the tee, you have thick gorse and long grass to the left, and the out-of-bounds to the right. These are scarier than normal because you can't see any of the trouble—you just know it's there. To the right and running behind the green is an old city road that gives the hole its name. Behind the road is a stone wall against which many balls come to rest, leaving either an unplayable lie or a bank shot that would even give Minnesota Fats difficulty—even if he were skinny. It was by this wall that Tom Watson met his doom in 1984.

It's almost like Dante's Inferno: the further down the hole you get, the more horrifying it becomes. I'm referring particularly to the pot bunker that fronts the left side of the green. It is known as the Sands of Nakajima, from an episode that occurred in the 1978 Open. The fine Japanese professional, Tommy Nakajima, hit the green in regulation, putted the ball off the green into the bunker, then took three futile swipes from the pit before finally flopping it onto the green and two-putting for a nine.

I've always wondered how a scorer keeping stats in that group would have charted that hole. Let's see: hit fairway, hit green, one putt, bunker shot, bunker shot, bunker shot, bunker shot, putt, putt, vomit. The scorer would go

through three no. 2 pencils and a felt-tipped pen to get it all down.

I'd like to think that when the scorer asked Tommy what he had on the hole, he said he'd just send in an estimate, but I imagine he was too busy taking smelling salts to respond.

Anyway, I remember hitting my drive solidly down the left side that day. There was a strong left-to-right wind, so the play was to favor the left side to avoid the out-of-bounds right. When we got to the ball, I saw the wind hadn't moved it enough and I was about five yards off the fairway in the beach grass, sometimes called "love" grass. I can think of far more appropriate descriptions for it: like "horseshit."

It *is* possible to draw a good lie in that stuff. In fact, earlier in the tournament, from my hotel room which overlooked that fairway, I'd seen Faldo hit it in the left rough twice, draw good lies both times, and both times hit it onto the green. Apparently, the golf gods decided I needed to build some more character, because that wasn't an option for me. My ball settled deeper than a marble in a shag carpet. Although I had 220 yards to the green, my only hope was to try to chop it out and slightly forward with an eight-iron. A score of four was now out of the question. I just wanted to make five, and—as Ken Venturi loves to say—walk quietly to the next tee.

From the time I swung at that ball, everything seemed to shift into slow motion, almost as though it were happening in a dream, or shall we say nightmare. It was like the fight sequence from *Rocky*. I could almost read the lettering and number on the ball as it popped straight up and went over my left shoulder about six yards. I was now deeper in the rough and had actually lost yardage.

I was more shocked and embarrassed than angry. I thought, Holy Moly, I'm a professional. I can do better than that. I turned to my caddie, Mike, and said simply, "Wow!"

And Mike said, recognizing the severity of the predicament, "Let's just get this thing out of here."

I put the eight-iron back and grabbed a pitching wedge. Again, I was just trying to get it back in the short grass. Meanwhile, my playing partner, Nick Price, was waiting patiently in the fairway.

So I went after my third shot with the pitching wedge, and the ball did the exact same thing. It went about 10 yards and directly left. I was getting deeper by the swipe.

Now there were probably four or five thousand people in the bleachers on the back of the green and along the fairway and they were watching this like a presentation of *Macbeth*. There was a lot of blood being spilled, but no one could take his eyes off it.

I'm certain there were some snickers in the crowd, because in that heavy grass the ball has a mind of its own. I'd swung hard twice and the ball had just popped like a jumping bean behind me. It's funny to me even now, but I wasn't exactly splitting a rib at the time. I was seeing a great British Open getting devoured in the weeds.

For my fourth shot, I went with the sand wedge, and the good news was that I finally got the club under the ball, and got it airborne. The bad news is that it went further left, into even deeper hay.

Poor Nicky Price was watching this from the fairway like a man standing on a sidewalk staring up at a guy in a burning building: feeling horrible for him, but knowing there's not a thing he can do, and thanking God at the same time that it's not him up there.

I motioned for Nick to go ahead, and he hit his second

shot as I waded in to try to slash it out in five. This time, I finally got back to the fairway, and my reaction was to raise my arms in mock surprise and wave them in the air. I guess I was telling the stunned crowd that they could clap now, or cry now, and take their children home and tuck them in and assure them that the sun would rise again tomorrow.

I remember seeing the face of one older man, who wore a wry smile, and he was politely clapping for me. If I could put that smile into words, it would say something like, "Aye, the poor bastard's getting it oop the ars-el on the Road-el. Next time eel know to stae oot-a the garden."

I caught my sixth shot a little heavy and it came up short of the green. And as I walked up to hit my seventh, I flashed back to the day before and how great I had felt running across the green to pick that monster birdie putt out of the hole. I had to smile at the fickle fortunes of golf. I told Mike, "Ya know, yesterday I pissed off the legends, and today they're gathered by the hearth with a pint of Guinness laughing at me."

I didn't feel like pouting. I just felt totally humbled. Looking back, it was probably the most disappointing single golf hole I've ever played, because it knocked me out of the top five to a tie for 16th in the world's oldest tournament on the world's most revered golf course. It all ended somewhat positively, though. I hit my pitch shot over the bunker to about 10 feet from the cup, and holed the putt for an eight.

I thought of the old joke: Question: "How in the world did you make an *eight* on that hole?"

Answer: "I sunk a ten-footer."

When the putt went in, I took off my visor and made a deep bow to the crowd, and they gave me a big ovation. A lot of heads were cocked in sympathy. As Shivas Irons

says, "Gowf is a way o' makin' a man naked," and I've probably never felt more exposed than at that very moment. I didn't know whether to laugh or cry or just run off into the undergrowth like a screaming banshee.

As frustrating as that experience was, it's also a poignant memory and one that gives me a sense of pride as well. Because through it all, I never lost my cool and was able to smile and laugh at myself and at the situation. If you're not able to do that at golf, no matter how tough it gets, you're missing the point of the game.

The one consoling factor about making that putt for eight was that I was able to trim the "Sands of Nakajima" by one stroke and escape the humility of having the left rough forever named in my honor as "The Beater of Peter," or "The Wake of Jake."

I'm certain when Shivas made his comment about golf making you naked, however, he didn't have in mind anything like the scene that occurred at Royal St. George's on the last hole of the British Open in 1985.

I was in contention after three rounds that year, and was paired with Tom Kite in the third-to-last pairing. Right behind us was Sandy Lyle, who would win the tournament.

The final hole at Royal St. George's is a difficult par-four, and tough to reach in two into the big wind we were facing. I was in the right front junk, preparing to pitch on, when the most astonishing event transpired: one of the marshals behind the green ripped off his coat, bolted from the gallery, and started running buck-naked around the green. He ran from the back of the green and circled around from the left side, around in front of me and to the back again. The people laughed and cheered, and Kite and

I had a chuckle as the streaker got a second wind and did another lap. He wasn't happy with a 440; he wanted to do an 880. Well, it ceased to be funny as Lord Godiva completed that circuit and carried on to the mile run, because he was tromping on my line.

So the third time around, here came the bobbies, with the nightsticks and the whistles and those great hats with the chinstraps. One hand is on the hat and the other is on the whistle. There were now about six people on the green, five with shoes and one without. The elapsed time of the run was about a minute, and I started to wonder if this could be the son of Roger Bannister. I mean, the guy was really striding. Then I remembered Sandy Lyle back in the fairway trying to win the British Open, and I got angry for the intrusion. It had gotten way out of hand.

On the guy's fourth lap, he starting running right at Kite. Tom quickly backed out of the way, not overly eager to have a close encounter with this fruitcake. I wasn't ecstatic about the idea myself, but the guy just wouldn't stop.

So as he ran toward me, I got down in my best Lawrence Taylor stance and put a couple head-jukes on him to let him know I was ready for contact. I remembered from playing tackle football as a kid that you didn't look at a runner's head or eyes, you aimed for his midsection. So when the guy got about five feet from me, I lowered my shoulder and dove at his hips. I made certain I turned my head at the last minute, so I wouldn't end up with a mouth full of parsley.

It was a clean hit, and as I drove him to the green I could hear the wind rush out of him. About this time, the bobbies scurried over and dogpiled him, and led him off the green. One bobbie had his hat hiding the guy's frontal area, and another his backside. The crowd was going nuts, and

I realized what it must feel like to make the winning tackle in the Ohio State/Michigan game.

As long as play was being held up anyway, I did a Mark Gastineau sack dance. I don't know what came over me, but I held up my thumb and index finger about an inch apart, to let the fans know that this guy literally was no big deal.

The next day, sure enough, most of the U.S. newspapers and many of the British papers ran the streaker's picture on page one, and poor Sandy Lyle's victory had to take second billing.

No matter what happens with the rest of my career, I know there is one statistical category on the Tour in which I will always be number one, and that is Leading Tacklers. I have one, and everybody else is tied for second with none.

CHAPTER 2

Nice Shot!

IN MY SEVENTEEN YEARS on the Tour, I've seen an untold number of great shots and great rounds. But there are a few that stand out as being really special—either because of the player involved or the circumstances of the day. One was Bob Tway's bunker shot to beat Greg Norman in the 1986 PGA, which I'll get to in another chapter. In terms of the impact it had on those two golfers' careers, that was probably the most important shot I've witnessed up close.

Earlier that same year, however, I was privileged to watch a final-round stretch run that I'll be able to tell my grandkids about. It grew as those things do, with one great shot building on another, and it drove the fans into a frenzy that you rarely see in golf.

It was a case of the greatest golfer of all time turning it on in front of his home-town fans, in a tournament he'd founded and on a course he'd designed himself. I'm talking about Jack Nicklaus playing in the Memorial Tournament at Muirfield Village in Columbus, Ohio.

The context and the surroundings are what made it

special. Just a few weeks before, as most golf fans remember, Nicklaus had shot the greatest final nine holes of his career to win the Masters. At the age of forty-six and at a time when most writers considered Jack too old to capture another major title, he had shot 30 on the back side at Augusta National to win his sixth Masters and twentieth major championship. It was certainly the crowning achievement in an incredible career, and nothing Jack could ever do would top it. The fact that his son Jackie had been caddying for him added a special dimension to the victory.

It was just a month later that I was paired in the final round of the Memorial with Jack and Andy Bean, who two years before had lost a playoff to Nicklaus at the same tournament. We had an immense gallery, but then they'd flock to watch Jack at Muirfield if he were playing in a blind-bogey tournament on a Monday with the juniors six-hole group. In Ohio, Nicklaus would win a popularity contest over a parlay card of Mother Teresa, Johnny Carson, and Elvis back from the dead. And many of the people who watch him there have followed him for forty years, from his boyhood in Columbus, to his college days at Ohio State, through his incredible pro career.

That week at Muirfield in 1986 had the effect of a victory lap for Nicklaus, as the excitement of his Masters win was still fresh in everyone's memory. Every move he made drew applause. They cheered when he took off his glove.

Anyway, none of us had generated much excitement on the front nine of that final round. We were all about even-par. We were having a good time, and had a nice camaraderie among us, but it looked like we were just playing for position, because Hal Sutton had a big lead. Or so I thought until Nicklaus entered . . . the Twilight Zone.

On number 10, Jack hit a good drive and a six-iron 12 feet behind the hole and made it for birdie. On the 11th, a tricky par-five that is difficult to reach under less than perfect conditions, he got home in two with a drive and a one-iron, and two-putted for another birdie.

Number 12 is a par-three that is reminiscent of the 12th hole at Augusta. It's a pretty little jewel until it eats your lunch once or twice. Then, like the prom queen who loses her dentures when she bites into a cheeseburger, she never looks quite the same again. There's water short and right and the green's just a little sliver cut into the side of a hill. If you're overly cautious and hit it to the left, you land either in a bunker or on the hill, and getting it up and down from there is mission impossible. Too far right, you need fins and a snorkel. This day, the pin was cut back right, which is the most difficult spot. But Nicklaus went dead at it. He hit a beautiful cut seven-iron in there about 12 feet, and made the putt for his third birdie in a row. It was starting to get interesting.

With each birdie, the crowd screamed louder and the whole atmosphere got more electric. People abandoned other groups and rushed over to ours, as the leader board flashed the news that Jack was going deeper and deeper into the red.

Andy and I both started to play better as well, like cars in a stock-car race drafting the leader and getting pulled along in his vacuum.

After the birdie at 12, Jack was about four strokes behind Sutton, but he also knew that if he made a few more birdies he could post a number that might hold up. Nicklaus always analyzes the totals after 54 holes and picks a number he'll need to shoot in the final round to win. And after that birdie on the 12th, I could just sense that he was thinking of a number like 65.

On the 13th hole, a downhill par-four dogleg left, Jack hit a drive and a middle-iron about eight feet, and made it. Now he really had the "look"—intense but slightly glazed—that great players get when they're in a zone of perfect concentration. Ray Floyd gets it, as do Lanny and Curtis. At those times the fairways look wider, the hole looks bigger, and you just can't wait to get to the next shot because you know you'll hit it well. It's the way golf is played in Heaven.

The 14th hole at Muirfield Village is a truly spectacular par-four. It's short, only about 350 yards long, and calls for a precise shot off the tee for position, and then a short-iron to a tiny little green, with water guarding the right side. The pin that day was in the back right position, the toughest place they can put it.

I had hit my second shot into the left bunker, a tough spot from which to make par. Bean had hit his second about 12 feet from the hole, and Nicklaus about 15 feet. An amphitheater frames the left side of the 14th green, and all of Western civilization had gathered there to cheer on their man. They were yelling, "Go Jack" and "We love you, Jack." Andy and I might as well have been hawking programs and soft drinks for all we meant to the crowd at that moment.

One of the things I've learned on Tour is that I don't have to put my ego in check at a time like that, because the crowd does it for you. From playing so much with Palmer, I've gotten a master's degree in protocol when playing with a legend. I always give them their due respect, much like a rookie might do with a more experienced player. Respect is something you earn as a golfer, and not many players had earned more than Nicklaus. At the same time, I had a darned tough up-and-down facing me, so I didn't want to get so caught up in the adulation for Jack that I

threw away my own round. Somehow, I hit a good bunker shot and it trickled down to about four feet from the hole.

Although Nicklaus was clearly away, Bean went up and set his ball down and putted first. I thought it was strange that Andy was playing out of turn, because I hadn't seen him and Jack communicate with each other. But Andy knocked it in and got a nice round of applause.

Immediately, people started yelling encouragement to Nicklaus again. I was standing next to Jack, just holding my ball and waiting for him to putt, when he turned to me and nonchalantly said, "Peter, do you want to go ahead and putt out?"

That really caught me off-guard, because you usually do that kind of thing only on the final hole of a tournament when you're saving the last putt for the winner. I looked at him and said, "Why would I putt out, Jack? You're away."

He replied, without any hesitation, "Because when I make this putt, the people here are going to go crazy."

I distinctly remember he said "when," and not "if."

Now, he had a 15-footer with about a nine-inch break from left to right. It was a darned tough putt. But I could tell from his eyes that he had absolutely no doubt that he was going to make it. He was merely offering me the courtesy of hitting my crappy little par putt before all hell broke loose.

Even though I sensed that he was right, that I should putt out, I said, "Jack, you go ahead, because I have to learn to deal with these types of situations."

And I remember Jackie Nicklaus, who was caddying for his dad and had his own aspirations as a player, nodding at me as if to say, yeah, that's all part of learning to play in the big leagues. Good move, Peter.

Then Jack hunched over his putt, and with the concen-

tration of a safecracker leaning in to hear the tumblers click, he measured the line to the hole. Even with all those thousands of people surrounding the green, it was so quiet you could have heard a bird chirp.

And then he knocked it in. Just like he said he would. For his fifth straight birdie.

True to Nicklaus' word, the crowd went absolutely bonkers and a deafening roar went up. It was the loudest ovation I've ever heard. You'd have thought everybody around the green had hit the Ohio state lottery at the same moment. Jack was holding up his hands to try to get them to be quiet, and he was probably thinking about me, *You dumb shit, I told you to putt. Now you've got no chance to make par.*

Actually, that was what I was thinking about myself because it was absolute bedlam, and I still had this testy little uphill four-footer while everybody was high-fiving and hand-jiving and uttering orgasmic screams. I half-expected the crowd to start doing the Wave.

I remember looking over at my caddy Mike, because I wanted him to read the putt for me, and he was holding the pin and staring up at the crowd in disbelief. I yelled "Mike . . . Mike . . . MIKE!" at the top of my lungs, and although he was only 20 feet from me, he didn't come close to hearing me. I should mention that Mike Cowan is a card-carrying Deadhead, a guy who never misses a Grateful Dead concert if they're in the area, so he's no stranger to bedlam. But this was overwhelming even to him.

After a few seconds of futility, I had to walk over and touch his shoulder to bring him back to reality. I said, "Mike, read this putt for me," and he gave me a dazed look as if he'd just seen an alien spacecraft land in the bunker. So I finally said, "I got it," and went over to hit the putt.

I took a deep breath and gathered myself, determined to

deal positively with this situation that I had created. When I hit the putt, there was still so much commotion that I never heard the click of the putter on the ball. That's an eerie feeling, almost as though you've whiffed it. But somehow it went in.

I felt really good that I'd been able to make it, and I immediately looked over at Mike and expected him to say, good putt, or way to go, but he was still staring off into the crowd. He looked like Robert DeNiro in the opening scenes of *Awakenings*.

I was finally able to bring Mike back to earth as we walked to the next tee, and he was blown away to hear Nicklaus' remark, how he'd said *"when* I make it."

On the 15th hole, an uphill par-five, Nicklaus poured some adrenaline into his drive, and reached the green with a beautiful one-iron that stopped about 20 feet from the hole. At that point, I thought, this guy's gonna shoot 27 on this nine. As he stood over the eagle putt, Jack knew he was going to make it, and Andy knew he was going to make it, and I knew he was going to make it, and 10,000 misty-eyed Nicklausites knew he was going to make it.

And the ball rolled perfectly up to the cup, peeked in . . . and just tickled around the edge of the hole. I swear that ball saw more lip than Bianca Jagger on her wedding night. But the kiss never came.

Jack had given it his patented victory step, with the putter raised in his left arm, just like he'd done the previous month at Augusta. But this time the golfing gods said, "No, you've reached your limit, Big Fella. It's time to throw a few back."

When it didn't drop, Jack raised his arms in disbelief and covered his head and stared back at the ball, as if to say, Don't you know who I am?

But the ball didn't. It just sat there staring at him with its dimples twinkling in the afternoon sun.

Although it was Jack's sixth birdie in a row, I could sense that he was oddly deflated as he went to the 16th hole. He'd wanted the eagle and he'd hit a perfect putt. When it hadn't dropped, the spell was broken. And what happened to him on the next three holes was as surprising as the previous six. He bogied them all.

As much as he'd used positive thinking to roll to those six birdies, so the negative effect of that near-miss had turned to dust at the end. And it made me appreciate once again how fickle golf can be.

Even though Jack didn't win the tournament, and didn't close out a fabulous round the way he could have, it was nevertheless the most interesting nine holes of golf I've ever watched. I still distinctly remember every shot he hit. And that's because I knew that, at least for a few short hours, I was seeing the best that ever was playing as good as he could. And that's something.

While Nicklaus' run at Muirfield Village is the best stretch of holes I've seen, there have been hundreds of fabulous shots over the years.

One year I watched Jerry Pate make a hole-in-one on the infamous 16th at Cypress Point in the Bing Crosby Pro-Am. It's the only time a pro has ever aced that hole in the tournament, and he did it with an orange golf ball—which I'm sure caused the Scottish shepherds who invented this game to spin like pinwheels in their graves.

The wind was slightly behind us and blowing from right to left, so Jerry hit a one-iron and started it out over the ocean and the cliffs, which takes some guts. But Jerry was having a bad day, and was missing the cut, so it wasn't *that*

heroic. Anyway, the ball blew back perfectly, took a nice bounce, and the roll was pure radar.

My trusty partner Jack Lemmon turned to Jerry and said, "If you give me four shots on this hole, I'll play you for a beer." Pate accepted the bet.

As I recall, they tied.

Another great shot I saw firsthand came from Bob Gilder on the final hole in the third round at Westchester in 1982. As a national television audience looked on, Gilder hit a perfect three-wood from 251 yards and holed it for double-eagle. That shot had far greater significance than Pate's, because Gilder had a three-shot lead at the time, and the albatross gave him a nearly insurmountable six-shot lead over Tom Kite, and eight over me. And both of us were paired with him at the time.

The shot also gave Bob a 54-hole total of 192, 18 under par, and a legitimate opportunity to break Mike Souchak's all-time 72-hole Tour record of 257.

I remember I had shot 68 in the opening round of that tournament, but as the scoring was extremely low, I was in about twentieth place. After Jan looked at the scores, she said, "Honey, if you shoot under 65 tomorrow, I'll do something really special for you tomorrow night." It obviously provided serious incentive, because on Friday I shot a course-record 62.

Even with a 10-under par total of 130, I was still three back of Gilder, who'd opened with 64–63. And I'd fallen even further behind as we played the 18th on Saturday. Creamy Carolen, Palmer's one-time caddy, was packing for Bob that day, and when Gilder ripped that three-wood at 18, I said to Creamy, "That's going in."

Bob has a habit of rocking back on his right foot after he's made a big swing, and immediately after he hit it, I remember he rocked back, then took off like a hunting dog

after a downed pheasant. Because the green is elevated, we didn't see it go in, but the gallery's reaction was unmistakable. When a shot like that heads for the green, you always look to the gallery to find out how good it is. If there's a huge scream and everybody's arms go up, signaling a touchdown, you know you've holed it. But if their arms go up, then quickly come down, followed by a groan, you have to settle for the field goal.

In this instance, we also had a CBS cameraman there, and he quickly turned to Bob and said, "It's in!"

And Bob was incredulous. He said, "It's in?"

And the cameraman said, "Yes, dammit, it's in!"

Then Gilder asked him one more time, just to make sure.

Jan had walked ahead of us up to the green, and she hadn't seen who'd hit the shot, so she turned to a man next to her and said, "Who hit that?" And he said, "The kid from Oregon."

She started to celebrate until she learned it was the other kid from Oregon, namely Bob Gilder from Corvallis. But that was okay, too, because how often do you see *anyone* make a double-eagle? Gilder went on to win the tournament easily, and Kite and I tied for second. All in all, it was a good week for me, especially my reward on Friday night for the 62.

I've been asked a few times to describe the greatest shot of my life, and that's a tough one. Maybe it was the first time I hit a ball on the face and told my dad, "Hey, this is fun." Or maybe it was the downhill three-iron from 250 yards that I hit onto the green in 1990 to win the Bob Hope Chrysler Classic. But in terms of sheer importance, a fairway bunker shot I hit in Brownsville, Texas, in 1976, has

to rank at the top. As usual, a little background is in order.

I turned pro in the fall of 1976, just after my collegiate career had ended. I was engaged to be married to Jan Davis later that year, and so I spent that summer and fall playing as much competition as I could. My goal was to enter the PGA Tour qualifying tournament in Texas in the late fall.

I played in the Western Amateur and the U.S. Amateur that summer, and did fairly well. Then in my last tournament as an amateur, I won the Oregon Open. I shot 65 the last round to beat Bob Duden, a golfer who's a legend in the Pacific Northwest. Duden had won every important tournament in the region about five times, so that was a real confidence-builder. The next week, I went to the Northern California Open at Lake Shastina, and in my professional debut, I won again. First prize was $3,500, and I was so thrilled with the idea of all that money that I thought I could retire and move to Florida on it. I still have the oversized check they presented me at the awards ceremony.

More importantly, I proved to myself that I could play for money without letting the pressure get to me. Then I spent the next month playing in a four-event mini-tour series in Arizona, from which I picked up another fifteen to twenty thousand.

I was on a pretty good roll, but past credentials don't mean a thing at the Tour qualifier. The list is long of great players who've failed that school at least once.

Back then, they had two qualifying tournaments a year, and the fall qualifier was held in Brownsville. There were no regional qualifiers, so basically anybody who could pony up the entry fee could tee it up. That year there were 349 players going after 29 cards, meaning only one in twelve would earn the right to join the Tour. We played six rounds, 108 holes, and it was the most terrifying week

I've ever spent. The only part of my body that stayed loose was my bowels.

You just can't imagine the pressure and fear you feel during that tournament. It's far worse than the Masters or U.S. Open, because in those events you know you've earned your way in, and there's always next week if you don't play well. But if you blow the Tour qualifier, you start practicing lines for your next job, such as, "Would you like paper or plastic, sir?" or "Those wiper blades look a little worn."

I had the additional incentive of knowing that I could sign with the best management group in the world, IMG, if I earned my card. Hughes Norton, who runs IMG's golf division, had already signed Curtis Strange, and he had an interest in me as well, contingent on my making it.

The weather didn't ease the situation any. It was 40 degrees, rainy, and cold. The windchill was right around freezing. A lot of guys wore the kind of ski masks that cover the entire face, with holes just for the eyes and mouth. It looked more like the World Wrestling Federation out there than a golf tournament. I wouldn't have been surprised if the clubhouse leader was Honky Tonk Man, with Jesse "The Body" Ventura two shots back.

Plus, there were none of the other familiar trappings I expected to see at an event that would determine my future: like leaderboards and concession stands. And like fans. Even the ducks had split.

Making matters worse was that I spent the entire week hovering right around the cutoff line. I shot 73s and 74s the first three rounds, 69 in the fourth, and a disappointing 77 in the fifth round. Going into the last day, I needed to shoot even-par or one-over to make it. And the weather was the worst it had been all week. The odds were not in my favor.

I kept grinding, however, making one tough par after another, and as I walked to the final hole, I was informed I needed a par to earn my card. That was less than comforting, because the 18th was a difficult par-four dogleg left, with water guarding the left side of the fairway and the front of the green. Not surprisingly, I blocked my drive right, into a fairway bunker. When I got to the ball, it was not pretty. There were several puddles in the bunker, and although my ball was not in one, I couldn't tell just how soft the sand was. It was sort of like hitting out of freshly mixed cement. My yardage, incidentally, was 180 to the front of the green, with 170 to clear the water.

It was pretty elementary: all I had to do was pick the ball clean, yet hit it high enough to clear the lip of the bunker and the greenside water hazard. Plus, there was wind and rain in my face. I remember thinking, I don't have this shot. And yet I *had* to have this shot or I would not be allowed to wear cranberry Sans-a-Belt slacks for a living.

It even occurred to me that if I didn't par that hole, Jan might head on down the road with one of the guys who'd earned his card, quite possibly Jesse "The Body."

I was so cold and wet and scared walking into the bunker to hit that shot that I thought I might faint. If I'd been playing pinochle, I definitely would have passed. My last thought before taking the club back was to try to hit it thin. And I did.

At that point, God took over and guided that skinny little four-iron shot up onto the green 8 feet from the cup. And I two-putted for par, but not until I'd clogged three more arteries by knocking the first putt four feet past.

Just as I thought, I made it right on the number. My friends Keith Fergus and Mike Sullivan finished first and second. Tied with me were several other players who've gone on to have fine careers on the Tour, including Jay

Haas, Mike Reid, and Don Pooley. Today we still talk about surviving the Nightmare in Brownsville.

One stroke back, and out of luck until the next spring, were my good friends Phil Hancock and Curtis Strange. As it turned out, Hancock won the next qualifier, and Curtis, well, I guess everyone knows things turned out okay for him, too.

Mind Games and Other Matters

ONE OF THE HARDEST QUESTIONS the media can ask a touring professional when he's on a roll is, "Why are you playing so well?"

It's a stumper for many reasons, the main one being that you really don't like to think about it too much, for fear of analyzing away all those good thoughts. Also, when a player has found a secret to lower scoring, he's not about to give it away in an interview. Usually it's a key that works only for him, and to share it is to diminish it.

The typical answer that comes from a Fred Couples or a Davis Love III, or anyone who is shooting the lights out is, "Well, I have a lot of confidence right now." Or, "I feel comfortable over the ball." Or, "Gee, I'm just having a lot of fun these days."

Those are honest answers, although they're not exactly brimming with insight. The guy listening at home is prob-

ably thinking, damned right, it's fun to shoot 65 or 66 and take home six-figure checks. Tell me something I don't already know.

But the players aren't necessarily being elusive when they give those simple answers; they're just being honest. We play our best golf when our brain is not working overtime, and our muscles react most effectively when not under great tension. Often, it's easier to play well in the lead of a tournament because you've made a lot of great shots and your confidence is high. When you're trying to fight out of a slump or birdie the last hole to make a cut, the feeling is much different. In the first instance, the stress is positive; in the second, with all those demons of fear screaming warnings at you, the stress can be very negative.

When I didn't play well during parts of 1991 and 1992, it had a lot to do with too much tinkering with my golf swing and overloading the circuitry in my brain.

I've often been criticized for spreading myself too thin, and having too many outside interests away from competitive golf. But that criticism comes from people who don't know me. The truth is, I've played my best golf when I've had the most stuff going on. During stretches of time when I don't have a jam-packed schedule, I get sort of lethargic and don't do as well.

My on-course problems the last two years (apart from the allergies I was suffering) were related to too much instruction. It started when I made some swing changes to accommodate problems I'd had for years with my back. I wanted to use the big muscles more in my golf swing and take the strain off my lower back, and I did that successfully with the help of instructors Jimmy Ballard, John Rhodes, and Randy Henry. But I never quit tinkering, and I was probably guilty of soliciting too much advice from too many different people.

There comes a time when a golf instructor has to look in a student's eye and say, "You're done." The best instruction is like getting a haircut. You sit in the chair, the barber snips away, and after about a half hour he says, "All right, thank you, give me twelve bucks." He's finished, and you go away and don't come back again for two months.

There's a tendency among golf instructors to fall into a "We're never done" attitude. Often, I didn't have enough time to incorporate a lesson into my game before I was trying something else. And I have to blame myself for that. My instructors were only trying to help. So in 1992, I started "de-toxing," if you will, from golf lessons. I got confused, so I had to clean out the circuitry from an overload of information. I found that Fred Couples' swing was a good model, but I'll get to that later.

Jackie Burke told me a story once that applies to my situation last year. A friend of Jackie's had a wonderful wooden statue of a dog in his office. Jackie raved about the statue and asked him where he had gotten it. The friend said, "Well, thanks. I carved it myself."

Burke said, "Wow! That's incredible. How did you do that?"

And the friend said, "I just cut away everything that didn't look like a dog."

That's a good way of looking at golf instruction, and even golf course architecture. In designing a golf course, you just cut away and move dirt and remove everything that doesn't look like a golf course, and in golf instruction the teacher eventually has to say, "Enough cutting, now go play."

Unfortunately, I kept whittling away at the foundation of my swing until there was hardly any shape or artistry left . . . just an ugly lump of wood. What had once looked

like a dog had been whittled down to a rat. So I went back to my natural swing, and any inherent athletic ability I might have, and reestablished confidence from there.

Golf swings are like snowflakes: there are no two exactly alike. I try to emphasize how different they all are when I do my swing impersonations. When I do Lee Trevino, I line up way open, take the club back way outside, and drop it back to the inside. When I do Miller Barber, I make sure that the first thing that comes back is my right elbow, which flies out as far away from my body as I can get it. When I do Johnny Miller, I try to do an early set and cock the club as much as I can. These swings are as different from one another as they can be, but they belong to players who have all been tremendously successful on Tour. The point is, they all return to the impact zone in the same position.

When you're playing your best golf, you're not aware of these idiosyncrasies. You just put your hands on the club, take it back, hit the ball, and go find it. The sole aim is to get it into the hole, and even though it appears the golf hole gets bigger as you approach it, it's really an optical illusion, because the ball fits as easily into the hole from 180 yards as it does from two inches. You just have to understand that and get the ball and the mind moving in that direction.

Sometimes we get so stuck on fundamental and technical thoughts that we forget that the golf ball is simply meant to be projected in a certain direction toward a flag stuck in a hole in the ground.

And here's where Couples comes in. His success in 1991 and 1992 really changed my outlook on the golf swing. As I said, I had gotten too technical with my swing changes, and here was a guy winning everything with a beautiful-looking swing, but one that was far from classic if you

broke it down. Fred would credit his instructors Dick Harmon and Paul Marchand for preserving his natural ability and working within it. They've never made Fred start from scratch when making a swing adjustment.

After Fred won at Bay Hill by nine strokes in early 1992, there was an action picture of him on the cover of *Golf World* magazine. His right palm was completely off the golf club just after impact. The only contact points were the tips of his thumb and little finger. That told me that poor Freddie was a slapper. All he did was slap it around in 19 under par that week and kick everybody's butt.

I've done many clinics with Freddie over the last ten years, and when I ask him to come up and hit some fades, he'll hit half a dozen of the prettiest fades you've ever seen. So for the benefit of the crowd, I'll ask him what he does when he needs to hit a fade. And he always looks at me with that infectious grin and says, "Gee, Peter, I don't know. I just get up to the ball and I see it start down the left side of the fairway and kind of slice back to the right, and when I have that picture in my mind I make my swing."

Everybody in the grandstand always laughs. So I ask him to hit some hooks, and he'll hit half a dozen great-looking right-to-left shots, and when he tries to explain he blushes and says, "I really don't know. I just get up there and see the ball hooking and then make the swing, and the ball hooks."

What Fred is describing is a sort of Zen-like state, which Ben Hogan called "muscle memory," and it's the essence of the teachings of my friend Chuck Hogan (no relation). That is, using your mind to direct your golf shots. In Freddie, it comes across at times as lackadaisical, carefree, and non-analytical, but what he's really tapped into is the essence of great golf, which is arriving at a zone of total

relaxation and total confidence. He just steps up to the golf ball, takes a deep breath to relax, takes it back, and whomps it. Then he goes and finds it and whomps it again. And when he adds up the whomps, the total is usually lower than that of the other 143 whompers.

Couples' casual, wonderfully fun approach caused me to realize that I was thinking too much about where the clubhead was halfway into my backswing, and where it was on the follow-through. It was almost a "connect-the-dots" exercise. As I've often said, golf is really a mind game; in fact, it is a sport that relies almost entirely on the imagination of the individual playing it. The golf ball is in motion for only about six minutes in a four-hour round of golf played in even-par. So that means that the other three hours and fifty-four minutes are spent either reflecting on the last shot or imagining what might happen on the next one.

As Shivas Irons says, "It's all in the walking, lad."

That's just another intriguing aspect that makes this sport so wonderful. Ninety-eight percent of golf is played between the ears. I didn't really appreciate this until I got to know Chuck Hogan and believe in him as a great golf educator. I had known Chuck only casually as a golf pro in Oregon, when I received a couple of letters from him suggesting that we get together. He felt he could give me some help with the mental side of the game. In the summer of 1984, suffering from both physical and mental wounds (a bad back and low confidence), I drove down to Eugene, Oregon, where I'd gone to college, and spent four days with Chuck. He was gaining a good reputation, and I certainly needed help.

We had several long conversations before we started doing any drills. During one of our talks, he held his fingers about two inches apart and said, "See this ball?"

"What ball?" I said, darned certain he was holding nothing but air.

"Don't you see a ball in my hand?" he said.

"Am I supposed to?"

"Yes," he said.

"Okay, I do," I conceded, although, of course, I didn't.

"Take this ball from my hand, and we're going to go to the back putting green at Eugene Country Club and practice making putts with it," Chuck said.

Now this made me a little squeamish, because having played Eugene C.C. as my home course in college, and having been on the Tour several years, most of the members at the club knew who I was. But part of Chuck's theory is that the best ego is no ego, so this would be part of the exercise.

When we got there, Chuck told me to drop the "ball" about ten feet from the hole and try to knock it in. I looked up on the veranda overlooking the practice green, and several people waved and the rest looked on intently.

I started to line up the "putt," and then I backed off.

"This is kind of embarrassing," I said. "They're watching me putt without a ball."

"What do you care, as long as they all go in?" Chuck said.

So I hit the first putt, and he said, "Where did it go?" I said, "I made it."

And he said, "Good. Because if you'd have missed it, your mental problems would be too deep for me to solve."

I had a good laugh at that, and kept putting. I'd stroke the putt, my eyes would follow it down the line and watch it go into the hole. Then I'd lift the miniature flag out and dump the ball to the side, rake it back a few feet, and putt again.

Sure enough, I kept holing one imaginary putt after

another, and started to get mesmerized with the whole process. After I'd hit fifteen or twenty putts, I noticed a man sitting on the veranda, intently watching me and eating lunch at the same time. He was obviously more fascinated with my practice technique than his lunch, because he had mayonnaise all over his mouth and chin.

"Look at that guy," I said to Chuck, under my breath. "I've knocked ten putts in the middle of the hole with an invisible ball, and that guy is only one-for-four hitting his mouth with a turkey croissant."

Despite my perplexed gallery, I stayed on the practice green for forty minutes and fulfilled my goal of making every single putt I hit. Obviously, I had also learned to put my ego aside, at least for a time.

In the next few days, Chuck worked with me on many concepts and taught me that we have the answers to our questions deep inside—that it's just a matter of listening to ourselves. He also emphasized that our subconscious mind didn't know the difference between real and imagined, so if we trained our imagination to do positive things, such as consistently making ten-foot putts, we could make real ten-foot putts as well.

The entire week I was home I never hit a real golf ball; I just worked on mental exercises. When I went to the next tournament on the schedule, the Colonial National Invitational in Fort Worth, I was very relaxed, and concerned only with practicing what I'd learned.

What do you know? I won the tournament, beating Payne Stewart with a birdie on the first hole of sudden death. That victory was extra special for another reason. My father had undergone his initial cancer surgery back in Portland, and I was able to dedicate the victory to him. It made both of us feel pretty darned good.

Needless to say, I became a true believer in the theories

of Chuck Hogan, and am to this day. Whenever my mind gets cluttered with too many thoughts, I visit Chuck and he really helps me clear my head.

On one occasion I asked Chuck to work with Jack Lemmon prior to our annual appearance in the AT&T National Pro-Am. Jack gets very uptight on the golf course, so Chuck tried an exercise to take him out of the reality of the situation.

"Jack, you're the greatest actor in the world," Chuck told him, "and your role in the movie you're about to star in is to play a man competing in a national pro-am, who rises to the occasion and plays brilliant golf, topped off by holing a putt on the final green to win the tournament."

A little smile came over Jack's face, and he said, "Hey, I like that idea."

Well, I wish I could tell you this session worked as well as mine had, but at least for 27 holes the concept took hold, and Jack played very well. After a while, however, the pressure of the tournament and all the distractions snapped my partner out of that zone, and we missed the cut again. As Chuck put it: "Unfortunately, Jack ended up playing the role of an anchor rather than a Kite."

Hey, if I could successfully apply Chuck's method every time, I'd have won four Grand Slams by now.

Another minefield I've learned to handle in my career is an affliction known as rabbit ears. It's caused by letting peoples' off-the-cuff comments slip through your auditory canal and into your brain. It's especially prevalent with golf broadcasters.

One occurrence in 1982 really got to me. CBS announcer Ben Wright was at his post on the 17th hole at the Westchester Classic. I was having a good tournament,

in second behind Gilder during Saturday's play, and I'd placed in the top three at Memorial and Atlanta in recent weeks. So I was on a pretty good roll.

CBS flashed a graphic on the screen that indicated I had hit an incredible percentage of greens in regulation in recent weeks, something like 63 out of 72 at Memorial and 64 of 72 at Atlanta, and that I'd missed only two greens out of 52 by the time I reached Ben's hole on Saturday. It was actually just one of these streaks one goes through—even my bad shots were still catching the corner of the green. Johnny Miller has said that the surest sign you're playing well is when your bad shots aren't that bad. That was the case for me then. My bad shots were still finding the putting surface, but Ben didn't read it that way.

He said, on camera, "Wow, this kid can't putt. Look how many greens he's hit." And then he said to Ken Venturi, in the booth at 18, "Kenny, can you give Peter a putting lesson? He looks like a good young player, but he needs to learn how to putt."

Well, I went on to tie for second with Tom Kite at 14 under par behind Gilder.

When I watched the replay of Westchester and heard Ben's comment, it hurt me, because I thought I was a pretty good putter. I'd been knocking on the door of victory several times in recent weeks, but nobody was home. Or maybe someone was inside but the door was jammed. Anyway, that started a period in which the "conventional wisdom" (a misnomer if there ever was one) was that I was a good ball-striker but a poor putter. And it caused my self-image to suffer with the short stick.

I got back at Ben when I did an interview with *Sports Illustrated* a couple years later, and relayed the anecdote to

writer Jaime Diaz. I explained to Jaime that one of Chuck Hogan's theories was to dispel negative thoughts from your head by plotting ways to make them disappear. Jaime came up with the idea of staging a photograph in which we air-lifted a Ben Wright dummy out of the CBS booth by heli-copter. Ben and I both laugh about the incident now, and I've learned not to be so sensitive to stupid commentary.

Another instance of rabbit ears occurred just a few days after I'd won the Sammy Davis Jr.–Greater Hartford Open in 1984. Hartford had been just one more great week in a really fun year for me, coming on top of the win at Colo-nial and that great week in the British Open at St. An-drews. Everything Chuck Hogan had preached to me had really sunk in.

Hogan had also espoused that at the level of the PGA Tour, a player has proven many times over that his swing is reliable under pressure, and that the biggest window of improvement is in the mystical side of golf. Basically, Chuck convinced me that I didn't need to be such a perfectionist about my golf swing, and that I had to play more by feel. And that's what I was doing that summer. I had "felt" my way to a solid victory at Hartford, and a couple days later was home in Portland watching the replay of the final round. I was hitting a seven-iron to the 14th green, a shot that landed in the middle of the green, and Steve Melnyk, who was doing the commentary for CBS, had made a comment about my backswing.

He said something to the effect that Peter Jac makes kind of an awkward-looking backswing. the club and lays it off quite a bit, so that th way to the left of the target, but he s through the hitting area and the ball

Now I understand that comme

role of analyst, but the Golf Hall of Fame is full of players with unusual-looking swings, and some of the prettiest swings you've ever seen in your life are made on the far end of the public driving range by guys who couldn't break an egg with a baseball bat.

Anyway, that comment really affected my ego and buried itself in my subconscious. I let Steve know about it when I next saw him. I was hitting balls with Lee Trevino on the driving range at the World Series of Golf, and when Steve walked over I got it off my chest. I told him that I didn't appreciate his criticizing my swing at Hartford and that it didn't make him look too smart, seeing as I was hitting every green and winning the tournament.

Although I went on to finish third that week at the World Series, I still couldn't get the notion out of my head that I had a flawed swing, and that I had to fix it so a broadcaster couldn't criticize it on national television. My rabbit ears had infected my brain, and as a result I didn't play well the remainder of that year. Through my own hypersensitivity, I had fallen out of playing by feel and into a stupid search for the perfect swing.

In my ~~...~~ s a broadcaster, I never ~~...~~ e although I realize the ~~...~~ or instruction, analyzing ~~...~~ re a thousand different ~~...~~ ed Couples' right hand ~~...~~ club pro would scold ~~...~~ us has a flying right ~~...~~ made a big lunge at ~~...~~ s of his swing.

~~...~~ laying off the club ~~...~~ e of my best season ~~...~~ elnyk's fault. All I ~~...~~ was a set of ear-

plugs. But that's what the Tour is all about—learning from experience.

While I still have Fred Couples on my mind, I should mention that his recent status as one of the best players in the world has been great for golf. I've known Fred since he was about nineteen and playing at the University of Houston. He grew up in Seattle, and players from the Pacific Northwest have a mutual admiration society because there aren't many of us on Tour.

But more than that, Freddie is the type of player who improves the image of the sport because he's a kind person, has no arrogance, and is totally focused on golf. I don't think his playing career will be the slightest bit diminished by outside interests, because for him golf is the biggest turn-on. He's also not swayed by the money, because he's made a ton of it over the last ten years and he's hung on to most of it.

When Fred won the Masters in 1992, which completed an incredible run where he'd finished in the top six in twenty of his previous twenty-five tournaments, he put a stop to a lot of the talk about European domination of professional golf. Couples had led the American Ryder Cup team to victory over the Europeans in 1991 and had stopped a four-year run of European winners at Augusta.

Remember, one of the reasons the Americans stopped dominating golf and fell off the ladder a bit was because of the responsibilities that come with corporate contracts, endorsements, media pressure, and the responsibilities that players feel to "do the right thing."

It's extremely difficult to turn down the offers that come when you've reached the pinnacle of golf. Look at players like Curtis Strange, Greg Norman, and Payne Stewart.

They're offered incredible sums of money to sponsor products or compete overseas, and it's a chance for them to provide permanent financial security for their families.

If you have an opportunity to take a $150,000 offer to go overseas, or to sign a five-million-dollar contract to wear a brand of clothing or play a certain make of golf club, your better judgment tells you to take it. If you turn it down, you have to live with that voice inside you that says, "You could start hitting snap hooks tomorrow, or shanking your chip shots, or you might get the yips. Take the money while you can."

Remember, there are no guaranteed contracts or injured-reserve lists on the PGA Tour, so relatively short reigns at the top of the world are common. Nick Faldo has enjoyed a longer stint at the top because he has maintained an incredible focus on his golf. As other sports champions have said, "It's tougher staying at number one than it was getting there."

It just makes me appreciate all the more those special golfers like Hogan, Palmer, Nicklaus, and Watson, who were able to stay on top for long stretches of time. I could write a whole chapter about Arnold Palmer. In fact, I think I will.

Chapter 4

Arnold Palmer

I CAME BY my admiration for Arnold Palmer naturally: I inherited it from my dad. Dad was an excellent player in his prime—a legitimate scratch golfer—and he always joked that his handicap increased as his number of dependents rose. He went from a zero to a one after David was born, to a two after me, a three after Paul, and a four after Susie. Fortunately, the same progression never occurred to me or I'd have had to find a real job soon after our first child Amy was born.

Anyway, like so many golfers in the 1960s, Palmer and Nicklaus were Dad's two heroes, and, of course, they were on television all the time, because one or the other was winning every week. Nicklaus was always in control—cool, collected, and obviously special—but Palmer was the one that really caught my attention, because he was unique. He combined grace, force, and brute strength in an unnatural motion that seemed perfectly suited to his personality.

He'd take that furious swing, and when he got to impact

he seemed to be on the toes of his shoes, his feet spinning, his heels coming off the ground, and the club going in fifteen different directions. Depending on how many hazards the ball had to elude, that's exactly how many neck jerks and head tilts he employed. He looked like a guy trying to dodge hornets.

Even as a kid, I thought: what an incredible swing this guy has! The ball had left the clubface and yet here he was twisting and jerking and urging it on down the fairway, and the gallery would go nuts, and Palmer would snatch up his tee and hike up his trousers and off he'd go to rip an iron right at the flag.

So I started practicing his swing, and that became my first impression: doing Arnold Palmer in the backyard. I was all of ten years old. It's a shame *Star Search* wasn't on the air back then. I would have gotten three and a half stars in the Junior Swing Impersonation competition and gotten to meet the Junior Spokesmodel.

I'll always remember how I first met him. It was around a dozen years later, in my rookie year of 1977. Coincidentally, it occurred at a tournament that has become very special to me through the years, the Bing Crosby Pro-Am. We had the Monday qualifying system back then, and I had missed the first two qualifiers at Phoenix and Tucson. I had finally made it into my first official PGA Tour event at the Crosby and was out playing a practice round at Monterey Peninsula Country Club, one of the courses used in the rotation at the time.

It was late Tuesday afternoon before the tournament, and I had played the front nine and was somewhere on the back side when I noticed a large cloud of dust billowing up

in the distance. It was like in the old cowboy movies when there's a cattle drive or the posse's ridin' up on the bad guys, and I knew something important was happening. But I went about my business and, sensing I didn't have time to finish all 18 holes, I cut over to the 16th tee.

As this was my first time on the course, I really didn't know the layout of the holes. I just knew I had about half an hour of sunlight left. So I hit a couple drives off the 16th, when all of a sudden, out of nowhere, an incredible throng of spectators emerged over the rise behind me and surrounded the back of the tee.

It was like when the entire Bolivian army encircled Butch Cassidy and the Sundance Kid and aimed their rifles at them. These people weren't armed and dangerous, but they were sure looking at me with expressions that said: Who is this kid, and what's he doing out here?

And then the Red Sea parted, and who should walk through it but Arnold Palmer himself. The King. He couldn't have been more regal had he been wearing a robe and carrying a staff.

I felt a chill come over me. I was shocked and embarrassed. I mean, here was my boyhood idol, and I'd just cut right in front of him, and hit two balls no less. I wanted to crawl into the ball-washer and disappear. But true to his character, Palmer walked up to me, shook my hand, introduced himself, and said, "How are you?"

I managed to squeak out a "fine," although I wasn't. And he said, "Could we join you?"

Now that was the first thing he ever said to me, and it struck me so funny because I was thinking, "Can *you* join *me?*" What I wanted to say was, "Can I have your permission to crawl under a rock and stay there for a day as penance for getting in your way?"

But, of course, I acted cool, considered his request for a long second, and said, "Sure, love to have you," like it was no big deal.

This was gut-check time, even if there was no money on the line, because in addition to meeting my idol for the first time, I also met Mark McCormack, who was Palmer's amateur partner. McCormack was head of IMG, with whom I had signed just a few weeks before, but I wasn't sure he even knew who I was.

Nevertheless, I was determined not to let the situation intimidate me, or worry about embarrassing myself. I've always loved the challenge of golf, whatever it may be, so I looked on this as just another challenge, and a darned good preparation for the coming week. After all, this was just a practice round, so I couldn't worry about future endorsements, or impressing these guys. My goal at that point in my career was simple survival. All I wanted to do was make some cuts, make some money, and keep my playing privileges. I was recently married and I wanted to be able to make it to that Christmas and have enough money to buy my wife a nice present.

But back to the 16th hole. Arnold hit a nice drive, and I remember feeling good that both of my drives were past his. If I felt a moment of cockiness, however, it quickly evaporated when I snap-hooked a seven-iron into the bunker. Fortunately, I got it up and down, and that eased my nerves. On the next tee, Arnold asked me what kind of ball I was playing, and I told him it was a Titleist.

He said, "You ought to try one of these *good* balls," and tossed me a Palmer ball. I hit it and liked it, so he tossed me a three-pack and said, "As a rookie starting out, you need good equipment, and these might help you along the way." He was sincerely trying to be helpful, because it

wasn't as if he needed the endorsement of an unknown kid from Oregon playing his golf balls.

As abruptly as the experience of playing golf with Arnold Palmer had begun, so it ended. After holing out at 18, Palmer thanked me, wished me luck in my career, and disappeared into the madding crowd. When I looked up a few seconds after shaking his hand, everyone was gone. I mean *everyone*. There was no more Arnie's Army, only Peter's Poltergeists. I had to shake my head to make certain it had really happened.

When Mike Stoll and I conceived The Fred Meyer Challenge in 1985, we agreed that if we were going to have a successful tournament, we needed to start with Palmer and build a field from there. Early in 1986, at the Bob Hope Chrysler Classic in Palm Springs, I called Arnold and told him we were starting a new tournament in Portland to bring world-class golf back to the Pacific Northwest, and that we'd really be honored to have him play. Without hesitation, he said, "Sure, Peter. I'd love to help you out."

When I put down the phone, we knew right then we had launched a tournament. For the last five years in a row, I've taken Arnold as my partner in the Challenge because I can have no bigger honor as a golfer than to be partners with the man who's done so much for golf.

We've had some wonderful tournaments together, as well. We've finished third twice in the Fred Meyer, but our shining moment together was in the 1990 Shark Shootout, hosted by Greg Norman. In that tournament, Fred Couples and Raymond Floyd shot 34 under par for three rounds, with an incredible 57 in the alternate-shot segment the second day, and they lapped the field. But

Arnold and I finished second, three strokes ahead of the next three teams.

The first round that year, Curtis Strange and Mark O'Meara shot a best-ball 59, with Curtis making 11 birdies on his own. Meanwhile, my partner was struggling at the start. Palmer hit a bad drive on the first hole, another bad one on the second, and sort of a pop-up on the fourth, but I was able to birdie two of those holes. Arnold came over to me on the fifth tee and said, "Son of a bitch, I'm just not *hitting* that ball."

Because I love to needle him, I said, "Don't worry, partner. I'll carry you, just like I do every year in this thing."

Now it's been said of Palmer that he doesn't walk onto the tee of a golf hole. Rather he climbs into it, almost as though it were a boxing ring. And that's the way he looked right then, like he was ready to toss some leather around. He gave me a double-take, as if he were not certain whether I was kidding or not, and then stood up on number five, pumped his drive past everybody in the group, hit a three-wood into a greenside bunker, then holed his sand shot for an eagle. He had enough fire in his eyes to roast a pig. We went on to shoot 61 (which, incidentally, was his age at the time), then the last day shot 60. It was so great to see him turn it on, just like he'd done on television when I was a kid.

We also had the low round at the Fred Meyer Challenge last year when we shot a 63 at the Oregon Golf Club on the final day. A couple of times that week, Arnold got big laughs from the crowd. We had a poor start the first day, bogeying three of the first eight holes, and although we salvaged the round with some late birdies, at one point on the back nine I said to Arnold, "Partner, we may not win this year, but we'll get 'em next year."

And he gave me a startled look. "Next year?" he said. "Peter, at my age I don't even buy green bananas."

Also that week, during a clinic on the 18th green in front of the grandstands, I was talking with Billy Andrade, who had attended Wake Forest University on an Arnold Palmer golf scholarship. I asked Billy what the grant included.

With a straight face, he said, "Well, you get tuition, books, food, a car, a plane, and girls." The crowd laughed, and Arnold leaned over and said, "Shoot, I think I'm going back to school."

The truth about Arnold is that he still hits it beautifully from tee to green, but he doesn't believe in his putting the way he should. So much of golf is mental, and Arnold believes he hits it better than ninety percent of the players, but he sometimes doesn't believe the putts will drop.

I always include my impersonation of him when I do exhibitions, and he's seen me do it over and over, and he even joins in if I ask him. I added one part a few years ago that is pure Palmer. I pretend I'm Arnold studying the shot, and I'm hitching my trousers and checking the tops of the trees to judge the wind, but I'm still not sure. So I reach inside my shirt, pull out a few chest hairs and toss them up to check the wind. Everybody laughs, because Palmer's so manly it would almost be in character for him to do something like that. Every now and then, when he's watching me do him, I get just a little uneasy for fear that people think I'm mocking him. But Arnold always laughs, and he understands me perfectly.

I'm often asked by friends what I've learned from Palmer, and the answer is, plenty, and much of it just by paying attention. I like watching Arnold hit practice balls, because he has such a great swing plane. He's good at

repeating the same action over and over, and he's so strong through the hitting area. He's also imparted a few pearls of wisdom, on those few occasions when I keep my mouth shut and ears open. Arnold has said to me many times, "Peter, you are only out here to win. Second doesn't matter. Second is about as important as fifty-second. Winning is the reason you are playing."

Now while I haven't won as many tournaments as I'd like, I understand what he's saying, and when he offers me this advice I sometimes rub up against him, in the hope that a little of that Palmer magic will rub off on me.

There was a special moment for me in 1991, at Arnold's tournament at Bay Hill. Keeping in mind that most of the players playing today, myself included, had not seen Arnold in his prime, with his hair falling in his face and blood coming out of his fingernails from scratching and scraping his way to a 67 to beat somebody, I decided to thank him in a small way.

Between organizing and hosting the tournament, and even redesigning the course on which it's played, Arnold had not made the cut at Bay Hill in a while, but he did make it in 1991. So after Friday's round, I went to the bakery department of a local supermarket in Orlando and told the woman I needed a sheet cake that would feed 200 people or so. She asked me when I needed it, and I said the next day. She said that would be impossible, that it would take at least four days. I told her it was for Arnold Palmer, and she said I could pick it up in an hour.

I had the Palmer umbrella logo put on it, and the Nestlé Invitational logo and an inscription that read: "Congratulations, Arnold, on making the cut, and thanks for a great week from all the players."

As luck would have it, all seventy-five players who'd made the cut were in the locker room Sunday morning, waiting for a decision on a rain delay, when we presented it to him. You could tell from their faces that they all held him in awe.

I made a little speech and ribbed him about finally making the cut, and he was really touched. He took a moment to gather himself, so I needled him a little more, and then he took the cake knife and pretended that he was going to cut my throat.

So often, with the fast pace of the Tour, we move from week to week, never looking back to thank or show appreciation for the people who made it all possible. That was a chance for a younger generation of professional golfers to thank the man who's probably most responsible of all for the great showcase known as the PGA Tour.

Chapter 5

"Impressions" of the Tour

THERE'S A LOT OF PRESSURE playing golf for a living, and if you don't step back from it every now and again your brain will calcify and become crustier than an elephant's toenail.

Laughter is by far the best remedy I've found to deal with stress, so in those relaxed moments around the Tour when I'm with friends in the locker room or on the driving range, I just love to get goofy and start laughing. Laughter is the reason I enjoy impersonating other players' swings, and why the fans get such a kick out of it as well. Who doesn't like to laugh?

Although I had practiced doing impressions at home as a kid, the first guy I saw do them in public was Billy Harmon, one of the many talented sons of the late Masters champion, Claude Harmon. It was at the driving range at Thunderbird CC in Palm Springs when I was fifteen, and he had Gary Player down cold, from the voice to the swing

to the tilt of the head. People would just howl when Billy would do his stuff, and I thought right then that mimicry would be a great way to have fun.

Through the years, I played around with it, adding a new player from time to time to my basic repertoire, choosing those with distinctive swings, and whom I really admired. I did them for an audience on the Tour for the first time in 1978, during a long-driving contest in Atlanta. The Tour had its own special competition, and the winners qualified for the National Long Drive contest sponsored by *Golf Digest*.

Although I'm only average long as far as the Tour goes, my buddy D. A. Weibring said I should enter and give the crowd a taste of something different. We were allowed just six shots, so I hit the first three as Peter Jacobsen, the fourth as Arnold Palmer, the fifth as Johnny Miller, and I closed with Hubert Green. I believe that in the "Sybil" derby, Miller won, followed by Jacobsen #2 and Jacobsen #3. Unfortunately, none were long enough to qualify for the real gorilla show at the Nationals, but the crowd didn't care. They just wanted to see more impressions. I couldn't believe the ovation I got.

That's when D.A. and I realized that we could make this dog yodel. Shortly afterward, we started doing junior clinics at the Tour stops, in which we'd offer groups of up to 200 kids some basic golf instruction. Then D.A. would play the straight man as I did impressions.

In exchange for our time, the tournament sponsors would give us courtesy cars (this was in the days before every player received one), or invitations to play in the pro-am. In a couple of instances, we even got exemptions into the tournament, which was pretty juicy for a couple of guys in only their second year on the Tour.

Those youth clinics got so popular that before long we

were doing about twelve to fifteen a year. Several offers also came in to do special outings away from the Tour. One week, D.A. and I traveled around the country and did five outings in a seven-day period. We would do the clinic, the impressions, a question-and-answer session, then play one hole each with every foursome in a pro-am. It was exhausting but a lot of fun.

The outings became a nice sideline, but the best part was that we hopefully turned a lot of boys and girls on to golf and away from some of the other damaging distractions that kids face today. Parents can be pretty certain that their children are not getting into trouble if they're on the golf course, and the kids are playing a game that will help them build character.

I'm really proud of the fact that the clinics D.A. and I did have grown into a full-fledged corporate program for kids. They were originally underwritten by Gatorade and are now sponsored by Coca-Cola. Every week on Tour, boys and girls are offered instruction and inspiration from the top professionals. There's even a club giveaway program, to help kids get started.

Sometime during this period, I got a call from Bob Hope, who asked me to do my impressions at the Bob Hope Chrysler Classic Ball. I told him I had all these props, and that I really wasn't sure I could do it inside, and he just said, "Peter, you'll figure it out."

So I took that to mean we were on the bill, ready or not.

The night of the dinner we were all in tuxedos, and Bob and former President Gerald Ford were the co-emcees. When they announced our act, D.A. went out first and introduced me as Lee Trevino. I was standing in the wings next to these two distinguished Americans, and as I took off my evening jacket and cummerbund and tie, and put on a Mexican hat, I looked for somewhere to put the

clothes. Well, there wasn't anywhere, so I shoved them in President Ford's arms, and he politely held it all while I did Trevino. Next, I did Palmer, and then Miller, and each time there was a wardrobe change. Like it or not, the President was stuck with the job. After about four or five changes, Tom Dreesen, a comedian on the bill, came over to me and said, in an alarmed voice, "Peter, Peter, you're treating the former President of the United States like he's a damn stagehand!"

I hurried over to Mr. Ford and took all the stuff out of his arms and dumped it in Bob Hope's lap. The President seemed slighted that I'd replaced him, so he lifted the pile off Bob and said, "I'm holding this stuff, thank you." Apparently, he liked the job.

Dreesen followed our act and shook his head as he took the microphone. "Ladies and gentlemen," he said, "this is a first. I've opened for Frank Sinatra for years, but I've never followed a professional-golfer act doing swing impressions. Especially one that uses a former President as a wardrobe man."

After five or six years, we decided to cut back on our performance schedule. I was becoming known more as the Mimic of the Tour than as Peter Jacobsen, Tour player, and I didn't want a sideshow to overshadow my main purpose for being out there. I knew the only way I could change this image was to become a better player. Lee Trevino is an example of what I mean. Although Lee is one of the funniest, most entertaining personalities in the history of golf, he is known as a champion first, and as a funny guy second. As much as I enjoyed entertaining crowds, I wanted to be more like Arnold Palmer than Rich Little.

The clinics also became very time-consuming, and were

getting in the way of my preparation for the tournaments. I remember a broadcaster once saying on the air, "Peter Jacobsen does such great imitations. He must really work on them. Maybe he should spend more time imitating his own swing."

Although the criticism stung, I knew that if I didn't prove myself first as a player, there was a danger of creating a monster that would eat me alive. In the last several years, I've limited my impersonations to about four performances a year. But I still enjoy doing them as much as ever.

Creating impersonations of golfers is no different than a political cartoonist's doing caricatures of Presidents. You choose one or two distinctive features and exaggerate them for effect. When the cartoonists drew Jimmy Carter, it was his smile and teeth. With Reagan, it was the pompadour hair and wrinkled neck. With Bush, the prominent jaw.

I have about ten players who are always in my repertoire, and the impressions have come together from a variety of sources. For my Craig Stadler imitation, I got pointers from his good friend Jeff Miller when we were in Japan for the Dunlop Phoenix tournament. We came up with the idea of pulling the pants way down in back, pouring two buckets of range balls down the front of my shirt, and wearing the facial expression of a man who has just bitten into a bad avocado.

I also worked on the walk. I took that from his nickname. Craig Stadler walks like a walrus would walk . . . if a walrus could walk. His legs never really bend at the knee. All you see moving is this big upper body with a mustache on it.

As the final exclamation point to the Stadler routine, I always drop the club and walk away while the ball is still in flight. I know when I do this skit in front of Craig, he'll laugh harder than anyone in the crowd. That's because he's

a great guy who's exactly the opposite of the scowling creature you see shooting all those frustrating 67s and 68s. (Craig's got his own imitation of Seve Ballesteros that is priceless . . . in Spanish, no less.)

After Stadler's controversial disqualification from the Shearson Lehman Brothers Andy Williams Open in San Diego in 1987, I had some fun recreating the incident in which Craig placed a towel on the wet ground and kneeled on it to hit a recovery shot from under a tree. For those who don't remember, he was disqualified the next day when it was ruled that he'd built an artificial stance and hadn't called a two-shot penalty on himself. It ended up costing him $37,000, which was $36,950 more than he paid for the pants.

Perhaps the best-received impersonation I've ever done was with Craig at The Fred Meyer Challenge in 1991. Tom Dreesen, who'd first demonstrated his ad-libbing skill to me at the Bob Hope Classic dinner years before, came up with the idea. We had Stadler come out and hit a few shots for the people in the grandstands. Then Tom announced that he had a big surprise: Craig's long-lost brother "Haig" Stadler had resurfaced after several years away from civilization, and was here to show that he, too, had a little ability as a golfer. So with my pants halfway down my rear, and my shirt bulging with about seventy-five golf balls, I came out and hugged my more famous brother, and then we hit a few balls, using the identical swing. It was truly a touching moment in the annals of golf.

I really have fun doing Johnny Miller, because he has such distinct mannerisms. A key to doing Miller is the walk. He's sort of knock-kneed when he walks, as if he's trying to hold an aspirin between his knees. He also lifts his legs from the inner ankle, which gives the appearance that he's trying to walk through chicken wire without getting

his spikes caught. The knees come straight up. Of course, the shirt collar has to be up, and he always has that squinty-eyed look, like he's gazing into the sun. Which is only appropriate for a guy they call the Golden Boy.

Later in his career, Johnny started swinging harder and both his heels would come off the ground at impact. On the follow-through he would roll onto his left ankle so severely that it was almost flattened on the ground when he finished. Of course, after his iron shots landed two feet from the pin, he'd always hold up his index finger, which served a dual purpose: it both thanked the crowd and signaled his position on the leader board.

I've always considered Johnny a role model, both as a golfer and a person. I'd especially like to imitate his twenty-three career victories.

Lanny Wadkins is another guy I love to do. He has a cocky way of carrying himself that lets all the other players know that he's the sheriff. And he is. Lanny's about the last guy on earth you'd want to face in a golf showdown with your life on the line. When I do Lanny, I get a lot of movement going with the head. Then I step up and address it, with my head cocked slightly back. I never take a practice swing, because Lanny's never taken one in his life. They're a waste of time and slow down play. Then I swing as fast as I can, but I don't hold the finish. I bring the club back down to waist-high and start twirling it in my hands. Then I tear off my golf glove and start walking. Fast.

If I were to do Lanny putting, I'd have to have a few teeth pulled and work on my stick-handling, because he hockeys those short putts around the hole. And he's good at it. Try standing on the wrong side of the cup and banging one-footers backwards into the hole if you don't believe me. Lanny converts about 98 percent of 'em.

Tom Kite's got a distinctive style, with that fist pumping

and his head cocked as if to say, "How about that?" As in, How about the fact I've won eight million dollars and continue to beat the crap out of all these guys with so much more God-given talent than me?

With Tom I put on dark glasses and his new-look straw hat, and slather several layers of chapstick over my lips, like a little girl who's just discovered her mother's make-up kit. Early in his career, Tom used to hold his finish until every Kodak on the property could go through six rolls of film. So when I was doing him years ago, I would freeze that finish until it felt like my spine was ready to snap. (I wonder if that's how I developed back problems?)

And then there is Raymond Floyd. He approached me with a big smile on his face after he'd won the U.S. Open in 1986 at Shinnecock Hills.

"Am I good enough to be in your show now?" he asked. Well, of course, he was, and with D.A.'s help, I learned how to do the Ray Floyd walk. He has a distinctive hip swivel and takes short steps and leans forward slightly, almost as though he were bucking a head wind. He also has a habit of constantly touching the bill of his visor with his right hand. Raymond's swing is unique. He takes it back to the inside, gets the club slightly laid off, then quickly gets back to a great position at the ball. After impact, he glares at that ball as if to say, Don't you dare miss the fairway or the green or I'm taking you out of play.

I don't imitate Raymond chipping, because I'd have to knock the ball in the hole every time, then point my finger at the cup and fire a bullet at it. Fact is, I'm non-violent. I also can't chip that well.

I suppose if I'm going to continue to do impressions, I'll have to incorporate the current stars in my routine. The audience only responds if they know the swing and have seen it repeated a thousand times. Nowadays, if I did one

of my old reliables, Doug Sanders, it would be like doing *Colonel* Sanders because Doug's not as visible as he was in his prime. With no recognition, there's no laughter. So I'll probably work on a Corey Pavin and a John Daly and a Paul Azinger. But it won't be quite the same.

The truth is, I started doing impersonations because I idolized all the guys that I was mimicking. And as much as I respect all the top current players, I don't have the same feeling for them as I do the older players. It's just not healthy to idolize guys you're trying to beat every week.

CHAPTER 6

Major Memories

SPEAKING OF TRYING to beat guys—I hope to rectify one glaring disappointment in my professional career before I'm done playing: I want to win a major championship. You just can't overemphasize the importance of a major to a golfer's career.

No matter what a player does the rest of his playing days, he will be most remembered for winning major titles. The best recent example is Tom Kite. He was the all-time leading money-winner on Tour, with sixteen titles, a marvelous record in the Ryder Cup matches, and probably the best record of consistently excellent play in the last two decades, yet when his record was discussed he always had to hear, "Yeah, but . . ."

That all changed when he won the U.S. Open at Pebble Beach in 1992. Any implied asterisks after Kite's name were erased with that victory.

The importance of a major championship is even more pronounced if a popular player wins just one. Think of broadcasters such as Dave Marr and Ken Venturi. Every

time those guys are introduced, it's as if their names con-
tained five or six words instead of just two. It's never
simply Dave Marr. It's always former-PGA-champion
Dave Marr, or former-U.S. Open-champion Ken Venturi.
Instantly, a hyphenated adjective appears in front of their
name, giving them a credibility unquestioned by the golf-
ing public.

I've never won any of the top four tournaments, but I
have had opportunities, and I'd like to share with you the
feeling of seeing your name at the top of a major cham-
pionship leaderboard, and the mental challenge of dealing
with that pressure.

In hindsight, perhaps my best-ever chance to win a
major was at the 1983 PGA at Riviera Country Club in Los
Angeles. Broadcasters always talk about going out early
Sunday, posting a low number, and letting the boys shoot
at it. Johnny Miller came from nowhere to win with a
final-round 63 in the 1973 U.S. Open at Oakmont, and
Gary Player's final-round 64 at Augusta in 1978 snatched
the Masters from a trio of players. That's what I had a
chance to do at Riviera—fire early and hope the rest
would fall back.

I began the last round of the PGA eight shots behind
third-round leader Hal Sutton, and by the time I teed off
on the last hole, I was in need of just one more birdie to
have an excellent chance of winning the tournament. But
let me back up to explain how I got there.

Going into that week, I was hitting the ball terribly and
really struggling with my swing. My friend Jim Hardy, an
excellent instructor who played the Tour in the 1970s, was
watching me on the driving range after the final practice
round on Wednesday, and he said, "Peter, you have the
club shut at the top and you are laid off. I want you to try

to get the club more square, so next week when you're at home, try cupping your left wrist at the top of your back-swing."

I made an exaggerated swing and said, "Like this?"

"That's perfect," he said.

Well, as with all major swing changes, it felt horrible, and when I tried the new swing I pushed the shot about 100 yards to the right.

Jim laughed and said, "Believe it or not, that looks better."

I continued with it and hit about ten more foul balls into the right-field bleachers, places even the peanut-vendor wouldn't go near, and Jim said, "Okay, put that thought away and work on it next week when you get home."

I said, "Don't worry. I can get this by tomorrow." Now, maybe that's one of the things that sets Tour players apart from other golfers. I don't want to sound cocky here, but we sometimes feel we're invincible. I thought, hey, I need to make a change, so I'll do it right now and I'll be fine by tomorrow. I took a totally positive attitude. Rather than worrying about how high the rough was that week, or that if I hit any crooked balls off the fairway I'd just have to wedge it out, I felt that I could incorporate the change overnight and then hit the ball well all week. Hardy proba-bly went to dinner that night regretting ever opening his mouth, but I had made a decision: I would go with the new swing.

The first two rounds, I hit it pretty well and shot 73–68, but I was ten back of Sutton, who opened with a PGA record 65–66. I started the third round by knocking my tee shot out of bounds on the first hole, which is easy to do at Riviera, but still shot a respectable 70. After 54 holes, I was in about twentieth place, just hoping to move up in the last

round and get the benefits that come with a high finish in a major, such as an exemption into the Masters, the Open, and the PGA.

In Sunday's final round, I birdied the second, fourth, and eighth holes, and thought, hey, this is getting interesting. But I especially remember the ninth. Jack Lemmon was walking with me; when Jack's there he keeps a very low profile, but I always know he's there. It comforts me to know my partner is watching and making sure I do everything right. On the ninth, I had driven into the right rough, but it was the best angle of approach because that green angles from short right to long left, and I had a straight shot at the pin. I hit an eight-iron, and although there were a couple hundred people around, Lemmon was right behind me and he has that distinctive voice. The only thing I heard when the ball was in the air was Jack saying, "Yes."

The shot, as we say, was hit so straight at the flag that I had to lean sideways to follow the flight of the ball, and I remember perfectly hearing Lemmon, with his cigarillo hanging from his lower lip, going "Yes."

I made the putt to complete a front nine of 31, then ran off three more birdies in a row on 10, 11, and 12 to go seven under for the day. When you start bunching birdies in the last round of a major championship, you leave skid marks all over the fairways from passing people so quickly. At that point I was definitely in the chase, although Jack Nicklaus was also putting on one of his patented last-round charges.

The spell finally broke when I bogied number 13, but I birdied the par-five 17th to return to seven under par for the day and nine under for the tournament. Sutton, I believe, was at minus ten, with about five holes to play. A

birdie at the last hole would tie me for the lead, or even give me a chance to win if Hal stumbled coming home.

As I walked to the 18th tee, however, I let myself down and failed to think like a champion. Rather than roll up my sleeves and tell myself I *was* going to birdie the hole to win, I thought about what I *didn't* want to do. I didn't want to make a bogey. As a result, I made a very scared swing with the driver, and blocked it slightly into the right rough. That's Deadsville on 18 at Riviera, because huge eucalyptus trees block the entrance to the green. I had to wedge back to the fairway, then hit another wedge, which rolled to the back of the green. I two-putted for a bogey.

I had shot a 65 in the last round of a major championship, and ended up at third alone, two behind Sutton and one behind Nicklaus, who closed with a 66. It was my best showing ever in one of golf's four biggest events.

So did I feel great? Hardly. I was as disappointed as I'd ever been, because I hadn't *thought* like a champion at a critical moment. I had tried to protect my position instead of throwing caution to the wind and going after the victory like I deserved it. It's just so hard to get into position to win a major title, that when you're right there and you fail, it's a horrible letdown.

Three years later, I had another chance to win the PGA, but what happened to me that week is long forgotten behind the dramatics that took place between my playing partners in the final threesome.

The 1986 PGA at Inverness Country Club in Toledo, Ohio, will probably be seen through the rear-view mirror of history as the beginning of the Greg Norman Curse. But

at the time, it looked like the blooming of the Greg Norman Era.

That was the year that Norman "won" what was called the 54-hole Slam, which meant that he led all four majors after 54 holes. He had led the Masters and U.S. Open, only to be overtaken by two great players, at Augusta by Jack Nicklaus, and at the Open by Raymond Floyd. Coincidentally, both players were the oldest to win those championships at the time of their victories.

If Greg had self-doubts because of the lost leads, they seemed to disappear with his victory in the British Open at Turnberry, in which a marvelous final round stretched a three-round one-stroke margin into a five-shot triumph.

So when Norman finished three rounds of the 1986 PGA in eight under par for a commanding lead, most armchair observers were predicting his second major victory in as many months. I certainly wouldn't have bet against Greg as I teed off with him and Bob Tway in the final threesome on Sunday. Tway was in second place, four shots back, and I was six back at two-under-par 208.

I don't recall the exact scores, but none of us burned up the front nine and Norman still had at least a four-shot lead after 63 holes. He was hitting the ball so well, though, that I expected him to go on a birdie tear any minute. I remember telling my caddie Mike that the only one who could beat Greg Norman was Greg Norman. If one thing was bugging Greg that week, it was how much backspin he was putting on the ball. He would land his iron shots by the hole, and they would just zip back off the front of the greens.

He was using a new balata ball noted for exceptional spin, I remember, and with the hard, fast greens at Inverness, the only way he could keep his iron shots close was

to fly them to the backs of the greens, which is a dangerous proposition.

On the 10th hole, a short par-four that is played with a one-iron and a wedge, Greg's wedge shot landed about six inches from the cup and sucked back to the front of the green and into the second cut of fringe. He failed to get it up and down and made bogey. The backspin in that case cost him two shots, from a birdie to a bogey.

Then on the 11th, he drove the ball into a divot, couldn't get to the ball cleanly, and left his second shot in a bunker. He could do no better than a double-bogey. He'd lost three shots of a four-shot lead, and Tway and I were back in the tournament. We were both just one or two shots behind at that point. Although I felt positive about my own game, I still thought Greg had his game under control because he was striking the ball so well. He was driving it long and straight, his irons were right at the flag, and he was putting well. The bad holes at 10 and 11 had not affected his demeanor at all.

Greg and I talked a lot during that round, because we're good friends, and I saw nothing in his behavior that indicated he wasn't going to win the golf tournament.

As it happened, though, Tway made a birdie late in the back nine, and by the time we reached the 18th hole, he had pulled even with Norman. I had made a string of pars and was still three shots back. I knew it would take a miracle for me to catch them, and while a miracle did indeed occur at the 72nd hole, it was reserved for another member of our threesome.

The last hole at Inverness is a short par-four, maybe 330 yards, and all of us hit irons off the tee. Greg and I were perfect in the middle of the fairway, and Bob was in the right rough, which was dead on that hole, because the pin

was cut on the front and there was no way for him to get to it. He had no chance to keep the ball on the green, so he did the next best thing, which was to put it in the front bunker.

I sensed nothing but confidence from Greg as he hit his second shot. He hit a wedge perfectly, about six feet from the hole, but once again the rotation got him. The ball zipped back into the front fringe, just as it had done on the 10th hole.

Now, although I can't put spin on the ball like Greg, I didn't want to do the same thing, so I took a nine-iron and hit the shot with more of a half-speed swing, which automatically takes some of the rotation off the ball. I tried not to pinch it, but just to make nice contact. The ball landed twelve feet from the pin, and stopped on a dime.

I needed to make my putt, and Norman and Tway had to make sixes, for me to get in a playoff, and while I never wish bad luck on another golfer—I believe it pisses off the gods of golf—I'll admit I was concocting a scenario for exactly that as I walked up to the green. Anyone would do the same. Tway's bunker shot was to a downhill pin, and if he got too aggressive he could either leave it in the bunker, or blast it long and three-putt the slick green.

Norman was far less likely to make a six, but you never know how the ball is going to come out of that long grass, and a poor chip could lead to a three-putt. Then if I rolled in the birdie, we would all be tied at 279. As far-fetched as that sequence of events seems, it's the kind of thought process that goes through every player's mind when he or she still has a remote chance to win.

When I got to the green, I marked my ball, and noticed that Greg had a very poor lie, and Bob had a difficult bunker shot, although his lie was all right. I still thought, Maybe, just maybe.

Tway didn't take long to hit his bunker shot, and when it first came out I thought it was a good one that would roll probably ten feet past. Then it looked good enough to make no worse than five, which meant my chances were done. And then his ball hit the pin and disappeared.

I looked at Bob, who was in total shock for an instant, then he started jumping up and down in the bunker, pumping his fists in the air. Then I looked at Greg, and to his credit, his expression didn't change a bit. He maintained the same straight face he'd had walking to the green, and went about the business of studying his chip shot.

Remember, in 1986, Greg Norman had no sense of being cursed. Tway's miracle preceded those of Larry Mize at Augusta and Robert Gamez at Bay Hill and David Frost at New Orleans, and even the great playoff comeback of Mark Calcavecchia at the British Open.

Although many fans watching at home surely realized what Tway's shot meant, that he had holed a shot from off the green on the last hole to win a major championship (a feat that happens about once every quarter of a century, or at least until Larry Mize did it at Augusta eight months later), what it meant to me was that my chance of winning the PGA was over.

I never once thought that Greg wasn't going to win that tournament until Tway's shot went in the hole. And if it hadn't gone in, and Greg had won at Inverness, I honestly believe that he would have totally dominated golf for about the next five years. That bunker shot set off a chain of unbelievable events, almost as though they were conjured up in a black pot of magical spells and thrown on Greg as a curse. Certainly no player in the history of golf has had to bite his lip harder than Greg Norman at the odd twists of fate.

Because I'm a friend of Greg's, I've been asked several

times what those setbacks have done to him as a person. I feel qualified to answer the question because I've been with him after all five of those tournaments—the four-holed shots and the playoff loss at the British Open—and not once did I see him treat anybody with disrespect or unkindness, but, rather, with the compassion of a true gentleman. But I do believe those losses have made Greg question his own game, and his immense talent, and that is a shame.

Greg Norman is good for golf, because he plays with such bravado. He's confident and flamboyant, and he hits shots that other players can't hit. He's also a little like the great Walter Hagen, in that he can lead the golf tournament, throw the party that night and entertain everybody till the wee hours, then wake up the next day and beat your brains out.

Who knows how long his great run in the late 1980s would have gone had he not suffered those gut-wrenching losses?

But because he is a tough competitor, I believe we'll see Greg Norman win many more championships, and more majors as well, before he takes off his spikes for the last time.

One recent major championship memory has absolutely nothing to do with my performance in the tournament, but in an unlikely way it does speak to the popularity of golf.

Several friends meet us at the Masters each year, people from different parts of the country that I've befriended from various pro-ams, and I jokingly call them the Masters Mafia. We have an annual barbecue with them on the Tuesday before the tournament, and dinner on Sunday afterwards. Among this group are Peter and Jean Hum-

phrey, and Dick Bruno from New London, Connecticut. Now, Dick is a bachelor and a fun-loving guy, who is not averse to doing a little "mingling" when he's in Augusta.

On the Wednesday night before the opening round last year, Dick found himself at a popular watering hole called T-Bones, where he managed to introduce himself to two attractive women. They accepted his invitation to buy them dinner. Feeling no pain, Dick was throwing more pitches than Roger Clemens, hoping, of course, that his witty repartee would lure one or both of them into romance, at least for the night. He told them he was a friend of mine and that he would be at the tournament all week. He then gave them the name of his hotel and the room number, just in case they were curious.

Well, they apparently had other plans, because they thanked him for the dinner and excused themselves. Dick was satisfied he'd given it his best shot, so he cabbed it back to his hotel and crashed. About midnight, as he was in a deep sleep dreaming of what might have been, Dick was awakened by a knock on his door. He stumbled out of bed and opened it to find his two lovely dinner companions smiling brightly and asking if they could come in. Dick said they looked even better in the shadowy light of his room than they had in the brightly lit restaurant, but then don't we all?

One of them sat on the bed with him and started to express her gratitude for the wonderful dinner, and the other coyly stood over by the dresser, leafing through the Spectravision guide. She said she was looking for a good adult movie they might watch. Dick was thinking, Holy Moly, how good does it get? I'm here at the Masters with two gorgeous women who are absolutely crazy about me.

About then, the woman who was standing said to Dick, "Look, I'm parked in a handicapped zone and if we're

going to stay a while I better move my car." She quickly left the room. The woman on the bed with Dick continued her friendly ways, then suddenly sat up and said, "I left my purse in the car. Let me go get it and I'll be right back."

When she left, Dick quickly brushed his teeth and flossed and gargled and performed other hygienically-proper procedures, then returned to bed awaiting the fulfillment of all his fantasies.

After a few minutes, he started to get nervous. He couldn't understand what was taking them so long. Then he realized he had over a thousand dollars in his wallet, which was on the dresser. He jumped up and checked it. The money was all there, as were all his credit cards.

Then he thought of his car—but, no, the keys were right where he'd left them.

Another ten minutes passed. Finally, the light flashed on. His Masters tournament badge—probably the most cherished ticket in all of sports—had been placed on a side table. It was gone!

Poor Dick was down and out in Augusta: trick-rolled for his Masters badge, with no way to replace it.

But Dick's luck wasn't all bad that night. When he realized his dilemma, he went next door and awakened Eddy Ellis, a business associate of mine who had come down from Portland. As Eddy listened to Dick's tale of woe, he nonchalantly said, "Don't worry about it, Dick. I just happened to stumble onto an extra ticket today. You can have it."

Postscript: Dick gave me permission to tell this story in the hope that other die-hard male golf fans will use better judgment. He sums it up this way. "In Augusta, in April, the Masters is all anyone cares about. Money, cars, and sex aren't even a close second."

CHAPTER 7

The Human Hinge

I'VE MENTIONED JACK LEMMON enough times by now that I suppose I ought to introduce him properly.

My first personal contact with Jack was a phone call. I was home in Portland and I happened to be on the throne, reading the sports page, which is one of my favorite things to do. Anyway, the phone rang and Jan answered it and this voice said, "I understand Peter Jacobsen needs a golf lesson and I'm going to give it to him."

Jan said, "Who *is* this?" because her first thought was that it was a crank call.

The voice said, "It's the Human Hinge."

I yelled from the toilet, "Who is it?"

Jan said, "Honey, it's for you. He says it's the Human Hinge."

"Who the hell's that?" I grumbled, and went back to studying batting averages for the Portland Beavers.

Jan asked, "Could I have a name, please?"

The voice said, "It's Jack Lemmon."

So Jan covered the phone and said, in an urgent tone, "It's Jack Lemmon!"

Well, I didn't even sit up. I just kind of slid off the pot and did the turkey-trot over to the phone—the sort of thing you can do in your own home, even if the kids do look at you funny—and sure enough it was Jack Lemmon. I knew the voice immediately. And he said, "I understand you need a partner in the Crosby, someone who can carry you around, and I'm looking for one. Let's play together."

It turns out my accountant, George Mack, had been paired with Lemmon in a pro-am and told him I was a young player on the Tour and that I liked to have fun in pro-ams. Lemmon's the same way. As hard as Jack tries to win, he never forgets that the real purpose is to have fun, and that's what we've done, ever since 1983. It's been a great marriage in every respect. I know that Lemmon's missed the pro-am cut in that tournament every year since the Emancipation Proclamation—which includes the ten years he's been my partner—but we've had such a blast together it doesn't really matter.

Mark my words, however. Not only do I believe we will make the cut one year, I believe we'll win the doggone thing. I really do. In fact, I advise all readers of this book to rush to Las Vegas and see if you can get a future bet on us at about ten million to one.

Just how bad does Lemmon want to make the cut at Pebble? Well, Jack has said he'd trade both his Oscars if that happened, but I think he's lying. He'd only give up one.

I have so many stories about Lemmon at the Crosby (now called the AT&T Pebble Beach National Pro-Am), that it's hard to choose only a few.

One that stands out, because it was on national TV, was the Infamous Hanging Ice Plant Wedge Shot at the 16th hole at Cypress Point, the most notorious golf hole in the

world. But I have to offer some preliminaries to that moment, because the whole day was a riot.

Jack and I were paired with Greg Norman and Clint Eastwood, so naturally we had a huge gallery and there were a lot of cameras clicking away at Clint and Jack. Every now and then, Greg and I would jump into the picture just so we wouldn't develop an inferiority complex. Anyway, we were on the 11th tee at Cypress, which is a congestion point, and play was backed up by a couple of groups. The foursome right in front of us included Jack Nicklaus, Dee Keaton, Hale Irwin, and President Ford—with Secret Service agents in tow—and, of course, there were paramedics and ambulances nearby in case the former Commander-in-Chief shanked any one-irons and flattened a few galleryites (just kidding, Mr. President).

Now, what many people don't know is that Greg Norman is a real prankster. He's very serious about his golf game, but he loves to have fun and play practical jokes.

So we were in this bottleneck, with about a fifteen-minute wait, and Lemmon snuck off in the direction of the Port-a-Potty. Greg and Clint and I all looked at one another, and I made a throwing motion. My companions enthusiastically nodded. We crept up to the crapper, which was constructed from hard plastic, and we all went into our best Nolan Ryan windups and threw our golf balls at the can as hard as we could.

Bang! Bang! Bang! It sounded like three pistol shots. I half-expected the Secret Service agents to draw their sidearms. But instead there was dead silence, and the next thing we saw was a sweet little lady, who'd peeked her head out the door and asked, "Is it safe to come out now?" She looked like she'd seen a ghost.

Then Lemmon walked around from behind the can, where he'd been standing talking to a friend, and said,

"What the hell are you guys doing?" The three of us just stood there, like cats with cream on our whiskers. We were all embarrassed, but there wasn't much to say. So Jack went over to the lady, put his arm around her, and apologized for his choice in golfing partners, while the Three Stooges shuffled back to the tee, stifling hysteria. It wasn't as if we could pretend it was an accident. At least a thousand people standing nearby had seen us do it, and most of them hadn't known we thought Lemmon was the one inside. Oh, well.

That poor lady probably needed professional counseling before she was able to use outdoor plumbing again.

By the time we reached the 16th, there had been some serious male-bonding going on. As usual, there was another big backup on the tee, which affords a player plenty of time to appreciate the beauty of the hole, and just how big the Pacific Ocean really is. As a golfer standing on that tee, you see a couple of measly acres of grass and a million miles of water. As Bill Murray said during play last year, "And that's just the *top* of it."

The wind always howls, usually dead in your face, and rumor has it the seals down on the rocks below raise one flipper to call for a fair catch on all the balls dropping over the cliff. In other words, it's scary as hell.

The carry to the green is 215 yards, and depending on the direction of the wind, the pros will normally use a driver, three-wood, or one-iron to reach it. Because on most days Jack can't carry it to the green, he normally plays to an inlet of grass to the left, and then hits a wedge for his second shot. On this day the wind was so strong in our faces that none of us went for the green. Norman and Eastwood and I laid up successfully to the left.

Then it was time for the Human Hinge to show his stuff. Jack took a long pull on his cigarillo, blew the smoke into the air to test the wind, then made a horrible pass at the

ball. I've seen better swings on a condemned playground. He hit a fluttering quail which barely trickled off the grass and got hung up in the ice plant on the edge of the cliff. It was a mere sixty-foot dropoff to the rocks and crashing surf below.

I assumed Jack would just shake his pom-poms and cheer us on for the rest of the hole, but Eastwood, who sprinkles testosterone on his Wheaties every morning, said "C'mon, Jack, you can't just leave the son of a bitch sittin' there flippin' you off. You've got to play that mother."

Keep in mind there were two groups on the tee watching us, another three or four thousand in the gallery, and about twenty million more on television. Obviously, there was some male ego on the line here. So Lemmon swallowed hard and grabbed his infamous L-Wedge, designed for lob shots. When he started to crawl over the edge, I got nervous. Let me emphasize: this was a dangerous situation. We're talking ice plant growing out of the edge of a rock wall with certain death below. And here went one of the world's greatest actors to hit it.

With trepidation in my voice, I said, "Partner, Hollywood and the movie-going public need you for your next film far more than I need you to make a nine on this hole."

But Eastwood didn't want to hear it. He said, "C'mon, Jack, I'll help you."

At this point, Lemmon didn't need coercing. With a gleam in his eye and a mischievous smile, he started his climb down the cliff. Clint instinctively grabbed Jack by the belt and back of his pants. I grabbed Eastwood's arm, Norman grabbed mine, and his caddy Pete Bender grabbed his. Instantly, we had formed a human chain of safety. Talk about safe sex, well, this was safe golf. I don't think any of us was wearing a rubber at the time, but it might not have been a bad idea.

Although what we were doing broke about six rules of golf, that wasn't our primary concern at the time. After a few tense moments, Lemmon chopped at the ball and it miraculously popped out in the fairway. We all crawled back up to safer terrain, laughing our butts off, while the crowd gave Jack a huge ovation. I remember Lemmon pumping his fist in the air, and the rest of us giving him high-fives like he'd just won an Olympic gold medal.

Jack now had about 70 yards to the hole, and his adrenal glands were pumping wide open as the world pulled for him to complete this miraculous recovery. He took a couple of waggles, drew the wedge back slowly . . . and shanked it into the ocean.

Which is where the damn ball belonged in the first place, if you really think about it.

There's another story about Lemmon and an outhouse that I have to tell, although Jack will want to kill me for including it. He'll say something like, "Gee, Peter, thanks for all the mentions in your book. It's just unfortunate that every story you told about me took place on or near the growler."

This one occurred during a pro-am at the Fred Meyer Challenge. Jack was playing with me and he hit his drive in the trees on the 11th hole at Portland Golf Club. As he went in there to hit it, he told me he had to make a pit stop. So he cracked a five-wood out of the trees, it hit a tree limb and bounced back out into the fairway, and all the people applauded. Lemmon then handed the club to his caddy and politely got in line behind about eight people at the Port-a-John.

A television camera had been focused on the play, and the funny thing was that all the people lined up there had

just applauded this recovery shot by an Academy Award winner, yet nobody would give him cuts in the line so he could do his business and rejoin his foursome.

Finally, my wife's Aunt Eileen, who recognized the situation, said, "Jack, you can cut in here and get back to your group." Jack thanked her for being so thoughtful and went in and started to drop trow. Just then, Aunt Eileen pulled the door open and said, "Oh, Jack. Can I get a picture?"

So Jack, holding his pants up, stuck his head out like a dog peering out the side window of a station wagon, and gave her a polite, albeit beleaguered smile. One of the broadcasters, who didn't realize his mike was open, said on the air, "I think she just snapped a picture of his Willy."

I'll bet I've watched the tape of that twenty times, and it cracks me up every time.

Jack Lemmon takes a lot of ridicule as a golfer, and he is as gracious about it as he is with all the honors that have come his way. It's not easy to smile when you get publicly humiliated each year in a golf tournament that means as much to you as the AT&T does to Jack. Lemmon has said many times that he would feel less anxiety opening on Broadway in *Hamlet* with no rehearsals than he feels hitting that first tee shot at Pebble Beach.

Every year, it seems, the television cameras catch him in horrible predicaments. They must use the same crew to shoot *Emergency* and *Rescue 911*. I'm convinced CBS's cameramen wait to find Lemmon in trouble before they put him on the air. It's sort of sadistic, but it's probably good for ratings.

Jack's wife Felicia once put together a "low-light" reel of all the bad shots he'd hit in the AT&T, and it ran longer

than *Dances with Wolves*. Several years ago, Byron Nelson analyzed Jack's swing for the television audience and found eight things wrong with it. They ran the tape backwards and forwards, over and over. Bing Crosby was in the booth with Byron and he said, "My God, he looks like he's basting a chicken." And Phil Harris said, "This guy's been in more bunkers than Eva Braun."

One time, it took Jack eleven strokes to reach the 18th green at Pebble Beach. He'd had intimate contact with all the elements—water, sand, earth, wind, and fire—by the time he got there, but he refused to pick up. He eventually ended up with a thirty-foot putt for a 12, so, of course, he plumb-bobbed it. He then looked back over his shoulder at his caddy, and said, "Which way does it break?"

And the caddy said, "Who cares?"

But nobody ever laughs *at* Jack, they always laugh *with* him, because he's such a warm, wonderful person. And if I don't ease up on him, he'll dump me next year and team up with Freddie Couples.

CHAPTER 8

The Man on the Bag

ONE OF THE RUNNING JOKES on the Tour is to refer to the player/caddy relationship as a "marriage." When Bruce Edwards quit working for Greg Norman in 1992 and went back to Tom Watson, they kidded them about getting divorced.

This analogy is stretching it a bit. While having a compatible caddy is important to any player, it doesn't hold a candle to having a good marriage. And if each time a player and caddy split up was actually a divorce, most Tour players would have been "married" more times than Zsa Zsa and Liz combined.

I've been extremely fortunate in both respects. I've had the same great wife since 1976, and the same great caddy since 1978. My caddy, Mike Cowan, certainly knows that my wife is vastly more important to me than he is, and a whole lot better-looking. That said, however, I also feel I've got the best caddy in the business: he's extremely professional, he's never been late for work one day in the last fifteen years, he's a good player himself who under-

stands the physical and mental aspects of the game, and he knows exactly how to handle me.

I met Mike at Silverado Country Club in Napa, California, in the fall of 1977. This guy who looked like a cross between Grizzly Adams and Jerry Garcia introduced himself to me and said he was impressed with my game. I saw Mike a few other times, but he didn't start packing for me until the Heritage Classic the next spring. He was sort of rolling the dice with me because I was an unproven second-year player at the time, and had won only twelve grand as a rookie. But Mike saw potential in me, and he had qualities I liked. The main one was that he was very quiet. One way I release nervous energy on the course is to be a motor-mouth, and the last thing I needed was Gabby Hayes on the bag.

I had a brief taste of caddying myself when I was in college, so I understood firsthand the aspects of the job. Jan's brother, Mike Davis, had played the Tour in 1974 and 1975, and I'd caddied for him in a few West Coast tournaments. It had given me a valuable first peek into the world of professional golf.

A better comparison of the caddy/player relationship would be that of an executive assistant to a businessman. The employer wants things done a certain way, and it's his assistant's job to see that those idiosyncrasies are catered to, without having to ask a lot of questions.

Every golfer has his own quirks, and it's the caddy's job to adapt to them. Some players want a total yardage to the pin read to them, such as 176 yards. Others want it broken down, such as 138 to the front, 15 to the swale, and another 23 to the pin. Players frequently want a yardage behind the hole, also, so they'll know how much room they have before the ball goes bounding off into the great unknown.

The famous streaker incident at the 1985 British Open. Poor Sandy Lyle had to take second billing—he only won the tournament.

Undress of a different sort: Curtis Strange and I sell off his jeans at the 1989 Fred Meyer Challenge charity auction. Greg Norman seems to be considering a bid himself. (*Photo by Kristin Finnegan*)

The Infamous Hanging Ice Plant Wedge Shot at Pebble Beach. From right to left, Jack Lemmon, Clint Eastwood, me, Greg Norman, and Greg's caddy Pete Bender.
(*Photo by Dave Button*)

The Human Hinge: Jack Lemmon
(*Photo by Tom Treick*)

Weird bulges and strange tan lines: my *Golf* magazine center-fold. Keith Fergus, Greg Norman, Payne Stewart and Rex Caldwell also got photographed—but I was the lucky one with staples in my navel. (*Photograph © 1983 by Jules Alexander*)

My best times as a golfer have been partnering with Arnold Palmer. (*Photo by Mike Lloyd*)

Peter's impressions: Counter-clockwise from above, as Johnny Miller; as Tom Kite; preparing myself for Craig Stadler; Stadler in full swing. (*Photos by Tom Treick*)

There's always fun at The Fred Meyer Challenge. Left to right, Mark Calcavecchia, Curtis Strange, Andy Bean, me, Bob Tway and Arnold Palmer. (*Photo by Tom Treick*)

From left to right, Mark Lye, Payne Stewart and me—the one, the only, Jake Trout and the Flounders. Huey Lewis, eat your heart out. (*Photo by Kristin Finnegan*)

Michael Jordan's reaction to my comment that I will be playing in the NBA someday. (*Photo by Chick Natella*)

Bill Murray and me getting psychologically prepared for the Western Open Celebrity Shoot-Out. Somehow it worked. (*Courtesy of Peter de Young and the Western Open*)

With Bob Hope after winning the 1990 Bob Hope Chrysler Classic. (*Photograph copyright © 1990 by Mitchell Haddad*)

Mike Cowan, the best caddy in the business.
(*Photograph copyright © 1990 by Mitchell Haddad*)

With my dad, Erling.

The Jacobsens. Left to right: Kristen, Jan, Amy, Mickey and me.

The one absolute imperative for caddies is to be able to add properly. Those who played hooky in the second grade had better pack a pocket-calculator. One bad shot can ruin a tournament or even turn an entire year around, so giving an incorrect yardage is a capital offense for a caddy. It's also important for him to be a clock-watcher, and to keep his player constantly updated on the time, to make sure the golfer's pre-round regimen of practice and other matters can be completed comfortably before the starting time.

In my rookie year, at the Southern Open in Columbus, Georgia, I was on the driving range warming up before the first round. I had told my caddy to keep an eye on the first tee—which is over a hill and out of sight of the range—so he could inform me when the group ahead of us had teed off. Well, he wasn't paying close attention and when I walked up to the tee, my playing partners had already hit and were walking down the fairway. I was slapped with a two-stroke penalty, and ended up missing the cut by one. My caddy was slapped with his walking papers.

As I said, Mike works well for me primarily because of his personality. I don't want a cheerleader out there. I want a reliable guy who understands how I want to manage my time, has a good feel for the mental side of the game, and will put up with my stream-of-consciousness ramblings as we're walking along. The fact that Mike knows my golf swing, and can help spot flaws if I ask him to, is strictly a bonus.

Mike and I have a calm, professional relationship, but there are those, such as Lee Trevino and his long-time caddy Herman Mitchell, who succeed as partners despite an occasional eruption. They lob a lot of barbs back and forth, which are fun to hear, but this only gets Lee revved

up, which makes him play better. I've seen Lee hit a couple bad shots and say, "Herman, you can't add." And Herman will say, "Well, you can't play golf."

Lee likes to tell his amateur partners to play their putts to break toward the side of the hole where Herman is standing, because he's so big the green will slope toward him. The bottom line is that Lee wins everything in sight, and Herman's so famous he has his own endorsements. Theirs is an unconventional but highly successful business partnership.

The best Tour caddies, like the best players, work their tails off. Contrary to the perception that the Tour player's life is a fairly cushy berth, there're thousands of hours of hard work behind every victory. The public sees the pro with the winner's check and the crystal trophy and the devoted wife smiling up at him and thinks, "Tough life." But they don't see the long hours of preparation and, in some cases, years of frustration and disappointment, that led up to that moment.

When Mike and I are on the road, it's a seven-day work week, with us usually arriving at the course about eight or nine A.M. and leaving at six or seven in the evening. A lot of times there's a Monday outing, followed by a Tuesday practice round and a Merrill Lynch Shoot-Out, and another pro-am on Wednesday. All of these functions are preceded by a bucket of balls and a session of chipping and putting, and then the same after the round. Squeezed in between are news interviews and autographs to sign and people to talk to.

Mike is always with me when I'm practicing, and he's on standby when I'm doing the other stuff, because as soon as it's over we'll practice some more.

Thursday through Sunday, there's less of the outside activities, but that's when the mental stress of competition

begins. I don't hit a lot of practice balls during the tournament, unless I'm struggling with my swing or feel a certain part of my game needs work, but I will spend a lot of time fine-tuning my short game. Mike can be helpful there by watching me practice, and keeping his eye on certain keys I work on from week to week. He also helps keep me focused, because I have been known to get caught up in high jinks with other players.

Once at Westchester, Mike and I had a flare-up over something that was my fault, but the story tells you a little about both of us.

The driving range was being used for parking, so we were using a fairway on the other course to practice. I had my own practice balls, which Mike was shagging for me. He had the flu, but he hadn't said anything about it. Anyway, a bunch of us had hit a lot of balls and our session had kind of deteriorated to where everybody was hitting trick shots. I started doing my swing impersonations, and we were all laughing. Those kinds of relaxed times when you can enjoy your friendships with the other players don't happen enough, and I remember having a great time. I was hitting Johnny Miller six-irons and Miller Barber wedge shots, and we were all yukking it up.

Suddenly, Mike walked in from the landing area and got right up in my face and said, "Look, are you gonna practice or are you gonna screw around, because if you're not gonna work, I've got better things to do!" Then he turned around and stomped back out. I could tell he wasn't feeling well because his breath melted my visor.

Needless to say, I got back to serious practicing, and although I got on him later about how he had handled the situation, he was right. If I was going to screw around, it should have been on my own time. But that's another reason why Mike is good for me. Whereas I have a tend-

ency to get carried away with having fun or telling jokes, Mike never lets me forget why we're there—and that is to play good golf and to win tournaments.

As I said, Mike's a good player in his own right, a solid five-handicap. He has such a simple, effective swing that he can drop the bag after caddying three or four hours, take one practice swing, and flush a three-iron right at the flag. That's not easy under any circumstances, much less wearing a jumpsuit or a caddy bib!

He also has a little competitive fire. We like to do something that's strictly against Tour regulations, but is always entertaining. In practice rounds, Mike often challenges one of the pros in our group to a one-hole match for a few bucks. We usually choose a par-three, where he can hit one quick shot off the tee, putt a couple times, and then pretend that it never happened, so I won't get fined. (As a two-time member of the Tour Policy Board, I'll probably get fined just for telling the story here.)

Mike absolutely owns Curtis Strange in these one-hole bets. I don't think he's ever lost to Curtis. And overall, against guys like D. A. Weibring and Dave Eichelberger and Tom Byrum, I'd say he's won about 75 percent of the time.

A couple of times, we've had fun with our pro-am team. In 1991 at Bay Hill, a daughter of one of my amateurs was caddying for her dad, and she was a college golfer. I really wanted to see her hit the ball, so on the 18th hole, knowing her dad and the other amateurs wouldn't mind, I asked her to play Mike in a one-hole match. I winked at Mike and said, "Five dollars says she beats you."

She used her dad's clubs, and I caddied for her. Mike, of course, had to caddy for himself. Now, in 1990, the last

hole at Bay Hill was rated as the most difficult hole on the Tour, but she got right up by the green in two and made a bogey. Meanwhile, my faithful caddy, after packing all day, took out my driver, ripped it long down the right side, then froze a three-iron in there about twelve feet. The crowd went nuts and I lost five bucks.

My amateurs always like Mike, anyway, because he's willing to give them yardages and read putts for them. Mike appreciates, as I do, that pro-am day in the various cities is the biggest day of the year for local amateur golfers. It's their one chance to play with the big boys. However, it never fails that some high-handicapper in the group, a guy who has no idea how far he hits the various clubs anyway, will start really getting into the yardage thing. Mike will be walking off a yardage for me on a par-five, for instance, pacing forward from a 297 sprinkler, and the amateur will be back just ahead of the ladies' tee somewhere, and say, "How much have I got, Mike?"

Mike will patiently pace back to the guy's ball and say, "Well, you've got three-forty-one to the front and another twelve to the pin. Three-fifty-three, Mr. Oglethorp."

And Mr. Oglethorp will say, "So what do you think?"

Of course, Mike is thinking, You can't get there by bus, pal, but he'll say, patiently, "I think it's a three-wood."

The real art of it is to give the guy the yardage without ever cracking a smile. Three-forty-one to the front, and another twelve to the pin. I love that.

The guys who caddy for consistent money-winners—players who are always in the solid six-figures in annual prize money—can make a good living. Five or six of them have made over $100,000 in a given year, plus some endorse-

ment money for wearing a certain type of visor. Joe LaCava has admitted that he earned over $200,000 in eleven months caddying for Fred Couples when Fred was winning everything in sight, and Bruce Edwards has had several years in which he's earned in the six-figures.

I pay Mike eight hundred dollars a week, plus eight percent of what I make, so if I win $15,000, he'll make $2,000 for the week. If I win the tournament, he gets ten percent. (I hope that jibes with the figures Mike turned into the IRS. If not, I guess I'll see him again the next time they hold the San Quentin Invitational.)

Anyway, Mike's happy with the arrangement, and that's important, because I need to know there are at least two people at each tournament pulling for me—him and me.

While I'm thinking about it, let me say I feel the Tour has always treated caddies miserably, and there's no excuse for it. Until recently, caddies never had a good place to eat at the tournaments. Players could take relatives or friends who were caddying for them on a particular week into the buffet lines, but regular Tour caddies were relegated to the barnyard. Lately, Joe Grillo, a former caddy nicknamed Gypsy, has taken to driving a big chuckwagon from stop to stop, and preparing hot food for the caddies. It's called the Caddy Wagon, and I find myself eating there about three times a week. It's a great retreat from the congested clubhouse scene.

I hope this treatment of caddies as second-class citizens ends in the near future, because the Tour should acknowledge their importance to the whole business of professional golf. As a whole they're a good group of guys, with a strong sense of loyalty to one another that goes beyond color or ethnic origin or regional ties. It takes a new caddy about a year to gain the trust and respect of the other caddies, but once he does he has friends for life.

Despite some inequities, the whole economic situation has improved dramatically for caddies, and as I said, those who pack for winners can have lifelong careers. Guys like Mike Hicks, who caddied for Payne Stewart, and Mike Carrick, who caddies for Tom Kite, may have started originally just to travel for a year or two and see the Tour up-close before they planned on getting a "real" job. But they've done so well as caddies that they could never go back to conventional employment without taking a serious pay cut.

Besides helping me in all the obvious ways on the golf course—carrying the bag, reading greens, giving yardages—a caddy can also be extremely helpful by directing traffic around the course and functioning as a personal marshal. Mike can ask for quiet when I'm over a shot, and help clear out spectators when I drive it into the rough. A caddy is also the only security guard a player has around the course.

I generally like to get to the driving range about an hour before I play. I'll hit balls for about thirty minutes, chip and putt for twenty to twenty-five minutes, then get to the first tee about five minutes before my starting time, so I can properly introduce myself to the first-tee announcer and his assistant, and the lady scorers and volunteers, and the kid carrying the standard. (You especially want to make an impression on the lady scorer so she can cheat for you and help you have better statistics in the Greens-in-Regulation and Driving Distance categories.)

The hour before I tee off is pretty much all business, and Mike helps me keep my mind on the upcoming round. Autographs are something I sign only after my round is over. I'm happy to sign them at that point, but I just won't

do it before I play, because it costs me valuable practice time and causes me to lose my focus on the task at hand. This policy occasionally causes hard feelings.

In 1988, a fifteen-year-old boy who was watching the PGA Championship at Edmond, Oklahoma, had apparently asked me for an autograph as I was walking to the driving range, and I had told him I couldn't sign until after the round. That fall in school, he wrote a paper for an English class in which he said Peter Jacobsen had been one of his idols, but I had proven to be just another prima donna athlete because I had refused to sign his autograph book.

His parents sent me the essay, and although they were apologetic about it, they thought I should see it. I wrote the boy back and explained that I had my own rules and regulations to follow. It worked out okay, because he got a letter *and* an autograph, but it's an example of how you can hurt people's feelings without meaning to.

Another time, Mike had to physically step between me and a man who was angry with me for not signing his book. It was at the Tournament of Champions at LaCosta in 1991, and he was standing by the locker room door as I walked out. He had a book full of golf trading cards. It looked like he had every card from every sport in there, including the Honus Wagner original and the Mantle rookie card and the Billy Ripken four-letter-word card. Anyway, he asked me to sign, and I said what I always do, that I couldn't right then, but that if he'd catch me after the round I'd be happy to.

He said, "Everybody else has signed for me."

I replied, "Well, I make it a rule for myself not to sign anything before I play," and walked on.

He said, "How come? What's so special about you?"

I turned back to the guy and said, "Look, I didn't fly all the way to San Diego to sign your cards. I came here to

win this tournament, and if you can't understand what I'm trying to tell you, then fine."

Then he got real nasty. He said, "Why don't you appreciate the fans? It's the fans who pay your bills."

This debate was obviously not going to be settled with a handshake and a pat on the shoulder, so Mike interceded and pushed me out the door and toward the driving range. He knew if this kept up I'd either shoot 79 or score a technical knockout.

The point is, professional golfers are not like baseball or football players. We don't have somebody hauling our luggage for us, we don't take a team bus to and from the field of competition, and we don't have a shroud of security into and out of the stadium. We're pretty vulnerable out there, and an aggressive fan or spectator can pose a threat.

The plus side is that by not being owned by anybody, I can't get benched, or put on waivers, or optioned to the Durham Bulls.

As I've implied, if there's one thing Mike likes better than golf, it's the Grateful Dead. When we got to the Bank of Boston tournament a few years ago, Mike informed me that the Dead were playing just up the road in Providence, Rhode Island. Although he'd already been to about fifty of their concerts in the previous twelve months, he announced he was going and said it was way past time that I caught their act. Not having a good excuse to turn him down, I decided I better see what the fuss was all about.

I threw on a pair of khaki jeans and a blue denim workshirt with the sleeves rolled up and put on my Nikes. It was about as casual as I could get with my limited traveling wardrobe. A pullover sweater and golf slacks just

weren't going to cut it in that crowd. When Mike came to pick me up, he was wearing a Grateful Dead T-shirt and slip-on moccasins with socks. I was thinking he'd be better off without the socks, but then, Mike's not exactly a slave to fashion. And under the circumstances I was in no position to criticize.

I figured that I'd be identified as a charter member of the Geek Patrol once we got there, but what the hell. Maybe there was a Certified Yuppie section I could sit in. Hoping to allay my fears, I asked Mike if I would be the squarest-looking guy at the concert, and he just gave me that sly smile of his that means "Yes" multiplied by a thousand.

When we got to Providence, there were police barricades set up all over the place and a mob of people in the street. It looked like there was some sort of protest march going on, but it was actually just the Deadheads mingling around before the concert. Everyone was wearing tie-dyed T-shirts, and tie-dyed pajama bottoms, or at least tie-dyed headbands with ponytails sticking out.

I felt like the guy in *Quantum Leap,* as though I'd been time-warped back to the late 1960s and dropped on the corner of Haight-Ashbury in San Francisco. Many of the people were about forty or forty-five years old, but it looked like they'd hung onto their college wardrobes. Even the little kids with their parents were dressed in hippie chic.

It was an interesting role reversal for the two of us, because no one knew me from Adam, and everyone knew Mike. Men and women alike were shouting his name, and he was nodding and waving at everyone. These were fellow Deadheads that he'd met along the concert trail, and they were like a big family. Very few of them had any idea that Mike Cowan was a Tour caddy; they just knew he

hung out with the Dead. They also probably wondered who the Nerd was tagging along with him.

Inside the concert hall, the communal atmosphere was even more pronounced. The music at Dead concerts is piped into the hallways and refreshment areas, and in all parts of the arena people were dancing around with their arms waving, tracing invisible patterns in the air. There was also a distinct aroma pervading everything that smelled sort of like Bermuda grass without the Bermuda. And it seemed to be making everyone quite happy.

I walked around a while just to soak up the atmosphere, and when I returned and sat down, a startling thing happened; an extremely heavyset girl seated next to me put her hand on my leg and started rubbing it. Her hand had been on the armrest, but it casually slipped off, landed just above my knee, and stayed there. Then the fingers started moving. I kind of twitched my leg to shake her free, but the hand held its position. Now when I say this girl was heavyset, I'm trying to be nice. The fact is, she looked like Refrigerator Perry's big sister.

I could tell that Mike saw it, but he didn't say anything. He just kept smiling. So I whispered to him, "Mike, do you suppose she thinks her hand is on her *own* leg?" I actually wondered whether her legs were so big that maybe she had lost the feeling on the outer edges. I realized it was a crazy notion, but the girl never once looked at me or gave me any other signals. Still, there was no denying the fact that her hand had attached itself to my leg like a land crab, and it was heading for deep sand.

Finally, Mike couldn't hold it any longer. "She recognized you," he said. "When you were gone, she told me she was a *big* Peter Jacobsen fan, and she wants to know if we want to go to a party later."

"Big is right," I said. "C'mon, we're leaving now." And we split. Hey, I'm a happily married guy, and even if I weren't, I would have purchased the girl a Richard Simmons "Sweatin' to the Oldies" video long before I would have squired her to a party of Deadheads!

The recognition count for the entire evening was: Mike Cowan, 327 fans; Peter Jacobsen, 1. At least I didn't pitch a shutout.

And my caddy and I had a lot more to talk about the next day than the speed of the greens.

Great caddy stories abound on the PGA Tour, but I do have a couple of favorites:

—A few years ago, Adolphus Hull, known as Golf Ball, was caddying for Raymond Floyd at Memphis. Golf Ball is one of the best veteran caddies around, but on more than a few occasions he's had trouble finding his way back to his motel at night. Anyway, through the first four holes of the opening round, Raymond had missed every green, a couple long and couple short. As usual, he had made a bunch of difficult up-and-down saves for par, and going to the fifth hole, he was even-par.

He hit a big drive, and Golf Ball gave him a yardage to the green. Ray took out a seven-iron and flushed it twenty yards over the green. He couldn't believe his eyes. He'd been hitting everything perfectly, and he'd just missed his fifth green in a row.

He grabbed the yardage book from Golf Ball and looked at the fifth hole diagram, which bore no resemblance to the hole they were playing.

"What the hell book you got here?" he said. "Is this the book for Memphis?"

And Golf Ball's eyes grew wide. "Memphis?" he

shouted. "Are we in *Memphis*? . . . I thought we were in Fort Worth!"

As if having the wrong yardage book weren't enough, Golf Ball threw gasoline on the fire when they climbed into the bushes over the green and, with Raymond fuming over a nearly impossible recovery shot, said, "Now get this one up and down for me, podnaw."

—This story could be called "A Downer for Upper." Five or six years ago, a popular caddy named D. J. (Father) Murphy, who passed away last year, was caddying for Brett Upper in the AT&T Pro-Am at Cypress Point. On the famous 16th hole, Brett hit his tee-shot long left over the green, down onto the beach. The ball usually goes in the ocean there, but when they got to the edge and looked over, there it was sitting up nicely in the sand. He took a wedge and went down to hit it. Meanwhile, Father Murphy stood by the green to give Brett a general direction. Brett got over the shot and was all set to hit it, when Murph yelled at him to hold up. It seems one of the amateurs, who was well out of Upper's vision, was getting ready to hit a chip shot.

As Brett politely waited for the amateur, with his back to the ocean, a big wave suddenly came crashing in and drenched him up to the chest. He was absolutely soaked. As if that weren't bad enough, the wave washed the ball out to sea, so Brett had to slosh back to dry land and take a penalty for a lateral water hazard. Needless to say, he was not a happy camper.

And one other thing: Brett had teed off on the back nine first, so it was only his seventh hole of the day. I wonder which hole his socks dried out on.

CHAPTER 9

Showbiz

As SOMBER AS the PGA Tour may seem at times, it still exists primarily for entertainment. Despite the large QUIET paddles fans are always having shoved in their faces when players are trying to hit shots, we do want them to have a good time at the course. And if golf tournaments weren't televised, and corporate America didn't feel it could reach a lot of consumers with its products, the million-dollar purses we play for each week would be cut in half.

Although it may be difficult for a touring pro to think of golf as entertainment when he's lipping out three-foot-ers or bouncing balls off condos, part of being a professional is not letting your own troubles ruin the enjoyment of the fan who's paid money to see you play. The bottom line is that it's a business for us players, but an entertainment for the fans, and the more we can blend the two the better off the sport will be.

I've always tried to acknowledge the showbiz aspect of golf, and I feel a responsibility to do all I can to show the public that golfers can be fun-loving and entertaining. This

has caused me to risk making an ass of myself at times, but what the heck. If I were deathly afraid of embarrassment, I'd never be able to put a ball on a tee in front of a big crowd.

I don't mind doing something outrageous if it'll help break the unfair stereotype of Tour-player-as-robot. An example was my infamous *Golf* magazine centerfold in 1983. Not surprisingly, it was CBS announcer Gary McCord who first came up with the idea of spoofing the fashion layouts the women professionals did each year in *Golf*. They have always been tastefully done, primarily to promote the femininity of the lady pros, and while there has been lively debate surrounding the marketing strategies employed by the LPGA, most men and women golfers alike really enjoy the pictures.

Many of the women who have posed for these photos, such as Jan Stephenson, Cathy Reynolds, Kris Tschetter, Laura Baugh, and Cindy Figg-Currier, are friends of mine, and they all look terrific in the layouts. McCord's idea was not to put the women down, but to play a joke on the men and show how basically untanned and unattractive we look when we take our clothes off.

We ended up with Keith Fergus, Greg Norman, Payne Stewart, Rex Caldwell, and yours truly. Obviously, there was no intention of using flattering lighting or air-brushing or anything to disguise the fact that we were basically un-buffed guys with weird tan lines. Our forearms were brown, and that little V at the neck was brown, and all other body parts were "A Whiter Shade of Pale." Greg Norman's lucky his nickname wasn't changed from Shark to Albacore, because that perfectly described his coloring in the pictures.

The photo editors at *Golf* got very excited about this project, which was shot in the locker room at the Players

Championship in Jacksonville. They had all the pictures mapped out—Greg in the shower, Payne shaving, Keith in the sauna, Rex toweling off—and they'd gone out and purchased this awful-looking tight underwear that accentuated every bulge. The sad fact is that professional golfers tend to have a lot of bulges in the rear and sides and not much where it counts. Our sport does not require rippling abdomens or popping veins or calves shaped like bowling pins. The only vein that pops on my body is in the middle of my forehead, when a birdie putt does a 180-degree lipout.

On the other hand, we can hit five-irons farther than the longest drives of the last three Mr. Olympia winners.

Everything about the layout was a lark. The first picture was of us standing in the locker room, with a foot up on a bench. The attitude we were supposed to project was something like: "Here we are, we've just finished our round of golf, we've stripped down to our bulge-hugging red Speedos, and we're ready for a hot night on the town." Yeah, sure.

Our actual plans after the session were to rush back to our hotels, order up room service, and watch *F-Troop* on the cable channel. What a joke! But we just smiled and yukked it up and wondered whether we'd be able to live through the heat we'd take from the other players.

Somehow, I got selected for the centerfold, probably because they figured I had the highest threshold of humiliation, or maybe because they felt I was the most decadent. Anyway, they laid me over a bench and draped a big towel with *Golf Magazine* printed on it over my mid-section. What a waste of linen! A ball-washer hankie would have been sufficient to preserve my modesty and ensure that I wouldn't expose the old rut-iron.

The layout was copied from *Playboy,* complete with the

"Golfmate Data Sheet" with all my vital statistics and personal comments. My "Turn-ons" were: big galleries, small scores, long drives, short rough, fat paychecks, and skinny trees. My "Turn-offs" were: water hazards, players whose swings I couldn't copy, three-putts, and four-putts.

When the pictorial appeared, the reaction was ninety percent positive. Nearly all readers realized we were just poking fun at ourselves. Of course, there are always a few that catch you by surprise. A couple of readers thought none of this had been done tongue-in-cheek (if you'll pardon the expression). They said stuff like, "What are you doing? These guys have got terrible bodies, and they've got bad tan lines."

To which our reaction was, "Well, no shit!"

And naturally there were the feminists who thought we were having a joke at the expense of the women golfers. Jan Stephenson—who's taken a little grief from feminists herself—was asked about the layout, and said, "Well, it just goes to show what we've been saying all along. That all the good-looking professional golfers are on the ladies' tour." Her response was right on, and it was exactly what we had had in mind when the project was conceived.

I also got a surprising reaction from a long-time Portland friend, who had moved away a few years back. He wrote a letter attacking me from a Christian standpoint, citing several verses from the Bible about the immorality of it all. I get the feeling he missed the point, too.

I guess it's just like golf: every shot makes someone happy, and someone else unhappy. And that's the way it was with my "beefcake" shot in *Golf* magazine.

Another "showbiz" opportunity came along in 1987, when I was offered a small part in the HBO movie *Dead*

Solid Perfect. The film was based on Dan Jenkins' novel of the same name, and tells the story of an also-ran on the PGA Tour who somehow manages to overcome a mangled personal life and win the U.S. Open. Jenkins is one of my favorite writers, and his book was hilarious, so when Dan and the director, Bobby Roth, offered me the chance to play myself as a guy who beats Randy Quaid's character in the Colonial Invitational, I couldn't resist. (I had beaten Payne Stewart in a playoff to win the Colonial in 1984, so I knew for sure I could handle Randy Quaid.)

Ben Crenshaw had been originally slated to play the part, but Ben got cold feet after he read the script, which contained a fair amount of spicy language, and a little nudity. Crenshaw has that image as Gentle Ben, you know, so when he decided to pull out, the obvious choice was Dirty Peter, the decadent slut who had posed for a nearly nude centerfold. I was secretly disappointed when they told me they didn't want me for my body after all, and in fact would prefer it if I kept all my clothes *on* during the entire filming of my part.

They paid me $10,000 for one full day's work, and they gave me a Screen Actors Guild card, so it was actually a pretty good deal. They also relied on me for technical advice, to make certain the golf scenes looked authentic. I thought that would be the easiest part of the job. It turned out to be the toughest.

Bobby Roth had said to me, "Now, Peter, keep your eyes out for anything that doesn't look right. And give me the benefit of all your experience so that these scenes will have total credibility with golfers."

Well, in my first scene, in which we were being announced on the first tee at Colonial, I noticed that Randy's caddy—an actor named Larry—was standing there with

the bag on his shoulder. Larry obviously had not done a lot of looping in his climb to screen stardom. I walked over to him and said politely, "Larry, you wouldn't be holding the bag while we're still on the tee. You'd have it standing on the ground in front of you, with your hands on the head covers or on the sides of the bag."

He ignored me and turned to Roth, and said, "You're the director. You're the only one I take direction from."

Bobby then repeated what I had just said, so Larry took the bag off his shoulder and set it on the ground. It was obvious I needed to be more assertive in my new role as a Hollywood technical advisor.

We played along, and did several takes hitting each shot, and I thought to myself, "Hey, what's so tough about Hollywood? You get as many mulligans as you need to get it right."

I couldn't help thinking how nice it would be in actual tournaments if every time I hit a bad shot I could drop another ball and say, "Take two. Roll 'em."

Shoot, if you gave me just five mulligans a year on the PGA Tour, at exactly the right spots, I could play my way into the Hall of Fame. And so could a hundred other guys.

But I must say I was impressed with Randy Quaid's golf game. On most takes, his first shot was more than acceptable. In fact, when they announced us on the first tee that day, he ripped a beautiful drive down the middle about 250 yards. When we shot a second and third and fourth take, he did the same thing. The guy really showed me something. He was also just great to work with, as were Jack Warden and most of the other people I met that day.

My friend John Rhodes, a teaching pro at Colonial, caddied for me in those scenes, and whenever the camera crew was setting up for another shot—which was often—

John would work with Randy on his swing. It really shows in the final product. Believe me, there are worse swings than Randy Quaid's in professional golf.

I hope the movie came off as being authentic in the golf scenes, but as I said, it wasn't without some effort. In one scene around the second green, Randy is in the left bunker, the pin is on the right, I'm on the back left of the green lining up a putt, and Randy has to blast a shot all the way across the green to the hole. As they were preparing to roll film, I looked over, and my pal Larry was standing in the bunker with the bag. I walked over and said, "Larry, you wouldn't be standing in the bunker. You'd be off to the side holding the rake."

Larry turned away, just like one of my daughters does when she's mad at me for making her turn down her boom box as it's blasting that creative new rap music that we've all come to love.

So Roth went over and once again repeated what I'd just said, and Larry grumpily removed himself from the bunker. The amazing thing is that when I saw the final cut of the film, I thought Larry did a convincing job as the caddy. I guess it speaks for him as an actor, because in real life I swear he didn't know an embedded ball from a hole-in-one.

My favorite scene in the movie is when Randy's character comes back to the motel room after a miserable day in a tournament resembling the AT&T National Pro-Am at Pebble Beach. His wife, played by Kathryn Harrold, asks him what he shot.

He says, "I shot a seventy-f——five."

She says, "Oh, I'm sorry. By the way, honey, I saw a deer today." And she looks up at him with an expression of awe and wonder at the beauty of nature.

He comes totally unhinged, and tells her and the deer

and the world in general that they can go f—— themselves. Granted it's a harsh scene, but every golfer who's ever played the game seriously can understand this volcanic eruption. I just hope I've never been so consumed by my golf game that I've done that to Jan, although she could probably tell you a few stories if you asked her.

On second thought, don't ask her.

While we're on the subject of movies, one of my great frustrations is that I've been unable to secure the movie rights to my favorite book, *Golf in the Kingdom*. Ever since reading it in 1984, and then having that first-round lead at St. Andrews, I've been talking the book up, and my enthusiasm has infected Jack Lemmon as well.

Jack sees himself producing the film and playing the role of Seamus MacDuff. We've talked to Sean Connery, another true golf aficionado, and he's expressed interest in playing Shivas Irons. Should we ever be able to put the deal together, I'd be more than willing to take a hiatus from the Tour for several months for the chance to play the part of Michael, though I've never made that a contingency of the deal. I just want to have some say in the making of a story that really gets to the core of the game I love so much.

For those who feel I'm being foolish in thinking I could pull off the acting job, remember what I learned from my brief involvement with *Dead Solid Perfect*. In Hollywood, they get a bunch of mulligans if they don't get it right the first time. That's a luxury I don't have when performing my impersonations in front of thousands of people, or doing a television broadcasting stint for millions, or playing a sidehill three-iron to the final green tied for the lead. And it's not as if the role is really a stretch for me. Michael is a fellow on a quest to understand the meaning of golf and

how the game fits into the big picture. Heck, I've been on that quest all my life.

Whether I ever play Michael or not, I know the part has to be played by an excellent golfer. I don't want a situation like the one in *Follow the Sun,* the movie of Ben Hogan's life. Although I liked that film very much, every time Glenn Ford, portraying Hogan, set up to make a swing, the camera cut away to the real Ben Hogan hitting the ball. The viewer is jolted out of the illusion and reminded that he's only watching a movie, and I don't want that to happen to *Golf in the Kingdom*.

I started looking into the rights as soon as I got back to the States after the British Open in 1984, and eventually called Michael Murphy himself. Over the last several years, we've had many wonderful conversations, and I've become somewhat of a disciple for *GITK* and Murphy's other books, including *The Psychic Side of Sports*. For various reasons, though, I've never been able to get those movie rights.

My quest goes on to this day, however, and while I'm probably too old now to play Michael, I'm not worried. With every passing year, Jack Lemmon and Sean Connery become even more appropriate to play Shivas and Seamus.

CHAPTER 10

Learning About Celebrity

AS YOU GAIN NOTORIETY in any highly visible arena, be it golf, music, or films, there comes a time when you have to show a face to the public. My role models in this regard have been Palmer and Lemmon. They've been stars nearly all their lives, and yet they never show the strain of their celebrity. They simply have a way of making the fans who approach them feel special.

Arnold is the best I've ever seen at signing autographs, or going out of his way to smile when he's frowning inside. On many occasions, I've seen him finish a round disappointingly, maybe by hitting a poor iron-shot to the final green or missing a makeable birdie putt. But he'll immediately shake it off and sign autographs for twenty minutes. Believe me, when you finish poorly you'd rather chew the scorecard—and the pencil—than sign autographs. It's Arnold's generosity with his fans that has, above all, made him

the most popular golfer in the history of the sport. Palmer understands that the fans don't care how he played the last hole or the round, they just want to have contact with him.

Jack is also cordial and giving, almost to a fault. As hard as Jack works at playing his best golf when we're grinding it out in the AT&T National Pro-Am, he will still stop along the fairway and pose for a picture, or take the time to chat with fans who've come out to the course to cheer him on. I've said many times, if Jack and I could play that tournament in a soundproof booth, with no one around, I'm convinced we'd win it. But that's one of the prices of fame, and Jack Lemmon gladly pays it each time he's in the public eye.

If these two guys, with their level of celebrity, can take the time to show respect and kindness to their fans, then I certainly can do the same.

I won't deny that it's very flattering to have people point you out. When I first started playing the Tour, I was disappointed when fans didn't recognize me as a professional golfer, but, of course, it was because I hadn't done anything to deserve their recognition. You've got to go to war and show them what you're made of to earn their respect.

When many of the fans did get to know me, they naturally assumed my personality off the course was the same as the one on it, and it created some awkward situations. While I like talking with fans away from competition, and enjoy a good joke as much as the next guy, it's another matter entirely in the heat of battle.

Sometimes people will poke their heads out of a gallery and tell me they went to school with my dad or were a sorority sister of my mother's, and that can really set me on my heels. In any other situation, I'd love to engage them in conversation and ask them questions about their friend-

ship with my parents way back when, but if the comment comes as I'm needing a birdie to make the cut, or am in contention to win a tournament, I have to keep my blinders on and stay focused, even at the risk of being rude.

If professional golfers could educate fans to any one thing, I'll bet it would be this: that playing golf for a living requires tremendous concentration, regardless of what kind of exterior we show. Even the most talkative players, such as Chi Chi Rodriguez, Fuzzy Zoeller, and Lee Trevino—while they're great entertainers and sometimes act as if they're doing standup routines on the course—are actually just letting off steam. That's how those guys handle the anxiety of their profession. When the pros talk to the crowd, a lot of times they don't necessarily want the crowd to talk back to them.

I don't want this to sound harsh, but touring pros in competition should be treated the same as any on-the-job professional making a living. I've known doctors and lawyers who think nothing of approaching me in the middle of a round and chatting away like I've got nothing better to do. How would a surgeon feel if I busted into an operating room when he was doing open-heart surgery, and said, "Hey, Doc! What kind of scalpel are you using today?" Or, "When you stitch him up, are you going to use a conventional knot or a Windsor?"

Obviously, professional golf is not open-heart surgery, but the etiquette of respecting someone's profession should be the same.

I've heard the argument that the fans pay their money, so they should be entitled to scream whatever they want. But there is a difference between a major-league ballpark or basketball arena and a golf course. I mean, Charles Barkley has a guaranteed contract that pays him several million dollars a year, whether he makes that free throw or

not; and Jose Canseco can go zero for twenty-four, as he did in 1992, and still get paid in gold bullion on the first of the month. If Peter Jacobsen misses four cuts in a row, he gets zero, zed, zipperino. There are no guarantees in my contract. In fact, I have no contract. Not to mention that Jose gets to wear skin-tight pants that show off his butt, and I have to wear lime-green plaid pants with a thick white belt. It's just not fair.

Lee Trevino has said, "Guarantee *me* three million a year and you can scream, yell, or spit on my ball when I'm putting. Because even if I miss it, I still get paid."

Until that time, I'm certain Super Mex would appreciate your silence when he's sweating over those ten-footers.

Let me repeat: in the proper setting, I love talking to fans, especially about topics *other* than golf—because I'm not certain there's a whole lot they can tell me about golf that I don't already know. My least favorite conversation is one in which a fella insists on giving me a shot-by-shot description of his most recent round.

When a guy starts out with a line such as, "On number one, I pulled out my trusty Big Bertha and hit this pretty fade . . . ," I have a stock comeback. I'll put my hand on the guy's shoulder and say, "Excuse me, Harold, but can I ask you a question?"

And he'll say, "Uh-h, sure."

And I'll say, "Are we going all eighteen holes today? Because if we are, I'm going back to the clubhouse and rent a cart."

Ideally, at this point I can get him laughing and be spared a fifteen-minute verbal excursion of his 93 with six one-putts. That's one reason I'm glad they televise our rounds on Tour: it saves me a lot of explaining.

There can be awkward moments with fans even off the golf course. One in particular I'll never forget.

I was in Palm Springs with the family for the Bob Hope Desert Classic, and my oldest daughter Amy was just three or four at the time. We were walking out of a Kentucky Fried Chicken outlet with a bucket of wings—extra crispy, I believe—when an older couple, walking in, recognized me. Now, when you're with a little one, as any parent will tell you, you have to hang onto their hand at all times in public, but I was caught in the middle of holding Colonel Sanders in one hand and opening the door with the other, when this woman said, "Say, you're Peter Jacobsen. How are you?"

I said, "I'm fine, thanks."

She said, "What did you shoot today?"

Meanwhile, it happened in a flash. Amy bolted out the door onto a side street of Highway 111, which is the main drag in Palm Springs. She was about four steps into the street when a car came barreling about forty miles an hour right at her. It was a dark street and the driver was not paying attention.

I had one eye on this woman and one on Amy, and just as I was in mid-sentence, I screamed, "Amy!"

Thank God, she stopped stone-cold in her tracks. The car whizzed by her and I know the driver never saw her, because he didn't even touch his brakes. He missed her by no more than three feet. She would have been killed for sure.

I ran to her and grabbed her and was near tears, because I had almost let my inattention allow my child to be run over. It had been nobody's fault except mine, because the woman was just trying to be friendly. I was still shaking when I got back to the hotel and told Jan what had happened.

When I'm out with the family now, people will approach for autographs or to chat, and I honestly enjoy that.

But no one can detain me for long, because Kristen will remind me that she's hungry for pizza or Mickey will inform me that we're late for *Ernest Goes to Camp* or *Pee-Wee's Big Adventure*.

Priorities. They're the stuff of life.

I had my own close encounter with a celebrity years ago, with unexpected consequences. It was at a 1980 press luncheon for Muhammad Ali in Montreal. I was up there for the Canadian Open. The announcer was introducing all the dignitaries in the crowd, and finally he looked over at a side table and said, "And from *Saturday Night Live,* Mr. Bill Murray, and from *Rolling Stone* magazine, Dr. Hunter S. Thompson." Murray was in the middle of filming *Where the Buffalo Roam,* Thompson's "life" story.

I'll never forget the sight. Those two characters were sipping Wild Turkey through straws from a large ice bucket, with their feet up on the table. I snuck over to their table and introduced myself. I loved Murray's comedy so much I had to do it. Bill and I hit it off right away.

Some years later, at the U.S. Open at Shinnecock Hills, Bill and his brother, Brian Doyle-Murray, came out to watch me play. It was Thursday afternoon, I'd just completed the round and had given my caddy, Mike, the afternoon off. I was in the locker room with Bill, just putting some stuff away. Shinnecock is an old club and the locker area is very small. Many of the players had their golf bags lined up in front of their lockers. I decided to go to the range to hit some balls, so I said to Bill, "C'mon, grab my bag. You are now my caddy."

Immediately, he dropped his lower lip and went into his Carl the Greenskeeper impersonation from *Caddyshack*. "Yes, sir," he said, "I will be right along."

He picked up my golf bag and swung around, and inadvertently created a domino effect which knocked over the two bags standing next to mine, belonging to Hale Irwin and Barry Jaeckel. While the normal person would have been embarrassed to death, Murray immediately went into his improvisational comedy mode and started intentionally knocking over bags. He'd swing around and knock over a bag, swing the other way and knock over another one. All the time, he kept apologizing as though they were people. "Oh, excuse me, Mr. Palmer. Oh, please forgive me, Mr. Nicklaus." Suddenly, I was watching a *Saturday Night Live* skit.

About four or five other guys were in the locker room eating lunch and they were all doubled over laughing. Then Murray went into a nerdy trot out the back door, with the bill of his cap turned backwards, his pants hiked up over his belly button, and the bag swinging all over the place.

Curtis Strange was just walking into the locker room as Bill flew past him, and Curtis' eyes became like saucers. He put his back to the wall, and said, "Whoa, let me get out of this guy's way." I could tell from his expression that Curtis was wondering how I'd ever hooked up with this guy, and how in the world he had gotten past the USGA Dobermans into the locker room.

We headed over to the driving range, and the first person we saw was Raymond Floyd. I introduced Bill to him, unaware that the swing Raymond was honing right then would lead him to the U.S. Open title just three days later.

This being the Open, security was pretty tight on the range and greater than normal restrictions were in place. Obviously, no one other than the players was allowed to hit practice balls, so we moved to the quieter end of the

range, so we could break the rules. After I'd hit a few, I asked Bill if he'd like to show me his action. He didn't hesitate a second. He grabbed my driver and immediately started pumping tee-shots, providing his own commentary as he went.

With the lip jutted firmly out, he'd hit one and describe its flight for the fans: "Ah, it's looking pretty good . . . oh, it's heading for trouble . . . oh, my God, it's found the second cut of rough. The dream has ended."

It didn't take long before players and fans alike started to watch this exhibition, and with the increased attention, Bill really turned it on. A green snow fence was between us and a hospitality tent, where hot dogs and hamburgers were being cooked, and Bill started lobbing wedges in that direction, reenacting the scene in which "Carl" swings a rake in the tulip bed at Bushwood Country Club.

Bill would take several waggles, then lisp, "What an incredible Cinderella story. This unknown comes out of nowhere to lead the U.S. Open at the Dunes at Shinnecock Hills . . . the normally reserved crowd is on its feet for the Cinderella Kid . . . what a difficult up and down . . . I think he's got a wedge."

He took the club back slowly, then lobbed the ball in the direction of the tent. "Oh, he's got to be pleased with that one, it looks like a miraculous . . . it's in the hole!"

Just then, the ball bounced off the top of the tent, and Murray dropped his club and put his hands to his head.

I thought for certain I was going to become the Pete Rose of golf—wrongly banned for life from the Tour.

One time, Bill and I were actually partners in a team competition. It was at Butler National Golf Club, prior to the Western Open; a celebrity shootout had been organized to benefit charities in the Chicago area.

All the celebs were current or former professional ath-

letes, guys such as Michael Jordan, Mike Ditka, Jim McMahon, Walter Payton, Ernie Banks, and Doug Wilson of the Chicago Blackhawks. Murray, a Chicago native from a golfing family, was the only non-athlete, and so, of course, I chose him as my partner so the gallery would pull for us as underdogs.

The format was alternate shot, in which both players hit a drive on each hole, select the better ball, then alternate from that point on.

When we got to the last hole, we were down to just two teams: D. A. Weibring–Michael Jordan vs. The Underdogs. On the 18th, Bill hit a big fade into the 10th fairway, but we had an open shot to the green. The wind started to howl about forty miles an hour and it looked like we might get some lightning, which reminded me of *Caddyshack* again—the priest who plays a perfect round until he's struck dead by lightning on the last green. (I also recalled that it was on this same course that Lee Trevino, Bobby Nichols, and Jerry Heard actually were hit by lightning.)

It seemed appropriate under the conditions that the finish be dramatic, and it was. Bill hit an incredible flop wedge for our third shot, over the front right bunker, and I made a four-foot-par putt to win $10,000 for Bill's designated charity.

All the print and electronic media swarmed around Murray to get his reaction, so naturally he dropped his lip and went into his spiel.

"Finally, I'm vindicated," he said. "I'm certainly one of the most talented athletes ever to come out of the Chicago area, and I've been largely unappreciated. People like George Halas and the Wrigley Family and Ditka and Payton have kept me down all these years, but at last I'm able to claim the glory that is rightly mine. I am now recognized

as a true athletic hero . . ." And on he rambled in a frenzied state for five minutes.

It was wonderful for the event, and the charity, to have Murray steal the moment. And I remember just standing back watching him, with a big smile on my face, thinking, Damn, I love this game.

That same week I played a practice round with Michael Jordan and became aware of just how big a star he was. I guess I'd been unaware of it before because Michael is so down-to-earth. He's not one of those bow-down-and-kiss-my-ring type of guys, with an entourage of yes-men always around him. He talks to everybody in the same manner.

I had bumped into Michael in an equipment van earlier in the week, while he was getting his grips changed and having the lie and loft on his irons checked. It started to rain, and he was really disappointed.

"Man, I was hoping to hit some balls this afternoon," he said.

So I asked him if he wanted to play with us the next morning.

He said, "Sure, but you better okay it with Mr. de Young."

Peter de Young, the Western Open tournament director, said he thought it would be okay. The next morning, at eight A.M., Michael teed off with Ben Crenshaw, Chip Beck, and myself. By the time we reached the third hole, word had spread that Air Jordan was on the course, and our gallery had gone from around twelve people to twelve hundred.

About then, a PGA Tour official approached me and

said, "Peter, you know you can't do this. This is highly irregular and against Tour policy."

Which it was. Only the contestants playing in the tournament are allowed to play practice rounds. I had asked Michael to play, however, and I wasn't about to tell the world's most famous athlete that he had to pack it in. Besides, the gallery was having a great time. So I asked the official what the fine would be, although I knew from my position on the Tour Policy Board that it would probably be about a thousand dollars. The official said, "I don't know, but I'm probably going to have to write you up."

"I understand," I said. "That's your job, and I'll pay the fine. But the people out here are having a great time, and that's more important than the fine."

I wasn't crazy about the idea of paying a thousand dollars in greens fees for Michael, but I was in no position to argue.

To his credit, the official never did write me up. He even came up to me later and said, "It was really great to see him out there. Everybody was lovin' it."

It goes to show that with someone as special as Michael Jordan, even the PGA Tour can bend the rules a bit. The Tour is, after all, show business.

I got a greater sense of how Jordan is worshipped in Chicago when I teased him on national television during the 1992 NBA Finals between the Chicago Bulls and the Trailblazers. When Chicago was in Portland for Games three, four, and five, I invited Michael to play golf at The Oregon Golf Club, the new course that I had co-designed. We played eighteen holes one day, and the next night he had his normal, brilliant game.

The Oregon Golf Club is a difficult course, rated at 75, and that day Michael shot 85 from the tips of the back tees:

46 on the front nine, and 39 on the back, highlighted by an eagle on the par-five 13th hole. That night at the game, I was pulling hard, as always, for the Blazers, and Ahmad Rashad, who'd played football at the University of Oregon and whom I'd known for years, saw me and told me he was going to ask me on camera about playing golf with Michael.

Sure enough, in the third quarter, with the Blazers making a run and the crowd screaming so loud I could barely hear my own voice, we went on the air, and Ahmad said something like, "We all know Michael Jordan wants to be a championship golfer, and here's a real championship golfer who played with Michael yesterday. Peter Jacobsen."

I was standing there trying to guess what Ahmad was going to ask me in front of thirty million Michael Jordan fans. He said, "Peter, Michael really wants to play the Tour. When do you think he'll be good enough to go out there?"

Well, with Michael being the star of the Bulls, and my being a diehard Blazer fan, I had to dig him a little. So I said, tongue in cheek, "I'll be playing center for the Bulls before Michael plays on the Tour."

And then I reported what Michael had shot that day, and I added that I thought he was a very good player, with a lot of potential.

The next day, the Associated Press ran a blurb on my comments in every newspaper in the country, and the post-game talk shows in Chicago made a big issue of the fact that I had criticized Michael's golf.

Peter de Young called me the next morning from Chicago, and said, "Boy, do they hate you back here!" I had to remind myself how tough it is to poke fun at things that

people consider sacred—and believe me, in Chicago, nothing is more sacred than Michael Jordan.

Let me just say here and now—so I don't further alienate the Chicago fans—that Michael could surprise a lot of people. He hits the ball long and has probably the best coordination I've ever seen. But there's a lot more to it than that.

No contemporary athlete has made the transition from super-stardom in one sport to success in golf, with the sole exception of John Brodie. But unlike Jordan, Brodie was hardly a latecomer. He'd been a competitive golfer since he was a little kid, a scratch player in college at Stanford, and even took a brief fling at the regular Tour during the off-season when he was in the National Football League.

Michael would have to spend the next fifteen years after his basketball days ended totally focused on improving his golf game, and playing in good competition, to get ready for the Senior Tour. The odds would still be long—but if anyone could ever pull off such a feat, it's probably Michael.

Long ago, when he was cut from his junior high school basketball team, I'm sure no one thought he would become one of the most admired basketball players of all time, either.

CHAPTER 11

The Politics of the Tour

NOW THAT I'VE MENTIONED my position on the Tour Policy Board, this is a good occasion to get a few things off my chest.

Although I occasionally enjoy public speaking and like to debate a good issue, the closest I'll ever get to politics is my service on the Board. While it's an elected position, there's no campaigning allowed. You can't stump for the job, or make Willie Horton commercials, or hire a private investigator to take pictures of other candidates kicking their ball in the rough. You just agree to have your name put on the ballot, and then submit to a vote of the other players. My first term lasted from 1983 to 1985, and my current term is through 1993.

There are nine members on the board: three Independent Directors, representing the public interest; two PGA Directors, who are national officers of the PGA of Amer-

ica; and four Player Directors—myself, Jeff Sluman, Brad Faxon, and Rick Fehr. Together, we oversee all the marketing, television dealings, promotions, finances, policies, and rules that govern the activity of the Tour and its players.

We meet four times a year, for a day and a half each, and there's never enough time to address all the issues. It's often a no-win proposition, too, because all the players on the Tour are independent businessmen used to running their own show and getting their own way. Their opinions run all over the place, and a decision for the collective good always means that there are individuals opposed—and that the Player Directors will hear from them.

A few years ago, for instance, some players were opposed to having R. J. Reynolds as a corporate sponsor, because they felt it implied the Tour was advertising a cancer-causing product. No action was taken on it, and they felt their opinions had fallen on deaf ears. Nothing could have been further from the truth, but for a while, the Player Directors were looked at suspiciously, instead of as the allies that they are.

I know I base all my votes on what would be good for the future of the Tour rather than what would be good for me individually, and the other players on the Board do the same. There's no compensation or reward for serving—it's just a way to give something back to the game.

There's also been some controversy around the role of the Commissioner. The Tour Commissioner is appointed by the Policy Board to be chief executive and administrative officer of the PGA Tour, and while Commissioner Deane Beman attends all our meetings, and offers important input, he is directed by, and works for, the Board. Some people feel Beman tells the Player Directors what to say—some call us Deane's Dopes or Deane's Clones—but

that just isn't the case. And anybody who knows me can tell you: *nobody* puts words in *my* mouth.

While Beman exhibits a great knowledge of business, he sometimes falls short at public relations. He definitely could use more PR types around, so that the lines of communication with the media and the players would be more open and less susceptible to hearsay and rumor. I also believe more needs to be done to generate support for the tournament directors and the corporate sponsors, because they are the lifeblood of the Tour.

Overall, however, I think he's been good for the Tour. He's kept it organized, kept it moving forward, and deserves credit for engineering the tremendous increase in prize money. He's also been a driving force in the growth of the Senior PGA Tour and the Ben Hogan—now the Nike—Tour.

Having said all that, several issues still need to be studied further, and here goes:

I believe the current rule that exempts from qualifying the previous year's top 125 money-winners, is wrong. I'd like to see the number reduced to 90 or 100 at the most. It's an unpopular position to take, but I liked the old system, which exempted only 60 players each year and which changed in 1982.

Obviously, the old Monday qualifying that was held each week was a nightmare for the Tour's field staff to operate, and it was tough on scheduling—but it was eminently fair for all the players, because it gave everyone who had earned a Tour card the chance to play each week. It also really taught you how to play golf under pressure. Guys such as Tom Watson, Tom Kite, Lanny Wadkins, Calvin Peete, Bruce Lietzke, John Cook, Hale Irwin, Craig Stadler, and Chip Beck all learned to be great com-

petitors by climbing their way up through the Top-60 system.

The only thing that rankled me was that everyone called those who weren't in the Top-60 "rabbits." The term implied that the non-exempt players just lived on the fringes of the Tour, nibbling from week to week on any lettuce that had slipped off the table where the big boys dined. Well, if that was the case, they should have just called it the PGA Rabbit Tour, because at least three-quarters of us had to face Monday qualifying from time to time.

Once you got into a tournament, and then made the cut, you were exempt for the next tournament, so streaks of good play were rewarded. Conversely, a missed cut sent you back to square one. There were times when I played seven or eight weeks in a row if I was making the cuts, even if I was brain-dead, because if I skipped a tournament I defaulted my exemption and it was back to Monday qualifying.

At the beginning of each year on the West Coast, for tournaments such as Tucson and Phoenix, there were often only one or two spots available on Monday, so I'd go out knowing I had to shoot a course record to get in. That was pretty tough. But later in the year there were always plenty of spots available, and I usually had a good idea before I teed off what it would take to qualify.

Knowing that 70 or 71 is the magic number will force you to learn course management: whether to lay up or go for it on par-fives, whether to shoot for middles of greens or dead at the flags. There's no question those Monday qualifiers either broke you or made you stronger than tempered steel. Those of us who survived the "rabbit era" are much better players for it today, I'll guarantee.

Under the current system, which exempts as many as 150 to 160 players from a variety of categories, a player can float from week to week and month to month without feeling any serious pressure. It may be the main reason the Tour went for the latter half of the 1980s without any individual domination.

I'm not advocating a return to Monday qualifying, because Mondays have become a valuable source of revenue to players who've earned the privilege of doing special outings around the country. These exhibitions also expose the stars of the Tour to regions of the country that don't host regular Tour stops, and thus enhance the popularity of our sport. I just think we need to look at lowering the number of exemptions.

Oddly enough, these thoughts come following a season when I finished 126th on the official money list, one spot below the cutoff of totally exempt players, so my thoughts are obviously not tied to my own situation. (My status for 1993 is as a conditionally exempt player. Fields are filled currently in the following way: top 125 on the previous year's money list and tournament winners within the last two seasons, top-ten money winners of the 1992 Ben Hogan Tour, top 40 qualifiers from the 1992 qualifying school, then numbers 126–150 off the 1992 money list. With my current position, and hopefully a few sponsors' exemptions, I should still play a full schedule of 25 tournaments this year.)

Quite simply, I need to play better this year, and am more determined than ever to do so. In a game in which you have to let your clubs do the talking, my clubs barely spoke in a whisper in 1992.

As Chip Beck said to me as we played together in the last regular event of the year, the H.E.B. Texas Open, "Pain

and suffering are inevitable in our lives, but misery is an option." Chip's right on the money.

What I've learned from the experience is that I have to work harder, stay more focused, and fight my way back to where I feel I belong. If we all look to ourselves for improvement, rather than looking for handouts, we'll keep the American Tour the world's most elite showcase of golf. And that's in the best interest of all the players.

I also have strong feelings about the Tournament Players Clubs. The idea of stadium golf, in which courses are designed to give greater accessibility to the fans and provide unrestricted views of tee-shots, fairway shots, and putts, is a tremendous innovation. The master plan went awry, however, when so many of the TPCs were designed as target golf courses. All those railroad ties, and the humps and bumps in the greens that sometimes cause good shots to bounce over the boards into water hazards, are an absolute joke.

The original idea was that each TPC course would be designed by a well-known architect, who would be assisted by a Tour player functioning as a consultant (in some cases, two players). The theory was that the consultant would offer playability suggestions so that the final result would be liked by the people who actually had to use it, but it didn't work out—simply because the architects had wax in their ears.

Time after time, the guys on the Tour would hate the new TPC courses, and blame the player/consultant, who would say, "Look, I suggested this or that, but the architect didn't listen to me."

And then the sportswriters would fuel the controversy

by writing about the prima donna players on the Tour crying about their own golf courses. But the fact was, they *were* poorly designed. They didn't reward creativity, they were predictable in their sameness, they weren't fair, and they weren't fun.

When I won the Sammy Davis Jr.-Greater Hartford Open in 1984, I was openly critical of the TPC of Connecticut course at Cromwell, which had been redesigned from a traditional Scottish-type course into a target golf course.

In the press conference, I said I was thrilled to win the tournament because of the great tradition of the event and Sammy Davis' long-time involvement, and because of the wonderful people of Hartford, who were as supportive as any golf fans in the country. But I questioned the redesign of the back nine. I didn't like it at all. And then, throwing diplomacy to the wind, I listed all the reasons why.

Gordon White, a writer with *The New York Times*, told me after the press conference that it was the first time he'd ever heard a pro win a golf tournament and then criticize the course.

Fortunately, we've softened the design of many of these abominable target courses, and most of the TPCs are now much improved over the first go-round. That includes the course in Cromwell, Connecticut, which is now excellent. A decade from now, I think target golf will be looked back on as the disco music of golf course architecture. We'll simply laugh and wonder how we could ever have been so light-headed.

I hope the architects we select from now on will put those railroad ties where the sun doesn't shine and return to the wonderful traditions established by men like Donald Ross, Dr. Alister Mackenzie, and A. W. Tillinghast.

We don't need to reinvent the way golf is played. It's been a pretty darned good sport all along.

Another area in which the Board needs to become much more aggressive is the problem of slow play. It's gotten progressively worse through my years on the Tour, and we never do much more than talk about it. We were talking about it during my first term in 1983, and we're still talking about it today.

The increase in prize money is certainly a factor. Because players realize the importance of every shot, they take as much time as they can to avoid making errors of judgment.

I'd guess the average round on Tour these days is four hours and thirty minutes when we play threesomes, and three hours and forty minutes when we play twosomes. It's not uncommon for us to play the first hole, and then wait ten minutes on the second tee. We then play the second hole, and wait five or ten minutes on the third tee. It's ridiculous how bad it's gotten, yet the Tour has gotten away from the two-shot penalty for slow play. The only penalty in recent years is a piddling fine of five hundred or a thousand dollars, and I can't remember the last time a fine was levied. Besides, one thousand dollars doesn't exactly strike fear in your heart when you're playing for top prizes of $180,000 or more each week.

The two-shot penalty would be far more effective than a small fine, because if you're in contention and are warned about slow play, you know two shots could cost you a victory and all the perks that go with it.

The Tour has come up with a pace-per-hole formula for monitoring play, but it hasn't worked, and it's too hard to

police, anyway. None of the tournament officials likes putting a stopwatch on the players. Besides, our officials are too valuable as rules experts to be wasting their time as speed cops.

We ought to institute the simple practice of keeping up with the group in front of you. It's the way I was taught to play by my father, and it's still the best rule of thumb. If your group falls more than a hole behind, it should be given one warning, and if it doesn't catch up quickly, all players should be given a two-shot penalty. Believe me, peer pressure within a threesome will take hold if one player is dragging his feet.

It would also help if the Tour went back to the practice of "ready golf," as opposed to "who's away?" It's something we do when a player has to change his shoes at the turn, or use the facilities, so why not do it all the time? If *we* did it, the golfing public would follow suit and play would speed up all over the country.

I also think too many Tour players waste time around the greens by not lining up their putts until it's their turn. At least ten minutes can be saved during each round if players were more time-efficient around the greens. Maybe the Tour should just do a video of Lanny Wadkins and Jim Gallagher, Jr., playing three holes on a normal day, and give it as a model to each player who makes it through the Qualifying School. That might solve the entire problem.

While I'm striding around on that soapbox, I believe certain existing restrictions on Tour players need to be reviewed and revised. The first of these deals with a player's right to appear on television. Basically, when you join the PGA Tour, you turn over your rights to play golf on

television to the Tour's discretion. This can be unfairly restrictive at times.

Let's say I want to have three fellow Tour players join me on a weekend when we're not competing to have a memorial tournament honoring my father. And let's say all proceeds will go to junior golf or cancer research or the Muscular Dystrophy Association. Additionally, a local television station wants to broadcast the event. Well, I can't do it because it's against the by-laws of the Tour to play in any other event from Wednesday to Sunday when a Tour event is being played.

A tournament like our Fred Meyer Challenge is okay under this rule, because it's played on Monday and Tuesday. But it's hardly cheap. This year we'll have to pay the PGA Tour $140,000 for the right to have our tournament televised on ESPN.

Basically, the Policy Board has decided that to protect the PGA Tour's ability to get on TV and to negotiate the proper rights fees, they have to prevent an influx of golf tournaments from being televised. The irony is that many of these events are developed by their own players, such as Jack Nicklaus Productions, and Greg Norman's fun event of a few years ago, which pitted him against Wayne Gretzky, Ivan Lendl, and Larry Bird.

While I understand the Tour wanting to prohibit the flooding of the market, I believe more golf on TV builds a greater interest in the game. After all, people watch an event on television because it excites them, not just because it's a PGA Tour event. Evidence of this is the long-running success of the *CBS Golf Classic* and *Shell's Wonderful World of Golf.*

Another area I find restrictive is the PGA Tour's ability to prevent a player from competing overseas. There's an unwritten rule of thumb: you get to compete in one over-

seas tournament for every five regular Tour events in which you play. If you play in the required fifteen tournaments, you're allowed three overseas events. But there are inconsistencies in the way these approvals are given by the PGA Tour. Some players have never asked for a release in their long careers on the Tour, and when they do request one the first time, even if it's for a non-televised one-day pro-am, they're sometimes turned down. On the flip side, some highly successful major-championship winners get released for four or five overseas tournaments, a few above the limit. And some of the big boys don't ask at all and still go!

Put simply, the control of these releases is inconsistent, unfairly preferential, and shouldn't exist at all. All our players are proud members of the PGA Tour and would never do anything intentionally to hurt it or its future marketability.

While you may see a Fred Couples go overseas and receive tremendous appearance fees to play—as much as $150,000 for a single tournament—Fred also knows where his bread is buttered, and that's on the PGA Tour. Couples would not abuse the privilege if there were greater flexibility, because he knows those appearance fees exist primarily because of his Top Dog status in America. If he slips down the money list in the U.S., there are plenty of guys anxious to jump into his spot, and then the overseas guarantees would be there for those players, and Fred would have to work his way back up.

If anything, Couples' appearances in Europe improve the marketability of the PGA Tour over there, much as the Dream Team's participation in the Barcelona Olympics enhanced the worldwide stature of the National Basketball Association.

The fact is that the various world tours, be they men's

or women's or seniors', revolve around the three American tours. While the European Tour has grown stronger, and is doing very well, it still falls behind the U.S. Tour in the number of good players, and in the organization of the whole show. The PGA Tour is the undisputed jewel, and I think the Commissioner has to show more faith in the judgment of our players to do what's right.

The bottom line is that it is the players in any sport who make it popular, not the administration.

I also have a few thoughts about the four major championships—those special tournaments that draw all the fanfare and are the most valid gauge of determining greatness. Each of the majors has its own unique identity, with one exception—and I think that can be rectified.

Let's start with the Masters. For tradition, beauty, and excitement, it's in a class by itself. It's the only major played on the same course each year, which gives it a sense of nostalgia and history unrivaled by the others. It's also the greatest offensive show in golf: there's no rough, the par-fives are all reachable, and the back nine is eminently dramatic, from Amen Corner to two par-fives where both eagles and double bogeys are possible. The electricity in the air on Sunday is unmatched in all of golf.

If the Masters is an offensive show, the U.S. Open is the greatest defensive test in golf. This was demonstrated by Tom Kite's win at Pebble Beach, in which every par felt like a victory. The winds were howling, the greens were like linoleum floors, and the rough felt as if you were walking through a burial ground for sheepdogs. There was no moisture at all on the course—each blade of grass had cotton-mouth—so the ball would not stop on the greens, which meant you were scrambling for par on every hole.

And that's precisely what the USGA has in mind—to make par a precious figure. I don't have a problem with that. It's their show, and that's fine.

The third major, the British Open, is totally different. It's played on a rotation of seven seaside links, magnificently natural courses with no trickery. No one tries to grow rough; they take whatever is there. There are huge sand dunes, and hardly any grass on the fairways, much less the greens. It's totally un-American, which I think is great, because it demands more creativity. The British and Scottish courses bring bump-and-run and the art of chipping back into golf for the ugly American.

Ken Venturi told me he goes to Ireland for two weeks each year so he can learn to play golf again. After playing so much target golf in America, he said, he almost forgets that the ball is round and was meant to roll on the ground.

The best thing about the fourth major, the PGA, is that it offers forty spots to PGA club professionals, who are the backbone of golf in this country. Those fellows teach the game and sell the game to the average fan who comes out to watch the Tour, and they do much more to promote the sport of golf than the Tour players. For them, the PGA is a chance to prove to their club members that they can play good golf, as well as administer all the other responsibilities of their job.

However, the PGA Championship needs to be rethought, because at present it is the only major tournament with no individuality in its course set-up. It's perceived as a U.S. Open–wannabe. The PGA sets up golf courses just as the Open does, with baked-out greens and pet-cemetery rough.

It's actually very simple to practice for the U.S. Open and the PGA, because you know if you miss the green you have only one or two shots to play: a blast out of a bunker,

or a lob wedge that you hack out of long grass. A player may have an arsenal of different chip shots, but he won't need them for these two tournaments.

David Feherty editorialized on this very issue in *Golf World* magazine shortly after last year's PGA. In describing how you must hit a shot out of abominable rough around the greens, David wrote: "You're reduced to a hundred-yard swing with your buttocks clamped at 2,500 psi, hoping that the recipient of the venomous swipe doesn't fly out like a wounded snipe across the green straight into the very same crap." How funny. How true.

I'd suggest the PGA let the USGA have the patent on rough around the greens, and by mowing the fringes bring back the craft of pitching and chipping. It will be more fun for the players and more interesting for the fans.

In addition, both the Open and the PGA often go to a great course and then dishonor it by making changes, such as turning a medium-length par-five into a 480-yard par-four, or doing something unusual that essentially alters its nature. I would argue that if you select a great course to host your tournament, you should respect its greatness. Making those changes is like hosting an art show and saying, "For this special show, we're going to turn Leonardo Da Vinci's *Last Supper* into a Texas barbecue, and add one arm to the Venus de Milo, so she can embellish the product of our corporate sponsor, Rolex."

While I do understand that technology changes through the years and that the golf ball does go farther, these courses are masterpieces and shouldn't be tampered with.

I would also recommend they rethink the way the fairways are cut at the PGA. At Bellerive in 1992, and in most PGAs, they usually have 26 to 30 yards of fairway, and just one mower-cut (four to five feet) of perimeter rough, before you get to the cabbage. This isn't the best way to do

it, because a straight driver who mis-hits his tee ball a little bit will jump and roll easily through the perimeter rough and then stop one foot into the cabbage—with no shot. Meanwhile, a wilder driver, who missed the fairway by twenty yards right or left where the gallery's been walking, will often land in tromped-down grass and have an easier shot. I'd suggest cutting the fairways slightly narrower, then having maybe eight to ten yards of perimeter rough on either side. You'd still have the same general width of playable grass, but the straighter driver won't be penalized as much as the wild one.

Finally, I'd suggest that the PGA Championship go back to being played on national treasures that haven't been seen in a while, rather than on so many new courses, as has been the trend in recent years.

I just don't think a tournament with such a long history and tradition of its own wants to be thought of as *U.S. Open: The Sequel*.

CHAPTER 12

Bringin' 'Em Home

ALL THESE SUBJECTS I've been expounding on became of even more interest to me in the last few years, because I took on some new challenges: I helped start a tournament and co-designed a golf course.

My desire to bring the stars of the PGA Tour back to my hometown had its roots in the old Portland Open. My first memory of that event was as an eight-year-old kid, standing in a downpour on the driving range at Portland Golf Club with my dad.

We were watching a large man with a crewcut hit golf balls, and no one else was around. I remember Dad was totally immersed in studying this golfer's technique, and the fact we were getting drenched didn't bother him in the least. I wasn't nearly as interested and started to cry. It was a Saturday and I wanted to get home and watch *Flipper* and *The Jetsons*.

I guess the large man heard my whimpering, because he stopped practicing and came over and held an umbrella over our heads. He said something to Dad like, "Looks as

though you've got somebody here who doesn't want to be here."

The man and my dad chatted for a while, and then Dad finally gave in and took his snot-nosed kid home.

I would learn later that the golfer who had been so considerate was Jack Nicklaus. He was in his rookie year, a season which would see him win the U.S. Open and—wouldn't you know it—the Portland Open. When you're eight years old, you're not easily impressed.

Two other golfing events in my youth had a big impact on me. In 1969, Portland Golf Club hosted the Alcan Golfer of the Year tournament. I was then fifteen, and golf had long since surpassed cartoons as my favorite passion. Neither rain, nor sleet, nor dark of night would keep me from watching the world's best golfers in my backyard.

I remember the Alcan had an incredible finish that year. Billy Casper birdied the last four holes and came from six shots behind to nip Lee Trevino by one for the title. Trevino hit an eight-iron into the bunker on number 17, left it in there a couple of times, and made a triple-bogey six. First prize was $55,000, the richest in golf, and second dropped all the way down to $15,000. I also remember Trevino joking and being gracious despite what was probably the worst collapse of his career.

Then in 1970, the U.S. Amateur was held at Waverley Country Club, my home course, and I worked on the greens crew. My job was to oversee several holes and make certain the bunkers were raked and all divots were replaced. Lanny Wadkins made a 25-footer on the 72nd hole to edge Tom Kite by one shot. An eighteen-year-old phenom named Ben Crenshaw, whom I was anxious to watch play, had to withdraw due to a bad back.

During my college years and early years on the Tour, I regretted that the people of my home state no longer had

the opportunity to witness up close the best golfers in the world. I resolved that if an opportunity ever came up to do something about it, I would. That time came in 1986.

Mike Stoll, a Portland businessman, and I conceived the idea of having an event that would do just that. At first I thought the only possibility was a one-day, Monday pro-am, but Stoll wisely talked me into a 36-hole two-day event. The two keys to making it happen were getting Arnold Palmer to agree to play (which drew several other top players), and the willingness of the Fred Meyer Corporation and their CEO, Mr. Oran B. Robertson, to sponsor the tournament. The Fred Meyer Challenge was born.

It's been extremely gratifying over the last seven years to know that I had something to do with exposing Oregon golf fans, and especially the young golfers of the area, to the same level of talent I watched growing up. It's also been great to see the wonderful spirit and cooperation of the more than 1,500 volunteers and my staff people at Peter Jacobsen Productions who run the event so beautifully each year. Most gratifying of all is that we've raised over $2.75 million for Portland-area charities.

Several of the traditions that are now so much a part of the Fred Meyer Challenge began that first year, such as the Monday night party. It's a big affair for about 1,500 people, and it's a chance for the contestants and other guests to let their hair down. While we may attend a number of so-called "parties" as professional golfers, we wanted to have a party in the true sense of the word—we wanted people to talk about what a great time they had for days afterward.

That first year we held a charity auction, which happened by accident. One of the premier items was Arnold's sportcoat, which was forcefully snatched from him by our aggressive auctioneers, Curtis Strange, Fuzzy Zoeller, and Greg Norman. They ended up getting a huge price for the

coat—a few thousand dollars—and it just spiralled from there. Fuzzy eventually auctioned his own coat, then his tie, then his shirt. By the end of the evening, he was dancing topless to the cheers of the crowd. The last I heard, Chippendale's talent scouts had not made him an offer.

Fuzzy's skin-show started a trend that culminated in our wildest party ever, in 1989. That was the year Curtis was coaxed into violating about sixteen Oregon state blue laws. I was onstage with Arnold and Greg and Curtis and we had made several thousand dollars auctioning off garments, when some lady from the middle of the room yelled out, "The heck with the coats, I'll pay $5,000 for Curtis' jeans!"

Strange understandably protested, but we weren't about to ignore five grand for a local children's charity. Curtis had had a couple beverages, as we all had, and there was an embarrassed grin on his face. The reigning U.S. Open champion really didn't want to take off his 501 button-fly Levis in public, but what with the headlocks and cajoling, we finally persuaded him. He went backstage, and moments later walked back out with his jeans in his hand. All he had on was his grabbers, with his shirt-tail out to around mid-thigh of his bare legs.

When the woman who made the offer saw this, she shrieked and came tripping up to the stage like she'd just been told to Come on Down at *The Price Is Right*. She was panting furiously and her hands were flapping around her head like she'd been attacked by African bees.

Peter Bonanni, the publisher of *Golf* magazine, was seated at a front table with two of my tournament staff, Eddy Ellis and Jim Whittemore, and Peter said, "I just hope no one has a camera here, because every one of those guys onstage is a playing editor for us."

Eddy said, "I'd say *playing* editors describes them perfectly."

We also started a tradition of close, exciting finishes that first year. There were just four teams in 1986, competing in a stroke/match-play format. The team shooting the better score won the match. Curtis and I were partners and we beat Zoeller and Fred Couples that first day, and were paired in the finals against Norman and Gary Player, who had beaten Palmer and Tom Watson. We had a one-shot lead going to the par-five 18th hole at Portland Golf Club, but we played the hole poorly. Curtis made six and I was left with an eight-footer to save par. But Norman and Player also had problems. Greg was fifty feet from the hole in three. It was just two weeks before that I had seen him lose to Bob Tway's bunker shot in the PGA, so I yelled to him, "Tway stole one from you. Why don't you steal one from us and knock this in?" To my amazement, he did.

He got a huge ovation, then Curtis turned to me and laughed, "Now look what you've talked yourself into. You've got to make that to tie."

Although that eight-footer meant absolutely nothing to the world of golf, it sure did to me. For the first time since turning professional, I was playing in front of my hometown. Fortunately, I shook that baby in, and we declared the two teams co-champions.

Another dream was realized in 1992 when we completed the construction of the Oregon Golf Club, a course I co-designed with Ken Kavanaugh. It became the new home site of the Fred Meyer Challenge, primarily because my long-term goal is to bring either the U.S. Open or PGA Championship to our city, and that would never have happened at Portland Golf Club, a wonderful course that isn't big enough to accommodate an event of that magnitude. All of our design features at the Oregon Golf Club—from the golf course to parking facilities, clubhouse, and practice areas—were done with the express

purpose of some day hosting a major. With the Fred Meyer Challenge played there annually now, the course will become familiar to the Tour's best players, and to the whole country on national television.

As my youthful interest in playing golf developed, so did my fascination with the artistry of golf course design. I used to make drawings of golf holes during class at Ainsworth Grade School. Later, at Lincoln High School, I would make aerial maps of all eighteen holes and then give the courses unusual names, such as Anchovie Country Club, or Skunk's Breath Municipal. Then I'd hang the drawings in my bedroom and study them, to see how they might be improved.

Coincidentally, the kid who sat next to me in home room in grade school was also preoccupied with illustrations. His drawings were of people, in particular his family, which included his father Homer and his sister Lisa. His own character he called Bart, a variation of Brat, which rhymed with his first name. He called them the Simpsons, and his name was Matt Groening. I wonder what ever became of him?

Although Matt was far more introverted than I, we got along very well, because we both had a slightly twisted view of life. Maybe it's all the rain in Portland. Anyway, I'm hopeful that some day Bart Simpson will become the official trademark of the Challenge, much like Snoopy is for the AT&T Pebble Beach National Pro-Am. (Note to Matt: if you're reading this, call me—collect. We need to do lunch.)

I'm like all golf course designers in that my design tendencies reflect my personality, and my likes and dislikes. I think a golf ball should roll to its natural stopping point,

and not always be interrupted by sand traps and water hazards. I therefore employed a minimum of adjoining hazards at The Oregon Golf Club. Most sand traps aren't hazards in the truest sense of the word. Traps usually provide a much easier shot than the player would have had if the ball had kept rolling. Tour players today are so proficient out of sand that they love to see an errant shot go in a trap. It's about two out of three that they'll get it up and down.

When we designed The Oregon Golf Club, I wanted to employ the natural slopes on a hilly piece of property. I tried to leave runways off the sides of the greens, so that a hard-running iron shot, poorly struck, would not be saved by a sand trap but would roll down an embankment, leaving a challenging chip shot.

I wanted the course to reward strategic golf and pay dividends to a player with a good touch. Like tennis or Ping-Pong or billiards, golf should require a lot of feel, so that the force with which you strike the ball determines its outcome. I also wanted to make creative chipping a requisite to scoring well. I was not surprised at all that the first players to win the Fred Meyer Challenge at its new home were good ball-strikers and course-managers, Tom Kite and Billy Andrade. Two other players who fit the same mold, Corey Pavin and Steve Pate, finished second.

The greens were extremely fast—twelve on the Stimpmeter—but they were fair. The players liked the fact that we didn't trick them up with big humps and mounds. Steve Elkington appreciated that they had a minimum of slope, and Pavin said, "Those were some of the best greens we've seen all year. Augusta National's are the only ones comparable." The players were very gracious and most felt the course could be a suitable site one day for a major championship.

I gained a great respect for golf course architects from my work on The Oregon Golf Club. There's so much involved that doesn't meet the eye, from studying topographical maps to solving drainage and engineering problems. It's incredibly time-consuming.

I currently have two other designs under way, Genoa Lakes GC in northern Nevada, and Creekside Golf Club in Salem, Oregon. I'd like to do more if the situation is right, but again only as a pastime. My principal goal continues to be playing as well as I can on the PGA Tour, and, as always, having fun along the way.

CHAPTER 13

Breaking Out of the Mold

"FUN ALONG THE WAY" is as good a way as any to introduce the subject of a certain infamous rock band, beloved by millions around the world. I'm speaking, of course, of Jake Trout and the Flounders.

Who? Let me explain.

I've been a music lover all my life. I enjoy just about every type of music, from country to blues to rock and roll, and my favorites include a pretty wide spectrum: Bruce Hornsby, Huey Lewis, Bonnie Raitt, Jethro Tull, Genesis, Ivan Neville, Dan Fogelberg, and Elton John. I even pick at a guitar occasionally, but I'm about a fifteen-handicap on the strings, and that's with mulligans.

One of my favorites growing up was Alice Cooper, who was as outrageous a rocker as you'll find. He painted his face and dressed weird and did all sorts of grotesque things when he performed, so it should come as no surprise that

his favorite hobby is golf. One of these days I hope to play in a pro-am with Alice, whose real name is Vincent Furnier, just to tell him how much I liked his music.

My being a fan of his demonstrates that kids can enjoy rock music without carrying it any farther, because I've never been really big on wearing mascara and eye-liner. I think too often parents use rock music as a scapegoat for their children's problems, but I'll withhold further opinion on that until I become Brother Peter and open a television ministry and theme park with a toll-free 800 number.

When I would mess around with a guitar as a kid, I naturally dreamed of one day being a rock-and-roll star, and my friends and I toyed with the idea of forming a band. With all of our attention focused on girls and golf, however, we just never found the time.

Oddly enough, it was the PGA Tour that finally gave me the opportunity to rock out in front of an audience. In 1987, Commissioner Beman approached Larry Rinker, who plays a mean guitar, and asked him if he could provide some entertainment for the annual players' family clambake at the Players Championship at Sawgrass. Larry asked me if I would get involved and we also talked to Mark Lye (another guitarist) and Payne Stewart, who's a killer on the harmonica.

Larry had some musician friends in Jacksonville, including a keyboardist and a drummer, and we all practiced together outside one of the banquet halls in the lobby of the Marriott at Sawgrass.

Obviously, we couldn't get too sophisticated, so we stuck to two songs that everyone knew—"Twist and Shout" and "La Bamba." We rephrased the words to "La Bamba" to use the names of the Spanish players on the Tour. So the main chorus went "Na-na-na-na Lee Tre-vee-no," and then we strung in the names of Chi Chi Rodriguez and Eduardo

Romero and Ernie Gonzalez. It was every bit as ridiculous as it sounds here, but we knew if we hammered it up enough we could pull it off. And we did.

I was designated as the lead singer, probably because I was the least proficient musician, and because I had the highest embarrassment threshold. I could also come closest to being on key, whatever key we were in. Anyway, we wore sun glasses and put our collars up and tried to fantasize that we were a real rock-and-roll band. The crowd of about 200 players, families, and officials took it in the right vein and really got into it. They stood up and cheered us, and several of the kids circled the stage and clapped their hands, and we had a blast. I thought about ripping off my shirt and doing a flying Wallenda trapeze dive into the crowd, à la Jim Morrison, but two things held me back: my love handles.

While our impromptu concert was good family entertainment, the same can't be said for the way we got our name. People often call me Jake, and Curt and Tom Byrum suggested that since a "peter" is actually a one-eyed trouser trout, I should be christened Jake Trout. John Cook also deserves some credit (blame?) for my stage name.

Mark Lye was looking up definitions in the dictionary one day, and trying to find something "fishy" that tied in with golf. He discovered that a flounder was not only a flatfish of the families Bothidae and Pleuronectidae, but an intransitive verb that meant "to proceed clumsily and in confusion." Obviously, this was the perfect name for our group. So there you have it, the heretofore untold story behind the naming of the best—and only—rock-and-roll band ever comprised of PGA Tour professionals. (I'll bet you're sorry you were ever curious.)

Later on, Rinker suggested we put some music down on tape, so we went over to his house and recorded some stuff

with John Inman, who is a good piano player. Naturally, we thought it sounded pretty good for a bunch of amateurs. We were sort of like beginners at golf, who after a round tend to remember the good shots more than the bad ones. Everything about the recording that stunk, we just ignored.

A few months later, we had another jam session at the Buick Open in Flint, Michigan. Danny Briggs played drums, and Willie Wood and Scott Verplank were also there. It was then that we realized that we couldn't get too serious about this stuff. It wasn't as if I could stand up there and croon "Let It Be" or "Bridge Over Troubled Waters" and expect people to be moved to tears—unless it was tears of pain. We couldn't harmonize like the Temptations or move and groove onstage like Archie Bell and the Drells. We were, after all, just a bunch of vagabonds who wore polyester pants for a living. So we decided that if we were going to do this as a hobby, we had to make it funny, and we had to tie it to golf.

Mark Lye and I started taking popular songs and messing around with the lyrics so they'd pertain to our profession. We worked independently at first, then together, sort of a poor man's version of Lennon and McCartney. No, poor doesn't get it. More like destitute.

Mark re-penned "Cocaine" by J. J. Cale to be "Slow Play."

"When you're in a rush, nothin' bothers you as much as Slow Play . . . Don't let it happen today, I gotta catch me a plane, Slow Play . . . We don't like, we don't like, we don't like . . . Slow Play."

Next Mark did "Square Grooves are Goin' " to the tune of Warren Zevon's "Werewolves of London," a play on the square-groove controversy that has dogged the game of golf these past four years.

Then, over at the Kapalua International in Hawaii, I was hanging out at the beach with entertainer Scott Record and we made up the lyrics to "Don't Worry, Keep Swingin'," giving Bobby McFerrin a real run for his money.

"I just saw that shot you hit . . . you're playing so bad you want to quit . . . But don't worry, keep swinging' . . . You just hit your ball into some trouble . . . If you don't chip out, you'll make a double . . . Don't worry, keep swingin'."

Lye had introduced me to two of his good friends, Duck Dunn and Steve Cropper, both of whom play with Booker T and the MGs, and played with The Blues Brothers. Duck and Steve are nuts about golf, and they agreed to perform with us. Shortly after that, I rewrote the great Otis Redding song "Sittin' on the Dock of the Bay," which had been co-written by Cropper. My version was called "Hittin' on the Back of the Range." It went like this:

"Hittin' in the morning sun / I'll be hittin' when the evening comes / Watching all my shots in flight / Knowing I ain't doing it right . . . I'm just hitting on the back of the range / Making a swing that feels so strange / Hitting on the back of the range / Not making a dime.

"I shanked a shot on seven / Chunked a wedge at number nine / three-putted number eleven / I think I'm gonna lose my mind . . . I'm just hitting on the back of the range / trying to be like Curtis Strange / Hitting on the back of the range / Not feeling so fine."

I was relieved that Strange had won the eighteen-hole playoff in the U.S. Open that year, because it's hard to find words that rhyme with Faldo.

When we decided to record all these songs for an album, we did it under out own label, Course Records. Naturally, we had to contact the original artists and music companies to get their permission. My friends Huey Lewis and Bruce

Hornsby, who are golf nuts, enthusiastically gave us the okay. "I Want a New Drug" became "I Want a New Glove," and Hornsby's "Defenders of the Flag" was adapted to "Attackers of the Flags." In fact, when we've attended their concerts from time to time, Bruce and Huey have dedicated songs to us and sung a few of *our* lyrics rather than their own.

But not all musicians we contacted were as gracious. We had changed Randy Newman's "I Love L.A." to "I Love to Play," but apparently Randy didn't want to play, because he turned down our request. I found that surprising, because nearly all of Newman's music consists of parodies anyway, like what we were doing, from "Short People" to "It's Money That Matters." Apparently, Randy is better at dishing it out than taking it.

The other one who snubbed us was Neil Young, whose brother, I had heard, is a golf professional. We had redone his song "This Note's for You," which was a knock on musicians who sell out to corporate America, and written "This Shot's For You." But Neil invoked the stymie rule and proved that he doesn't really have a Heart of Gold.

A friend named John Baruck, who represents several rock acts, including REO Speedwagon and Gino Vanelli, helped us produce the album. John is a great guy and truly a degenerate golfer, because all he wanted for his trouble were free balls and gloves and pro-am tickets, plus an occasional lesson. God bless the barter system.

We recorded at Pegasus Studios in Tallahassee, which is owned by Lye's friend Butch Trucks, the drummer for the Allman Brothers. Butch was also very cooperative, selling us studio time for just a little over his cost. (Butch Trucks helps Jake Trout—sounds a little like a vignette from *Sesame Street*.)

We hired the personnel at Pegasus, and we were backed

by a group of talented Memphis musicians, Ross Rice, Kye Kennedy, and Steve Ebe. All the instrumentals were first class; then they sort of got ruined when I put the vocal tracks over them. But then, nobody would have believed it was us if everything sounded perfect.

If the tape does get your fingers snapping, and isn't too abrasive on the ears, it's because Payne and I did what all true blues musicians do before they record—we got shit-faced. That wasn't our original plan, but when we got to the studio for the big day, and saw all those professionals in there wondering what the hell these two golf bums were doing, we both got nervous. Although it was before noon, Payne said, "Look, I can't do this sober. This is one shot I've never practiced."

It's interesting to consider that here was a guy who could hit a perfect putt to win the PGA or U.S. Open with about twenty million people watching, yet with just a few musicians present, he got the yips with a mouth organ.

Anyway, we made a run to the liquor store in Tallahassee, bought a couple of sixers of Michelob Light, and Payne bought a tin of Red Man. It was the perfect attitude adjustment to prepare for our professional recording debut.

When all the tracks were laid down and post-production had been completed, we came out with just 5,000 copies of the tape. Our expectation level was not very high because we didn't know if we could move even 100 of them. To the surprise of absolutely everyone, however, we've sold nearly 20,000 copies so far. This proves either that P. T. Barnum's line about suckers being born every minute is true, or the damn tape isn't that bad after all. I'd prefer to think the latter.

Certainly part of the tape's success is that everyone out there who watches golf knows that those of us who play the Tour can shoot great scores from time to time, but they

want to see the other side of our lives as well. Professional golfers are often criticized for being robot-like, or cookie-cutter impressions of one another, so when we show a more human side, people get interested.

Everyone's seen Payne Stewart striding to victory in his knickers, so it's refreshing to see him in crazy sunglasses getting funky on the harmonica. And Mark Lye, who's sort of a bouncy, energetic guy on the golf course, is a mellow fellow when he's working that guitar. Maybe I'm the least surprising guy in the group, because people expect to see my gums flapping.

Most gratifying of all is when people tell me they bought the tape as a gag, or as a fun gift for another golfer, but then really enjoyed the music when they listened to it.

We got a big publicity boost in the summer of 1989 when former CBS announcer Bob Drum, on his segment "The Drummer's Beat," did a feature on Jake Trout and the Flounders playing at the pro-am party for the Federal Express St. Jude Classic in Memphis. They showed us jamming at the party, and then did interviews with us. I'm glad Drum didn't ask for a percentage of our cassette sales, because it sold like hotcakes after that.

Our biggest gig ever was in Naples, Florida, at a pro-am hosted by Lye and his good buddy Glenn Frey, formerly of the Eagles. Jake Trout and the Flounders played golf during the day and performed outdoors that night in front of 15,000 people on a ticket that included Frey, Jack Mack and the Heart Attack, Vince Gill, and Jimmy Buffet. When we were introduced that night, I'm sure many of the concert-goers probably thought we were hosts of one of the Saturday morning fishing shows on ESPN. But they didn't throw us overboard. In fact, we got a nice ovation.

Curiously enough, on two of the occasions when the Flounders performed, I have had two of my best tourna-

ments. I went on to finish second to Jodie Mudd at Memphis that year, losing by one shot. Then in 1989, we opened the show at Kapalua and did our last three songs with the entire Blues Brothers Band backing us up. Two days later, I won the tournament, beating Steve Pate in a playoff.

I bring up those two occasions because I'm often criticized for getting involved in too many activities, the claim being that these hobbies hurt my golf game. The truth is that my outside interests keep me enthused about golf, and help me to play better. If all I did was play and practice, I might go a little crazy. As much as I love golf, there's a whole lot more to life than fairways and greens.

There is a downside to doing something colorful and fun as a professional golfer, though, and that is when people don't know where to draw the line between my occupation and my hobby. People frequently yell "Hey, Jake Trout!" at me on the golf course, or ask me how I learned to play the harmonica or some other instrument I don't play, or ask when our next album is coming out. If I'm preparing to hit a shot at the time, I have to back off and try to regroup. I know the person is just trying to be friendly, but it's difficult for me, because I can't shift gears that fast.

In response to the next album question, all I can say is that Mark and I have rewritten enough good songs to fill another one, and if time permits, we'll probably do it. I think one of the next songs will be a parody of Pink Floyd's "Another Brick in the Wall." We'll call ours, "Another Nick in the Ball," and dedicate it to all our pro-am partners.

As I mentioned earlier, this desire of mine to break out of the stereotype of the boring touring pro has gotten me into trouble from time to time. I can think of no better example than the stunt I pulled during the final round of

the Western Open at Butler National in 1990. A little background is in order here.

As you may know, I live in Portland and am an avid fan of the Portland Trailblazers. I've watched them go from an expansion team in 1970, to the world championship with Bill Walton and Maurice Lucas in 1977, through some more lean years and back to where they're now one of the top teams in the NBA. As a result, I was very proud that they made the NBA Finals against the Detroit Pistons in 1990. The championship series was underway the same week as the Western Open.

Now, some golf fans may also recall that Butler National had been a bittersweet venue to me the prior two years. In 1988, needing only a par on the 18th hole for an outright victory, I hit my second shot into the proverbial watery grave over the green and in the process snatched defeat from the jaws of victory. As the saying goes, every shot makes someone happy, and I had caused a little-known professional named Jim Benepe to become well known with that shot. Jim not only won the tournament, but became an exempt player for two years and got all those nice perks that go to tournament winners, such as invitations to the Masters, Tournament of Champions, and World Series of Golf.

The next year, 1989, I lost a Monday morning sudden-death playoff to Mark McCumber. So I had a higher than normal profile with the Chicago area fans. They viewed me as something of a tragic figure, sort of a poor man's King Lear, for lack of a better analogy.

In 1990, I had started the final round of the Western six strokes behind 54-hole leader Wayne Levi, but I really got it going and after birdieing numbers 12 and 13, I was six under par for the day and had moved to second place. I was still well behind Levi, who was blitzing the field, but I was

looking for my third good finish in three years at Butler.

I decided to have some fun at that point and show the fans and a national television audience where my sympathies rested. I pulled a Portland Trailblazers souvenir jersey out of my golf bag and put it on over my shirt. I then proceeded to birdie the 14th hole, wearing the jersey.

The fans couldn't believe what they were seeing, and I knew the CBS announcers couldn't ignore it in the booth. I was having a blast with it, because I knew my golfing Blazer friends, like Clyde Drexler, Terry Porter and all the Portland faithful, would get a kick of it, and it was just another way of showing the fans that all of us pros have a life outside golf. As I walked down the fairways, I could hear people saying things such as, "What's this guy doing?" or "Go Blazers," or "Go Pistons," or, in one instance, "What a jerk!"

Most of the Chicago fans were polite and supportive, perhaps because they also had practice rooting against the Pistons, who had eliminated their beloved Bulls in the playoffs that year. And after the round, in which I shot 68 and finished third, I got a good-natured ribbing from the media, who understood that what I had done had been in good fun.

It was the next week, at the U.S. Open at Medinah, that a delayed reaction to the jersey incident really blew up in my face.

I've always considered my game well-suited to U.S. Opens, and in fact, of the twelve Opens I've been privileged to play in, I've made eleven cuts. The one cut I missed was that year at Medinah.

The first omen that it wouldn't be my week was when the shaft of my driver snapped on the practice range on Tuesday. I couldn't find a replacement that I trusted, so I played all week using a three-wood off the tee.

That little problem was nothing compared to the reaction I got from the fans. A picture of me wearing the Trailblazer jersey had run in all the Chicago-area newspapers, and the rest of the country had seen it on CBS, so to quote a song from my youth, there was "nowhere to run to, baby, nowhere to hide."

The U.S. Open is different from most tournaments, in that golf fans fly in from all over the country, so it's truly a national gallery. And the folks that had flown in from the various regions all had their favorite NBA teams. These people, I'm here to tell you, were loaded and cocked and ready to fire on me. It was vicious at times, with fans vocally expressing their displeasure with the Blazers, or their support for the San Antonio Spurs or the New Jersey Nets. I mean, the Open is tough enough on your nerves without getting heckled on every hole.

By the time the tournament started, the Trailblazers had lost in the Finals four games to one—including three straight in Portland—so I heard various terms of endearment, such as "The Blazers Suck," "Portland Sucks," "You Suck," "Your Wife and Kids Suck," "Your Dog Sucks."

Come to think of it, we don't have a dog, just two cats.

Anyway, I played the first two rounds with Ian Woosnam and Fred Couples, and Ian turned to me at one point and said, "You know, I thought our English football (soccer) crowds were bad, but this is worse."

I was literally getting barbecued every step of the way. I can only compare it to one of those rides at Disney World, in which each time you pass a certain point, a monster jumps up and startles you. Walking down those fairways at Medinah was an E-ticket on the Jungle Ride. As soon as I'd pass a group of people, they'd feel it was their turn to speak, and they'd jump up and fire away. Obvi-

ously, not everyone was demeaning—some were actually cheering me on—but it's the nasty ones you remember at times like that.

In the second round, I was safely under the cut line with three holes to go, but then I bogeyed the 16th and 17th holes. Now I needed a par on number 18, or I would miss my first-ever cut in an Open. I drove into the right rough, but fortunately had a decent lie for my second shot.

When you drive a ball off the fairway, and fans scurry around the ball to get a vantage point to watch your recovery, you are really challenged to maintain your patience and composure. This is where golf is like no other sport.

In basketball, when a player dives for a loose ball, he lands in some pharmacist's lap. Of if he's lucky he lands on a cheerleader. But at least he has the option of getting up quickly and returning to the court.

When you drive into the rough as a Tour player, however, you can't just jump back into the fairway. You have to gather all your powers of concentration to avoid making a big number. This is never easy. Having already hit it into the junk, you're not in a good mood to begin with, and then you have to deal with some of the fans rubbernecking around you, secretly hoping you'll play knock-knock like Woody Woodpecker and make a nine. Others behave as though you've ventured off the fairway for the express purpose of having a conversation with them.

Anyway, I had a four-iron to the green, and I needed to slice it around a tree out of a semi-flyer lie. I knew I had to make par to make the cut, so I was really bearing down. Just as I completed my pre-shot routine and was settling into my stance, some malt-liquor connoisseur yelled, "Hey, where's Kevin Duckworth when you need him? He might move that tree for ya." (Hiccup, burp!)

My thoughts at that time were a million miles from the

Trailblazers and Duckworth, but now I had to back off the shot and wait for people to quit giggling. When I finally hit the ball, it came out slightly fat and short of the green. I pitched poorly and missed my par putt, and all of a sudden I was down the road with an empty load.

Walking to the car after signing my scorecard, I was totally enraged at what had gone on for those two days. Here, I'd tried to do something amusing by donning that jersey—something I'd hoped would give the fans a kick— and it had backfired on me. I remember fuming to Jan, who was walking cautiously behind me, "Boy, I'm never going to show my support for anything again. If they want robots out here, then I'll become one."

About then, as Mike Cowan was putting my clubs in the trunk, a couple of guys walked by and one of them said, "Go, Blazers! They'll get 'em next year."

I didn't even think about the fact that he was trying to say something nice to me, I just knew I'd had it up to my gills with comments about basketball. So I turned and said, "Oh, yeah? Well, f—— you!"

Jan quickly shoved me in the car and said, "I've never heard you talk to anyone like that!" And fortunately, before the guy walked over to retaliate, we peeled out of there.

I didn't sleep much that night because I was angry, embarrassed, confused, and full of self-pity as well. Looking back on it, I hope that fellow I unloaded on will read this book and know I'm sorry. But there's not much chance of that. He probably holds me up there with Don King and Mike Tyson as one of the true gentlemen of sport.

CHAPTER 14

Wired for Sound

THERE'S A BUMPER STICKER that says, "Old golfers never die. They just lose their balls." I certainly hope that's not true, but if it is, thirty years from now I'm going to regroup with Jake Trout and the Flounders and go on the road performing the greatest hits of Little Anthony and the Imperials. I can see it now: a bunch of old farts in plus-fours singing falsetto.

Actually, most professional golfers never retire. They don't call press conferences, as Sugar Ray Leonard did three times, to announce that they're quitting, and they don't have farewell tours like John Havlicek or Kareem Abdul-Jabbar. Old golf pros tend to do one of three things: they go on the Senior Tour or retire to the broadcast booth or become inventors of golf gimmicks guaranteed to shave ten strokes off your game.

I had been asked many times whether I would eventually pursue a career in broadcasting, and with my new agreement with ABC Sports I'm looking forward to doing much more TV work this year, and at the same time playing a full

schedule of tournaments. I feel I still have many good years as a player, but then touring pros always think they're just a day away from finding the key to perfect golf. It reminds me, once again, of a scene from *Caddyshack*.

At one point, Murray's character has a pitchfork against a caddy's neck, and he's reflecting on having once "looped for the Lama." But the Dalai Lama was a little slow with payment, so Murray asked him, in his distinctive Carl the Greenskeeper slur, "Hey, Lama. How 'bout, ya know, something for the effort?"

And the Dalai Lama told him he was not going to give him money, but rather on his deathbed Carl would receive Gunga-la-Gunga, or total consciousness.

Eyeballing his captive listener, Murray said, "So I got *that* goin' for me."

One of the advantages to my working with ABC is that the network is giving me the best of both worlds, as an announcer *and* a player. I'm going to enjoy working with Brent Musberger, and I've been encouraged to have fun in the booth. So far, most of the TV work I've done has been as a roving reporter, breathlessly whispering compelling stuff such as, "He's got 178 to the pin, with a little breeze in his face. He's chosen a five-iron."

I've been told in the past that I come off much more conservative as a broadcaster than I do in person. Well, that will change in my new role as a color analyst, but I'm not sure I could totally unwind the way I do when I give a clinic or do impersonations. When people come to watch golfers offer instruction, or to see me mimic swings of the great players, we're the show they're coming to see. When people tune into a golf broadcast, they're certainly not doing so to watch the announcers. The golfers trying to win the tournament are the show. All of the broadcaster's

efforts should be toward enhancing the show, but never stealing it.

One of the problems with American telecasts is that there are so many announcers, the director must constantly switch from one to another, so that every thirty seconds we have to hear, "And now out to you, Bill," or "Back to you, Mike," or "Up to you, Fred." It's as if the microphone were a hot potato that no one can hold for long without getting burned. It doesn't necessarily have to be done that way.

I love watching golf broadcasts when I'm in Australia or Europe, because you often have one announcer speaking over a thirty- to forty-minute period covering several holes, and the effect is like a documentary, or a Herbert Warren Wind essay on golf in *The New Yorker*. It's as though you have one voice of reason weaving the story of the day, and if that announcer is good, like Peter Alliss or Alec Hay of the BBC, the viewer has a idyllic experience, much like playing an enjoyable round of golf.

Having been criticized by broadcasters as a player—only to hear the criticism several days later when I'm reviewing the telecast on a VCR—I'm sensitive to the way some analysts get tough on the players. I think an analyst should delve more into a player's mind, and explain what the player's tendencies are under pressure, rather than proclaiming, "That was a bad swing," or "That was a horrible putt," or "I can't believe he hit *that* shot."

Johnny Miller took some flak once for saying I was faced with a perfect opportunity to "choke" when I was hitting my second shot to the final green at the Bob Hope Chrysler Classic in 1990. He referred to the fact that I had

a long iron off a slice lie to a green with water all around. Well, he probably could have used a better word than "choke," but he certainly had a point. It was a damn tough shot. Fortunately, I pulled it off and won the tournament, or we might really have something to talk about here.

I must say, though, that, after reviewing the tape, I had a totally different perception of his comment. In context, it sounded as if Johnny was actually trying to protect me from criticism if I did dump it in the drink, because he appreciated just how precarious a shot it was.

Overall, Johnny is an outstanding broadcaster. He's honest, insightful, and funny, and he has absolute credibility with the players because of his great career, in which he faced about every situation a golfer could. He's won tournaments by fourteen shots, and bogeyed the last hole to lose. He's won by coming from way behind (1973 U.S. Open) and while leading the field (Tucson and Phoenix, in 1975) and he's had heart-breaking defeats (the Crosby and at least two Masters come to mind).

Gary McCord's a captivating announcer because he's unpredictable and irreverent, and because he works harder than anyone to get to know the younger players. He can even describe the tendencies of a first-year player who finds himself suddenly leading a tournament. And that's no accident. It's because Gary does more research on players than anyone in the business. He's in the locker room, and on the range, and going to dinner with guys, and basically just working his tail off so he can bring fresh insights to the viewers.

I especially like the "New Breed" segment on CBS, which has been done by both McCord and Jim Nantz. Features which reveal the personalities of the players can only help to humanize them and show that we're not all carbon copies of one another.

People are sometimes surprised at how Gary comes up with all his information. He simply has it stored in a lap-top computer, so if I get in contention and am hitting a shot on-camera, he can call up Peter Jacobsen on the screen and immediately know my likes and dislikes, whether I use an electric razor or a double-edged, what my favorite foods are, what I ate for breakfast, whether I held it down, the whole nine yards.

McCord also uses imaginative descriptions that the audience can understand, but that you appreciate even more if you've played the course. One of my first memories of Gary on the air was his description of a shot at the 16th hole at the Memorial Tournament. Someone had missed the green to the right and the pin was back left. I had played earlier that day and, believe me, the shot he was facing was impossible. Gary said, "Ladies and gentlemen, to illustrate how difficult this shot is, go out into your front yard and chip a ball from your lawn down onto the hood of your car and make it stop. Pretty hard to do, huh? Well, this is tougher."

I laughed and thought, hey, he's absolutely right. And yet I'd never heard a broadcaster say something that off-the-wall. McCord continues to come up with great lines week after week. Putts that lip out have gone over a "cellophane bridge," putts hit too hard have been "nuked," and a player who chunks a pitch shot is said to have splattered Hormel chili all over himself.

Gary's also a much better golfer than he gives himself credit for. In 1992, he won over $60,000 in the first three months, then basically retired to the booth. He also won an event on the Ben Hogan Tour one year by five shots. "They must have been embarrassed that I won," he said, "because they canceled the tournament the next year."

I also appreciate Ken Venturi, because he brings to a

broadcast a reverence for the history of the game and its traditions. And like Johnny Miller, Kenny has been there. I think it's great that Venturi and McCord are on the same network, because between them you get a nice mix of respect for the integrity of the sport, and a more contemporary look at the modern-day player. Their contrasting personalities remind me of the Smothers Brothers. I don't have to tell you which one is Tommy.

As I said, it's important for broadcasters to get to know the players and their tendencies if you're talking about them to a national audience. You want to understand their history of performing under pressure, and discuss each player's mental battle in the last nine holes of a tournament he's in contention to win.

I would also hope that in wearing my analyst's hat at ABC, I would never forget how difficult it is out there. When you're over a shot with a four-iron into a crosswind to a green that runs away from you, and you've got alligators left and pterodactyls right, and you've got to make a birdie to make the cut or win the tournament, your major orifices pucker up, believe me. And it never gets easier, no matter how many years you've been at it.

Part of the challenge of playing on Sunday, when you're in contention to win, is the exorcism of a band of demons that perch on your shoulder and entice you to recall every bad shot you've ever hit in a similar situation. Ideally, you have a few angels on your other shoulder to counter the attack.

As you face a difficult shot, the demons scream, "You aren't that good! You can't pull this off!"

And the angels reply, "You're a Tour player. You had to be good just to get this far. You've hit millions of great shots under pressure. You *can* pull it off!"

And back and forth they go:

"No, you can't."

"Yes, you can."

"No, you can't."

Until you want to scream, "Shut up and let me hit the damn thing!"

I guess when Johnny Miller talks about choking, he means letting the uncertainty in your ability prevent you from swinging naturally through a shot; in other words, giving in to the demons.

But I wish they could come up with another word for it, because it has no similarity to having a piece of prime rib stuck in your throat. Now *that's* choking!

A few broadcasters have a habit that I really hate: they'll approach a player with questions on the driving range as he's preparing to play the final round of a tournament. It's an awkward predicament, especially for a young player, who might not have been in that position before. He doesn't want to turn down the broadcaster, for fear of being thought of as uncooperative, and yet he deserves all that pre-round time to himself, to do whatever he feels is necessary to prepare.

The broadcaster's questioning usually follows this sort of pattern: "Hey, how 'ya doin? Gee, you're playing really well this week. So what are you working on? Who's your teacher? What's the strongest part of your game right now? How will your life change with a victory here? What does it mean to you as a person? Is your family here this week? Are you going to be nervous playing with Curtis Strange and Greg Norman?"

And here's the player hitting short irons to get his muscles in sync, trying to work on up to the driver before he hits a few putts. And he's got this important round to play,

and maybe only thirty minutes of practice time remaining, and his concentration gets shattered by someone who should have gotten this information after the previous day's round when the player was unwinding.

I guarantee, now that I'm announcing more, I'll never bother a player in the hour before he plays. A good rule of thumb for broadcasters is the same one often used by players: you better bring your game to the golf course, because you can't count on finding it once you get there.

A pet peeve of my family and the families and friends of all Tour players is: Why on earth don't the networks show more golfers' scores during the telecast? The networks typically show only the first page of the leaderboard, and occasionally a second and a third page, but they'll seldom run through the entire field more than once. NBC does a ten-minute ticker during a football telecast, which shows the scores of all the games, and I believe the audience would be better served if all the networks had a similar feature for golf. Everyone watching has a favorite player or players, and the odds are they aren't on the first page of the leaderboard during a given week. If they ran the scores on a ticker at the bottom of the screen, it wouldn't interrupt the narrative at all.

I do like most of the instruction that's given during a broadcast, especially Venturi's Stroke-Savers, which are concise and not too complicated to understand. I'd actually like to see the networks offer *more* instruction, because the golfing public is growing so rapidly, and golfers are insatiable when it comes to hearing a new tip to improve their games. It might cut down slightly on the number of live shots, but taping significant shots to show one or two minutes later doesn't hamper a telecast at all. Obviously, all the instruction should be slated prior to the last forty-five minutes of air time.

I'd also like to see the players miked more often, as they are each year in the Skins Game. I recognize that it might turn the telecast into an R-rating, but we could start out miking only the fellows who regularly attend the Bible study sessions on Tour, until the rest of us got used to the idea.

And one final item. It would be great if the networks would use natural sound more often. I just love it when there are no announcers talking, and you see a player setting up to his shot, and you hear the crowd in the background, and birds chirping, and the rustle of his clothes, and then the sound the club makes at contact. Natural sound brings the feel of the tournament into a viewer's living room like nothing else.

CHAPTER 15

The Ryder Cup

I'VE BEEN FORTUNATE to be closely involved with two Ryder Cup matches. The first was in 1985, as a member of the American team that played the Europeans at The Belfry in Sutton Coldfield, England. The second was six years later, as a broadcaster for NBC Sports, in the so-called "War on the Shore" at Kiawah Island in South Carolina.

They were two distinctly different experiences. In the first, I was in the heat of battle, buoyed by all those chest-swelling feelings of national pride. In the second, I watched helplessly from the sidelines, pulling hard for my American pals, but feeling for my European friends as well. Both occasions were full of dramatic moments that created conversation for months afterward, and both left me with strong opinions about the true purpose of this international competition.

I remember how thrilled I was to make the team in 1985. While I hadn't won any tournaments that year, I had lost a playoff to Curtis Strange at the Honda Classic, and had several other top tens. But it was still touch-and-go for

me, heading into the last qualifying tournament, the PGA at Cherry Hills. A tie for 10th there nailed down my spot on the team.

I was really anxious to get to Britain for the competition because my few trips over there had been so enjoyable. This was the year after I'd led the Open in the first round in 1984, and just two months after I'd finished eighth in the Open at Royal St. George's (and gone one-on-one with that streaker).

As much as anything, I liked playing in Britain because the fans were so friendly. They were always quick to applaud a good shot, and showed compassion when a player's luck went bad. The Brits were known for going out of their way to be cordial to American players competing in their most important event. This made what happened at the 1985 Ryder Cup matches at The Belfry all the more surprising: our American team received a less than gracious welcome.

For instance, when Curtis and I were introduced at the first tee of an alternate-shot match, we received only a smattering of applause. You'd have thought they introduced us not as America's Best Golfers, but as America's Most Wanted. Then our opponents, Paul Way and Ian Woosnam, were introduced, and they got a huge ovation. And so it went all weekend. The only times the crowd really cheered an American golfer was when he missed a putt or hit a ball into the water. I understood that national pride was at stake, but this was still just a golf match.

Perhaps the cumulative weight of recent history had finally caved in on the British, because in the thirteen matches before that year, the U.S. team had a record of twelve wins, no losses, and just one tie, even though the European team had been achingly close in the 1983 match, bowing by a 14½–13½ score on American soil. So 1985

was the year the Europeans were certain they could win the Cup, and the crowd was determined to do all it could to help.

I must say it bothered me to be treated that way, after I'd played so well the previous season to win a spot in the competition. It just went against everything I felt the Ryder Cup was supposed to represent, which was a sharing of abilities and a celebration of accomplishment among the top players from the two continents. I thought the matches would have an Olympic Games flavor, in which the competition was intense but the sportsmanship outstanding. The British and American press had stirred up the crowd with a nationalistic furor, however, and I think the gallery's aggressiveness caught even the European team off guard.

The notion that there was strong animosity between the Americans and Europeans had been given wide play in the British tabloids, but was just a figment of some writers' imaginations. I consider guys like Seve Ballesteros, Bernhard Langer, Nick Faldo, Sandy Lyle, and Sam Torrance to be friends, and in nearly every other circumstance in which we play against one another, the nationalism part of it has no relevance. Europe's captain, Tony Jacklin, and players such as Woosnam and Manuel Pinero even apologized to us for the behavior of the fans.

For whatever reason, on the last day our guys had a horrible time on the final nine, and particularly on the 18th hole. Our late collapse caused us to lose several matches, and the Europeans captured the Cup by a score of 16½ to 11½. I lost my own singles match to Sandy Lyle 3 and 2. While it was no fun losing, I didn't feel it was the end of the world, either. In fact, the European victory provided a good boost for international golf, because it pumped a tremendous amount of public interest back into an event that had been totally one-sided for decades.

When the American team lost again in 1987—for the first time ever on American soil—and had another final hole collapse in 1989, which led to a tie and the Europeans retaining the Cup, the media started stoking the fires of nationalism. Several articles appeared that really stuck it to the Americans, and every writer had his own opinion about why the Europeans had regained the upper hand.

I felt there were two basic reasons. The first one was obvious: in 1979, eligibility for the Great Britain–Ireland team was expanded to include all British PGA/European Tournament Players Division members who were residents of European nations. This not only greatly enriched the talent pool but brought in perhaps the fiercest Ryder Cup competitor ever in Ballesteros. His leadership, which inspired other newly eligible teammates such as Langer, Pinero, Jose Maria Canizares, and Jose Maria Olazabal, was analogous to adding Magic Johnson to a basketball team. Not only would Seve win, but he'd raise the level of the other players.

The second reason was more subtle, and dealt with golf course architecture and the type of course we're forced to play all too regularly on the U.S. tour. I'm referring, of course, to target golf courses, about which you've already heard me expound, where the design dictates the style of shot that has to be hit. If you're standing on a tee and you have water in front and back and water to the right and left, there's only one style of shot that will work: the one that goes straight up and down with backspin. The result of playing so many courses like this is that American professionals have, by and large, become very unimaginative golfers. When you play in high wind, you don't want to put the ball in the air. So what have you got on a target golf course when the wind blows? An unplayable course.

They say these target courses require so much skill, but

they actually require less. You don't have to be a great shotmaker, like a Trevino or a Ballesteros or a Watson. The only skill you need is a mental toughness not to let those crazy bounces off railroad ties and humps on the greens drive you nuts. I swear, some of the courses in America have imported so much wood they are in danger of burning down.

As a result, the European players, who by necessity have learned to play all manner of approach shots and pitch-and-run shots, and therefore take a more creative approach to the game in general, had inched ahead of the Americans.

Anyway, after two years of intense hype and analysis and talk of revenge, by the time we got to Kiawah Island in late September 1991, all the players were incredibly uptight and just ready to get on with it. It was really a nerve-wracking week. Little things got magnified, as every journalist from both continents was fighting to get a scoop.

At one point, Paul Azinger heard that Johnny Miller had criticized him during the opening day, and Paul said, under his breath, "Johnny Miller's the biggest moron on the air." A writer overheard it, and it made the papers. Paul, being the classy guy that he is, got up much earlier than normal and went looking for Johnny so he could apologize.

Meantime, Bob Trumpy walked in and picked up the newspaper and inserted a big M in the middle of "moron," and announced to everyone that it had been a misprint, that Azinger had actually called Miller "the biggest Mormon on the air." We all credited Trumpy with the best save of the week, better even than the par that Corey Pavin made on the 17th hole the last day to win his match and earn a crucial point for the U.S. Fortunately, all parties were able to put the incident behind them, but not until entire forests of trees had been sacrificed to provide enough paper to fully critique the episode.

We heard a lot of "Let's kill the Europeans," that week, and flags were being waved everywhere. There were also several allusions to Desert Storm, as though these matches remotely resembled the stakes of the Iraqi conflict. Most of the players felt that everything had been terribly over-blown.

The fact that the matches were played on a Pete Dye course that was very difficult under the best of conditions only added to the stress.

It was by far the toughest assignment I've had in broad-casting. I'm more used to events such as the Skins Game in Palm Springs, where the weather is perfect and the players are in a light mood. The journalistic challenge there usually doesn't reach beyond asking Nicklaus, after he's won five skins with a birdie putt, "Uh, Jack. How does it feel to win $170,000 and a Lady Rolex for Barbara?"

The Ryder Cup, on the other hand, was all business.

Anyway, the design of the course made it difficult on me and my fellow foot soldiers—Mark McCumber, Roger Maltbie, Mark Rolfing and Trumpy—who were tracking the various matches. On both nines, the routing went away from the clubhouse for five holes, then back to it the last four. We would lose power by getting so far from the truck, so we had to carry battery packs around our waist and trek over and through the sand dunes like Rommel through the desert. I was fighting the allergies that had infected my throat, and the sand and dirt did wonders for my voice. My periodic updates sounded like Joe Cocker with a head cold.

Having played in the Ryder Cup the one time, I can say I felt more nervous just watching these matches. That was because all of these guys were my friends, including the Europeans, and I could see how uptight everyone was. The media attention and public interest was greater

than any major championship of which I had been a part.

The last day, naturally, everything was magnified even more. I walked along with the Ballesteros–Wayne Levi match, which had importance beyond its own point value. I said on the air that even though Wayne was not playing well, and was behind in the match at the turn, he could greatly help the American team merely by extending Ballesteros late into the round. As I said, Seve is a great cheerleader and a tremendous motivator to his teammates, and everyone knew that if he won early, he would go back out to the most critical match he could find and give the European player a big morale boost. If you've got Ballesteros standing by your bag looking at you with that gleam in his eye, saying, "C'mon, you can do it!" you're going to hit better shots.

Well, Wayne did just what he needed to. He made a couple of back nine birdies and he had about an eight-footer for par on the 14th hole to pull even. Although he missed the putt and eventually lost, 3 and 2, he still achieved something important by hanging in there like that.

Another outstanding incident was a confrontation between Seve and Ray Floyd on the 16th hole. Mark James was playing Lanny Wadkins; Seve had just finished, and Floyd had lost earlier in the day to Nick Faldo, and they were both on the scene. Mark James hit it over the green into a sandy area, where a lot of people had been tramping over the ground. His ball was sitting down, so he requested a ruling. During play, a competitor is allowed to receive direction only from his team captain, which for the Europeans was Bernard Gallacher, but Seve walked right over and started talking to Mark, trying to pump him up.

Having been the U.S. captain in 1989, Raymond was going to have none of this, so he stepped in there and hit him with the Evil Eye. Seve hesitated, then went back to

talking to Mark again, so Ray turned up the heat about fifty degrees on his glare and took another step forward. Seve could now tell without reservation that Floyd was dead serious, so he sat down and got real quiet. Here were two of the most competitive guys in the history of golf standing jawbone to jawbone. I half-expected them to face away from each other, take six giant steps, turn, and at the count of three, fire!

However, nothing compared to the intensity of the Hale Irwin–Bernhard Langer match coming down the stretch. That was the most dramatic two holes of golf I've ever seen. They came to the 17th hole with Irwin one up, and the U.S. needing him to do no worse than tie his match to reclaim the Ryder Cup. On a nearly impossible hole which required a one-iron shot over water with about a thirty-mile-per-hour crosswind, Irwin missed the green left and Langer hit the fringe on the left side. Hale hit a good chip about eight feet away, but missed the putt, then Bernhard made an absolute must five-footer to stay alive. Those types of putts have less to do with technique than with the size of your heart.

Nearly everybody remembers the last hole. It was as though a Hollywood scriptwriter had penned those last fifteen minutes for the golf movie equivalent of *High Noon* or *Rocky*. It all came down to only lonely man, Bernhard Langer, standing over a six-footer with the fate of two continents in his hands. He makes the putt, and Europe earns a tie and retains the Cup, and the Americans have to listen to two more years of grief from a legion of armchair critics. He misses the putt, and the Americans are heroic and a monkey the size of King Kong is off their backs.

What can you say? Bernhard hit a good putt, and it missed. Never had it been more vividly dramatized that golf is a game of inches. Normally the Cup is determined

while matches are still in progress, so what were the odds when the competition began that it would come down to the last group on the last day with the last player on the last hole hitting the last shot for all the marbles? That's pretty amazing, if you think about it.

To Bernhard's credit, he handled himself beautifully in the moments and days and weeks following the matches. In fact, he won the next tournament in which he played. The guy is a true champion, in every respect.

Anyway, when Langer was over his putt, I was kneeling on the side of the green next to Payne Stewart, Fred Couples, and Mark O'Meara. It was hard to watch. But when it missed and everybody erupted at once, it got downright scary. It was like one of those rock concerts with festival seating. I had the feeling if anybody fell down he'd be trampled to death. And yet I couldn't be concerned about any of that because I wasn't done working. I was hearing Larry Cirillo and Terry O'Neil from NBC yelling through my headphones to grab anybody on either team for an interview.

I managed to get to Mark and Sheryl Calcavecchia, and Mark was about the most relieved guy on the planet. He'd spent the previous hour in a state of despair, thinking he was going to be the goat if the Americans lost. Mark had lost the last four holes to end up tied with Colin Montgomerie, and it looked for a while that the half-point would cost the U.S. Fate had smiled on him, however, just as it had frowned on Bernhard a moment before. Amidst the pandemonium I congratulated Mark for his contributions to the victory, and he thanked me and finished his quart of Pepto-Bismol.

I've been asked a few times whether I was jealous I wasn't on the team. Obviously, I'd rather have been carrying a driver in my hand than a microphone, but I'm not

sure I would have wanted to be in Hale Irwin's shoes playing the 18th hole with all that at stake. I'm a competitor, but I could barely breathe, and all I had to do was walk down the fairway.

It was intense. There's no other word for it.

CHAPTER 16

Off-Camera

TELEVISION HAS CAPTURED many of the great moments in golf over the last two decades, but often it's the subtle moments away from the footlights that are the most character-revealing.

When I started on the Tour at the beginning of 1977, Tom Watson had won just two official titles in the U.S. and one British Open. That season, however, he took off on an incredible eight-year run in which he won twenty-nine times, including two Masters, a U.S. Open, and four more British Opens. He was named Player of the Year six times in that stretch. It's no surprise that Tom quickly became my idol. He was realizing the dreams of every professional golfer, and doing it with style.

I jump at the chance to play practice rounds with Tom because I learn so much just by watching him. He's very aggressive with his swing. He once told me something that he'd learned from Byron Nelson: that it's always better when you're under the heat to hit less club and swing hard,

than it is to take more club and swing soft. With the harder swing, you're more inclined to make a natural, athletic move at the ball.

When Tom was winning everything, I heard him say something at a clinic that went to the heart of his positive attitude. He said it never bothered him to miss a green because one of four things could happen, and three of them were good: he could hole the shot from off the green or out of the bunker, he could hit it close and tap in, he could hit it poorly and make a good putt, or he could hit it poorly and miss the putt. He said if you added up all those scores—a birdie, two pars, and a bogey—it came to even-par. So if you practiced your short game, you had nothing to fear. If I had to choose one player to hit a life-or-death five-foot putt, it would be Tom Watson in his prime. The guy had absolutely no fear.

Tom's always been a manly type of golfer, sort of like Palmer. He's strong, he hits the ball a mile, and he doesn't lag his putts. One day in a practice round at Colonial, we were walking down the second fairway and he said to his caddie Bruce Edwards, "Bruce, give me a Bandit." Bruce flipped him something, which he stuck in his mouth.

I asked him what it was, and he said, "It's a Skoal Bandit. Here, try one." Well, I figured if it was good enough for Watson, then it couldn't hurt Jacobsen. It was a little bag about the size of a Chiclet with tobacco in it, and I stuck it between my cheek and gum just as Tom had done. In about thirty seconds, my mouth was a burning truckload of jalapeñas, and I was spitting and coughing off to the side of the green. My head looked like Linda Blair's just before the priest jumped out the window.

Tom chuckled and looked at me like I was a sissy. The rest of the day, between gulps of water, I watched him with

that Bandit in his mouth, and I never once saw him spit. He apparently swallowed all the juice. That was all the proof I needed that the guy had a cast-iron stomach.

I'm constantly impressed by the ability of Tom Kite to wring the most out of every round. I remember when Bob Gilder holed that shot for double-eagle at Westchester when Kite and I were chasing him. I thought, hey, that's kinda cool—a double-eagle. Then I looked over at Kite, and he had a perturbed look on his face. The only thing Gilder's miracle shot meant to him was that he'd just fallen at least two more strokes behind in his quest to win the tournament. His reaction caused me to question whether I had the right attitude.

Kite is one of the best golfers, pound for pound, that ever played the game. He's earned every single penny of his record winnings through hard work and discipline. Guys like Nicklaus and Palmer give the impression they fell out of their cribs with exceptional ability, an innate talent to win, and all the requisite charisma and class that goes with being a champion. It's second nature to them. But when you look at Tom, you don't think that. If Tom has a fifty-gallon drum of potential, he's using forty-eight gallons of it. Percentage-wise, no one else comes close.

I also want to say that Tom Kite is a tremendous individual. Despite the times he's been overlooked—such as the 1992 Masters and the 1991 Ryder Cup—when he finally won the Open at Pebble Beach he didn't change one bit. That's not always the case. Sometimes guys have personality transplants after they win a major, or they assume their IQ rises as they climb up the money list. The week after Pebble, Tom honored his commitment to play in the Buick Classic at Westchester, even though he probably

would have preferred to go back to Texas and celebrate with his friends and family. As usual, he finished in the Top Ten.

Fuzzy Zoeller is one of the great characters in the game. How many men can say they won both the Masters and the U.S. Open, and gave the gallery some big laughs along the way? One of his classiest moves ever was at Winged Foot in 1984, when Greg Norman holed a putt on the last hole from off the green, with Zoeller watching from the fairway. Fuzzy thought Greg had made birdie, which would likely have won Norman the tournament, so he held a white towel above his head and waved it in surrender. The crowd roared in delight. Actually, Greg had saved par, and they ended up in an eighteen-hole playoff the next day, which Fuzzy won easily by shooting 67. The point is that Fuzzy didn't hang his head when Greg's putt went in; he showed the class of a true sportsman with a great sense of humor.

Fuzzy may be the best needler on the Tour. In the Merrill Lynch Shoot-Outs, he's incorrigible. If he decides to use you as bait for his jokes, you just pray you're eliminated on the first hole, because the abuse you take is not worth the prize money.

Fuzzy tore into Craig Stadler once during our pre-round clinic at the Fred Meyer Challenge. We'd been playing in a lot of rain in the previous weeks, and Craig had been on the road for about two months with the same pair of shoes. Those babies had been through several rain delays and traipsing through mud puddles and they looked more brown than white, with lots of cracks in them. Fuzzy yelled out, "Nice clods, Stadler. Did you get those at a Buster Brown fire sale?"

The Walrus didn't miss a beat. He immediately kicked off his shoes and threw them at Fuzzy and began hitting balls in his stocking feet. Fuzzy picked one of the shoes up, crinkled his nose, and lobbed it and its mate back over his head into the grandstands. I'm certain that to this day those shoes are being worn by some avid golfer at Gopher Creek Muny, who tells his buddies they once belonged to Craig Stadler and were a personal gift to him from Fuzzy Zoeller.

I also remember a time in 1981, just after Bobby Knight's Indiana Hoosiers had beaten Dean Smith's North Carolina Tar Heels in the NCAA basketball finals, that Fuzzy, who's from New Albany, Indiana, showed up at the Greensboro N.C. pro-am wearing a T-shirt that said, "Bobby Knight 1, Dean Smith 0." It was the equivalent of wearing a Black Power shirt to a Ku Klux Klan rally. Somehow, though, with that big grin on his face, Fuz pulled it off without creating a riot.

I can't think of Fuzzy's gesture in the Open without recalling Hale Irwin's monster putt at Medinah in the 1990 U.S. Open and his unbridled hand-slapping lap around the 18th green. Hale didn't know whether the putt meant he'd won or not; he just knew his regulation 72 holes had ended on a big high and that he might have made the biggest putt of his life. The thing I liked about the celebration was that it was purely spontaneous, and it gave so much back to those fans that were there.

Like Raymond Floyd, Hale's a big inspiration to those of us in our late thirties. He's proof that older can mean better if you keep plugging away.

* * *

What stands out about Ben Crenshaw, for me, is his intense love for the history and traditions of the game. A lot of times on the Mondays and Tuesdays before tournaments, when many guys are playing in pro-ams or Shoot-Outs or just working on their yardages or getting the feel of the greens, Ben will go to other golf courses in the area simply because he hasn't played them before. He'll call ahead and set up a game with the host pro or the club champion or just a couple members of the club. He likes to look at all the distinctive design features and learn about the history of the course. Much of what he picks up he incorporates in the courses he designs, such as the spectacular Plantation course at Kapalua.

Because he has such respect for the traditions of golf, I would say Ben's Masters win in 1984 meant more to him than any major has to a player before. Ben had been close in majors so many times, and to win a tournament with that much history was really special.

Of all Mark O'Meara's victories, the one that stands out for me is the 1990 AT&T Pebble Beach National Pro-Am. His father Bob played with him as his partner, and they made the cut. You could sense how proud Bob was walking down the 18th hole the last day with his son in command.

I'll especially remember Mark, and his wife Alicia, for being so nice to my dad when we went to Japan for the U.S. vs. Japan team competition in 1984. They sort of adopted him and did whatever they could to make him comfortable, as did his parents, Bob and Nelda. Dad had had his first cancer surgery and had to be fed with a liquid poured through a tube in his stomach, but even with all his infirmities, he was a great cheerleader and a wonderful

inspiration to the American team, so much so that my teammates named him our honorary captain. When we all toasted sake to celebrate the victory, Dad ignored his doctor's orders and had us pour some through the tube in his stomach. Then he shrugged and said, "Heck with it," and put a cup to his lips. I had to carry him off the team bus and tuck him in bed when we got back to the hotel, but he had a big smile on his face as he fell asleep.

I've told many Lee Trevino stories already, but there's one moment with him I'll never forget. I was having my best tournament ever in 1978 at the B.C. Open, and was in solid contention after two rounds. I found myself paired with Trevino on Saturday—the first time I'd played with him. Going down the ninth fairway, I was three under for the day and Lee was three over. Rather than cop an attitude, though, he said to me, "How long you been out here?" I told him it was my second year. He said, "You've got a good swing. I think you're going to have a good career out here."

That was shocking enough, but then he said, "Look, this isn't my day, but I've had plenty of good ones in the past and I'll have plenty more in the future. Why don't you just win this darned thing?"

I didn't win—Kite did—but I finished third and earned my biggest check ever on the Tour. Even greater than the high finish was the thrill I got from Trevino's generous comment. Since I've gotten to know Lee as a friend through the years, I see how typical that gesture was. Although he guards his privacy, he tries to be nice to everyone. Lee's family comes first with him, but everybody else, whether it's a corporate CEO or the locker room attendant, is tied for second.

* * *

I'd be remiss if I didn't recount an incredible stretch of holes Johnny Miller had with me in the Chrysler Team Championship in 1989. After a poor first 36 holes, we had an equally poor start on Saturday and had no chance of making the 54-hole cut. That is, until Johnny experienced *déjà vu* from the mid-1970s. He birdied five straight, from the ninth to the thirteenth, we parred fourteen, and I birdied fifteen. I then hit a long-iron one foot from the hole at the 220-yard sixteenth. Knowing I had the birdie locked up, Johnny pulled out a one-iron and merely knocked it in the cup for an ace. After a quick celebration, he finished with birdies on the 17th and 18th holes. We had played the last ten holes in ten under par, and Miller had played them in nine-under, to make the cut right on the number.

Don't think for a minute Johnny's all through as a player, just because he's wearing a headset on weekends. If his chronically bad legs hold up, he'll grab his share of victories on the Senior Tour in a few years.

It's fantastic that Gene Sarazen, this rare man who competed head-to-head with the likes of Walter Hagen and Bobby Jones and won all four major professional championships, is still active at ninety. I see Mr. Sarazen at least once a year, at the Masters.

Last year at Augusta, I was in the first twosome to play on Thursday, paired with Dillard Pruitt. When we walked onto the first tee, he was seated chatting with Byron Nelson and Ken Venturi. Sarazen had hit the ceremonial drive off the first tee, and they were sort of holding court. Now, I proudly represent Toyota on the Tour, and as always I

was wearing a Toyota visor. I shook hands with all of the legends, then Mr. Sarazen said (mainly for the benefit of the others), "How much do they pay you to wear that visor, a million bucks?"

His comment kind of took me back, but I just said, "I wish it *was* a million, Mr. Sarazen."

Then he turned around and jokingly said, "Aw, you young kids will put anything on your heads for the right price."

This, of course, got a wry laugh from the others, because when you're ninety years old and as well liked as Gene Sarazen, nearly anything you say is funny.

Although I was thinking that Toyotas didn't exist in his day or he certainly would have accepted their endorsement money, I walked over to my bag, took off my visor, and handed it to Mike. "Mr. Sarazen," I said, "out of respect for you I will play this first hole without my visor."

He just chuckled, but Venturi winked at me, as though I'd done the right thing. I mean what else could I have done? We're talking about a man who had won the U.S. Open seventy years before, in 1922. I'd say that deserves respect.

If ever there was an original on the Tour, it's Chi Chi Rodriguez. Every time I see him, he's surrounded by several kids he's taken under his wing, but it's certainly not just for show. He owns and staffs a youth foundation in Florida, and he constantly imparts wisdom to those children so they can lead constructive lives. He is truly a pied piper.

Last year at the Fred Meyer Challenge clinic, Chi Chi cracked everyone up when Larry Mize was demonstrating

how to chip. "Greg Norman has to turn his head when Larry's chipping," he said, alluding to Mize's miracle shot which robbed Greg of the 1987 Masters. "Greg's the Great White Shark, but I'm the Loan Shark."

I was playing with Chi Chi once when he ripped a five-iron dead at the flag, but the ball landed on the back of the green and bounced over. As he calmly handed his club to his caddy, he said, "Right string, wrong yo-yo."

He also likes to have fun with his impoverished upbringing in Puerto Rico. He says, "Playing golf is not hot work. Cutting sugar cane for a dollar a day—that's hot work. Hotter than my first wristwatch." And, "Everyone knows Arnie Palmer loves Pennzoil. I think he drinks the stuff. And everyone knows he's got that old tractor . . . but I've got the hubcaps."

Isao Aoki may have the best short game in the world, due to a magical touch in his hands and wrists and the fact that he knows how to practice. He's given me bunker lessons through the years which have been very helpful, and he's generously shared time with dozens of other players who aspire to his wizardry around the greens.

One of Aoki's practice techniques in sand traps is to give himself horrible lies. He'll plug the ball or put it in a footprint or on a difficult downhill lie. There's no sand shot he could confront that would be totally unfamiliar.

I'll never forget the 1983 Hawaiian Open, when I played the final round with Jack Renner, in the second to last group. When Jack finished at 19 under par, it looked like he had the tournament won. We were in the scorer's tent signing our cards as Aoki was playing the par-five 18th hole and needing a birdie to tie. But he was lying two in the

rough, some 130 yards from the green. I congratulated Renner, thinking he had probably won the golf tournament or, at worse, was looking at sudden death.

Just then a huge scream went up, and Tom Seaver, who was on NBC's broadcast team, said to me, "It's in!" And Renner turned to me and said, *"Where* is it?" And with a feeling of sympathy, I replied, "It's in." And Jack said, "It's in *what?*" He quickly realized, as the crowd continued to go bananas, exactly where Aoki's shot had gone—right into the hole and right through his heart. Aoki's miracle enabled him to be the first player from Japan ever to win on the PGA Tour.

To Renner's credit, he behaved with great composure, despite the shocking setback. In fact, he returned to Hawaii the next year and won the tournament.

When I first started playing in Europe, Nick Faldo was having a horrible time with the British press and tabloids. The scrutiny on him was intense because he and Sandy Lyle represented Britain's hope for the future. Although Nick had won his share of tournaments, he had also lost some, and the press dubbed him Nick "Foldo." I remember reading these cruel stories and seeing the agony on his face as he withstood the unfair criticism.

Faldo has clearly had the last laugh in every respect, because since 1987 he has won five major championships, and exhibited a sharp sense of humor as well. When Nick won the 1992 British Open with a strong finish, after losing a sizeable final-round lead, he said that had he lost, "I might have become a fishing pro. There's no pressure dragging out trout."

Then he added, alluding to his past treatment, "I'd like to thank the media from the heart of my bottom."

While it's easy to joke after a victory, Nick is also capable of humor in adversity. In the U.S. Open at Pebble Beach, he climbed a tree to try to identify his golf ball on the 14th hole of the second round. Balanced precariously on a limb, he looked around and said, "Where the hell is Jane?" He ended up with a triple-bogey eight, which seriously hurt his chances of winning the tournament, but he could still appreciate the humor of his predicament.

Faldo does things his own way. His caddy, Fannie Sunesson, is the only full-time female caddy among the top players, and Nick and his instructor, David Leadbetter, have elevated the standards of teacher-pupil relationships. Through their joint commitment to excellence, both have reached their common goal—to be the best in the world in their given professions.

There are dozens of Raymond Floyd stories I could tell about heroic moments on the golf course, but most fans already know them. I like one that had nothing to do with golf. Several years ago, we were flying back from the British Open, and I was seated in the row in front of Ray, his wife Maria, and his daughter Christina, who was eight at the time. Christina was intently doing the hair on one of her dolls. I told her that she was quite the hairstylist. She thanked me and asked if she could do mine.

We had a long flight ahead of us, so I thought, why not. Christina moved up and sat next to me and for the next forty-five minutes she put ribbons and barrettes in my hair and gave me the full salon treatment. I stopped her just before she went for the lipstick and eye-liner. I then peered over the seat at Ray to get his opinion of my new coiffure. He just gave me that famous laser stare of his, but he

couldn't hold it. After a few seconds, his face broke into a big grin, and he said, "Peter, you're nuts."

I wish I could have seen Tommy Bolt play in his prime. He was one of the purest ball-strikers ever. I have played with him a few times, however, and watched him hit a lot of balls when I was on the NBC broadcast team at the Legends of Golf in Austin, Texas. There are so many hilarious stories about "Lightning" Bolt's temper that every time he's around, his contemporaries relive a few. I heard this one in the locker room at the Legends:

It seems that back in the 1950s some of the women score keepers who follow along with the players had complained to Tour officials about Tommy passing gas on the golf course . . . loudly. So one of the officials came to Tommy and gave him a warning. He said, "Tommy, if we hear any more complaints, we're going to have to fine you." Tommy just laughed about it. It wasn't like fines were a novelty to Bolt. He included them in his annual budget. Anyway, at the next tournament, sure enough, Tommy's breakfast was not agreeing with him once again, and a woman scorer filed a complaint after the round. Soon thereafter, an official approached Bolt.

"Tommy, we're gonna have to fine you $100," he said.

"What on earth for?" Tommy said. "Simply for doing something natural?"

The official said, "Well, it wasn't so much the farting that upset the lady. It was the fact that you kept lifting your leg and clutching your thigh in celebration."

As Bolt handed over a C-note, he turned to the other two golfers in his threesome, who were falling off their chairs laughing, and said, "Damn, they're trying to take all the color out of the game."

* * *

One year when I was playing in the Johnnie Walker Cup in Madrid, Gary Player and his wife Vivienne invited Jan and me to dinner. We were in a restaurant and Gary was preaching, as he often does, about the benefits of exercise and a proper diet. Suddenly, Vivienne interrupted and said, "C'mon, Gary. Don't bore Peter with these stories."

Then she turned to me and said, "He's not as fanatical as he says. Every time Gary returns to South Africa from the States, he brings an extra bag to carry all the Snickers, Three Musketeers, Kit-Kats, and Reese's Peanut Butter Cups he can smuggle in."

Gary was squirming and trying to get her to stop, but she was on a roll.

"And you know he has a special chocolate cabinet in the house with a lock on it, and whenever he leaves he takes the key," she said. "So one day I picked the lock and took a couple of candy bars. Five minutes after he'd returned, he came to me and said, 'Vivienne, someone's broken into my cabinet and stolen two Snickers bars. I know, because there were thirty-nine when I left and there's only thirty-seven now.' "

Jan and I were cracking up, and by this time so was Gary. "A little sweet tooth won't kill a man," he said, "as long as you do one hundred pushups and eat your granola in the morning."

When Seve Ballesteros is on, he's the most creative player in the game. I've always enjoyed playing with him, and he's even given me a few short-game pointers through the years. Once, in Spain, it backfired on him. In 1981 (the same week Vivienne Player had exposed her husband's one

vice), I won the Johnny Walker Cup. The next year I returned to defend in Barcelona. Seve is far more at ease on his home turf than he is in America. Early in the week he spent an hour and a half with me around a practice green, showing me different chip shots and bunker shots. He gave me pointers on ball position and technique that I still use today. As luck would have it, I was two shots behind him after 54 holes, and caught him the last day to win by one. The pointers he gave me clearly made the difference in the victory, but that shows the level of camaraderie that often exists between players.

Ian Woosnam is a throwback to some of his Irish and Welsh predecessors, who were proud to admit they enjoyed the 19th hole and the camaraderie that accompanies it. In other words, Ian's not averse to taking a sip from time to time with his golfing friends.

There's a story about Woosie being hired by the Sultan of Brunei, reputedly the world's wealthiest man, to give golf lessons to his nephew. The compensation for this instruction would be enough to launch a space program in a small country, but it was just ball-marker change to the Sultan. After all, a golfer ranked number one in the world, as Woosnam was at the time, doesn't come cheap. Anyway, knowing his client might balk at the offer if he knew all the pertinent facts, Ian's agent chose not to inform him that the country of Brunei is much like the state of Utah: drier than a camel's mouth.

Ian wasn't told of this deprivation until he had gotten on the plane to Brunei. Apparently, he avoided any unnecessary temperance by stocking up on the flight, and prevailing upon the "stewardi" to give him all the extra miniature

bottles they could collect. By all accounts, Ian had a great time. There's been no word, however, on whether the Sultan's nephew cured his duck-hook.

The great Scottish player, Sandy Lyle, is one of my favorite people in golf, a man of honesty and integrity. In 1989, for instance, he didn't feel he deserved a spot on the European Ryder Cup team, so he asked not to be considered for one of the captain's selections. That showed real character.

Sometimes Sandy's honesty is very literal. Ask him a question, you get a straight answer.

A few years ago, Tony Jacklin, who had been Sandy's Ryder Cup captain, ran across Lyle in Kennedy Airport. They had not seen each other in months, and Tony was surprised to see his friend in New York. As they passed each other going in opposite directions, Jacklin waved to him and said, "Hey, Sandy, where are you going?"

Sandy replied, "To the toilet."

On another occasion, in 1987, a Jacksonville, Florida, radio personality was interviewing Sandy after winning the Players Championship. Sandy had also won the British Open in 1985. Some people consider The Players to be a fifth major championship, and that was where the interviewer was leading when he asked Lyle, "What's the difference between the British Open and the Players Championship?"

Sandy replied, "About 120 years."

The first time I saw John Cook play was in 1976, when I was caddying for my future brother-in-law, Mike Davis, in the Crosby. I remember this eighteen-year-old kid with

long blond surfer hair playing with the pros, and how he was driving it past them and hitting it every bit as good as they were. He looked like a world-beater even then.

John is yet another example of a player who has learned from adversity and then taken his game to a higher level. After being sidelined most of 1989 by wrist surgery, Cook has played marvelous golf ever since, culminating in his great 1992 season, when he won three times and finished second at the British Open and PGA. John certainly didn't engage in self-pity when he was injured; in fact, he told me it was his most enjoyable year as a professional. He really liked seeing his kids go from day to day and week to week in their daily routines. It was much more rewarding for him than trying to play catch-up on their lives during weeks off his regular Tour schedule, as though he were watching a home video on fast-forward. How well I know. Like the Cooks, we have two girls and a boy, and when I'm gone for three weeks at a time, I feel like I've missed a chunk of life that I can never get back.

Because John has his priorities so well in place, I know he really appreciates his current success.

No American professional has played consistently better than Paul Azinger in the last six years. He's averaged well over $800,000 per season in that time, won eight tournaments, and shown he's bulletproof under pressure, first by beating Seve Ballesteros, and then Jose Maria Olazabal, in Ryder Cup singles matches in 1989 and 1991. But "Zinger" paid his dues to get to his present position. He and his wife Toni traveled the Tour in a motor home for four years in the early 1980s, and were subject to some humiliating incidents.

In 1982, at the Walt Disney World Golf Classic in

Florida, Paul had camped their "home" in the golf course parking lot early in the week. Sure enough, at two in the morning, six hours before an eight A.M. tee time, he got a knock on the door and a Disney World security guard soberly informed him that he'd have to move immediately. Paul explained that he was playing in the golf tournament, but got no sympathy from the guard and was forced to relocate to a church parking lot.

"I was so angry, I went about one mile an hour on my way out," Paul told me, "and that security guard was right on my bumper all the way to the front gate, making sure I didn't flip a U-turn and go back."

Another time, just after Paul had missed a 36-hole cut, he was napping in the back of the motor home as Toni was driving it out of town. She miscalculated and got the vehicle wedged in a toll booth. "The bang was so loud when we hit the overhang that our Persian cat Cleo jumped about two feet in the air and screeched in my face," Paul said. "When we backed out, the whole awning tore off . . . And they talk about the glamour of The Tour."

Azinger cites an off-course incident near the end of the 1986 season as turning his career around. Another player made a disparaging remark in the locker room, with several other players within earshot, suggesting that Paul had intentionally skipped the last tournament of the year so that he could retain a small lead in the Sand Saves statistical category, and thereby win a cash bonus. In reality, Paul had withdrawn from the tournament because his father had suffered a heart attack. Azinger told me his feelings were deeply hurt by the jab, and he determined that he would go about his business the next season with a killer instinct, looking out for only himself. The result was that he won three times, finished second in the British Open, and was named PGA Player of the Year in 1987.

Smiling, Paul said, "I wish I could find someone to tick me off like that again."

Every year at the Colonial there's a dinner honoring all past champions. Each Colonial winner receives a red plaid jacket, which I believe glows in the dark. I'm certain all the 1956 Buicks in Fort Worth are missing their upholstery because it went to make up those sportscoats. Before I won there in 1984, I remember kidding Fuzzy Zoeller on his way to the dinner. "Hey, Fuz, where'd you get the coat? Did you shoot a couch?"

But after I won a coat of my own, it suddenly became the best-looking garment I owned, and each year at the banquet I wear it with pride.

Anyway, Ben Hogan and his wife Valerie always sit on the top dais at the dinner, sometimes next to the defending champion. Although I'd seen Mr. Hogan several times, it wasn't until I was the defender that I got up the courage to introduce myself to him. I'm not one to ask for autographs, but I had him sign a visor for me when all the winners at Colonial posed with him a few years ago at the Wall of Champions. I wore that visor for the entire week of the tournament.

Professional golfers pride themselves on being able to work the ball left or right, hit it high or low, and generally hit whatever shot is required by the circumstance. However, Hogan had standards that were a clear level above everyone else's when it came to ball-striking. From talking to other players, and watching films of him, I believe he came the closest of anyone to hitting perfect golf shots on a consistent basis.

* * *

A trait of most of the great players is that they have to go through fire to get to the promised land. That certainly was the case with Payne Stewart. Before 1989, the caddies called him Avis because he finished second so often. I know that nickname really hurt him. I remember watching him double-bogey the final hole and lose a playoff to Bob Eastwood at the Byron Nelson in 1985, and how down he and his wife, Tracy, were afterwards. He also lost four other playoffs, including two at Colonial, before he won one. Despite those disappointments, though, he always handled himself with a lot of style.

The obvious breakthrough for him was at the PGA at Kemper Lakes in 1989. Although some people say Mike Reid gave away that tournament, don't forget that Payne shot 30 on the final nine and birdied the last hole. It was his great charge that put the heat on Reid.

I had finished earlier that day, and Jan and I were packing to leave our hotel as we watched the finish of the tournament. When Payne won, we decided to cancel the flight and return to the course to celebrate with him and Tracy. When he saw me, he greeted me with a big bear hug and his adrenaline was running so high I thought he'd broken about six of my ribs. We had a few glasses of champagne with them, and Payne's emotions were going up and down the scale. One minute he was high as a kite, and the next sentimental. He was thinking of his father, whom he'd lost to cancer a few years before. I could feel nothing but joy for my friend, who had at last made it through the fire to the promised land.

I got my first look at Curtis Strange when he won the 1974 NCAA title in San Diego as a freshman. He came to the last hole, a par-five, and was one behind Florida's Phil Hancock

individually. He was told that a par would be good enough to win the team title. All Curtis did was hit a one-iron about eight feet from the hole and make the putt for eagle—to lock up both the team and individual titles.

When he failed to repeat as NCAA champion the following year, a writer said to him, "You can't win them all." Curtis stared a hole through him and said, "Why not?"

The next year I went to Japan with him as part of an American college all-star team, and on a cold, windy day when everyone was shooting 74s and 75s, Curtis went at it with Masahiro Kuramoto, who, incidentally, was co-medalist at the 1992 PGA Tour qualifier. The guy is about five-three with massive forearms, and he was by far the best college player the Japanese had to offer. They just kept firing away at each other and both ended up shooting 64. Neither one budged an inch. Curtis, it goes without saying, has industrial-strength testicles.

Curtis and Sarah traveled a lot with Jan and me when we were both starting out, and neither of us had any money. In Milwaukee we got fifteen-dollar-per-night rooms at the Edge-O-Town Motel—that was the actual name of it. To save money on food, we carried a portable hibachi on our travels, and one night had a cook-out on the corner down by the Pepsi machine. People kept walking by in bathrobes to fill up their buckets at the ice machine. That Friday, after we'd both made the cut, we celebrated in style—by dining out at the local pizza parlor.

What a contrast to a couple of years later, when Curtis and I went with then-touring pro Ron Cerrudo to a tournament hosted by the King of Morocco. It was quite a culture shock. For instance, we got in trouble for paying our teenage caddies a couple hundred bucks apiece; we had been instructed to pay them only three dollars a day, but we had felt that wasn't enough. It turned out it was so as not to create

disharmony in their families—we had given them more money than their fathers made in an entire month!

We both finished in the top ten at that tournament, which meant we would be honored at the awards ceremony. Lee Trevino won, and was presented with an incredible jeweled saber from the King. It was inlaid with diamonds, rubies, and emeralds and must have been worth $50,000.

Curtis and I were drinking Moroccan beer, which will put hair on your teeth, and as the ceremony crept along, we couldn't hold it any longer and snuck out to the john. Our timing when we returned was not good. We walked back in just as the Prince and his entourage were making their grand entrance, and these rough-looking security guards grabbed us and demanded to know who we were and what we were doing. The movie *Midnight Express* had just been released, and it flashed in my mind that they were going to throw us into some Moroccan prison and violate us horribly and bite off our tongues. I remember thinking, why, oh why, did we have to finish in the top ten? Fortunately, everything was cleared up, and we were allowed back in. But we didn't drink any more Moroccan beer that night, I can tell you.

I love to kid Curtis about having uttered a few choice words on camera through the years. In the 1989 PGA, he called an intrusive photographer a son of a bitch, with a live mike about ten feet away. Two weeks later, we were at the Fred Meyer Challenge, when I called Curtis up at the clinic to hit a few. As he began to speak, I grabbed the microphone from him and said I couldn't trust him with it, what with all the women and children in attendance.

He took it good-naturedly, of course. Why, you can barely see the cleat-marks on my back anymore.

CHAPTER 17

A Candle in the Wind

THERE'S A LOT OF LEVITY and joy that goes with being a professional golfer, not to mention the many privileges afforded those who achieve success at the top levels of the sport. I've tried to bring to life in this book the flavor of several of these funny and triumphant moments.

But it would be misrepresenting the whole experience of the PGA Tour to imply that the men who compete out here are somehow exempt from the pain and sorrow of everyday living. Like all the players, I'm reminded from time to time that what we do every day—often with the solemn demeanor of heart surgeons—is nothing more than a game, and that the genuine business of life takes place outside the ropes, far removed from all the lights and cameras. This chapter is about the real world.

A lot of people know my older brother David. He played a year ahead of me on the University of Oregon golf team, and is still an excellent player in the Pacific Northwest.

David has competed in the U.S. Amateur, was a semifinalist in the U.S. Mid-Amateur a few years ago, and when I'm home and we play practice rounds together, I have to play my best or David will beat me out of my last month's Tour winnings.

My sister, Susie, is also a fine athlete, with a large circle of friends. Susie earned eleven varsity letters in high school and was all-state in lacrosse at Pitzer College in California. She twice played in the U.S. Junior and U.S. Women's Amateur golf championships and reached the semifinals of the Oregon women's amateur when she was just fifteen. She had the potential to play professional golf.

Much less is known about my younger brother, Paul, and there are reasons for that. Paul elected to live his life in relative quiet, apart from all the fuss and bother that I've come to accept as routine. I've never spoken publicly about Paul because I felt his story had to be told at the proper time and in the proper context. This book is the right place to tell Paul's story.

In one sense, it has nothing to do with my life as a golfer; in another, it has everything.

Peter and Paul: the two names are linked together all the way back to the Bible, and when brothers just two years apart are given those names, comparisons are inevitable. As much as every parent aspires to equal treatment of all their children in a good-sized family, it's impossible to ensure that each child gets his full share of attention. In Paul's case, I think it was difficult, because he had two very active older brothers to follow and to be compared against. David and I were both athletic, and involved in golf and other sports. We were both sports editors of the high school paper and took part in a number of other school activities. We made friends easily and had a relatively carefree time of it.

Paul, on the other hand, didn't care much for sports, and

was more introverted by nature. He had to listen to friends and teachers constantly asking, "Why aren't you like your older brothers?"

As the third boy in the Jacobsen family a lot was expected of Paul, and he just couldn't or didn't want to live up to it. So he went his own way, and, as too often happens these days, he eventually fell into problems with drugs.

As we got older, Paul and I drifted apart. We still loved each other, and stayed in contact, and I would hear from his friends that he was proud of what I had done in my career, but it was difficult for him to express that pride directly to me. It was very important to Paul that he establish his own identity. He didn't want to stay in Portland and have to be pestered with questions about being Peter's brother, and why Peter missed that five-footer on television last week, and all the other burdens that David and Susie put up with all the time.

So he moved to Los Angeles and got a job as a graphic artist, and did some modeling on the side. In Southern California he could be just Paul Jacobsen, and have his own life. I thought it was a courageous thing to do, and I admired him for it.

However, there was a certain tension between Paul and the rest of the family that wouldn't go away. When Jan and I would go to Los Angeles each year for the L.A. Open, it seemed that Paul was usually too busy to come out to the course to watch me play. It was his way of telling me that his life was much more important than coming to a golf tournament, and I understood. We would always talk on the phone when we were in town, but that was about it.

About ten years ago, when Paul was twenty-six, he just blurted something out in a phone conversation with me. "You know I'm gay, don't you?" he said.

And I told him that, of course, I knew, and that it was

no big deal to me. Although I was surprised that he had told me so suddenly, I was glad for him that he could get it off his chest. It meant he was coming to grips with his life and facing who he was.

Paul's problems with drugs and alcohol grew worse through the years, and it was not uncommon for us to get phone calls from him at three or four in the morning. These would start out normally enough, with "Hi, how're ya doin'," then quickly deteriorate into bouts of ranting at us about all the problems in his life. He would get irrational and start calling us names. Mom and Dad would get the calls, or David or Susie, or whomever he could reach on the phone. He was using a lot of cocaine during the day, and drinking vodka at night to come down from it, and just hurling himself around on this emotional rollercoaster.

It got so bad in late 1987 that we checked him into the Betty Ford Clinic in Palm Springs. Thankfully, through the good work of the people there, Paul got clean. He seemed to be getting his life back on track in 1988, when I got the phone call that changed everything.

It was August 24, the day after the Fred Meyer Challenge. Mom called to say that Paul had been admitted to the hospital with pneumonia. Jan and I were immediately concerned that he might have AIDS. I called Paul and he sounded upbeat and said he thought he'd been living on too fast a track and needed to slow down and rest. He even talked about moving back to the Northwest. However, by the next week, when I was in Toronto for the Canadian Open, the news was all bad. Paul did, in fact, have AIDS and had been admitted to the intensive care unit at Cedars Sinai Hospital. I was worthless in Canada, and withdrew after shooting a first-round 79. My mind had never been further from a golf course than it was that day.

I flew back to Portland, and Jan and I caught the first flight to Los Angeles to be with Paul.

I had heard from friends that Paul's weight was down, and that he had not been in good health for a while, but seeing him in the hospital was a shock. I hadn't seen him since we'd checked him into the Betty Ford Center eight months before, and it was obvious that his condition was critical. He had lost a lot of weight and was extremely gaunt. In hindsight, I think Paul had known he was seriously ill for months before he was tested, but his fear of learning the truth was so great that he put off going to the doctor. By the time he was examined, he had full-blown AIDS.

Despite his drug problems, Paul had always stayed in shape with regular exercise, but now he was so thin and pale. He had lost more than thirty pounds off a slight frame. It broke my heart to see him. I told Jan that we better put all our plans on hold, because we really needed to be with Paul.

An especially vivid memory is of walking into his room and seeing him hooked up to a respirator. He looked up at me with terror in his eyes. Then he wrote something on a pad and handed it to me. It said, "Peter, you can do anything. Please make this go away."

My eyes filled with tears, then Paul put his arms around me and hugged me real tight. It was the most powerless feeling I'd ever had. Here, my kid brother was telling me I could do anything, but there wasn't a damn thing I could do to help him when he most needed it. I couldn't find anything to say, and I started to cry. I finally choked out something like, "Paul, we'll do everything we can for you."

The poor guy was just so scared and desperate. I'll never forget that look in his eyes.

I stayed in his room for several hours at a time, and we all took turns being with him. Then we'd return to the hotel, catch a nap, and go back. Just the third day after we'd arrived, Paul took a horrible turn for the worse. He'd been fighting the respirator, which, of course, he needed to keep breathing, and the doctors had just started using a paralyzing drug on him so that his body would relax and he'd be better able to fight the pneumonia. Then he suddenly slipped into a coma.

We went home that evening, aware that the end was near. It was September 5, just twelve days after I'd been told of Paul's illness and only a week since he'd been diagnosed. I was sound asleep when something unusual happened. At exactly one-thirty in the morning, I woke up suddenly and felt a fluttering movement inside my body. I asked Jan to turn on the light, and I told her that Paul was with us.

I said, "He's inside of me."

"Are you all right?" she asked.

I was oddly at peace. I told her that Paul had come there to tell me everything was okay, and that he was fine. I also told her I just wanted to lie there for a moment and feel the spirit of my brother, because that's exactly what it was. Paul's spirit was with me, and it was comforting.

I remember the fluttering movement didn't go away, it was almost like butterflies inside of me, and then I faded off to sleep. When I awoke the next morning, Jan asked if I remembered waking up the previous night, and I recalled it all perfectly. I told her Paul had come to visit me, and that he was finally out of his pain, but that he had left something with me.

That morning I called one of Paul's close friends, who lives on a farm in the state of Washington, and before she heard my experience she told me that she had been awak-

ened the previous night by an owl that had flown down and landed on her open windowsill and started to hoot into the room. An owl is universally regarded as a sign of death. I asked her what time it had happened, and she said one-thirty.

Later in the day, I talked to Paul's roommate, and he said that the dog and cat had been going crazy all week without Paul there, and that the animals had been keeping him awake at night. But at one-thirty in the morning, they had suddenly calmed down. He said he felt Paul's spirit had been with them.

It's extraordinary that three different people who were close to my brother—one of them a thousand miles away—felt his presence at the same time.

When we went to the hospital, one of Paul's nurses told me that his vital signs had dropped sharply at one-thirty in the morning. "In my opinion, he has left us," she said.

Paul never came out of his coma, and died peacefully later that day. He was thirty-two years old.

The sorrow of his death was eased for me by the certain knowledge that he'd visited me. Paul had said something to me that night that I remember distinctly. "Peter, you're okay just the way you are," he said. "Be nice to people and don't let anything get you down." And then he said, "Go out there and win. Just go out there and win."

The official cause of Paul's death listed on the certificate was pneumonia, so it was never revealed in the Portland newspaper that he had died of AIDS. That was because Paul told me he didn't want my children or David's children, all of whom were very young, to have to deal with the stigma of his disease. Paul knew that kids can be cruel about things like that, and he was sensitive enough to want the cause of his death concealed until David and I felt the children were ready to hear about it. We told my oldest

daughter Amy, who is now twelve, but we waited to tell the others until this book was published.

Naturally, we told the true circumstances of Paul's illness to his close friends and our relatives immediately after he died.

We had a small burial service for him in Hollywood, as he'd requested, and a larger service at Trinity Church in Portland. All the family members spoke, even my dad. Although Paul and Dad had had a rocky relationship, it was important to my father to make some final comments about his youngest son.

There was my dad in his fourth year of fighting cancer, with half his tongue removed, speaking to all assembled about the death of his youngest son, and how he loved him. Dad's speech was hard to understand, but the message wasn't in his words anyway. It was in the courage he showed just being up there.

While there's a lot more awareness of the AIDS epidemic today than there was even five years ago, due in large measure to the courageous actions of athletes such as Magic Johnson and Arthur Ashe, our administration and all citizens need to do much, much more. We respond quickly in sudden disasters such as earthquakes and hurricanes, which rip through communities and leave devastation behind, but we're so much slower in reacting to this epidemic, which will kill tens of millions before it's contained. We must put aside our personal feelings about drug abuse and homosexuality, and recognize that the effect of AIDS is the same as a hurricane. Our brothers and sisters are dying, and their dignity is being sacrificed as well.

I can only hope that the day is not far off when this horrible disease doesn't have to be a source of shame to those who suffer and die from it.

* * *

Our family struggled for quite a while after Paul's death to make sense of what had happened. I knew that all I could do was try to honor his life by carrying forward with the message he'd given me: just to be myself and go out and win.

While I hadn't won on the PGA Tour since 1984, I had been close on several occasions. I'd had something like seven runnerup finishes in the past five years. But I won the Isuzu Kapalua International in November of 1989, and then, in a victory that was extra-special, I won the Bob Hope Chrysler Classic two months later, playing the final round on the PGA West/Palmer Course. Coincidentally, the last round of golf I'd ever played with Paul was sixteen months before on that very course. My dad was also with us.

I struggled with that realization the entire last round. I was paired with Steve Elkington and Mike Reid, and had a two-shot lead, but I was also wrestling with vivid memories of playing the Palmer course with Paul and Dad. Every time my mind would wander and I would think about Paul, I'd hear him say, "Don't think about me. I'm fine. Just go out and win." That thought carried me all day.

When I birdied the last hole to win, David, who had come to Palm Springs for the week, gave me a big hug, and I said, "I sure wish Dad and Paul were here to see this."

And David said, "Paul saw every shot. I think he helped you keep that last three-iron on line."

Then all of a sudden I was surrounded by media, and presented the crystal by Bob and Dolores Hope, and flash bulbs were popping and a big check was being held up, and all the other hoopla was taking place that goes with a victory. But inside I still had all these sad, quiet thoughts

that I couldn't talk about. I did mention Paul briefly in the press conference, but I shared only a small part of what was on my mind.

I waited until now to tell the rest.

Afterword

ALTHOUGH SOME PEOPLE may see the game of golf as repetitious—chasing a stupid ball with a stick—or intrusive, as in Mark Twain's definition, "Golf is a good walk spoiled," I find it endlessly fascinating. You never hit the same shot twice in your life. A four-foot putt from the identical spot may move differently in the afternoon than in the morning because of the shadows, or the traffic that's passed through in the interim.

Like life, golf is a constant struggle, but the mistakes we make are really just opportunities to learn and grow. Bruce Cudd, a former Walker Cup player and touring professional from Portland, told me when I joined the Tour, "Peter, remember never to look back when you've finished a tournament. Simply sign the card, cash your check, and move on. Rehashing missed opportunities will only eat you alive."

I've tried to follow Bruce's advice, and shake off adversity in pursuit of a better tomorrow. I've also remembered my father's last comment to me, that humor is the most important part of golf.

This book has provided an opportunity for me to reflect

on hundreds of memorable moments in my life, and made me realize the large debt of gratitude I owe to so many people.

Thanks first to all the professional golfers who came before me, whose skill and charisma made the PGA Tour the wonderful traveling show it is today. Thanks also to the many people who've helped me pursue my dreams.

I'd like to thank Hughes Norton, my manager, for taking a gamble on an unknown kid from Oregon.

Also, a nod to all those knowledgeable golf professionals who were instrumental in the development of my game:

Jack Doss, the former head pro at Waverley, was always willing to work with me as a junior player, to help me develop good swing habits and reinforce positive thinking. Every time I had a competition, Jack was willing to watch me hit balls beforehand, and keep my mind on track. He had a courteous, classy style that demonstrated great pride in his profession.

I learned a great deal from a professional named Marlow Quick, the head pro at Astoria Country Club on the Oregon coast where we spent our summers. Marlow was the consummate club pro: a good instructor, a really fine player, a great storyteller, and even a trick-shot artist. Mostly, I remember that Marlow always made golf fun, something for which I'm greatly indebted to him today.

All kids have somebody they look up to and say, gee, I wonder if I could ever be that good. For me, that was Pat Fitzsimons, who as a young player from Salem, Oregon, won everything in sight. I remember distinctly when I was about fourteen, watching Fitz and Bob Duden walking down an adjacent fairway with a loyal gallery braving the rains. Duden had won the Oregon Open so many times they'd lost count, and here was this seventeen-year-old kid with red hair and glasses beating him in a head-to-head

showdown. I though that was just awesome, that a kid just a little older than myself could whip all the best players in the area and win the state open. I remember feeling a little ache in my stomach, which were the seeds of a desire to improve my own game and see if I could ever get that good.

It's great how things work out sometimes. Now Pat Fitzsimons is a good friend and the head pro of our new course, the Oregon Golf Club.

But I'll always look at him and see that seventeen-year-old kid who was able to whip the old pro.

And there were so many others: Buck McKendrick, Jon Peterson, Claude Harmon, Dick Harmon, Bob Ellsworth, Jerry Mowlds, Mike Davis, Tim Berg, Jimmy Ballard, John Rhodes, David Leadbetter, Joanne Beddow, Randy Henry, Ross Henry, Bob Torrance, Jim McLean, Dave Glenz, Jim Hardy, Carol Mann, Dave Pelz, and Pat Rielly.

My gratitude also to my original sponsors: Peter Murphy, Don McKellar, Norm Parsons, Gay Davis, Mark Johnson, Ed Stanley, Bill Swindells, Jr., Harry Kane, Maury Pruitt, Will Gonyea, J. H. Gonyea, Bob Wilhelm, John Tennant, Bob Benjamin, Bill Kilkenny, and Rich Guggenheim.

A big thank-you to Bob McCurry, Vice-Chairman of Toyota Motor Sales U.S.A., who was so kind to me during the latter stages of my father's illness. Thanks also to Phil Knight of Nike for his belief in golf. And to Ben Bidwell, my partner in the Chrysler Team Championship days and a charter member of team "No-Name." And to Dennis Rose and Thos Rohr at Waikoloa Resort, for a slice of heaven.

Thanks to my mother, Barbara, for her love and support of all my endeavors, no matter how offbeat. And to An-

nabelle and Esley Davis, the greatest in-laws a guy could have.

Most importantly, thanks to Jan, who is everything to me—my wife, my lover, my best friend, and the perfect mother to our children. Thanks for your love, respect, patience, and understanding. I couldn't have done any of it without you.

To Amy, Kristen and Mickey, thanks for understanding your old man's obsession with a silly game.

And finally, a special thanks to my friend Chuck Hogan, who has taken my most stubborn muscle—my brain—and gotten it in sync. I can still consistently hole invisible putts from ten feet.

Gunga-la-Gunga.

FOR THE BEST IN PAPERBACKS, LOOK FOR THE 🐧

In every corner of the world, on every subject under the sun, Penguin represents quality and variety—the very best in publishing today.

For complete information about books available from Penguin—including Pelicans, Puffins, Peregrines, and Penguin Classics—and how to order them, write to us at the appropriate address below. Please note that for copyright reasons the selection of books varies from country to country.

In the United Kingdom: For a complete list of books available from Penguin in the U.K., please write to *Dept E.P., Penguin Books Ltd, Harmondsworth, Middlesex, UB7 0DA.*

In the United States: For a complete list of books available from Penguin in the U.S., please write to *Consumer Sales, Penguin USA, P.O. Box 999— Dept. 17109, Bergenfield, New Jersey 07621-0120.* VISA and MasterCard holders call 1-800-253-6476 to order all Penguin titles.

In Canada: For a complete list of books available from Penguin in Canada, please write to *Penguin Books Canada Ltd, 10 Alcorn Avenue, Suite 300, Toronto, Ontario, Canada M4V 3B2.*

In Australia: For a complete list of books available from Penguin in Australia, please write to the *Marketing Department, Penguin Books Ltd, P.O. Box 257, Ringwood, Victoria 3134.*

In New Zealand: For a complete list of books available from Penguin in New Zealand, please write to the *Marketing Department, Penguin Books (NZ) Ltd, Private Bag, Takapuna, Auckland 9.*

In India: For a complete list of books available from Penguin, please write to *Penguin Overseas Ltd, 706 Eros Apartments, 56 Nehru Place, New Delhi, 110019.*

In Holland: For a complete list of books available from Penguin in Holland, please write to *Penguin Books Nederland B.V., Postbus 195, NL-1380AD Weesp, Netherlands.*

In Germany: For a complete list of books available from Penguin, please write to *Penguin Books Ltd, Friedrichstrasse 10-12, D-6000 Frankfurt Main I, Federal Republic of Germany.*

In Spain: For a complete list of books available from Penguin in Spain, please write to *Longman, Penguin España, Calle San Nicolas 15, E-28013 Madrid, Spain.*

In Japan: For a complete list of books available from Penguin in Japan, please write to *Longman Penguin Japan Co Ltd, Yamaguchi Building, 2-12-9 Kanda Jimbocho, Chiyoda-Ku, Tokyo 101, Japan.*